D. C.

A CAPITOL HILL

B CONNECTICUT AVENUE

C THE ELLIPSE

D THE FEDERAL TRIANGLE

E GEORGE WASHINGTON MEMORIAL PARKWAY

F JUDICIARY SQUARE

G THE MALL

H MASSACHUSETTS AVENUE, NW

I NORTH CAPITOL STREET

J PENNSYLVANIA AVENUE, NW

K POTOMAC PARK

L SIXTEENTH STREET

M VIRGINIA AVENUE

N WISCONSIN AVENUE

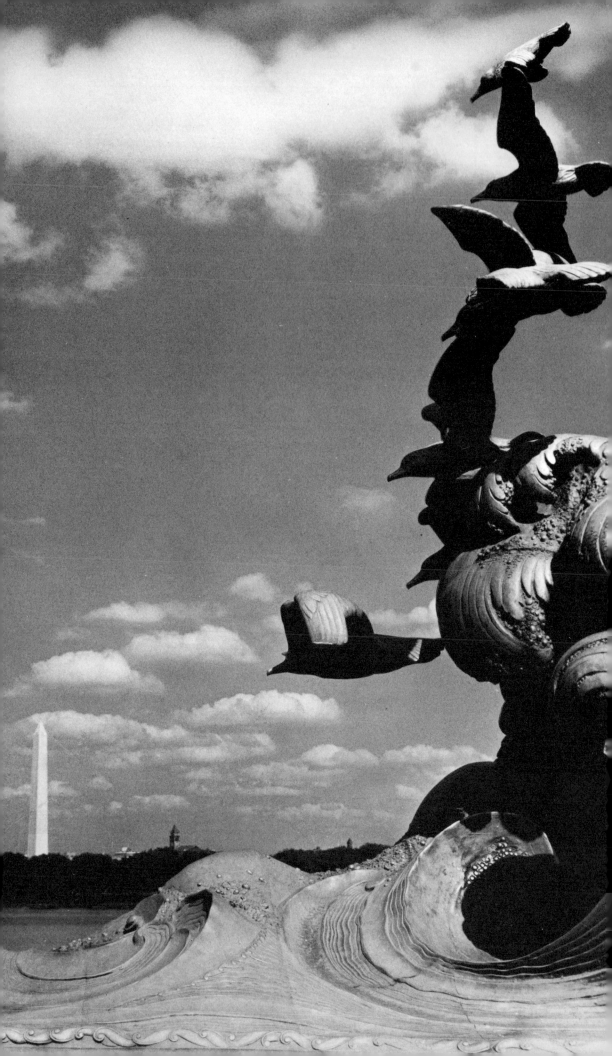

James M. Goode

THE

OUTDOOR

Smithsonian # SCULPTURE

Institution Press # OF

Washington, D.C. # WASHINGTON,

1974 # D.C. *A Comprehensive Historical Guide*

Copyright © 1974 James M. Goode
Smithsonian Institution Press Publication Number 4829
Designed by Elizabeth Sur
Printed in the United States by Stephenson Lithograph, Inc.
Distributed in the United States and Canada by George Braziller, Inc.
Distributed throughout the rest of the world by Feffer and Simons, Inc.
First edition
Second printing

Library of Congress Cataloging in Publication Data
Goode, James M.
The outdoor sculpture of Washington, D.C.
Bibliography: p.
1. Washington, D.C.—Monuments. I. Title.
NB235.W3G66 917.53 74-5111
ISBN 0-87474-138-6
ISBN 0-87474-149-1 (pbk)

Cover: The Court of Neptune Fountain by Roland Hinton Perry
Frontispiece: Navy-Marine Memorial by Ernesto Begni del Piatta

Support for the publication of this volume was provided by
The Barra Foundation, Inc.

DEDICATED

TO

ALL

WASHINGTONIANS

COMMITTED

TO

PRESERVING

THE

ARCHITECTURAL

AND

SCULPTURAL

HERITAGE

OF

OUR

NATION'S

CAPITAL

CONTENTS

FOREWORD

THE STUDY OF THE SCULPTURE of the Nation's Capital is a subject of growing interest, from both the historic and the artistic viewpoints. This is the first book to appear which presents an organized, comprehensive approach. The author's diligent research in uncovering data and lesser known sculpture and in adding information about major works gives a depth and breadth of treatment which should appeal not only to varied popular interests but also will offer a useful supplement to architectural and other studies of Washington, D.C. Since this is a pioneer effort, it undoubtedly will provide motivation and possible guidelines for future studies in other cities.

Curator of the Smithsonian Institution's historic "Castle," James M. Goode, the author, is well-suited for the project. In this capacity, he has developed sculpture tours of the city over the past four years and has had access to research sources, personnel, and other facilities in governmental and related agencies. Over four hundred examples of sculpture in the greater Washington metropolitan area are presented, including, in addition to important equestrian and free standing portrait sculpture, lesser known architectural, fountain, cemetery, animal, and abstract works. Not only were these sculptures examined for condition, medium, inscriptions, and placement, but also photographed, measured, assessed according to style, and researched for supporting documentary data relative to the artist, subject, and commissioning.

In his book, Mr. Goode has arranged the city and its environs into fourteen geographical areas, with an indication of which section is best seen on foot or by automobile. Each of the fourteen areas is preceded by a detailed map noting the locations of all sculpture mentioned and including a brief historical sketch of that section of the city. All sculptural examples are illustrated, with some having an additional detail or unusual view. The majority of the photographs have been taken recently, expressly for this publication, and, where appropriate, many old and rare photographs have been used for historic interest.

The Introduction contains a section on the importance of the cemetery as an incentive and repository for American sculpture, followed by notes on post-Civil War and contemporary sculpture in Washington, D. C. Comments are made on types of subjects portrayed in monumental sculpture, the appropriateness of the design, and modern problems—for example, the effects of pollution, and the steps necessary before a public statue may be erected in Washington, D. C. A plea is made for better maintenance of existing works and consideration for revised landscape settings for sculpture located in areas where the growth of the city has altered their effectiveness. A glossary of technical terms is also included.

The appearance of a handbook of this type and scope—particularly in an age which has seen so much of the past destroyed on the one hand, yet, paradoxically, which has also experienced a dramatic increase of interest in American art—is both timely and welcome, fulfilling as it does a definite need.

FRANCIS S. GRUBAR
Chairman, Art Department, The George Washington University
December 10, 1973

PREFACE

THE PREPARATION OF THIS MANUSCRIPT for eventual publication began in 1970 following a six-hour tour of portrait statues in downtown Washington, D.C., which I conducted for some thirty members of the Smithsonian Associates. The purpose of this original sculpture tour was to acquaint Washingtonians with the brief history of some fifty portrait statues and with the significance which the persons represented played in American history. This was one of several historical tours which I have organized during the past four years relating to the architectural history of the Nation's Capital and nearby towns in Virginia and Maryland. The Smithsonian Associates have sponsored numerous tours of this nature, conducted by Washington architect Francis D. Lethbridge; Mr. Charles Atherton, Mr. Donald Myers, and Mr. Sibley Jennings of the United States Fine Arts Commission; and my colleagues at the Smithsonian Institution—Mr. Herbert Collins, Dr. Richard H. Howland, and Dr. Harold K. Skramstad, Jr. I am indebted to those members of the Smithsonian Associates who, four years ago, suggested that I expand my research into a historical guide to the outdoor sculpture of the entire city. Because of the lack of published sources on this subject, over a dozen research assistants and I have devoted thousands of hours first in actual walking around the city to locate all types of outdoor sculpture and then in searching the records and files of many government and private institutions for the history of each work.

The plan of the City of Washington as laid out by French engineer Pierre L'Enfant, with the assistance of George Washington, Thomas Jefferson, and other leaders of the young republic, is ideal for the placement of outdoor sculpture. His grid system of streets, with numbered streets running from north to south and alphabetical streets running east to west and his diagonal avenues named for the states of the Union, resulted in the creation of a multitude of circles, squares, and pocket parks throughout the capital. In these oases of green have been placed many of the statues honoring American heroes for the past 120 years. In addition to the placement of these sculptures on federal lands, many more have been erected by the hundreds of foreign embassies and national organizations with headquarters in the Nation's Capital. The upkeep of these monuments, both by private parties and by the National Park Service, often working within a meager budget, has been surprisingly good.

An attempt has been made to select examples of all types of sculpture to indicate the rich variety found here, much of which is frequently overlooked by the area resident and the visitor alike. For the most part, these outdoor sculptures are all within the "Washington Beltway," or major express highway which circumscribes the outer edge of the city. The limitation of space in this book, however, has necessitated the omission of scores of minor sculptures found in Washington cemeteries, on buildings, and on the grounds of private residences. Likewise, other sculptures, such as the many abstract works in the courtyard at the National Collection of Fine Arts, Smithsonian Institution, Eighth and G Streets, NW, and those on the rear lawn of the Textile Museum, 2320 S Street, NW, are not included because they are temporary displays that change from time to time. These sculp-

tures, as well as those within the courtyards of other Washington buildings, can be seen during normal week-day working hours unless otherwise noted.

In most cases the detailed photographs exclude the pedestal or building on which the outdoor sculpture appears, in order to focus on the work itself. Many views of the entire buildings concerned can be found in *A Guide to the Architecture of Washington, D.C.*, compiled by the Washington Metropolitan Chapter of the American Institute of Architects and edited by Washington architect Hugh Newell Jacobsen. Because of the difficulty of measuring many outdoor sculptures in the city, I have frequently cited only the approximate measurements. The reader thus can judge the general scale of each piece although adjacent buildings have been omitted.

I have also attempted to refrain from making value judgments for most of the sculptures included here, since the purpose of this volume is a historical account of the sculpture itself and of the person or event memorialized rather than an artistic survey. There is a tremendous need today for both historical guides and aesthetic studies of the outdoor sculpture of all major American cities. In recent years there have been published small historical guides to the outdoor sculpture in the cities of Boston, Massachusetts; Fresno, California; Ottawa, Canada; and London, England. A similar work is being prepared for the city of Philadelphia, Pennsylvania, by the Fairmount Park Art Association. It is encouraging to note that Professor James L. Riedy, of Mayfair College of the City Colleges of Chicago, Illinois, is nearing completion of a comprehensive historical guide to the outdoor sculpture of Chicago. Other scholars, such as Professor Francis Grubar, chairman of the Art Department of The George Washington University; Mr. Michael Richman of the National Portrait Gallery of the Smithsonian Institution; Professor William H. Gerdts of Brooklyn College; Professor Wayne Craven of the University of Delaware; and others have recently undertaken extensive studies of outdoor American sculpture. Indeed, Professor Craven's recent comprehensive work, *Sculpture in America*, and his establishment of the Index of American Sculpture at the University of Delaware, have laid a sound foundation for scholarly research in this field.

With the passage of time, new sculptures will be erected and old ones relocated in Washington, necessitating revisions to this work should a second edition be published. Hopefully, this book will bring about, in a small way, a better appreciation of outdoor sculpture and American history in the Nation's Capital and begin a movement for other guidebooks on this subject in other major American cities. Indeed, we can all learn from the stories each sculpture has to tell, such as the allegorical statue *Heritage*, by James Earle Fraser at the National Archives, which bears the inscription: "The Heritage of the Past is the Seed That Brings Forth the Harvest of the Future."

JAMES M. GOODE
November 24, 1973
Washington, D.C.

ACKNOWLEDGMENTS

THE LONG AND OFTEN TEDIOUS preparation of this volume would have been impossible without the aid of a number of dedicated research assistants. I am deeply indebted to Mr. William O. Baxter, Mrs. Tanya Beauchamp, Miss Mary Brady, Mrs. Esther P. Brabson, Miss Cynthia Keller, Mr. Douglas Kellner, Miss Judith Kozfawski, Susan and Bruce Lehman, Mrs. Mary V. Lindberg, Mr. Peter Maxson, Miss Katherine Menz, Mrs. Julia Randall, Mrs. Clifford F. Ransom, Mrs. Ruth Rose, Miss Frances Sears, Mr. Larry Steele, and Miss Sharon Stein. In addition to spending long hours in the archives of many government and private organizations, several of these staff members have rendered invaluable aid by measuring dozens of sculptures while others assisted with the actual preparation of the manuscript. Mrs. Lindberg was most helpful in offering improvements to the style of the manuscript.

My colleagues at the Smithsonian Institution have assisted in innumerable ways. I am indebted to S. Dillon Ripley, Secretary, for his interest and support of the manuscript for publication. Others who have given advice and shared their knowledge of American history have been Dr. Richard H. Howland, Office of the Secretary; Dr. Harold Skramstad, Jr., Mr. Donald E. Kloster, and Mr. Philip K. Lundeberg of the National Museum of History and Technology; Dr. Thomas Lawton of the Freer Gallery of Art; Mr. Lynford E. Kautz, Mr. Henry Steele, and Miss Patricia Wilkinson of the Office of Development; Dr. Joshua Taylor, Mr. William H. Truettner, and Mr. Russell Burke of the National Collection of Fine Arts; Mr. Michael Richman, Mrs. Mona L. Dearborn, and Mrs. Genevieve A. Stephenson (retired) of the National Portrait Gallery; Mr. William Walker, Mrs. Joyce M. Chisley, and Mrs. Sara B. Hanan of the National Collection of Fine Arts/National Portrait Gallery Library; and the late Mr. Douglas G. MacAgy of the Joseph H. Hirshhorn Museum and Sculpture Garden.

The untiring assistance of the personnel of local institutions and agencies in making available their records concerning outdoor sculpture in Washington include Mrs. Florian Thayn, Office of the Architect of the Capitol; Miss Virginia Daiker, Dr. Alan Fern, Miss Helen-Anne Hilker, and Mrs. Francis D. Lethbridge of the Library of Congress; Miss Josephine Cobb (retired), Mr. Richard Maxwell, Miss Charlotte Palmer, Mr. Charles Thomas, and Mr. Steven Lee Carson of the National Archives; Mr. M. Garnett McCoy and Mrs. Beverley H. Smith of the Archives of American Art; Mr. Robert A. Truax of the Columbia Historical Society; Miss Jean Sachs and Mr. Karel Yasko of the Fine Arts and Historic Preservation Office of the General Services Administration; Miss Jeanne Butler and Mr. George Pettengill of the American Institute of Architects; Mr. Charles Atherton, Mr. Sibley Jennings, Mr. Donald Myer, and Miss Lynda Smith of the United States Fine Arts Commission; and Miss Susan Shivers (retired) and Miss Betty Culpepper of the Washingtoniana Collection of the Martin Luther King Jr. Public Library. Records of considerable value for this study which were located outside of the city of Washington were made available by Mrs. Howard M. Stein and Miss Theodora Morgan of the National Sculpture Society in New York and Professor Wayne Craven, who shared the records of the Index of American Sculpture with me at the University of Delaware. Help was also generously rendered by Miss

Sandra Alley, Mr. Russell Dickerson, and Mr. Earl Kittelman of the National Capital Parks of the National Park Service; Mr. Richard T. Feller of the Washington Cathedral; and Miss Susanne Ganschinietz of the National Capital Planning Commission. I appreciate the comments and suggestions made by Washington architects Hugh Newell Jacobsen and Francis D. Lethbridge.

The tabulation of outdoor sculpture in Washington was made much easier through the previous studies on this subject by Mr. William Arnheim, Mr. DeWayne Cuthbertson, Mr. Michael Richman, and Mr. Bruce Moore. Dr. Francis O'Connor shared with me his research on the American Art Deco sculpture in the city and Mr. Patrick Butler was helpful through his expert knowledge of colonial American tombstone sculpture. A number of sculptors of Washington works have shared their information and memories with me, including Mr. Felix de Weldon, Mr. Edmond Amateis, Mr. Carl Paul Jennewein, the late Mr. Carl Mose, and Mr. Raymond Kaskey.

The staffs of many private organizations in the city, including the Organization of American States, the Daughters of the American Revolution, the Pan American Health Organization, the National Guard Association of the United States, Dumbarton Oaks of Harvard University, the Folger Shakespeare Library, the American Legion, and many, many others have generously shared their records. Numerous entries for mortuary sculpture would have been completely void without the kindness of the superintendents of the Arlington National Cemetery, Congressional Cemetery, Glenwood Cemetery, National Memorial Park, Oak Hill Cemetery, and Rock Creek Cemetery.

The staffs of many embassies, including those of Indonesia, Australia, Great Britain, Iran, The Netherlands, Switzerland, and Venezuela, have assisted by securing information on foreign sculptors with works in Washington. The staffs of the picture sections of the *Washington Post* and the *Washington Star-News* have located a number of valuable early photographs used here.

I am also indebted to my many Georgetown neighbors who have assisted me by reading the seemingly endless pages of galley proofs, including Ella Atkins, Nancy Belden, Betsy Gainey, Mark and Sally Grunewald, David Thomas Jones, Jon Keenan, Stefani Ledewitz, Jan Richter, James Schumaker, and Chad Snee. Others included Joann Brabson Conrad, Rose Rita Fanger, and Gerald Holmes.

An important part of the book is the collection of handsome photographs taken by Mr. David Blume. For many weekends during the past two years Mr. Blume has walked across rooftops, rowed on the Potomac River, suspended himself from ladders, and stood in the middle of busy avenues in order to assemble the fine collection of pictures in this book. Because of the difficulty caused by the reflection of the sun on marble and granite and bronze sculptures, he has had to photograph a number of works as many as five times, often at different seasons of the year, in order to secure fine impressions. His enthusiasm and devotion to this project have indeed bolstered my own efforts when it appeared that the project would never reach completion.

I have deeply benefited by the assistance of Professor Francis Grubar, chairman of the Art Department of The George Washington University. Professor Grubar, who has taught hundreds of students in his courses on the history of American sculpture during the past ten years at both the University of Maryland and The George Washington University, has taken a great deal of time from his busy schedule to read this manuscript and to offer critical suggestions. I have also benefited from the use of his valuable private files on Washington sculpture. The president of the National Sculpture Society, Mr. Robert A. Weinman, has also rendered valuable aid in reading the manuscript and in offering suggestions.

Many long-time Washingtonians have supplied me with information on their own sculptures or with the history of the city, including Mrs. Calvert Carey, Mrs. Katherine McCook Knox, Mr. David Lloyd Kreeger, Mrs. Jefferson Patterson, Mrs. George Renchard, Mrs. Demaris Craig, Mrs. John Patterson, and Mr. John Brennan.

The publication of this volume would have been impossible without a generous grant from The Barra Foundation, Inc. of Philadelphia. Both Mr. Robert L. McNeil, Jr., and Mrs. Gail H. Schmidt of The Barra Foundation have taken a personal interest in this project.

Finally, I could not conclude any acknowledgment without a special word of thanks to Mr. Gordon Hubel, director of the Smithsonian Institution Press, who has shown a constant faith in the educational value and usefulness of this work. The many hours which Mrs. Nancy Link Powars, editor, and Mrs. Betty Sur, designer, have spent, not only in their official capacities but also during their free time, in advising me on ways to improve the layout and organization of this work are greatly appreciated. Their many years of experience have enriched the book in countless ways. I am also indebted for the well-designed special area maps prepared by Mr. Stephen Kraft of the Smithsonian Institution Press. The book would not have been possible without the generosity of dozens of people, not mentioned by name here, who have germinated inspiration and assisted in innumerable ways, and who all have one thing in common: a love of American history and a fascination with the study of the development of one of our Nation's most beautiful cities—Washington, D.C.

INTRODUCTION

WASHINGTON, D. C., IS A CITY OF GREAT BEAUTY, and a part of this beauty may be found in the hundreds of outdoor sculptures embellishing its buildings, its parks, it avenues, and its cemeteries. Even though many of these sculptures are significant for their stylistic designs, they deserve equal attention for their historical messages. A study of the individual history of each work often contains rewarding insight into the numerous great men and events that have molded our culture since Columbus first landed in the New World.

The Outdoor Sculpture of Washington, D.C. is the most comprehensive historical guide published on the outdoor sculpture of any city in North America. This book traces the history and significance of over 400 open-air sculptures in the metropolitan area, treating not only allegorical, portrait, and equestrian statues and sculpture groups,. but other consistently overlooked types of sculpture, such as fountain, animal, abstract, cemetery, and architectural sculptures. The latter category, architectural sculpture, consists of pediments, doors, relief panels, keystones, and other related works, such as flagpole bases and spandrel figures. Of all these, the most important category, historically, remains the free standing portrait statue and the equestrian statue.

Early American Sculptors before 1830

An account of the outdoor sculpture in Washington, D.C., would be incomplete without brief mention of the early historical developments of the art of sculpture elsewhere in America. Before the Civil War, the development of sculpture in America fell into three general categories: primitive and folk art sculptures by native Americans, 1650 to 1830; memorials executed by professional European sculptors for American cities, 1760 to 1830; and the rise to prominence of the first group of professional American sculptors in the three decades prior to the Civil War.

One of the first attempts at sculpture by native Americans involved the carving of low reliefs on sandstone, limestone, and slate tombstones in New England and elsewhere in the colonies. The seventeenth-century stones, of which slate was the most popular and permanent, consisted of incised lines carved at the top and sides of the slab, illustrating through symbols the terror of death and the fleetness of time for man on earth. The motifs consisted of winged skulls, hourglasses, death heads, crossed bones, skeletons carrying the "dart of death" while attempting to snuff out the candle of life, and Father Time carrying his scythe and the peculiarly American abstract designs of pinwheels, rosettes, and other stylized motifs. The art of portrait sculpture began in the early eighteenth century when crudely designed heads of the deceased began to appear at the top of the slabs. The development of more elaborate cemetery sculpture was closely connected with the rise of a prosperous and educated upper middle class in the colonies. With the arrival of the dignified Neoclassical style during the last half of the eighteenth century, American stonecarvers began using such symbols as the draped urn, the weeping willow tree, the reversed torch, and classical architectural designs.

The woodcarver was the second type of early native American sculptor. In the seventeenth century flat geometric designs were commonly carved in New England on such items as Bible-boxes and chests.

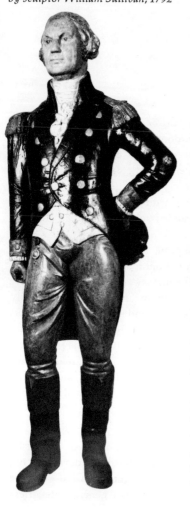

Painted wood portrait statue of
General George Washington
by sculptor William Sullivan, 1792

By 1730 American woodcarvers were beginning to carve elaborate designs on such furnishings as chairs, chests, and fireplace mantles, often copied from English design books. Elaborate woodwork was frequently carved for many of the fine Georgian mansions of the prosperous merchants, shippers, and planters; motifs included the egg-and-dart, acanthus leaves, and elaborate festoons of flowers and vines. Both the Hammond-Harwood House and the Chase-Lloyd House by William Buckland in nearby Annapolis, Maryland, are good examples of this style. Simeon Skillin and his sons carved dozens of fine ship figureheads in the Boston area during the late colonial period. Samuel McIntire of Salem, Massachusetts, who executed relief carvings for cornices, mantlepieces, and masterpieces of Chippendale furniture, was also noteworthy. Joseph Wilson carved many wooden portrait statues in Newburyport, Massachusetts, for the residence of Timothy Dexter. One of the last great woodcarvers was William Rush of Philadelphia who executed some of the finest ship figureheads in America in the late eighteenth century and early nineteenth century.

The 9½-foot-high statue of *George Washington* by William Sullivan for Bowling Green Square in lower Manhattan, New York City, was one of the most impressive vernacular carvings in the eighteenth century. The wooden statue, painted in bright colors, remained at this site from 1792 until 1843, when it was sold at auction by the city. The work was being used as an advertisement for a Manhattan barbershop when discovered by T. Coleman duPont in 1912. DuPont purchased it and donated the statue to the Historical Society of Delaware in Wilmington, where it remains preserved.

The third sculpture medium in early America consisted of wax portrait busts and profile medallions. Patience Lovell Wright of Bordertown, New Jersey, and New York City, completed a number of fine wax busts before she moved to London in 1772 to open another studio. All of these vernacular styles, executed in slate, wood, and wax were important in the development of American sculpture, for they were the major examples of the art which most Americans saw.

European Sculptors in America before 1830

Before 1830 most monumental sculptures in America were executed by some two dozen professional English, French, and Italian sculptors, working both here and in their studios in Europe. In addition, other early works were created by several sculptors who emigrated from Germany, Ireland, and Scotland. A number of English sculptors were commissioned to execute memorial statues for the American colonies. Joseph Wilton, sculptor to His Majesty, George III, executed a gilded lead equestrian statue of *George III* for New York City. It portrayed the king in Roman toga, crowned with a laurel wreath, and astride a horse, probably inspired by the earlier Roman equestrian statue of *Emperor Marcus Aurelius* in Compidoglio, Rome. A second work by Wilton, a marble portrait statue of *William Pitt*, also was dedicated in New York City in 1770. The equestrian statue of *George III* unfortunately was destroyed by a mob of patriots at the outbreak of the Revolutionary War and was melted down into some 40,000 lead bullets for the Continental Army. Only a few fragments remain today in the New-York Historical Society. The Pitt statue, although damaged in retaliation by British troops, during the occupation of New York City a short while later, has been preserved in the New-York Historical Society. A copy of the Pitt statue was placed in Charleston, South Carolina, the same year that the original was erected in New York. The work remains in place there although damaged by a British cannonball during the Revolutionary War. A fourth early sculpture, a marble portrait statue of the popular royal governor of Virginia, *Norborne Berkeley, Baron de Botetourt*, was executed in England by Richard Hayward for Williamsburg in 1773. This work, like the others, also was mutilated during the

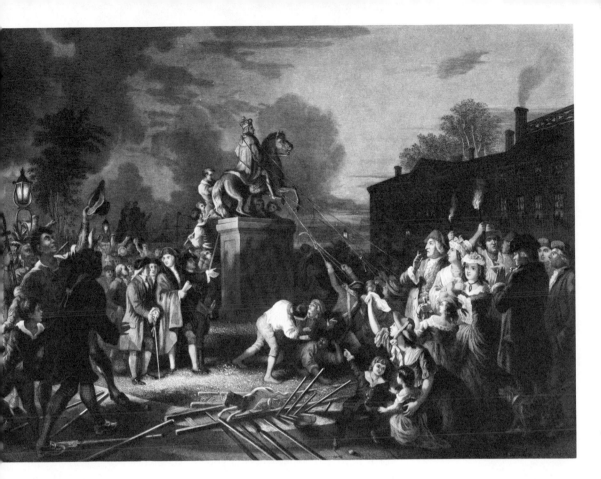

Revolutionary War. Several decades later, in 1802, a colossal statue of
William Penn was sent from London to adorn the Pennsylvania Hos-
pital Building in Philadelphia.

Several significant sculptures were executed by French artists dur-
ing the Revolutionary War and soon afterwards. The American Con-
gress commissioned Paris sculptor Jean Jacques Caffiere to design a
portrait of *Major General Richard Montgomery*, which was completed
in France in 1778 and finally erected in New York City in 1789. Jean
Antoine Houdon, the most celebrated European sculptor of the last
quarter of the eighteenth century, came to America in 1785 after re-
ceiving a commission from the Virginia legislature for a statue of
George Washington. Houdon's famous full-length marble portrait of
George Washington, incorporating the features of the sculptor's life
mask of the "father of his country," remains in place in the Virginia
capitol in Richmond. In addition, Houdon executed portrait busts of
Benjamin Franklin, Thomas Jefferson, John Paul Jones, and others.

Italian sculptors were responsible, however, for the majority of
sculptures executed for America before 1830. Philadelphia received a
handsome life-size marble statue of *Benjamin Franklin* by Francesco
Lazzarini in 1792. In 1791 Giuseppe Ceracchi arrived in America from
Rome to seek a commission for a huge allegorical statue of Liberty from
Congress. Although he failed to receive this appointment, he did exe-
cute a number of busts of prominent statesmen, such as *Alexander
Hamilton, David Rittenhouse, George Clinton,* and *George Washing-
ton*. The works by both Houdon and Ceracchi were especially im-
portant in providing excellent examples of sculpture for aspiring native
American sculptors to study.

Although Philadelphia and New York were the artistic centers of the
Nation during the Federal period (1783–1820), the work produced by
many Italian sculptors on the United States Capitol in Washington,
D.C., between 1806 and 1840 was of considerable importance. Archi-
tect of the Capitol Benjamin Latrobe successfully induced Giuseppe

Franzoni and Giovanni Andrei to come to Washington, D.C., to work on various decorative sculptures in 1806. The work of these two men on the United States Capitol and on major buildings in Baltimore was all in the Neoclassical style. This style was especially acceptable in the United States because of the popular political and philosophical identification of the young American government with that of the ancient Roman republic. Unfortunately, many of these early works were destroyed when British troops burned the Capitol during their occupation of Washington in August 1814. Following the War of 1812, Latrobe sent Andrei back to Italy to bring other sculptors to work on the Capitol. Most of these reliefs, sculpture groups, and architectural sculptures, by Carlo Franzoni, Enrico Causici, and Luigi Persico, can still be seen in place within that structure. Luigi Persico was especially important because of the exterior sculpture he executed for the Capitol: *The Genius of America* pediment, 1825–1828; the statues *War* and *Peace*, ca. 1835; and *The Discovery*, a sculpture group executed in 1837–1844 and now in storage. In addition to their work in Washington, D.C., these artists executed a number of important sculptures for the city of Baltimore. Perhaps the most impressive was the work by Giovanni Andrei on the new Baltimore Cathedral in 1809, Enrico Causici's colossal statue of *George Washington* atop the Washington Monument at Mt. Vernon Place in 1829, and the sculptural elements on the Battle Monument done under the direction of Maximilian Godefroy.

A number of important sculptures were executed for the impressive new Greek Revival state capitol buildings in the United States in the 1820s by European sculptors. Following Virginia's lead, the state of North Carolina commissioned a portrait statue of *George Washington* for the rotunda of its new capitol in Raleigh. A seated George Washington, clad in toga and sandals, was completed by Europe's most outstanding Neoclassical sculptor of that era, Antonio Canova, and shipped to America in 1822. In this provincial town of 2,000 people was located one of the finest works of sculpture in North America. Unfortunately, this work was virtually destroyed when the state house burned in 1831. (A marble copy, made from Canova's original model, however, has been replaced in the old North Carolina Capitol in recent years.) A third statue of *George Washington* was executed for the new Massachusetts State House in Boston by Sir Francis Chantrey, England's leading sculptor, in 1826. Bertel Thorwaldsen, the famous Danish Neoclassical sculptor, was also supposed to do a sculpture of Washington, but the project never materialized.

The First Professional American Sculptors

There were very few professional American sculptors executing marble or bronze monuments before 1830. First, there were no schools or studios to turn to for training on this side of the Atlantic. A second important reason was the lack of bronze foundries and marble quarries. The means of transporting materials needed for the execution of sculpture was still crude. No large corps of highly skilled marble carvers, such as one could expect to find easily in Rome, Florence, or Paris, existed to assist an American sculptor. The skilled native American stonecarvers then at work spent most of their time on portrait busts, cameos, and cemetery monuments, and were usually not sufficiently trained to execute monumental sculptures.

By the 1830s, several factors occurred which helped to change these conditions and to foster sculpture in the United States and in Washington, D.C., in particular. During this decade, transportation was greatly improved by the spread of both railroads and canals along the East Coast. Locally, the expansion of the nearby Baltimore and Ohio Railroad, the first in the Nation in 1828, and the Chesapeake and Ohio Canal, begun in the District of Columbia in 1832, greatly increased

communications and commerce between Washington, D.C., and other eastern seaboard cities. Also, economic conditions improved with the termination of the War of 1812 and the commencement of new industries in the northern states. An era of nationalism swept the new country in the 1820s and a need arose to memorialize American heroes. Soon both the national and state governments, with more plentiful funds available for art works for the first time, began to seek native Americans to execute statues of prominent American statesmen and military heroes. The first Americans then began traveling to Italy to learn the art of sculpting.

The loss of the North Carolina statue of *George Washington* by the celebrated Canova was considered a national disaster and had a direct effect on the United States Congress commissioning a new statue of General George Washington for the United States Capitol in Washington, D.C. For the first time the federal government commissioned an American sculptor, Horatio Greenough of Boston, then studying sculpture in Rome, to execute a commemorative work. Since politicians controlled the allocations and subject matter, it is not surprising that the bulk of nineteenth-century sculpture honored politicians and military figures. With sculptors receiving considerable sums for public monuments, from Greenough's *George Washington* of the 1840s down through the century, a whole group of talented and ambitious Americans were attracted to careers in sculpture. Thus the ante-bellum American sculptor's path was well laid out: he would follow the accepted Neoclassical style after the Italian masters, use marble or bronze as a medium, and depict military heroes and statesmen, often clothed in antique garb.

The City of Washington is indeed fortunate in possessing many original works by America's first professional sculptors. In addition to Greenough's statue of a seated George Washington, now located in the National Museum of History and Technology of the Smithsonian Institution, Thomas Crawford's important sculptures on the United States Capitol remain securely in place. One of the original copies of Hiram Powers's *Greek Slave* rests in the Corcoran Gallery of Art. The first wave of American sculptors, including these three, went to Florence and Rome to perfect their art in marble. After 1850, American sculptors began to learn the art of casting in bronze on a large scale for the first time. Although most American sculptors had their early bronzes cast at the leading foundries in Rome and Munich, several—Clark Mills, Henry Kirke Brown, and John Quincy Adams Ward—were the first to cast their bronzes in the United States in the 1850s. Washington, D.C., contains early works of all three of these sculptors.

The first outdoor sculpture in Washington was the *Tripoli Monument*, commissioned privately by American naval officers in Italy to honor the fallen heroes of the Tripolitan War of 1804–1805 in North Africa. This monument, a sculpture group, was erected in 1807 in the Navy Yard on Capitol Hill. After serving as a decorative piece adjacent to the west front of the Capitol Building, it was moved in 1860 to the United States Naval Academy grounds in Annapolis, Maryland, where it can be seen today. As mentioned earlier, a group of foreign stone-carvers was imported to work on the Capitol during the first half of the nineteenth century. Other ante-bellum Washington, D.C., sculptures included a portrait statue of *Thomas Jefferson* in bronze executed in Paris by the celebrated David d'Angers and located on the north lawn of the White House in 1847, and Clark Mills' equestrian statues of *General Andrew Jackson,* 1853, and of *General George Washington,* 1860, on Pennsylvania Avenue. The *Andrew Jackson Downing Urn* by Calvert Vaux, 1856, helped to embellish the Mall, while over a hundred sculptured monuments were erected in Washington's cemeteries between 1809 and 1861.

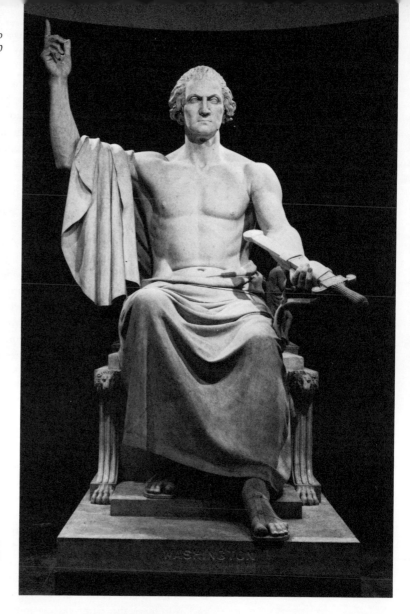

George Washington by Horatio Greenough, 1840

Clark Mills is shown standing in front of his brick octagon-shaped bronze foundry, ca. 1862, on Bladensburg Road, NE. In this building he cast the bronze statue of Freedom for the Capitol dome

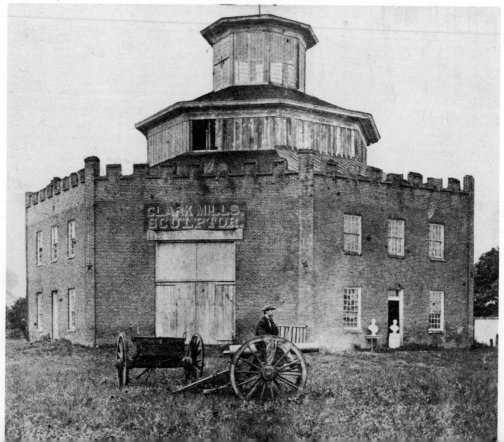

*Exhibition of **The Greek Slave** by Hiram Powers in 1858*

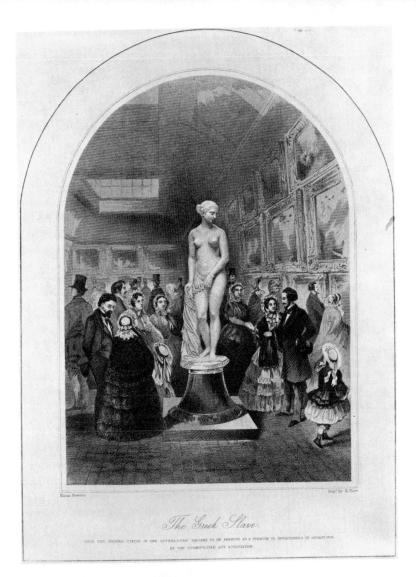

One of the earliest collections of sculpture on public view in Washington was the sculpture gallery in the west range of the Smithsonian Institution Building, as shown in this 1856 photograph

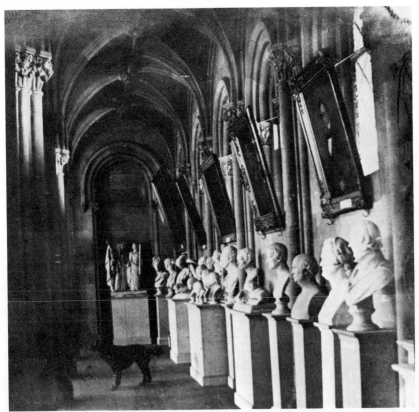

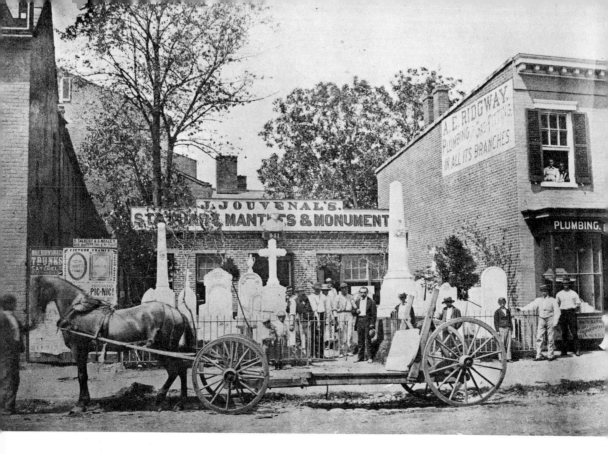

The Importance of the American Rural Cemetery

The development of the American cemetery played an important part in fostering sculpture in eastern cities in the three decades before the Civil War. Early cemeteries in Washington are an untapped museum for the study of art motifs in stone. Amid this wake of mournful and sentimental monuments, angels prayed, willows wept, doves descended, lambs slept, and broken shafts pointed toward heaven. The concept of the "rural cemetery," so important to sculptural development in Washington, D.C., was advocated in 1831 by Jacob Bigelow, a prominent Boston physician. Bigelow reasoned that additional burials in the overcrowded Boston churchyards were a menace to community health. He and other community leaders organized the Mount Auburn Cemetery Company in the Cambridge countryside by the Charles River. This cemetery contained carefully landscaped walks and botanical gardens and doubled as a park retreat for city dwellers. Mount Auburn soon became a kind of sculpture garden as wealthy families vied with one another for grand and complex monuments. Rural cemeteries, such as Philadelphia's Laurel Hill, New York's Greenwood, Richmond's Hollywood, and Washington's Oak Hill, were ante-bellum forerunners of the planned city park. Early guidebooks often lavished more space on the local cemetery than on any other subject, pointing out the various grassy glades, rustic dells, and the best hills from which to view the "marble city." These cemeteries were considered incomplete without elaborate winding paths, lakes, landscaped terraces, gate houses, and chapels, often designed in the romantic early Victorian Gothic, Italianate, and Romanesque Revival styles.

Post-Civil War Sculpture in Washington, D.C.

With the close of the Civil War a new era for sculpture arrived in Washington, D.C. Both Congress and the numerous veterans groups granted large commissions for equestrian statues to honor the victorious Union generals. Because Washington, D.C., was the capital of the Union during the Civil War, it held a partisan position relative to the conflict; this explains the quantity of statues of Union military figures and the almost total absence of outdoor Confederate figures.

Left: Many of the cemetery
monuments in Washington were
produced by the firm of Jacques
Jouvenal's Marble Works during
the 1860s and 1870s. This photo-
graph, ca. 1875, shows the staff and
shop at 941 D Street, NW

Correspondingly, the modern-day visitor to the former capital of the Confederacy, Richmond, Virginia, can find a multitude of statues of Confederate generals. Sculpture became a peculiarly Victorian "event." This meant that the dedication of a statue often resulted in the closing of all businesses, with crowds of 20,000 or more attending the band concerts, parades, and marathon speeches that accompanied nineteenth-century dedications in Washington. During this productive post-Civil War era, Washington, D.C., acquired a large number of important statues by the country's most outstanding sculptors. The Capital City's claim today to having the largest number of equestrian statues of any city on the continent is primarily a result of the large number of statues of this type erected during the last three decades of the nineteenth century. Vinnie Ream Hoxie, born in Madison, Wisconsin, but a long-time resident of Washington, became one of the first professional woman sculptors to execute memorial statues in the Nation at this time. Indeed, periods of peace and prosperity after major wars have been the greatest contributor to the growth of Washington's marble and bronze population. Some members of the second generation of American sculptors, who created most of these works, rejected the Neoclassicism so popular before the Civil War and turned to American ideals. They frequently pictured Americans dressed naturally and engaged in realistic activities. Another important change occurred in the 1870s when Paris replaced Rome and Florence as the center of sculpture training. Americans went to France to study the Beaux-Arts style. In place of Roman togas, American heroes came dressed in military uniforms executed in scrupulous detail.

One of the great American sculptors to emerge from this new school of the last quarter of the nineteenth century, Augustus Saint-Gaudens, caught the spirit of his time and translated it into bronze. Born in Ireland, Saint-Gaudens was reared in New York City. He financed his education in Paris by working long hours at night producing cameos and busts. Saint-Gaudens mastered all of the techniques then known in Europe and produced statues reflecting the rugged individuality so crucial to the American dream. His timeless Adams Memorial in Rock Creek Cemetery remains one of the favorites of all outdoor sculptures to Washingtonians. Saint-Gaudens clearly left his mark on Washington, D.C., for during his reign as dean of American sculpture, he inspired such artists as Daniel Chester French, Frederick MacMonnies, James Earle Fraser, Charles Henry Niehaus, and Gutzon Borglum. All of these sculptors produced many works for the Capital City from 1900 until the 1930s.

Modern Sculpture in the Nation's Capital

The development of outdoor sculpture changed greatly in the 1930s. Although Neoclassical and Beaux-Arts influences continued to dominate American sculpture until after World War I, a major change came with the Depression. Sculpture received a tremendous financial boost throughout the United States, and in particular in Washington, D.C., from the New Deal government agencies which employed both painters and sculptors who were without jobs. The nine New Deal art agencies, most of which were headed by Edward Bruce and Holger Cahill, extended from December 1933 to June 1943. Most of these bureaus existed for only two years, after which they were superseded by another agency. Perhaps the most prominent of these bureaus were the Works Progress Administration; Federal Arts Projects, 1935–1939; and the Treasury Section of Painting and Sculpture, 1934–1938. Thousands of unemployed painters and sculptors were commissioned to execute murals and modern sculptures for schools, post offices, hospitals, airports, and other government buildings under construction. The freedom of expression permitted the artists was one of the finest features of these programs. These works, forgotten since World War II, are now being

cataloged and preserved by the General Services Administration of the federal government. Scores of Neoclassical and Art Deco architectural sculptures were produced during this period for both the exterior and interior of the handsome granite Federal Triangle Buildings between Constitution Avenue and Pennsylvania Avenue in downtown Washington.

The arrival of the new stark and austere glass office buildings in the 1940s spelled an end to most architectural sculpture in Washington. No longer were grand terra-cotta friezes, such as those found on the Pension Building, produced for local structures. Indeed, the richness of the architectural sculpture found on many of the late nineteenth-century and early twentieth-century buildings in Washington, D.C., is very important. The Library of Congress Main Building possesses a vast array of granite busts, sculptured keystones, spandrel figures, bronze doors, pediments, and lamppole bases. The fourteen buildings of the grand Federal Triangle complex contain the finest single collection of sculptured Neoclassical pediments in any one place in the Nation. The many late nineteenth-century private residences still standing in the Judiciary Square and Dupont Circle areas contain dozens of important terra-cotta and granite sculptured architectural details. All of these and many more buildings in Washington deserve detailed studies before the wrecking balls take their toll in the name of progress. In recent years the National Trust for Historic Preservation and several local groups, such as Don't Tear It Down, Inc., the Georgetown Citizens' Association, and the Capitol Hill Restoration Society, have fought, with some success, to save many noteworthy structures.

The early 1960s brought the first dramatic reflections of change in the nature of art, witnessed in this century, to the outdoor sculpture of Washington. American sculptors now are not always required to create monumental sculptures in the Neoclassical manner required of their nineteenth-century and early twentieth-century counterparts. The marble and bronze renditions of idealized heroes in carefully executed uniforms, or the togas and honorary laurel wreaths of antiquity, are less frequently produced in the 1970s. Today the meanings of the Classical and Biblical themes and symbols which were so familiar to the public until the early twentieth century are generally obscure, or altogether forgotten. The works of Alexander Calder, George Rickey, and José de Rivera placed around the Smithsonian Institution's National Museum of History and Technology in the 1960s are involved with the artists' personal visions of themes which celebrate the dynamics of life or creation. A major addition to Washington's sculpture collections is the new Joseph H. Hirshhorn Museum and Sculpture Garden of the Smithsonian Institution. The addition of this carefully chosen collection of over 6,000 modern sculptures and paintings will doubtlessly enrich area residents' knowledge and appreciation of outdoor sculptures around the city.

The Subjects Portrayed by Memorial Sculpture

No mention of the development of outdoor sculpture in Washington, D.C., would be complete without taking into account the subjects for these memorials. Most outdoor statues honor military figures, with those of statesmen coming next. Callings represented only modestly include inventors, authors, clergymen, scientists, and physicians; the omission of men now considered representative of their eras is rather evident. There exists, for instance, a monument to John Ericsson, a Swedish immigrant who perfected the screw propeller for the Union navy during the Civil War, but nothing memorializes Robert Fulton or the Wright brothers. One finds a statue to Longfellow but none to commemorate Thoreau, Whitman, Poe, or Mark Twain. Columbus is honored, but no such recognition is given to the many eighteenth- and

nineteenth-century American explorers. Only ten of the thirty-seven presidents are commemorated. There are over twenty-five statues of Union officers of the Civil War, but only two Confederate—Stonewall Jackson and Albert Pike. During the administration of President John F. Kennedy, Secretary of the Interior Stewart L. Udall found many statues in the Nation's Capital mediocre or unfitting. He tried unsuccessfully to establish a moratorium on outdoor sculpture in the city and to establish a rule that the person to be commemorated by a memorial would have to have been deceased for fifty years before he could be so honored. It is perhaps slight consolation to note that no capital in the world has a truly representative collection of its national figures. As Osbert Sitwell has pointed out in his amusing book, *The People's Guide of London Statues* (1928), half of that city's open-air sculpture is devoted to English merchants and first cousins of the kings.

The Appropriateness of the Design

Many of these sculptured memorials have been executed in the Neo-classical style, copied from that of ancient Greece and Rome. They fail in the majority, however, to associate the persons commemorated with their accomplishments. Often their setting has been poorly conceived to reinforce their message. One truly successful sculpture, however, is the *Navy and Marine Memorial* to those American military men and women who sacrificed their lives in World War I; it is adjacent to the Fourteenth Street Bridge on the George Washington Memorial Parkway in Lady Bird Johnson Park. This monument consists of a grouping of seven seagulls flying over the crest of a huge breaking wave. The bronze sculpture is indeed a powerful expression of human sacrifice at sea. It conveys a universal message of the ultimate peace of man. The graceful seagulls, which hover on the tip of the breaking wave, represent the souls of those departed. The wave below symbolizes eternal nature, or their bodies lost underneath the sea. The sculpture, usually silhouetted against the constantly changing Potomac River, is in keeping with the monument's message. The opposite side of the monument is unfortunately close to the George Washington Memorial Parkway which does not permit the motorist time to view the sculpture or to stop his automobile in order to inspect it at close range. Other sculptures which offer some emotion in relating the role the individual played in history would include those honoring Robert Emmet, Nathan Hale, General Philip Sheridan, and Winston Churchill. Repetitive and unprovocative are adjectives which may be applied to some of Washington's nineteenth-century portrait statues. The sculpture methods in use in Europe by the early nineteenth century helped produce this mechanical look so common to American sculpture of the last century. Artisans copied the sculptor's model in marble, thereby losing much of his original design and expression. In contrast, during the Renaissance and Baroque periods, sculptors often carved the entire work themselves, producing fewer but finer works of art. It is a mark of achievement, however, that the city boasts so many sculptures from the nineteenth century when so few American artists possessed the skills necessary to execute such complicated works.

The problems in the creation of these statues are more than matched by their decay under the constant attacks of rain, air pollution, and temperature fluctuation. Thus, polluted air containing harmful oxides produced by the burning of fossil fuels and motor vehicle exhausts eats away inscriptions and carved designs and can change a hard, sound, outdoor sculpture into a crumbling, flaking mass within forty years. Recent chemical research has made it possible to arrest the decay of outdoor sculpture. A chemical can be sprayed on stone sculpture to seal the pores of the surface and to preserve the original color, texture, and appearance of the surface. The high expense of this new treatment unfortunately prohibits its widespread use at this time.

At least a score of the major outdoor sculptures in Washington have been damaged by air pollution or vandalism. All of the early nineteenth-century figures on the east front of the Capitol, for example, had to be removed and replaced when the building was extended in 1958–1960. These sculptures, extremely damaged at that time were transferred to the Smithsonian by the architect of the capitol in 1974. Other sculptures extensively damaged by air pollution can be found in historic Congressional Cemetery on Capitol Hill. Sculptures executed in sandstone, a soft porous material, are especially susceptible to damage. A few successful sculptural restorations have been made in Washington in recent years. These projects, including the lions on the Taft Bridge on Connecticut Avenue, the architectural sculpture on the main façade of the Renwick Gallery on Pennsylvania Avenue, and the *Andrew Jackson Downing Urn* adjacent to the old Smithsonian Institution Building, reflect the skills of Mr. Renato Lucchetti, an Italian-American sculptor who now specializes in such restorations.

The Process Followed for the Erection of a Memorial

There are four tedious steps necessary before a public sculpture may be erected in the Nation's Capital today. If a group of citizens desires to erect a monument they must petition a member of Congress to sponsor a bill granting permission to build the memorial on federal property, usually in a park. If Congress approves, the organization then commissions a sculptor to design the work. This design must then be approved by the United States Fine Arts Commission. Next, the organization must raise the funds necessary for the execution of the sculptor's design. The National Park Service is responsible for landscaping and maintaining the site after the sculpture has been erected.

Only one out of three monuments proposed in Congress reaches completion because of the lack of approval or the lack of funds. Statues would have honored such figures as Zachary Taylor, engineer Alfred Noble, Grover Cleveland, Secretary of the Treasury Salmon P. Chase, Robert E. Lee, circus promoter P. T. Barnum, navigator Pietro Alonzoa, and reformer Dorothea Dix, to name only a few. As late as 1960, President Dwight D. Eisenhower signed a bill for a statue of the late Negro educator, Mary McLeod Bethune (1875–1955), to be placed in Lincoln Park on Capitol Hill. Sculptor Robert Berks designed a 12-foot-high statue of Mrs. Bethune handing a copy of her legacy to a Negro boy and girl. The National Council of Negro Women, the sponsor of this memorial, had raised only half of the necessary funds by 1972. In an unusual move, the federal government supplied a financial grant to this citizens' group in 1973 to allow for its completion and erection in 1974 on Capitol Hill.

A study of the records of the United States Fine Arts Commission since 1910 suggests Washington is fortunate in that some proposed sculptures were not erected because of their questionable design, good taste, or noteworthiness, such as a campaign in 1945 for an enormous statue of a German Shepherd dog to honor the dogs who served in World War II. This monument was to have been placed at the front entrance of the Pentagon. On the other hand, a number of curious monuments were indeed erected on public lands, such as the *Temperance Fountain* and the *Serenity* monument. Other odd sculptures, which seem inappropriate today, have been recently removed, such as the *Cuban Friendship Urn* and the *Jackson Sarcophagus*.

Since 1910, the United States Fine Arts Commission has been given the responsibility for approving or rejecting proposed designs for sculpture to be erected on government grounds in the District of Columbia. The Fine Arts Commission has on several occasions advised the National Park Service on suitable ways of restoring sculptures in need of attention. The National Capital Planning Commission, established in 1926, also advises on the proper location of such proposed

sculpture. Usually, the location and removal of a sculpture donated by a private party on federal ground in the District of Columbia must be approved by a special act of Congress.

To help solve the problems connected with the erection and maintenance of the sculpture located on federal property in Washington, Secretary of the Interior Udall requested in 1961 the establishment by Congress of a special congressional commission which would report to Congress on the suitability of sites for sculpture in Washington. No action has been taken by Congress on such a commission. Such a commission could presumably have the authority to approve proposed monuments, accept or reject the design of them, remove them should they become out of taste, relocate them, and supervise their proper preservation while on display. All of the federal agencies involved with public sculpture in Washington have recently expressed a desire to have their roles concerning their jurisdiction over sculpture more clearly defined by law.

One of the most pressing needs today is a comprehensive new program for the creation of a fitting landscape setting for many of the sculptures in Washington. Although most statues were well located originally, many are now incongruous to their surroundings. The statue of *John Witherspoon*, for instance, on Connecticut Avenue and Eighteenth Street, NW, was erected in 1909 in a small park faced by Victorian townhouses and the Romanesque-style National Presbyterian Church; now, however, it seems out of touch amid new high-rise buildings. The same situation exists at Washington Circle on Pennsylvania Avenue, NW, the site of the 1860 bronze equestrian statue of *Lieutenant General George Washington*; the Victorian mansions and huge trees are gone. The appearance of the *General George McClellan* equestrian statue at the intersection of Columbia Road and Connecticut Avenue, NW, could be improved by relandscaping. Dupont Circle, with Daniel Chester French's graceful fountain, on the other hand, invites people to rest on benches under shady trees; it is scaled to fit the surrounding buildings. The *Robert Emmet* statue at Massachusetts Avenue and S Street, NW, is perfectly situated in a tiny, well-maintained park. The equestrian statue of *General Philip Sheridan* at Sheridan Circle on Massachusetts Avenue, NW, is one of the best sited sculptures in the city. The landscaping, the dignified embassies, and the view of the statue from all directions could not really be improved.

Certainly this guidebook will need revision as new outdoor sculpture is added and old pieces relocated. Because of lack of space, many minor sculptures have been omitted as well as extensive biographical sketches of the subjects portrayed. It is the author's hope, however, that *The Outdoor Sculpture of Washington, D.C.* will be sufficiently provoking, both in its deficiencies and in its achievements, to rekindle appreciation not only for the many portrait and equestrian statues but also for the numerous other types of sculpture which have their own stories to tell.

J.M.G.
November 24, 1973
Washington, D.C.

GLOSSARY

Abstract sculpture	The presentation of an object or form in a nonrealistic manner.
Academic sculpture	Following the traditions or style of an academy, often lacking in original concept by the sculptor.
Acanthus	A prickly herb found in the Mediterranean region, the leaves of which were a principal decorative motif for furniture and architecture in classical times, such as the Corinthian capital; especially popular in the United States during the Greek-Revival period, 1815–1850, and the Beaux-Arts period, 1890–1930.
Acropodium	A classical term referring to a large pedestal for a statue, usually made of marble and highly embellished with low-relief carvings.
Acroterion	Carved decorative devices placed above the corners of a pediment on Classical or Neoclassical buildings.
Allegorical sculpture	Symbolic representation of an idea or principle.
Apotheosis	In classical times the elevation of a mortal to the rank of a god or the glorification of a person, principle, or ideal.
Architrave	In Classical architecture that part of the entablature resting immediately above the capitals of columns and supporting the frieze.
Armillary sphere	An early astronomical instrument composed of bronze rings representing the positions of principal circles of the celestial sphere.
Art Deco	A term which originated about 1960 referring to the style used in art and architecture between World War I and World War II; the name was taken from the Exhibition of Decorative and Industrial Arts held in 1925 in Paris; the style consists of streamlined lines, geometric patterns, boldness and simplicity, and the popular use of aluminum as a medium for sculpture; often referred to as Art Moderne at the time.
Art Nouveau	A term referring to the style used in art and architecture during the period 1880–1910 which was a reaction against academic traditions in art and the various decorative revivals which had been dominant for 100 years; the principal feature consisted of the curved, slender, elegant line with the most popular motif employed being the lily plant; especially popular in France.
Atlantes	The plural form for atlas; figures or half-figures of a human male used as a column to support a building or entablature.
Atlas	One figure or half-figure of a human male used as a column to support a building or entablature. Atlas, one of the Titans—a family of giants in Greek mythology—was defeated by Zeus after a long battle. The Titans consequently were harshly punished, especially Atlas, who was forced to hold up the heavens, with his arms, for eternity.
Aztec	An ancient Indian tribe which wandered into Mexico in the fourteenth century and founded a highly developed civilization before the arrival of Columbus; this civilization was largely destroyed by Spanish rule under Cortez in the early sixteenth century.
Baroque	A style developed in sculpture, architecture, and art in the late Renaissance in reaction against the severity of classical forms; employing great use of elaborate scrolls, curves, and carved ornament.
Bas-relief	Low relief; sculpture or carving with little depth or with slight projection from the background.

31

Beaux-Arts	Fine arts; a movement in art and architecture which originated about 1870 in the École des Beaux-Arts (National Academy of Fine Arts) in Paris in which the Classical style was followed but with greater exuberance in form; the style became highly popular in the United States with its introduction at the World's Columbian Exhibition in Chicago in 1893 and its influence was felt as late as 1930.
Bronze	An alloy of copper and tin, frequently including other elements; used for sculpture castings and for the most durable metalwork.
Bust	A piece of sculpture representing the upper part of the human figure including the head and neck and usually the upper section of the shoulders and chest; often referred to as a portrait bust.
Byzantine	Architecture of the Byzantine Empire, developed during the fifth and sixth centuries; principal features include a dome carried on pendentives over a square, richly colored mosaics, marble veneering, and often with capitals carved in an endless variety of design with flat low-relief carvings, the style originated in what is now modern Turkey.
Caduceus	A staff used by a herald or messenger in ancient Greece, decorated with two serpents coiled about it with two wings at the top; associated with speed and healing, and in the United States used as a symbol for communication offices, postal services, and the medical profession.
Capital	The head or uppermost part of a column or pilaster and carrying the weight of the roof or entablature.
Carrara marble	A fine white marble mined in the mountains near Carrara, Italy, and having a flat rather than glossy surface when sculpted.
Cartouche	An elaborate decorative panel with a border frequently with a carved inscription or armorial seal; often found on architecture of the Baroque and Beaux-Arts periods.
Caryatid	A column sculpted in the form of a female figure used to support a roof or entablature.
Cenotaph	A monument erected in honor of a person whose body is buried elsewhere, usually found in a cemetery or park.
Cheek-block	A large block of marble or stone, carved or uncarved, used on the side of a flight of steps to support decorative sculpture or as an architectural device to support and balance the steps; often found in front of the porticos of Classical and Neoclassical buildings and bridges.
Cherub	A winged child, childlike angel, or a child's head with wings, frequently found as a decorative motif for American cemetery sculpture during the second half of the nineteenth century and on American Beaux-Arts buildings from 1890–1930.
Classical	Following the traditions, rules, or styles of ancient Greece and Rome in sculpture, architecture, and art.
Columbia	A female figure symbolic of the United States, similar to the *Britannia* of Great Britain.
Corinthian	The most ornate of the three ancient Classical orders of architecture; characterized by columns surmounted by elaborate capitals featuring acanthus leaves and volutes, or scroll-like devices, at the corners.
Cornucopia	The classical "horn of plenty," the horn of a goat used in ancient Greece and Rome to hold liquids and fruits; this motif was frequently used as a decorative device for carved pedestals for sculpture and for friezes in both Classical and Neoclassical architecture.
Cornice	The projecting horizontal part of the upper section of a building, frequently carved as an embellishment on Classical and Neoclassical architecture.
Cresting	The decorative work on the ridge of a roof, usually as a continuous series of finials, often using the acanthus leaf as a motif on Classical and Neoclassical buildings.

Crocket	An ornament carved on the sloping edge of a gable or spire of a Gothic cathedral, often resembling bent foliage; used on spires above flying buttresses for a practical purpose to anchor them to the ground.
Doric	The oldest and simplest of the three ancient Greek orders of architecture, usually with fluted columns with plain rounded capitals.
École des Beaux-Arts	The National School of Fine Arts in Paris, founded by Jacques Louis David in the late eighteenth century, usually associated with fostering an academic revival of the Classical style in the arts during the late nineteenth century; especially significant in the development of American sculpture and architecture, 1870–1930, because of the large number of American sculptors and architects trained there.
Effigy	An image or representation, especially of a human, carved or cast for the upper section of a tomb and usually resting horizontally.
Entablature	In classical architecture, the upper section of a building between the column capitals and the roof, divided into three parts—the architrave (lowest part), the frieze (middle part), and the cornice (upper part).
Equestrian statue	A statue of a person or persons on horseback, especially popular as a form of sculptured monument in the United States, 1850–1920.
Escutcheon	A highly decorative shield often carved in marble to embellish Beaux-Arts architecture, often found over doorways and in pediments.
Exedra	A stone semicircular bench, usually in the open air, used in ancient Greece and frequently erected in the United States during the Beaux-Arts period; often embellished with a statue in the center or low-relief carvings at the ends.
Fasces	A bundle of rods bound by leather cords with a projecting ax blade at the upper end, carried in processions in ancient Rome to symbolize the authority of the law; often found as a decorative device carved on Neoclassical buildings over windows and doors, etc.; especially popular in the United States, 1910–1940.
Frieze	In Classical architecture, the middle section of the entablature, located between the architrave and the cornice, usually consisting of a horizontal course of alternating metopes and triglyphs.
Gargoyle	A grotesque sculptural projection from the cornice of a roof, especially on Gothic architecture, with a lead pipe fitted through the center to carry large quantities of rainwater off the roof to the ground and clear of the walls.
Genius	A spirit presiding over the destiny of a person or place, from Greek mythology, often seen as a youth carved for the pediment of a Classical or Neoclassical building.
Gothic	Medieval architecture of the thirteenth, fourteenth, and fifteenth centuries in Europe, usually associated with stone cathedrals erected vertically with walls supported by elaborate buttresses and with pointed arches and stone tracery.
Griffin	A monster, often half lion and half eagle, used as a common decorative device in Greek and Roman art and sculpture; often symbolic of protection.
Grotesque	A grotesque sculptural projection from the upper section of a roof, especially on Gothic architecture, designed to carry small quantities of rainwater from the upper spires and towers to the lower roof to protect the tower walls; the rainwater drips over the nose of the beast or animal and not through its mouth.
Heroic	Larger than life size but smaller than colossal.
Hieroglyphics	Picture writing of primitive peoples, especially associated with the ancient Egyptian civilization.
High relief	Sculpture or carving with great depth or with considerable projection from the background, but not free standing.

In situ	In its natural or original position, often referred to relief panels carved on the sides of buildings after the stone has been placed in the wall.
Ionic	One of the three orders of Greek architecture in which the capital is carved with a pair of volutes or scroll-like devices.
Jet d'eau	French term for a spray of water, often used in describing sculptured fountains.
Keystone	The wedge-shaped top part of an arch, often carved with an allegorical head or decorative motif.
Kinetic	Pertaining to motion, especially to modern abstract sculpture which was designed by the sculptor to move through space.
Laurel	The leaves of this tree were used by the ancient Greeks to crown the victors in athletic games and also as a mark of distinction for certain offices and functions; commonly used as a motif on cemetery sculpture for military officers in the United States during the second half of the nineteenth century.
Lintel	The upper horizontal section of a door or window frame often decorated with low-relief carvings during the early nineteenth century, especially on Federalist and Greek Revival buildings.
Lost wax process	A technique for casting bronze sculpture in the United States during the nineteenth and twentieth centuries which consists of constructing a plaster model with a wax surface of suitable thickness, forming the outside mold about this, heating so that the wax melts and runs out, and filling the vacant space with bronze.
Low relief	Bas-relief; sculpture or carving with little depth or with slight projection from the background.
Lunette	A small, half-round or arched-top window in a vaulted or coved ceiling or roof.
Mausoleum	A memorial structure to honor a deceased person usually found in a cemetery and housing several bodies of one family, often with carved panels over the entrance; especially popular in the United States, 1875–1930.
Medallion	A circular or oval low relief used in decoration, especially for portraits.
Metope	The plain or sculptured stone panel between adjacent triglyphs in a Doric frieze on a Classical or Neoclassical building.
Monel	Trade name for a metal alloy of nickel and copper having high resistance to corrosion.
Mosaic	Inlaid surface of small pieces of colored glass or stone which form a design or pattern, especially popular during the Byzantine period and the Art Nouveau period.
Neoclassical	Pertaining to a revival of the art and architecture of ancient Greece and Rome, especially popular in the United States between 1810–1850 and 1890–1930.
Nymph	In Greek and Roman mythology, one of the inferior divinities of nature represented as a beautiful maiden dwelling in the mountains or forests, a sculptural motif popular in the nineteenth century.
Obelisk	An upright four-sided pillar, gradually tapering as it rises with the top terminating in a pyramid, especially popular in the second half of the nineteenth century as a cemetery monument in the United States.
Patina	A film, often green, formed on copper and bronze sculpture by long exposure to a moist atmosphere; also formed on sculpture by treatment with acids.
Pedestal	The base for a column or a piece of sculpture, usually of stone or bronze.
Pediment	In Classical architecture, the triangular space forming the gable of a pitched roof, the interior of which is often carved and known as a tympanum, usually found over a portico.

Pendentive	An architectural detail which permits a dome to be constructed above a square room, or, more specifically, a triangular segment of vaulting that makes possible the transition at the angles from a square or polygon base to a dome above.
Pilaster	A vertical architectural member with flat surfaces, which projects from the façade of a building and is treated as a column, with capital, shaft, and base.
Porphyry	A highly polished, finely textured hard stone, found in varying shades of red and green.
Portico	A colonnaded porch found on Classical and Neoclassical buildings, usually with a pediment above.
Prometheus	A figure in Greek mythology regarded as the founder of civilization and as the creator of the human race. Prometheus aided the Olympians in their victorious struggle against the Titans or giants, but, grieved at the Olympians' neglect of mankind, stole fire from heaven and bestowed it upon man along with the arts by which man can control it. For punishment Prometheus was chained to a rock and a vulture daily visited and consumed his liver, which grew again at night. He was doomed to this fate for eternity.
Putti	Nude children, wingless, used in decorative sculpture during the Classical, Neoclassical, and especially the Beaux-Arts periods.
Quatrefoil	An ornamental foliation having four lobes or foils especially popular in the period of Gothic architecture and sculpture.
Renaissance	Referring to the transitional period in Europe between the end of the medieval period in the fourteenth century and the beginning of modern times in the seventeenth century, characterized by a renewed interest in the classical culture of ancient Greece and Rome, especially in architecture.
Rinceaus	Low-relief carving in strips consisting of a sinuous and branching scroll elaborated with leaves, fruits, or flowers, especially popular in architectural sculpture of the Beaux-Arts period.
Rococo	A style of excessive ornamentation which combined such motifs as rocklike forms, scrolls, and shells.
Rosette	A circular carving of foliage or flowers in relief used as a decorative motif, usually sculptural.
Rotunda	A high-ceilinged room having a circular space and covered by a dome.
Sarcophagus	A stone tomb or coffin to hold a human body during the ancient Greek and Roman civilization, often elaborately carved on the exterior.
Sculpture in the round	Free standing sculpture which is carved or designed to be viewed on all sides.
Spandrel	The space above the two curves of an arch on a window or door and the enclosing right angle above, often decorated with architectural carvings of allegorical figures in low relief.
Sphinx	A sculpture in ancient Egypt and ancient Greece having the body of one animal and the head of another, often symbolic of wisdom; the three principal types of sphinxes in the ancient world included the androsphinx which represented the body of a lion with the head of a man, the criosphinx with the body of a lion and the head of a ram, and the hieracosphinx with the body of a lion and the head of a hawk.
Stabile	A stable abstract sculpture typically executed in such mediums as sheet metal, wire, iron, or stainless steel; opposite to mobile, a sculpture designed to move through space by wind currents or operated by an electric motor.
Stele	An upright slab of stone bearing an inscription and often low-relief sculpture, frequently used as a memorial to a person or event.
Street furniture	Utilitarian designed objects which are placed along, or adjacent to the

	street; the term includes such items as lampposts, flagpole bases, benches, traffic lights, gates and fences, and railings or balustrades.
Swag	A decorative form consisting of a simulated net-held mass of fruit and flowers sagging between two supports, often executed in heavy low-relief carving.
Terra-cotta	A clayware extensively used as low-relief architectural sculptural panels on American buildings during the period 1870–1920.
Transept	Each of the two lateral arms in a church of cruciform plan; the transept portals of cathedrals are usually decorated with statues and relief panels referring to Biblical stories.
Trefoil	An ornamental window or relief sculpture on a building with three divisions or foils shaped like a clover.
Triglyphs	One of the two parts comprising a Doric frieze on a building between the columns and pediment, consisting of three vertical projecting thin bars; alternating with a plain or sculptured metope or square panel.
Trumeau statues	Statues located on the post separating two arched doors of a Gothic cathedral or other building.
Trylon	A tall, slim, triangular-shaped stone which tapers to a point at the top; often the three sides contain sculptured relief panels.
Tympanum	The space within a three-sided pediment of a building which often contains sculptured figures designed from ancient Greek temples.
Valve	One of a pair of folding or sliding doors; one of the leaves of such a door, often executed in bronze with low-relief sculptured panels.
Volute	A scroll-shaped ornament forming the chief feature of the Ionic capital, from ancient Greek architecture.

HOW TO USE THIS BOOK

The Outdoor Sculpture of Washington, D. C. is designed as a working volume—a guide for the visitor, as well as a reference for the serious historian.* The fourteen geographical areas covered are listed alphabetically in the contents. The index provides quick reference to *all* entries: sculpture works, artists, place names, and historical figures.

maps
- Maps inside the covers locate all fourteen areas within metropolitan Washington.
- Each section is introduced by a detailed map. Numbers shown correspond to those of the individual entries for that area.

the best way to proceed
- A quick overview of all sculptors and their works within each section is available in the list accompanying each of the area maps.
- The order in which subjects are discussed—and numbered—within an area is designed as the simplest and most direct way of proceeding from one sculpture to the next.
- Binoculars can be helpful for studying distant details.

getting around
- Of the fourteen geographical areas, eight may best be seen on foot; six by car or bus. Following are minimum recommended times for covering the sections:

Time	Walking	By car or bus
1 hour	Ellipse	
	Judiciary Square	
2 hours	Federal Triangle	Connecticut Avenue
	Mall	
	Potomac Park	
4 hours	Capitol Hill	George Washington
	Pennsylvania Avenue, NW	Memorial Parkway
	Virginia Avenue	Massachusetts Avenue, NW
		North Capitol Street
		Sixteenth Street
		Wisconsin Avenue

* This book is published simultaneously in a paperback and in a clothbound edition, identical in all respects except that the following material appears only in the clothbound: Appendixes—Sculpture Removed, Selected Biographies, Techniques in Executing Marble and Bronze Statues—and Selected Bibliography.

CAPITOL HILL

A

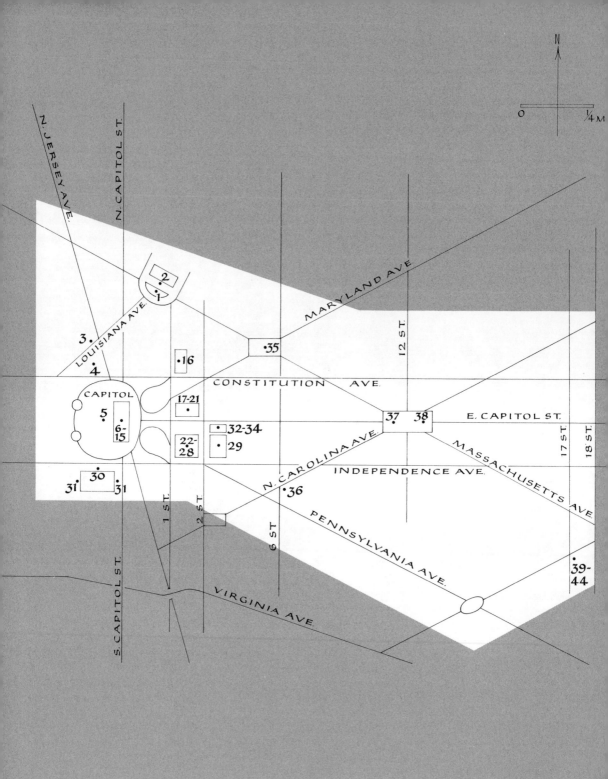

THE DAY THAT PIERRE L'ENFANT, who first laid out a plan for Washington in 1791, declared the rural Maryland hillock known as Jenkins Heights to be a pedestal waiting for a superstructure could be called the beginning of the history of Capitol Hill. L'Enfant laid out the District of Columbia in a perfect 10-mile square, with the United States Capitol as the center. The boundaries radiating from the Capitol, East Capitol Street, North Capitol Street, South Capitol Street, and the Mall divided the city into four quadrants—northwest, northeast, southeast, and southwest. Much of the southeast and southwest sections were lost when the area of the city south of the Potomac River was returned to the state of Virginia in 1846, since it was expected at that time that the area would never be needed for the federal government for future expansion. L'Enfant faced the Capitol Building to the east because he expected the city to develop commercially in that direction. Indeed, at the time of the laying of the cornerstone of the Capitol in September 1793, many new residences, taverns, and shops were under construction nearby. The business district of the city, however, never developed on Capitol Hill as L'Enfant planned, since much of the area was held by land speculators.

Capitol Hill is first and foremost the seat of the United States Congress. Unknown to the many tourists who visit it each year, it is also a residential community. Consequently, Congress and Hill residents vie for the land. The growth of government structures has been extraordinary. The Capitol itself has been enlarged numerous times since its cornerstone was laid. In addition, three vast buildings have been constructed as offices for representatives, two for senators, plus the Library of Congress and the Supreme Court. Architecturally, one is faced with a decrease in quality of style with each succeeding building. The Library of Congress (1897) demonstrates a certain flamboyance that may be a trifle overpowering, but is not offensive. The Old Senate Office Building (1909), now known officially as the Richard B. Russell Senate Office Building, and the Cannon House Office Building (1908) reflect the Beaux-Arts phase of American architecture and are still somewhat impressive. The Longworth House Office Building (1933) and the Supreme Court Building (1935) are reasonably literal interpretations of Classical architecture, while the Library of Congress Annex Building (1939) reflects more of the Art Deco influence contemporary to architecture of the thirties. Unfortunately, during the past two decades, the government buildings have been constructed with an attempt to combine both modern and Neoclassical designs, which has resulted in aesthetic failure. The Everett M. Dirksen Senate Office Building (1958), the Rayburn House Office Building (1965), and the Library of Congress's James Madison Memorial Building (under construction) are primary offenders in this category.

The Marine Barracks, occupying an entire block of southeast Washington, is dominated by the Commandant's House, built in 1806. It has served as the home of every Marine Corps Commandant from that time to the present day, making it one of the oldest governmental buildings continuously used for the purpose for which it was built. Only a block from the Commandant's House, on G Street, SE, may be found the boyhood home of America's "march king," John Phillip Sousa, the most well known of the directors of the Marine Band, which is headquartered at the Barracks. A few doors west of Sousa's home, which is identified by a brass tablet, is one of Washington's oldest churches, Christ Episcopal Church, established in 1794 and the house of worship for many early Washingtonians, including Presidents Thomas Jefferson, James Madison, James Monroe, and John Quincy Adams. Christ Church is the oldest of more than a score of Capitol Hill churches, the newest of which, Capitol Hill United Methodist Church,

was built in the 1960s on the Seward Square site of the birthplace of the late Federal Bureau of Investigation Director J. Edgar Hoover. Many other historical attractions include the Congressional Cemetery, established in 1807 and for many years the unofficial national burial ground. This site, at the eastern end of Capitol Hill, contains the largest collection of historical cemetery sculpture in the city.

The residential sector of Capitol Hill is essentially Victorian. Almost all of the early Federal townhouses, which were frequented by Thomas Jefferson and other figures of the early Republic, have long since been demolished. Many were pulled down in the 1880s when the Library of Congress Main Building was begun. The handsome block of Victorian townhouses known as Grant Row was demolished in the 1920s for the construction of the Folger Shakespeare Library Building. The building housing the Supreme Court rests on the site of the residence used by Abraham Lincoln while he was a congressman in the 1840s and on the site of the Old Brick Capitol used by Congress after British troops burned most government buildings in the city in 1814.

The neighborhood near the Capitol deteriorated after the First World War, and renovation of the many row houses did not begin until the 1950s. Since then, the area has gained greatly in popularity. Capitol Hill, in addition to being the home of both the judiciary and legislative branches of the national government and a pleasant, fashionable residential area worthy of historic preservation, is the important site of one of the richest collections of publicly and privately owned outdoor sculpture in the city.

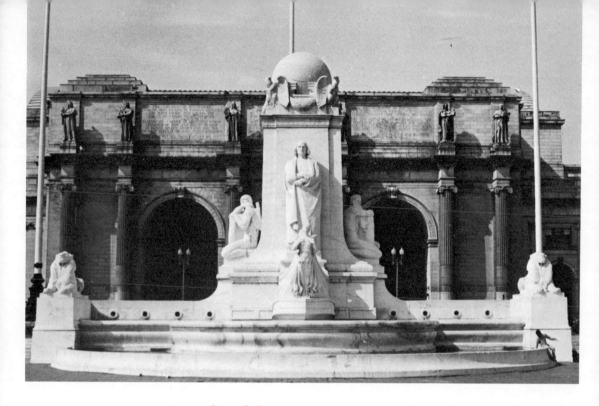

A-1

Title COLUMBUS FOUNTAIN, 1912

Location Union Station Plaza, Massachusetts and Delaware Avenues, NE

Sculptor Lorado Z. Taft

Architect Daniel H. Burnham

Medium Marble

One of the more prominent memorials in the District is this semicircular fountain richly embellished with sculptured figures, lions, and flagpoles. At the center is a large 45-foot shaft from which projects the prow of a ship with a winged figurehead symbolizing Discovery. The ship acts as a pedestal for a heroic statue of Christopher Columbus, about 15 feet tall, who wears a medieval mantle and stands quietly with folded hands and a steady, confident gaze. With its suggestion of calmness and permanency, his figure is reminiscent of the simplicity of Egyptian sculptures. Surmounting the shaft is a large globe on which appears the outline of the Western Hemisphere. Four eagles, united by garlands, support the sphere.

The sides of the shaft are decorated by single male figures. On the right or east side appears an elderly figure, representing Europe or the Old World, while the opposite side contains the figure of an American Indian, symbolic of the New World. On the rear of the shaft is a low-relief medallion picturing Ferdinand and Isabella, the Spanish monarchs who financed Columbus's travels. The medallion is about 3 feet in diameter. The grouping is completed by two couchant lions, each about 5 feet in height, which act as guardians. Three flagpoles behind the marble shaft represent the ships which carried Columbus's discovery party to America in 1492; each is topped by a small globe on which rests an American eagle.

Taft's *Columbus Fountain* was influenced in part by the Frederick MacMonnies fountain at the World's Columbian Exhibition in Chicago in 1893. In this earlier work the figure of Columbia sat enthroned on a ship, while Fame stood with her trumpet on the prow and Father Time dominated the stern.

Christopher Columbus (1451–1506), the Italian-born explorer, has been traditionally credited with being the first European to have discovered America. In spite of his fame, one finds in Columbus a character study of frustration. He had great difficulty financing his expeditions, landed on the wrong continent, and died when he was not completely "in favor." Even in death he cannot have found real peace, since his body has been interred and reinterred several times in the Caribbean and Spain; he now rests in Seville. His fascinating life has been vividly portrayed in the bronze reliefs on the *Columbus Door* of the United States Capitol.

Detail from left of pedestal: American Indian symbolizes the New World

Title THE PROGRESS OF
RAILROADING, 1908
Location Union Station,
Massachusetts and Delaware
Avenues, NE
Sculptor Louis Saint-Gaudens
Architect Daniel H. Burnham
Medium Granite

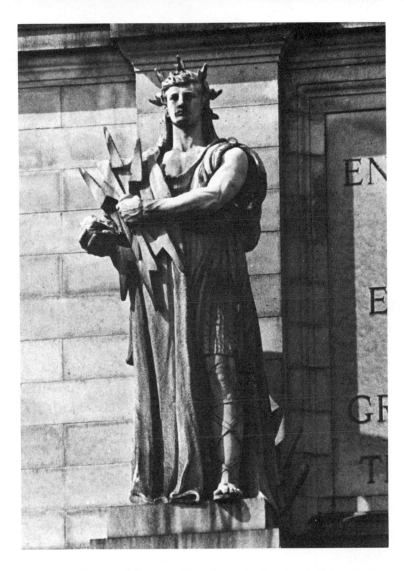

Thales (Electricity)

Six heroic allegorical figures adorn the main façade of Union Station
north of the Capitol. They are placed above three continuous triumphal
arches which compose the central pavilion. Although the statues are 18
feet tall, they are in scale with the vast proportions of the Neoclassical
edifice. During the train station's construction, there was considerable
debate about the subject matter for these figures. Some favored historic
Americans, but these were judged out of place for a Baroque building;
allegorical figures were next most logical. Charles W. Eliot, former
president of Harvard University, and others, were consulted, and the
result is as follows (west to east): Prometheus (Fire), Thales (Elec-
tricity), Themis (Freedom or Justice), Apollo (Imagination or Inspira-
tion), Ceres (Agriculture), and Archimedes (Mechanics). Figures on the
east and west deal with the operation of railroads, while the center
figures foster creativity.

In addition, 8-foot stone eagles surmount the old carriage entrances,
and other Neoclassical decorations are festooned about the exterior of
the building.

Union Station was completed in 1908; its architect, Daniel H. Burn-
ham, had been responsible for the famous World's Columbian Exhibi-
tion, held in Chicago in 1893. The Burnham station replaced several
others in Washington, including one on the site of the present National
Gallery of Art. Railroad tracks had gone helter-skelter through the city,
along streets and across the Mall, causing eyesores, inefficiency, and
about thirty fatalities a year. Plans are now underway for the conver-
sion of Union Station into a National Visitors Center, expected to open
for the Bicentennial in 1976.

A-3
Title ACACIA GRIFFINS, 1936
Location Acacia Mutual
Life Insurance Building, 51
Louisiana Avenue, NW
Sculptor
Edmond Romulus Amateis
Architect Shreve, Lamb,
and Harmon
Medium Limestone

Flanking the steps at the main entrance to the Acacia Mutual Life Insurance Building are the two limestone *Acacia Griffins*, each 5½ feet high, 4½ feet wide, and 9 feet deep. The griffin is a mythological creature consisting of the body of a lion, the head and wings of an eagle, and at times the tail of a serpent. In ancient Greece the griffin usually had a mane of spiral curls, while a crested head was more typical of sculptured Asiatic griffins. Customarily the creature was portrayed either in a recumbent position or seated on its haunches. In mythology, the griffin guarded the gold stored in Scythia, a country north of Greece, from the Arimaspians, who tried continually but unsuccessfully to steal it. These creatures, thus, became symbols of guardianship against the theft of gold and treasure; they frequently appear as symbols of vigilance on medieval European heraldry. Mr. Edmond Amateis, the sculptor, has portrayed these unique *Acacia Griffins* with slightly different designs, the left one being a female and the right one a male having a more elaborate feathered structure. Each holds a nest of agate eggs between its paws, representative of the defense of their home. At the time of the dedication of this building, the Acacia Mutual Life Insurance Company adopted the griffin as its symbol or logo.

The Acacia Mutual Life Insurance Company was founded by nineteen Washingtonians and chartered in 1869 as the Masonic Mutual Relief Association of the District of Columbia. In 1922 the company was reorganized and the present name adopted. The word "acacia" relates to the ancient tree which has been representative of resurrection and immortality. The company has existed in seven buildings since it first established a full-time office in Washington in 1874, having moved to the vicinity it now occupies in 1926.

The *Acacia Griffins* are especially appropriate sculptures since they embellish the restrained Neoclassical architecture of the building and are symbolic of the company's purpose.

Title ROBERT A. TAFT MEMORIAL,
1959
Location U.S. Capitol grounds,
between Constitution, New Jersey,
and Louisiana Avenues, NW
Sculptor Wheeler Williams
Architect Douglas W. Orr
Medium Bronze

The 11-foot statue of Senator Robert A. Taft is overpowered by a 100-foot shaft containing a 27-bell carillon. The somewhat undistinguished statue took the sculptor two and a half years to complete. Taft is shown standing, with one hand at his waist and the other casually near his pocket. Ideally, the monument is said to suggest the qualities of the man—simple strength and quiet dignity. President Eisenhower and former President Hoover attended the dedication ceremonies in 1959. Vice President Nixon, as president of the Senate, officially accepted the statue.

Robert Alphonso Taft (1889–1953), eldest son of William Howard Taft, twenty-seventh president of the United States, was born in Cincinnati, Ohio, and educated at Taft School in Connecticut, at Yale University, and at Harvard Law School. He was a member of the Ohio House of Representatives and served as its speaker from 1921 until 1926; he was first elected a United States senator in 1932. A staunch Republican, often called "Mr. Republican," he was a bitter foe of Franklin D. Roosevelt and the New Deal. His son and namesake now represents Ohio in the Senate.

A-5
Title John Marshall, 1884
Location U.S. Capitol Building,
west terrace
Sculptor William Wetmore Story
Architect Unknown
Medium Bronze statue and marble
relief panels

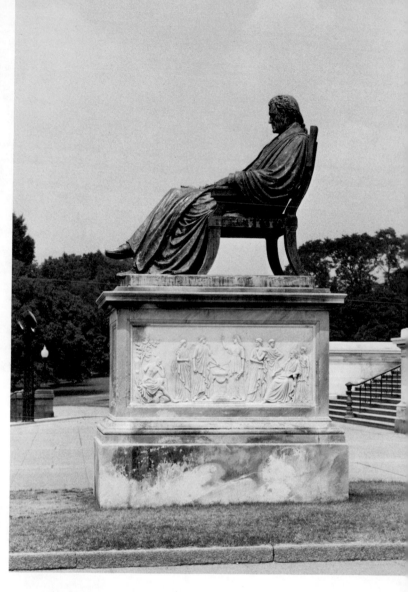

The United States Bar Association commissioned the noted Boston sculptor, William Wetmore Story, to execute this 5-foot bronze statue of the seated chief justice. The sculptor was the son of Marshall's longtime colleague on the court, Associate Justice Joseph Story of Boston. One of many early expatriate American sculptors working in Rome, Story cast the bronze statue in 1883 and carved the low-relief marble allegorical panels which appear on each side of the pedestal. On the north side, the goddess Minerva dictates the Constitution to America, who writes diligently on a scroll. On the south, Victory, a Neoclassical female, lays down her sword and spear to lead young America to the altar to swear eternal loyalty to the Union of the States. An identical bronze statue, cast from the same mold, is located at the front of the Philadelphia Museum of Art.

John Marshall (1755–1835), one of the most significant chief justices of the Supreme Court and a principal founder of judicial review, was born in Fauquier County, Virginia, the son of a prosperous farmer and a member of the colonial House of Burgesses. Marshall, who followed the liberal leadership of Patrick Henry, entered the Revolutionary War as a soldier in late 1775 and served as a captain in many battles, including Brandywine, Monmouth, and Valley Forge. Upon honorable discharge from the Continental Army, Marshall studied law under the famous Chancellor George Wythe at the College of William and Mary in Williamsburg. He was elected to the Virginia legislature in 1782 and became a noteworthy and able lawyer in Richmond at the same time.

Detail: Victory Leading America to Swear Eternal Loyalty to the Union of the States

Marshall, who was a first-hand witness to the weak government of the United States under the Articles of Confederation, became the leading supporter of the new federal Constitution in Virginia in 1787. During the 1790s Marshall strongly supported the new national government including both George Washington's and John Adams's administrations and Hamilton's financial programs. He served in the U.S. House of Representatives from Virginia in 1798, accepted the position of secretary of state under John Adams in 1800, and was appointed chief justice of the United States Supreme Court in 1801. Marshall served in the latter position for thirty-four years and strengthened the entire course of American Constitutional law through his many far-reaching decisions. He was a supreme debater, although his emaciated appearance and clumsiness in dress and gestures often misled people. One of the first of many cases in which the new chief justice's decision resulted in the establishment of the Supreme Court as the final authoritative interpreter of the Constitution was that of Marbury vs. Madison in 1803. Marshall's conduct of the Aaron Burr trial for treason in 1807, in which Burr was acquitted, further aroused Thomas Jefferson's animosity toward the conservative Federalist chief justice.

Marshall's publication of his five-volume biography of George Washington appeared at this time. Although the work has a number of defects it is important for an insight into the framing of the Constitution in 1787. Because the Supreme Court only met for two months annually during most of the time Marshall was chief justice, he was able to devote much of his free time to legal research, writing, and an active social life. Many of the justices resided elsewhere and usually took lodgings together in the same boardinghouse when the court was in session in Washington. During those weeks of close contact, Marshall was able gradually to bring the associate justices to his point of view on the Constitution.

Marshall, through such famous decisions as Fletcher vs. Peck, McCulloch vs. Maryland, Dartmouth College vs. Woodward, and Gibbons vs. Ogden, made the Constitution the supreme law of the land. He fought endlessly, against the "state sovereignty" doctrine so popular during the first half of the nineteenth century. During his years as chief justice, 1801–1835, he sat on some 1,215 cases. Much of his free time was spent with his invalid wife discussing literature, a main source of pleasure to him. He was also fond of his clubs, such as the Barbecue Club of Richmond, famous for its drinking, feasting, and debating. The famous Federalist died in his eightieth year, on July 6, 1835, following an injury he received when the stagecoach in which he was traveling overturned.

The United States Capitol as it exists today is the product of almost two centuries of evolution. The Federalist style, which draws on elements from the architecture of Greece and Rome, was chosen by George Washington and Thomas Jefferson because they felt it signified the similarities between those ancient republics and that of the United States.

The original plan was the creation of an amateur architect and physician, Dr. William Thornton. That plan included the present central portion of the building, minus the present Senate and House wings and the dome. As Thornton knew little about the principles of construction, his plan was executed by other men including James Hoban, the architect of the White House, and Benjamin Latrobe, who came to the fore in 1803 to complete the original Senate and House wings. Latrobe is also the creator of the famed interior columns whose capitals are decorated with corncob motifs rather than the traditional acanthus leaves.

During the War of 1812, the interior and roof of the building were burned to ashes. Preliminary reconstruction was supervised by Latrobe, but the job was given over to Boston architect Charles Bulfinch in 1818. Bulfinch was responsible for landscaping the grounds around the Capitol as well as for reconstructing the low, wooden, copper-plated dome. The present House and Senate wings and the high dome were the work of Thomas U. Walter, who became Capitol architect in 1851. After Walter's additions were completed during the Civil War, the building was not altered until 1958 when, under the direction of George Stewart, the central portion of the east front was brought forward 33 feet in line with the two wings.

In the 1870s, the grounds surrounding the building were landscaped by the famed Frederick Law Olmsted, who also created Central Park in New York City. Olmsted terraced the grounds, thereby rectifying the teetering appearance of the huge building atop the small hill, and embellished the spacious lawns with Victorian fixtures, whose delightful frivolity provides an incongruous touch to the Neoclassicism of the building.

The original exterior sculptures were largely commissioned during the 1840s and 1850s. Most of the works were designed by American artists studying in Rome. Little opportunity for formal training in the arts existed on this continent at that time, so it was the custom of artists to travel to Europe—to Paris for painting and to Rome and Florence for sculpture. In retrospect, the inappropriateness of applying Classical principles to works dealing with the American experience seems obvious. But it was not until the twentieth century that the pragmatic pioneer spirit which developed the country was to manifest itself in the arts.

Most of the works have been enthusiastically received throughout the years; however, there have been a few exceptions. Horatio Greenough's portrayal of *George Washington* scantily clad in Roman toga is one of the exceptions, along with *The Rescue* group which adorned a cheek block, or marble platform, to the side of the steps at the central portico of the east front, and its companion piece by Luigi Persico, known as *The Discovery*. These works have been removed from the Capitol, and now reside at the Smithsonian Institution. Only the Washington statue is on display. The first monument ever to be erected on the grounds of the Capitol has also been removed; it honored those American naval officers who fell in combat with the Tripolitan pirates in North Africa in 1804. During Thomas U. Walter's building program in the 1860s, the monument was taken to the United States Naval Academy at Annapolis, where it has remained ever since.

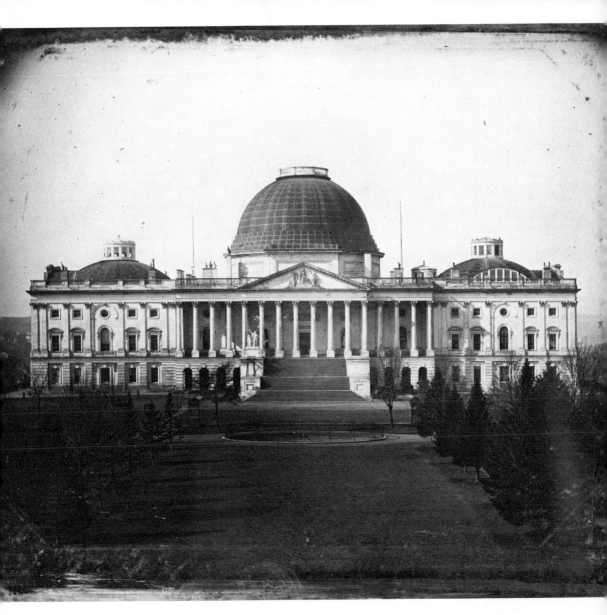

The above view of the Capitol, taken by John Plumbe, Jr., about 1846, shows *The Discovery*, sculpture group by Luigi Persico, to the left of the steps and the Rotunda pediment, *The Genius of America*, by Luigi Persico, above the steps. The statues *War* and *Peace* can barely be identified behind the columns of the portico. This daguerreotype, purchased in 1972 by the Library of Congress, is extremely important historically since it is the earliest known photograph of the building. It is also significant as the earliest known photograph of outdoor sculpture in the city.

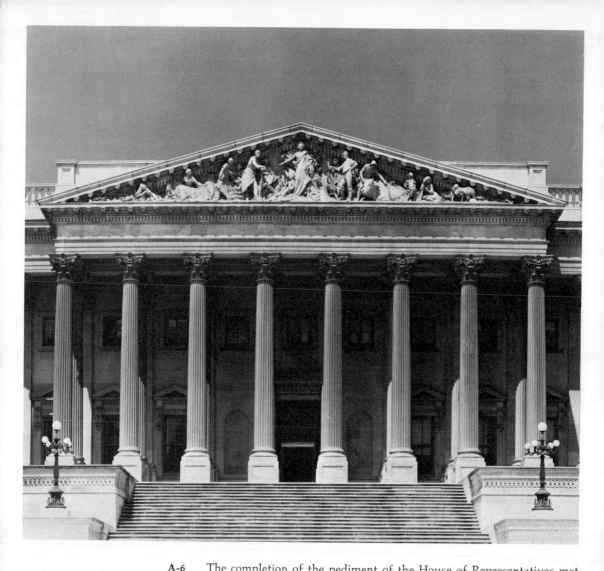

A-6
Title Apotheosis of Democracy,
1916
Location U.S. Capitol, House of
Representatives portico, east front
Sculptor Paul Wayland Bartlett
Architect Thomas U. Walter
Medium Marble

The completion of the pediment of the House of Representatives met constant delays from its inception in the 1850s until final erection in 1916. In 1857, Erastus Dow was awarded the House pediment commission, but the sculpture was not completed at that time for lack of funds. Further plans were postponed until 1908, when another competition was held and won by Paul Bartlett.

The work deals with a theme appropriate to its location on the façade of the House of Representatives. As Bartlett himself stated in his speech at the unveiling in August 1916: "We thought because the House represents in its largest sense the people, that the people, the life and labors of the people, should be portrayed in this building. . . this temple of Democracy."

At the center of the pediment is Armed Peace protecting the youthful figure of Genius, who nestles at her feet. Peace is wearing a long mantle beneath which can be seen a breastplate and coat of mail. Her left arm rests on a buckler, which is supported by the altar at her side, while her right arm is extended over the head of Genius. In the background is the olive tree of peace.

The two sides of the pediment are composed of representative figures from the two great sources of wealth: Agriculture and Industry. To the right of the apex are a reaper and his helper, a husbandman and a cow, a child garlanded with fruits of the harvest, a mother, and finally a child playing with a ram. The Industry group to the left consists of a printer, an ironworker, a founder, a factory girl, and a fisherman. The pediment is bounded at both ends by waves symbolizing the Atlantic and Pacific oceans. At its peak, the pediment measures about 12 feet, while the length is about five times that figure.

A-7
Title THE REVOLUTIONARY WAR
DOOR, 1855–1857 (erected 1905)
Location U.S. Capitol, House of
Representatives wing, east front
Sculptor Thomas Crawford
Architect Thomas U. Walter
Medium Bronze

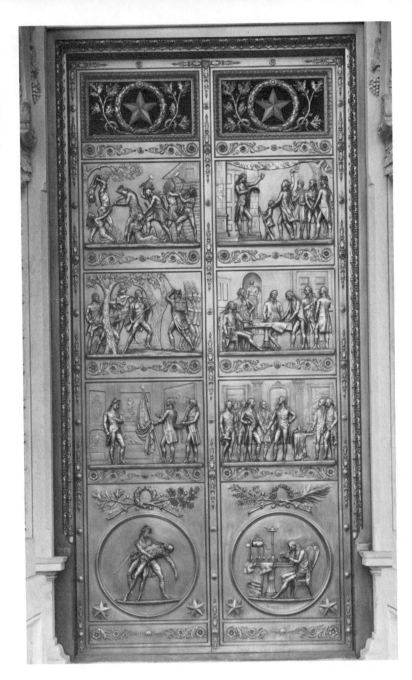

The door at the entrance of the east portico of the House of Representatives wing was designed by Thomas Crawford in Rome, 1855–1857. Upon the death of Crawford, William H. Rinehard executed the models from the Crawford sketches, 1863–1867. Stored in the crypt of the Capitol for a time, the models were cast in 1904 and the door was installed in 1905.

The door, which is about 8 feet wide and 15 feet high, resembles in general that of the Senate. Each valve, or half-door, consists of three panels and a medallion depicting great events in the American Revolution. The three left panels represent (top to bottom): *Massacre at Wyoming, Pennsylvania, July 3, 1778*; *Battle of Lexington, April 19, 1775*; and *Presentation of the Flag and Medal to Major General Nathanael Greene*. The left medallion shows the *Death of Major General Richard Montgomery, December 31, 1775*. On the right side appear the following panels (top to bottom): *Public Reading of the Declaration of Independence at Philadelphia*; *Treaty of Peace at Paris Between the United States and Great Britain, September 3, 1783*; and *Washington's Farewell to His Officers, New York, December 4, 1783*. The right medallion illustrates *Benjamin Franklin in His Studio*.

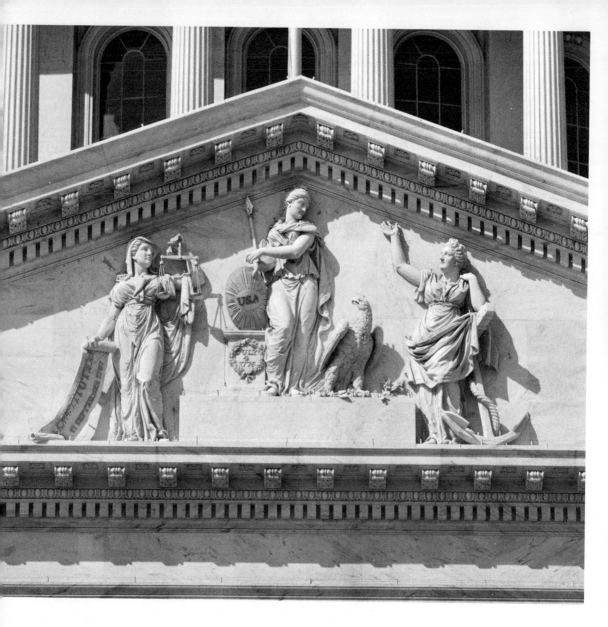

A-8
Title THE GENIUS OF AMERICA, 1828
Location U.S. Capitol, central portico, east front
Sculptor Luigi Persico
Architect Charles Bulfinch
Medium Originally sandstone; reproduced in marble

John Quincy Adams played a role in designing *The Genius of America*. A letter written by Charles Bulfinch dated June 22, 1825, reveals the President's dissatisfaction with the various plans for the Rotunda pediment and the reasons for his disapproval.

> The President . . . disclaimed all wish to exhibit triumphal cars and emblems of victory and all allusions to heathen mythology and thought that the duties of the Nation or its Legislators should be expressed in an obvious and intelligent manner.

Having received no satisfactory proposals, Adams suggested a design to sculptor Luigi Persico, who then composed it and executed the work.

At the apex is armed America accompanied to her left by the American eagle. She holds a spear and supports a shield inscribed: "U.S.A." Beneath the shield is a pedestal bearing the wreathed inscription: "July 4, 1776." To the right of America is Hope with the customary anchor. Justice stands opposite Hope with a pair of scales and a scroll which reads: "Constitution, 17 September 1787." On this date the Constitution was approved by the majority of delegates to the Constitutional Convention in Philadelphia and subsequently sent to the states for final ratification. Hope is making a gesture of encouragement in the direction of America, who looks at her while pointing at Justice. The implication is that America may hope for success so long as she cultivates justice. This pediment is 12 feet high and about 60 feet long.

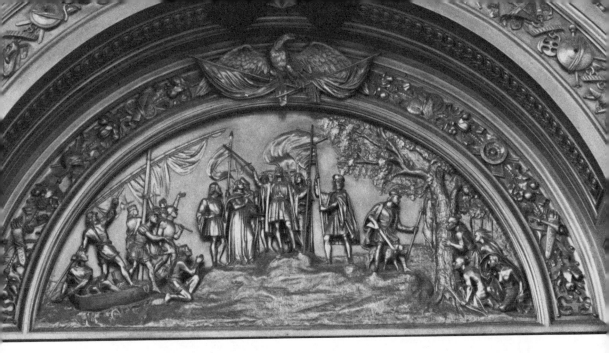

A-9
Title COLUMBUS DOOR, 1858
Location U.S. Capitol, central
portico, east front
Sculptor Randolph Rogers
Architect Thomas U. Walter
Medium Bronze

Above: transom, The Landing of
Columbus in the New World,
October 12, 1492

Below: panel detail, Columbus
in Chains

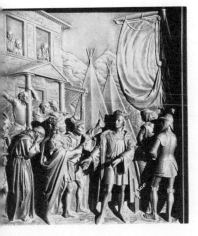

The *Columbus Door*, or, as it is often called after the sculptor, the *Rogers Door*, was acquired for the United States Capitol in 1858 when Thomas U. Walter was the Capitol architect. It was cast by Ferdinand von Müller, director of the Royal Bavarian Foundary in Munich, and measures 17 feet in height and 10 feet in width.

The door consists of two valves, or half-doors, with four panels each, dealing with important events in the life of Columbus. Bordering the valves are niches in which stand illustrious people who participated in the Columbus drama. Above the two valves is a semicircular transom or lunette portraying his first landing in the New World. A casing border, around the lunette, is decorated with various nautical motifs, such as, anchors, rudders, and armor; figures around the valves represent Asia, Africa, Europe, and America.

Sixteen portrait statuettes of persons connected with the story of Christopher Columbus are found adjacent to the relief panels on the door. Clergymen include Juan Perez de Marchena, prior of the Convent of La Rabida, Spain; Pedra Gonzales de Mendoza, archbishop of Toledo and cardinal of Spain, who supported Columbus's cause from the beginning; and Pope Alexander VI, a native of Spain, who also supported Columbus. Explorers include Hernando Cortez, who conquered Mexico; Don Alonzo de Ojeda, a Spanish explorer of America who turned against Columbus; Amerigo Vespucci, cartographer and lifelong supporter of Columbus's explorations and after whom America was named; Bartolomé Columbus, a brother of Christopher, who was lieutenant governor of the Indies; Martin Alonzo Pinzon, who commanded the *Pinta*, one of the three ships which formed Columbus's fleet; Núñez de Balboa, the Spanish explorer who first saw the Pacific Ocean when he crossed the Isthmus of Darien in 1510; and Francisco Pizarro, who conquered Peru. Another friend of Columbus was Dona Beatrix de Bobadilla, a favorite of Queen Isabella. The monarchs shown include Ferdinand and Isabella, king and queen of Spain, who financed Columbus's voyages; King Charles VIII of France; King Henry VII of England, who was active in supporting navigation proposals in the fifteenth century; and King John II of Portugal, who rejected Columbus's request for aid before he applied to Isabella and Ferdinand. The bronze relief heads, numbered 1 through 10 in the following diagram, include two American Indians and eight authors of books on Columbus; among the authors are Washington Irving and William Hickling Prescott, but records of the other six have never been found.

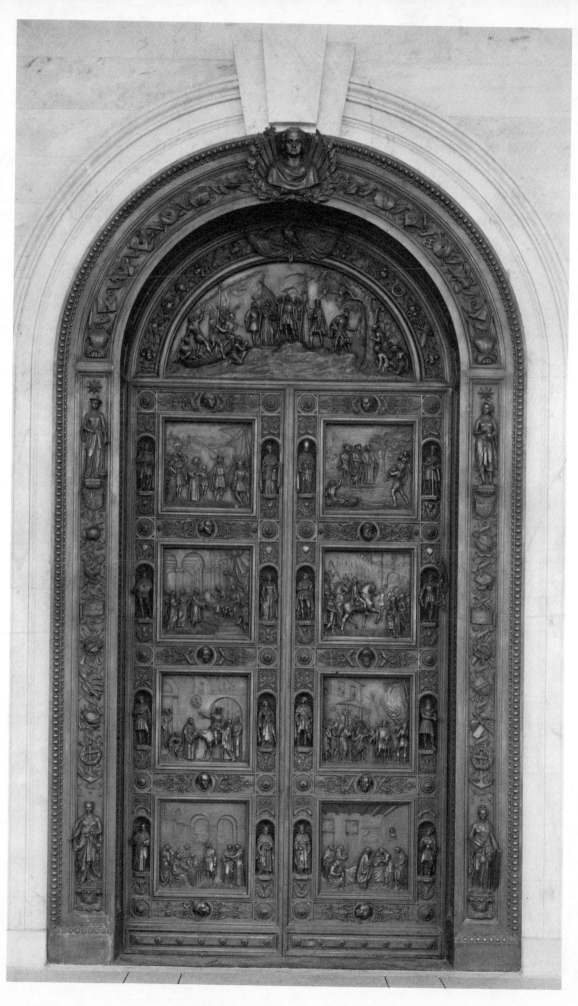

56 Capitol Hill

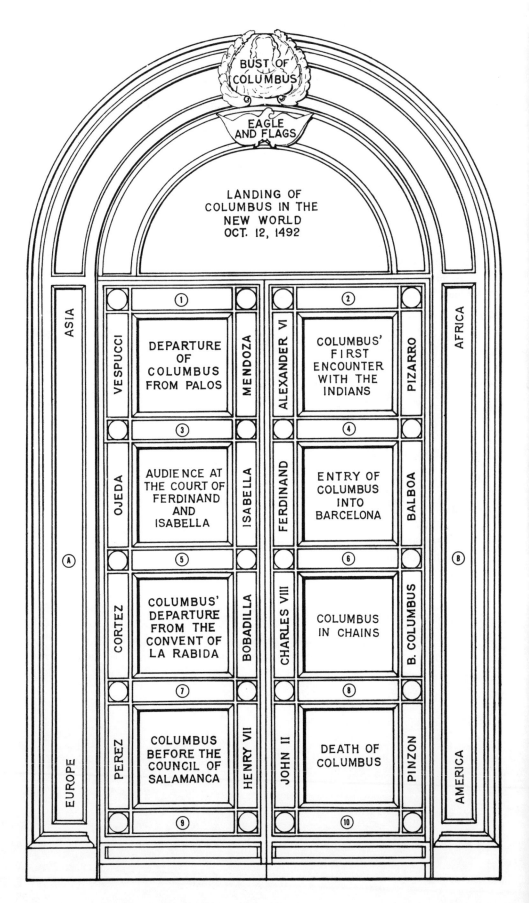

BUST OF COLUMBUS

EAGLE AND FLAGS

LANDING OF COLUMBUS IN THE NEW WORLD OCT. 12, 1492

ASIA

AFRICA

VESPUCCI

MENDOZA

ALEXANDER VI

PIZARRO

① DEPARTURE OF COLUMBUS FROM PALOS

② COLUMBUS' FIRST ENCOUNTER WITH THE INDIANS

OJEDA

ISABELLA

FERDINAND

BALBOA

③ AUDIENCE AT THE COURT OF FERDINAND AND ISABELLA

④ ENTRY OF COLUMBUS INTO BARCELONA

Ⓐ

Ⓑ

CORTEZ

BOBADILLA

CHARLES VIII

B. COLUMBUS

⑤ COLUMBUS' DEPARTURE FROM THE CONVENT OF LA RABIDA

⑥ COLUMBUS IN CHAINS

EUROPE

PEREZ

HENRY VII

JOHN II

PINZON

AMERICA

⑦ COLUMBUS BEFORE THE COUNCIL OF SALAMANCA

⑧ DEATH OF COLUMBUS

⑨

⑩

A-10

Title FAME AND PEACE CROWNING
GEORGE WASHINGTON, 1827
Location U.S. Capitol, over
Columbus Door, central portico,
east front
Sculptor Antonio Capellano
Architect Charles Bulfinch
Medium Sandstone originally;
reproduced in marble

This 1958 reproduction of the original 1827 Antonio Capellano panel portrays a bust of George Washington about to be crowned by the angels of Fame and Peace. Five feet high, the panel measures 19 feet in width. On the right, the angel Fame, clad in flowing robes, holds a trumpet while Peace, to the left, clasps a palm branch. Both of these symbols represent the immortality of the founder of the Nation.

A-11

Title WAR and PEACE, ca. 1835
(installed 1853)
Location U.S. Capitol, niches,
central portico, east front
Sculptor Luigi Persico
Architect Charles Bulfinch
Medium Originally sandstone;
reproduced in marble

The statues *War* and *Peace*, originally designed and executed ca. 1835 by an Italian sculptor, Luigi Persico, were duplicated in marble from plaster casts during the Capitol Extension Project of 1959–1960. The badly damaged originals were first restored by Carl Schmitz of New York, then plaster casts were made of the restorations by George Gianetti and marble reproductions were taken from the casts.

In the niche to the right is the 11-foot statue of *War*, represented in the costume of a Roman soldier. His countenance is firm rather than furious while he seems to listen to *Peace*, who stands to the south of the door. *Peace* is portrayed in flowing drapery, holding in her left hand a fruit-bearing olive branch which she extends toward *War*. With her right hand she points to her bosom in a gesture of sympathetic understanding for the human condition. This statue of *Peace* is about 10 feet tall.

War

Peace

A-12
Title FREEDOM, 1863
Location U.S. Capitol, surmounting dome
Sculptor Thomas Crawford
Architect Thomas U. Walter
Medium Bronze

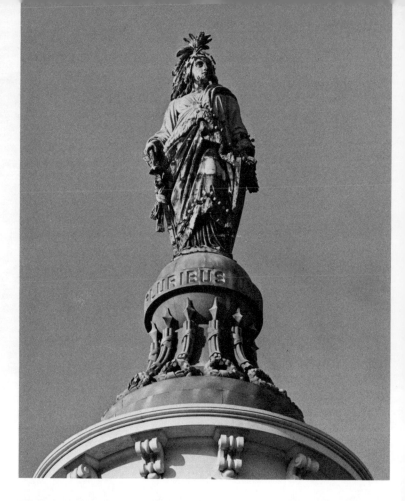

The statue *Freedom* was designed by Thomas Crawford (1814–1857) for the present iron dome of the Capitol, created by Thomas U. Walter in the 1850s to replace the original low, wooden dome which was proportionally too small for the building. The dome was designed by Walter from motifs found in the domes of three European cathedrals: St. Peter's in Rome, St. Paul's in London, and St. Isaac's in St. Petersburg (Leningrad).

The plaster model of *Freedom* was prepared in Italy, shipped to the United States, and taken to the Clark Mills Foundry on Bladensburg Road, NE, where, ironically, it was cast in bronze by slave labor. The original plaster model, which stood for many years in the great rotunda of the Smithsonian's Arts and Industries Building, is now stored in the National Collection of Fine Arts.

The colossal 19½-foot-high figure is that of a woman in flowing draperies, bearing tools of defense. In her left hand she holds a wreath and a shield, while her right hand clutches a sheathed sword. Her clothing is gathered at the waist by a buckle inscribed: "U.S.A." Originally, *Freedom*'s outfit was completed by a Liberty Cap (worn in ancient Rome by freed slaves), but was changed after objections by then Secretary of War Jefferson Davis, who asserted that the headdress embodied a not-very-subtle Yankee protest against slavery. Today's cap follows Jefferson Davis's suggestion of a helmet encircled by stars "expressive of endless existence and heavenly birth." The helmet is topped by an eagle's head and flowing plumage reminiscent of an American Indian headdress. *Freedom* stands on a globe 7 feet in diameter in symbolic vigilance over the world; around the sphere is the inscription "E Pluribus Unum"—One Out of Many. The statue was erected amid fanfare on December 2, 1863, in hopes that the ceremony would provide inspiration for dispirited Union troops. Platinum lightning rods on each shoulder and on top of the headdress have protected this statue although struck by lightning many times.

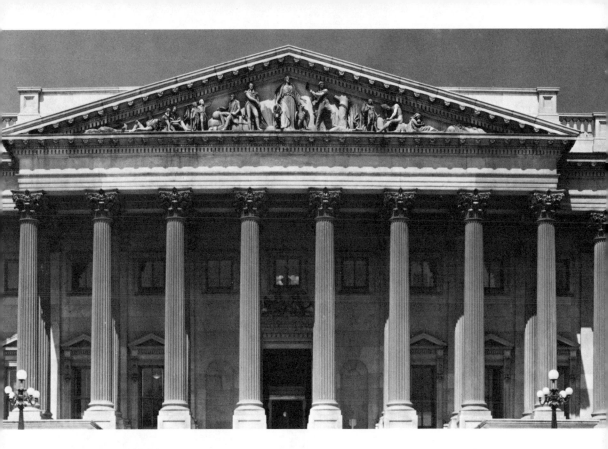

A-13

Title THE PROGRESS OF
CIVILIZATION, 1863
Location U.S. Capitol, Senate
portico, east front
Sculptor Thomas Crawford
Architect Thomas U. Walter
Medium Marble

The theme of this pediment seems bigoted to the twentieth-century beholder, and maybe even more so once he is cognizant of early correspondence between the sculptor and the chief engineer, Montgomery Meigs, in which it was referred to as "American Civilization and the Decadence of the Indian Races." Captain Meigs had encouraged Crawford to produce a work which would be intelligible to the whole population, and Crawford replied, "I have faith enough to believe that poetry and grandeur are inseparably connected with the history of our Country's past and future and that the dignity of sculpture may well be devoted to the perpetuation of what the people understand."

The central figure represents America standing on a rock, against which beat ocean waves. She is attended by the American eagle; the sun rising at her feet symbolizes the enlightenment of Progress. In one hand she holds the rewards of civil and military accomplishment, laurel and oak leaves. Her left hand is extended toward the pioneer for whom she asks the protection of the Almighty.

The group to the right of America deals with the confrontation between pioneer and Indian. The pioneer is the athletic backwoodsman clearing a forest; the Indian race is portrayed in the adjoining group by an Indian chief and his family. The chief's son returns from the hunt with game on his spear; the scene also includes an Indian mother and child and an Indian grave. The attitude of the chief is meant to communicate despair and grief over the white man's triumph.

Advantageous effects of Liberty and Civilization are shown by the figures to the left of America. A soldier stands in Revolutionary dress, his hand on his sword to indicate preparedness. Next, a merchant sits on packaged export goods, his right hand resting on a globe—America's commercial hegemony. An anchor at his feet, symbolizing Hope, connects him with two young boys advancing to devote themselves to their country. Behind the boys sits a teacher instructing a youth; and the group is completed by the mechanic who, resting on a cogwheel, holds the symbols of trade. Sheaves of corn at his feet express abundance and fertility in contrast to the despair of the Indian grave. The pediment is 12 feet high and 60 feet long.

Title GEORGE WASHINGTON AND THE
REVOLUTIONARY WAR DOOR, 1868
Location U.S. Capitol, Senate wing,
east front
Sculptor Thomas Crawford
Architect Thomas U. Walter
Medium Bronze

Thomas Crawford received the commission for this door along with the commission for the House of Representatives bronze door in 1853. He did most of the work on the plaster models, but they were completed by William H. Rinehart after Crawford's death in 1857. The Senate door was cast by James T. Ames at his foundry in Chicopee, Massachusetts, between 1864 and 1868, and then placed in the Capitol.

Measuring 14½ feet in height and 7½ feet in width, the Senate door consists of two valves, or half-doors, of four panels each. The right valve deals with the Revolutionary War; the left one portrays events following the Revolution. The bottom section of the right valve is an allegorical medallion depicting an American farmer, protecting his wife and child, in combat against a Hessian soldier. The companion section on the left valve shows Peace and Agriculture with Infancy, Maternity, Childhood, Youth, and Manhood grouped around a plow. The top section on each valve is a decorative composition of a star encircled by a laurel wreath and oak leaves, symbolizing civic and military merit. Momentous events of America's early history are treated in the remaining six reliefs. All panels should be read from top to bottom.

The three left panels are: *Laying of the Cornerstone of the United States Capitol, 1793; Inauguration of George Washington as First President, 1789;* and *Ovation for George Washington at Trenton, New Jersey, 1789.* The right panels represent: *Battle of Bunker Hill and Death of Major General Joseph Warren of Massachusetts, 1775; Battle of Monmouth and Rebuke of Major General Charles Lee of Virginia, 1778;* and *Battle of Yorktown and Gallantry of Major General Alexander Hamilton of New York, 1781.*

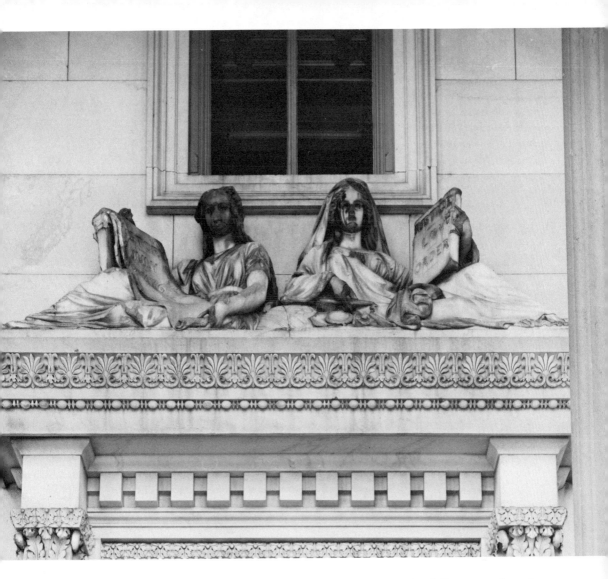

A-15
Title JUSTICE AND HISTORY, 1863
Location U.S. Capitol, Senate wing,
east front
Sculptor Thomas Crawford
Architect Thomas U. Walter
Medium Marble

Visibly the worse for over 110 years of indifferent weather, these 11-foot-long figures above the Senate bronze door need restoration. *Justice and History* was carved in Rome by unknown craftsmen from plaster models created by Thomas Crawford. Justice, on the right, holds a volume bearing the inscription, "Justice, Law, Order," and a pair of scales, symbol of justice. History supports a scroll inscribed: "History, July 1776."

A-16

Title SCENES FROM AMERICAN INDUSTRY, 1956

Location Everett M. Dirksen Senate Office Building, 1st Street and Constitution Avenue, NE

Sculptor Otto R. Eggers, designer

Architect Eggers and Higgins

Medium Bronze

Lumbering

Between the third- and fourth-floor windows of the Everett M. Dirksen Senate Office Building are low-relief panels, measuring about 3½ feet square, which depict scenes from American industry. Five phases of American life are included: *Shipping, Farming, Manufacturing, Mining,* and *Lumbering.* The spandrels have small low-relief fasces on both sides of each panel.

In addition, three medallions are on the bronze and aluminum doors at the Constitution Avenue entrance. These represent Equality (on the left), the Seal of the United States (in the center), and Liberty (on the right). The eagle pediment on the main façade was executed by sculptor Ulysses A. Ricci during construction of the building in 1956.

In 1972 Congress changed the name of the Old Senate Office Building to the Richard B. Russell Senate Office Building in honor of the Democratic senator from Georgia, and that of the New Senate Office Building to the Everett M. Dirksen Senate Office Building, honoring the Republican senator from Illinois.

Everett McKinley Dirksen (1896–1969), a leading Republican statesman of his generation, was born in Pekin, Illinois, the son of a German immigrant. His education at the University of Minnesota was terminated when he entered the United States Army during World War I. Dirksen served in the United States House of Representatives from 1932 to 1949. In the 1930s he was a strong isolationist, but his views changed shortly before Pearl Harbor. Dirksen served in the United States Senate from 1950 until his death in 1969. For ten years he held the important post of Senate minority leader and was noted for his colorful speeches, often made extemporaneously and with dramatic flair. Over the years his speeches of praise for the marigold, which he wanted to be made the national flower, became part of Senate lore. It is said that his early interest in drama helped mold his speaking style; he was the author of a number of plays, five novels, and many short stories, all of which are unpublished. Noted for his ability to find the key to agreement and compromise between conflicting interests in the Senate, he played a prominent role in both the ratification of the Nuclear Test Ban Treaty of 1963 and the Civil Rights Act of 1964.

Title Supreme Court Flagpole
Bases, 1935
Location Supreme Court, 1st Street
between East Capitol Street and
Maryland Avenue, NE
Sculptor John Donnelly
Architect Cass Gilbert
Medium Bronze and marble

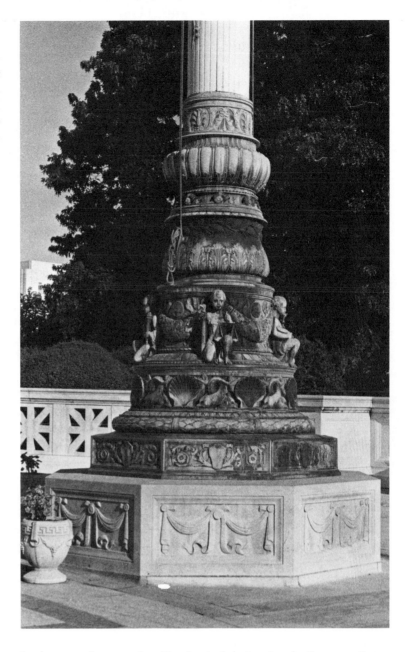

In the quest for a perfect Neoclassical design for the Supreme Court, architects and designers were hard pressed to find Greek or Roman precedents for flagpoles and electric lampposts. The best idea seemed to be to employ essentially modern forms distinguished with Classical details; this was the course followed.

At the beginning of the west entrance steps are a pair of candelabra-like light fixtures modeled by John Donnelly, Jr. These have four low-relief panels and rams' heads at the corners of the bases; the shafts are double inverted acanthus leaves, surmounted by four circular lights. Less ornate, single-globe fixtures are found at each end of the portico. These are supported by turtles, symbolic of the slow but steady movement of justice.

The two flagpoles of the entrance court are reminiscent of a wedding cake: the bases are octagonal with swags of drapery in relief on each face. Each of the second tiers has a shield and rinceau (ornate leaves and flowers) motif; the third, a pattern of thorns; the fourth, shells and dolphins; the fifth, cherubs with symbols of justice and swags and medallions; the sixth, acanthus leaves and pine cones; the seventh, snails; the eighth, an egg-and-dart molding; the ninth, an anthemion (design of palmettes). A fluted column rises above this, and an eagle sits atop each flagpole! The bases measure 9 feet high and 6 feet wide.

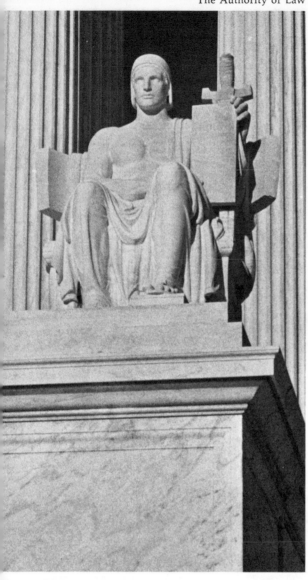

A-18

Title THE AUTHORITY OF LAW and
THE CONTEMPLATION OF JUSTICE,
1935

Location Supreme Court, 1st Street,
NE, between East Capitol Street
and Maryland Avenue

Sculptor James Earle Fraser

Architect Cass Gilbert

Medium Marble

The federal government moved to Washington from Philadelphia in 1800. From that time until 1935, the United States Supreme Court had no permanent home. Benjamin Latrobe, in a letter to President James Monroe in 1809, wrote: "During the session of the Supreme Court last Spring the Library became so inconvenient and cold that the Supreme Court preferred to sit at Long's Tavern." The judicial branch of the government was shuffled from one undesirable part of the Capitol to another, and, in 1814, took refuge at Bell's Tavern across New Jersey Avenue. In 1921, former President William Howard Taft became chief justice and was influential in initiating legislation for the construction of an appropriate building for the highest tribunal of the land.

Architecturally, the result is correct, if somewhat academic. This "palace of justice," consists of a central temple in the Roman style flanked by two wings.

Two 45-ton marble cheek blocks on each side of the main west entrance steps act as pedestals for heroic statues by James Earle Fraser. The 10-foot male figure to the south represents *The Authority of Law.* His companion, a woman in classical garb, is called *The Contemplation of Justice.* Her head is cloaked, and she seems to have a brooding expression; her left arm rests on a book, while she holds a miniature statue, symbolic of Justice. This rather unusually designed feature is not incorrect in Classical sculpture. The heroic statue *Athena Parthenos,* by the Greek sculptor Pheidias, on the Parthenon in Athens, ca. 440 B.C., likewise held an allegorical statue in her right hand.

A-19
Title THE EVOLUTION OF JUSTICE
DOOR, 1935
Location Supreme Court, west
façade, 1st Street between East
Capitol Street and Maryland
Avenue, NE
Sculptor John Donnelly
Architect Cass Gilbert
Medium Bronze

Sculptor John Donnelly, in collaboration with architect Cass Gilbert, designed this handsome bronze door, each valve of which weighs 3,000 pounds, having low-relief panels depicting famous episodes in the evolution of justice. An electronic device rolls each half-door or valve into its adjoining wall. The entire door measures approximately 17 feet high and 9½ feet wide. Each of the two doors contains four panels.

The earliest scenes from history appear on the four panels of the left door or valve: the *Shield of Achilles* which shows two men debating the "straightest judgment," the winner to receive two gold pieces on a stone; *Praetor's Edict*, which proclaims judge-made law in Rome; *Julian and the Scholar*, which portrays the development of law by the scholar and advocate; and *Justinian Code*, which shows Justinian publishing *Corpus Juris*, the first code of laws. The relief panels of other Roman emperors are carved on the east façade or rear of the building.

The four scenes on the right door portray more recent developments of justice: *Magna Carta*, which shows King John signing the document that gave legal rights to the freemen of England; the *Westminster Statute*, wherein the chancellor publishes the statute in the presence of King Edward I; *Lord Coke and James I*, in which Lord Coke bars King James from participation in England's highest court, making the court independent of the executive; and *Marshall and Story*, which shows Chief Justice John Marshall delivering the Marbury vs. Madison opinion, and setting the precedent for the Supreme Court to declare acts of Congress unconstitutional. There is an anachronism in placing Story in this panel. He never participated in any decision in which an act of Congress was invalidated; not until eight years after Marshall's history-making decision did Joseph Story become a member of the Supreme Court.

A-20

Title EQUAL JUSTICE UNDER LAW,
1935

Location Supreme Court, 1st Street
between East Capitol Street and
Maryland Avenue, NE

Sculptor Robert Aitkin

Architect Cass Gilbert

Medium Marble

Sculptured pediments are found over the porticos of the east and west entrances to the United States Supreme Court Building. The Aitkin pediment at the main entrance is called *Equal Justice Under Law*, and is about 18 feet tall at its apex and 60 feet long. Rising above the Corinthian colonnade, the central figure is, allegorically, Liberty enthroned. She is looking confidently into the future and has the scales of justice in her lap. Liberty is flanked by two Roman soldiers representing Order and Authority. Beyond them are two pairs of historical personages symbolic of Council. Left are Cass Gilbert (architect of the building) and Elihu Root (noted lawyer); to the right, are Charles Evans Hughes (chief justice, 1930–1941) and the sculptor, Robert Aitkin. At the far ends, two more figures represent Research. These are, left, William Howard Taft (twenty-seventh president and chief justice, 1921–1930) and, right, John Marshall (chief justice, 1801–1835). The historical personnages, attired in classical garb, seem to be chatting quite amicably.

A-21
Title JUSTICE, THE GUARDIAN OF LIBERTY, 1935
Location Supreme Court, 2nd Street between East Capitol Street and Maryland Avenue, NE
Sculptor Herman A. MacNeil
Architect Cass Gilbert
Medium Marble

Justice, the Guardian of Liberty, the pediment located on the east façade of the Supreme Court, is about 18 feet tall and 60 feet long. It emphasizes the contributions of Eastern and Mediterranean civilizations to the development of the law. Moses, with the tablets of Hebraic law, is the central figure. To the left is Confucius, the great lawgiver of China; on the other side is Solon, master codifier of Greek law. This central group is flanked by symbolical figures. On the left appears a kneeling man holding a child and a fasces, thus bearing the means of enforcing the law. On the right is a kneeling woman and a child symbolic of tempering justice with mercy. The next two soldiers have shields; the left one represents the settlement of disputes between states through enlightened judgment while the right figure is symbolic of the protection of maritime and other rights by the Supreme Court. The next pair of figures includes, left, a reclining woman representing the study and pondering of judgment, and, right, a reclining man showing the high character of the Supreme Court. Aesop's famed tortoise and hare appear in the extreme corners of the pediment, symbolic of the slow but sure course of Justice.

A-22
Title THE COURT OF NEPTUNE FOUNTAIN, 1897–1898
Location Library of Congress Main Building, 1st Street, SE, between Independence Avenue and East Capitol Street, adjacent to the westernmost sidewalk on 1st Street
Sculptor Roland Hinton Perry
Architects J. L. Smithmeyer and Paul J. Pelz; later, Edward Pearce Casey
Medium Bronze and granite

The Court of Neptune, in front of the Library of Congress Main Building entrance, is certainly one of the more exuberant works of sculpture in the city. This grottolike fountain seems to epitomize the lavish excesses of the Victorian era, but the overall effect is not unpleasant.

The granite section consists of a semicircular basin 50 feet wide set in a retaining wall broken by three large niches. The bronze section creates a feeling of animation, not surprising with its various marine and mythological population. In addition to the 12-foot Neptune, king of the sea, other creatures found in the pool include a serpent, sea nymphs, seahorses, turtles, frogs, and tritons. The latter are gods, men with the lower portions of their bodies like that of fish. The tritons are 12 feet tall, the nymphs 10. King Neptune sits on a rock in the center while he keeps his sons, the tritons, at his side; the tritons use conch-shell trumpets to call the sea-people to their father. Two frogs spout

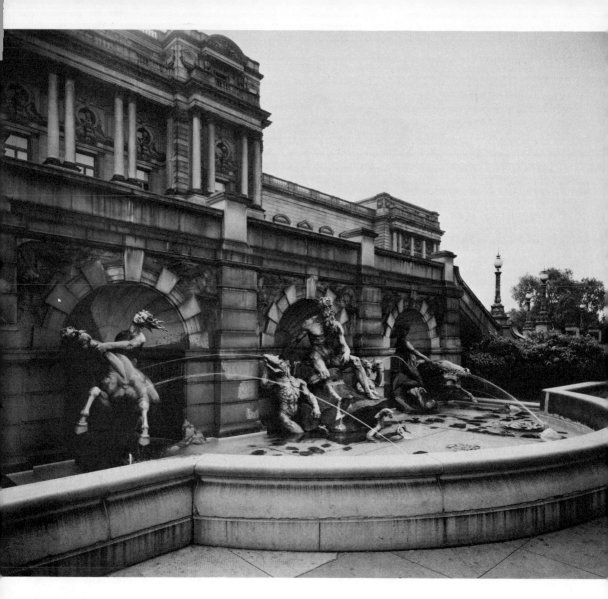

water nearby; a sea serpent waits in front of Neptune for the king's orders, while carefree nymphs ride splashing seahorses on each side, with water provided by four large turtles. The dolphins and stalactites, sculptured in relief on the granite wall, are by Albert Weinert.

Inspiration for the Neptune piece was possibly the *Trevi Fountain* in Rome which was completed in 1762 from an early eighteenth-century design by Nicolo Salvi. The Trevi Neptune is attributed to Bernini, one of the great Italian artists of the Baroque period, famous for his work on the Vatican. Both fountains were based on classical legends. Neptune, the god of the sea and of lakes, was a Roman divinity, nearly the same as Poseidon, the Greek god. He was the son of Saturn and Rhea and the brother of Jupiter and Pluto. His children by his wife Amphitrite were Triton and Rhode. The dolphins in the fountain possibly relate to the legend that Amphitrite's affections were finally won by Neptune after he came riding to her on a dolphin. The horses relate to Neptune's use of one in his contest with the goddess Minerva for the right of naming the city of Athens. The horse, sacred to Neptune and to the rivers, was employed as a general symbol of the waters. Neptune was often pictured dwelling in his splendid palace beneath the Aegean Sea, where the monsters of the deep gathered around their king. He is usually shown as being very muscular and holding a trident, the three-pronged symbol of his power. Neptune became king of the sea after he and his brothers divided the world among themselves by lot. Jupiter thus came to rule the heavens while Pluto became the king of the underworld.

A-23

Title Literature, Science, Art, 1895
Location Library of Congress Main Building, 1st Street SE, between Independence Avenue and East Capitol Street
Sculptor Bela L. Pratt
Architects J. L. Smithmeyer and Paul J. Pelz; later, Edward Pearce Casey
Medium Granite

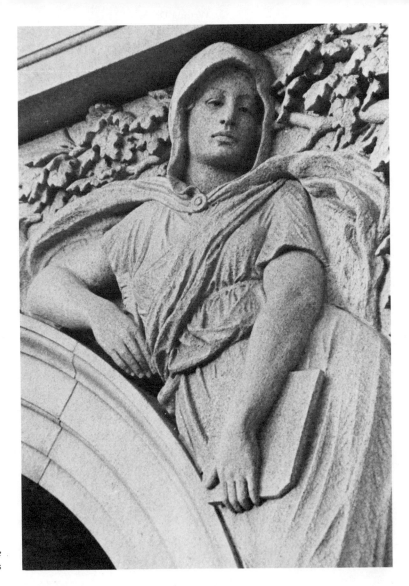

Reflection, a spandrel figure above the Tradition Doors

Six languishing female figures grace the spandrels above the bronze doors at the front entrance to the Library of Congress Main Building. The reliefs in the spandrels were completed before the nearby doors and tympanums, which are set inside the arches beneath the spandrels. Those life-size figures above the arch of *Tradition Doors* (left) represent two aspects of *Literature—Composition* and *Reflection.* The figure to the left writes on a tablet, while her companion, perhaps the most striking of the group, seems to meditate. *Science,* the pair of spandrels in the middle, is represented in its abstract aspect by a rather proud figure carrying a torch of knowledge and by another with a glove in her left hand depicting the practical side of science. The third set of spandrels, *Art* (right), portrays one passive-looking female sculptor with a bust of Dante in progress. Across from her is a painter literally dabbling in the arts. All six figures wear loose-fitting Neoclassical garb; vegetation is the common background.

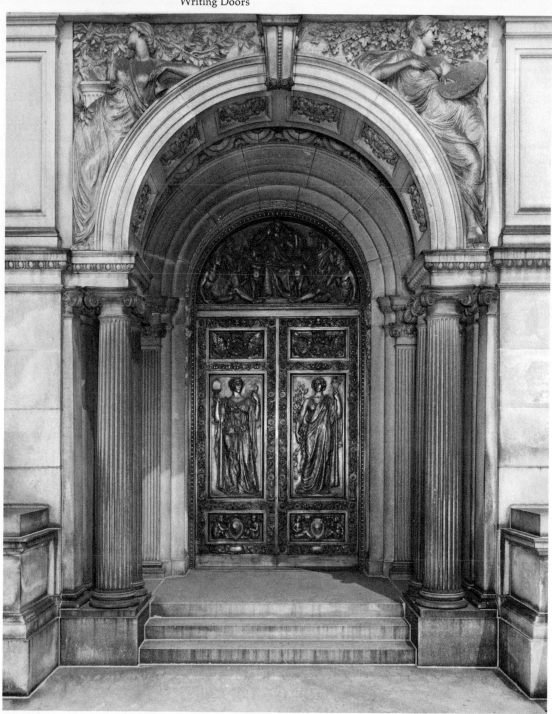

A-24
Title TRADITION, PRINTING,
WRITING DOORS, 1895–1898
Location Library of Congress Main
Building, 1st Street, SE, between
Independence Avenue and East
Capitol Street, main entrance
Sculptors Olin Warner (*Tradition*
and part of *Writing*), Frederick
MacMonnies (*Printing*), and
Herbert Adams (part of *Writing*)
Architects J. L. Smithmeyer and
Paul J. Pelz; later, Edward Pearce
Casey
Medium Bronze

The Library of Congress Main Building is certainly one of the most flamboyant in the city, and perhaps in the Nation. Erected between 1889 and 1897, the massive library was fashioned in the Italian Renaissance style, although, in later perspective, Victorian Rococo might seem more descriptive. While that particular style may not be the height of taste at present, few can deny that the building has a vastness, an eclectic splendor, even a peculiar fascination.

Three sets of double bronze doors, each set measuring 14 feet tall and 7½ feet wide, are found at the main entrance above the grand staircase facing the Capitol. They are locked in winter when all visitors are routed through the ground-level entrance. When the steps are free of ice, however, the hardy winter visitor, by braving the wind and the staircase, can see these extraordinary doors with their intricately carved tympanums.

The tympanums above the doors represent "*Tradition*, *Writing*, and

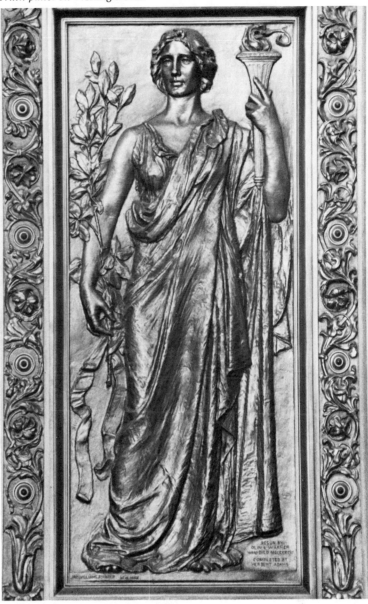

Printing, the principal means by which, as civilization has evolved, man has communicated and preserved the record of the world he knows." The doors to the left, symbolic of *Tradition,* depict a woman with a lyre in her arms (Imagination) and the widow of a warrior slain in battle (Memory). Above them, in the tympanum, is a woman on a throne telling past lore to a small boy. Also depicted are representatives of several cultures whose history is known mainly through folklore. The center doors, beneath the tympanum of *Printing,* contain female figures symbolic of the Humanities and the Intellect. In the tympanum is *Minerva Diffusing the Products of Typographical Art.* Prominent, in addition to the Roman goddess of wisdom, are Pegasus, the winged horse (Poetic Inspiration); a stork (Filial Piety); an hourglass; an inking ball; a printer's stick; and an early printing press. To the right is the tympanum symbolic of *Writing.* Research and Truth are in low-relief on the doors, and a teacher, an Egyptian, a Jew, a Christian, and a Greek are symbolic of major literary cultures.

The Library of Congress was founded in 1800 and has become the largest library of its kind in the world. Its buildings on Capitol Hill are the Main Building on First Street, the Annex Building on Second Street, and the James Madison Memorial Building, now under construction on Independence Avenue.

A-25
Title Ethnological Heads, 1891
Location Library of Congress Main
Building, 1st Street, se, between
East Capitol Street and
Independence Avenue
Sculptors William Boyd and Henry
J. Ellicott after design of
Otis T. Mason
Architects J. L. Smithmeyer and
Paul J. Pelz; later, Edward Pearce
Casey
Medium Granite

Chinese keystone

Thirty-three keystones, each modeled as a human head, represent the major races of the world. These architectural sculptures are found above the second-story pavilion windows. When the Library of Congress Main Building was constructed, as the country's greatest single repository for knowledge, it was thought that even the exterior of the building should be a source of information or edification. Professor Otis T. Mason, curator of the Department of Ethnology of the Smithsonian Institution, spent six months studying the ethnological collections of the Smithsonian, and executed plaster models of "savage and barbarous peoples" which were helpful to the sculptors. Each keystone is about 18 inches in height. All are of men, each said to be in the prime of life. Beginning at the north end of the Entrance Pavilion, heading south and then circling the building, the racial groups are as follows: Russian Slav, Blonde European, Brunette European, Modern Greek, Persian, Circassian, Hindu, Hungarian, Semite, Arabian, Turkish, Modern Egyptian, Abyssinian, Malayan, Polynesian, and Australian. Continuing, one finds the carved heads of a Negrito, Zulu, Papuan, Sudan Negro, Akka, Fuegian, Botocudo, Pueblo Indian, Esquimo, Plains Indian, Samoyede, Korean, Japanese, Aino, Burmese, Tibetan, and Chinese.

Title EMINENT MEN OF LETTERS,
1894–1895
Location Library of Congress Main
Building, main pavilion, 1st Street,
SE, between East Capitol Street and
Independence Avenue
Sculptors Herbert Adams, F.
Wellington Ruckstuhl, and J. Scott
Hartley
Architects J. L. Smithmeyer and
Paul J. Pelz; later, Edward Pearce
Casey
Medium Granite

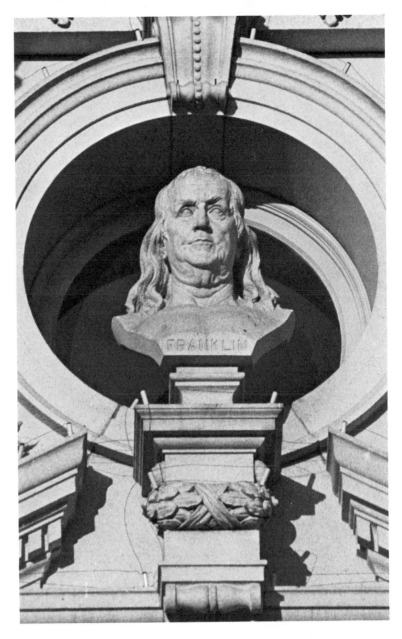

Benjamin Franklin,
the central bust

Above the main windows of the third story of the central pavilion
appears a series of nine circular windows which serve as a background
for 3-foot high granite portrait busts of men eminent in the history of
western literature. The pedestals of the busts rest on the pediments
below. Seven are placed along the front and one at each end of the
central pavilion. The busts appear, from left to right, as follows:
Demosthenes, Emerson, Irving, Goethe, Franklin, Macaulay, Haw-
thorne, Scott, and Dante. Demosthenes, Scott, and Dante were executed
by Herbert Adams; Emerson, Irving, and Hawthorne by J. Scott Hart-
ley; and Goethe, Franklin, and Macaulay by F. Wellington Ruckstuhl.
Each bust is of uniform size. The bust of Franklin is centered in the
series to give it the most important position. The sculptor conceived
him "as one of the greatest men of this country, and as a writer and
philosopher, the patriarch, and therefore aimed to make him dominate
the rest."

These busts are flanked either by boldly sculptured figures of children
reclining upon the sloping pediments, or, alternately, by massive gar-
lands of fruits. Each of the keystones of the circular windows supports
the standing figure of a winged cherub, or genius, introduced as the
accentuating feature of a frieze of foliated ornament extending along
the three sides of the pavilion.

A-27

Title AMERICA FOSTERING THE ARTS
AND INDUSTRIES and ATLANTES,
1897

Location Library of Congress Main
Building, main pavilion, 1st Street,
SE, between East Capitol Street and
Independence Avenue
Sculptor William Boyd
Architects J. L. Smithmeyer and
Paul J. Pelz; later, Edward Pearce
Casey
Medium Granite

Above the two small balconies at each end of the fourth story on the main pavilion appear rounded pediments supported by *Atlantes*. These pediments, *America Fostering the Arts and Industries*, appear from the ground level to be identical. The viewer will notice, at close observation, however, that they are slightly different.

The left pediment contains an American eagle with wings outstretched behind two putti or small nude Neoclassical boys. The left child sits with a globe at his feet and holds an open book atop two other volumes. He is symbolic of Industries. The putto on the right side, Arts, sits adjacent to a painter's palette and brushes and an Ionic capital, which are representative, respectively, of Painting and Architecture. The right pediment, shown above, also has the American eagle with a putto on each side. The left figure, Industries, sits beside a cogwheel and anvil, symbolic of Commerce. The right figure, Arts, sits beside a harp with an open book (again on two other volumes) to symbolize Music and Literature.

The *Atlantes* are half-figures of human males used as columns to support the pediments. These 6-foot figures originated from Greek mythology in which the Titans or family of giants were overthrown by the Olympian gods and one of their number was forced to support the heavens.

Title TORCH OF LEARNING, 1893
Location Library of Congress Main Building, atop the dome, 1st Street, SE, between East Capitol Street and Independence Avenue
Sculptor Edward Pearce Casey, designer
Architects J. L. Smithmeyer and Paul J. Pelz; later, Edward Pearce Casey
Medium Copper

The *Torch of Learning* marks the center and apex of the Library of Congress Main Building, 195 feet above the ground. The *Torch of Learning* is about 15 feet tall and varies from its 4½-foot-wide flame to a base 6½ feet wide. The dome and the flame of the torch were covered originally with 23-carat gold leaf. In 1931 the original gold-leafed copper of the dome, which had developed tiny leaks attributed to the nineteenth-century practice of tinning the copper, was replaced. The new copper was not gilded lest it conflict with the weathered granite.

This building was erected because of overcrowded conditions in the Capitol, where the library was housed from its founding in 1800 until 1897. The holdings of the Library of Congress were greatly increased in size after 1840 by international exchange and in 1866 by an Act of Congress, which transferred to the library the Smithsonian Institution's massive collection of some half a million volumes. An amendment to the copyright law in 1870 required that two copies of every published item be deposited in the Library of Congress to perfect copyright, and the development of international copyright in 1891 ultimately added many more volumes to the library's shelves. Special purchases by Congress and gifts from private citizens also augmented the collections.

The grandiose main building, with its triple-arched entrance, twinned columns, low dome, and lantern cupola, was built under the direction of the chief of the United States Army Engineers, Brigadier General Thomas L. Casey. The basis of the design was created by John L. Smithmeyer and Paul J. Pelz, Washington architects, with some later modifications by Edward Pearce Casey, a New York architect, who completed the interior designs. The largest structure in the world devoted to a library and probably the most elaborate library ever constructed in the United States, it is still admired by the visiting public for its sculptures, murals, and mosaics.

The Library of Congress has published an illustrated history of the construction and decoration of the building in its *Quarterly Journal* (Vol. 29, No. 4, October 1972), which may be purchased by visitors at the library or by mail from the Government Printing Office in Washington, D.C.

Title LIBRARY OF CONGRESS ANNEX
BRONZE DOORS, 1938
Location Library of Congress
Annex Building, 2nd Street at
Independence Avenue, SE
Sculptor Lee Lawrie
Architect Pierson and Wilson
Medium Bronze

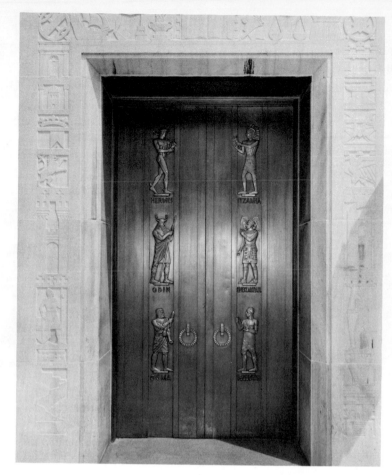

Center doors at west entrance

Seven sets of low-relief doors are found on the Library of Congress
Annex Building, just east of the Library of Congress Main Building.
The annex is smaller and less ornate than its Victorian parent, and its
12-foot bronze doors also reflect a different inspiration. Vaguely classi-
cal and historical motifs are still employed, but the effect is rather
severe by comparison.

The center doors at the west entrance depict six figures. They are
Hermes, the Greek god who served as messenger; Odin, originator of
the Viking alphabet and mythical god of war; Ogma, who performed
the same alphabetical task for the Irish; Itzama, chief god of the
Mayans; Quetzalcoatl, fair-haired god of the Aztecs; and Sequoyah,
American Indian. Each of these figures is said to have made a major
contribution in some aspect of written communication. They are re-
peated on the doors flanking the central doorway at the east entrance.

The single doorway at the south entrance, facing Independence
Avenue, has two figures. A male, symbolic of physical labor, stands
beneath the seal of the United States; a female, representing intellectual
labor, is placed adjacent to an open book, encircled by a laurel wreath.

At the center doorway of the east side are six more sculpted figures
of individuals, said to have contributed to the history of the written
word in their respective cultures. These are Thoth, Egyptian god and
conveyor of speech; Ts'ang Chieh, Chinese patron saint of pictographic
letters; Nabu Sumero, Akkadian god; Brahma, supreme god of the
east Indian trinity; Cadmus of Greece, who planted the dragon teeth
from which sprang armed men; and Tamurath, a cultural hero of
Persian antiquity. These six figures are repeated on the doors flanking
the central doorway at the west entrance. The reader should note that
each of the mythical gods or men listed had several attributes. For in-
stance, although Hermes' contribution to written communication was
as a messenger, he also was supposed to have invented astronomy,
music, numbers, and the alphabet.

A-30

Title THE MAJESTY OF LAW and
THE SPIRIT OF JUSTICE, 1964
Location Rayburn House Office
Building, Independence Avenue
between South Capitol and 1st
Streets, SW
Sculptor Carl Paul Jennewein
Architect Harbeson, Hough,
Livingston and Larson
Medium Marble

The principal sculpture on this controversially designed office building is the pair of 8-foot tall allegorical statues by Carl Paul Jennewein. The statues are located on each side of the Independence Avenue entrance to the building. The left, or upper statue, *The Spirit of Justice*, is represented by a female figure, which resembles the ancient *Pallas Athena*, the civic goddess who was also wise in the arts of peace. Her lamp symbolizes truth and righteousness. The maternal left hand, around the shoulder of a small boy, signifies justice tempered with love.

The Majesty of Law, a seminude bearded male, represents supreme authority, dignity, and respect for the law. The sword in his right hand indicates valor. A book of federal laws, with the United States seal on its cover, is held in his left hand.

The building received considerable criticism because of its design, which is composed of a mixture of modern and Neoclassical elements, poor proportions, and enormous expense. It was named in honor of Sam Rayburn of Texas, a member of the United States House of Representatives from 1913 until his death in 1961. Rayburn, a life-long bachelor, served as Speaker of the House from 1940–1961. He was born in Roane County, Tennessee, in 1882 but moved with his parents to Fannin County, Texas, at the age of five. After graduating from East Texas Normal College in 1903, he studied law at the University of Texas and was admitted to the Texas bar in 1908. Rayburn served in the Texas legislature from 1907 to 1912 when he was elected as a Democrat to the 63rd Congress. Visitors to the building should note that a marble bust of Rayburn by Paul Manship (1964) is located in the interior. A slightly larger than life size statute of Rayburn by Felix W. de Weldon (1965) can also be found in the interior near the entrance to the garden. Both of these sculptures portray the Speaker with gavel in hand.

Above left, The Spirit of Justice;
above right, The Majesty of Law

A-31

Title GREEK VASES, 1964
Location Rayburn House Office
Building, Independence Avenue
between South Capitol and 1st
Streets, sw
Sculptor W. H. Livingston, Sr.,
designer
Architect Harbeson, Hough,
Livingston and Larson
Medium Marble

Four of these enormous 9-foot-high sculptured *Greek Vases* on the west façade and four more on the east façade attempt to transform the Rayburn House Office Building into a Neoclassical structure. The sculptures in themselves are interesting variations of the ancient Greek vase. They are all identical and consist of a design of four parts. Each of the vases includes a ram's head, neck, and bent front legs. A fluted cornucopia then extends from the shoulder area of the ram. Neoclassical marble wings connect the ram with the cornucopia and serve as a graceful motif in joining the other two sections. The entire composition rests on a carved pedestal of leaves.

The vases are modeled after the ancient Greek drinking horn with a mythical chimera having bent knees. The chimera in Classical sculpture was a grotesque animal often consisting of a fanciful combination of lion, goat, and serpent. The ram's head is representative of wisdom, power, strength of purpose, and defender of right. The cornucopia or ancient Greek drinking horn symbolizes abundance and plenty. A low-relief metope of a similar design appears in the frieze of the Freer Gallery of Art of the Smithsonian Institution on the Mall in Washington.

Other minor embellishments of this building include a lion panel and a panel portraying the Seal of the United States, both located on the west retaining wall, and an eagle pediment.

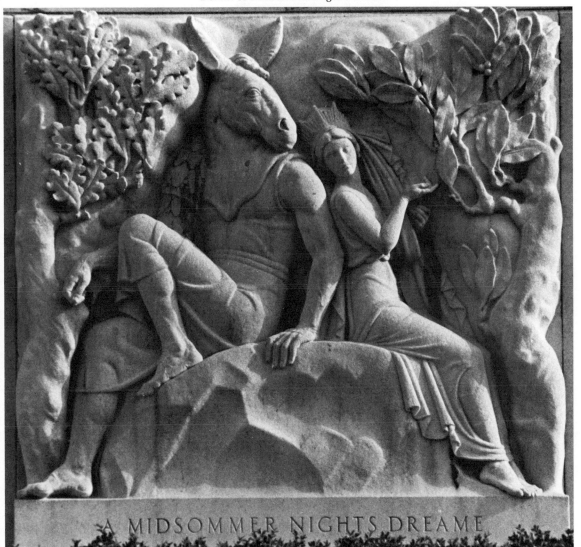

A MIDSOMMER NIGHTS DREAME

A-32

Title Scenes from Shakespeare, 1932

Location Folger Shakespeare Library, East Capitol and 2nd Streets, SE

Sculptor John Gregory

Architect Paul P. Cret

Medium Marble

Nine handsome bas-relief panels showing scenes from the plays of William Shakespeare adorn the main façade of the Folger Shakespeare Library. The sculptures, approximately 6 feet square, are placed below windows of the Exhibition Room.

Left to right, the first is from *A Midsummer Night's Dream*. It depicts Bottom, the weaver, and Titania, the fairy queen. Next is a representation of Romeo and Juliet parting after their wedding night, attended by Juliet's nurse. The third is from *The Merchant of Venice*; it portrays five figures which are, from left to right: Shylock, a judge, Portia, Bassanio, and Antonio. Portia, in the climax of this drama restrains Shylock who, holding a knife, demands the "pound of flesh" from Antonio.

The fourth panel is from *Macbeth*. The three witches chant incantations on the left, and Macbeth enters. The center relief is from *Julius Caesar*; Caesar has just been assassinated, Brutus and his comrades look on. Next is the heath scene from the third act of *King Lear*. Stripped of his power, the king shouts at a storm, with only the Fool and the loyal Earl of Kent for companions.

The seventh shows Richard III, then Duke of Gloucester, with his two nephews and soon-to-be victims, the young Edward V and his brother Richard; the Archbishop of Canterbury and the Duke of Buckingham stand at each side. The eighth panel depicts Prince Hamlet, his mother, Queen Gertrude, and the ghost of his murdered father. Last is a scene from *Henry IV*. Prince Hal, who later became Henry V, stands on the left. Cavorting in the middle is "Plump Jack" Falstaff, and on the right is the luckless Bardolph.

Title TRAGEDY and COMEDY, 1932
Location Folger Shakespeare
Library, East Capitol and 2nd
Streets, SE
Sculptor John Gregory
Architect Paul P. Cret
Medium Marble

Tragedy

In addition to the sculptured scenes from Shakespeare, several other examples of relief panels are found on the exterior of the Folger Shakespeare Library Building. The Greek masks of *Tragedy* and *Comedy* are on the west and north façades. These masks, symbolic of William Shakespeare's role as the greatest English playwright, are taken from classical Greece. The ancient Greeks always used masks for theatrical performances both to identify the characters and to project the voice. Greek drama was always performed with a limited number of male performers—three actors and fifteen members of the chorus. For comedy the actors, wearing the jovial masks, used everyday speech; but for tragedy, which required the use of serious masks, the language was always austere and formal. As early as 535 B.C. dramatic contests, including both types of plays, were held in Athens. The use of the mask appears to have developed as a result of the limited number of players, since each actor was required to perform many roles, both male and female.

Other sculptures on the building include two pairs of winged horses, symbolic of Pegasus. These are at each of the two entrances on East Capitol Street. In classical Greek mythology, Pegasus was considered the steed of the Muses. He carried the poets during periods of poetic inspiration. According to Greek legend, Pegasus evolved when Perseus cut off Medusa's head. The drops of blood which fell from her neck turned into a winged horse, Pegasus, which flew to the stables of Zeus, king of the gods. Pegasus was involved in many daring exploits and adventures, such as the time he stamped on a rock at Corinth and caused a fountain of clear water to burst forth. This Horse's Fountain, known also as Hippocrene, was considered the fount of poetic inspiration, since all who drank from it, following the visit of Pegasus, produced literary triumphs.

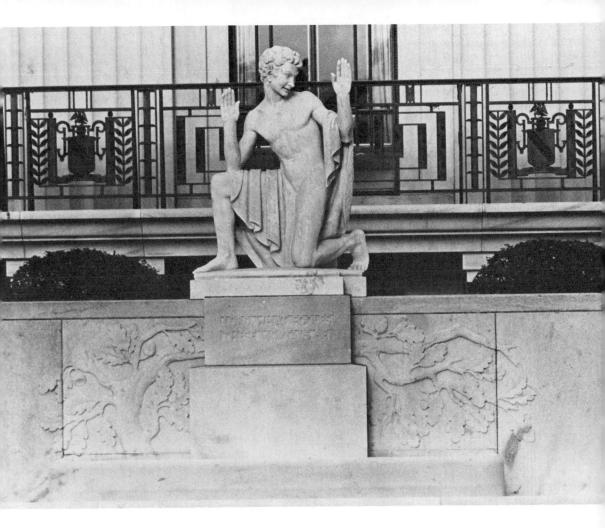

A-34
Title PUCK FOUNTAIN, 1932
Location Folger Shakespeare
Library, East Capitol and 2nd
Streets, SE
Sculptor Brenda Putnam
Architect Paul P. Cret
Medium Marble

This delightful 4-foot-tall statue of Puck, the hobgoblin from Shakespeare's *Midsummer Night's Dream*, stands at the west side of the Folger Shakespeare Library. Puck, sometimes called Robin Goodfellow, was a servant of Oberon, king of the fairies, and played pranks in the woods near Athens, including changing Bottom's head into that of an ass. In English folklore, Puck was thought to be a household demon or sprite; Shakespeare made him into a gay and impish fairy. One of Puck's lines is inscribed on the pedestal of the statue: "What fools these mortals be." The Putnam Puck kneels on his left knee, his hands raised in mock horror in front of a long, narrow fountain.

The Folger Shakespeare Library was founded and financed by Henry Clay Folger (1857–1930), Standard Oil magnate. Folger began collecting works relating to Shakespeare and to Tudor and Stuart England in 1900. The library has the world's largest number of first folio editions of Shakespeare's plays. Unfortunately, Folger did not live to see the completion of the building in 1932. Since his death, the library has acquired several other important collections. The library is administered by the trustees of Amherst College, Folger's alma mater.

Title Major General Nathanael
Greene, 1877
Location Stanton Square, Maryland
and Massachusetts Avenues, ne
Sculptor Henry Kirke Brown
Architect Unknown
Medium Bronze

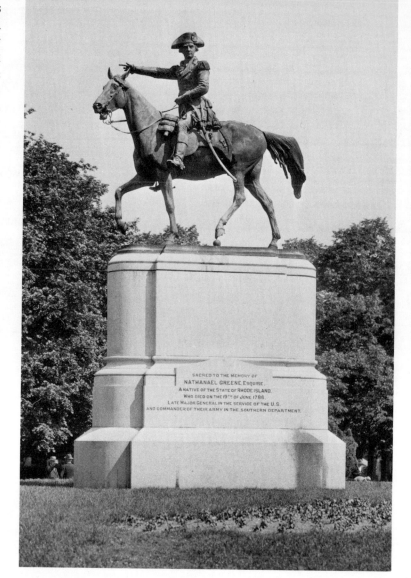

Results of the 1930 windstorm

Major General Nathanael Greene's monument is said to be one of the best equestrian statues in Washington. Erected by Act of Congress in 1877, the bronze statue depicts the general leading his troops into battle, the usual occupation of those chosen to be memorialized by equestrian statues. Greene's horse surmounts the 20-foot pedestal, and he holds the reins in his left hand. His right hand appears to be pointing toward the enemy.

Nathanael Greene (1742–1786) was born in Rhode Island and worked in his father's iron foundry until shortly before the beginning of the Revolutionary War. He helped organize the Kentish Guards, Rhode Island's militia, but a slight physical infirmity caused him to join as an enlisted man rather than an officer. A private in October of 1774, he was made a brigadier general less than a year later. Greene's defense of New York was not altogether successful, and his short temper resulted in the expenditure of as much energy in fighting fellow officers and the Continental Congress as in fighting the British. Ultimately he was created quartermaster general and on occasion acted as commander in chief in Washington's absence. Greene was successful in outmaneuvering Cornwallis in the South. After losing much of his own money during the war, he made his home near Savannah on land given him by the state of Georgia.

In 1930, a windstorm caused the statue to fall. It was not damaged, and was soon returned to its pedestal with the aid of a derrick. The statue measures approximately 13 feet in height and 13½ feet in width.

A-36

Title Olive Risley Seward, 1971
Location 601 North Carolina
Avenue, se (at 6th Street)
Sculptor John Cavanaugh
Architect None
Medium Lead

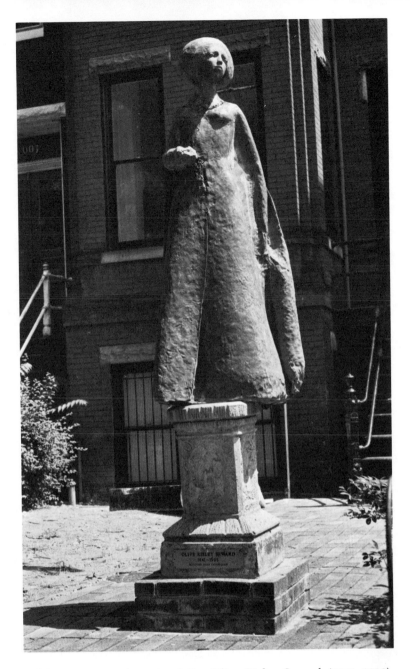

A life-size statute honoring Miss Olive Risley Seward (1841–1908) stands on North Carolina Avenue, se, in front of a remodeled townhouse. The sculptor, John Cavanaugh, wished to commemorate a member of Secretary William H. Seward's family, and his foster daughter seemed an intriguing subject. No existing likeness was known at the time, so the idealized likeness of a Victorian lady was substituted. Later, a photograph was found, and the idealized statue bore a striking resemblance to Olive Risley Seward.

William H. Seward, after whom the adjacent square is named, was secretary of state under President Lincoln and President Andrew Johnson. He was a staunch abolitionist, strongly influenced by his wife and daughter Olive, and narrowly escaped assassination himself at the time Lincoln was murdered. His purchase of Alaska from Russia for seven million dollars in the Johnson Administration was not popular, and the acquisition of the land which eventually became the fiftieth state was scornfully referred to as "Seward's folly."

The impressionistic statue was hammered from a 46-foot-square sheet of lead. It depicts a standing female figure in a long dress and cloak. Her right hand is extended, and her left dropped at her side. Her head is tilted to her left, and she seems to look toward Seward Square.

Title EMANCIPATION MONUMENT,
1876
Location Lincoln Park, East Capitol
and 11th Streets, NE
Sculptor Thomas Ball
Architect Major O. E. Babcock
Medium Bronze

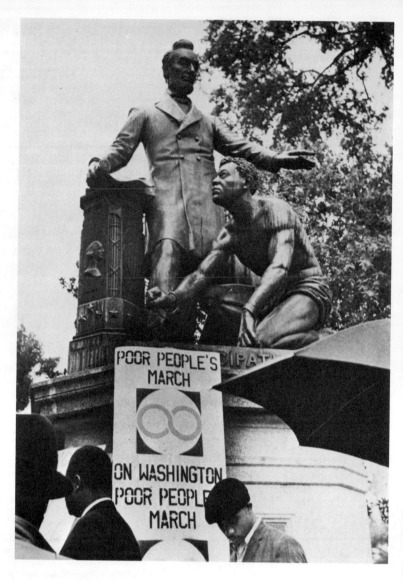

The *Emancipation Monument* shows a life-size Abraham Lincoln bidding a slave rise to freedom. Lincoln stands with a copy of the Emancipation Proclamation in his right hand, with his left hand raised and his head turned toward the kneeling figure. The unshackled slave looks straight ahead; beside him are a whipping post, chains, fetters, frayed whip, and other symbols of enslavement. A rose vine creeps up the post to show it is a thing of the past. The head of the slave was modeled from a photograph of Archer Alexander, the last Negro to be recaptured under the Fugitive Slave Act.

This $18,000 sculpture was erected by the Western Sanitary Commission of St. Louis from funds contributed solely by emancipated slaves. Charlotte Scott, a freed woman of Virginia, made the first contribution of five dollars, the amount of her first earnings in her new-found freedom—a freedom resulting from Lincoln's Emancipation Proclamation which went into effect on January 1, 1863. Mrs. Scott conceived the idea of building a monument to Lincoln the day she heard of his assassination.

The dedication was held on April 14, 1876, the eleventh anniversary of Lincoln's assassination, when Lincoln Park was bordered on the east only by fields. President Ulysses S. Grant and his cabinet attended the ceremony, and Frederick Douglass, the famed abolitionist, made the principal speech. Douglass described Lincoln as the only white man with whom he could speak for more than a few minutes who did not draw attention to the fact that Douglass was black. The statue was so popular that a duplicate was ordered for the city of Boston in 1877.

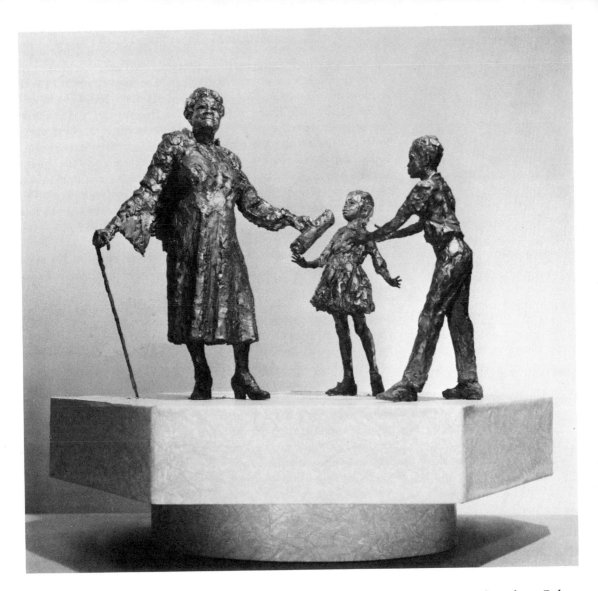

A-38
Title MARY MCLEOD BETHUNE
MEMORIAL, 1974
Location Lincoln Park, East Capitol
and 12th Streets, NE
Sculptor Robert Berks
Architect Unknown
Medium Bronze

The *Mary McLeod Bethune Memorial* by New York sculptor Robert Berks is scheduled for dedication on July 10, 1974, the birthday of Mrs. Bethune (1875–1955), on a site located at the east end of Lincoln Park on Capitol Hill. The sculpture group honors one of the leading American Negro educators. The National Council of Negro Women, Inc., a group which Mrs. Bethune founded in 1935 to help improve the living and working conditions of Negro families, made plans in the late 1950s for this memorial. Although Congress authorized the memorial on federal land within the city and the design was subsequently approved by the United States Fine Arts Commission, the original target date of completion of 1963, the 100th anniversary of emancipation, was abandoned because of lack of funds and because of the sponsoring group's involvement in the movement for civil and human rights for Negroes. The $400,000 bronze memorial consists of a 17-foot-high statue of Mrs. Bethune handing a copy of her legacy to two Negro children, an 11-year-old boy and an 8-year-old girl. She holds in her right hand a cane given to her by President Franklin D. Roosevelt. Although lacking in financial wealth but rich in love and compassion, she wrote in part in her "Last Will and Testament" a final message to America's Negro youth:

> I leave you love. I leave you hope. I leave you the challenge of developing confidence in one another. I leave you a thirst for education. I leave you a respect for the use of power. I leave you faith. I leave you racial dignity. I leave you a desire to live harmoniously with your fellow men. I leave you, finally, a responsibility to our

young people.

This stirring quotation appears on the six-sided pedestal which has been designed by the sculptor to support the three figures.

Mrs. Bethune was born the fifteenth child of freed slaves in 1875 on a cotton plantation near Mayesville, South Carolina. She was educated in the Presbyterian Board of Missions for Freedmen in Mayesville, at Scotia Seminary (now Barber-Scotia College) in Concord, North Carolina, and the Moody Bible Institute in Chicago. After serving as a teacher for several years in mission schools administered by the Presbyterian Church, she moved to Daytona Beach, Florida, and founded the Daytona Literary and Industrial School for Training Negro Girls. This school was kept open only by her personal appeal for funds from both impoverished Negroes and wealthy northern families living in the area. In 1923 her school was merged with the Cookman Institute of Jacksonville and the Methodist Church assumed financial support. For more than thirty years Mrs. Bethune served the college as president, until her retirement in 1947.

As early as the 1920s Mrs. Bethune became well known in both Negro organizations and in national educational and government agencies. She was invited to attend a child welfare conference at the White House by President Calvin Coolidge in 1928. She was the only Negro woman adviser to President Franklin D. Roosevelt in the 1930s. As Director of the Division of Negro Affairs of the National Youth Administration, Mrs. Bethune helped thousands of Negro youths acquire jobs in work projects and scholarships to college during the Depression. Mrs. Bethune's greatest achievement was the legacy of a lifelong career dedicated to young people, which won her worldwide recognition and acclaim. This sculpture is not only the first such memorial in the Nation's Capital to a Negro leader but also the first to an outstanding American woman.

Congressional Cemetery

A39-44

The most historic collection of funeral sculpture in the city is located in Congressional Cemetery, sixteen blocks southeast of the United States Capitol and within sight of the Robert F. Kennedy Stadium and the Anacostia River. The cemetery, now comprising thirty acres, was established in 1807 by a group of Capitol Hill residents, who, five years later, turned it over to Christ Episcopal Church, the oldest religious body on the "Hill." As early as 1816, a committee selected part of the area for the interment of members of Congress, and the grounds were known thereafter as the Congressional Cemetery. From the 1820s to the 1870s, Congress made irregular appropriations to Christ Church for improvements to the cemetery, such as the paving of drives, the construction of walls, and the erection of the gatekeeper's house and chapel. Because of this semiofficial connection and because of its role as the "first national cemetery," a bill was introduced into Congress in 1973 for the transfer of the cemetery from private control to the care of the National Park Service, which would be able to restore and maintain this historic site as a national landmark.

The monuments shown here are only a few among the dozens of important pre-Civil War sculptures found in Congressional Cemetery. Visitors should also note the Jane Watterston Gravestone (1804), the William Swinton Gravestone (1807), the Walter Jones Monument (1861), the Lieutenant George Mifflin Bache and Crew Cenotaph (1846), the Ulrich Mausoleum (1842), and the grave sites of a number of famous early Washington architects, including William Thornton and Robert Mills. The Neo-Baroque Public Vault (1835)—constructed with funds appropriated by Congress—once housed the bodies of three United States presidents, John Quincy Adams, William Henry Harrison, and Zachary Taylor. Other well-known figures buried here include Matthew B. Brady (1895), Civil War photographer; John Philip Sousa (1932), Marine Corps bandmaster and "march king"; and John Edgar Hoover (1972), director of the F.B.I.

The cemetery grounds are open seven days a week. Visitors should inquire at the gatekeeper's house for maps and detailed information on the location of various grave sites.

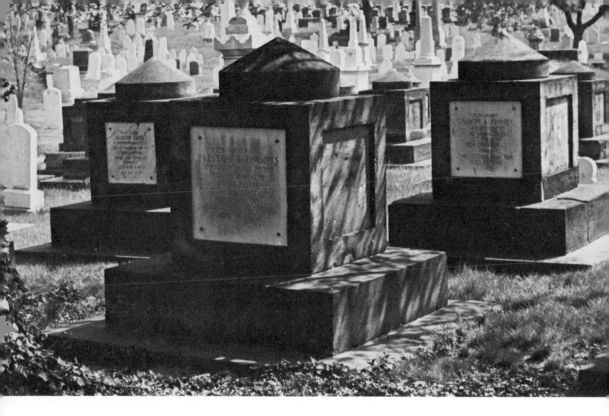

A-39
Title LATROBE CENOTAPHS,
1816–1877
Location Congressional Cemetery,
18th and E Streets, SE,
northeast section
Sculptor Benjamin Henry Latrobe,
designer
Architect Benjamin Henry Latrobe
Medium Sandstone

After passing through the main gate on E Street, SE, and past the gate-keeper's house, one finds the original burial ground in the northeast corner of the cemetery. Here are located many handsomely carved gravestones in the earlier Neoclassical style and the later eclectic Victorian styles. The most important monuments are the so-called *Latrobe Cenotaphs*, ominous sandstone memorials to those congressmen who died in office from 1807 to 1877. The noted architect Benjamin Henry Latrobe designed the massive square bases surmounted with conical caps. Although several hundred of these monuments were erected, less than eighty bodies were interred under them. Latrobe's original 1815 watercolor drawing of these cenotaphs has been preserved in the Library of Congress. Note the proposed Neoclassical cenotaph in the foreground and the simpler Egyptian-style cenotaph, which was adopted, in the background.

Occasionally the federal government erected these cenotaphs to prominent private citizens, such as the architect of the Capitol, Dr. William Thornton, and Push-Ma-Ta-Ha. The latter was a Choctaw Indian chief who fought under Jackson in the Pensacola Campaign and died of diphtheria in Washington in 1825, while negotiating a treaty between his people and the United States. Carved on his cenotaph are his last words, "let the big guns boom over me." In accordance with his wish, a full military funeral was conducted by the United States Army. The practice of erecting these curious 4½-foot-tall monuments was halted in 1877 because of an animated speech by Senator George Hoar of Massachusetts in which he remarked that being buried beneath one of them would add a new terror to death. After that date, Arlington Memorial Cemetery became the national burial ground.

Latrobe's drawing of the cenotaphs

A-40
Title Elbridge Gerry Monument,
1823
Location Congressional Cemetery,
18th and E Streets, SE,
northeast section
Sculptors W. Frazee and John
Frazee, stonecarvers
Architect None
Medium Marble

The handsome Neoclassical *Elbridge Gerry Monument* was erected by Congressional authorization in 1823. The principal inscription reads: "The tomb of Elbridge Gerry, Vice President of the United States; who died suddenly in this city on his way to the Capitol as president of the Senate, November 23, 1814, aged 70. Thus fulfilling his own memorable injunction: 'It is the duty of every citizen, though he may have but one day to live, to devote that day to the good of his country.'" The 12-foot-high shaft, a truncated pyramid of marble, is surmounted by an urn and flame.

Elbridge Gerry (1744–1814), a native of Massachusetts and a Harvard graduate, was first drawn into opposition to the British taxation measures through the influence of the fiery Sam Adams in Boston in 1772. During the British march on Lexington and Concord on April 18, 1775, he barely escaped capture by fleeing an inn in his nightdress. A close friend of Samuel Adams, John Adams, John Hancock, and other Revolutionary War leaders, Gerry played an active role in the Second Continental Congress. Although he supported the Federalists and Alexander Hamilton's financial policies as a member of Congress in 1789–1793, he soon turned against that party because of their pro-British sentiments. He was a member of the famous "XYZ" mission to France in 1797 with John Marshall and Charles C. Pinckney, and sought to stave off war with that country by negotiations with Talleyrand. Following this, Gerry became a confirmed Republican and was elected governor of

Massachusetts in 1810. During this time a redistricting bill was passed by the Massachusetts legislature which greatly assisted Republican interests in that state. One redrawn election district appeared like a salamander on the map. Because of his position as governor at the time, his name was connected with this measure and the term "gerrymander" was coined—a political term still quite alive today.

Gerry was elected vice president on the same ticket with James Madison in 1812. He became alienated from his home state because of his support of the War of 1812 against Britain. At his death in 1814 he was buried at public expense because his fortune, acquired as a Boston merchant years before, had been depleted after long public service.

A-41
Title MAJOR GENERAL ALEXANDER MACOMB MONUMENT, 1841
Location Congressional Cemetery, 18th and E Streets, SE, northeast section
Sculptor Unknown
Architect None
Medium Marble

Perhaps the most striking of pre-Civil War, Neoclassical monuments in the cemetery is that to Alexander Macomb, commanding general of the United States Army. The marble base, badly weatherbeaten, is surmounted by four pairs of lion paws on which rests a marble obelisk bearing a draped American flag and a Roman officer's helmet. On the front facade are carved laurel leaves, the traditional emblem of the victor, and a Roman sword. On the left or north side appear the typical

Neoclassical funeral carvings of a butterfly and a snake, which are symbolic of the resurrection. On the right or south side an hourglass is superimposed over a scythe and a pair of wings, symbolic of the swiftness of time for man on earth. The willow branch represents sorrow. The entire monument is about 14 feet tall.

Alexander Macomb (1782-1841) was born in Detroit and spent his adult life in the United States Army. His father, by the same name, was born in Belfast, Ireland, in 1748 and died in Georgetown, D.C., in 1832. The elder Macomb immigrated to the United States as a young man and engaged in the western fur trade with John Jacob Astor. Through a fortune acquired in this business, the father settled in New York City where he became a prominent shipping magnate and real estate speculator. Young Macomb turned down his father's offer to manage the family's huge tract of 3½ million acres of land in upstate New York and entered the United States Army as an officer at the age of sixteen. When the War of 1812 began he was a lieutenant colonel of engineers but was promoted to brigadier general for his gallant action at the Battle of Niagara and the Battle of Fort George in 1814. Later the same year he defeated the greatly outnumbered British forces under Sir George Provost and drove them back into Canada. Congress passed a vote of thanks to Macomb, presented him a gold metal, and promoted him to major general, the highest rank in the military service at that time. Following the war he returned to serve in the engineer corps; upon the death of Major General Jacob Brown in 1828, he became commanding general of the army. The following year he achieved a degree of notoriety by recommending abolition of the traditional whisky ration. Macomb's last active service was against the Seminole Indians in Florida in the 1830s. He was the author of several books on courts-martial before his death in Washington, D.C., on June 25, 1841. Except for his

Detail: Relief carving on south side of shaft

magnificently designed funeral monument, Macomb has become forgotten by history.

A-42
Title Lieutenant John T.
McLaughlin Monument, 1847
Location Congressional Cemetery,
18th and E Streets, SE,
southeast section
Sculptor Struthers, stonecarver
Architect None
Medium Marble

This unusual monument, carved by Struthers, a stonecarver of Philadelphia, is erected in the military sector of the Congressional Cemetery. The cannon and four cannon balls, carved from a single block of marble, rest on a simple base with this inscription: "Sacred to the memory of John T. McLaughlin, a Lieutenant in the Navy of the U.States, died July 6, 1847, AG. 35 years." It is unique in that it does not bear the usual motif found on military monuments between 1825 and 1875, consisting of crossed swords, anchors, or a Roman helmet.

Title MARION OOLETIA KAHLERT
MONUMENT, 1905
Location Congressional Cemetery,
18th and E Streets, se,
soutwest section
Sculptor Unknown
Architect None
Medium Marble

One of the fine late Victorian sculptures is the monument to Marion Ooletia Kahlert, aged ten, who in 1904 became Washington's first victim of a motor vehicle. The 3-foot-high-statue, which was commissioned by her mother in Rome, is dressed in high Victorian fashion with cigarlike curls, high button shoes, and a deep lace bertha or collar covering the shoulders.

A-44

Title Arsenal Monument, 1867
Location Congressional Cemetery,
18th and E Streets, se,
northwest section
Sculptor Lot Flannery
Architect Unknown
Medium Marble

The *Arsenal Monument*, funded by donations from Washington citizens, consists of a statue atop a 20-foot-high shaft dedicated to the memory of the twenty-one women buried underneath in a mass grave. The explosion of the Washington Arsenal, a 100-foot-long wooden shed with a tin roof, located at the foot of Four and One-Half Street, sw, occurred at noon on June 18, 1864, as a result of the accidental ignition of rocket shells. The explosion of the factory, which employed 108 women, was the worst civil disaster in the city during the Civil War years. The coroner's report stated that the superintendent, a Mr. Brown, "was guilty of the most culpable carelessness and negligence in placing highly combustible substances so near a building filled with human beings, indicating a most reckless disregard of human life, which should be sincerely rebuked by the Government." Members of the funeral procession, seated in some 150 carriages, included President Abraham Lincoln and Secretary of War Edwin Stanton. The procession with the bodies of the twenty-one women moved from the Arsenal to Congressional Cemetery on June 20, 1864.

A low-relief panel on the front of the pedestal portrays the burning of the Arsenal. On top of the pedestal stands a statue representing a weeping Neoclassical female with clenched hands. Little is known of the sculptor, Lot Flannery, except that he directed one of Washington's largest stonecarving firms in the 1860s. His major sculpture is the statue of Abraham Lincoln at Judiciary Square.

B

22

EAST-WEST HIGHWAY

MARYLAND

DISTRICT OF COLUMBIA

WESTERN AVE.

CHEVY CHASE CIRCLE

MILITARY ROAD

NEBRASKA AVE.

RENO RD. AVE.

CONNECTICUT AVE.

TILDEN ST.

RODMAN ST. •21

PORTER ST.

20•

12-19

NATIONAL ZOO

34 ST.

CATHEDRAL AVE.

CLEVELAND AVE.

CALVERT ST.

COLUMBIA RD.

9•• •11

•10

ROCK CREEK DR.

9•• •8

7• •6

MASSACHUSETTS AVE.

FLORIDA AVE.

N. HAMPSHIRE AVE.

•5

DUPONT CIRCLE

R. I. AVE.

•4

3• •2

M ST.

N

K ST. •1

0 1 MI.

BETWEEN 1875 AND 1925, southeastern Connecticut Avenue around Farragut Square became the city's center of diplomatic, social, and commercial fashion. Until the Civil War, the Square had remained an unimproved site, used as a campground for Union Troops and as temporary headquarters for the Freedmen's Bureau. In 1871, it was made into a public park named for the hero of the Battle of Mobile Bay, Admiral David G. Farragut (see B-1).

Since 1925, Connecticut Avenue has increasingly assumed a commercial complexion, from its southeast end out toward Chevy Chase, Maryland. From 1925 until 1950, the change took place in the form of small fashionable shops. The years since 1950 have witnessed the rise of numerous office buildings, replacing many of the beautiful older structures, among them the old Shepherd Mansion at Farragut Square and the original National Presbyterian Church, a gray stone structure in Neo-Romanesque style erected in 1887 at Connecticut Avenue and N Street. Sculpture generally has not fared well by the modern metamorphosis; this is particularly true of the Witherspoon and the McClellan statues. Suited to the bucolic landscape of thirty years ago, these statues seem lost amid today's traffic and skyscrapers. They are easily overlooked by speeding motorists intent upon going about the work day.

Connecticut Avenue begins at Lafayette Park and continues northwest for five blocks through the downtown financial district and heavy subway construction. The *Nuns of the Battlefield* monument and the *Henry Wadsworth Longfellow* and *John Witherspoon* statues are located within this section. In the next six blocks after DuPont Circle, one finds the atmosphere less hectic with tall buildings counterbalanced by small shops and restaurants. This stretch includes the *Major General George B. McClellan* statue and David Smith's *Cubi XI*. The Avenue then extends across Rock Creek Valley via the Taft Bridge into a more residential area, where the great apartment buildings of the 1930s with their Art Deco embellishments await slow inevitable destruction at the hand of progressing commercial development as the business area of the city moves in that direction. Already, most of the handsome mansions that once girdled DuPont Circle have been replaced by unimaginative glass office buildings. Finally, Connecticut Avenue runs past the Smithsonian's National Zoological Park and continues northwestward to the exclusive suburban residences of Chevy Chase.

B-1

Title ADMIRAL DAVID G. FARRAGUT, 1881
Location Farragut Square, K Street between 16th and 17th Streets, NW
Sculptor Vinnie Ream Hoxie
Architect Unknown
Medium Bronze

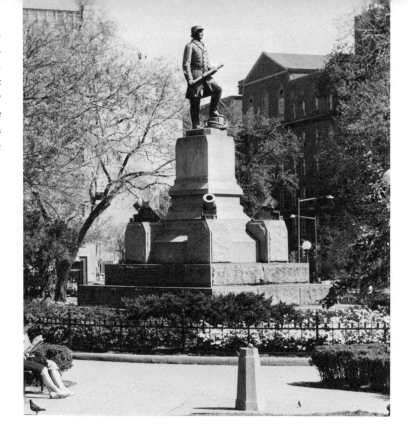

"Damn the torpedoes! Full speed ahead!" Lashed to the rigging of the U.S.S. *Hartford*, Admiral David G. Farragut boldly led his fleet through the minefields guarding Mobile Bay in August 1864. During the engagement which followed, the Confederate fleet was destroyed, the forts taken, and the port closed to blockade runners. Earlier, Farragut had captured New Orleans and then fought his way up the Mississippi River to Vicksburg, dividing the Confederacy and opening the river to Union navigation. Farragut, who had joined the U.S. Navy at the age of ten and fought in the War of 1812 and the Mexican War as well as the Civil War, was the first vice admiral and the first full admiral in the United States Navy. The latter rank was created by Congress especially to honor him. Lincoln acknowledged his appointment of Farragut as "the best made during the war."

The 10-foot portrait statue of Admiral Farragut is the work of the celebrated woman sculptor, Vinnie Ream Hoxie. It shows Farragut standing as on a ship's deck, his right foot on a capstan, and his telescope ready in his hands as he watches the progress of a naval engagement. It is an excellent portrait, conveying the character of the man whom Lincoln's secretary of war declared more ready to hazard high risk for high stakes than any other ranking military or naval officer.

After his death, Mrs. Farragut visited Mrs. Hoxie in her studio at 235 Pennsylvania Avenue, NW, to commission a bust of her late husband. The sculptor, equipped with photographs belonging to Mrs. Farragut, worked on the statue for six years in a studio set up at the Washington Navy Yard. The completed model was cast there from the propeller of the U.S.S. *Hartford.* Four chopped mortars, also cast from the propeller, guard the massive rusticated pedestal of Maine granite. A box containing documents relating to Farragut's career and to the history of the statue, a copy of the *Army and Navy Register,* and a miniature bronze model of the propeller of the U.S.S. *Hartford* were placed within the pedestal. The statue faces south toward Farragut's birthplace in the East Tennessee Valley. It was the first monument erected in the Nation's Capital to a naval war hero, and its dedication on April 25, 1881, was accompanied by colorful and wildly enthusiastic ceremonies.

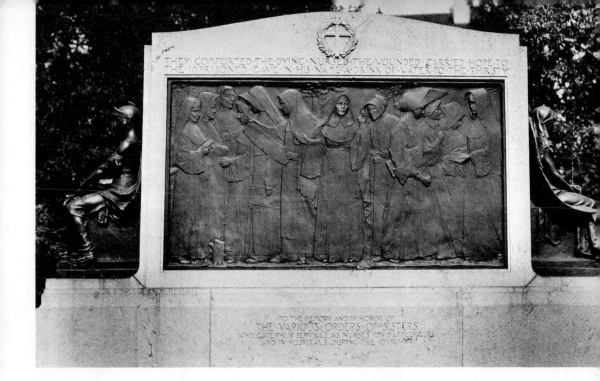

B-2

Title NUNS OF THE BATTLEFIELD, 1924

Location Rhode Island Avenue and M Street, NW

Sculptor Jerome Connor

Architect Ward Brown

Medium Bronze

Erected in 1924 by the Ladies Auxiliary of the Ancient Order of the Hibernians, an organization of the Roman Catholic Church, this monument honors nuns who volunteered to care for the sick and wounded of the Civil War. The large bronze relief panel, 6 feet high and 9 feet wide, portrays life-size figures of nuns garbed in representative habits. The bronze angel of Patriotism on the north end wears a helmet and armor but is not armed, indicating the peaceful patriotism displayed by the nuns. Seated opposite Patriotism is the Angel of Peace. Above the panel and under a cross surrounded by a wreath is the inscription: "They comforted the dying, nursed the wounded, carried hope to the imprisoned, gave in His name a drink of water to the thirsty." Below the panel is written: "To the memory and in honor of the various orders of sisters who gave their services as nurses on battlefields and in hospitals during the Civil War."

A number of complications surrounded the erection of this memorial. Before agreement on the present location, sculptor Jerome Connor had two sites, one at Arlington National Cemetery and another behind the Pan American Union Building, each of which brought objections from both the War Department and the Fine Arts Commission. The size of the monument had to be adjusted to the new site at the intersection of Rhode Island Avenue and M Street, NW, just off Connecticut Avenue. Along with this alteration, the Fine Arts Commission suggested that Connor give more vitality to the bronze angel, rearrange the front steps, and move the inscription from the back. A final episode was Connor's $45,000 suit against the Ancient Order of the Hibernians for alleged nonpayment.

Title HENRY WADSWORTH
LONGFELLOW, 1909
Location Connecticut Avenue and
M Street, NW
Sculptors Thomas Ball and William
Couper
Architect Van Amringe Granite
Company
Medium Bronze

Henry Wadsworth Longfellow (1807–1882), one of the most celebrated American writers of the nineteenth century, was born into the prominent Longfellow family of Portland, Maine. Longfellow acquired an early interest in writing from his invalid mother, an enthusiastic admirer of poetry and music, rather than from his father, a lawyer and congressman. Upon graduation from Bowdoin College, of which his father was a trustee, Longfellow spent three years studying and traveling throughout Europe. After his return to the United States, he was appointed to the faculty of Harvard College in 1835. While living in Cambridge, Massachusetts, Longfellow was very active socially, forming friendships with such figures as Charles Sumner and Nathaniel Hawthorne. His many books of prose and poetry began to appear in 1837 and eventually, because of his devotion to writing, he resigned from the Harvard faculty in 1854. Following the tragic death of his beloved wife in a fire in 1861, Longfellow became increasingly lonely and distressed. Longfellow's romantic writings were influenced by such figures as Irving, Goldsmith, Keats, Wordsworth, and Goethe and other German romantics. He failed to show any sympathy for social reforms except in the abolition of slavery. Longfellow became extremely popular in America during his old age; and during the last third of the nineteenth century, many public schools throughout the East Coast celebrated his birthday. Gentle and kind, he has the distinction of being one of the few poets who was as admired for his personal qualities as he was respected for his professional accomplishments. Many of his poems, such as *Evangeline*, *Hiawatha*, *The Wreck of the Hesperus*, and *The Village Blacksmith* are known today as classics in American literature.

The 6-foot-high seated bronze figure of Longfellow rests on a pedestal of polished pink granite which faces east. He is represented in academic gown, with his right hand supporting his chin and his left arm casually over the arm of the chair, holding a book. His intense gaze reflects that gentle nature for which he was acclaimed. At the dedication in May 1909, a granddaughter of the poet unveiled the statue. The presentation was made by the president of the Longfellow Memorial Association and accepted by Attorney General Wickersham for President William Howard Taft, who was detained by illness from attending the ceremonies. The statue was begun by Thomas Ball and completed by William Couper.

Title John Witherspoon, 1909

Location Connecticut Avenue and N Street, NW

Sculptor William Couper

Architect Unknown

Medium Bronze

Dedicated on May 20, 1909, by the Witherspoon Memorial Association, this 10-foot-high statue depicts John Witherspoon (1722–1794) standing in colonial dress with a Bible in his right hand. A bronze plate on the south front of the pedestal reads: "1722-Scotland-John Witherspoon-Princeton-1794." On the west face is the inscription "Signer of the Declaration of Independence," and on the east: "Presbyterian Minister." On the north side of the pedestal another bronze plaque bears the quotation:

> For my own part, of property I have some, of reputation more. That reputation is staked, that property is pledged on the issue of this contest; and although these gray hairs must soon descend into the sepulchre, I would infinitely rather that they descend thither by the hand of the executioner than desert at this crisis the sacred cause of my country.

Seven years before the Declaration of Independence, Richard Stockton of New Jersey and Benjamin Rush of Pennsylvania persuaded Witherspoon to immigrate to America from Scotland. He completely devoted himself to the service of the Presbyterian Church in America and to his duties as president of the College of New Jersey at Princeton. In 1774 he entered into politics, enthusiastically backing the cause of American liberty. He successfully led the move to remove William Franklin, the Tory governor of New Jersey and son of Benjamin Franklin, from office. Throughout the Revolutionary War he served ably in the Second Continental Congress. He strongly supported the Declaration of Independence in the debate over its passage, stating that America was "not only ripe for the measure but in danger of rotting for the want of it." Not only did Witherspoon sign the Declaration of Independence, but he urged ratification of the Federal Constitution in 1787. Following the war, he worked for years to restore the College of New Jersey to a strong academic standing. Witherspoon was the leader in the movement to unify the Presbyterian Church in America and he presided over the first General Assembly in 1789. The only clergyman in Congress, he was highly respected by his colleagues for his unfaltering devotion to independence and to the unifying of the colonies into one nation possessing a strong central government.

Originally, the Witherspoon statue was set against the background of the old Victorian-style National Presbyterian Church. In 1966 that historic Romanesque Revival church was razed, and the property was sold to make way for commercial development. Since that time, disagreement has continued between government officials and the congregation of the National Presbyterian Church over the proposed relocation of the sculpture at the church's new edifice on Nebraska Avenue, NW. The Presbyterians argue that besides the fact that Witherspoon was a Presbyterian minister, the organization of the Witherspoon Memorial Association was initiated by the former pastor of the church, the Reverend Dr. George Graham. Government officials, on the other hand, maintain that the statue cannot be moved without an act of Congress, and that Witherspoon's reputation as a patriot is sufficiently great to warrant leaving the statue where it now stands, namely, in the center of the well-traveled commercial district of the city. The statue remains today at its original location, honoring the man who was both patriot and preacher.

This abstract piece of sculpture by David Smith, one of the most important American sculptors of the twentieth century, was dedicated in 1964. Bought from the artist by a division of the Cafritz Corporation, it is the first of the artist's works to be placed on permanent display in Washington. Smith designed twenty-eight pieces of sculpture for his "Cubi" series between 1961 and 1965. The other twenty-seven pieces were sold through a New York art gallery. The "Cubi" series is part of the artist's third period, which lasted from 1951 until his death. During this period, Smith's technique became increasingly monumental and formal and less symbolic than his earlier style.

Cubi XI is an asymmetrical construction of chrome, nickel, and steel on a black marble pedestal; the overall height is about 11 feet. Smith has created in *Cubi XI* a feeling of motion, strength, and power in these massive geometric forms. The sense of strength is emphasized by the highly polished steel surface of the sculpture, emphasizing the cold, hard nature of the medium itself. The use of steel as the medium for the sculpture also is symbolic of the mechanized and highly industrialized society of the twentieth century. Smith felt that steel had little association with the history of art until fairly recently. Before his death in 1965, he wrote of the use of steel: "What associations it possesses are those of this century: power, structure, movement, progress, suspension, destruction, brutality." The sense of power can be seen as that force which holds the forms of the sculpture in place. The same power could be unleashed to let the form come crashing down to earth. Its situation in front of the Universal North Building is somewhat unfortunate from an aesthetic point of view. This kind of sculpture is best seen surrounded by free, flowing space. Much of its potentially imposing character seems lost against the massive background.

Visitors to the Universal North Building will be interested to know that in the foyer to the left of the entrance is a large 1962 work by Alexander Calder, entitled *Fountain*.

B-6

Title MAJOR GENERAL GEORGE B. MCCLELLAN, 1907
Location Connecticut Avenue and Columbia Road, NW
Sculptor Frederick MacMonnies
Architect James Crocroft
Medium Bronze

This imposing equestrian statue honors Major General George B. McClellan, commander of the Army of the Potomac during the Civil War. McClellan, a quiet, scholarly man, was a brilliant military strategist but in the final test a somewhat reluctant soldier. McClellan had to his credit the victory over Lee's army at Antietam in 1862; but, eventually, his extreme caution and hesitation resulted in Lincoln's replacing him with General Burnside in November 1862. Lee considered him the best commander who had ever faced him and is said to have remarked, when he learned of McClellan's dismissal, that he regretted to part with him, "for we always understood each other so well. I fear they may continue to make these changes until they find someone I don't understand."

Sculptor Frederick MacMonnies's commission for this 9-foot-tall statue was the result of a competition which took place in April and May of 1902. The board of judges included architect Charles F. McKim and the sculptors, Daniel Chester French and Augustus Saint-Gaudens. Twenty-eight designs were submitted, and in 1903 a contract was signed with MacMonnies. The statue was exhibited at the Paris Salon of 1906 before being shipped to the United States for its dedication in May 1907. McClellan is mounted on a horse in the military dress of the Union Army, his right hand poised on his hip. The work, particularly the richly decorated pedestal, displays more the influence of MacMonnies's teacher at the École des Beaux-Arts in Paris, Alexander Falquière, than that of his earlier teacher, Saint-Gaudens, with whom he had studied for four years, beginning at the age of seventeen. The pedestal is enriched by eight escutcheons honoring McClellan's battles. The two principal sides are decorated with bronze trophies representing cannon, flags, and arms. At each of the four corners, eagles bear garlands of oak and laurel.

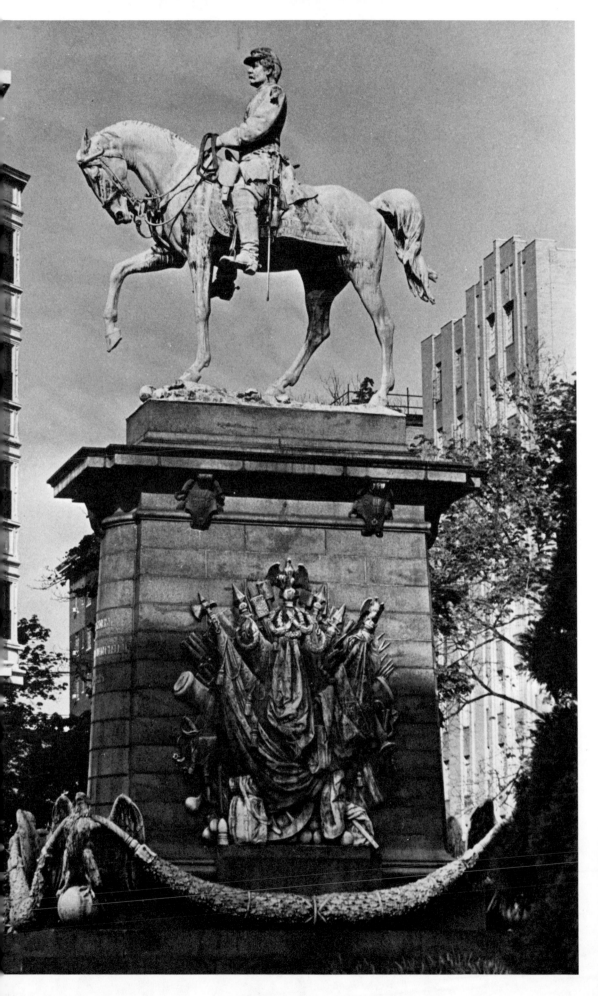

107 *Connecticut Avenue*

B-7
Title HABITAT, 1968
Location 2020 Connecticut
Avenue, NW
Sculptor Alfredo Halegua
Architect None
Medium Reinforced fiberglass

This sculpture, located in front of the sculptor's recently remodeled late Victorian townhouse at 2020 Connecticut Avenue, is part of a group which was executed in 1968 for a one-man show at the Baldwin Museum in Baltimore. The exhibit investigated the monumental possibilities of sculpture.

Habitat, measuring 5 feet square, was constructed of white fiberglass forms with polished surfaces. The technique involved first building up the cubical forms in styrofoam then covering them with layers of epoxy, polyester plastic, and reinforced fiberglass.

Mr. Halegua's numerous works include a 14-foot-square fountain for the Waxter Center for Senior Citizens in Baltimore.

B-8
Title PARROTS, ca. 1930
Location Apartment house, 2101
Connecticut Avenue, NW
Architect Unknown
Sculptor Unknown
Medium Limestone

Connecticut Avenue, from the 2100 block to the 3900 block, is the site of numerous apartment houses of the 1930s, decorated in the Art Deco style popular between World War I and World War II. This style, which developed out of Art Nouveau, is characterized by a more geometric version of the floral patterns. This obsession with geometry explains the use of Islamic, Egyptian, and Indian forms, of which there are several fine examples among these buildings.

The apartment house at 2101 Connecticut Avenue is characterized by a mixture of Islamic and Medieval motifs. The sculptured decoration on the entrance portal consists of five Islamic arches, above which are placed four parrot gargoyles appearing to function as water spouts. The parrots extend about 2 feet from the wall. Over the parrots and directly above the pilasters of the arches are lions' head medallions with stylized curling manes and grinning faces. High above the sidewalk on the roof appear eight atlantes. These elaborate figures can hardly be seen without the use of a telescope!

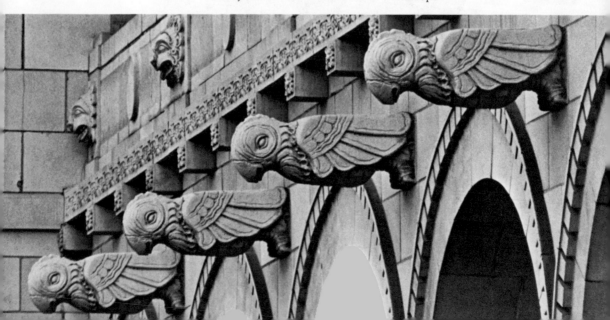

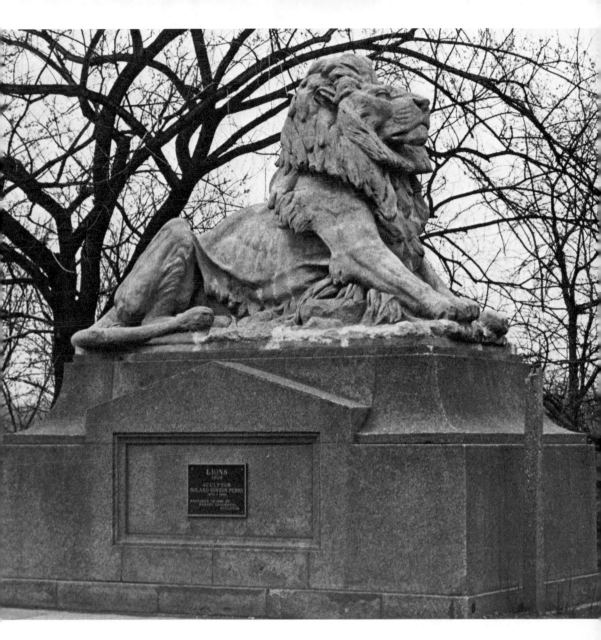

B-9

Title PERRY LIONS, 1906

Location Taft Bridge, Connecticut Avenue, NW

Sculptor Roland Hinton Perry

Architect Edward Pearce Casey

Medium Precast concrete

Built between the years 1897 and 1906, the Taft Bridge, or Million Dollar Bridge as it was originally known, was one of the first in the country to be constructed of precast concrete. After the death of William Howard Taft in 1930, the bridge was renamed in his memory.

Taft served one term as president of the United States (1909–1913) and as chief justice of the Supreme Court (1921–1930). He was not by nature a political man and enjoyed much more his duties as Supreme Court chief justice then as president. Taft's failure to attain reelection in 1912 was due in part to opposition within the Republican Party, which eventually led to the organization of the Bull Moose Party around former President Theodore Roosevelt; and it was due in part to solid support among the Democrats for Woodrow Wilson, who won the election.

The pair of lions at each end of the bridge, one roaring and one sleeping, were sculpted by Roland Hinton Perry, creator of *The Court of Neptune Fountain* at the Library of Congress Main Building. Amid enthusiasm over the bridge's new material, it was decided that the 12-foot-long lions should be molded out of precast concrete. Concrete was not a suitable material for this kind of sculpture, and through the years the beasts fell into extreme disrepair. In 1964 the lions were restored by a local sculptor, Renato Lucchetti, and were also weather-proofed.

B-10

Title Bairstow Eagle Lampposts,
1906
Location Taft Bridge, Connecticut
Avenue, NW
Sculptor Ernest C. Bairstow
Architect Edward Pearce Casey
Medium Iron

One of the most notable features of the Taft Bridge is the series of elaborately decorated 10-foot-tall eagle lampposts, which span its length on each side. Ernest C. Bairstow, the sculptor, specialized in architectural decorations for many prominent buildings in the city between 1900 and 1940. His work can be found on the Richard B. Russell Senate Office Building, the Washington City Post Office Building, the District of Columbia Building, and the Lincoln Memorial.

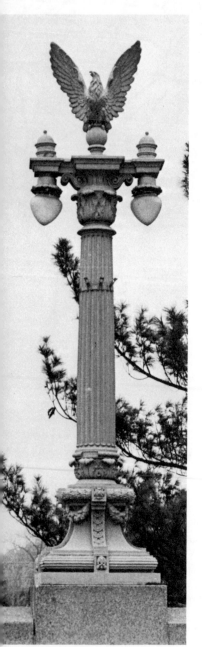

B-11

Title Four Modes of Modern
Travel, 1935
Location Calvert Street Bridge,
Calvert Street and Connecticut
Avenue, NW
Sculptor Leon Hermant
Architect Paul C. Cret
Medium Limestone

The Calvert Street Bridge, opened on October 12, 1935, replaced an older bridge which had become antiquated and unsafe. Designed by architect Paul C. Cret, it is a limestone structure with three graceful 146-foot arches. Of interest here are the four sculptural low-relief panels which grace the abutments, each relief measuring about 3 feet high and 4 feet wide.

These reliefs, designed by Leon Hermant, exhibit an awkward marriage between Classicism and modern technological subject matter. Representing the four modes of travel—locomotive, plane, ship, and automobile—each relief depicts a nude Neoclassical figure and appropriate symbols. The Train panel pictures a male figure mounted on a locomotive wheel, amid clouds of smoke. The Automobile panel depicts, similarly, a woman riding on the fender of an automobile. The Air Travel relief shows a man in flight, complete with flight helmet and goggles, with an airplane wing in the background. The Maritime panel depicts a female figure reclining on a large anchor, riding the waves, with a small ship in the background. Although all of this seems humorous now, it was quite serious to the artist with his basic nineteenth-century education which offered little insight into the mysteries of the advanced twentieth century.

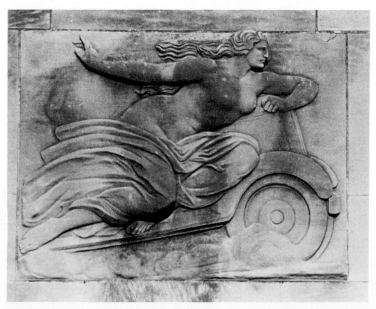

Automobile panel

National Zoological Park

People have always been fascinated by captive wild animals, but the modern type of public zoo was an invention of the nineteenth century in the United States. Zoos rapidly became enormously popular and were established in cities all over the world. Most of them were started by cities or by zoological societies organized for that purpose. Washington acquired a zoo by accident many years before it had a name, a permanent home, or any formal status. As early as 1856 the Smithsonian Institution was being given live animals which it did not want and had no way of caring for. Fortunately, according to the Smithsonian Institution's *Annual Report*, the problem was solved just before the Civil War by "the kind cooperation of Dr. Nichols, Superintendent of the Government Insane Asylum (St. Elizabeth's Hospital), who has provided suitable accommodations for the animals on the extensive grounds of that institution, and rendered them subservient to its benevolent object in the amusement and consequent improvement of the patients. As they are in the immediate neighborhood of this city, they are readily accessible to strangers, and students of natural history, who visit the seat of government."

The patients continued to benefit for a number of years, but in the 1880s the animals were moved to pens and sheds adjacent to the Mall, on the south side of the original Smithsonian Institution Building. The National Museum was preparing for exhibit a collection of mounted specimens of North American fauna, and the live animals were used as models for the taxidermists. When they had been studied, they were either donated to the Philadelphia Zoo or added to the Smithsonian's mounted collection. Naturally, crowds of people came to see the animals. When Dr. Samuel P. Langley, secretary of the Smithsonian, saw the extent of the public interest, he established a Department of Living Animals as part of the National Museum and put William Hornaday in charge of it in 1888. Secretary Langley was concerned at that early date over the possible extinction of a number of species of animals through uncontrolled sports hunting.

The idea for a national zoo grew out of this concern for wildlife and the obvious public interest in wild animals. The Rock Creek Valley contained land that was hilly, rocky, and in what were then the suburbs, so that it would be relatively cheap. There was, on the site ultimately purchased, an historic residence known as the Holt House, erected in 1805 and for many years used as the residence of Congressman John Quincy Adams. This building, since 1890, has been used as the administrative headquarters of the National Zoo.

The first attempt in 1888 to persuade Congress to establish a national zoo failed. But in 1889 a bill was passed authorizing purchase of the land. It was an amendment to the District of Columbia appropriations bill, a fact which caused difficulties in later years. Some 167 acres were bought, and later increased to 175. On April 30, 1890, Congress placed the National Zoological Park under the direction of the regents of the Smithsonian Institution to administer "for the advancement of science and the instruction and recreation of the public." Funds were then appropriated for roads, fencing, buildings, and sewer and water supplies.

The funds provided were just enough to lay out a small section in the center of the park, where land had already been cleared and could easily be developed. The great landscape architect, Frederick Law Olmsted (creator of New York's Central Park) was commissioned to lay out the zoo.

Mr. Hornaday had been appointed superintendent, but he resigned almost immediately and was replaced by Dr. Frank Baker. Mr. William Blackburne left the Barnum and Bailey Circus to become head keeper, a position he held for fifty-three years. It is said that in one day he quit the circus, joined the zoo, gave up drinking, and got married. This may account for his attitude in later years, when he pointed out to an

*The Great Flight Cage, with
its graceful and elegant
arches, is an outdoor
sculpture in itself*

employee who asked for the day off to get married that it only took ten minutes.

Before the site was ready, the owner of the Adam Forepaugh Circus presented the government with two Indian elephants which had become too unruly for the circus to keep. Mr. Blackburne had to march the animals from the circus grounds to Rock Creek Valley, going ahead of them to warn people to watch out for their horses. The elephants were chained to trees in the park and lived in the open until a shed could be built for them. They drank 80 gallons of water a day, which had to be hauled up from the creek until the water pipes were installed.

By June 15, 1891, work in the park had progressed to the point where the animals could be transferred there from the Smithsonian. Mr. Blackburne borrowed a wagon from the Society for the Prevention of Cruelty to Animals to move the smaller animals, but how he got the six bison and four American elk through the streets of Washington is not recorded. The new Zoo was an instant success. There are no attendance figures, but the road almost immediately proved too narrow for the large number of carriages that thronged the park on Sundays, and the bridge was too narrow for the foot traffic.

After this promising beginning, the Zoo faced ten years of hard times. The new Congress contained many members who were unsympathetic to the Zoo, and there were some who wanted to abolish it altogether. One speaker said, "so far as I am concerned, I do not believe that it ever is proper to tax men and women to support monkeys and bears, and if the Treasury vaults were bursting with the money that had already been wrongfully taken from the people, I should say, rather than misspend it after this fashion, let us emancipate the people from taxation." This gentleman's views did not prevail, but the Zoo's permission to buy animals was withdrawn (henceforth it could only make trades or accept gifts) and the appropriation was cut in half.

This meant the end of Langley's original plan for a preserve for endangered species. There was not enough money for everything, and he felt that, since the people of Washington paid for the Zoo with their taxes, they had a moral right to have the money spent on what interested them, the public display area. Even developing a conventional zoo was not easy with little funds, and ingenuity had to take the place of cash. When a kangaroo was offered for sale at $75.00, a Washington animal dealer bought it and traded it to the Zoo in exchange for guinea pigs which the Zoo was to raise at 15 cents apiece. It took three years to raise those 500 guinea pigs, but the kangaroo was worth it. On another

occasion a mangy old tiger donated by a circus was cured with sulfur and oil treatments and became a handsome animal.

In 1899 the Smithsonian published a circular asking Americans stationed abroad to collect animals and send them to the National Zoo. The instructions for crating, feeding, and shipping were enough to frighten all but the bravest spirits; however, several men did become interested in animal collecting and sent such valuable specimens as Tasmanian wolves, an echidna, a harpy eagle, and a tapir. After the first decade, things became a little easier. Congress restored permission to buy animals, and though the Zoo continued to operate on a shoestring, it began a long period of slow but steady growth.

Although the first building was constructed in 1891, the National Zoo did not build an impressive physical plant for many years. The animal collection was another matter. In those days a zoo was judged on the basis of the number of species it was able to display, especially those which were seldom seen in captivity. The National Zoo constantly increased its collection and always had a number of desirable rarities. By 1924, the Zoo had 494 different species and a particularly successful record in the breeding and rearing of animals.

Dr. William M. Mann became director of the National Zoo in 1925. In 1927 he succeeded in getting funds for a Bird House; until then the birds had occupied a temporary building. When it was completed in 1928, the first animal to move in was an ancient sulfur-crested cockatoo which had been given to the Smithsonian in 1890. The Reptile House was soon built in 1930. The first Depression years were difficult ones for the Zoo, but when the federal government began its public works program there was a dramatic change. Unemployed workers were given jobs in the Zoo doing maintenance work, repairs, landscaping, and clerical work. For the first time in its history the Zoo had all the help it could use. And in 1936 a major building program was begun. Dr. Mann used to tell how people would ask him at dinner parties about his most exciting moment, expecting to hear of some lurid encounter with a savage jungle beast. He always enjoyed their shocked surprise when he answered that it was when the head of the Public Works Administration told him that the Zoo had been allotted $870,000. This was the money that built the Elephant House, the Small Mammal House, a new wing for the Bird House, the restaurant, and made possible many renovations and repairs.

These were also the years of the last great zoological expeditions. Since 1909 the Zoo had, on a number of occasions, sent people abroad to get animals. Mostly these were relatively short collecting or buying trips, but some were full-fledged expeditions, lasting for many months. The 1926 Smithsonian-Chrysler expedition to Africa resulted in the largest collection of animals ever to come here at one time, and included the Zoo's first two giraffes. The 1937 National Geographic-Smithsonian expedition to the East Indies took eight months and produced another large collection. The last major expedition was the Smithsonian-Firestone expedition to Liberia in 1940. Trips of this sort will never be possible again because of the restrictions since placed on collecting wild animals by all African countries.

The animal collection was also enlarged, as it still is, by the custom of giving to the National Zoo animals presented by foreign governments to the president or people of the United States. The most spectacular animals the Zoo has received in this way are, of course, the two giant pandas which the People's Republic of China gave to President Richard M. Nixon. The custom apparently started in 1904 when King Menelik of Abyssinia sent President Theodore Roosevelt a lion, an ostrich, a Grevy's zebra, and a pair of Gelada baboons, and the president gave the animals to the National Zoo.

World War II put an end to travel, to animals from abroad, and to construction work. The public worried about what would happen if the

Zoo were bombed until Dr. Mann explained, in a newspaper interview, the precautions that had been taken. All the poisonous snakes had been disposed of. When there was an air raid alarm, the Zoo gates shut automatically, and keepers would be stationed near the animal houses. The keepers had been trained to handle incendiary bombs and had firearms to use if dangerous animals escaped. If part of the fence should be destroyed, the gap would immediately be covered by armed guards.

As it turned out, what the Zoo required during the war years was the kind of ingenuity which had kept the Zoo going in its early years. Suddenly, there were no more bananas, no more ant eggs, no more sunflower seeds (all of these foods had been imported), and substitutes had to be found immediately.

Following the war, the Zoo declined in physical appearance and became overcrowded with more than 900 species. The lack of adequate funds was the major problem faced by Dr. Theodore Reed when he became Zoo director in 1956.

The source of the trouble was the original legislation which had attached the Zoological Park to the District of Columbia appropriation bill. Apparently this was done simply to ensure quick consideration and passage, but it meant that the Zoo, which was a national institution, a part of the Smithsonian, was being supported by a single city. In the 1930s extra funds had come from the public works programs, but those had ended when World War II began.

Congress remedied the situation in 1963 by allowing the Zoo to make requests for capital improvements as part of the Smithsonian budget, though the District of Columbia would still be responsible for maintenance. The same year it authorized funds for a ten-year building program. The two-budget system was cumbersome, and since 1968 all Zoo expenses have been part of the Smithsonian Institution budget.

Before the building program was interrupted by the freeze on federal construction projects, enormous improvements were made. Auto traffic through the Zoo, which had been a major annoyance and a serious hazard, was eliminated by new roads and parking lots. The Bird House was completely remodelled and the beautiful outdoor Great Flight Cage was built in 1965. A new hoofed stock area and Delicate-Hoofed Stock Building (half of which is now the Panda House) provided good living conditions and fine display areas for these animals. A modern hospital and research laboratory building was constructed.

A master plan for the entire Zoo has been prepared and approved, and will be carried out as funds permit. The first part of the plan, replacement of the old Lion House by a modern display area, was started in 1973.

The Zoo now has a full-time scientific research staff and is able to include research activities in its regular program. New kinds of exhibits are being developed and already exist in many parts of the Zoo. Today the aim of the Zoo is to show groups of animals in natural-looking surroundings where they can exhibit normal behavior, including social behavior.

Wildlife conservation programs are increasingly important. With a few possible exceptions, vanishing species cannot be saved from extinction by zoos. What zoos can do was understood by Secretary Langley when he wrote in 1893, "it was not indeed thought that any efficient check could be given to the final extinction of these animals solely by such limited number as could thus be preserved, but it was considered that their presence here . . . would be not only useful as regarded the number saved, but as a constant object lesson . . . and in this was a most important adjunct to the larger reservations; while it was evident that opportunity could thus be afforded to study and observe their habits and characteristics, where they were under the eyes of the numerous naturalists in the government service. . . ."

B-12

Title KEMEYS BEAR CUB, 1907

Location Monkey House roof,
National Zoological Park,
Connecticut Avenue and
Hawthorne Street, NW

Sculptor Mrs. L. S. Kemeys

Architect Unknown

Medium Cast stone

Sculpture at the National Zoo is often overlooked by visitors because it is applied to the buildings in the form of relief panels, doorway arches, and other types of embellishment. An early example of this kind of sculpture is the group of three bear cubs, four fox cubs, and two bobcats, which sit atop different roof pinnacles of the Monkey House. The creator was a Mrs. L. S. Kemeys, about whom little is known except that she usually worked in watercolors and that her husband was a well-known sculptor of animal figures. The figures here were installed at the time this building, the second major structure erected at the Zoo, was completed in 1907. The *Kemeys Bear Cub* is about 2½ feet high. The Monkey House was constructed to house not only monkeys but many small mammals when the original building, the Lion House, became overcrowded. This rectangular building, constructed of roughly hewn granite blocks, has an impressive green and purple tile roof.

The Smithsonian's National Zoological Park was founded seventy-five years ago by Samuel Pierpont Langley, a middle-aged astrophysicist who had a bachelor's fondness for entertaining children. In 1887, when Langley became the third secretary of the Institution, some two hundred creatures, huddled in sheds behind the old Smithsonian Institution Building, constituted a miscellaneous menagerie the National Museum had assembled to serve as taxidermy models. After their modeling days were over, the specimens either were killed or sent to the Philadelphia Zoo. But during their temporary detainment in Washington, they were a popular side show for crowds that swarmed around the Smithsonian on Saturday afternoons. Among the species quartered by the Institution were six buffaloes, survivors of the fifty million that once roamed over the North American continent. Langley took it upon himself to provide the beasts with "places of seclusion in which to breed and replenish their dying race . . ." On April 30, 1890, Congress formally established the National Zoological Park at Rock Creek Park, operating under the direction of the Smithsonian Institution, for the advancement of science and the instruction and recreation of the people.

Title MAMMOTH AND MASTODONS,
ca. 1934
Location Elephant House, National
Zoological Park, Connecticut
Avenue and Hawthorne Street, NW
Sculptor Charles Knight
Architect Edwin H. Clark
Medium Stone

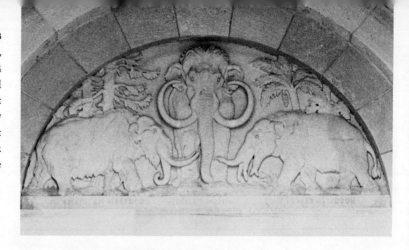

Several of the Zoo's finest sculptures were acquired by Director William Mann under the Public Works of Art Project during the Depression years of the 1930s. The National Zoological Park of the Smithsonian Institution was one of the first federal agencies to apply for the services of the artists employed by this program. Although there has been some difference of opinion as to the quality of art produced under the aegis of the P.W.A.P., an article in the February 2, 1934 *Washington Post* reveals that the work received high acclaim by a board of critics, which included such discerning connoisseurs as G. Powell Minnegerode, director of the Corcoran Gallery of Art; Duncan Phillips of the Phillips Gallery of Art; and Dr. Charles Bittinger, president of the Arts Club of Washington; and Mr. Charles Moore, secretary of the United States Fine Arts Commission. This relief, shown above the left entrance on the main façade of the Elephant House, measures about 3 feet in height and 6½ feet in width and depicts a mammoth and two mastodons. The panel is inscribed at the bottom: "American Mastodon, Woolly Mammoth, Four Tusked Mastodon." A companion relief panel over the right door portrays three other prehistoric relatives of the modern elephant: "Uintatherium, Titanotherium, and Woolly Rhinoceros." These two relief panels were designed by Charles Knight and executed by Erwin Springweiler who also sculpted the *Giant Anteater* (see B-15).

Both the mammoth and mastodon are prehistoric relatives of the modern elephant. The mammoth lived on every continent except Australia and South America. Although there were many kinds of mammoths, they all differed from the modern elephant in skull shape, tusk form, and molar structure. The woolly or Siberian mammoth is the most famous since more evidence has been recorded of this type from frozen carcasses, cave paintings, statuettes, and drawings and carvings during the time of Paleolithic man. Standing 10 feet tall, he had enormous and elaborately curved tusks. The woolly mammoth was able to live within the Arctic Circle in Europe, Asia, and North America because of a very thick growth of hair.

The mastodon was much more numerous, living in vast herds which rivaled the American bison of the 1800s. The first mastodons, which lived in Egypt 40 million years ago, evolved over millions of years from the size of a pig to a height of 9 feet. The modern elephants were more similar to the mastodon than the mammoth. It is thought that the North American mastodon, which lived 8,000 years ago, was extensively hunted by early man, contributing to its eventual annihilation in what is now the United States.

Charles Knight, the sculptor, was well known as an author and lecturer during the 1930s. For a number of years he worked on the restoration of prehistoric animals at Chicago's Field Museum of Natural History. This project was carefully recorded in his books *Before the Dawn of History* and *Life Through the Ages*. In addition to his two

overdoor relief panels on the Elephant House main façade, Knight completed other art works for the building before it opened in 1937: a series of 12 aluminum panels representing ancient animals around the four interior walls above the cages and five colorful mosaic medallions on the floor representing an Indian rhinoceros, a hippopotamus, a Brazilian tapir, and both African and Asian elephants. Knight's mosaic of a dinosaur over the main entrance to the Reptile House, completed in 1931, remains in place.

B-14
Title REPTILE PORTAL, 1931
Location Reptile House, National Zoological Park, Connecticut Avenue and Hawthorne Street, NW
Sculptor John Joseph Earley
Architect Albert Harris and Edwin H. Clark
Medium Stone

Among the creations of the 1930s is the intriguing sculpture on the exterior of the Reptile House: the elaborately arched stone entrance portal about 25 feet high with its carved capitals and columns resting on turtles and surmounted by toads. A brightly colored mosaic dinosaur is located immediately above the door while thirteen small reptile relief panels and two giant lizards embellish the upper section of the gabled porch. Within the three brightly colored mosaic arches framing the entrance, reminiscent of Byzantine architecture, are found two ornately carved wooden doors, each side of which is decorated with five ceramic relief panels of reptiles. The bronze door handles are in the form of entwined snakes. Within the foyer on the floor is a medallion, 3 feet in diameter, consisting of inlaid pieces of green, brown, white, and black stone which forms the design of a giant turtle. Also within the main foyer above the inner door is a handsome marble relief panel, approximately 1½ feet high and 3½ feet wide, of two frogs in a pond facing one another. The smaller door to the right of the main entrance contains a relief panel of two giant lizards facing one another with tongues touching.

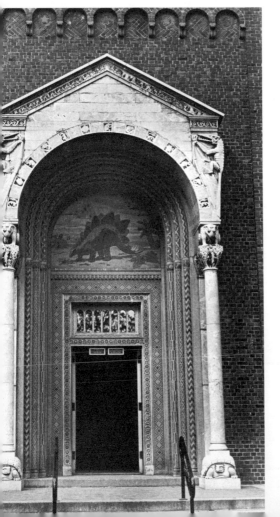

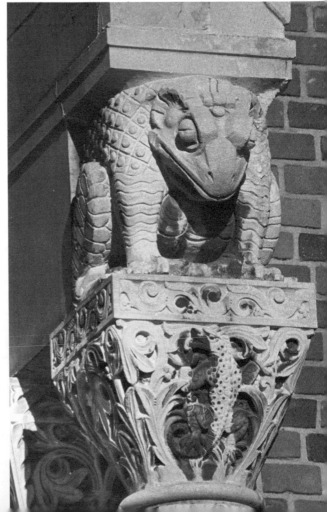

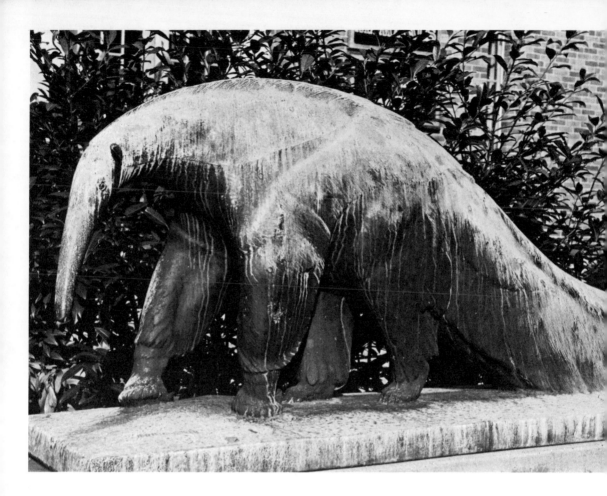

B-15	This animal sculpture, located in front of the Small Mammal House of
Title GIANT ANTEATER, 1938	the National Zoological Park of the Smithsonian Institution, represents
Location National Zoological Park,	the *Giant Anteater*, or antbear, the largest in size of several types of
Connecticut Avenue and	tropical anteaters which live on both ants and termites. Adult giant
Hawthorne Street, NW	anteaters measure 4 feet in length, excluding the tail, and are 2 feet tall.
Sculptor Erwin Frederich	They live in both Central America and South America and grow a coat
Springweiler	of gray-black hair 16 inches long. The anteater is distinguished by a
Architect None	long, tapering snout, small mouth, a long, sticky 9-inch tongue, no
Medium Bronze	teeth, and powerful curved claws. The latter are used to defend itself

and to wrench holes in the homes of termites and ants.

Erwin Springweiler's *Giant Anteater* is a life-size replica of its lively counterpart inside the Small Mammal House. Unlike Warneke's *Wrestling Bears*, which is so poorly placed and landscaped that it is often overlooked, the *Giant Anteater* benefits by eye-catching placement and landscaping. The piece was first shown in the National Academy of Design Exhibition in New York City, where it was awarded the Speter Memorial Prize before being installed at the Zoo in the spring of 1938. The sculptor's work can also be found at the Detroit Zoo and in Brookgreen Gardens in South Carolina.

Title WRESTLING BEARS, ca. 1935
Location National Zoological Park,
Connecticut Avenue and
Hawthorne Street, NW, in back of
the Main Bear Line across from
the Friends of the Zoo Shop
Sculptor Heinz Warneke
Architect None
Medium Cast stone

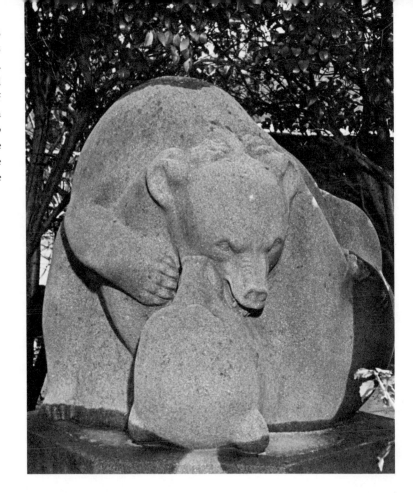

This 3-foot-high statue is a fine example of the work of Heinz Warneke, one of America's foremost animal sculptors, who for many years was a practicing artist and teacher in Washington, D.C. The bear sculpture, which was installed in the 1930s, displays Warneke's special talent for imposing subtle but unyielding naturalism on a basic structure of abstract, geometric form. The cubs are tumbling and cavorting; one is on top while they are gripping each other around their necks with their paws. The first impression is one of broad, rounded form, but a closer look will reveal that neither anatomical structure nor expressive detail has been omitted. The piece embodies the wonderful whimsical quality common to Warneke's work.

As a child, Warneke spent much time at his grandfather's home, which was located near a hunting reserve in Germany. Thus, at an early age, the artist began to observe animals and draw their pictures. While studying sculpture in Berlin, he became familiar with anatomy at a nearby surgical institute. Warneke's early training laid the groundwork for the fine animal sculpture he created in later years.

Other works of Warneke's in Washington include the *Last Supper* tympanum over the east door of the National Cathedral, *The Prodigal Son* in the Bishop's Garden at the Cathedral, and the *Lewis and Clark* bas-relief at the Department of the Interior Building.

B-17

Title CHAPIN BEAR CUB, 1952
Location National Zoological Park,
Connecticut Avenue and
Hawthorne Street, NW, Short Bear
Line
Sculptor Cornelia Van Auken
Chapin
Architect None
Medium Volcanic rock

This volcanic rock statue by Cornelia Van Auken Chapin was dedicated in December of 1952. It is a typical example of Miss Chapin's style, characterized by the simplicity and uniformity found in Egyptian sculpture. Like most of the artist's other works, this 2-foot-high piece, located on the lawn between the Reptile House and the Small Mammal Building, was carved directly from the stone. Miss Chapin, noted primarily for her animal sculpture, also created the *Byzantine Christ*, which stands on the high altar at the Cathedral of St. John the Divine in New York City, and the giant 1,800-pound frog in Rittenhouse Square in Philadelphia.

B-18

Title PENNSYLVANIA RAILROAD
EAGLE, 1965
Location National Zoological Park,
Connecticut Avenue and
Hawthorne Street, NW, in front of
Bird House
Sculptor McKim, Mead and
White, architects
Architect McKim, Mead and
White
Medium Granite

The 5-foot-tall, granite *Pennsylvania Railroad Eagle* in front of the Bird House is one of a group of twenty-two which graced the old Pennsylvania Railroad Station in New York City. The old Pennsylvania Railroad Station, designed in the Neoclassical style after Hadrian's Villa near Rome, covered 7½ acres on Eighth Avenue in midtown Manhattan and cost over $120 million to build in 1910. It was the largest and most handsome railroad station in the world. When the station was razed in 1965, the bird was donated to the Smithsonian Institution. In 1967, it was flown to Montreal for exhibit at Expo '67.

B-19

Title LIPKIN BEAR CUB, 1969
Location National Zoological
Park, Connecticut Avenue and
Hawthorne Street, NW
Sculptor Jacob Lipkin
Architect None
Medium Porphyry

The most recent acquisition to the Zoo's sculpture collection is the *Lipkin Bear Cub*, located just within the main iron gates of the pedestrian entrance on Connecticut Avenue. Given to the Zoo by the artist in 1969, it is a semiabstract piece in porphyry and about 2 feet tall. When Lipkin brought his stone bear to the National Zoo in 1969 he selected both the base and the site himself. Upon his return to New York, he wrote the Zoo director:

> Two birds affected me profoundly on my junket to Washington. Both were made by that Master Craftsman. In one, I zoomed at unbelievable speed into the cloudy snowfields of the sky on huge metallic pinions. It was very exciting. The other experience was having that little humming bird in your zoo pluck a hair from my

head to line its tiny nest with. It was one of the loveliest moments of my life—like when a very beautiful woman kisses you unexpectedly.

Sculptor Jacob Lipkin, who teaches, lectures, and works at odd jobs in New York, only sells his sculptures to museums and other public institutions so that they can be enjoyed by many people.

B-20
Title GEOMETRIC EAGLES, ca. 1932
Location Kennedy-Warren
Apartment Building, 3133
Connecticut Avenue, NW
Sculptor Joseph Younger,
designer
Architect Joseph Younger
Medium Granite

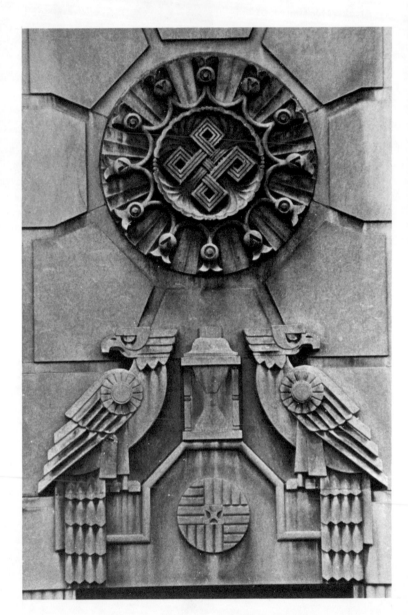

When it first opened in 1932, the Kennedy-Warren Apartment Building, which cost $3,200,000 to construct, was considered to be the best address on Connecticut Avenue. The building is eleven stories high, contains 317 units and is decorated with numerous Art Deco relief panels on the main façade. Above the windows on both sides of the main entrance are two high reliefs, consisting of two eagles facing each other with their heads turned in opposite directions; this arrangement results in a balanced and geometric effect. The eagles are about 3 feet high. Between the birds is a rectangular form, and underneath it is a circle enclosing a design composed of horizontal and vertical lines. Above the windows on four of the façades are bronze low-relief panels of intricate geometric patterns. At the top of the building are two griffins facing each other in high relief.

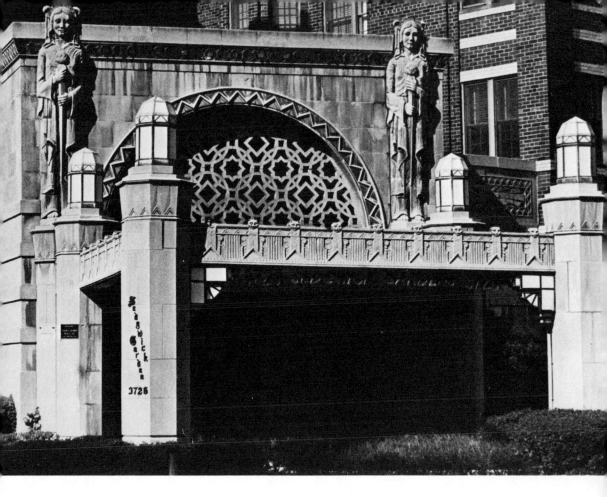

B-21
Title SEDGWICK GARDEN
ARCHITECTURAL SCULPTURE, 1932
Location Sedgwick Garden
Apartments, 3726 Connecticut
Avenue, NW
Sculptor M. Mestrobian, designer
Architect M. Mestrobian
Material Limestone

The elaborate marquee in front of the Sedgwick Garden Apartments is supported by four streamlined octagonal posts, which are surmounted by Art Deco lamps reminiscent of lighthouse beacons, perhaps to guide the residents back safely in their Packards and LaSalles from the speakeasies of the era. Behind the marquee are two eclectically dressed women grasping medieval staffs. Adjacent to them appear two relief panels, one on each side of the marquee; the panels show three seminude females riding stallions.

To further stimulate the spectator, a two-story, high-relief panel appears on the façade of the building in the background with a pair of male figures in Neoclassical garb looking in opposite directions. The modern traveler should be wary of studying this collection of architectural sculpture while behind the wheel of a car!

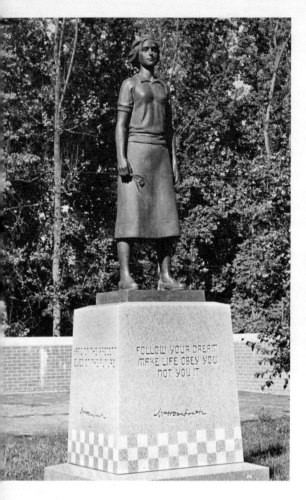
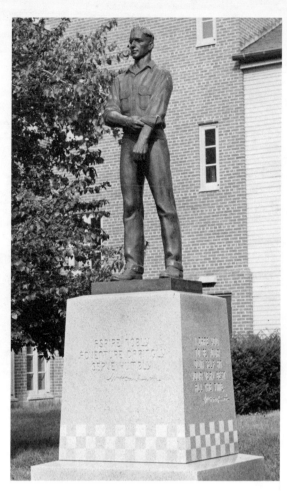

FOLLOW YOUR DREAM
MAKE LIFE OBEY YOU
NOT YOU IT

B-22
Title THE AMERICAN FARM BOY
and The AMERICAN FARM GIRL, 1959
and 1961
Location The National 4-H Club
Foundation of America, Inc., 7100
Connecticut Avenue, Chevy Chase,
Maryland
Sculptor Carl Mose
Architect Unknown
Medium Bronze

The Ralston-Purina Company of St. Louis commissioned Sculptor Carl Mose in 1959 to execute a statue entitled *The American Farm Boy* for the grounds of the Ralston-Purina Experimental Farm at Gray Summit, Missouri. In 1961 Mr. Donald Danforth, president of the Ralston-Purina Company, gave a bronze copy of *The American Farm Boy* to the National 4-H Club Foundation of America, Inc. The same year he commissioned Carl Mose to execute a new bronze statue of *The American Farm Girl*; both statues were given to the National 4-H Club Foundation of America, Inc., in memory of William H. Danforth, founder of the Ralston-Purina Company and of the Danforth Foundation. The life-size statues, modeled after St. Louis area high school students by the sculptor, are located in the courtyard of the foundation's headquarters building in Chevy Chase, Maryland. The Ralston-Purina Company, famous as one of the leading American manufacturers of feed for cattle, dogs, and cats, has presented academic scholarships to members of American 4-H Clubs and has supported the National 4-H Club Foundation in a multitude of ways for many years. The bases of both statues are decorated with the well-known checkerboard, a trademark of the Ralston-Purina Company, and with quotations of advice to young Americans by Mr. Danforth.

In 1903 the first Youth Clubs were established in the United States by the U.S. Department of Agriculture's extension service for the training of farm youth in sound agricultural practices, such as the care of livestock, the repair of farm machinery, the preparation of food, and on the furnishing and managing of a farm home. In 1924 the name "4-H Clubs" was adopted and membership has since expanded to include over two and one half million Americans, ages 10 to 20. The clubs are also popular today in urban areas and include training in good citizenship, strong leadership, cooperation with others, good health practices, and community services.

THE ELLIPSE

C

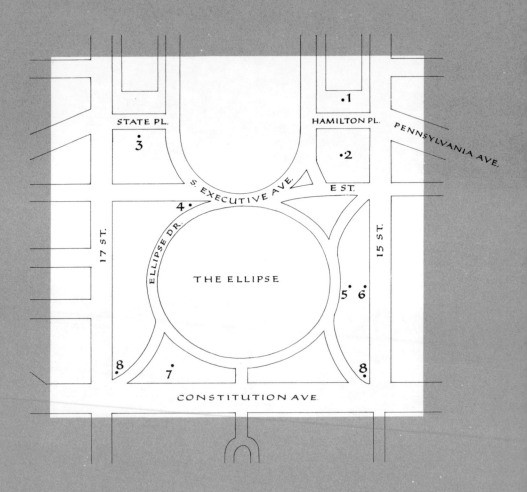

STATE PL.

·3

HAMILTON PL.

·1

PENNSYLVANIA AVE.

·2

S. EXECUTIVE AVE.

E ST.

4·

17 ST.

ELLIPSE DR.

THE ELLIPSE

15 ST.

5· ·6

8·

7·

·8

CONSTITUTION AVE.

N

O ¼ MI.

THE ELLIPSE, or President's Park South as it is now officially known, consists of 54 acres of land immediately south of the White House and in the center of the city. The site of the city was chosen by President Washington, and Pierre L'Enfant drew the first plan in 1791. On it he indicated the location of the President's House, the President's Park, and the site for a proposed equestrian statue to honor George Washington that had been approved by Congress in 1783. Before 1870 the White House, located on a high ridge of land, could clearly be seen from Alexandria, Virginia.

During the administration of President Thomas Jefferson (1801–1809), a low stone wall was erected to separate the White House grounds from the Ellipse area. The South Park then was a swamplike area through which flowed the waters of Tiber Creek, and in the autumn flocks of wild ducks disported themselves there. Being low marshland, it was flooded when the spring freshets flowed down the Potomac.

From about 1850 through the 1930s, the Ellipse was known as the White Lot, owing to the whitewashed wooden fence which enclosed the park. During the Civil War, the grounds of the White Lot as well as those farther south, the grounds of the incomplete Washington Monument, were used as corrals for horses, mules, and cattle. Union troops, bivouacked in Washington, used the grounds for camp sites and troop maneuvers.

The Ellipse was bounded on the south by the Washington Canal, which occupied the present Constitution Avenue and extended from the Potomac River to about Sixth Street, NW, where it crossed the Mall and extended around the south side of the Capitol Building to connect with the Anacostia River. This canal, designed in 1815 by Benjamin Latrobe, was never a financial success. By 1860, the Washington Canal, into which the Tiber Creek flowed, was navigable only as far as the Center Market at Pennsylvania Avenue and Eighth Street, NW. By the time of the outbreak of the Civil War the canal was used primarily as a public dump, and the smell was so bad that Lincoln preferred to spend the summer nights at the Old Soldiers' Home miles away on North Capitol Street, rather than at the nearby White House. In 1866 the city spent $75,000 to cart earth and muck dredged from the Washington Canal to fill some three million square feet of the White Lot. By 1880 the canal was filled in and graded, and the present Ellipse was created.

President Millard Fillmore commissioned Andrew Jackson Downing, the "father of American landscape gardening," to design the grounds for the public parks of Washington in 1850. Downing died by drowning on the Hudson River in 1852 before his plans for the Ellipse could be carried out (see G-10). It is Downing's plan for the Ellipse, however, that was finally carried out under the Grant Administration (1869–1877).

The Ellipse was greatly improved under the Army Corps of Engineers, beginning in 1867. The park was filled and graded because of the final completion of the adjacent Washington Monument (1876–1886) and the subsequent large crowds of visitors who came there, and also because of the dredging of the Potomac River (1872–1900), which created over 600 new acres of land, the present Potomac Park.

In the 1890s, Congress authorized the use of the grounds to special groups, such as for the encampment of the Grand Army of the Republic in 1892 and the tent meeting of the International Christian Endeavor Association in 1896. The extensive damage to the grounds by such use eventually caused the government to end this practice. Nevertheless, such facilities as baseball diamonds, tennis courts, and croquet courts existed there as late as 1925. Practically all types of sports activities were held in the area, attesting to the popularity of the White House neighborhood and the glamour associated with the Executive Mansion.

During World War II, temporary wooden barracks were erected in the area immediately south of the Old Executive Office Building, formerly known as the State, War and Navy Building, adjacent to the First Division Monument. These temporary buildings housed the 703rd Military Police Battalion, which was guarding the White House, and units of the 71st Coast Artillery (AA), which manned the antiaircraft guns erected in early 1942 on top of the Old Executive Office Building, the Washington Hotel, the Treasury Building, and the Department of Commerce. These temporary buildings were not removed until late in 1954.

Today the President's Park South is distinguished by some of the most notable monuments and memorials in Washington. The oldest and most elaborate memorial is the *General William Tecumseh Sherman Monument*, designed and erected 1892–1903. The most recent are the *Haupt Fountains*, dedicated in 1968. This area has been used extensively in the past ten years by groups both protesting and endorsing the Viet-Nam War. It is also the site for the annual Pageant of Peace during the Christmas season.

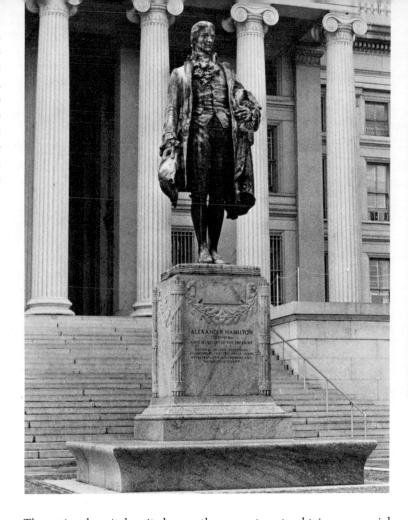

C-1

Title ALEXANDER HAMILTON, 1923
Location Department of Treasury
Building,
south entrance, Treasury Place
between East Executive Avenue
and 15th Street, NW
Sculptor James Earle Fraser
Architect Henry Bacon
Medium Bronze

The national capital waited more than a century to obtain a memorial to Alexander Hamilton, the first secretary of the treasury. When the tribute was unveiled in 1923, it was generally agreed that the wait had been worthwhile. The portrait is widely regarded as one of the best of the series of monuments created by Augustus Saint-Gaudens and his school. James Earle Fraser, the sculptor, was one of Saint-Gaudens's outstanding pupils and assistants. His statue of *Albert Gallatin*, on the Pennsylvania Avenue side of the Treasury Building, is another excellent portrait statue (see J-10).

The bronze sculpture of Hamilton details the dress of an eighteenth-century gentleman and is noteworthy for its virility and charm. The 10-foot-tall figure stands with a long dress coat in one hand and a three-cornered hat in the other. He wears knee britches; hose; a fichu at the throat; ruffles at the wrist; and low, buckled shoes. The inscription reads: "He smote the rock of the national resources and abundant streams of revenue gushed forth. He touched the dead corpse of the public credit and it sprang upon its feet."

Detail: the realistically modeled face of Hamilton is one of Fraser's best portrait statues.

Hamilton believed in strong central government and advocated a liberal interpretation of the Constitution. As secretary of the treasury, he placed United States finances on a sound basis for the first time. Burdened by the heavy Revolutionary War debt, and without funds or credit, he succeeded in raising money to balance the national budget. In addition, he established a national currency, the United States mint, and a national bank. Chief Justice John Marshall ranked Hamilton's contribution as second only to that of Washington.

The statue has had, from the dedication date, an aura of mystery about it. At the ceremony, President Warren G. Harding referred to the donor whose identity remained secret. Popular news accounts of the day told of a veiled woman who supposedly donated funds for the sculpture. Even today the donor's identity retains its mystery.

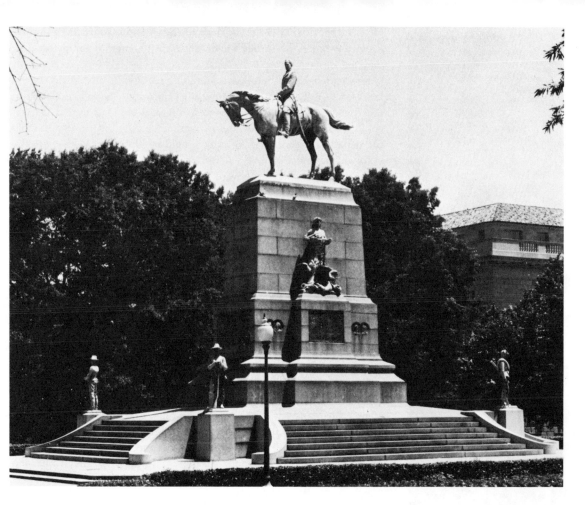

C-2

Title GENERAL WILLIAM TECUMSEH
SHERMAN MONUMENT, 1903
Location Intersection of 15th Street,
Pennsylvania Avenue, and
Treasury Place, NW
Sculptor Carl Rohl-Smith,
and others
Architects Carl Rohl-Smith and
Sara Rohl-Smith
Medium Bronze

This memorial to General William Tecumseh Sherman is one of the most elaborate in Washington. It consists of an equestrian statue, 14 feet tall, showing the general looking intently at some distant object in the field. He holds a field glass in his right hand, and his left grasps the reins in readiness for immediate action. On the main pedestal are a series of inscriptions, eight bas-reliefs, and two groups representing War and Peace. Because of the death of sculptor Carl Rohl-Smith, many of the sculptured sections of the memorial were completed by other artists, including: Lauritz Jensen (equestrian statue), Sigvald Asbjornsen (soldier statues), Mrs. Theodore A. Ruggles Kitson (eight low-relief portrait medallions), and Stephen Sinding (War and Peace groups).

On the pedestal's north face is the main inscription: "William Tecumseh Sherman." Adjacent is a bronze tablet that portrays Sherman and his troops marching through Georgia. Underneath is a quotation from Sherman upon hearing that his adopted home state, Louisiana, was about to secede from the Union. Following is another of his quotations, "War's legitimate object is more perfect peace."

Tecumseh Sherman was born in Lancaster, Ohio, in 1820. After the sudden death of his father in 1829, he lived with Thomas Ewing, who insisted that he add the Christian name William. He graduated near the top of his class at West Point and remained with the United States Army until 1853. After many unsuccessful business attempts, Sherman sought to reenter the military. When the army refused to accept him, Sherman taught at a military school in Louisiana that has since become Louisiana State University.

When the Civil War broke out in 1861, the Union Army commissioned Sherman as a colonel. After his service in the Battle of Vicksburg, Sherman was appointed by General Ulysses S. Grant to be major general in charge of the Army of the Tennessee. His duty was to cut off supplies to the Confederate Army by splitting routes of communication.

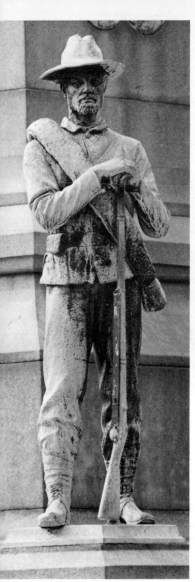

Detail: Infantry *statue on the*
Sherman Monument

He marched first to Atlanta, then to the Atlantic coast at Savannah. From Savannah, he turned north, allowing his men to forage on their way to Charleston.

Sherman believed that peace should be acquired at any cost. While in Louisiana, he had learned to love the South and its people almost as much as he loved the United States Constitution. He believed the war could be shortened if peace terms were generous, but he also thought the penalty for continued fighting should be high. Part of that penalty involved having civilians, as well as the fighting battalions, feel the pain. His orders, therefore, were to destroy all supplies of likely military value. At the same time, his men were ordered to protect all possible lives. When Confederate General Robert E. Lee resigned, Sherman helped to convince Lincoln to treat the South favorably. Unfortunately, after Lincoln's assassination, Congress refused the quick return of normal government to the South, imposing instead severe Reconstruction measures. Sherman, serving as second-in-command of the army, strongly opposed the Reconstruction proposals. When Grant was inaugurated president in 1869, Sherman became commanding general of the army.

Repeated efforts were made to draw Sherman into politics, especially during the 1884 Republican convention; his refusal to run for public office was adamant.

On the east side of the statue's pedestal is a bronze group, *Peace,* consisting of a woman and three small children. The boy on the left feeds a bird, and the woman holds an olive branch. Below this group is a bronze relief tablet of Sherman and his staff planning the Battle of Missionary Ridge. On the south are relief medallions of two favorite generals under his command, Andrew J. Smith of Pennsylvania and James B. McPherson of Ohio; next is a list of Sherman's various military assignments. On the west side of the pedestal is a bronze group, *War,* portraying a woman with her hands bound standing on a dead soldier, who clasps a rifle; two vultures prey upon his body. Below this morbid scene is a bronze tablet depicting soldiers at rest. Four more major generals who served under Sherman appear in bronze tablets: on the left, John A. Logan of Illinois and Francis Preston Blair of Kentucky, and, on the right, Edward G. Ransom of Vermont and Grenville M. Dodge of Massachusetts.

At each corner of the plaza's terrace is a life-size standing soldier, one from each branch of the army: *Infantry* on the northwest, *Artillery* on the northeast, *Cavalry* on the southeast, and *Engineers* on the southwest. Around the base of the monument is a mosaic about 6 feet wide. Inlaid there are the names of all of Sherman's battles.

Original plans for the memorial were submitted by Carl Rohl-Smith. The site was chosen because Sherman is reported to have stood there while reviewing returning Civil War troops in 1865. Rohl-Smith died in 1900, before much of the monument was completed. Supervision of the work was continued by Lauritz Jensen under the direction of Smith's widow, Sara. Jensen did the finishing touches and saw the monument assembled in accordance with the original drawings. The elaborate nature of the structure is often cited by peace groups as an unjustifiable glorification of one of America's cruelest military leaders. Defenders insist it is actually a memorial to peace, Sherman's main objective.

Title First Division Monument,
1924
Location President's Park South,
immediately south of the Old
Executive Office Building, State
Place and 17th Street, NW
Sculptor Daniel Chester French
Architects Cass Gilbert and Cass
Gilbert, Jr.
Medium Gilded bronze and granite

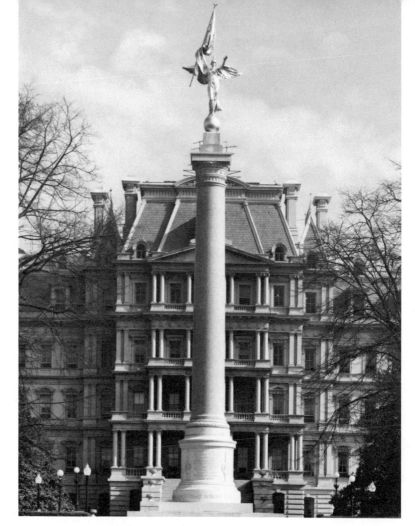

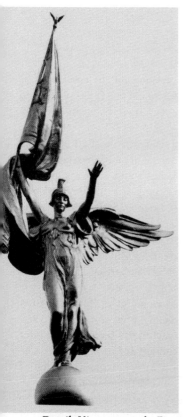

Detail: Victory atop the First
Division Monument

A winged statue of Victory proclaims the heroism of those soldiers of
the First Division of the American Expeditionary Force . . . "who gave
their lives in the World War that the liberty and the ideals of our
country might endure." The memorial is located south of the Old Execu-
tive Office Building, previously known as the State, War and Navy
Building, in the northwest corner of the President's Park in the Ellipse.

The memorial is 80 feet tall. This pink, Milford granite column from
Massachusetts is one of the largest single pieces ever taken from a
quarry in the United States. Daniel Chester French designed the tri-
umphant, gilded bronze figure of Victory which surmounts the column.
Standing 15 feet tall on a sphere, she is supported by wings suggesting
the perfection of body and soul. In her right hand she carries a flag,
while her left extends in a blessing of the dead. At the base of the
memorial are bronze plates inscribed with the names of the 5,599 men
of the First Division who were killed in World War I. The campaigns
and battle honors of the Division also are carved on the column. The
names of the 4,365 dead of World War II have been added on bronze
tablets in exedra form, and a stele lists the First Division's campaigns.
Cass Gilbert designed the original monument and his son drew the
plans for the addition.

The cost of the memorial was subscribed entirely by members of the
First Division. President Calvin Coolidge gave the dedication address
on October 4, 1924. More than 6,000 veterans were present, among
them General John Pershing and General Charles Summerall, former
army chief of staff, chairman of the memorial, and one of the Division's
great leaders. The ceremony on August 24, 1957, honoring the dead of
World War II, was presided over by General Clarence Huebner, com-
mander of the First Division in that war.

Title BUTT-MILLET MEMORIAL
FOUNTAIN, 1913
Location The Ellipse, Executive
Avenue and Ellipse Drive, NW
Sculptor Daniel Chester French
Architect Thomas Hastings
Medium Limestone and marble

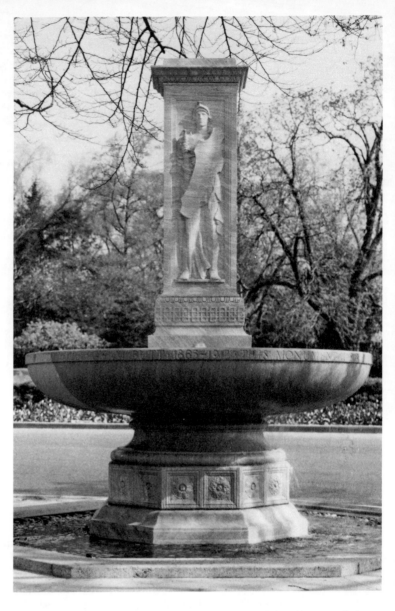

The *Butt-Millet Memorial Fountain* was erected by the contributions of friends of Major Archibald Wallingham Butt (1865–1912) and Francis Davis Millet (1846–1912), who lost their lives on the S.S. *Titanic* on April 14, 1912.

This 8-foot-high fountain is composed of a marble shaft of simple Neoclassical design rising from an octagonal basin of Tennessee marble. Today, the sculpture suffers from poor landscaping and proximity to roads. The sculpture on the fountain consists of two low-relief panels on the sides of the shaft. On the south side appears a military figure with sword and shield, representing Military Valor and Major Butt. On the north side is a relief panel containing the figure of an artist with palette and brush, representing Art and Francis Millet. Both Butt and Millet, so well known in Washington cultural and social circles at the time of their death, have been forgotten today.

This piece of commemorative art may serve many as an introduction to Francis Millet. Accompanying his surgeon father to the Civil War, Millet served as a drummer boy to a Massachusetts regiment and later served as a surgical assistant. A brilliant student at Harvard, he became a reporter, then city editor, of the Boston *Courier*. From a pastime of lithography and portraiture of friends, he decided to devote himself to art. Entering the Royal Academy of Fine Arts at Antwerp, Belgium, he won an unprecedented silver medal in his first year and a gold medal in the second. A constant traveler, Millet kept his newspaper contacts

open, and during the Russian-Turkish War he represented with distinction several American and English newspapers. He was decorated by Russia and Rumania for bravery under fire and services to the wounded. Millet's literary talents led him to publish accounts of his travels and, besides writing short stories and essays, he translated Tolstoy's *Sebastopol.*

Millet's work as a decorative artist includes the murals of the Baltimore Customs House, Trinity Church of Boston, and the Capitol Buildings of Wisconsin and Minnesota. His paintings are found in the Metropolitan Museum, New York City, and the Tate Gallery, London. In addition, his administrative skills won him acclaim as superintendent of decoration at the World's Columbian Exhibition in Chicago (1893), and as organizer of the American Federation of the Arts for the National Academy. At the memorial meeting for Millet, Senator Elihu Root said: "He must have been born with a sense of the beautiful and a love for it, for he devoted his life to it. . . . He was one of the most unassuming and unselfish of men. . . . He was a man of great strength and force, decision and executive capacity. . . . He always pressed on to the accomplishment of his purposes, purposes in which self was always subordinate. . . ."

Archibald Butt, noted as the influential military aide to President William Howard Taft and President Theodore Roosevelt, was born into a prominent Augusta, Georgia, family. After his graduation in 1888 from the University of the South in Tennessee, Butt began a career in journalism, first writing for the Louisville *Courier Journal* and later as a reporter in Washington for a group of Southern newspapers. While working in Washington he became secretary of the Mexican Embassy with General "Matt" Ransom, Confederate officer and former United States senator from North Carolina.

In 1898 Butt left Mexico to enter the United States army as a lieutenant during the Spanish-American War, and decided to make the military a second career. He served in the Philippines from 1900 to 1906, then in Cuba before becoming military aide to President Theodore Roosevelt in 1908. Butt's health began to deteriorate in 1912 because of his attempts to remain neutral during the bitter personal quarrel between Roosevelt and Taft. Needing rest, he took six weeks' leave from the White House and sailed for Europe with his close friend Francis Millet, who was enroute to Rome on business at the American Academy which he directed. They were returning to Washington on the S.S. *Titanic* when that ship struck an iceberg. Both men were last seen giving up their life preservers to women passengers shortly before the ship sank in the icy Atlantic waters.

Title BOY SCOUT MEMORIAL, 1964
Location The Ellipse, 15th Street between Constitution Avenue and E Street, NW
Sculptor Donald DeLue
Architect William Henry Deacy
Medium Bronze

This commemorative tribute is one of the few Washington statues representing a living cause. It was built to honor those who serve America's youth, and it was placed to mark the site of the First National Boy Scout Jamboree in Washington in 1937.

The center of the design is a three-figure group standing on a 5½-foot hexagonal pedestal. The 12-foot-high allegorical figures, representing American Manhood and Womanhood, are larger than the Boy Scout. The scout is in the forefront, hiking off into the future with faith and confidence. Some observers feel that the Neoclassical figures were a selection to symbolize ideals passed on to the young generation. Clothed in clinging, wind-blown drapery, they completely overwhelm the small figure of the scout. There is both an incongruous clashing between the scale of the figures and a questionable mixture of contemporary and Neoclassical details.

The pedestal is placed at the northeast end of an elliptical pool. Along the rim of the pool is inscribed: "In grateful tribute to the men and women whose generosity, devotion, and leadership have brought Scouting to the nation's youth and to honor all members of the Boy Scouts of America who in days of peace and times of peril have done their duty to God and their country this memorial was authorized by the Congress of the United States and erected in recognition of the fiftieth anniversary of the Boy Scouts of America." The Boy Scout oath is carved on the face of the pedestal. The statue was unveiled November 7, 1964, by three area scouts and accepted for the country by Associate Supreme Court Justice Tom Clark, who noted it was his fiftieth anniversary as an Eagle Scout. The memorial was financed by the contributions of scouts whose names were inscribed on scrolls placed within the pedestal.

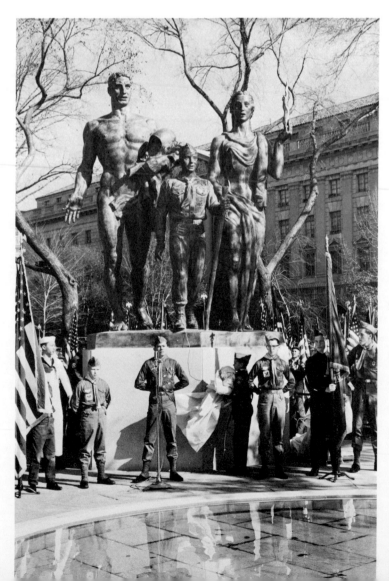

C-6

Title SETTLERS OF THE DISTRICT
OF COLUMBIA
MEMORIAL, 1936

Location The Ellipse, 15th Street
between E Street and Constitution
Avenue, NW

Sculptor Carl Mose

Architect Delos Smith

Medium Granite

A simple shaft stands just off the sidewalk on Fifteenth Street, NW, dedicated "to the original patentees prior to 1700 whose land grants embrace the site of the federal city." It is appropriate that the eighteen landowners whose property eventually became the National Capital should be honored in the President's Park South. The memorial was donated by the National Society of the Daughters of the American Revolution in April 1936, "as a way of teaching history."

Carl Mose, once an instructor at the Corcoran School of Art in Washington, carved the relief panels, which measure about 1 foot square. The four panels at the base of the shaft are symbolic of the early pioneers' agricultural pursuits, represented by corn and tobacco, and by the plentiful food supplies they found, symbolized by the turkey and the herring. A modest monument to forgotten men, it deserves a detour from the sidewalk.

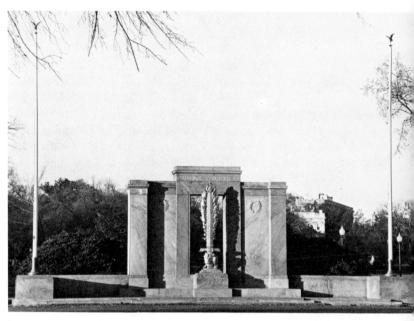

C-7

Title SECOND DIVISION MEMORIAL,
1936

Location The Ellipse, Constitution
Avenue near 17th Street, NW

Sculptor James Earle Fraser

Architect John Russell Pope

Medium Gilded bronze

This memorial honors the 17,669 dead who served in the Second Division of the United States Army during three wars. Its huge granite portal fronts to the south on Constitution Avenue. Guarding this gateway, a gilded, bronze, fiery, 18-foot-tall sword symbolically blocks the German advance to Paris.

Originally constructed to commemorate the Division's dead in World War I, the monument had two wings added later, with the battle honors of World War II on the west and those of the Korean Conflict on the east.

The first dedication was on July 18, 1936, with President Franklin D. Roosevelt paying his respects to the "memorial symbolizing the splendid achievements of the Second Division." The wings were dedicated on June 20, 1962, with General Maxwell Taylor speaking during a reunion of the Second Division. The monument was financed by Division members and friends.

Two hundred and fifty tons of granite were transported from Stony Creek, Connecticut, for the construction of the original memorial. All lettering is "V" cut and filled with gold leaf. Two wreaths carved in relief flank the gateway entrance, and the Division's insignia—the head of an Indian chief on a star—is embossed on the sword's hilt.

C-8
Title Bᴜʟғɪɴᴄʜ Gᴀᴛᴇʜᴏᴜsᴇs, ca. 1828
Location The Ellipse, Constitution Avenue at the intersections of 15th and 17th Streets, ɴᴡ
Sculptor Charles Bulfinch, designer
Architect Charles Bulfinch
Medium Sandstone

The *Bulfinch Gatehouses*, with their finely carved Neoclassical friezes about 1½ feet high and with central panels of ornate foliage, were designed by Charles Bulfinch. The gatehouses and a number of piers with identical sculptured friezes stood at the west entrance to the United States Capitol Building grounds on First Street from 1828 until they were removed in 1874 for the relandscaping of the Capitol grounds by Frederick Law Olmsted. Both the two gatehouses and the four piers, which were saved, were reconstructed on their present sites in 1880. The sandstone gatehouses were restored by the National Park Service during the winter of 1938–1939. One is located on the corner of Constitution Avenue and Fifteenth Street and the second at the intersection of Constitution Avenue and Seventeenth Street, ɴᴡ. The surviving piers or gateposts are found nearby on the opposite side of Constitution Avenue.

Charles Bulfinch (1763–1844), the first native-born professional architect in the United States, was born into a family of socially prominent Bostonians. After graduating from Harvard, he traveled throughout Europe studying city architecture. Between the years 1790 and 1825 Bulfinch practically rebuilt Boston in a style similar to the Neoclassicism popular in England at the time, but sufficiently original and fresh to be designated a style in its own right. It has been called Early Republican or Federal architecture. In 1817 Bulfinch was appointed architect of the United States Capitol Building, a post left vacant by Benjamin Latrobe. He is responsible for rebuilding the Capitol, burned in August 1814 during the British invasion, and with designing the west front portico.

D

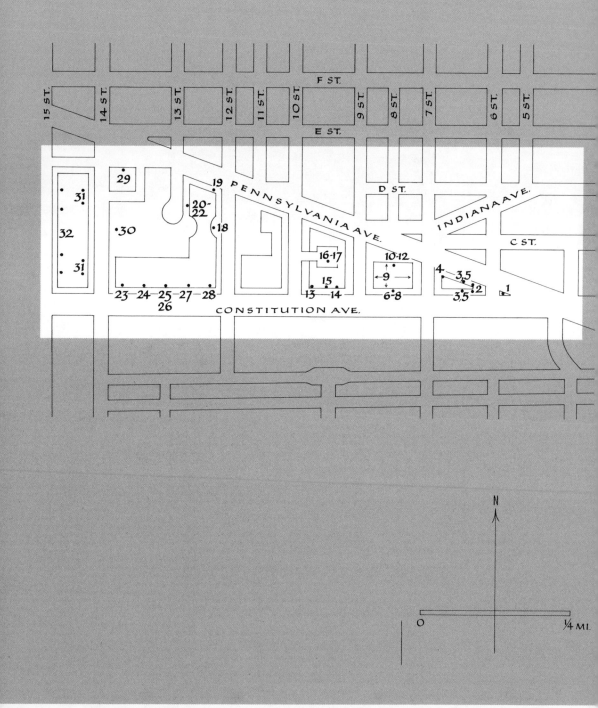

15 ST. 14 ST. 13 ST. 12 ST. 11 ST. 10 ST. 9 ST. 8 ST. 7 ST. 6 ST. 5 ST.

F ST.

E ST.

D ST.

C ST.

PENNSYLVANIA AVE.

INDIANA AVE.

CONSTITUTION AVE.

29

31

32

31

30

19

20-22

18

16-17

15

10-12

9

4

3,5

3,5

2

1

13 14

6-8

23—24—25—27—28

26

N

0 ¼ MI.

1 ANDREW W. MELLON MEMORIAL FOUNTAIN, Sidney Waugh, p. 144

2-5 FEDERAL TRADE COMMISSION

2 MAN CONTROLLING TRADE, Michael Lantz, p. 145

3 AMERICANS AT WORK, PAST AND PRESENT, Chaim Gross, Robert Laurent, Concetta Scaravaglione, and Carl Ludwig Schmitz, p. 146

4 FEDERAL TRADE COMMISSION EAGLE, Sidney Waugh, p. 147

5 AMERICAN TRANSPORTATION DOORS, designed by Bennett, Parson, and Frost, architects, p. 148

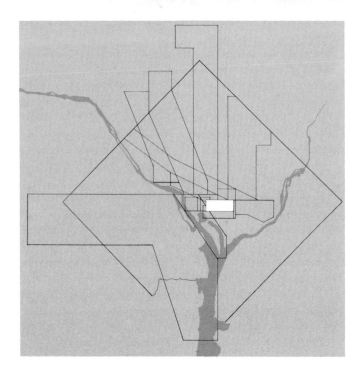

THE FIRST PLANS for a great complex of buildings to house the offices of the federal government, which eventually resulted in the construction of the Federal Triangle (1929–1938), began in 1908. In that year, the American Historical Association passed a resolution calling on the president and Congress to provide a separate building for the storage and preservation of government records in Washington, D.C. Records of various government agencies, which dated back to 1775, were being stored haphazardly in numerous basements and attics across the city. In 1913, Congress authorized the secretary of the treasury, then in charge of the erection of government buildings, to draw up plans for a fireproof national archives. Congress took steps, in 1916, to establish a public buildings program in Washington, not only for an archives building but for other government agencies also. The buildings followed the plan of the McMillan Commission, a group appointed by the U.S. Senate, which advocated the return of the appearance of the capital city to L'Enfant's original design and which urged the use of the Neoclassical style for all government buildings. They were to be erected along both sides of the Mall and around the White House. Owing to America's entry into World War I, the plans were temporarily shelved.

President Calvin Coolidge urged appropriations for new government buildings in his annual budget messages to Congress; these recommendations were passed by Act of Congress, May 25, 1926, authorizing the construction of nine massive buildings in the fashionable Neoclassical style of architecture, to be built in the area bounded by Fifteenth Street, Pennsylvania Avenue, Constitution Avenue, and Sixth Street, NW. Dozens of Victorian-style buildings, including the huge Center Market at Seventh Street and Pennsylvania Avenue, NW, were destroyed to make way for the design reminiscent of ancient Rome.

Secretary of the Treasury Andrew Mellon was most influential in guiding the design of the Federal Triangle. It was Mellon who insisted on individually different buildings but also on a unified treatment of the whole project architecturally. At a number of meetings of the building committee in 1928–1929, discussion centered on the types of building materials to be used. Mellon advocated the use of light-colored limestone for the entire project rather than granite or marble. The committee did propose the use of marble columns for both the Commerce Department Building and the Internal Revenue Commission Building. A focus of interest of the Federal Triangle was to have been the great plaza between Thirteenth Street and Fourteenth Street, with a fountain at each end. The plaza façades of the buildings were to have had as important architectural treatment as the street façades. A sunken garden was to have been the focus in the center of the plaza. This plaza today has deteriorated into a huge unattractive parking lot, which could, with planning, easily be completed as a most needed inner city park. A number of Neoclassical buildings in Paris were studied for ideas; some ideas were adopted as, for example, the pavilion on the Internal Revenue Commission Building on Constitution Avenue between Tenth Street and Twelfth Street, NW, was treated in a similar manner to that of the front pavilion of the Ministry of Marine, Place de la Concorde, Paris. Each building had extensive inscriptions cut into the stonework of the façade relating to the work of that department of the government.

The master plan for the Federal Triangle has never been completely carried out since two earlier structures, the old Romanesque Revival style Post Office Department Building (erected in 1899) and the District of Columbia Building (erected 1908), still occupy part of the site of the Federal Triangle. The dilemma still exists today whether to retain or destroy these two, now historic, buildings in order to complete the Federal Triangle scheme.

Most of the sculptures for the Federal Triangle were modeled and designed in an aircraft hangar at The Presidio at San Francisco in 1934–1935. Several of the sculptors who worked there are shown outside the hangar. Front row, left to right, are Karl Schmidt; unidentified assistant; Albert Stewart; Edgar Walter; and Sherry Fry. Back row, left to right, are Wheeler Williams; Edmond Amateis; Leon Hermant; Edward McCartan; unidentified assistant; and an unidentified workman.

D-1

Title ANDREW W. MELLON
MEMORIAL FOUNTAIN, 1952
Location Constitution and
Pennsylvania Avenues, NW
Sculptor Sidney Waugh
Architect Otto R. Eggers
Medium Bronze and granite

The circular *Andrew W. Mellon Memorial Fountain* was created for the intersection of Constitution and Pennsylvania Avenues, NW. It consists of three tiers of bronze basins, from which cascades of water flow into a low granite curbed pool. A single spout of water rising 20 feet high at the central plume supplies the water which spills into the major basin. The translucent curtain of water which overflows the rim of this third basin—the largest fountain basin ever cast in bronze—constitutes the major element of beauty. Underneath the sheet of water can be seen signs of the Zodiac in high relief and about 2 feet wide. The signs are carefully placed so that the sign of Aries the Ram, for instance, will be correctly touched by the sun's rays on the vernal equinox (March 21) and will face the rising sun directly from then until April 20. The design was inspired by a fountain in one of the public squares in Genoa, Italy.

The fountain, about 18 yards in diameter, and costing some $300,000, was donated by his friends as a memorial to Andrew W. Mellon (1855–1937), financier, industrialist, and statesman. Mellon served as secretary of the treasury (1921–1932) and as ambassador to Great Britain (1932–1933). The magnificence of the gift in 1937 of his priceless collection of old master paintings, of a building—the National Gallery of Art—to house the collection, and of a large endowment for the gallery, has been unequaled in the history of American art.

Detail: one of the signs of the Zodiac on the side of the Mellon Fountain

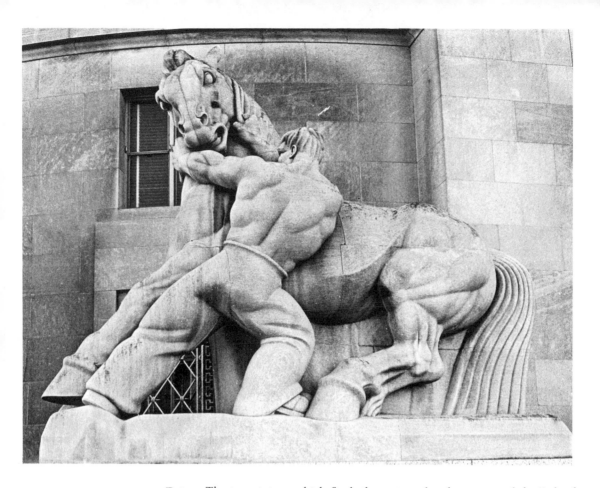

D-2

Title MAN CONTROLLING TRADE, 1942

Location Federal Trade Commission, apex of 6th Street, Pennsylvania and Constitution Avenues, NW

Sculptor Michael Lantz

Architect Bennett, Parson, and Frost

Medium Limestone

The two statues which flank the eastern facade or apex of the Federal Trade Commission Building are similar but not identical; they are approximately 12 feet in height and 15 feet in length. Each of these heroic works reflects the Art Deco style of the 1930s and depicts a man controlling a horse, symbolic of the Federal Trade Commission controlling monopolies. Michael Lantz, a 29-year-old W.P.A. instructor in New Rochelle, New York, won the $45,000 competition for this sculpture in January 1938. The competition was the first ever held by the federal government in which the artists who entered were permitted to elect their panel of judges. The statues, carved on the site from limestone, were finished in 1942. The straining muscles of the man are definitely reflected in the harassed eye of the balking horse. Because this building forms the eastern termination of the nine-block-long triangular grouping of federal office buildings, it is frequently referred to as the Apex Building.

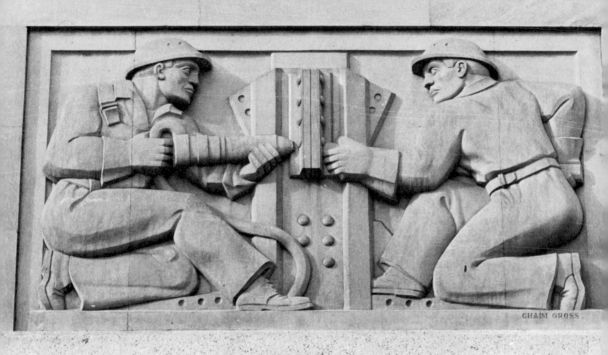

D-3

Title AMERICANS AT WORK, PAST AND PRESENT, 1937

Location Federal Trade Commission, Pennsylvania and Constitution Avenues between 6th and 7th Streets, NW

Sculptors Chaim Gross, Robert Laurent, Concetta Scaravaglione, and Carl Ludwig Schmitz

Architect Bennett, Parson, and Frost

Medium Limestone

This limestone relief panel, 12 feet by 7 feet, is one of four different panels located over the entrances to the building. *Industry*, by Chaim Gross, depicts two steel construction workers riveting steel beams together with bolts. The sculptor has skillfully designed this composition of the two figures and the central steel beams into a rectangular panel. The bold simple lines and solid forms of the figures reflect the Art Deco style popular when the building was constructed in 1937. All of these panels reflect the geometric rigor and mundane reality typical of art in the Depression years.

The panel on the Pennsylvania Avenue façade, *Shipping*, by Robert Laurent, depicts two seamen hoisting a cargo by pulleys into a vessel. One of the Constitution Avenue panels, *Agriculture*, by Concetta Scaravaglione, depicts trade in wheat (see D-5). *Foreign Trade*, on the same façade, is by Carl L. Schmitz, and depicts ivory trade in Africa. Each panel includes two human figures engaged in that particular occupation.

Title FEDERAL TRADE COMMISSION
EAGLE, 1937
Location Federal Trade
Commission, Pennsylvania
Avenue and 7th Street, NW, corner
façade
Sculptor Sidney Waugh
Architect Bennet, Parson, and
Frost
Medium Limestone

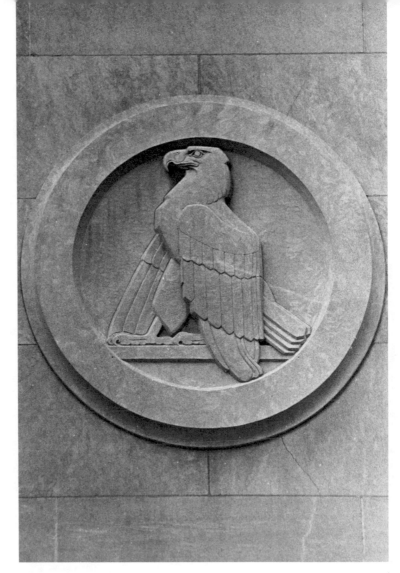

This circular medallion is about 4 feet in diameter and features the profile of an American eagle—the most commonly used decorative device, along with the fasces, found on the Federal Triangle buildings. This easternmost of the nine buildings in the Neoclassical style which compose the Federal Triangle was commonly known as the Apex Building when it was finished in July 1937. President Franklin D. Roosevelt used the same trowel for the opening of this building that President George Washington used in dedicating the United States Capitol on September 18, 1793.

The Federal Trade Commission, established by Act of Congress in 1914 to protect American trade and commerce against unlawful restraints and monopolies, also protects the public from deceptive methods of advertising, packaging of consumer goods, and improper use of consumer credit account data.

D-5

Title AMERICAN TRANSPORTATION
DOORS, 1938
Location Federal Trade
Commission, bounded by
Pennsylvania and Constitution
Avenues, and 6th and 7th Streets,
NW
Sculptor William M. McVey
Architect Bennett, Parson, and
Frost
Medium Aluminum

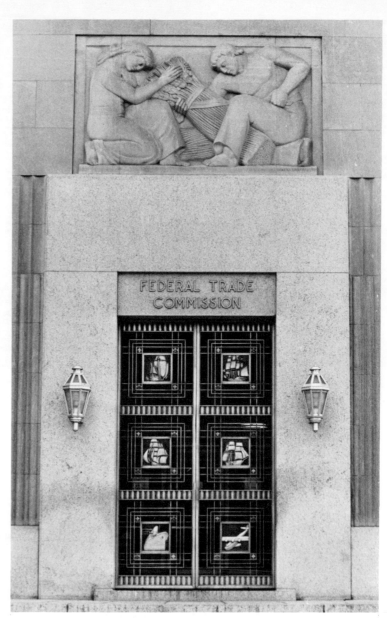

Airplane panel

The Federal Trade Commission has four identical aluminum doors with panels showing sailing ships, freighters, and an airplane, symbols of the old and the new means of conducting trade. Two of the doors are on the Pennsylvania Avenue façade and two are on the Constitution Avenue façade. They were designed in aluminum, the favorite material of Art Deco style, and were installed in time for the opening of the building in 1938.

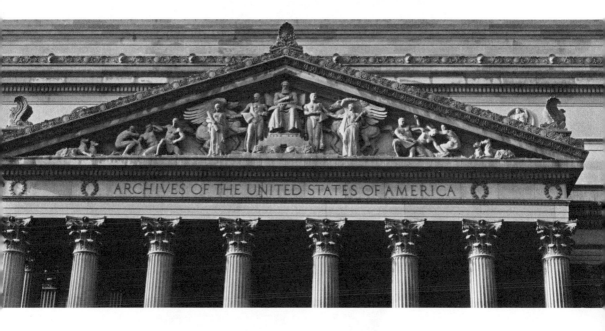

D-6
Title THE RECORDER OF THE
ARCHIVES, 1935
Location National Archives,
Constitution Avenue, between 7th
and 9th Streets, NW
Sculptor James Earle Fraser
Architect John Russell Pope
Medium Limestone

The well-modeled, highly professional work shown here makes this the finest sculptured pediment in Washington. The central figure of a dignified elderly man represents the Recorder of the Archives. He is seated high on an architectural throne which rests on recumbent rams, symbols of parchment. Above the rams runs a decorative frieze based on the flower of the papyrus plant, symbol of paper. These two mediums, parchment and paper, make possible the housing of the documents of a great nation in a single building.

Attendant figures on either side of the Recorder are represented as receiving documents. Each stands in front of a winged horse, or Pegasus, a classical symbol of Aspiration. These two men bring forward such inspired documents as the Constitution, the Declaration of Independence, and other works of great literary or historical value. Beyond these are groups of people shown acquiring and contributing records and documents of lesser importance. Groups of dogs at each end symbolize guardianship.

The figures in the pediment were carved in place from stone blocks weighing from 13 to 50 tons each. Sculptor James Earle Fraser is shown in the adjacent photogaph at work on the figures in 1935. Laura Gardin Fraser, the artist's wife, assisted in the execution of this 104-foot-long pediment. The Great Danes in the corners were executed from sketches by the sculptor's young assistant, Bruce Moore. The dogs in the rear of the Great Danes are portraits of the Fraser's household pets.

Sculptor James Earle Fraser and his assistant execute the final carving on The Recorder of the Archives, *in place, 1935.*

Title Acroterion Eagles, 1935
Location National Archives,
Constitution Avenue between 7th
and 9th Streets, NW
Sculptor James Earle Fraser
Architect John Russell Pope
Medium Limestone

Fierce-looking limestone eagles, 12 feet tall and decorating the upper corners of *The Recorder of the Archives* pediment, are faithfully located as other bird or animal figures would have been 2,000 years ago atop a Roman pediment. Two eagles are on top of each of the two pediments of the building, at the four points of the compass, and act as guardians of the archives. The decorative device at the top of the pediment represents a palmetto leaf, frequently used to embellish buildings in ancient Rome and Greece.

Corinthian columns rising 52 feet in height underneath the portico continue around the entire structure to form a massive colonnade which helps to relieve the severity of the façade. The Constitution Avenue pediment is supported by a portico which is eight columns wide and four columns deep.

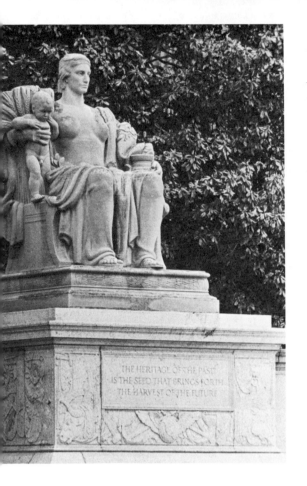
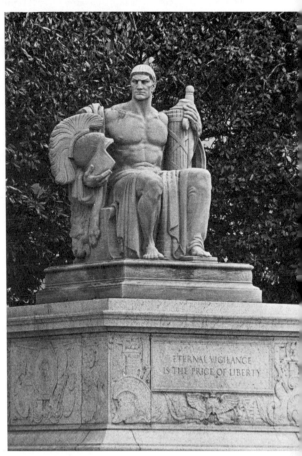

D-8

Title HERITAGE and GUARDIANSHIP, 1935

Location National Archives, Constitution Avenue, between 7th and 9th Streets, NW

Sculptor James Earle Fraser

Architect John Russell Pope

Medium Granite and limestone

At each end of the steps leading to the great doorway of the south portico of the National Archives Building are two large granite pedestals surmounted by powerful 8-foot-tall limestone figures representing *Heritage* and *Guardianship*. The male figure to the right side is expressive of *Guardianship*, not aggressive but watchful. The helmet of Protection is held in one hand, while the other hand clasps a sheathed sword and the fasces, symbol of Unified Government. The inscription under this figure, attributed to Thomas Jefferson, reads: "Eternal Vigilance is the Price of Liberty."

Located left of the portico steps, a Neoclassical female figure symbolizes *Heritage* as it relates to the government's protection of the sanctity of the home. In her right arm the mother holds a child and a sheaf of wheat, while her left hand rests on an urn, symbol of the Home. The inscription on the acropodium, or large highly decorated pedestal reads: "The Heritage of the Past is the Seed That Brings Forth the Harvest of the Future." It was composed by the sculptor, James Earle Fraser, and was slightly modified by two members of the Fine Arts Commission, Charles Moore and R.D.W. Connor.

Elaborate low-relief Neoclassical decorative devices are carved on the massive base or acropodium. Included on the four sides are the heads of horses, cows, and rams, all known as aegicrames; tools; a winged sphere; and other symbols of the hearth. In contrast, the base to the companion statue, *Guardianship*, contains low-relief carvings of weapons and helmets.

Limestone for this statue and the other three statues around the building was brought to Washington from Indiana on especially constructed railroad flatcars. One third of the block had to be cut away by the sculptor, working on top of the flatcar, before a crane could move the unfinished stone to the building site. At the time of construction, these were the largest solid blocks of limestone ever quarried in the United States.

D-9
Title SEALS OF THE FEDERAL
GOVERNMENT, 1935
Location National Archives, all
façades at the attic level
Sculptors James Earle Fraser and
Robert Aitken
Architect John Russell Pope
Medium Limestone

The thirteen medallions, each 8 feet in height, which are placed on the attic frieze on all façades of the building, represent the twelve departments of the federal government that surrendered their records into the keeping of the National Archives. The thirteenth medallion is the Great Seal of the United States.

The medallions on the Constitution Avenue side are the work of James Earle Fraser. They are, left to right: Department of War, a helmeted and powerful warrior holding a sword; Department of State, a bearded old man holding rolled parchments and documents; Department of the Treasury, an armed guard with an iron safe; and the Department of the Navy, a male figure carrying a model of a ship and surrounded by various maritime accessories.

On the left side of the Seventh Street façade is the Department of Commerce medallion portraying a male figure grouped with articles of trade—a box of jewels and bags of gold. To the right is the Department of the Interior medallion, a male figure with attributes indicative of the nation's natural resources, which was executed by Ulysses A. Ricci after designs by James Earle Fraser. The inscription between the two medallions is as follows: "This Building Holds In Trust The Records Of Our National Life And Symbolizes our Faith in the Permanency of our National Institutions." The stonecutter carved the inscription in three lines with each letter measuring over 2 feet in height.

The five medallions of the Pennsylvania Avenue façade were sculpted by Robert Aitken. They are, left to right: Department of Labor, a male figure with the attributes of industry, including a hammer, wheel of progress, and an anvil; the House of Representatives, a male figure holding a mace, the emblem of the House, with documents and books in the background; the Great Seal of the United States, the eagle and shield; the United States Senate, a male figure holding the fasces, symbol of authority, and a book containing the laws of the land.

The Ninth Street façade contains to the left, the Department of Justice, a male figure holding the statute books of the law and "the Reins of Guidance." To the right, the Department of Agriculture is represented by a man holding a sickle and a sheaf of wheat. These medallions also were executed by Ricci after designs by Fraser. The

Department of Commerce medallion

inscription between the two medallions is: "The Glory and Romance of Our History Are Here Preserved in the Chronicles of Those Who Conceived and Built the Structure of Our Nation."

The Great Seal of the United States medallion, almost completely hidden from the street behind the pediment apex, was incorrectly designed by sculptor Robert Aitken. Among the faults are the position of the eagle's head and the arrangement of emblems, the laurels and arrows, in its talons. Egerton Swartwout, in a 1934 letter to Lee Lawrie, fellow member of the Fine Arts Commission, wondered about public reaction to the errors. Swartwout cited Mark Twain's remark about the Missouri State Seal, which Twain said unfortunately appeared to include "a couple of dissolute bears supporting a beer keg."

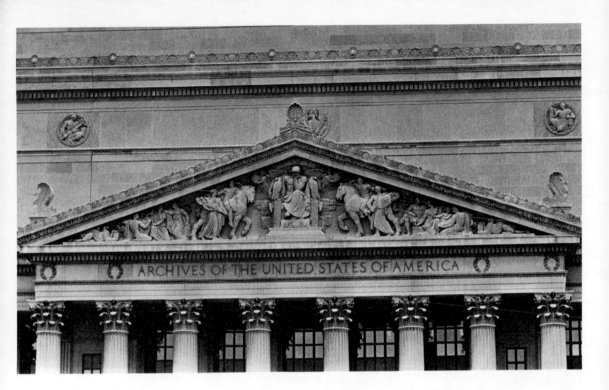

D-10

Title DESTINY, 1935
Location National Archives,
Pennsylvania Avenue and 8th
Street, NW
Sculptor
Adolph Alexander Weinman
Architect John Russell Pope
Medium Limestone

The pediment sculpture on the north, or Pennsylvania Avenue façade, of the National Archives is the concept of Adolph Alexander Weinman, who has executed other pediments on façades of the Department of the Post Office Building. His description of the meaning and symbolism contained in this handsome group of sculpture follows:

The dominant central figure represents "Destiny," flanked on either side by eagles mounted upon the fasces, the symbol of the strength that lies in unity. The eagles are used here as both the national symbol and that of "Lofty Courage." The two-winged genii appearing above are the "Bearers of the Fire of Patriotism." The whole of this central motif is crowned with a band of stars. At the left of this central group is the massive portrayal of a mounted husbandman accompanied by a female figure carrying the distaff and branches of olive and the palm, signifying both victory and peace. This group symbolizes "The Arts of Peace."

Opposite this, at the right of the central group, is shown a warrior mounted upon a powerful charger, accompanied by a warrior carrying the swords of vanquished enemies, the group being symbolic of "The Arts of War."

Following this to the right, is shown a group of four figures, two philosophers in contemplation of a crowned skull and sword and a kneeling figure and child with the scroll of History. This group symbolizes "The Romance of History."

Opposite this, to the left, is shown a group of four figures, the savant, a female figure with the torch of enlightenment, a child carrying a garland of flowers, and a kneeling male figure with a harp, singing "The Song of Achievement." In the extreme ends of the composition are shown two griffins, one with a casket of documents, the other with a sealed book. They symbolize "Guardians of the Secrets of the Archives."

In short, the composition may be described as follows: "Destiny" flanked on either side by "The Arts of Peace" and "The Arts of War." These are in turn flanked by groups representing "The Romance of History" on the right, and "The Song of Achievement" on the left. The ends are terminated by the "Guardians of the Archives."

This pediment is about 100 feet long.

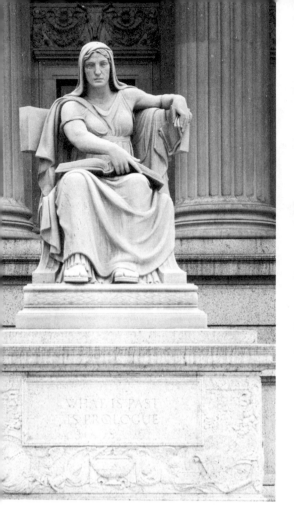

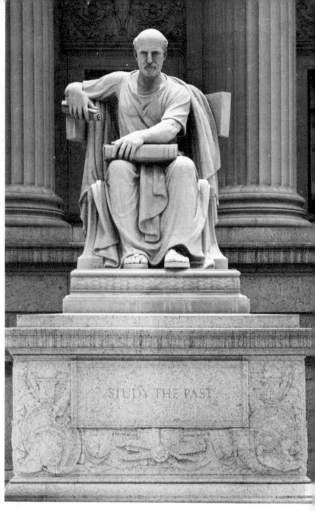

D-11

Title Past and Future, 1935
Location National Archives, Pennsylvania Avenue and 8th Street, NW
Sculptor Robert Aitken
Architect John Russell Pope
Medium Limestone

On the Pennsylvania Avenue side of the National Archives Building are two heroic 12-foot-tall allegorical Neoclassical statues by Robert Aitken, *Past* on the right and *Future* on the left. *Past* is depicted by a Roman scholar with book and scroll. The inscription, "Study the Past," is from a quotation by the Chinese scholar, Confucius: "Study the past if you would divine the future." John Russell Pope insisted, in 1935, that the inscriptions be carved onto the bases of these two statues, as well as on those of *Heritage* and *Guardianship* on the Constitution Avenue side of the National Archives, even against the advice of the supervising architect of the treasury, Louis A. Simon. These allegorical figures were carved by several Italian-American stonecarvers after sketches or models by the sculptors.

The allegorical female figure representing *Future* holds an open book on her lap with her right hand and several manuscripts in her left. An over-ornamented base detracts from the rather bland figures done in pseudo-Roman style. The inscription on the base, "What is Past is Prologue," is from Shakespeare.

Left, Future; *right*, Past

D-12
Title THE GUARDIANS OF THE
PORTAL, 1935
Location National Archives,
Pennsylvania Avenue and 8th
Street, NW
Sculptor Robert Aitken
Architect John Russell Pope
Medium Limestone

*Original clay model of the soldier
guarding the right side of the
doorway*

Carved in relief on single limestone slabs at each side of the central doorway of the National Archives on the Pennsylvania Avenue façade are two figures in Roman armor representing *The Guardians of the Portal*. The figures reach the full height of the door, about 9 feet high. They were set in place before the building opened on October 19, 1935.

Although contracts for the sculpture were arranged by the supervising architect of the Treasury Department, under authority of the Public Works Administration, the architect was allowed to select the sculptors for these works.

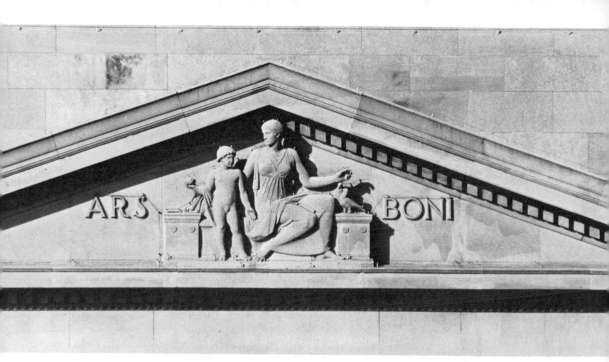

D-13

Title Ars Boni and Ars Aequi,
1934

Location Department of Justice,
Constitution Avenue between
9th and 10th Streets, NW

Sculptor Carl Paul Jennewein

Architect Borie, Medary, and
Zantzinger

Medium Limestone

A pair of small pediments, *Ars Boni* and *Ars Aequi*, each about 50 feet in length, by Carl Paul Jennewein, fail to relieve the rather stark Constitution Avenue façade of the Department of Justice. The meager size of the two Neoclassical figures leaves much wasted space within the tympanum or interior of the pediments. The pediment to the left on the façade toward Tenth Street, and here illustrated, is entitled *Ars Boni*, or "The Good of the State." The pediment to the right near Ninth Street is known as the *Ars Aequi*, or "The Rights of Man."

More interesting are Jennewein's interior sculptures within the building. Four statues in the fifth-floor elevator lobby (south wing) represent the basic elements: Fire, Earth, Water, and Air. His pair of heroic aluminum statues in the Great Reception Room on the second floor, *The Spirit of Justice* (female figure) and *The Majesty of Justice* (male figure), are fine examples of the Art Deco style. In the second-floor elevator lobby adjacent to the Great Reception Room are found his four aluminum Neoclassical urns with motifs symbolic of Prudence, Justice, Fortitude, and Temperance.

This building marked the first permanent home for both the attorney general and the Department of Justice in Washington, D.C. The post of attorney general was first held by Edmund Randolph of Virginia when the Judiciary Act of 1789 was passed by Congress. The office remained a relatively unimportant one, however, until 1870 when Congress authorized the Department of Justice; Congress further authorized this department to begin criminal investigations. What began originally as a force of investigators hired by the attorney general from other government departments became the Department of Justice's own Bureau of Investigation in 1908. Of approximately 45,000 employees in the Department of Justice today, over 19,000 are part of the Federal Bureau of Investigation staff. The latter agency moved to its new separate building on Pennsylvania Avenue and Ninth Street, NW, in 1974.

D-14

Title Captain Nathan Hale, ca. 1915

Location Department of Justice, Constitution Avenue, between 9th and 10th Streets, NW

Sculptor Bela Lyon Pratt

Architect Douglas W. Orr

Medium Bronze

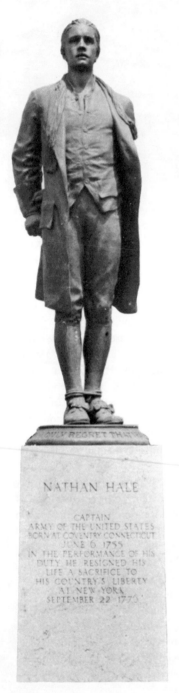

Awkwardly situated against the massive southern façade of the Department of Justice, this small-scale statue of Captain Nathan Hale, standing about 6 feet high, appears to be somewhat lost.

Captain Nathan Hale (1755–1776), the first well-known martyr of the American Revolution, was born in Coventry, Connecticut, graduated from Yale in 1773 and subsequently taught school in New London, Connecticut, until 1775. After the Battle of Lexington, he was commissioned an officer in the Continental Army, and then served against the British at Boston. When the American Army was evacuated from Boston in January 1776, Hale was reassigned to duty around New York City, which was then held by the British. In September of 1776, he volunteered to serve as a spy to secure information concerning the strength of the British on Long Island. By assuming the role of a school teacher and by carrying his college diploma as his credentials, Hale passed through the British lines, secured the information needed, and started back to Washington's headquarters.

While approaching his own picket lines, Nathan was betrayed by his Tory cousin, Samuel Hale, and was arrested as a spy and taken before the British Commander, General William Howe. Having found sketches and other military information on his person, Howe, without the form of a trial, gave orders for his execution the next day. Hale, while standing on the gallows, made a "spirited and sensible speech," as one witness recorded, of which the memorable words "I only regret that I have but one life to lose for my country" were the dramatic conclusion. This statue pictures Hale at that moment.

George Dudley Seymour, an attorney from New London, Connecticut, and a biographer of Hale, left this statue to the United States government upon his death in 1945. The statue formerly stood at Hale's birthplace in Coventry, Connecticut, which Seymour purchased in 1914, restored, and maintained as a museum for many years. A duplicate of the statue stands on the Yale campus. Many of Hale's wartime diaries and letters have been preserved in the Yale University Library. This memorial was rededicated by Attorney General Thomas C. Clark in April 1948; it is thought the statue was originally cast about 1930.

Detail: the bound feet of Hale

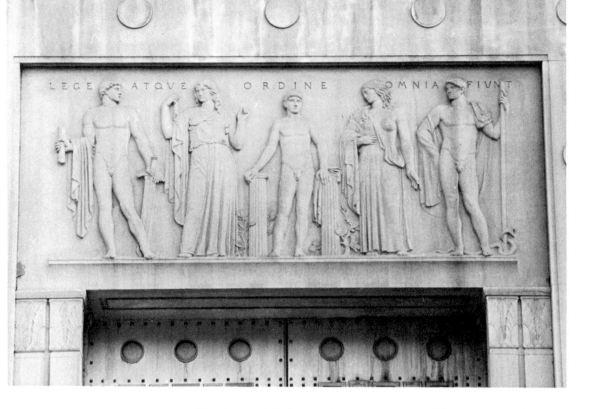

The *Law and Order* relief panel consisting of five Neoclassical figures, 6 feet high and 10 feet wide, is located above the Constitution Avenue door of the Department of Justice. The inscription, "Lege Atque Ordine Omnia Fiunt," was taken from Pliny's Epistle and means: "By law and order all is accomplished."

The central figure of a youth standing between two short Doric columns represents Opportunity. The columns symbolize Uprightness and Faith in the Future. A laurel tree and oak tree appear to grow behind the columns, symbolizing civil and military valor. On each side of Opportunity is a standing female figure, one representing Peace and the other representing Prosperity. Opportunity, Peace, and Prosperity result from the balance of Law and Order, which are represented by the two nude males standing on the far left and right respectively. The Law figure holds a parchment and a sword while the Order figure clasps a staff around which a snake, symbolic of Wisdom, is coiled.

Although the finished building was dedicated on October 25, 1934, by President Franklin D. Roosevelt, Attorney General Homer S. Cummings, and Chief Justice Charles Evans Hughes, the panel was not installed until 1935.

The inscription immediately above the second-floor windows reads: "Justice Alone Sustains Society—Founded On The Principles of Right —Expressed in the National Laws—Administered By Public Officers."

Carved relief panels alternate over the fifteen fifth-floor windows illustrating Viking ships and Scales of Justice. Other sculpture includes the giant aluminum door with a wheat-and-lion motif. The elegant torcheres near the doors have identical sculptured designs of a buffalo, a dolphin, and a swift at the base of each. A pair of handsome medallions of two lions, sculpted in the Art Deco style and enclosed in an octagonal frame, adorn the façade on Tenth Street near the driveway entrances.

D-15
Title LAW AND ORDER, 1934–1935
Location Department of Justice, Constitution Avenue, between 9th and 10th Streets, NW
Sculptor Carl Paul Jennewein
Architect Borie, Medary, and Zantzinger
Medium Limestone

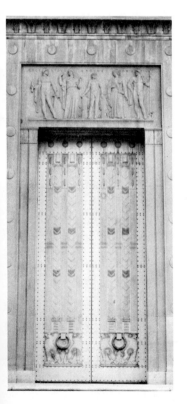

D-16
Title ROBERT FRANCIS KENNEDY,
1969
Location Department of Justice,
courtyard, entrance on 10th Street
between Constitution and
Pennsylvania Avenues, NW
Sculptor Robert Berks
Architect None
Medium Bronze and marble

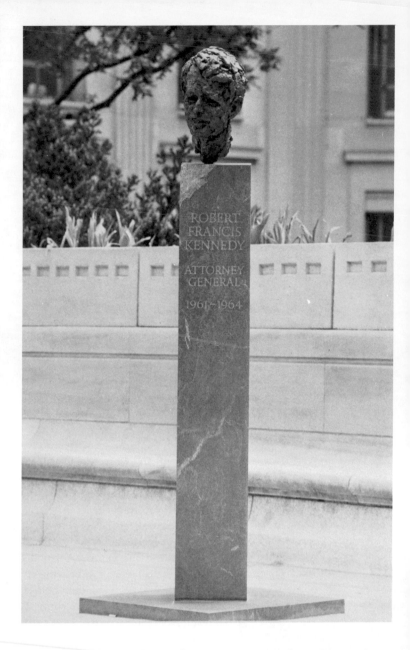

This life-size memorial to Robert Francis Kennedy (1925–1968), attorney general of the United States from 1961 to 1964, is located in the open courtyard of the Department of Justice and was placed there in 1969 at the request of his widow. The missing left corner of the top of the pedestal is symbolic of Kennedy's uncompleted life, due to his tragic assassination on June 6, 1968, in Los Angeles, California.

Kennedy was a native of Boston, Massachusetts, and the son of the former American ambassador to Great Britain and Democratic political leader, Joseph Patrick Kennedy. After receiving his B.A. degree from Harvard University and LL.B. degree from the University of Virginia, Kennedy was assistant counsel and chief counsel for a number of Democratic and government committees. He successfully managed the campaign of his brother, John Fitzgerald Kennedy, for the U.S. Senate seat from Massachusetts in 1952 and for the presidency in 1960. President Kennedy appointed his brother Robert to be United States attorney general in 1961, a position from which he vigorously prosecuted the mismanagement of labor unions and other criminal actions. He resigned in 1964 and then successfully won the U.S. Senate seat from New York in 1965, the position in which he served until his death. Between 1960 and 1964, Kennedy wrote three books, *The Enemy Within*, *Just Friends and Brave Enemies*, and *The Pursuit of Justice*.

D-17
Title THE FOUR WINDS, 1935
Location Department of Justice,
courtyard, entrance on 10th Street
between Constitution and
Pennsylvania Avenues, NW
Sculptor Carl Paul Jennewein
Architect Borie, Medary and
Zantzinger
Medium Limestone

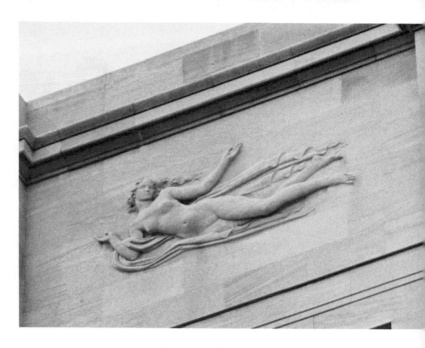

In addition to the bust of Robert Kennedy, a number of minor sculptures are found within the handsome courtyard of the Department of Justice. At each corner of the courtyard façade, at the attic level, is found one of *The Four Winds*. These seminude Neoclassical figures, portrayed in a horizontal position with robes swept back in the breeze, symbolize the transport of Justice to the four corners of the nation.

On the north and south façade of the courtyard are two pediments: *The Department of Justice Eagle Pediment* and *The Privilecium Obligato Pediment*, the first containing the American eagle and the second the Scales of Justice. The inscription PRIVILECIUM OBLIGATO appears within the tympanum of the latter. This inscription, one of the most appropriate of the many passages carved on the façades, means: "Where there is a privilege, there is an obligation." Below this pediment and over the north courtyard door is a great bronze seal of the Department of Justice. The design includes the words "Department of Justice" at the top, with an American eagle in the center clasping an olive branch in its right claws and a bundle of arrows in its left claws. A shield with the stripes of the American flag appears in the background behind the eagle. Beneath the eagle is arranged the motto of the Department of Justice: *Qui Pro Domina Justitia Sequitur*. It is thought this seal originated in 1849 when the attorney general was authorized by Congress to adopt one; the motto asserts that the attorney general prosecutes on behalf of justice. Its literal meaning is: "Who sues for the Lady Justice." The motto was probably added to the seal in the 1850s. The motto was taken from the official proceedings of court under England's Queen Elizabeth I, when the court would open with a statement that the English attorney general "prosecutes on behalf of our Lady, the Queen." In the American seal, the term *Domina Justitia* (our Lady Justice) was substituted for the original term *Domina Regina* (our Lady, the Queen).

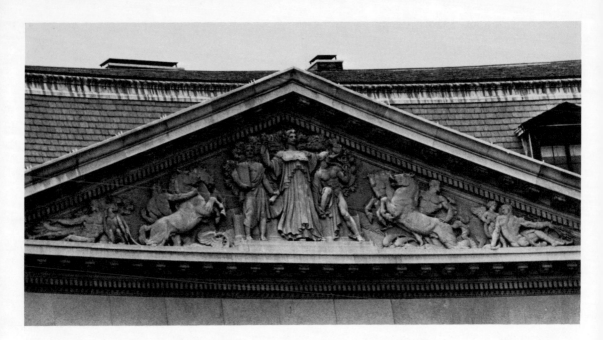

D-18

Title THE SPIRIT OF CIVILIZATION AND PROGRESS, 1934

Location Department of the Post Office Building, 12th Street between Pennsylvania and Constitution Avenues, NW

Sculptor Adolph Alexander Weinman

Architect Delano and Aldrich

Medium Limestone

The east or Twelfth Street façade, adorned with Ionic colonnaded pavilions and central portico, a sidewalk arcade, and a mansard roof, is designed to conform with the distinctively French treatment of the circular plaza planned for Twelfth Street in 1929.

Above this central portico on the east façade is an elaborately sculptured pediment about 40 feet long which is divided into three principal groups of figures. In the center, a woman, representing the Spirit of Progress and Civilization, holds aloft a torch and a winged sphere. At her right stands a youth with scroll and book, the Bearer of the Written and Printed Word. At her left, Mercury, Messenger of the Gods, is fastening his sandal, symbolic of the post as Quickener of Commerce.

To the left of the central group are two impatient steeds, held in check by a powerful male figure, symbolizing Transmission of the Post by Land; to the right a balanced group of seahorses is guided by a triton, and accompanied by dolphins, denoting Transmission of Mail by Sea.

The final group at the right is a virile male figure and winged genie guiding and controlling the wires of Electrical Communication; portrayed on the left is a reclining winged figure with eagles, emblematic of Transmission of Mail by Air. Here again are corner eagles.

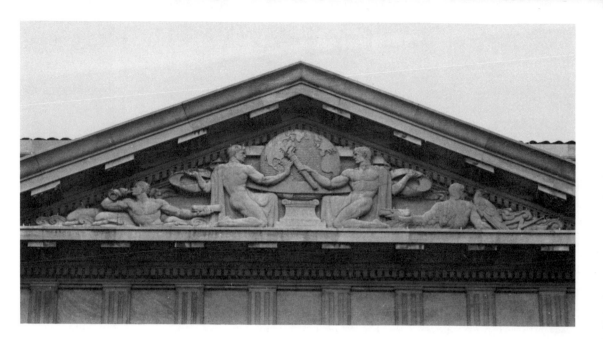

D-19

Title THE ADVANCE OF CIVILIZATION
THROUGH THE BOND OF WORLD
POSTAL UNION, 1934
Location Department of the Post
Office Building, Pennsylvania
Avenue between 12th and 13th
Streets, NW
Sculptor
Adolph Alexander Weinman
Architect Delano and Aldrich
Medium Limestone

This single pediment on the Pennsylvania Avenue façade measures about 40 feet in length; it shows as its central motif a hemisphere encircled by a broad band and supported by two youths, one handing the torch of Enlightenment to the other. At each end of the pediment is a half figure, one a triton with supporting dolphins, the other an aviator with an eagle. The whole composition represents the Bond of World Postal Union. This pediment is similar in design to the pair on the west facade.

The general plan of the Post Office Department Building was in accordance with the scheme of the Federal Triangle group of buildings. The building comprises two semicircular units set back-to-back to look like a script letter X. These semicircular units are flanked on the north by a rectangular wing, with the Pennsylvania Avenue pediment, and on the south by the Interstate Commerce Commission.

A sculptured eagle perches over the north door. Another interesting detail adjacent to the north pediment is the 1934 cornerstone, located at the corner of Pennsylvania Avenue and Twelfth Street.

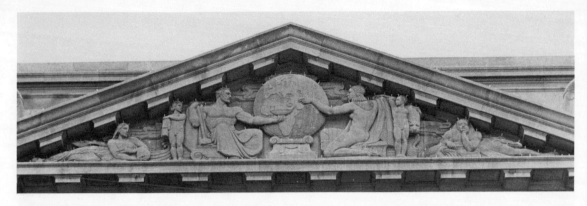

D-20

Title Intercommunication
Between the Continents of
Europe and Africa, 1934
Location Department of the Post
Office Building, 13th Street or west
façade, between Pennsylvania and
Constitution Avenues, NW
Sculptor
Adolph Alexander Weinman
Architect Delano and Aldrich
Medium Limestone

The two pediments on this west façade, which face the semicircular plaza, are seldom seen by the public. They represent the transfer of modern technological inventions and ideas from the continents of Europe and America to the continents of Africa and Asia. The central motif in each 40-foot pediment is a hemisphere, flanked by heroic seated figures and genii.

The left pediment on the Thirteenth Street façade shows in the center a large globe, with figures representing Europe and Africa. To the left, Europe, a heroic figure, seated on an Ionic capital, extends his left hand holding a classic lamp, symbolic of Knowledge, toward Africa. Next to Europe, a genie or brooding spiritual presence, symbolizing the Wisdom of Europe, is represented by a youth who carries a book. In the far left corner, a reclining Grecian female holds in her hand a small sphere representing Power.

To the right of the central globe, a seated heroic-size Egyptian female reaches across the globe to receive the Lamp of Knowledge offered to her by Europe. A standing genie carries a bundle. In the right corner, a drowsy Egyptian male, symbolic of the sleeping Dark Continent, rests his right arm on a jar from which water flows, while a crocodile's head rests on his thigh.

D-21

Title Primitive Means of the
Transmission of Communication,
1934
Location Department of the Post
Office Building, 13th Street or west
facade, between Pennsylvania and
Constitution Avenues, NW
Sculptor
Adolph Alexander Weinman
Architect Delano and Aldrich
Medium Limestone

These metopes or carved relief panels, set between the triglyphs or sets of vertical bars in the Doric frieze, are located under the two pavilions on the Thirteenth Street façade. With the rest of the sculpture, they reflect as a central theme the development of the postal service in relation to the progress of civilization.

The frieze consists of five differently designed metopes: *The Helio Signal of Antiquity*, *Blanket Signal*, *Smoke Signal of the American Indian*, *Drum Signal of the African Savage*, and *Communication by Carrier Pigeons*, shown below in this order.

The central frieze, located between the two pediments, contains a series of alternating metopes, *The Security of the Mail*, showing a Roman soldier with a bag of mail and a sword, and *Genii with Fasces*, symbolic of the government's postal role.

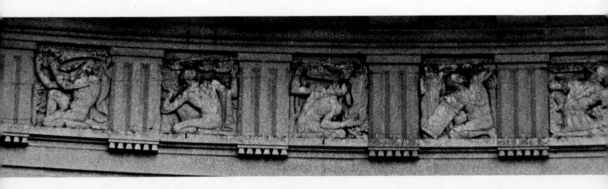

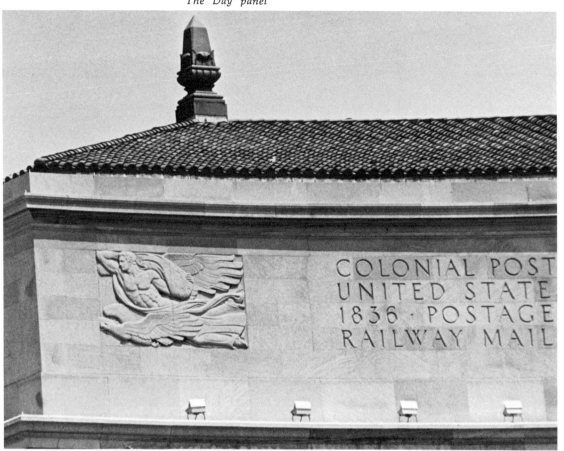

D-22

Title The Delivery of the Mail by Day and The Delivery of the Mail by Night, 1934
Location Department of the Post Office Building, 13th Street or west façade, between Pennsylvania and Constitution Avenues, NW
Sculptor Adolph Alexander Weinman
Architect Delano and Aldrich
Medium Limestone

Just within the great colonnaded semicircle, on the attic parapet between the two pediments on the west façade of the Post Office Department Building, are low-relief panels of *The Delivery of the Mail by Day* on the north and *The Delivery of the Mail by Night* on the south. The sculptor here has attempted to convey the idea of the unceasing work of the postal service in its aid to humanity. The "Night" panel pictures a robed female with wings carrying a mail pouch in her arms, with stars, the moon, and a flying owl in the left corner of the panel. The "Day" panel contains a seminude male with wings, also carrying a mail pouch, with the rays of the sun and an eagle in flight in the left corner above.

Between the two relief panels is the poetical inscription carved into the parapet wall dramatically describing the postal service as follows: "The Post Office Department, in its ceaseless labors, pervades every channel of commerce and every theater of human enterprise, and while visiting, as it does kindly, every fireside, mingles with the throbbings of almost every heart in the land. In the amplitude of its beneficence, it ministers to all climes, and creeds and pursuits, with the same eager readiness and with equal fullness of fidelity. It is the delicate ear trump through which alike nations and families of isolated individuals, whisper their joys and their sorrows, their convictions and their sympathies, to all who listen for their coming." The author of this unique inscription, which happens to be the longest on any building in the city, is unknown.

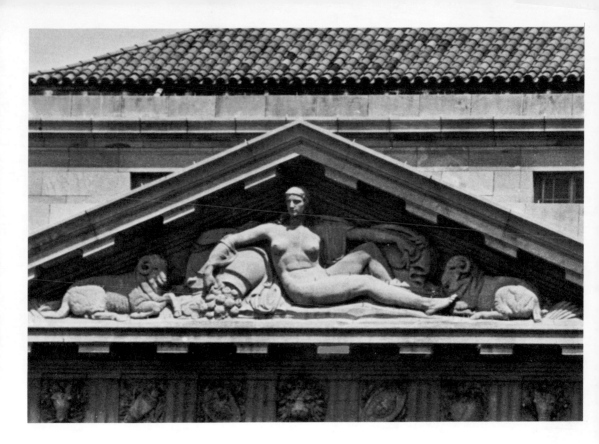

D-23

Title ABUNDANCE AND INDUSTRY, 1935

Location Department of Labor, Constitution Avenue between 12th and 14th Streets, NW, pavilion A, first pediment from left

Sculptor Sherry Fry

Architect Arthur Brown

Medium Limestone

Although three separate buildings are contained on the Constitution Avenue façade of the Federal Triangle between Twelfth Street and Fourteenth Street, they were designed identically as a unit by the same architect. The first pediment, on the Department of Labor Building, about 50 feet long, entitled *Abundance and Industry*, consists of a reclining nude female in the center with a ram at each end of the tympanum. The woman represents Abundance and Industry, while the rams represent Productivity and Security. A vase pours forth the Fruits of Industry.

Many American labor leaders, beginning with William Sylvis in the 1860s, called for the establishment of a Department of Labor. Labor unions advocated such a bureau to help the working class by "promoting their material, social, intellectual, and moral prosperity." In the 1890s, pressure on Congress became intense from such labor leaders as Terrence V. Powderly and Samuel Gompers (see H-4), the president of the new American Federation of Labor, for the creation of a Department of Labor for labor's "direct representative in the councils of the President." Business leaders during that decade, on the other hand, demanded the establishment of a Department of Commerce to promote the interests of trade and industry. In 1903, President Theodore Roosevelt signed into law a bill establishing a Department of Commerce and Labor, with Oscar S. Straus as the first secretary (see D-30). The American Federation of Labor, which termed the new department a "Dr. Jekyll and Mr. Hyde" and which clashed with Secretary Straus, continued to agitate for a separate Department of Labor which would better represent the workers' demands for higher pay and improved working conditions. Eventually, President William Howard Taft grudgingly signed a bill establishing a separate Department of Labor just two hours before he left office in 1913. The Department of Labor, originally established "to foster, promote, and develop the welfare of wage earners of the United States," has in recent years been greatly expanded. Its activities and goals have been outlined in the publications of two recent secretaries, John Lombardi, *Labor's Voice in the Cabinet* (1942), and Willard Wirtz, *Labor and the Public Interest* (1964).

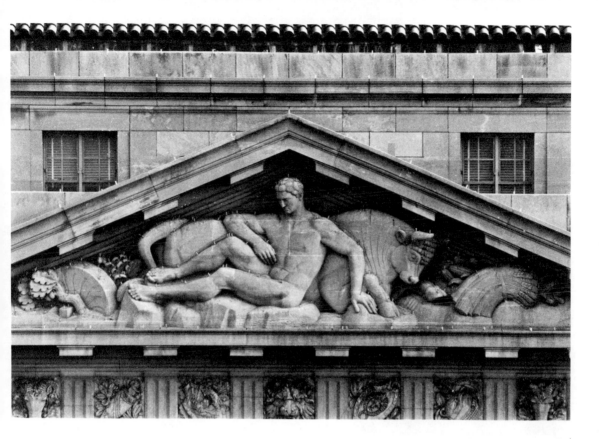

D-24

Title LABOR AND INDUSTRY, 1935

Location Department of Labor,
Constitution Avenue between
12th and 14th Streets, NW, pavilion
B, second pediment from left

Sculptor Albert Stewart

Architect Arthur Brown

Medium Limestone

The second pediment from the left, on pavilion B of the Department of Labor, *Labor and Industry*, by Albert Stewart, consists of a reclining nude male resting against the side of a large bull. At the right corner is a sheaf of wheat, while in the left corner is a millstone.

Additional sculpture for this building consists of the elaborate frieze under the pediment which extends the entire length of the three-building complex. The metopes, or sculptured relief panels, consist of aegicrames, that is, Neoclassical heads and skulls of rams, cows, and lions. More metopes consist of crossed fasces, shells, vases, shields, helmets, cornucopias, anchors, entwined snakes, eagles, and dolphins. Completing the decorative carving of the façade is the impressive series of keystone figures over the first-floor windows which consist of alternating allegorical Neoclassical heads.

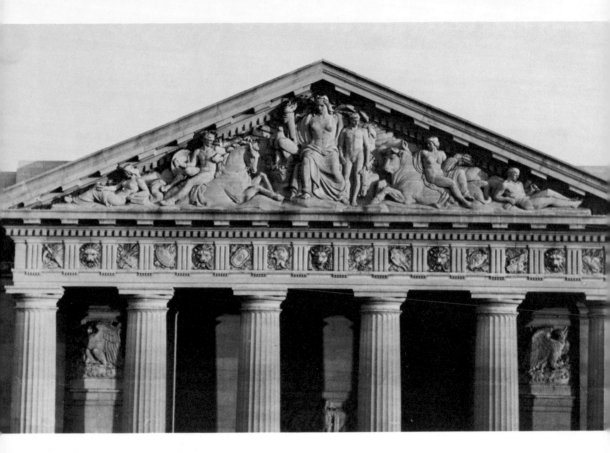

D-25
Title COLUMBIA, 1935
Location Departmental
Auditorium, Constitution Avenue
between 12th and 14th Streets, NW,
central pediment
Sculptor Edgar Walter
Architect Arthur Brown
Medium Limestone

The high Doric portico here forms the central motif for the three connected buildings on this block of the Federal Triangle. The central figure is the seated female *Columbia*. An eagle, also symbolic of the United States, is located at her right side; a nude youth stands at her left; the rays of the sun reach upward from behind her.

The figures to the left of Columbia represent National Defense. A nude soldier with a shield rides a horse, while a reclining nude female is shown in the corner surrounded by books. National Resources, to the right of Columbia, is symbolized by a nude female riding atop a bull and carrying a sheaf of wheat while the corner figure is a reclining male with a large hammer.

The interior of the building, designed in the French Empire style of circa 1810, must be considered one of the most magnificent auditoriums in the country. The interior includes a massive Doric colonnade along each aisle and elaborate gilt Neoclassical bas-reliefs on the walls. Huge polished crystal chandeliers add to the splendor. In addition to the auditorium, which seats 1,300 persons, there are to the rear three large conference rooms paneled in painted wood in the French manner.

Title WASHINGTON PLANNING THE
BATTLE OF TRENTON and
WASHINGTON'S CAREER IN PUBLIC
SERVICE AND AGRICULTURE, 1935
Location Departmental
Auditorium, Constitution Avenue
between 12th and 14th Streets, NW,
pavilion C, under portico,
second-floor level
Sculptor
Edmond Romulus Amateis
Architect Arthur Brown
Medium Limestone

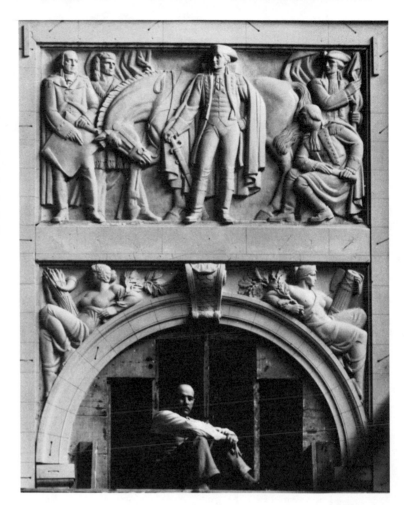

*Sculptor Edmond Amateis with his
completed clay model*

This relief panel, approximately 6 feet high and 9 feet wide, pictures
Lieutenant General George Washington, wearing a great coat, standing
in the center foreground before his horse during the Revolutionary War.
Major General Nathanael Greene (1742–1786) stands on the left, while
Major General John Sullivan (1740–1795), of New Hampshire, is seated
in the right foreground as Washington charts his course for the Battle of
Trenton. The face of General Greene is actually a portrait of the archi-
tect of the building, Arthur Brown of San Francisco, while General
Sullivan is actually a portrait of Edgar Walter, a sculptor friend of Mr.
Edmond Amateis, the sculptor of this work. The two standing figures in
the background, a scout on the left and a soldier on the right, hold
American flags. This handsome panel is one of the few realistic sculp-
tures which actually portrays an event from American history on the
Federal Triangle buildings. Most of the others are Neoclassical alle-
gorical sculptures.

With the American Army continuing to melt away in the last months
of 1776, the cause of the colonies reached its lowest ebb. Just at the
turn of the year, Washington, in a desperate attempt to salvage the
war, struck and defeated the British and their Hessian mercenaries in
surprise attacks at Trenton and Princeton. Washington's forces either
killed or captured the British detachment of 1,200 English officers and
Hessian soldiers on December 26, 1776, after he crossed the Delaware
River in a surprise move, which resulted in a complete American victory
at Trenton. These victories reaffirmed the faith of the colonies in the
Army, and they also restored the Army's faith in itself.

The sculptured spandrels, or surfaces above the corners of the door
frame, measure about 4 feet in height and represent Washington's two
chief interests and accomplishments. The left spandrel, Agriculture,
is represented by a reclining woman with a bundle of wheat. To the

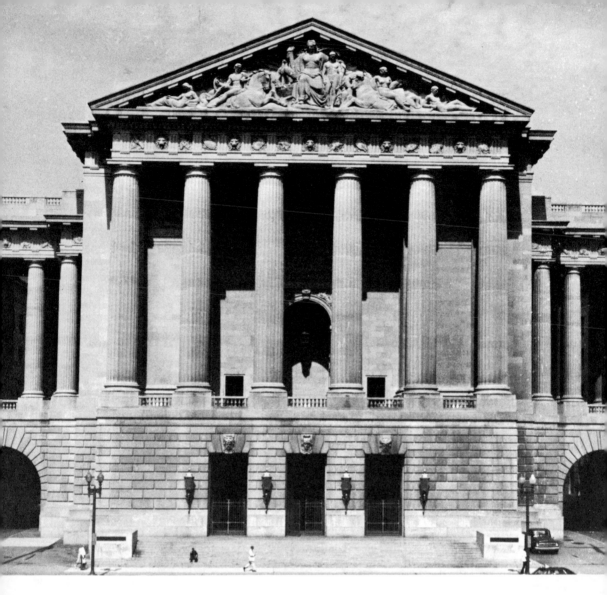

Departmental Auditorium, with the Amateis reliefs beneath the portico

right, a second reclining female holds a fasces symbolizing Public Service.

Many important historical meetings have been held by the government in the Departmental Auditorium since the building opened in 1935. Over 13,000 people crowded into the auditorium to witness the first Selective Service System lottery drawn by President Franklin D. Roosevelt on October 29, 1940. Other drawings were held here in 1941–1942. On April 4, 1949, the Foreign Ministers of eleven nations met here with President Harry Truman and Secretary of State Dean Acheson to sign the North Atlantic Treaty. Today the Departmental Auditorium is used for various conferences by all government agencies and until the opening of the F.B.I. National Academy at Quantico, Virginia, was used for the graduation exercises of the National Academy. Every December an impressive three-hour concert of Christmas music is presented by various military bands.

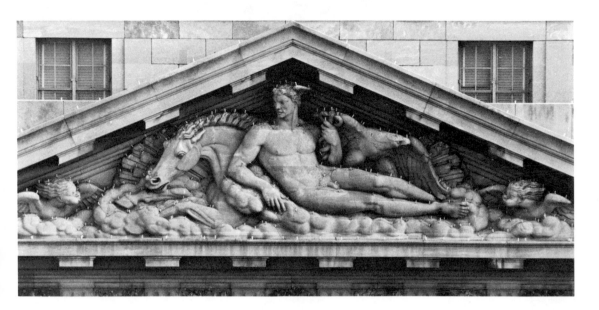

D-27

Title COMMERCE AND COMMUNICATIONS, 1935

Location Interstate Commerce Commission, Constitution Avenue between 12th and 14th Streets, NW, pavilion D, fourth pediment from left

Sculptor Wheeler Williams

Architect Arthur Brown

Medium Limestone

A nude male reclines against a horse traveling through swirling clouds. This figure, Communications, holds in his left hand the caduceus, symbolic of Mercury or a speedy messenger. An eagle is situated to the right. Winged genii blow the East and West Trade Winds from the corners of the tympanum. The rays of the sun rise in the central background. The pediment measures about 50 feet long.

The Interstate Commerce Commission was established in 1887 to regulate railroads and other common carriers engaged in interstate or foreign commerce. The eleven board members, appointed for six-year terms, have the power to raise or lower rates which may be charged by interstate carriers of goods.

D-28

Title INTERSTATE TRANSPORTATION, 1935

Location Interstate Commerce Commission, Constitution Avenue between 12th and 14th Streets, NW, pavilion E, fifth pediment from left

Sculptor Edward McCartan

Architect Arthur Brown

Medium Limestone

The second pediment of the Interstate Commerce Commission, on Constitution Avenue next to Twelfth Street, is Commerce, executed by Edward McCartan. The central figure in this 50-foot pediment is a reclining nude woman against a seahorse with a serpent's tail; she represents Energy as applied to interstate commerce. A pair of dolphins leap through the ocean in each corner.

Through the main entrance below the visitor will find a rich collection of architectural details in the Art Deco style of the 1930s. An elaborately designed massive metal gate, with crossed fasces, separates the central corridor from the small rotunda. Beneath the handsome Neoclassical coffered ceiling of the rotunda are four bronze busts of former commissioners of the Interstate Commerce Commission.

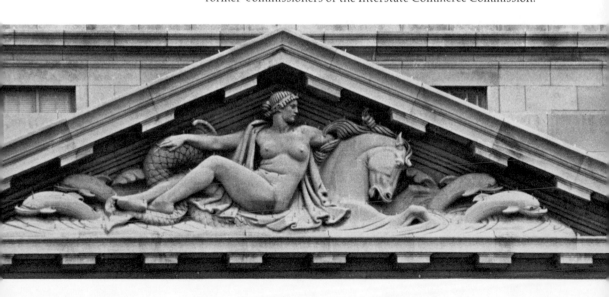

Title Arts and Enterprises in the
District of Columbia, 1908
Location District of Columbia
Building, E Street between 13th and
14th Streets, NW, attic level
Sculptor Adolfo de Nesti
Architect Cope and Stewardson
Medium Marble

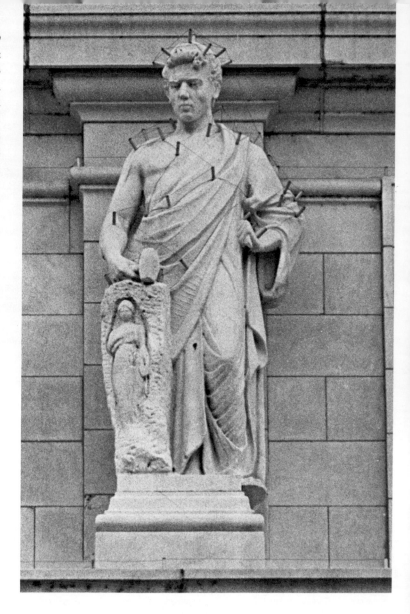

Sculpture, *one of the 28 allegorical
statues*

The District Building, as it is usually known, was designed as an elabo-
rate English Renaissance Revival structure in the Corinthian order; it
contains a series of twenty-eight decorative statues and one overdoor
group. Each of the statues is 8 feet high and located at the cornice level.
The north or main façade which faces E Street and Pennsylvania
Avenue, NW, contains these marble statues, left to right: *Sculpture*
(male), *Painting* (female), *Architecture* (male), *Music* (female), *Com-
merce* (female), *Engineering* (male), *Agriculture* (female), and *States-
manship* (male). Each figure holds one or more objects relating to its
function. *Sculpture*, for example, grasps a chisel and mallet, while a
partially completed small statue appears in the left foreground.

Above the north or main entrance, also on E Street, is a sculpture
group known as *Law and Justice*. On the left, a reclining woman carries
the Scales of Justice while a female to the right holds the Scrolls of
Law. An elaborate cartouche between the two figures contains the Seal
of the District of Columbia and is surmounted by a marble eagle. The
seal includes in the left center foreground the pedestaled figure of
George Washington. Justice stands in front of the pedestal, holding a
tablet, Law, in her left hand and a Wreath of Honor in her right. The
Capitol appears in the right background while to the left is the sunlit
city skyline. An American eagle is situated in the left foreground next
to the sheaf of wheat and bale of cotton which represent Agriculture
and Commerce. The top inscription reads: "District of Columbia."
The bottom motto, "Justice Omnibut, 1871," meaning justice for all,

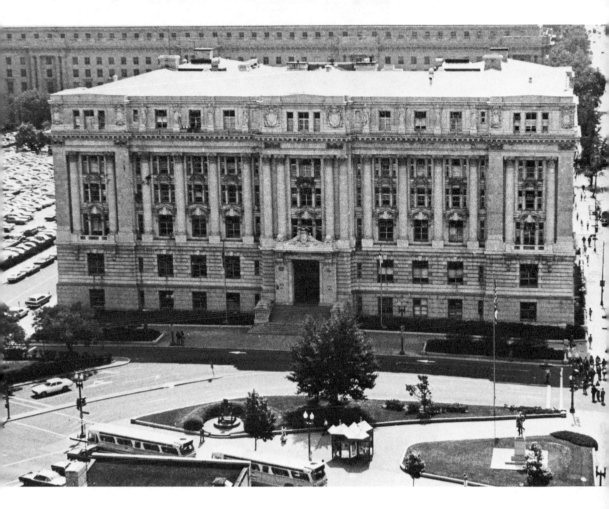

Main façade of the District of
Columbia Building

completes the seal as it was officially adopted in 1871.

The District of Columbia has had five types of government. Between 1790 and 1802, three commissioners were appointed by the president. Between 1802 and 1871, a mayor was selected by the president, and a twelve-member council was elected by the residents. The period 1871–1874 saw a territorial form of government, with a governor and an eleven-member council, or upper house, chosen by the president. A twenty-two-member District of Columbia House of Delegates was established with one nonvoting representative sitting in the U.S. House of Representatives. These delegates were elected by the residents of the city. This territorial form was abolished by Congress in 1874 when the District went bankrupt; a temporary board of three commissioners was then established. In 1878, Congress specified that the three commissioners would be appointed by the president and would consist of two civilians and one officer from the U.S. Army Corps of Engineers. In 1967, a government was established with a mayor-commissioner, a nine-member city council chosen by the president, and with an elected, though nonvoting, delegate to the U.S. House of Representatives. In recent years a growing number of residents of the District of Columbia have sought congressional legislation which would provide for directly elected local officials, and 1974 legislation moved closer toward the concept of actual Home Rule.

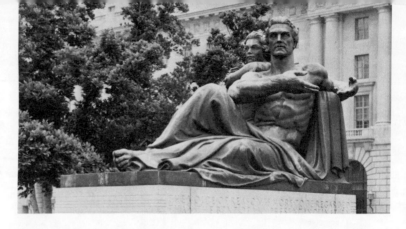

D-30
Title OSCAR S. STRAUS MEMORIAL
FOUNTAIN, 1947
Location 14th Street, between
Constitution and Pennsylvania
Avenues, NW
Sculptor
Adolph Alexander Weinman
Architects John Russell Pope;
Eggers and Higgins
Medium Bronze and marble

Although authorized by Congress in 1927, this monument was not constructed until 1947. The delay was due first to indecision over the site, and then to the interruption of World War II. Oscar S. Straus (1850–1926) is most noted for his brilliant efforts as one of America's first career diplomats. He came to the United States with his parents from southern Germany in the early 1850s. After a childhood spent in Georgia, Straus moved with his family to New York, where he practiced law and business. His first distinguished post came when he was appointed American ambassador to Turkey in the late 1880s by President Grover Cleveland. He was reappointed to the same position by President William McKinley in 1898, and by President William Howard Taft in 1909. Between 1902 and 1926, he served under three presidents at the International Court of Arbitration at The Hague in The Netherlands.

As Secretary of Commerce and Labor under President Theodore Roosevelt, Straus successfully settled many problems concerning Japanese immigration and naturalization. He worked tirelessly for America's entry into the League of Nations. No citizen did more to help Jewish refugees after World War I than Straus, himself a Jew. When he died in New York City in 1926, he was mourned as an outstanding diplomat and benefactor of humanity.

The monument consists of three parts, a fountain and two groups of statues representing Justice and Reason. The Neoclassical design is in exedral form, that is, arranged in the open air with curved stone benches convenient for conversation, as in ancient Greece and Rome. The three-tiered central fountain is inscribed: "Statesman, Author, Diplomat." The left group of bronze figures represents Religious Freedom. A reclining, draped female holds a tablet containing the Ten Commandments. A child nearby holds the open Book of Religion. The inscription reads: "Our Liberty of Worship Is Not A Concession Nor a Privilege But An Inherent Right." Reason, to the right, is a vigorous seminude male figure, about 5 feet tall, accompanied by a child, the Genius of Capital and Labor. Reason holds a purse, key, and hammer, symbolic of Capital and Labor. Below this group is the inscription: "The Voice of Reason Is More To Be Regarded Than The Light Of Any Present Inclination."

Above, Reason; right, Justice facing Reason

Title BUREAUS OF THE DEPARTMENT
OF COMMERCE, 1934
Location Department of
Commerce, 14th Street façade,
between Constitution Avenue and
E Street, NW, between south
driveway portals
Sculptor James Earle Fraser
Architect York and Sawyer
Medium Limestone

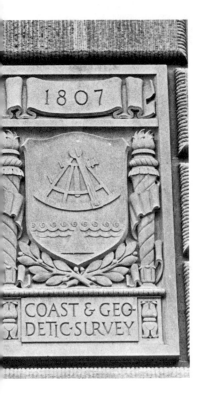

This seven-story building housing the Department of Commerce covers 8 acres of land and accommodates some 4,500 civil servants. It is the largest of the Federal Triangle buildings, and for several years after it was completed was the largest office building in the world. The enormous length of the structure on Fourteenth Street is relieved from monotony by a splendid colonnade of twenty-four columns and eight relief panels placed between the portals of the north and south driveway entrances.

The eight relief panels, each almost 5 feet high, represent the various agencies of the Department of Commerce when the building was erected, 1929–1934. Between the south driveway portals are the following panels, left to right: Census Bureau (1790, a scroll); Coast and Geodetic Survey (1807, ship's compass and waves); Bureau of Mines (1910, crossed hammer and pick and lantern); and the Bureau of Foreign and Domestic Commerce (1912, caduceus). The date of the establishment of each bureau appears at the top and the names of the bureaus at the bottom of each panel. A flaming torch is carved on each side of the panels. The design of the panels is not taken from the seal of the bureau, but is only symbolic of its function.

On the north driveway portals are located the panels representing the Bureau of Navigation (1789, shield and sailing ship); Bureau of Aeronautics (1926, airplane); Bureau of Steamboat Inspection (1838, anchor and life preserver); and the Patent Office (1802, eagle and shield).

Since 1934, four of these agencies have been transferred to the Department of Interior and to the Department of Transportation.

The Coast and Geodetic Survey has a long and varied history. It was founded in 1807 by President Thomas Jefferson to survey the coast of the new Nation and was first known, appropriately, as the "Survey of the Coast." Subsequently, the name was changed to "United States Coast Survey." In 1878, the agency was given the added responsibility of providing geodetic control for the interior of the country, and the name was changed again to "United States Coast and Geodetic Survey." As such, the country's oldest scientific agency continued until October 1970, when it became a part of a new organization, the National Oceanic and Atmospheric Administration, and was renamed "National Ocean Survey."

The personnel of the National Ocean Survey includes scientists, engineers, and technicians in cartography, geodesy, gravimetry, oceanography, and photogrammetry. Its work involves the preparation and distribution of some 50 million nautical and aeronautical charts each year, the carrying out of precise geodetic oceanographic and marine geophysical surveys, monitoring the earth's geophysical fields, and predicting the tides and currents. It operates a fleet of some 35 ships involved in oceanographic research, hydrographic surveys, and wire drag and tidal current tests.

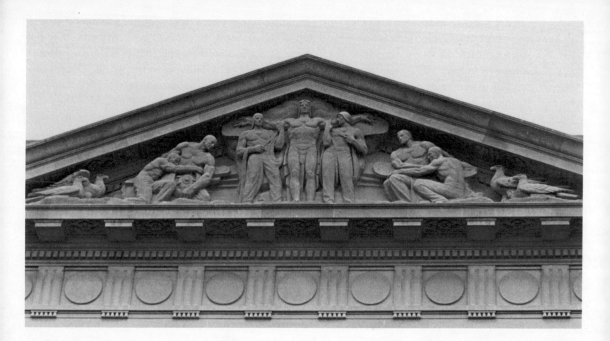

D-32
Title AERONAUTICS, 1934
Location Department of
Commerce, 15th Street façade,
between E Street and Constitution
Avenue, NW, third pediment from
the left
Sculptor James Earle Fraser
Architect York and Sawyer
Medium Limestone

Designed by James Earle Fraser, the four pediments on the Fifteenth Street façade relate to the activities of the Department of Commerce. The titles of the pediments from left to right are: *Foreign and Domestic Commerce, Fisheries, Aeronautics,* and *Mining.* The *Aeronautics* pediment, about 50 feet long, consists of a central figure of a seminude aviator with outstretched arms (see adjacent photograph). Two other aviators bind his arms to a pair of airplane wings. All three men wear typical leather aviator caps of the early 1930s. To the left, two mechanics carry an airplane engine toward the chief aviator, while on the right two more assistants drag another pair of wings toward the center. Perhaps the chief aviator will take off rigged as a bi-plane! A pair of vigilant eagles watch the entire operation with curiosity and excitement.

Beneath each of the pediments are the following inscriptions carved over the four doors at street level, left to right: "The Patent System Added The Fuel of Interest To The Fire Of Genius: Lincoln," and "Commerce Defies Every Wind—Outrides Every Tempest–And Invades Every Zone: Bancroft." The last two inscriptions are: "Commerce Among Nations Should Be Fair and Equitable: Franklin," and "Let Us Raise Standards To Which The Wise And Honest Can Repair: Washington."

The building is embellished on the E Street façade with a series of Neoclassic Roman and Egyptian heads over the third-floor windows within the colonnade, and with a pair of monumental limestone urns at the street level.

GEORGE WASHINGTON
MEMORIAL PARKWAY

E

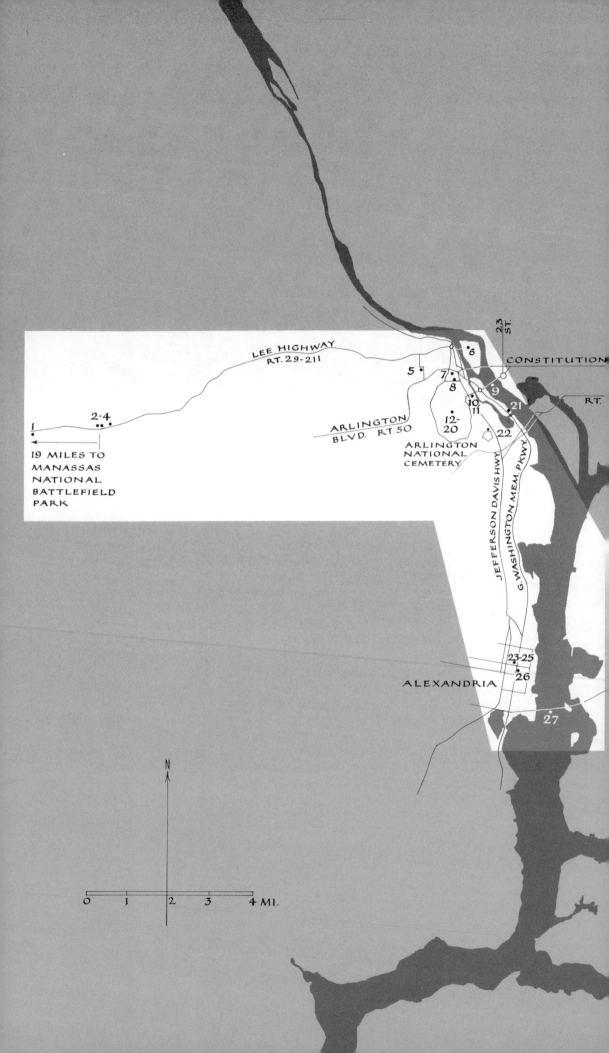

LEE HIGHWAY
RT. 29-211

23 ST.

CONSTITUTION

• 6

5 •

7 •
8 •

• 9

10 •
11 •

21

ARLINGTON
BLVD. RT.50

12-
20

22

RT.

ARLINGTON
NATIONAL
CEMETERY

JEFFERSON DAVIS HWY.

G. WASHINGTON MEM. PKWY.

1
•

2-4
• •

19 MILES TO
MANASSAS
NATIONAL
BATTLEFIELD
PARK

23-25
26

ALEXANDRIA

27

N

0 1 2 3 4 MI.

On May 23, 1928, Congress authorized the construction of the Mount Vernon Memorial Highway along the Virginia side of the Potomac River between Mount Vernon, in Fairfax County, Virginia, and the west end of the Arlington Memorial Bridge on Columbus Island in Arlington. Commemorating the 200th anniversary of the birth of George Washington, this highway was planned to preserve as parkland the shores of the Potomac, along which it passed, and to provide a dignified and scenic access from the Nation's Capital to the home of the first president. Construction was begun September 12, 1929, under the direction of the U.S. Department of Agriculture, Bureau of Public Roads. The highway was opened to traffic January 16, 1932, and was formally dedicated November 15, 1932, the year of Washington's bicentennial. It follows the low-lying, undulating bank of the river, offering views of incomparable beauty, through natural woodland and informally planted parkland, out across the water. There are facilities for picnicking, hiking, boating, birdwatching, and other activities. The highway passes through historic Alexandria along Washington Street, the main thoroughfare of the city, thus embracing many additional sites of interest. Except in Alexandria, commercialism is totally excluded.

On May 29, 1930, while this highway was under construction, Congress authorized the George Washington Memorial Parkway. This was to include the Mount Vernon Memorial Highway and to extend it to Great Falls on the Virginia bank of the river, and from Great Falls to Fort Washington, opposite Mount Vernon, on the Maryland side. The river would be crossed by a bridge above Great Falls and by a ferry between Fort Washington and Mount Vernon. By this plan, the Potomac shoreline, including the Great Falls of the Potomac, the Chesapeake and Ohio Canal, numerous forts, and other historic sites would be preserved from commercial encroachment. Forty years later, the project is still in progress. As of 1973, the Maryland section of the parkway extends from Washington north to Cabin John in Montgomery County; and the Virginia section extends from about this same point (the intersection of the parkway and the Capital Beltway, Route 495) south to Mount Vernon.

While several sculptures in this chapter are a few miles drive from the George Washington Memorial Parkway, they are included nevertheless because of their artistic importance and their proximity to the parkway.

E-1

Title LIEUTENANT GENERAL THOMAS J. JACKSON, 1940

Location Manassas National Battlefield Park, adjacent to Route 29, Manassas, Virginia, and approximately 28 miles west of George Washington Memorial Parkway

Sculptor Joseph P. Pollia

Architect Unknown

Medium Bronze

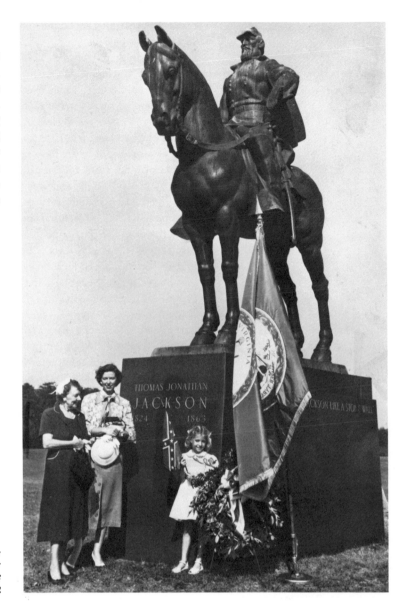

General Jackson's granddaughter, great-granddaughter, and great-great-granddaughter visit the statue in 1952

This equestrian statue of Confederate General "Stonewall" Jackson and his horse, "Old Sorrell," stands on the brow of Henry Hill in the Manassas National Battlefield Park. The site, commanding sweeping views of the surrounding countryside, is the position held by Jackson and his men as they withstood the murderous Union onslaught at the First Battle of Manassas on July 21, 1861. It was here that General Barnard Bee turned to his Confederate troops and shouted, "There stands Jackson like a stone wall. Rally behind the Virginians!" This provided Jackson with his famous nickname. The statue, one and a half times life size, conveys an impression of restrained power, of profound energy waiting to be unleashed. Jackson is strongly modeled with angular, boldly simplified planes. His muscular development is prominently displayed under his uniform; his left hand rests on his hip, holding the reins. His facial expression is immobile as he watches intently over the battlefield; a short cape blows dramatically out behind him. His horse, somewhat stylized in the Art Deco manner, presses forward, nostrils distended.

The Henry Hill property was formerly maintained by the Sons of the Confederate Veterans as the Manassas Battlefield Confederate Park, Inc. It was sold to the federal government on the condition that the State of Virginia be allowed to erect this statue of Jackson. The statue was unveiled August 31, 1940, by a great-granddaughter of General Jackson and the daughter of the man responsible for the project. Four

Confederate veterans, including one who had fought under Jackson, were present at the dedication.

Thomas Jonathan Jackson (1824–1863), was born at Clarksburg, in that part of Virginia which is now West Virginia. He graduated from West Point ranking high in his class in 1846, and immediately went to Mexico, where he served under General Winfield Scott in the Mexican War for the next two years. He had no part in public affairs before the Civil War; he had resigned from active duty in the United States Army to serve as a professor of artillery tactics at the Virginia Military Institute, at Lexington, from 1852 until 1861. Jackson entered the Confederate army in April 1861, and was promoted to brigadier general two months later. After brilliant service at the First Battle of Manassas, he was promoted to major general and assumed command of the Confederate forces in the Shenandoah Valley. Jackson's masterful strategy greatly assisted General Robert E. Lee in the defense of Richmond from federal attack. Because of Jackson's brilliant maneuvers, Lee was able to invade Maryland in 1862. Stern and exacting in discipline, Jackson was a devout Presbyterian. By the time of his death he had achieved the rank of lieutenant general. He was severely wounded by the fire of his own men as he was returning to camp at twilight; and he died of pneumonia near Fredericksburg, Virginia, on May 10, 1863. Lee never found a general who could duplicate the brilliant maneuvers of Stonewall Jackson.

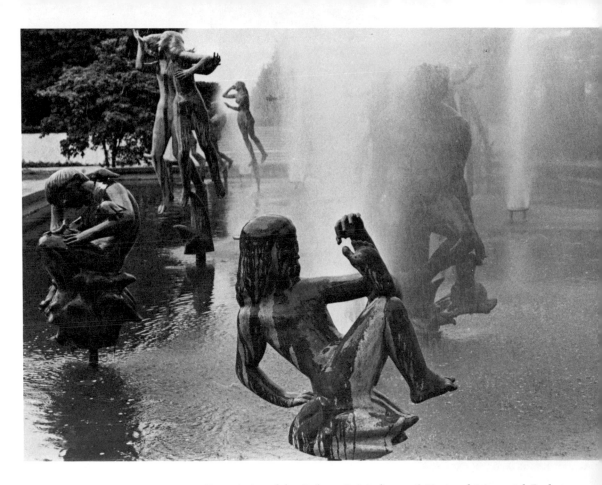

E-2

Title FOUNTAIN OF FAITH, 1952
Location National Memorial Park,
Route 29 south of Falls Church,
Virginia, approximately 8 miles
from George Washington
Memorial Parkway
Sculptor Carl Milles
Architect Walter F. Marlowe
Medium Bronze

Commissioned by Robert F. Marlowe of National Memorial Park to build a fountain expressing belief in the continuity of life, Swedish sculptor Carl Milles created the joyous *Fountain of Faith.* Here 37 bronze figures hover ethereally in a garden of water and fantastic plants. The spray of the fountains helps to obscure the metal rods which support the figures as they float, skim, run, and play above the waters of the pool. The theme is the joyful reunion of souls after death. Each life-size figure is a portrait of someone Milles had known: a boy who lost his life trying to save a young bird that had dropped from its nest, a family of three killed in an automobile accident, and an old man and his dogs. Those who had gone before are shown caring for the new dead, showing them the pleasures of the after-world. A faunlike angel hovers merrily over the group. The figures are light and supple, their somewhat stylized, curvilinear forms evocative of the spirit rather than the flesh. Surfaces are tactile, delicately modeled. Mr. Marlowe bought only four of the figures. The rest were given to him by Milles, whose enthusiasm for the project was unbounded. He considered the fountain, begun in 1940 and completed in 1952, three years before his death, to be his greatest work. Duplicate castings of some of the figures are in the Carl Milles sculpture garden in Stockholm. At the dedication, the National Symphony Orchestra of Washington, D.C., played in a specially constructed bandshell before a crowd of 25,000. The low rectangular pool of polished granite is set in a formal sunken garden located in a grove of pine trees. The walls of this garden, cruciform in plan, are faced with Georgia marble panels 5½ feet high which conceal burial vaults.

Title FOUR CHAPLAINS MEMORIAL
FOUNTAIN, 1955
Location National Memorial Park,
Route 29, south of Falls Church,
Virginia, approximately 8 miles
west of the George Washington
Memorial Parkway
Sculptor Constantino Nivola
Architect Walter F. Marlowe
Medium Concrete, sand castings,
fieldstone

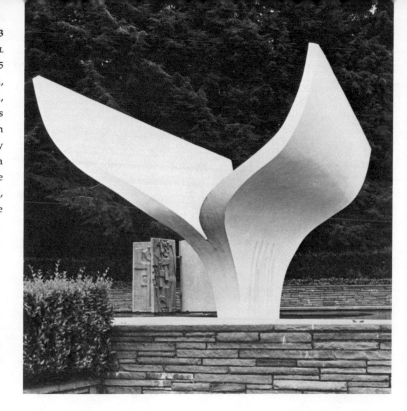

Panel: The Harmony of Man and
the Universe

On the evening of February 3, 1943, the troop transport *Dorchester* was torpedoed in the North Atlantic. As the ship sank, four chaplains —George Lansing Fox and Clark Vandersall Poling, Protestant ministers; Alexander David Goode, a Jewish rabbi; and John Patrick Washington, a Catholic priest—worked together to comfort the dying and to give courage to those setting out in the Arctic night in lifeboats. Handing their life jackets to others, they chose to remain on board the *Dorchester* with those who could not leave. In a final inspiring gesture of solidarity and brotherhood, they stood on the deck, arms linked together and voices lifted in prayer, as the icy waters swallowed the ship. This fountain, dedicated to the chaplains of the United States Armed Forces, memorializes their act. It is placed on a terrace raised a few feet above the ground, set off by cut fieldstone retaining walls, and reached by a short flight of low, broad stairs. An asymmetric star-shaped pool is set flush in the terrace. An abstract concrete form, about 18 feet in width and the same in height, symbolizing the hull of the *Dorchester*, stands in a circular depression in the center of this pool. Water flows from a ring at the outside of the star pool, down the sides of the depression, simulating a whirlpool. At the same time water flows from holes in the keel of the ship's hull. The hull, a winged shape coated with white silica, also represents the Dove of Peace, or the spirit of brotherhood in which the chaplains are shown ascending to heaven. A series of four sand-cast panels, each 6 feet high and 4 feet wide, stand vertically linked together at right angles by the side of the pool. Representing the four chaplains, these panels portray through abstract symbols the interdenominational bases of faith: harmony of man and the universe, the family, the power of prayer, and the eternal struggle between good and evil.

The adjacent panel, *The Harmony of Man and the Universe*, contains a symbol of God or "the prime mover of the Universe" in the upper section. Immediately below in the funnel-shaped central section is, from top to bottom, a circle representative of the Sun, a square entitled the "plateau of faith," a symbol of Fertility and the continuity of man, while the botton fern-shaped relief is of man's earthly environment. The objects to the left are symbolic of mountains and the soil of the earth while those on the right are of the union of man and woman.

E-4
Title SUNSINGER, 1928
Location National Memorial Park,
Route 29, south of Falls Church,
Virginia, approximately 8 miles
west of the George Washington
Memorial Parkway
Sculptor Carl Milles
Architect Walter F. Marlowe
Medium Bronze

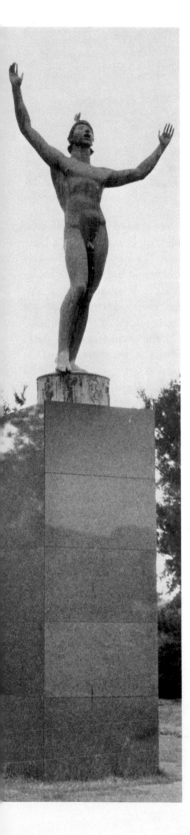

The idea of the memorial park, a cemetery without tombstones, beautifully landscaped and serene, was born at Forest Lawn in Los Angeles, California, in 1917. In 1933, Robert F. Marlowe began to build National Memorial Park, the first such cemetery in the Washington area. His outstanding creation includes mausoleums of striking contemporary design integrated with monumental groups of fine sculpture, as well as acres of pastoral parkland in which interment is below ground and is marked only by flush bronze plaques. The park has Christian, Jewish, Muslim, and nonsectarian areas. Through the years it has grown from 97 to 207 acres and has been an innovator in many ways, one of the latest being a proposal for a fifteen-story high-rise mausoleum with a chapel on each floor.

The *Sunsinger*, a monumental bronze on a tall pedestal of polished dark marble, measures about 25 feet in height overall and serves as the focal point for one of the mausoleum courts. Executed by the Swedish sculptor Carl Milles, its inspiration was the pagan worship of the sun. The nude male figure stands with head thrown back, arms raised to the heavens as he sings. The body is stylized, its structure subordinated to the vibrant power of the voice and the religious ritual being performed. The *Sunsinger* wears a classical helmet, its crest adorned with an equine figure; classically inspired bas-reliefs decorate the base of the statue. In 1942, Marlowe had commissioned a piece called *Astronomer*; however, due to wartime shortages, it could not be cast in bronze. As the date set for the dedication approached, Milles, in desperation, painted the plaster model to simulate bronze and placed it on the pedestal. He later became dissatisfied with the model and refused to cast it, offering Marlowe instead, in 1948, a casting of his *Sunsinger*; the original stands in a prominent square in Stockholm, Sweden.

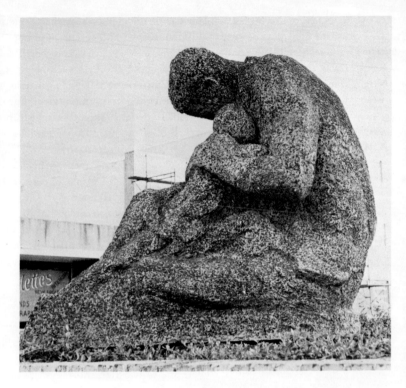

This sculpture is the focal point of a minipark created by the Arlington Jaycees, or members of the Junior Chamber of Commerce, at a busy intersection near the Arlington Courthouse. The park is raised a few feet above street level. Plantings of periwinkle and boxwood are incorporated into the textured brick walls. Paving is of rough-grained concrete with redwood strip dividers. "Floating" redwood strip benches are provided. The 4½-foot-tall sculpture is loosely placed on pieces of fieldstone in a bed of periwinkle at the apex of the small triangular park. It is an evocative, semiabstract group in cast stone, surfaced with a black aggregate.

The sculptor has explained: "The inspiration for the sculpture itself derives from a picture of the photographer, Wayne Miller, tenderly holding a little boy in his arms. I have tried to make my sculpture symbolic of several aspects of love, compassion, and brotherhood. In order that each person who looks at it can be free to make his own interpretation, I have not given the sculpture a title, nor have I done more than barely suggest the features of the man's face."

A bronze plaque quotes the Jaycee creed: "Service to Humanity is the best work of life." The sculpture was chosen as being illustrative of this creed. The minipark and sculpture were dedicated on January 26, 1969, with United States Congressman Joel T. Broyhill of Virginia as principal speaker.

Title Theodore Roosevelt
Memorial, 1967
Location Roosevelt Island, Potomac
River, adjacent to the George
Washington Memorial Parkway
and to Key Bridge
Sculptor Paul Manship
Architect Eric Gugler
Medium Bronze

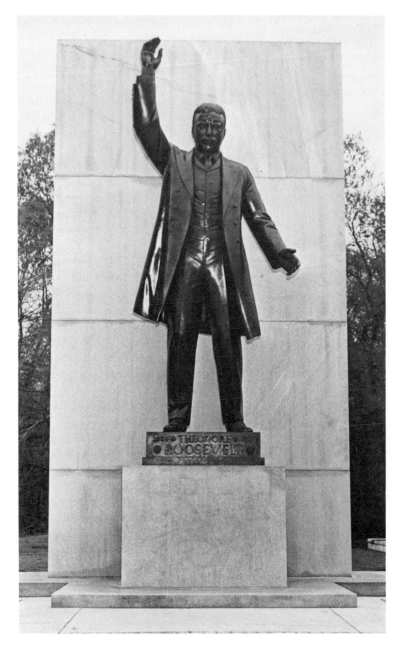

*1906 photograph showing Theodore
Roosevelt in a typical speaking pose*

Theodore Roosevelt (1858–1919), twenty-sixth president of the United
States, was born into a patrician New York family. Following his
graduation from Harvard University in 1880, he turned to the study of
American history and published a history of the United States Navy
during the period of the War of 1812. Following several years spent on
a ranch in South Dakota, Roosevelt returned to New York City and was
appointed civil service commissioner in 1889. In 1895, as president of
the New York City Board of Police Commissioners, he attracted public
attention to the need for police reforms. President William McKinley
appointed him assistant-secretary of the United States Navy in 1896, a
position from which he soon resigned to enter the Spanish-American
War. His exploits as colonel of a regiment in Cuba, "The Rough Riders,"
made him nationally prominent. In 1899 he was elected governor of
New York and began many reforms, such as taxation of corporations.
Thomas C. Platt, the Republican political boss of New York, engineered
Roosevelt's nomination as vice president under McKinley, reportedly to
get him out of New York state politics. McKinley's assassination in 1901
placed Theodore Roosevelt in the White House within a few months. He
was responsible for the Roosevelt Corollary to the Monroe Doctrine,
which asserted the right of the United States to intervene to prevent

disputes between Latin American nations and Europe. He is given credit with helping to end the Russo-Japanese War in 1905. In 1907 Roosevelt sent the newly built American naval fleet around the world as a show of American strength. In domestic affairs he concentrated on business and industrial reforms, especially on "trust-busting." Roosevelt also helped greatly to enlarge the government parks and forest reserves in the western states. Two years after he left the White House, upon his return from a tour of Africa and Europe, he clashed with his former secretary of war, William Howard Taft, who had succeeded him as president. Roosevelt ran as an independent candidate for president in 1912, which resulted in splitting the Republican party and in helping Woodrow Wilson to win the election. Before his death in 1919 he strongly supported war with Germany and military preparedness.

Selecting a design for a memorial suitable to the colorful Theodore Roosevelt was an arduous task. A colossal stone lion in Rock Creek Park, a statue at Sixteenth Street and Alaska Avenue, and a heroic colonnaded fountain near the Washington Monument were all considered by the Theodore Roosevelt Memorial Association before it decided, in the early 1930s, to purchase Analostan Island in the Potomac River near Georgetown, develop it as a wildlife preserve, and dedicate it in Roosevelt's memory. In the 1950s, a more formal memorial consisting of a huge bronze armillary sphere and reflecting pool were proposed for the center of the island. This idea, called a "celestial jungle gym" by Roosevelt's daughter, Alice Roosevelt Longworth, met with widespread opposition. In the fall of 1961, plans for the present memorial were approved.

This 17-foot-high standing bronze portrait of Roosevelt is before a 30-foot granite stele, as the focal point of a vast circular plaza near the center of the island. The old "Rough Rider" is depicted in a characteristic speaking pose, his weight slightly forward, his right hand raised for emphasis. Behind him, near the edge of the woodland, four monoliths are inscribed with his thoughts on Nature, Mankind, Youth, and the State. The formal plaza is raised, surfaced with flagstone and granite, and bounded by pools and formal plantings of trees. Raised plantings, benches, bridges, and fountains are incorporated into its design. The transition to this formal area from the woodland trails seems abrupt and jarring. On this island, where development is minimal and cars are banned, the memorial seems in some ways an intrusion, at odds with "the higher spirit of the wilderness . . . its mystery, its melancholy and its charm."

The island, located in the Potomac River and thus now part of the District of Columbia, was once the location of the residence built by General John Mason, son of the colonial Virginia patriot, George Mason, of Gunston Hall. The John Mason house, built by architect George Hadfield in the 1790s as one of the first Neoclassical style homes in America, was frequently visited by George Washington, Thomas Jefferson, and other distinguished guests such as Louis Philippe of France. The house was surrounded by formal gardens, extensive orchards, and had pastures of prize Merino sheep. Mason, a shipping magnate, grew cotton and corn on the island. In 1834 Mason retired to nearby Fairfax County, Virginia, and Analostan Island, or Mason's Island as it was often called, began a slow decline. After that date a series of owners used it for recreational purposes. When the island became federal property in 1932, the former mansion was a wreck; trees grew from the exposed walls and the roof had collapsed. In 1937 the last remains of the Mason houses were taken down. Among the 91 acres on the island today can be found 411 types of plants, 76 species of birds, 20 varieties of animals, and 9 types of reptiles. In addition to seeing the Theodore Roosevelt Memorial, visitors will want to visit the many nature trails which crisscross the island.

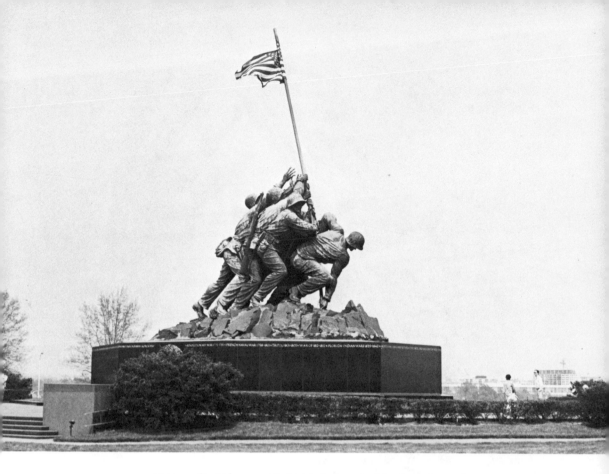

E-7
Title MARINE CORPS WAR
MEMORIAL, 1954
Location North of Arlington
Cemetery, at the junction of
Arlington Boulevard and Ridge
Road, Arlington, Virginia
Sculptor Felix W. de Weldon
Architect Edward F. Field
Medium Bronze

On February 23, 1945, during the bloody fighting for Iwo Jima, a small detachment of Marines made their way up Mount Suribachi to the highest point of this small Pacific island near Japan. Improvising a pole from a piece of pipe, they raised the American flag. A photograph of the event by Associated Press photographer Joe Rosenthal, a native Washingtonian, became a symbol of the indomitable courage of the American fighting man. It won a Pulitzer prize for Mr. Rosenthal on May 7, 1945, and has been more frequently reproduced than any other photograph of World War II. Sculptor Felix W. de Weldon, then in the United States Navy, began work at once on a sculpture inspired by this photograph. After his discharge he continued to work on the statue, creating thirty-six studies before completing the master model in June 1951. The model, with figures six times life size, was cut into 108 pieces for casting by the Bedi-Rassy Art Foundry in Brooklyn, New York. These were reassembled and then cut into sections. The 100 tons of cast bronze were then packed and shipped to Washington in five trucks. De Weldon created a closely massed group with great tension of form and realism of detail. The thrust of the first Marine's body, the crowding of the central figures, the outstretched hands of the Marine in the rear are powerful and moving. The figures were modeled in the nude, then draped in a manner suggesting the strain, sweat, and grime of battle. The faces of the three members of the group who survived, Corporal Rene A. Gagnon, Corporal Ira H. Hayes, and Pharmacist's Mate Second Class John H. Bradley, were modeled from life. The other three flag raisers, who did not survive Iwo Jima, Sergeant Michael Strank, Corporal Harlon Block, and Private First Class Franklin Sousley, were modeled from photographs.

A real flag and a pole of lead pipe are incorporated into the statue. Swedish black granite was used to simulate the volcanic rock of the 550-foot extinct volcano called Mount Suribachi. The base, an irregular octagon, faced with polished Swedish black granite, is inscribed with names of all Marine Corps engagements since 1775 and with Fleet

Detail of the flag raisers' hands

Admiral Chester Nimitz's tribute to the fighting men of Iwo Jima: "Uncommon valor was a common virtue."

The battle for Iwo Jima began five days before the photograph was taken. Three Marine divisions took thirty-five days to rout the 21,000 Japanese troops from Iwo Jima's rugged landscape. Most of the enemy and 6,321 American soldiers died during the conflict for this strategic island in the Pacific. This 78-foot-high sculpture cost $850,000 to complete; the entire cost was paid for by donations from Marines and other patriotic Americans. The sculpture was dedicated on November 10, 1954, the 179th anniversary of the United States Marine Corps.

Title NETHERLANDS CARILLON
and PANTHERS, 1960
Location North of Arlington
National Cemetery off Marshall
Highway
Sculptors Mrs. E. van den
Grinten-Lucker, bells, and Paul
Konig, feline figures
Architect Joost W. C. Biks
Medium Bronze, steel, lava stone

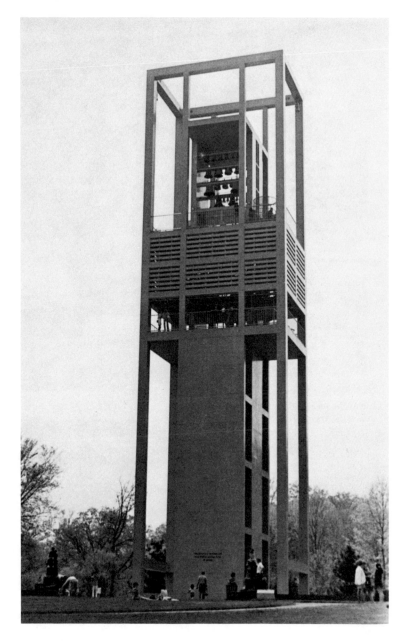

On May 5, 1945, the carillons in The Netherlands rang out the announcement of liberation from the Nazis. Five years later the Dutch people, in gratitude for war aid, decided to present a carillon to the Americans. Funds were raised all over The Netherlands. Three foundries were given the honor of casting the necessary forty-nine bells. These were graduated in size and weight, ranging from 41.8 pounds, 8 inches high, 10 inches in diameter, to 12,628 pounds, 6 feet high, 7 feet diameter. Each bell is a work of art, engraved with coats of arms and symbols of the segment of the Dutch population which donated it, and inscribed with verses descriptive of its particular tonal qualities. The bells were presented by Queen Juliana in a ceremony in Meridian Hill Park in Washington on April 4, 1952.

At this time, Queen Juliana declared her country's intention to build a tower to house the bells. The completed carillon, erected on a commanding site near the Iwo Jima memorial, was dedicated on May 5, 1960, the fifteenth anniversary of the liberation of The Netherlands.

The 127-foot-high steel frame of the tower is covered with steel plates and designed in a spare rectilinear form, reminiscent of the work of the Dutch painter, Piet Mondrian. It is placed in a simple square plaza paved in flagstone and surrounded by a low broad wall of polished lava stone. Two abstract bronze feline figures, often referred to as panthers,

One of the two panthers which guard the front of the carillon

Relief on the Antilles Islands bell

guard the plaza entrance. Each of these figures is about 6 feet high and twice that in length.

The carillon, a Flemish instrument dating to the twelfth century, has an interesting and varied repertory. It is somewhat like an organ, having both pedal and manual keyboards and bells tuned chromatically, like pipes, through four octaves. In 1964 the Dutch donated 10,000 tulip bulbs to be planted at the base of the carillon.

The adjacent photograph shows the relief panel of the Antilles Islands bell. The inscription on the bell, above the relief panel, reads: "Islands over the ocean shining in the sun—your wishes, hope and wanting, Antilles, shall ring out in my voice." This bell, presented by the people of the Dutch colony of the Antilles Islands, is one of the smallest of the 49 bells. The relief panels are different on each bell, but usually show the coat of arms of that Dutch province which gave it. Many of the inscriptions on the bells relate to the efforts of the Dutch to free themselves from occupation during World War II.

E-9
Title ARLINGTON MEMORIAL BRIDGE
EAGLES and FASCES, 1932
Location Arlington Memorial
Bridge, between the Lincoln
Memorial and Arlington National
Cemetery
Sculptor Eagles on pylons and
Eagle medallions: Carl Paul
Jennewein; Bison keystones:
Alexander Phimister Proctor
Architect McKim, Mead, and
White
Medium Marble

Arlington Memorial Bridge, built between 1926 and 1932, was intended to be both a symbolic and a physical union between the North and the South, with the Lincoln Memorial at one end and the Custis-Lee House at the other. The bridge was included in the 1901 plans of the McMillan Commission for returning the city to Pierre L'Enfant's original design. It was not until 1921, that decisive action was taken. While en route to the dedication of the Tomb of the Unknown Soldier, President Warren G. Harding and numerous other dignitaries were caught in a three-hour traffic jam on the old wooden bridge, located near the present Arlington Memorial Bridge.

The bridge has nine spans, and on the pylons of the piers of the spans are large circular discs which depict eagles; these massive birds were sculpted by the German-born sculptor, Carl Paul Jennewein. On the sides of the 8-foot discs are sculpted fasces; these are bundles of rods, each bound by a thong and showing a projecting axe blade surmounting the upper end. They were used as symbols of power and authority in ancient Rome. These fasces may also be found frequently throughout the city, such as on the front ends of the colossal chair of the seated statue of Abraham Lincoln by sculptor Daniel Chester French inside the nearby Lincoln Memorial.

The 6-foot-high bison keystones are found at the apex of each of the pylons. The bison were carved by the talented animal sculptor, Alexander Proctor. Proctor was also responsible for the huge bronze buffaloes on the Q Street Bridge over Rock Creek.

Four huge eagles, 8 feet in height, are perched on the massive pylons at the west end of the bridge, near the entrance drive to Arlington National Cemetery.

Arlington Memorial Bridge, built to the designs of the New York firm of McKim, Mead, and White, replaced a feeble wooden bridge which had survived only because rocks were dumped each year around the piers for support. This rock-piling was done with such regularity that unintentionally a dam was created, thereby further cluttering an already much-obstructed river. The original plans called for a row of Neoclassical statues on each side of the bridge. These were never added because of rising costs of construction.

Title THE HIKER, 1965
Location Avenue of Heroes, the approach to the Arlington National Cemetery
Sculptor Theodora Alice Ruggles Kitson
Architect Unknown
Medium Bronze

The Spanish-American War was a relatively popular engagement—a war of heroes, of little bloodshed, of short duration. It brought Puerto Rico, Guam, and the Philippines to the United States as territories. It marked the beginning of the role of the United States as a world power, with a policy of commitment to the welfare and development of disadvantaged nations. The resulting Philippine Insurrection, though embarrassing and comparatively more costly, did little to dampen the optimism of the period. The research of Dr. Walter Reed during the war made possible the eradication of yellow fever.

This 8-foot-tall memorial to the veterans of the Spanish-American War and the Philippine Insurrection (1898–1902) is idealistic and self-confident. Romantically entitled *The Hiker*, this heroic bronze portrays a handsome, muscular young American soldier standing at parade rest, rifle in hand, ready for action. He is dressed for tropical warfare, shirt sleeves rolled up, shirt open at the neck. His hat is set jauntily to one side. The clear gaze and the firm and resolute set of the jaw suggest high moral purpose. One can well imagine his saying with Captain John W. Phillip: "Don't cheer, boys; the poor fellows are dying." A cruciform bronze plaque on the granite pedestal bears a bas-relief which represents the American army and navy coming to the aid of the Spanish colonies. "Cuba," "Philippine Islands," "Puerto Rico," and "U.S.A." are inscribed in the arms of the cross. The monument was erected by the United Spanish War Veterans. When dedicated on July 24, 1965, only 15,000 of the original 458,000 veterans were still living.

Title REAR ADMIRAL RICHARD
EVELYN BYRD, 1961
Location Avenue of Heroes, the
approach to the Arlington National
Cemetery
Sculptor Felix W. de Weldon
Architect Albert Peets
Medium Bronze

Richard Evelyn Byrd, the first man to fly over both the north (1926) and the south (1929) poles, led five expeditions to Antarctica between 1928 and the time of his death in 1957. He was responsible for the exploration and mapping of hundreds of thousands of square miles of unknown territory; his expeditions provided the opportunity for scientific research in many fields. He wrote five best-selling books about his experiences. *Alone,* an account of five solitary months spent in a Ross Shelf ice shack in 1934, has been called a "great and living book . . . a breathless and almost shattering drama." Byrd was awarded numerous decorations, including the Congressional Medal of Honor, the Distinguished Service Medal, and the Legion of Merit.

This 8-foot-tall memorial was erected in Byrd's honor by the National Geographic Society, one of his long-time patrons, and was dedicated November 13, 1961. It is a heroic, bronze portrait statue on a pedestal of white Carrara marble. According to the sculptor, it portrays Byrd "pitting his will power against the polar elements and envisioning the scientific accomplishments of the future." He is in Arctic dress; the texture of his fur parka is carefully delineated. His pose is tense and active; legs braced, fists clenched, bared head tossed back, he looks toward the wind-swept horizon. His taut facial muscles further suggest Arctic winds and temperatures, the roughly cut marble on which he stands sparkles like snow in the sun. This is a dramatic yet sensitive work. The pedestal is inscribed: "Upon the bright globe he carved his signature of courage."

Arlington National Cemetery

E12-20

Arlington National Cemetery, located on the Virginia banks of the Potomac River opposite the Lincoln Memorial, was named for the Custis-Lee plantation, Arlington, which was established in the early nineteenth century by George Washington Parke Custis, the step grandson of George Washington. Shortly before the Civil War, the estate was left to Custis's daughter, Mary Anne Randolph Custis, the wife of Robert E. Lee. In 1861, soon after Virginia seceded, the estate was occupied by the Union army and referred to as the Lee Mansion by the soldiers stationed in the area, who knew it only as the former home of Robert E. Lee. Arlington House and the surrounding grounds became Arlington National Cemetery in 1864 on the orders of Major General Montgomery Meigs, quartermaster general of the Union army, who knew the estate would not be occupied by the Confederate general after the war so long as thousands of graves were placed adjacent to the house. In 1955, Congress officially changed the name of the house to the Custis-Lee Mansion.

This 1,100-acre estate received its first two soldiers for burial on May 13, 1864. At that time, Arlington House was occupied by Union troops, and some 700 freed Negroes camped on a small part of the estate. The hatred of Meigs and others involved with the cemetery, including Secretary of War Edwin Stanton, was such that Confederate widows were not permitted to enter the grounds to place flowers on the graves of Confederate dead until 1871.

Arlington is today the largest of all American military cemeteries. Among the ten miles of paved roads and three miles of walks lie the remains of over 150,000 members of the Armed Forces of the United States, from the Revolutionary War to the Viet-Nam conflict. Due to lack of burial space today only personnel on active duty, those persons who are retired but entitled to benefits, and Congressional Medal of Honor winners are permitted burial within the grounds.

In previous years, the government allowed private monuments to be placed and maintained at private expense. Current regulations permit private monuments only in areas where such memorials existed prior to 1947. Most of the headstones are the familiar uniform ones standing in countless white rows. Those with rounded tops and with the name, state, and the dates of birth and death are for all identified persons. Sunken shields with the same information symbolize service in the Civil War and Spanish-American War. Those headstones with pointed tops are for the Confederate veterans and may be seen surrounding the Confederate Monument. Over thirty monuments of unusual and distinctive sculptural qualities exist in Arlington National Cemetery. Only a few examples are presented here.

E-12
Title Confederate Memorial, 1914
Location Arlington National Cemetery, Jackson Circle near the intersection of McPherson and Farragut Avenues
Sculptor Moses Ezekiel
Architect Unknown
Medium Bronze

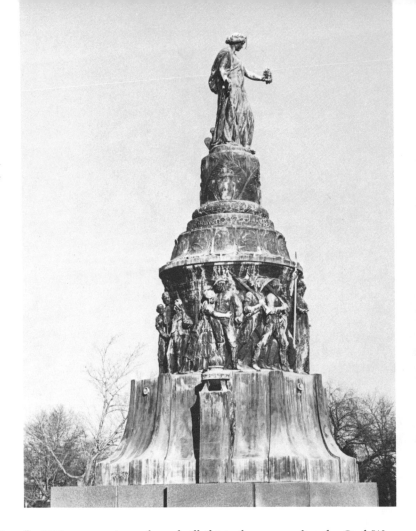

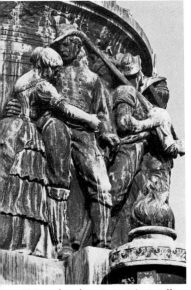

Frieze detail: poignant farewell as Confederate soldiers leave home for active duty

In 1900, as a gesture of goodwill thirty-five years after the Civil War ended, Congress permitted a Confederate section in Arlington National Cemetery; and the Confederate dead were gathered from all parts of the cemetery and from other area burial grounds near Washington to rest together. Later, President William Howard Taft granted permission to the United Daughters of the Confederacy to erect a Confederate Memorial. Sculptor Moses Ezekiel, of Richmond, Virgina, appropriately a Confederate veteran himself, was selected to design the memorial. The 32-foot-high richly modeled monument is crowned with a heroic-sized woman, symbolic of Peace, facing the South. Crowned with a wreath of olive leaves, she holds a laurel wreath, a plow stock, and a pruning hook. The verse from *Isaiah*, "They shall beat their swords into plowshares, and their spears into pruning hooks," is carved around the memorial.

A vigorous high-relief, circular frieze in bronze is located around the center of the shaft and shows thirty-two life-size figures of Southern civilians bidding farewell to Confederate soldiers leaving for the war. Their sad return from the conflict is recorded in the center part of the frieze. Above the frieze, which is a refreshingly realistic scene during a period when sculpture was dominated by allegorical Neoclassical figures, are carved in granite the seals of the Southern states.

The principal inscription of the south front was written by Dr. Randolph Harrison McKim, Confederate soldier and later a Washington, D.C., clergyman: "Not for fame or reward, not for place or for rank, not lured by ambition or goaded by necessity, but in simple obedience to duty as they understood it, these men suffered all, sacrificed all, dared all, and died." At the dedication in 1914, President Woodrow Wilson addressed some 3,000 Confederate and Union veterans who gathered there.

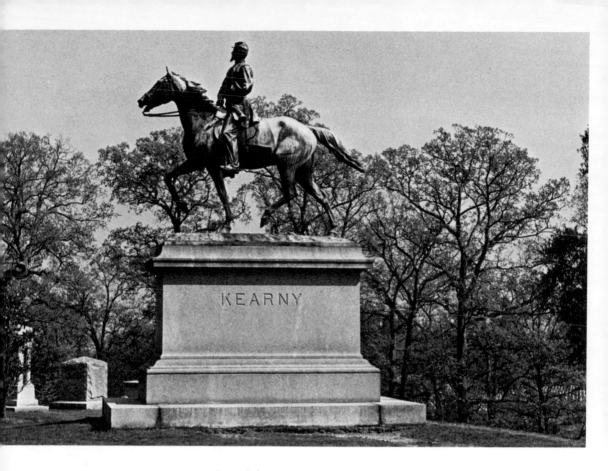

E-13
Title MAJOR GENERAL PHILIP KEARNEY, 1914
Location Arlington National Cemetery, intersection of Lee, Meigs, and Wilson Drives
Sculptor Edward Clark Potter
Architect Unkown
Medium Bronze

One of the two equestrian statues in Arlington National Cemetery represents General Philip Kearney (1814–1862), a most colorful and daring Union general. James Watts, his grandfather, refused to allow Kearney to attend West Point, feeling he was destined instead for a career in law or in the church. After his grandfather and guardian died, Kearney, a native of New York, inherited nearly a million dollars and immediately entered the famous French military academy at Saumur. Upon his return to the United States, he served as an American army officer in the West and then in the Mexican War, where he lost his left arm. During the Civil War, he became commander of the Third Division of the Army of the Potomac. He succeeded at this difficult task by expecting and receiving from his men the same devotion and daring that he gave. During any cavalry charge, Kearney was always in front, his cap at a jaunty angle, the reins between his teeth, and his right arm free to wave his men to the front. During the Second Battle of Manassas, known to the Union forces as the Second Battle of Bull Run, Kearney ranged too far ahead and was killed at Chantilly. General Robert E. Lee returned Kearney's body, his sword, and his horse under a flag of truce. Kearney's division could always be distinguished by the red fabric patches sewed to their caps. This emblem was one of his many efforts to increase the esprit de corps of his men. The shoulder patch of today's army evolved from these "red caps."

Another legacy resulted from Kearney's death. Each of the men in his division was awarded a cross of honor or medal to distinguish him as one of the martyred general's division. Known as "Kearney's Cross," the medal was then presented to all soldiers who showed exceptional valor in battle. The Medal of Honor, highest decoration for an American soldier, evolved from this Civil War medal.

The sculptor, Edward Clark Potter, an outstanding animalier or sculptor who specializes in animals, has executed an unusually spirited and exciting equestrian statue which measures about 10½ feet in height and 11 feet in length. Potter's many famous pieces include the huge lions at the entrance to New York Public Library.

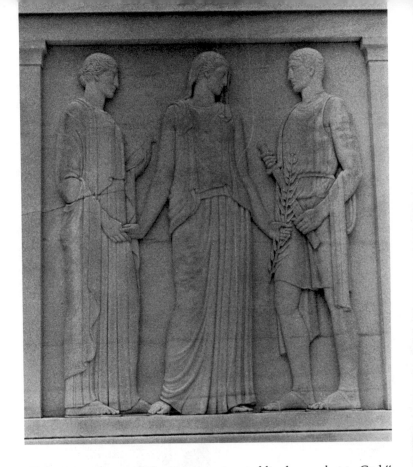

E-14
Title TOMB OF THE UNKNOWN
SOLDIER, 1931
Location Arlington National
Cemetery, to the rear of the
Amphitheater
Sculptor Thomas Hudson Jones
Architect Lorimer Rich
Medium Marble

"Here rests in honored glory an American soldier known but to God." This moving inscription, familiar to millions of Americans, appears on the simple marble *Tomb of the Unknown Soldier*. Beneath the tomb lies an unidentified American soldier of World War I, selected at random from the American dead at Châlons-sur-Marne, France, and brought back to the United States with great ceremony on the *Olympia*, former flagship of Admiral George Dewey at Manila Bay. After two days of rest in the United States Capitol Building on the catafalque which had borne the body of Abraham Lincoln, the Unknown Soldier was placed in the tomb by President Warren G. Harding, who conferred on him the Medal of Honor. Two other servicemen are buried nearby, the Unknown Soldiers of World War II and of the Korean Conflict, both interred on Memorial Day, 1958.

The allegorical marble relief depicts three figures, symbolic of the Allied Spirit in World War I. The male figure of Victory, symbolic of Valor, is offered a palm branch by Peace. This act represents a regard for the devotion and sacrifice which makes the cause of righteousness triumphant. The third figure is symbolic of the American Soldier. Doric pilasters appear on the sides of the memorial, which measures 9 feet tall, 11 feet wide, and 16 feet deep.

Thomas Hudson Jones, the sculptor, was chosen from among seventy-five competitors for the work. A jury of five persons, Mrs. William D. Rock, Hanford MacNider, Daniel H. Burnham, Paul P. Cret, and Charles H. Coolidge, made the final choice of Jones's design in 1929. Jones served as assistant to both James Earle Fraser and Rudulph Evans, each of whom did major works in the Nation's Capital. The sculptor has used figures reminiscent of those found on Greek tombstones, and the figures wear Greek draperies with smooth stylization; the joined arms provide an interesting rhythm. The relief harmonizes with the classically planned environment of the City of Washington and of Arlington National Cemetery.

Title Jane A. Delano Memorial, 1938
Location Arlington National Cemetery, near intersection of Memorial Drive and McPherson Avenue
Sculptor Frances Rich
Architect None
Medium Marble

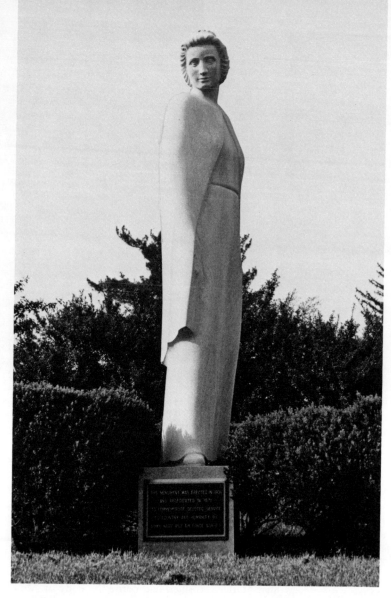

This handsome marble statue measures 10 feet tall and honors Jane Delano and the hundreds of other nurses who served in the American Armed Forces during World War I. The statue looks out across that section of the cemetery which is reserved as their final resting place. Jane Delano, one of the most outstanding of all American nurses in the twentieth century, served as the superintendent of the Army Nurse Corps from 1909 to 1912. Upon her father's death in the Civil War, she determined to enter the profession of nursing. After graduating from Bellevue Hospital, in New York City, in 1886, she served in many posts, including that of superintendent of nurses at her alma mater. Later, as head of the Army Nurse Corps, Jane Delano brought a close working relationship between the army and Red Cross. She not only raised the working standards and the pay, but completely reorganized the Army Nurse Corps into a highly efficient modern outfit. During World War I, owing to her efforts, over 18,000 nurses joined the Army Nurse Corps. Miss Delano died during the war while on an inspection trip to the French battlefields.

E-16

Title FIELD MARSHAL SIR JOHN
DILL, 1950
Location Arlington National
Cemetery, intersection of Weeks
and Roosevelt Drives
Sculptor Herbert Haseltine
Architect Lawrence Grant White
and Willis Bosworth
Medium Bronze

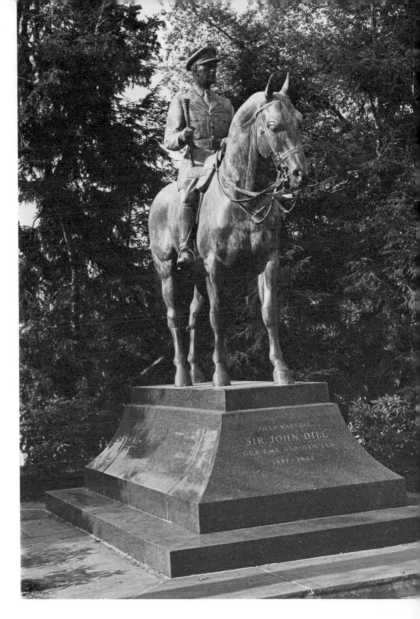

This handsome equestrian statue, 10 feet tall and 15 feet long, represents Field Marshal Sir John Dill (1881–1944), one of the most prominent British generals of World War II. Dill participated in World War I in France, after which he served as an instructor at the Imperial Defense College in England and as a general staff officer of the British forces in India. In the 1930s, his military assignments took him to Palestine and Jordan. With the outbreak of World War II in September 1939, he rose rapidly in rank. After serving as a British corps commander in France, he returned to England as chief of the Imperial General Staff in 1940. When the United States entered the war in 1941, he was created a field marshal and was sent to Washington, D.C., as the senior British officer of the British Chiefs of Staff, who formed a joint staff with the American Chiefs of Staff. He played a major role at the war planning conferences of Casablanca, Quebec, and Teheran; he was a major exponent of plans to form the United Nations. His sense of tact, diplomacy, and inborn courtesy made him a favorite in Washington military and social circles before his untimely death in November 1944. President Franklin D. Roosevelt awarded him the Distinguished Service Medal posthumously. By a special act of Congress, Sir John was authorized burial at Arlington National Cemetery. Some fifty other foreign, high-ranking military officers have been buried at Arlington by special authorization of Congress since the cemetery was established in 1864.

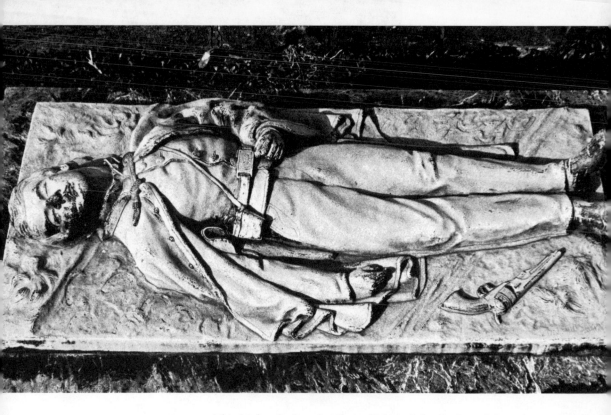

E-17

Title MAJOR JOHN RODGERS MEIGS MONUMENT, 1865

Location Arlington National Cemetery, Meigs Drive

Sculptor Theophilus Fisk Mills

Architect Unknown

Medium Bronze

This high-relief tomb effigy of Major John Rodgers Meigs (1842–1864) shows the young Union officer as he was found lying on the field of battle during the Civil War. The sculpture measures 7 inches in height, 39 inches in length, and 18 inches in width. A 22-year-old engineer of the Army of the Shenandoah, he was the only son of Major General Montgomery Meigs (1816–1892), the quartermaster general of the United States Army. The huge granite monument to General Meigs, a noted engineer and architect, has been placed only a few feet away from that of his son.

While on leave of absence from West Point, John Meigs served as a volunteer aide-de-camp to Colonel Richardson, commander of the Second Michigan Volunteers at the Battle of Bull Run, July 21, 1861. He distinguished himself by the coolness with which he urged the officers and men of other organizations to retake their positions and preserve the lines.

After graduating from West Point, he was appointed a first lieutenant of engineers for the construction of the defenses of Baltimore from possible Confederate attack. Meigs then helped to reopen Union communications with Harper's Ferry during Lee's retreat from Gettysburg. In August 1863, he assisted in General Sigel's raid upon Staunton, Virginia. In early 1864, Major Meigs was appointed aide-de-camp to Major General Philip Sheridan in the Shenandoah Valley area of Opequon and Fisher's Hill, Virginia; in September 1864, he was awarded the ranks of brevet captain and brevet major within a three-week period.

The brevet ranks were awarded to officers in the American army from the War of 1812 through the Civil War. Since there were no medals to award an officer for valor on the battlefield, honorary promotions known as brevet ranks were used. Thus, an officer, as in the case of John Meigs, could hold the regular rank of first lieutenant but wear the uniform and be addressed as a major. General Montgomery Meigs, also a West Point graduate, probably ordered the tomb for his son to be carved with the regular rank of first lieutenant, which meant more to most professional officers than the brevet rank. On October 3, 1864, when within his own lines, Major Meigs was killed by Confederate guerrillas near Harrisonburg, Virginia.

Title Brigadier General and
Mrs. Richard L. Hoxie Monument,
1915
Location Arlington National
Cemetery, Miles Avenue
Sculptors Vinnie Ream Hoxie,
statue; George Julian Zolnay,
relief panel
Architect Unknown
Medium Bronze

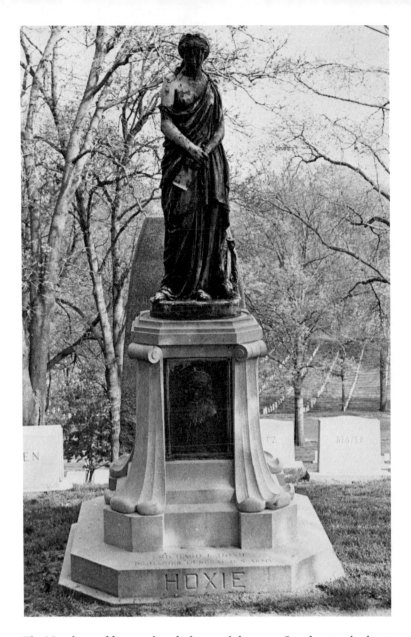

The Neoclassical bronze female figure of the muse Sappho stands about 7 feet high on top of the granite pedestal of the *Brigadier General and Mrs. Richard Loveridge Hoxie Monument* in Arlington National Cemetery. It is a copy of the original marble statue by the general's wife, Vinnie Ream Hoxie, executed in her Washington, D.C., studio between 1865–1870. At her death in 1915, General Hoxie gave the original statue of *Sappho* to the Smithsonian Institution's National Collection of Fine Arts.

General Hoxie first entered military service as a 16-year-old bugler in the opening months of the Civil War. After graduation from West Point in 1868, he accompanied several exploring expeditions to the West. Beginning in 1874, he served for many years in Washington, D.C., as an engineering officer. Hoxie was responsible for constructing new sewer systems, and also for planning Rock Creek Park and many new avenues and squares as the city expanded rapidly in the post-Civil War years. During the Spanish-American War, he was in charge of all fortifications of the United States Army from Maine to New York. At his retirement in 1908, Hoxie was regarded as an authority on fortifications and later served as an adviser in that capacity during World War I.

Although Brigadier General Richard L. Hoxie has been neglected by history, art historians still study the contributions made by his wife.

Her career cut a swath across American political history and art. She was the daughter of an army mapmaker on the Wisconsin frontier in the 1840s. Women then were not encouraged to become proficient in the arts, but Indians recognized the child's inborn talent and furnished her with materials with which to draw and paint. At the age of fifteen, she was helping her father prepare maps used by the Union forces in the Civil War.

Vinnie Ream's talents were recognized again when her father came to Washington, D.C. Still in her teens, she worked for a $50-a-month salary as a clerk in the main Post Office, but she spent her free time sculpting portrait busts of members of Congress, under the direction of Clark Mills, a prominent sculptor working in Washington. When she was seventeen, President Lincoln invited her to his White House office, where, during lunch hours, she modeled his portrait in clay. For five months, she sculpted while Lincoln dealt with the last days of the Civil War. Her portrait of him was finished on the afternoon of April 14, 1865. Both Lincoln and his wife praised her work; Vinnie Ream was one of the last civilians to speak with him before he left for Ford's Theater the night of his assassination. Two years later, Congress awarded her the $10,000 contract for the memorial to Lincoln, now standing in the Capitol Rotunda. This first major art contract awarded to a woman by the federal government caused a national uproar; Congress and the press were deluged with letters protesting the grant, mostly on grounds of "indecency." Opinion of the day held it indelicate for any woman, especially one of nineteen, to model a human figure. Ignoring the uproar, Vinnie Ream opened doors for women in the field of monument sculpture. She was to attract international attention and renown for her pioneering, but only after enduring a campaign of slander.

An ardent admirer of Lincoln and an advocate of President Andrew Johnson's determination to carry out the Emancipator's policies of compassion toward the defeated South, she was caught in a political crossfire. The congressional cabal attempting to impeach Johnson learned that Senator Edmund Ross of Kansas, who held the key vote on impeachment, was a boarder in her parents' home. In the belief that she was persuading Senator Ross to vote against impeachment, the nineteen-year-old girl was subjected to gross harassment and threats to her artistic career, as well as to her good reputation. She steadfastly supported Ross, who eventually prevented Johnson's impeachment by his single vote.

Miss Ream went on to win other commissions, among them Oklahoma's tribute to Sequoya, the Cherokee leader, whose memorial is in the Capitol's Hall of Fame. She also created the monument to Admiral David Glasgow Farragut located in Farragut Square on Connecticut Avenue in Washington. While modeling the Farragut memorial, she married Lieutenant Richard Loveridge Hoxie, a wealthy officer in the United States Army Corps of Engineers. Hoxie was in charge of the Navy Yard shed in which she finished the admiral's statue. As a prominent hostess, Vinnie Ream Hoxie fostered artists and the arts in Washington during the last quarter of the nineteenth century.

She gave up her career as a professional sculptor after her marriage but continued to produce portrait busts and small works for her friends. She did many allegorical statues, including *The West* and *America*. Her bust of Senator Charles Sumner, modeled from life, was greatly admired.

The low-relief bronze panel on the front of this cemetery monument measures 2 feet high by 1½ feet wide and was installed by General Hoxie in 1915 when Vinnie Ream Hoxie died. The panel was executed by George Julian Zolnay and is inscribed: "Words that would praise thee are impotent."

Title WILLIAM WORTH BELKNAP
MONUMENT, 1891
Location Arlington National
Cemetery, Meigs Drive, to the rear
of the Custis-Lee Mansion
Sculptor Carl Rohl-Smith
Architect Unknown
Medium Bronze

The upper section of this shaft contains a large bronze medallion of Secretary of War William Worth Belknap (1829–1890). Belknap was born in Newburgh, New York, the son of William Goldsmidt Belknap, a prominent general of the Mexican War. After attending Princeton College and studying law in Georgetown, D.C., William Worth Belknap practiced law in Iowa and served briefly in the Iowa legislature prior to the Civil War. He became commander of the Fifteenth Iowa Infantry in the early part of the Civil War, and was commended for valor at the battles of Shiloh and Vicksburg. Promoted to brigadier general, Belknap served under General William T. Sherman during the latter's march through Georgia and the Carolinas in the final months of the war.

In 1869 he was appointed secretary of war by President Grant. He was charged with official corruption in 1876 and permitted to resign from the Cabinet. Belknap was impeached by the House of Representatives on the accusation that he sold the office of trading post director at Fort Sill, Oklahoma, to a Caleb P. Marsh for the sum of $24,000. Impeachment proceedings were dismissed in the United States Senate on the grounds of lack of jurisdiction. Later evidence indicated that his wife arranged the selling of this office in order to finance the expenses of moving in Washington's Reconstruction Era "society." Mrs. Belknap, reputed to be one of the most beautiful women in Washington, found herself ostracized by the social set which she had hoped to impress; she left Washington for France. Belknap remarried and established a very successful law practice in Washington before his death in 1890.

E-20
Title MAJOR GENERAL HENRY W. LAWTON MONUMENT, 1922
Location Arlington National Cemetery, near the intersection of Sheridan Drive and Sherman Avenue
Sculptor Myra Reynolds Richards
Architect None
Medium Bronze

This noteworthy example of an Art Nouveau memorial is designed in bronze to resemble a hut built of palm branches. Two natives of the tropics, who serve as atlantes, are located at the ends of this 3-foot-tall work. Henry W. Lawton (1813–1899) entered the United States Army in 1861 as an enlisted man with the Ninth Indiana Volunteers. The following year he was commissioned as a first lieutenant and distinguished himself in 1864 at the Battle of Atlanta. Like so many Civil War officers, he was selected to pursue the Apaches, who were raiding homesteads in the West. After a march of 1,300 miles over the Sierra Madre Mountains, he surprised and defeated the Indians and brought peace to Arizona and New Mexico. During the Spanish-American War, Lawton participated in the San Juan charge and led an advance on Santiago, Cuba. He later served as military governor of Santiago after it fell. During the Philippine Insurrection, in January 1899, he was ordered to Manila and employed Indian tactics there as in Cuba, where he took Santa Cruz and other strongholds from the native rebels. Attacking San Mateo after an all night march in the rain, he was shot while walking in front of a firing line directing his men. The design of the monument symbolizes Lawton's last years of military service in the tropics.

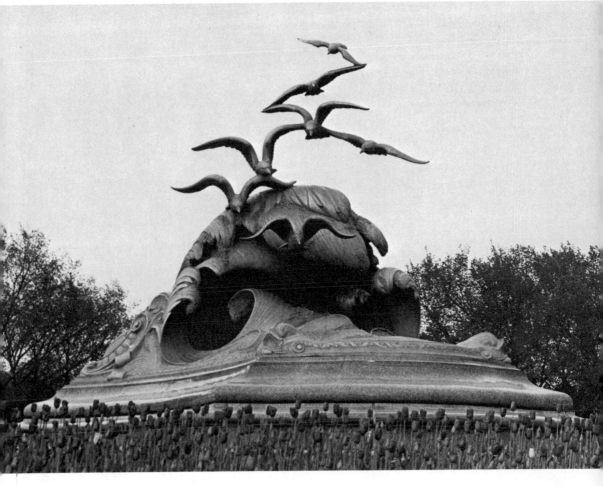

E-21

Title Navy-Marine Memorial,
1934

Location George Washington
Memorial Parkway, Lady Bird
Johnson Park, just southwest of
the 14th Street Bridge

Sculptor Ernesto Begni del Piatta

Architect Harvey W. Corbett

Medium Cast aluminum

Seven gulls hovering over a breaking wave honor those American servicemen in the United States Navy and United States Marine Corps who died at sea during World War I. The swirling waters, the cavernous wave, the impassively wheeling birds portray the dangers faced by those who have "gone down to the sea in ships, and have done business in great waters." The gulls are intricately balanced. The surface configurations of the water are like those carved by the sea itself on beaches, shells, and rocks. This is a dynamic and beautiful sculpture which cannot be fully appreciated when seen, as it usually is, from the traffic lanes of the George Washington Memorial Parkway. It measures approximately 35 feet tall and 30 feet long.

When originally designed in 1922, this sculpture was to have stood on a magnificent stepped base of polished green granite, simulating the movement and color of the sea. Bronze plaques depicting Navy and Marine history were to have decorated the landings of the base. Although school children, sailors, officers, high government officials, and others contributed $339,737.40 toward the erection of the memorial, funds proved insufficient and the plans for the elaborate base were dropped. Instead, the sculpture was transported to the site and mounted, at government expense, on a rough concrete base. It was dedicated in the fall of 1934. The sculptor devoted the remainder of his short life and half of his fee in a vain effort to secure a proper base. In 1940, the Works Progress Administration, a New Deal agency, landscaped the site and installed the present abbreviated base of an inferior grade of green granite. Choosing aluminum as the medium for this work, although it was a relatively new sculpture material in the United States, del Piatta's innovative methods included applying a thin coat of green pigment on the undersides of the waves and wings and yellow pigment, to simulate sunshine, on the wave's crest and the wing tips of the gulls.

E-22
Title James Forrestal, 1950
Location Pentagon Building, mall entrance
Sculptor Kalervo Kallio
Architect C. D. Persina
Medium Bronze

The model for this slightly larger than life bronze bust of James Forrestal, the first secretary of defense (1947–1949), was chosen in open competition from thirty-five entries. The decision, based on aesthetic excellence and the work's amazing likeness to Mr. Forrestal, was unanimous. With head held slightly forward and gaze somewhat guarded, the secretary's expression is weary but steadfast, suggesting inner determination. It is an interesting study of the man who, with tact and restraint, attempted an amicable reorganization and merging of the traditionally jealous War and Navy Departments. After his tragic death, this memorial was suggested by Chairman Millard Tydings of the Senate Armed Services Committee. More than $34,000 was raised from voluntary $1 contributions. The bust stands inside the shadowy portico at the mall entrance to the Pentagon, opposite the building's dedication plaque. The pink marble pedestal is inscribed: "This memorial to James Forrestal, as a spontaneous tribute to his lasting accomplishments in providing for national security and his selfless devotion to duty, was erected by thousands of his friends and co-workers of all ranks and stations."

Forrestal, who was a native of New York, served as a naval aviator in World War I, then turned to Wall Street, being named president of his banking firm in 1937. In June 1940, President Franklin D. Roosevelt appointed him to an administrative position in the government. Two months later he was named under secretary of the navy. In 1944 he became secretary of the navy, and in September 1947, secretary of defense. The new Forrestal Building in the L'Enfant Plaza complex in central Washintgon is named in his honor.

Christ Church Graveyard, Alexandria

E23-25

This graveyard of Christ Church (Protestant Episcopal), North Washington Street and Cameron Street, in central Alexandria, Virginia, remains the most important eighteenth-century cemetery in the metropolitan Washington, D.C., area. The few remaining sculptured gravestones which date from the last third of the eighteenth century are unique in this area. Most surviving sculptured eighteenth-century gravestones in America today are found in the New England states, because slate, a long lasting material was more commonly found in that area than in the South where the less durable sandstone was used. Also there were many more skilled stonecutters who were available to produce such works in the New England states. This graveyard is in many ways similar to the historic graveyard of St. Anne's (Protestant Episcopal) Church at Church Circle in Annapolis, Maryland, 40 miles away. At St. Anne's can be found several flat gravestones with carved skulls and crossbones or "death-heads" dating from the 1690s. The surviving stones there, which have sculptured relief panels, mostly contain motifs suggestive of the nearness of death for man on earth.

For many years the Christ Church Graveyard served as the Alexandria burying ground, regardless of creed. Burials were restricted to church members, however, in 1809. By 1815 almost all interments were stopped because of the lack of remaining space. Below the Palladian window of Christ Church is located the grave of William Ramsey, one of the founders of Alexandria and its first lord mayor. One of the many colonial Virginians buried here is Colonel Philip Marsteller, a pallbearer at George Washington's funeral. The most interesting epitaph can be found on the grave of Anne Warren, famous actress who died at nearby Gadsby's Tavern in Alexandria in 1808. In 1879, the remains of thirty-seven Confederate soldiers were reinterred in a mass gravesite near the North Washington Street side of the churchyard.

The adjacent Georgian building of Christ Church was designed by architect James Wren and built by James Parsons and John Carlyle, 1767–1773. The church is constructed of Virginia brick laid in English and Flemish bond, with stone trimmings from the Aquia Creek quarry, south of Alexandria. In 1818 the interior gallery, as well as the bell tower, was constructed. Christ Church is the most important church historically in Alexandria. Not only was George Washington a regular worshipper here, but many other well-known Northern Virginians, including Robert E. Lee, were members. It was immediately after attending morning service at Christ Church on April 21, 1861, that Lee was offered command of the Confederate Army of Virginia. Many American presidents have attended services here, usually on the Sunday nearest to George Washington's birthday. In 1942, President and Mrs. Franklin Delano Roosevelt and Britain's Prime Minister Winston Churchill attended morning services and sat in Washington's pew. The interior of the structure contains many original eighteenth-century Georgian details, including the handsome, finely lettered wooden tablets on each side of the pulpit. The graveyard and church are open daily to the public.

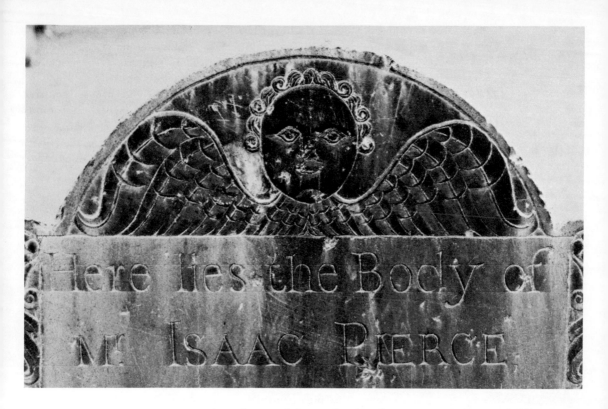

E-23

Title Isaac Pierce Gravestone, 1771

Location Christ Church (Protestant Episcopal) Graveyard, North Washington and Cameron Streets, Alexandria, Virginia

Sculptor Unknown

Architect None

Medium Slate

A crude, round, human head with wings attached on each side appears at the top of the relief panel of the *Isaac Pierce Gravestone*. Pierce, a native of Boston, most likely was living in Georgetown, Maryland, at the time of his death in 1771. The stone, which was definitely carved in New England, was probably ordered by his family and then sent by ship back to Georgetown. With the passage of strict health laws in the District of Columbia in the 1870s and with the opening of many new city streets and widening of others, almost all of the eighteenth-century cemeteries within the city were relocated. It was probably at this time that both the Pierce and Mumford stones were moved to the Christ Church Graveyard. Both of these stones face west rather than the customary direction of east, indicating that they were not originally installed in the cemetery here in the eighteenth century. The design of the Pierce stone, fairly popular in New England during the last half of the eighteenth century, represents the soul of the deceased ascending to heaven on Resurrection or Judgment Day. The Puritan faith in New England held that the soul of the deceased must wait for Resurrection Day when its fate would then be decided. Those to be saved would ascend to heaven while those persons who had sinned on earth and who were not forgiven would be damned for eternity in hell. This sculptured tombstone is one of the few surviving eighteenth-century works in the metropolitan Washington area. The inscription of the stone reads:

Here lies the Body of Mr. Isaac Pierce, Born in Boston, Son of Mr. Isaac Pierce, Distiller, Who departed the Life March 26th 1771, Aged 24 Years

There was little indulgence in symbolism by the colonial New England Puritans except in the case of the rituals surrounding death. In most New England towns of this time, where the people had little affluence, it seems surprising that a great amount of money, trappings, and ceremony were indulged in the case of a death in the family. Not only the gravestone itself but the burial rituals were often expensive, especially in Boston. It was not uncommon for the total burial expenses to come to half of a year's wages. The horses which drew the wagon carrying the coffin were often draped with cloth painted with the symbols of death. These motifs included winged death-heads (skulls with wings on each side or with crossbones), crossed bones, picks and

shovels, imps of death and even coffins. Guests were invited to the funeral by sending gloves and gold funeral rings by messenger—frequently over 100 pairs had to be purchased for this ritual. The relatives and friends invited to the funeral were expensively attired in great "mourning cloaks," fine gloves, large white neck scarfs, and gold mourning rings (engraved with angels, coffins, and often the initials of the deceased). Occasionally the funeral sermon was printed and distributed to those who had attended the services. Following the burial the family of the deceased held an open house for friends where large quantities of food and wine were consumed. In the case of the poorest of the population such expensive funeral rituals could not be performed.

Funerals were considered more significant than marriage, for death was conceived of as a spiritual marriage between Christ and the soul. The motifs used on many Puritan gravestones of the seventeenth and eighteenth centuries represented this interpretation of death. The symbols and rituals surrounding death were considered as acts of faith. Since tombstones were not often imported from England, the native New England carver was forced to find other sources for motifs, including copying designs from emblem books and broadsides printed in the mother country. As time went on many vernacular designs developed in rural sections which were quite different from those found in England. The extent to which New Englanders stressed the importance of carved tombstones never occurred in the South during the colonial period because of a completely different outlook on religion.

Title CAPTAIN GEORGE MUMFORD
GRAVESTONE, 1773
Location Christ Church (Protestant
Episcopal) Graveyard, North
Washington and Cameron Streets,
Alexandria, Virginia
Sculptor John Bull
Architect None
Medium Slate

This gravestone consists of a design of incised lines in the curved top
of the slab which includes a crudely designed human head and shoul-
ders with a scythe which has cut an hourglass in half. The unusual
symbolism here, executed by the Newport, Rhode Island, stonecarver
John Bull (1734–1808), is not clearly understood today. The grave-
stone of Elizabeth Coggeshall, who was buried in 1773 in Newport,
Rhode Island, is practically identical in both design and execution to
the *Captain George Mumford Gravestone.* Allan Ludwig in his schol-
arly *Graven Images* has reproduced the Coggeshall stone. The Mum-
ford stone could represent the Grim Reaper cutting short mankind's
time on earth. On the other hand the figure could symbolize the soul
of the deceased. This stone, like the adjacent Pierce stone, was prob-
ably moved here from a colonial cemetery in Georgetown in the District
of Columbia in the 1870s. The inscription below the relief, with the
original spelling and punctuation, is as follows:

> This Monument sacred to the Memory to the once lov'd & estem'd
> Cap't George Mumford, late of New London, in the Colony of
> Connecticut. He departed this Transitory Life at George Town,
> July 7th 1773 in the 28th year of his age. Behold Fond Man See
> here thy Pictur'd Life Pass some few Years thy flowery spirit Thy
> Summers ardent strength. Thy sober Autumn fading into age &
> pale concluding Winter comes at last & Shutts the Scene.

The carvings on New England tombstones often acted as symbols
for extolling the virtues of heaven and the eternity of the soul. Nar-
ratives from the Bible were not considered as suitable for portrayal as
relief panels on tombstones since they were considered to be related to
Roman Catholic art and were hardly tolerated or desired in the Puritan
world. The Puritan emblems suggested the rewards of the just. Tradi-
tional Christian symbols, such as the cross or the figure of Christ never
appeared. Carvings included many symbols of transformation or the
voyage of the soul through death to a new life. The death-head, or
winged skull, was a frequent motif used to suggest the victory of death
over life, which was in turn the beginning of life for the soul as it
traveled from death to paradise. The Puritans held these death symbols
in less dread than modern Christians for it was then believed that the
passing of the flesh was the renewal of life through the release of the
soul. Death and Time were commonly shown as partners, illustrated by
the winged skulls and the hourglass. In Rhode Island during the
eighteenth century it was common to symbolize Time by the use of a
scythe cutting an hourglass in half as on this gravestone; the design of
this figure was, however, quite rare.

Title ELEANOR WREN GRAVESTONE,
1798
Location Christ Church (Protestant
Episcopal) Graveyard, North
Washington and Cameron Streets,
Alexandria, Virginia
Sculptor Unknown
Architect None
Medium Sandstone

The *Eleanor Wren Gravestone* in the graveyard of Christ Church in
Alexandria, six miles from Washington, D.C., contains a very sophisti-
cated Neoclassical decoration at the top consisting of a carved urn,
swags and circular geometric rosettes (which may have represented the
soul). This design is common in Boston and Philadelphia for the late
eighteenth century. The color of the stone itself is unusual for the
Washington area, indicating that it may have been carved elsewhere or
that the stone was sent to the Washington area and carved here. The
monument has survived surprisingly well. The inscription follows:

> Erected to the Memory of Eleanor, the wife of Mr. Daniel Wren,
> Who departed this Life the 1st Day of April In the Year of our
> Lord 1798, age 32 Years. Revelation, Chapter XIV, Verse XIII.
> "And I heard a Voice from Heaven saying unto me Write Blessed
> are the dead which died in the Lord from henseforth: Yea faith the
> Spirit that they may rest from their Labors and their Works do
> follow them." This Stone Was placed over her by Order of her
> disconsolate husband who was left with two Children to lament
> her Loss. John William Renwick, her Son, being only three years
> old when his Mother departed this Life and Dina Eleanor Wren,
> Daughter, aged only seven days.

By the beginning of the nineteenth century the typical New England
gravestones with sculpted symbolic motifs were considered crude and
old fashioned. The New Englander then viewed Christianity in a differ-
ent light for the earlier dream of a perfect Puritan civilization in the
New World was realized to be impossible. The stylistic Neoclassical
designs, with their sentiments of restraint and balance and represented
by such motifs as the bent willow, the funeral urn, and the tomb, began
to make their appearance in the United States in the 1780s. By 1800
many coastal towns in America had abandoned their earlier vernacular
tombstone designs for the new fashion of Neoclassical carvings. This
new style became especially popular in the South and enjoyed a longer
life from Maryland southward, extending in time even past the Civil
War. While the new Gothic Revival style was the rage in Boston and
Newport in the 1850s, Neoclassical tombstones continued in full sway
in the Washington area, as evident in their proliferation in Congres-
sional Cemetery on Capitol Hill. Neoclassical details also included por-
trait relief profiles of the deceased, obelisks, and formal swags and
draperies. Thus the charming and vernacular Puritan cemetery stones
of geometric designs and other crude motifs symbolic of death, the
Resurrection, and the soul, represented by the nearby Pierce and Mum-
ford gravestones, succumbed to the Neoclassical style.

E-26

Title ALEXANDRIA CONFEDERATE
MEMORIAL, 1889
Location Prince and South
Washington Streets, Alexandria,
Virginia
Sculptor Casper Buberl after
design of John A. Elder
Architect Unknown
Medium Bronze

This life-size memorial to Alexandria's ninety-seven Confederate dead
was erected by their surviving comrades—the Robert E. Lee Camp of
Confederate Veterans—and dedicated on May 24, 1889. A bronze portrait
of a Confederate private set on a simple granite pedestal, it stands in the
intersection of Prince and Washington Streets near the historical
Lyceum Building. It was here, on the morning of May 24, 1861, that the
young men of Alexandria mustered before marching to join Robert E.
Lee and the Army of Northern Virginia. The soldier faces the South,
hat in hand, arms folded across his chest, his head bowed in sorrow.
Robert E. Lee's tribute, "They died in the consciousness of duty faith-
fully performed," is inscribed upon the north face of the pedestal. This
is one of the most poignant of countless similar memorials to the Con-
federate dead erected throughout the South. The design was taken from
a painting by Confederate veteran John A. Elder, entitled *Appomattox*,
which hangs in the Virginia State Library at Richmond. The sculptor,
Casper Buberl, had earlier created the frieze commemorating the Union
army and navy at the Pension Building in Washington, D.C. Funds for
the memorial were raised through various ingenious expedients, rang-
ing from fairs to lectures by Confederate heroes such as Colonel John
Mosby, the famous "gray ghost." General Montgomery D. Corse, a
commander of the Seventeenth Virginia Regiment in which the Alex-
andrians served, donated, with sardonic humor, the pension he received
from the United States government as a veteran of the Mexican War.
The memorial originally occupied a large grassy plot, ornamented with
urns and a cast iron fence. As the demands of motorists have grown,
this has been reduced to minimal size. Now the memorial is threatened
with an ignominious removal to "Yankee" Fort Ward or to the area of
motels and gas stations at the entrance to Alexandria, where it will no
longer constitute a "traffic hazard." Fortunately, the statue is protected
by an act of the General Assembly, passed in 1890, which states that it
"shall perpetually remain at the site" and that the location "shall not be
repealed, revoked, altered, modified or changed by any future Council
or other municipal power."

Title WOODROW WILSON, 1961
Location Woodrow Wilson
Memorial Bridge, Route 495,
connecting Alexandria, Virginia
and Maryland over the Potomac
River
Sculptor Carl Paul Jennewein
Architect A. Gordon Lorimer
Medium Aluminum

Designed by A. Gordon Lorimer of the Bureau of Public Roads, Department of Commerce, the Woodrow Wilson Memorial Bridge extends for over one mile across the Potomac River from Oxon Hill, Maryland, to Alexandria, Virginia. Midway on the bridge are two aluminum medallions about 5 feet in diameter, each with a profile portrait of Woodrow Wilson. These medallions are found on each side of the traffic tower, and were designed by Carl Paul Jennewein. In 1961, the bridge was dedicated to Woodrow Wilson (1856–1924), the twenty-eighth president of the United States. From the bridge, motorists can command dramatic views north toward historic Alexandria, and south toward Mount Vernon and Fort Washington. This continuous, girded bridge has a tall traffic tower and a drawbridge which permits oceangoing freighters to deliver cargo at the Alexandria docks.

Wilson, born in Staunton, Virginia, was the son of a Presbyterian minister and the grandson of a newspaper editor, who immigrated to America from Ireland in 1808. He received his education at Davidson College, Princeton University, and the University of Virginia before practicing law briefly in Atlanta in 1882. He returned to the academic world and received his Ph.D. degree in history and political science from Johns Hopkins University in 1886. Wilson served as a professor at Bryn Mawr College, Wesleyan University, and Princeton University, before becoming president of the latter institution in 1902. As governor of New Jersey, 1910–1912, Wilson achieved a national reputation through his successful program of social and economic reforms. His two terms as Democratic president of the United States, 1913–1921, were concerned with domestic reforms, such as tariff reforms, anti-trust laws, railroad reforms, and the establishment of the Federal Reserve banking system. Although he attempted to keep America out of World War I, he also was alert in building up the military forces of the Nation as an act of preparedness. With the victory of the Allies in 1918, Wilson assumed personal direction of the conference in Paris to make the peace terms in 1919. His failure to achieve the "Fourteen Points," which he proposed as a just settlement of World War I, was

an important factor in subsequently leading to World War II twenty years later. Dispirited because of the failure of Congress to admit the United States to the newly formed League of Nations, and suffering from serious illness, Wilson left the White House in 1921 to live in retirement from political affairs at his residence at 2340 S Street, NW, in Washington. Following Wilson's death in 1924, his widow, Edith Bolling Galt Wilson, continued to live in the house until her death. The house, containing many personal mementos, was left to the National Trust for Historic Preservation by Mrs. Wilson in 1962. Open daily to the public, this Neo-Georgian structure is one of the most authentic and noteworthy house museums in the city.

The Woodrow Wilson Bridge was constructed by the Bureau of Public Roads at a cost of 15 million dollars and was opened on December 28, 1961.

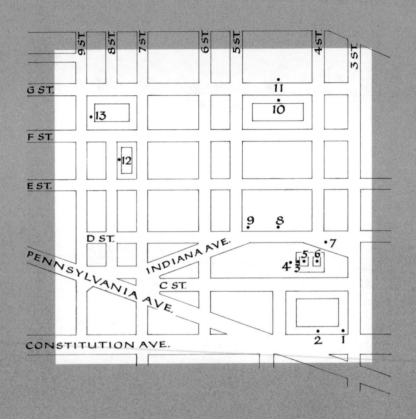

9 ST. 8 ST. 7 ST. 6 ST. 5 ST. 4 ST. 3 ST.

G ST.

• 13

• 11

10

F ST.

• 12

E ST.

• 9 • 8

D ST.

INDIANA AVE.

• 7

PENNSYLVANIA AVE.

4 • 5 6 3

C ST.

CONSTITUTION AVE.

2 • • 1

N

0 ¼ MI.

JUDICIARY SQUARE, an elongated rectangular area of approximately three blocks, is bounded by Fourth, Fifth, D, and G Streets, NW. Located on high ground overlooking the Mall, it is occupied primarily by buildings housing the federal and district courts.

In 1802, a jail was erected on the northeast corner of the Square. In 1842, this structure was converted into an insane asylum and hospital for soldiers and sailors. Two years later the Soldiers' and Sailors' Asylum, or Washington Infirmary, was turned over to the medical faculty of Columbian College for use as a training facility. As the National Medical College, it was enlarged by Congress several times; during the Civil War the building was requisitioned for use as a military hospital. On November 3, 1861, it was destroyed by fire.

The Old City Hall, a particularly fine example of early Greek Revival architecture, was designed by George Hadfield, one of the architects of the Capitol. Construction began on a site on the south side of the Square in 1820 but was not completed until 1849. Plans to finance the project through a lottery failed when the lottery manager embezzled the funds. In desperation, the impoverished city turned to the federal government for aid. In 1823 Congress appropriated $10,000 toward construction costs in exchange for housing the circuit court in the east wing of the building. In the aftermath of the Panic of 1873, the structure was turned completely over to the federal government for use as courts. The bankrupt city government moved its offices to rented quarters elsewhere.

In 1882, the federal government erected the red brick Pension Building on the north side of Judiciary Square. The land between this building and the Old City Hall—by then the U.S. District Court—was developed as a park. Informal plantings and winding paths similar to those designed by landscape gardner Andrew Jackson Downing for Lafayette Square, the Ellipse, and the Mall were used. In 1910 the U.S. Court of Appeals Building, by architect Elliott Woods, was begun at Fifth and E Streets. This was the first of the twentieth-century court buildings which have been constructed on the Square. These later buildings were designed in a modernized Classical style to harmonize with the Old City Hall Building.

The area to the north and east of Judiciary Square was once a fashionable residential neighborhood, prized for its convenient location, healthful elevation, and unobstructed views of the city. Today the fine mansard-roofed Victorian blocks of homes have all but disappeared; those that remain are run down and decaying. They house cheap hotels, small businesses, lawyers, and bondsmen. Construction of the huge General Accounting Office Building just outside the Square on G Street opposite the old Pension Office Building was completed in 1951. In the mid-1960s the old Patent Office Building on F Street, two blocks to the west of Judiciary Square, was remodeled to house the National Portrait Gallery and the National Collection of Fine Arts. Today the area figures prominently in downtown urban renewal planning. The new Metro Headquarters Building at Fifth and F Streets, NW, completed in 1974, has done much to revitalize the neighborhood. An expanded District of Columbia government center is projected around the Judiciary Square nucleus. This will serve as a focal point to development on each side of the Square, linking Union Station, which will be converted into a visitors' center, with the downtown commercial area.

F-1

Title Sir William Blackstone,
ca. 1920 (erected 1943)
Location Constitution Avenue
and 3rd Street, NW
Sculptor Paul Wayland Bartlett
Architect Unknown
Medium Bronze

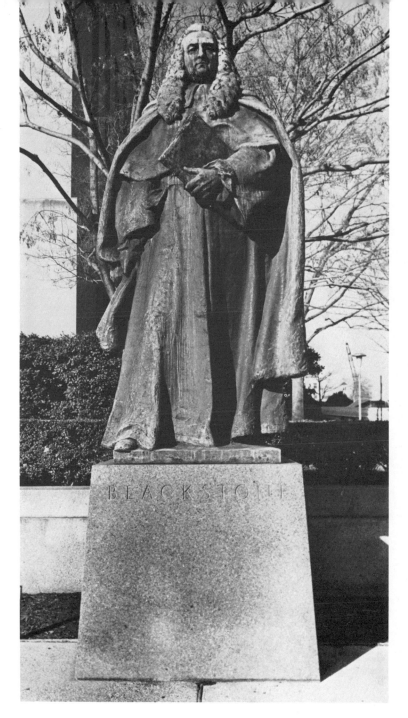

Sir William Blackstone, whose legal *Commentaries* aided the men who drafted the United States Constitution, was born at Cheapside, London, in 1723. As a student at Oxford his interests vacillated between law and poetry; manuscripts of his poetry compared with his later successes indicate he did well to choose the law. In 1758, he began lecturing at Oxford and was soon granted the University's first full professorship of law. These lectures provided the basis for *Commentaries*, a book which clarified English law. The artist has represented Blackstone standing in judicial robes, his stern countenance framed by the ceremonial wig, holding *Commentaries* in his left hand.

The statue was presented to the United States by the wife of the sculptor, to commemorate the ties which bind this nation with England. Originally it was intended to be a gift from the American Bar Association to the English Bar Association. It was decided, however, that the piece, which is 9 feet tall and 4 feet wide, was too large to stand with the other statues in the Hall of Courts in London. As a result, Bartlett designed a smaller replica for the English Bar Association.

F-2

Title TRYLON OF FREEDOM, 1954
Location Federal District Court
Building, Constitution Avenue
between 3rd and 4th Streets, NW
Sculptor Carl Paul Jennewein
Architect Justement, Elam and
Darby
Medium Granite

*Southeast face portraying the
freedoms of the press, speech and
religion*

The 24-foot-high *Trylon of Freedom* was unveiled on February 1, 1954, to mark the final completion of the new federal district courthouse. The sculpture represents the separation of powers of the American government among the legislative, executive, and judicial branches. The north side of the trylon faces the courthouse, typifying the judiciary branch; the southeast side faces the Capitol to symbolize the legislative branch; while the southwest side is exposed toward the White House to represent the executive branch.

The north side, facing away from the street, contains relief carvings of the Great Seal of the United States superimposed above a portion of the Declaration of Independence and the Preamble to the Constitution. Below these appear a quotation from Article V of the Bill of Rights: "No person shall be . . . deprived of life, liberty or property, without due process of law."

On the southeast face are scenes representing the right to trial by jury, and protection against cruel and unusual punishment and illegal search and seizure. At the bottom is a courtroom scene with a man standing before the judge, and with a jury deliberating in the background. The middle scene depicts a man mediating between the prisoner and his executioner. In the topmost panel, which portrays illegal search and seizure, is a wharf scene with seized goods lying scattered on the ground.

The southwest face depicts the freedoms of press, speech, and religion. Beginning at the bottom, sculptor Jennewein has pictured two men at a printing press; over them is an orator expounding his views to a crowd. Above the listeners are a kneeling woman, a man standing before a cross, and two tablets, which presumably represent the Ten Commandments. The granite monument was carved after Sculptor Carl Paul Jennewein's model by Vincent Tonelli and Roger Morigi.

F-3
Title MUNICIPAL CENTER DOORS,
1941
Location Municipal Center
Building, 300 Indiana Avenue, NW
Sculptor Nathan C. Wyeth,
designer
Architect Nathan C. Wyeth
Medium Cast aluminum

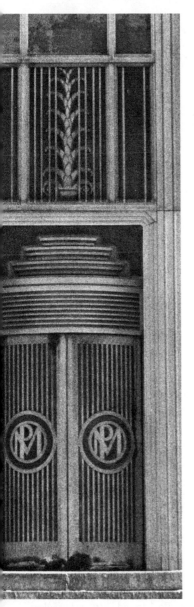

Nathan C. Wyeth's Municipal Center for the District of Columbia government, erected in 1941, is an imaginative and amusing adaptation of Classic style to the Art Deco idiom. The structure faces the early Old City Hall, designed in the Greek Revival style, and is integrated with it by means of a plaza on the west with a vista down to Constitution and Pennsylvania Avenues. Wyeth's use of bold cubic masses suggesting Classic form is similar to that of the twentieth-century buildings within Judiciary Square proper. On this building this severity is tempered with incised geometric design indicating the egg-and-dart motif, Corinthian capitals, fluting, triglyphs, and metopes—the latter on a narrow curved surface. Office fenestration, occurring between suggested columns, is organized vertically on a rectilinear grid pattern worked out in aluminum.

Cast aluminum entrance doors are the *pièce de résistance* of the building. Curving out from the building to enclose interior revolving doors, their streamlined design is emblazoned with the monogram "MP"—Metropolitan Police. Above, and also in aluminum, a streamlined plant form appears to be behind bars. Subsidiary doors incorporate a rising sun and lightning bolts into a similar design. At the corner of the building nearest to the Old City Hall is the Police Memorial fountain; a massive octagonal shape, it is decorated with mosaics of marine forms. A rusticated polished red granite base extends around the building; this material is repeated in the ornamental curbing.

Although the *Municipal Center Doors* are rarely noticed by the public, a citizen can hardly miss the District of Columbia flag which is displayed above the building and in dozens of offices and corridors within. The District of Columbia has been in existence since 1791, but it was not until 1938 that an official flag was adopted. In that year Congress authorized a contest for the design of the banner. The design submitted by Mr. and Mrs. J. Moultrie Ward of Washington and based on the family crest of George Washington was approved over the twenty-nine other entries. The United States Fine Arts Commission approved the Ward design of three red stars and two red bars on a field of white. The other two designs submitted which were closely considered and hotly debated included a picture of the Capitol dome and a large eagle.

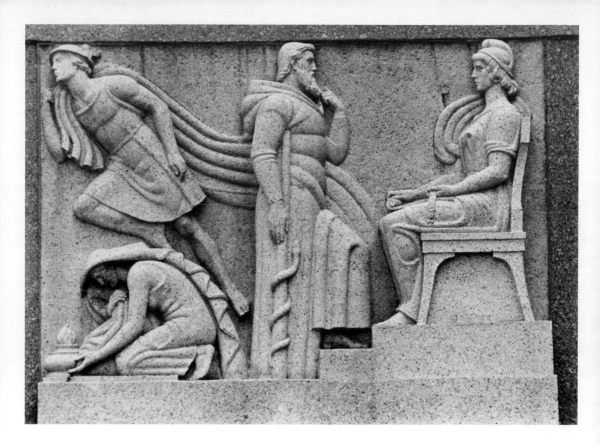

F-4
Title Urban Life, 1941
Location Municipal Center
Building, 300 Indiana Avenue, NW
Sculptor John Gregory
Architect Nathan C. Wyeth
Medium Granite

This high-relief panel, located at the west entrance to the Municipal Center Building of the District of Columbia, was designed by John Gregory, who also created the pier reliefs at the C Street entrance to the Federal Reserve Board and the relief panels representing Shakespeare's plays at the Folger Library. Here, various aspects of organized urban life are allegorically shown: courts, hospitals, business, and sanitation. The Courts are represented by Maia, the mother of Mercury by Zeus; Aesculapius, god of healing, symbolizes Hospitals; Commerce is represented by fleet Mercury, and the Sanitation Department by Vesta, goddess of the hearth. Maia sits in profile at the east end of the panel; Aesculapius, the physician, is standing before her with his staff; Mercury, with a wind-swept cloak, is behind him, and at Mercury's feet is Vesta, crouching over her lamp.

A model for the west flank of the entrance was submitted by Lee Lawrie. This panel was to have symbolized Light, Water, and Thoroughfare. In the center, it depicted a woman, Columbia, pouring water into a basin held by a mother and child on the left, while on the right she holds a lamp to light the way for her departing assistant. Holes which developed in the granite when the piece was two-thirds completed prevented further work. The city extracted $5,000 from the contracting company for supplying the faulty granite. Postponed until after World War II, the whole affair seems to have been forgotten, and the panel remains boarded up in its unfinished condition.

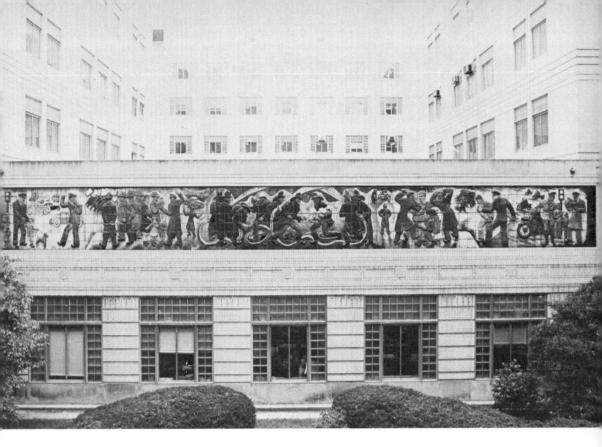

F-5

Title DEMOCRACY IN ACTION, 1941
Location Municipal Center, 300
Indiana Avenue, NW
Sculptor Waylande Gregory
Architect Nathan C. Wyeth
Medium Low-relief ceramic tiles

Democracy in Action, an enormous ceramic sculpture, approximately 81 feet long and 8 feet high, is located on the east wall of the west open-air courtyard of the Municipal Center Building, above the first floor windows. This work, considered to be the largest ceramic sculpture in the world at the time it was completed, has been hidden away from public view for over 32 years in one of the two interior courtyards of this vast building. This work is composed of over 500 separate tiles, each measuring approximately 14 inches square and glazed in both pastel and dark shades. The principal colors of the work are blue, tan, and buff, while the minor colors consist of red, pink, yellow, and orange. The tiles, set against a façade of buff-colored brick, were created by modeling raw terra-cotta clay and then dried, glazed, and fired. *Democracy in Action* was created by Waylande Gregory, one of the greatest American ceramic sculptors in this century, who was noted for his *Fountain of the Atoms*, erected near the main entrance to the New York World's Fair of 1939 and the colossal *Light Destroying Darkness* fountain in Roosevelt Park near New Brunswick, New Jersey.

The fifty life-size, low-relief figures in this composition depict the functions of the District of Columbia Police Department, Fire Department, and of the Department of Motor Vehicles. The frieze is inscribed in the lower right corner: "Designed and executed/Waylande Gregory." The five scenes of the frieze portray, left to right, traffic officials directing vehicles at a busy downtown intersection, traffic officials helping pedestrians along a sidewalk while a crowd of demonstrators carry placards in the background, firemen fighting a fire with water hoses while a child is carried to safety wrapped in a blanket, police apprehending criminals on foot, and the police motorcycle squad stopping to return a lost dog to a concerned boy.

Shortly after Gregory's frieze was installed in the summer of 1941, it received much unfavorable public comment because of one scene showing policemen in the act of grabbing a criminal by the neck and hitting him with a club. In response, Paul Manship of the United States Fine Arts Commission called the mural "superb, simple in its design, vigorous in action and beautiful in its color scheme."

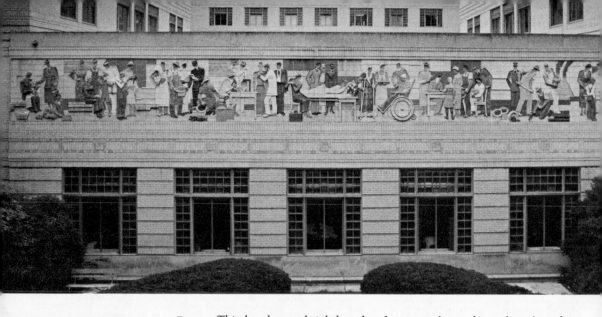

F-6
Title HEALTH AND WELFARE, 1941
Location Municipal Center, 300
Indiana Avenue, NW
Sculptor Hildreth Meiere
Architect Nathan C. Wyeth
Medium Low-relief ceramic tiles

This handsome, brightly colored ceramic frieze, located 18 feet above the ground on the west wall of the east open-air courtyard of the Municipal Center, is a masterpiece of Art Deco design. The work, unsigned, is by sculptor Hildreth Meiere of New York. The frieze, of approximately the same size as its companion piece by Waylande Gregory in the west open-air courtyard of the same building, 81 feet in length and 8 feet in height, can be viewed from the first floor east hallway of the interior of the building. Serious art students can gain admission to the courtyard for a closer study by applying to the guard's office on the first floor near the C Street or rear entrance to the Municipal Center. Although often referred to commonly as the "Police Department Headquarters Building," the Municipal Center actually houses five major offices of the local government: The Metropolitan Police Department, the Department of Finance and Revenue, the Department of Human Resources (health services), the Department of Motor Vehicles, and the Department of Vital Statistics.

The *Health and Welfare* ceramic frieze is much lighter and more cheerful in tone and feeling than the other nearby frieze, consisting of a tan background with blues, yellows, greens, oranges, browns, and white. The work portrays the public health and welfare benefits offered to the citizens of the Nation's Capital. The frieze actually consists of ten different scenes which are designed closely together. From left to right, a social worker is shown helping a mother with two children while nearby a physician and nurse give medical aid to a family of six. The next scene portrays an inspector looking at agricultural products offered for sale by a Washington butcher, fruit grower, baker, and fisherman. The four central panels show three municipal hospital scenes: two chemists work in a hospital laboratory, a physician inspects two patients, and a nurse and three visitors stand before a bed talking to a patient while a government nurse brings medicine to a group of three patients in the geriatrics ward of the hospital. The frieze terminates toward the right end with three scenes: two families apply for Social Security before a desk with two officials, an inspector watches a group of workers laying bricks with the brick kiln in the background, and a young couple apply for the adoption of a boy in front of a city official's desk. The sculptor has created a feeling of liveliness in the forty-seven figures portrayed by designing the faces of the persons in the background in a concave design while the persons in the foreground have faces in relief. The entire work contains bold, massive, and simple lines which complement the solid patches of color. The subjects of these two friezes are typical of the New Deal art of the Great Depression—the benefits of government services to the people.

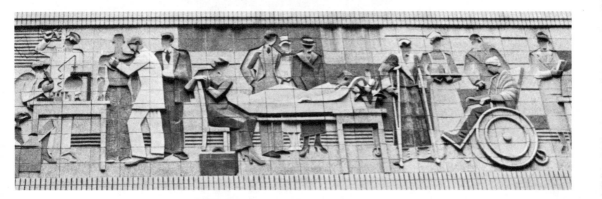

Only four sculptors entered the competition for the design of these two ceramic friezes. The jury, consisting of Nathan C. Wyeth, Lee Lawrie, George Harding, and Duncan Phillips, was chosen in early 1940 to judge the entries. Miss Meiere, the sculptor, received $25,000 for this work from the federal government as part of the Works Progress Administration art patronage. Although Waylande Gregory actually executed his frieze for the west courtyard, Miss Meiere employed the Atlantic Terra Cotta Company to produce her frieze from detailed drawings which she completed.

Title BRIGADIER GENERAL ALBERT
PIKE, 1901

Location 3rd and D Streets, NW

Sculptor Gaetano Trentanove

Architect Unknown

Medium Bronze

A Massachusetts school teacher, an acclaimed poet, a restless Western adventurer, a politically powerful newspaper editor and publisher, a prominent lawyer, an early advocate of a transcontinental railroad, a veteran of the Mexican War, an Indian expert, a Confederate general who only fought one disastrous battle, a high Masonic official and chief interpreter of Masonic rite, Albert Pike possessed a free-ranging intelligence and untrammeled independence of spirit which propelled him through a kaleidoscopic life. At the end of his life, the Ancient and Accepted Scottish Rite of Freemasonry erected this memorial to him on public land. That made him the only Confederate general to be so honored in Washington, although it must be admitted that he is in civilian dress and is presented as a Masonic leader rather than as a military man. The memorial consists of an heroic 11-foot standing bronze of Pike on a lofty and substantial granite pedestal of early Beaux-Arts design. Broad of brow, with flowing hair and ample paunch, Pike holds a large book in his left hand, perhaps his popular *Morals and Dogma of the Ancient and Accepted Scottish Rite of Freemasonry*. At his feet, on a ledge halfway down the west face of the pedestal, the Goddess of Masonry holds the banner of the Scottish Rite. She is in Greek dress, informally posed, looking downward and to one side as, with knees crossed, she dangles her sandled feet. In recent years the District of Columbia Division of the United Daughters of the Confederacy—ignoring Pike's infamous use of Indian troops at Pea Ridge and his irreconcilable quarrels with Jefferson Davis and other Confederate leaders—have held ceremonies at this memorial honoring him as a Confederate general. The monument was removed in late 1972 for subway construction, but present plans call for the replacement of the prominent Mason in the same location by 1975.

Title ABRAHAM LINCOLN, 1868
Location D Street, between 4th and 5th Streets, NW
Sculptor Lot Flannery
Architect Frank G. Pilerson
Medium Marble

LINCOLN

The reaction of the citizens of Washington to the assassination of Abraham Lincoln was intensely emotional. Within days they had begun to raise funds through popular subscription to erect a statue in his memory in front of their city hall, now the U.S. Courthouse. Lot Flannery, a Washington sculptor who had known Lincoln, received the commission. The statue was dedicated on April 15, 1868, the third anniversary of Lincoln's death, and was the first public monument to Lincoln. President Andrew Johnson, whose impeachment proceedings were underway, was present at the dedication. The statue is made of marble and originally stood on a column variously reported as 35 to 40 feet high. A life-size, standing figure, it portrays Lincoln as lawyer and statesman. His right arm is extended in a speaking gesture while his left hand rests on the Roman emblem of union. The right foot is forward and to the right as the body and head turn somewhat stiffly to the left. The eyes are deep set; the facial planes are boldly modeled. This is a charming and naive sculpture, appropriate as the spontaneous expression of the sorrow of the people in the city where Lincoln was assassinated. During enlargement of the Courthouse in 1919–1920, the statue was removed and placed in storage. Though government officials protested that the statue was the work of a "gravestone maker" and was not needed now that the Lincoln Memorial was under construction in West Potomac Park, a great public outcry rose on its behalf. On April 15, 1923, it was reerected on a simple low granite pedestal. The statue is badly in need of repair. The right hand especially, replaced earlier in too large a scale, needs to be recarved.

F-9

Title JOSEPH DARLINGTON
FOUNTAIN, 1923
Location Judiciary Park, 5th and
D Streets, NW
Sculptor Carl Paul Jennewein
Architect Unknown
Medium Gilded bronze

No sermon or eulogy was delivered at the funeral of Joseph James Darlington. There was simply a half hour of quiet, during which his friends and associates could "reflect and meditate on the living sermon which Mr. Darlington had enacted." This was "more effective, comprehensive and grand than any sermon even Bossuet could have preached or any eulogy that the greatest orator or poet could have pronounced." Darlington, a prominent and respected member of the District of Columbia Bar, led an exemplary life. His personal and professional integrity, his deep religious conviction, and his generosity toward his fellowman were legendary. Born in Due West, South Carolina, in 1849, he attended Erskine College for Boys and was a member of the first class graduated after the Civil War. He worked for several years as a teacher in South Carolina and Georgia; then, with a letter of introduction from former Confederate Vice President Alexander H. Stephens, came to Washington and entered Columbia Law School. He was soon launched into what was to become a brilliant career.

This memorial fountain was erected, shortly after his death, by Darlington's friends of the Washington Bar Association. Life-size figures of a nymph and fawn stand on an octagonal pedestal in the center of a low circular pool. Pedestal and pool are of marble; the pool is lined with pebbles. Water pours from four brass spouts on the pedestal. The nymph turns as if to protect the weak and innocent fawn; both figures are delicate and graceful, an effect heightened by the gilding. The nudity of the nymph raised protests from Darlington's fellow-Baptists; however, to this the sculptor sanctimoniously replied that the lady was "direct from the hand of God instead of from the hands of a dressmaker."

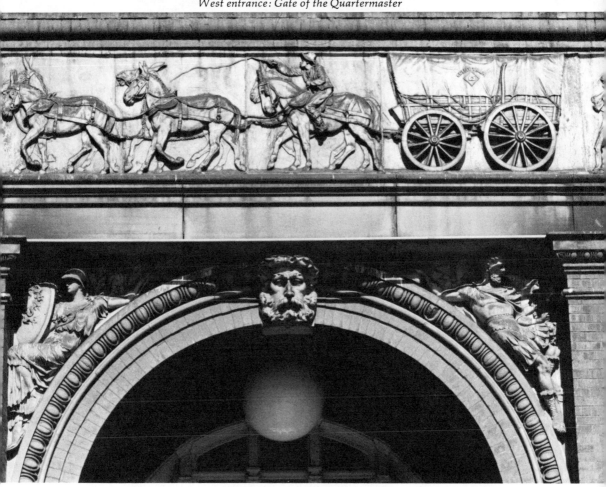

F-10
Title UNITED STATES SOLDIERS AND
SAILORS OF THE CIVIL WAR, 1882
Location Pension Building,
between 4th, 5th, F, and G
Streets, NW
Sculptor Casper Buberl
Architect Major General
Montgomery C. Meigs
Medium Terra-cotta

General Montgomery C. Meigs was a man who could perform the impossible. A West Point-trained engineer, he built the Washington Aqueduct and raised the dome of the Capitol. During the Civil War he served brilliantly as Lincoln's quartermaster general. Meigs had traveled in Europe, and he had a passion for exciting architectural spaces and fine sculpture. The Pension Building, designed by him in 1882, was inspired by the sixteenth-century Palazzo Farnese in Rome. Typically, he incorporated his own ideas into the structure: brick and iron fireproof construction, a roofed courtyard lighted by great clerestory windows. The building was to be used to disburse pensions to Civil War veterans, and the exterior is embellished with sculptures celebrating the deeds of the Union Army. A buff terra-cotta relief frieze, 3 feet high and 1,200 feet long, runs around the building between the first and second stories. It realistically depicts naval, infantry, cavalry, artillery, quartermaster, and medical units on active duty. Two smaller friezes appear above the second and third floor windows. One shows upright cannon and bombs bursting, while the other has a design of crossed swords, stars, and cannon balls.

Entrances in the center of each façade are ceremonially treated. That on the north is designated Gate of Invalids; on the west, Gate of the Quartermaster; on the south, Gate of the Infantry; and on the east, Naval Gate. Each of these designations is illustrated by that portion of the frieze directly above it. In addition, allegorical figures adorn the spandrels of the entrance arches; Justice on the north and Truth on the south represent Peace, while Mars on the east and Minerva on the west portray War. This fascinating building has always excited critical comment. Civil War General Philip H. Sheridan, proudly shown through by Meigs, was asked what he thought of it. "I have one fault to find with it," he commented laconically, "It's fireproof."

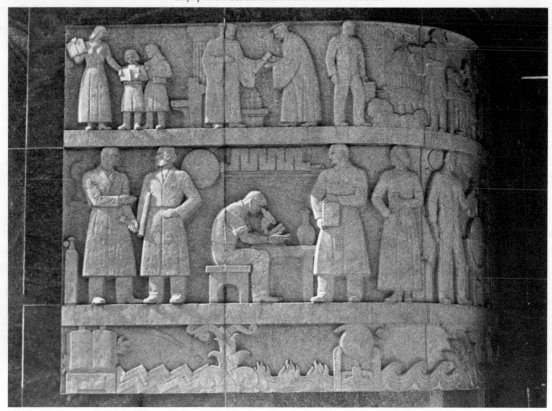

F-11

Title AMERICAN PROFESSIONAL
WORKERS and AMERICAN LABORERS,
1951

Location General Accounting
Office Building, 441 G Street, NW

Sculptor Joseph Kiselewski

Architect Supervising Architect of
Public Buildings, General Services
Administration

Medium Granite

When completed in 1951, the General Accounting Office Building was the largest office structure in downtown Washington and was also the first federal office structure to be built without wings or internal courts. Seven stories high, it makes maximum use of almost a full city block of ground space. Construction was begun in 1941, then was halted as steel and other building materials essential to the war effort became unavailable. In the Art Deco style of the late thirties, the simple cubic form of the building is relieved through rich textural articulation of its surfaces. The structure is faced with deeply striated squares of buff limestone set in a decorative pattern. At ground level a wide band of polished red granite runs completely around the building, curving in toward recessed entrances in the center of the F and G Street façades. At the G Street entrance, opposite the ornate Pension Building, these curving granite walls are carved in bas-reliefs. On each side of the entrance the bas-relief is about 9 feet in height by 15 feet in length and depicts, on the left, professional people at work and, on the right, laborers. The carvings are organized into three tiers of different heights with the central tier predominating. The figures are stylized, executed in the simplified rectilinear Art Deco manner, and organized into a limited number of planes. The conception of each figure is generalized and impersonal, and much use is made of conventionalized symbols. The bas-reliefs are purely decorative in intent, providing an especially rich textural surface to define the entrance area. They are subordinated to the architecture to the extent that nearby columns almost obliterate the inner sections from view. A shallow porch extends over the doors, designed in a complementary Art Deco style with stylized, streamlined American eagles cast in aluminum. Similar carvings by Lee Lawrie, Kiselewski's teacher, designed for the H Street entrance, were approved by the Fine Arts Commission but never constructed becaue of lack of funds. Lawrie's design included the portrayal of American Trade, Industry, Religion, Education, Science, and the Security of the Family. The Art Deco sculpture of the exterior of this building was continued on the interior with the streamlined aluminum panels by Heinz Warneke on and around the elevator doors just inside the G Street entrance.

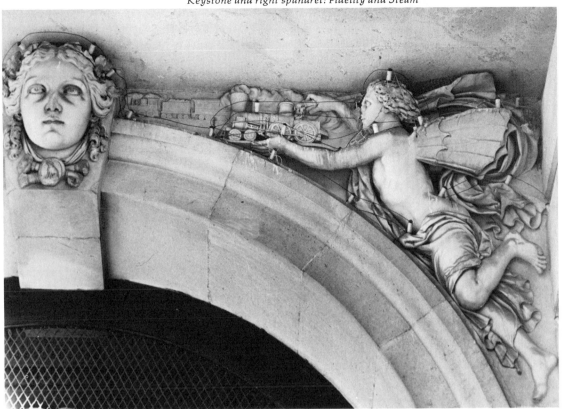

F-12

Title ELECTRICITY, FIDELITY, AND STEAM, 1856

Location United States Tariff Commission (Old Post Office Department), 8th Street, between F and E Streets NW

Sculptor Unknown

Architects Robert Mills; Thomas U. Walter

Medium Marble

The Old Post Office Department Building, now occupied by the United States Tariff Commission, is a finely proportioned Classic Revival building designed by Robert Mills. Construction of the south wing began under Robert Mills in 1839, and that of the north wing, under Thomas U. Walter in 1855. The capitals of the columns and pilasters are of an especially interesting original design, described by Mills as "bolder in outline, and more delicate in. . . detailed finish" than the conventional Corinthian columns which they resemble. The building was completed about 1866. These sculptures, carved in high relief over the arched carriage entrance on the Eighth Street side, were erected in 1856, as shown in an original dated photograph in the Columbia Historical Society. On the left spandrel, a winged female figure symbolizing Electricity holds aloft a lightning bolt in her right hand, a scroll in her left. On the right spandrel, a winged male figure symbolizing Steam holds a smoke-belching locomotive. The wings of the female figure are beautifully feathered; those of the male are webbed. Both figures are depicted in flight with blowing drapery disarrayed, creating lively curvilinear patterns. The keystone of the arch is carved with a large female head symbolizing Fidelity. These figures have reference to the postal service, Electricity being associated with the telegraph, and Steam with rapid delivery of mail by train. Unfortunately, they have been mutilated by the installation of an obviously ineffectual antistarling device. A bronze plaque on the Seventh Street side of the building reads: "Samuel F. B. Morse, artist and inventor opened and operated on this site under the direction of the Post Office Department the first public telegraph office in the United States, April 1, 1845. 'What hath God wrought.' " This plaque, placed here in 1913, was designed by Henry Bacon, architect of the Lincoln Memorial, and executed by Henry Hering, a student of Augustus Saint-Gaudens.

The site of the Old Post Office Department was first occupied by Blodgett's Hotel and Theatre. This structure, designed by James Hoban and begun in 1795, was offered as first prize in a lottery promoting the sale of lots in the new capital. In 1810 it was purchased by the federal government to house the Post Office Department, the City Post Office,

and the Patent Office. It was the only government building to survive the British invasion of Washington during the War of 1812. Architect William Thornton, then commissioner of patents, intervened, reportedly crying, "Are you Englishmen or only Goths and Vandals? This is the Patent Office, a depository of the ingenuity and inventions of the American nation, in which the whole civilized world is interested. Would you destroy it? If so, fire away, and let the charge pass through my body." The following winter, Congress convened here. In 1836 Blodgett's Hotel was entirely destroyed by fire, with the result that the present building was begun in 1839.

F-13
Title PEGASUS AND BELLEROPHON, 1967
Location National Collection of Fine Arts/National Portrait Gallery Building, 9th Street between F and G Streets, NW
Sculptor Jacques Lipchitz
Architect None
Medium Bronze

This sculpture was cast from a model for the 40-foot *Pegasus and Bellerophon*, commissioned by the Columbia University School of Law in the mid-sixties. Exhibited in the United States Pavilion at the Hemisfair, on Long Island, New York, in 1968, it was eventually brought to Washington on an indefinite loan from the artist and was installed near the entrance to the National Collection of Fine Arts. The subject is taken from the ancient Greek myth of Bellerophon, who subdues the winged horse, Pegasus, and flies heavenward on his back. Bellerophon, the son of the king of Corinth, had to run away because of having accidentally killed a man; he settled in Tiryns, another city of Greece, with King Proitos. The wife of the king fell in love with Bellerophon who refused her advances and, as a result, became the object of her wrath. Bellerophon managed to mount Pegasus when he came to drink from the Horse's Fountain, or pool of poetic inspiration. While riding Pegasus he was able to slay the monster Chimaira. Bellerophon was able to train and ride Pegasus because of a golden object given to him by the goddess of wisdom, Athena; this device enabled Bellerophon to master the mind of the winged horse. After a great struggle, however, Pegasus was able to throw Bellerophon off his back as he attempted to ride up to Mt. Olympus, home of the gods. Bellerophon was thus crippled and remained an outcast throughout his life.

According to sculptor Lipchitz, "Pegasus is the wild force of nature. Bellerophon is man harnessing these forces, bending them to his use. In codified form, these forces become man's laws." The small, squarish body of Bellerophon, with its powerful thick hands and arms, serves as a pivotal point to the cacophonic rhythms unleashed by the flashing hooves, the beating wings, the terrible contortions of Pegasus' struggling body. With a heavy rope Bellerophon pulls the fiery steed from the heavens; the head is twisted backwards, the mouth is open, the eyes are bulging with pain and fright. One of the wings pushes ineffectually at Bellerophon's head, the other is stretched heavenward like a huge imploring hand. The pedestal offers Bellerophon slim footing, thus focusing on the enormity of his heroic act. The work, powerfully organized, with its vigorous rounded forms boldly modeled, measures approximately 12 feet in height and 6 feet in width.

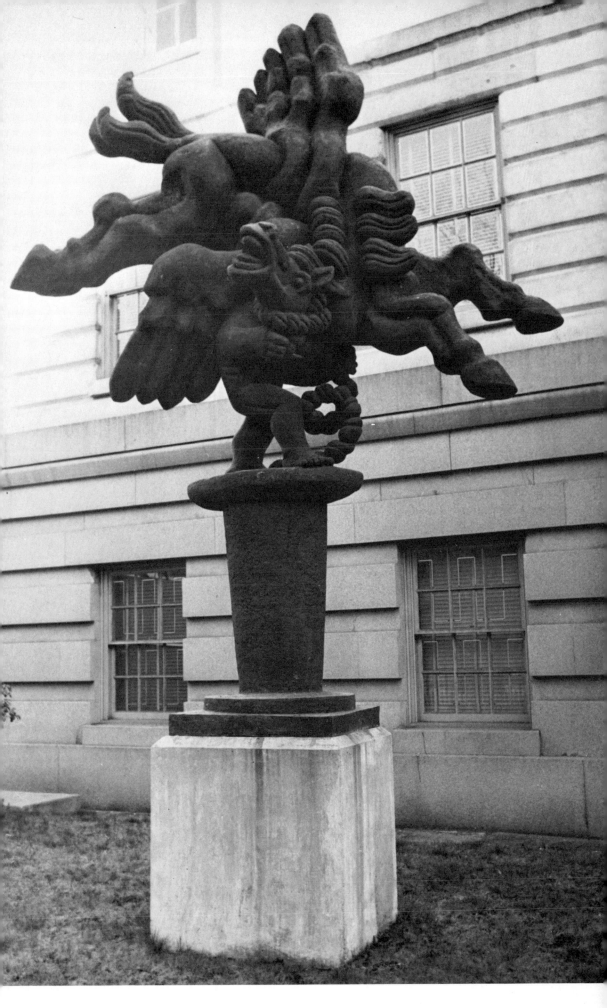

G

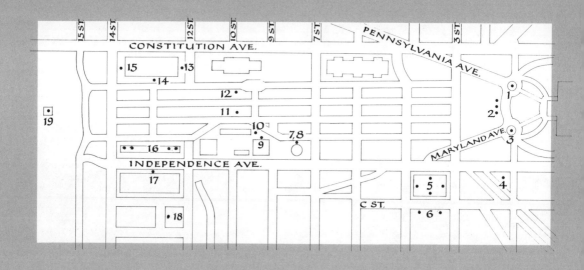

THE CONCEPT OF THE MALL—that broad sweep of lawn separating the United States Capitol Building and the White House—began with the original 1791 design of the city by Pierre Charles L'Enfant. The "Grand Avenue," as he called it, was to run a mile in length and 400 feet in breadth, bordered by gardens and houses of diplomats. This Grand Avenue was to terminate near the present site of the Washington Monument where an equestrian statue of General George Washington was to be placed on the axis with the White House. This statue had been voted by the Continental Congress in 1783, then meeting in Philadelphia, the temporary capital, for placement at the permanent capital of the country when that choice was settled. A canal would form the north boundary of this Grand Avenue. The Ellicott plan of the Mall of 1792 was essentially the same design. Ellicott, however, envisioned a national university on the Mall between Tenth and Twelfth Streets. The noted architect, Benjamin Latrobe, drew up plans for the university in 1816, but Congress failed to act on these plans. It is from these plans that Thomas Jefferson is thought to have derived many features for the University of Virginia, which he designed in 1818 and which opened in 1825.

Between 1810 and 1820, Latrobe constructed the Washington City Canal for a private corporation along the present route of Constitution Avenue. The canal originated at the Potomac River, near Seventeenth Street and Constitution Avenue, followed Constitution Avenue to Sixth Street where it cut across the Mall, moved around the south side of the Capitol, and terminated at the Anacostia River. This canal, never a success because of the high cost of maintenance and the competition from railroads that began in the 1830s, was covered over in the 1870s.

One of the earliest uses of the Mall was for the Botanic Garden established by Congress in 1820 near the west lawn of the Capitol. In 1846, Congress again granted a large area, between Ninth Street and Twelfth Street, on the south side of the Mall, to the newly chartered Smithsonian Institution. The following year construction began on the fashionable Romanesque Revival red sandstone Smithsonian Institution Building, designed by James Renwick, Jr., of New York; it was first occupied in 1849. In 1848, sixty-four years after Congress had made the first proposal for a memorial to the first president, it granted a 37-acre site to the Washington Monument Society for the erection of the 555-foot Egyptian obelisk designed by the South Carolina architect, Robert Mills.

Owing to the inability of Washington residents to get to the rather isolated Smithsonian Institution Building from downtown Washington because of the acres of mud which then comprised the Mall, Congress commissioned Andrew Jackson Downing, pioneer landscape architect from Newburgh, New York, to landscape the Mall. Much of Downing's design of romantic circular drives and paths, set amid gardens of native American evergreen trees and shrubs, was completed after his sudden death in 1852.

In 1855, Congress authorized the War Department to erect a three-story Armory Building at Seventh Street on the Mall. During the Civil War this structure was used as the Armory Square General Hospital. The entire section of the Mall between Third Street and Seventh Street nearby was covered with hospital tents, where Clara Barton and Walt Whitman offered their services to help the wounded. After the war the Armory was used by the United States Fish Commission, which also maintained large pools for the breeding of fish near the Washington Monument. During the Civil War, the grounds near the Washington Monument became the Washington Monument Cattle Yard, where cattle were slaughtered for meat for the thousands of Union troops then protecting the city from attack by the Confederate Army.

The first experiments for the use of the balloon in warfare were conducted on the Mall by Professor Thaddeus S. C. Lowe, chief of the Aeronautic Service, Balloon Corps. Just after the Civil War, in 1867, because of its deteriorated condition, control of the Mall was turned over to the War Department by the District of Columbia government. The Mall at that time was commonly known as "murderer's row" because of the use of the area by escapees and deserters.

The following year, 1868, Congress granted the area between Twelfth Street and Fourteenth Street, sw, to the Agriculture Department. The original building, in Second Empire style, designed by the Washington architect Adolph Cluss, stood at Fourteenth Street and Independence Avenue (then B Street, sw) until 1930. Another invasion of the Mall occurred in 1873, when Congress authorized the erection of the Baltimore and Potomac Railroad Station at the corner of Sixth Street and Constitution Avenue (then B Street, nw).

Although the railroad station was a setback to L'Enfant's design, the Army improved the Mall by finishing the Washington Monument in 1886 and creating West Potomac Park. Because of the centennial celebrations for the existence of the District of Columbia as the seat of the federal government in 1900, a movement was begun to restore the Mall to L'Enfant's original design of 1791. Spurred on by the recommendations of the American Institute of Architects, Congress created the McMillan Commission of 1901, composed of the Nation's leading architects, Daniel H. Burnham, Frederick Law Olmsted, Jr., Charles F. McKim, and the sculptor, Augustus Saint-Gaudens, who proposed to clear the Mall of the trees and gardens and the obstructions erected during the post-Civil War years.

This plan was not carried out completely until 1933, when Congress created the National Park Service which took over control of the Mall from the War Department. The last important improvement, in the 1960s, and the early 1970s, was the destruction of the temporary buildings on the Mall which had been erected as emergency temporary office buildings during both World War I and World War II. In 1960 the names of the four roads on the Mall were changed to Madison, Washington, Adams, and Jefferson Drives. The new design for the Mall, the Owings Plan of 1965, calls for the eventual elimination of motor traffic and the return to the Mall of activities to draw the public. The new reflecting pool at the east end of the Mall was finished in 1971 and adds much to the beauty of the area. A second reflecting pool, circular in design, was constructed opposite the National Archives Building in 1972–1974. In October 1974, the new Joseph H. Hirshhorn Museum and Sculpture Garden will be opened near Seventh Street; the new National Air and Space Museum Building on the opposite corner is still under construction. Innovations which help greatly to humanize the Mall include the recently established historical bus tours of the Mall for the public; the carrousel and a full-size dinosaur model for the children; and the American Folklife Festival on the Mall, jointly sponsored by the Smithsonian Institution and the National Park Service, which brings many folk art practitioners to Washington to illustrate American crafts and skills each summer.

Title PEACE MONUMENT, 1877
Location Pennsylvania Avenue
and 1st Street, NW
Sculptor Franklin Simmons
Architect Edward Clark, Architect
of the Capitol
Medium Marble

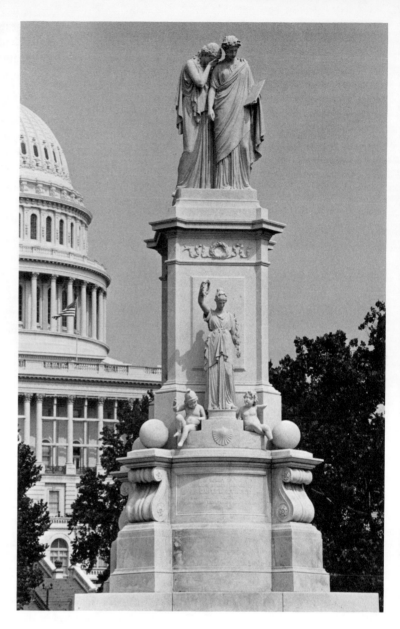

The Peace Monument, originally known as the Navy Monument, was executed by sculptor Franklin Simmons, in Rome, after a rough sketch by Admiral David D. Porter. The two allegorical female figures at the top represent America weeping on the shoulders of History over the loss of her naval defenders during the Civil War. History makes a record of these heroes in the book she holds; they are honored by the inscription on the page, "They died that their country might live."

Midway up the western or front side of the monument, facing Pennsylvania Avenue, is the figure of Victory holding a laurel wreath and an oak branch over the infant Neptune, god of the sea, and Mars, god of war. Thus, triumphant Victory crowns the sacrifices of the officers, seamen, and marines who carried on the naval warfare of the Civil War. A quatrefoil basin surrounds the 40-foot-high memorial with fountain jets provided on each side.

On the rear side of the monument, facing the Capitol Building, Peace is represented by a Neoclassical statue having an idealized face; a cherub is on each side. She extends in her right hand the olive branch, while her left arm sustains the drapery which covers the lower part of the figure. Nearby, a dove is resting upon a sheaf of wheat, which, with the horn of plenty and the broken ground on the right, indicate Agriculture and Plenty. On the other side are emblems of Science, Literature, and Art, symbolizing the progress which comes with Peace.

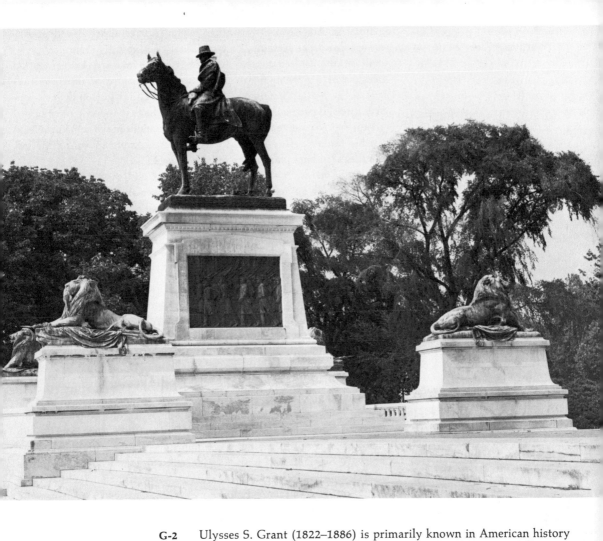

G-2
Title GENERAL ULYSSES S. GRANT
MEMORIAL, 1922
Location Union Square, east end
of the Mall
Sculptor Henry Merwin Shrady
Architect Edward Pearce Casey
Medium Bronze and marble

Ulysses S. Grant (1822–1886) is primarily known in American history as the most important military leader for the Union during the Civil War. He was born the son of a tanner in Seat Pleasant, a village southeast of Cincinnati, Ohio. After graduating from West Point, Grant served in the Mexican War but ultimately resigned as a captain from active duty in 1854. Between that date and the outbreak of the Civil War in 1861, Grant was a failure in all of the careers in which he briefly engaged—farmer, customshouse clerk, real estate dealer, and leatherstore clerk. Early in the war he was commissioned as colonel of the 21st Illinois Volunteers. By his bold action, Grant captured Paducah, Kentucky, in the early months of the war which helped prevent that border state from seceding. He then electrified the North by capturing Fort Henry and Fort Donelson, the northern boundary of Confederate control in February 1862 and prevented the further advance of Southern troops. Grant was made a major general by President Abraham Lincoln for these two important Union victories. Although he lost many men under his command, in July 1863 he captured Vicksburg, a strategic city in the control of the Mississippi River. After taking Chattanooga and Missionary Ridge in late 1863, Lincoln promoted Grant to the rank of lieutenant general—the first officer to acquire that rank since George Washington in the 1790s. In March 1864, he was made commander in chief of all United States Armies, over one-half million men. His final assignment was to take Richmond, the capital of the Confederacy. Grant stayed in the field and personally commanded the Army of the Potomac. On April 9, 1865, Grant accepted the surrender of General Robert E. Lee and the last major Confederate army at Appomattox, Virginia. Grant's generous terms of surrender were strongly criticized by many bitter Northerners and on the other hand won for him respect through much of the prostrate South. In 1866 Grant became the first full

general in American history, then served briefly under President Andrew Johnson as secretary of war. Grant's ill-fated two terms as president of the United States, 1869–1877, were marked by corruption because of his inexperience in politics and because of ill-chosen advisers. Soon after leaving the White House, Grant lost all of his property through poor business investments. Perhaps his second most heroic action was to complete his memoirs that he might make some provision for his family before his death. They were completed during his last months of intense pain from a terminal case of cancer.

The *Grant Memorial*, located at the east end of the Mall on First Street between Pennsylvania Avenue and Maryland Avenue, constitutes one of the most important sculptures in Washington. The memorial includes a centrally located equestrian statue of General Grant on a high pedestal with two sculpture groups of military figures at each end of the large marble platform, which measures 252 feet in width and 71 feet in depth. The memorial was first proposed in 1895 by the Society of the Army of the Tennessee, which Grant had formerly commanded. In 1901 Congress passed the Hepburn Act, authorizing the expenditure of $250,000 for the memorial and establishing the Grant Memorial Commission to select a sculptor and to supervise the preparation of the memorial. During the public competition for a sculptor in 1902, a jury which included Augustus Saint-Gaudens and Daniel Chester French, chose a design submitted by the relatively unknown young New York sculptor, Henry Merwin Shrady (1871–1922) from among twenty-seven models submitted by twenty-three sculptors. A furor resulted from this decision, since many who entered the competition, such as Franklin Simmons, George Julian Zolnay, Solon Borglum, and Charles H. Niehaus, were established and experienced sculptors who felt that this project, the largest ever commissioned by the Congress at that time, should not go to a relatively unknown artist. Charles H. Niehaus, who came in second place in the contest, demanded a retrial. The commission was again awarded to Shrady who quietly began his work amid charges that Saint-Gaudens was influenced in his decision by the fact that the 31-year-old Shrady came from a wealthy and socially prominent New York family.

Sculptor Henry M. Shrady in his New York studio with his sons, ca. 1902

Shrady, a graduate of Columbia University in 1894, was engaged in business for several years as the president of the Continental Match Company of New York, a firm owned by his brother-in-law, Edwin Gould, but was forced to leave because of an attack of typhoid fever. During three years of recuperation, Shrady began to sketch animals at the Zoological Gardens in the Bronx Park. He taught himself to sculpt, winning acclaim for his *Moose* and *Buffalo* at the 1901 Pan-American Exposition in Buffalo, New York, and his bronze equestrian statue of *George Washington* for the Williamsburg Bridge Plaza in Brooklyn. Shrady, amid many trials and tribulations, devoted the remaining twenty years of his life constantly to the Grant Memorial, the most extensive bronze sculpture cast in the United States at that time. A meticulous study of Civil War history and military trappings was made by the sculptor before work began. Not only did the secretary of war authorize the loan of actual Civil War uniforms to the sculptor but a number of military posts, including West Point, cooperated by conducting special artillery and cavalry drills to demonstrate the movement of troops for the benefit of the young sculptor. To gain a first-hand knowledge of military practices, Shrady even joined the New York National Guard for four years' service.

Work progressed slowly as Shrady sought and gained delays in the date for the completion of the enormous memorial. A tremendous uproar ensued over the location of the memorial, first proposed for the Ellipse. President Theodore Roosevelt and others objected because the memorial would block the view from the White House to the Potomac

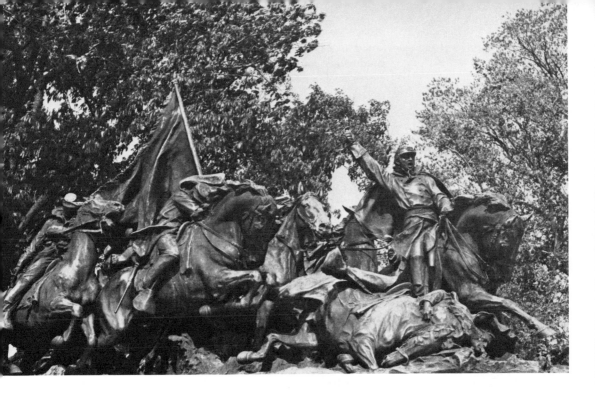

Cavalry River. The Grant Memorial Committee finally decided to locate it at the east end of the Mall. This decision then resulted in a massive protest from many Washingtonians because three large trees would be destroyed. The superintendent of the nearby Botanic Garden unsuccessfully took the case to court. Finally, in 1909, the enormous marble superstructure was laid and four large bronze lions were erected around the base of the empty pedestal. These lions, which guard both the United States flag and flags of the American Army, somewhat resemble Barye's famous lion watching the serpent. They are mostly decorative, but also reflect the qualities of strength and majesty and complement the dignity and calmness of the figure of Grant above.

The equestrian statue of Grant was erected on the pedestal in late 1920 while the *Artillery Group* was placed on the site in 1912 and the *Cavalry Group* in 1916.

The horse, similar to the Kentucky thoroughbred used by Grant, was selected for study by Shrady from among 300 belonging to the New York Police Department. Shrady carefully dissected a number of horses to learn their anatomy and watched countless military parades. He would even turn the water hose on his live equestrian model to observe the ripple of his muscles under the wet hide. Shrady has portrayed Grant in a characteristic attitude, sitting calmly with slouched shoulders and with an old battered hat observing a battle in the distance. The alertness of the animal as he hears the roar of musketry and as his nostrils catch the scent of battle is in striking contrast with the calm intenseness of the rider. Even in the midst of the most fierce engagements, Grant was known to have sat serenely upon his charger, "Cincinnatus," and whittle a stick. Shrady received details about Grant's personal characteristics from his father, Dr. George Shrady, who had attended the general in his last illness and from General Frederick Dent Grant, the general's eldest son. The sculptor studied the life mask of Grant in the Smithsonian Institution for facial proportions, the width of cheekbones, and other authentic characterizations. Grant is shown without a sword, since he rarely wore one while directing a battle. The equestrian statue is 17 feet and 2 inches high, weighs 10,700 pounds, and rests on a marble pedestal 22½ feet tall. The word "Grant" is the only inscription found anywhere on the enormous memorial.

On each of the two sides of the pedestal is inserted a large low-relief

bronze, referred to as the *Infantry*, which show the infantry in action. One panel portrays an officer with a raised sword who turns to encourage his marching men bearing long shoulder rifles. The other includes a column of marching infantrymen, wearing greatcoats and bedrolls and carrying flags and rifles. A drummer boy marches in front. The reliefs, designed by Shrady on paper shortly before his death, were modeled by sculptors Edmund Amateis and Sherry Fry and were not installed until some years after the dedication. For these panels, as well as for other parts of the memorial, Shrady executed many rough pencil sketches before making the finished drawings. His son has preserved many of these sketches made on the backs of envelopes and scraps of paper. It is not known to what extent Amateis and Fry contributed to the design of the relief panels since they were finished after Shrady's death.

To the left or north of the equestrian statue of Grant is the famous *Cavalry Group* of the memorial. This group of seven horsemen of the color squad of a cavalry regiment making a charge onto the field of battle possesses more dramatic interest and suspense than any sculpture in the city and, indeed, in the Nation. The lead horse carries the commanding officer who, with drawn sword, is giving the command to charge. One almost expects to hear the bugle notes from the bugler who has just caught the command to charge. His chest is expanded and his position tense. The viewer is immediately struck with the impending tragedy of the cavalryman who with his horse has suddenly fallen to the ground. Only the rider to the immediate rear of the fallen soldier is aware of the plight of his comrade. He has instinctively thrown back his arm while he is desperately pulling up his horse to avoid the fallen horse and rider ahead. The horse's jaw is pulled out of line because of the taut rein. Shrady himself posed as a model for the fallen trooper, using a mirror to capture his own features as he worked. The faces of the other men in the group are modeled from Shrady's friends, such as Edward Penfield, Ernest Thompson Seton, Maxfield Parrish, and Jerry Bogardus. Shrady so strived for accuracy with these figures that he modeled the lead horse, carrying the officer with drawn sword, nine times before he was satisfied. It is interesting to note the thumb prints of Shrady preserved on this bronze lead horse.

To the right or south of Grant is found the *Artillery Group*, a caisson carrying a cannon and three soldiers while being pulled by three horses, one bearing the guidon carrier. The viewer would assume initially that the guidon or staff has been portrayed incorrectly since it is flying against the wind. It accurately demonstrates, however, that while the movement and action is forward, the leader has violently thrown the guidon around as a signal to those seated soldiers behind for a sharp right wheel. One also wonders why two of the horses are beginning to stop while the third continues forward at a violent speed. A close inspection of the trappings of the horses will reveal that the strap has broken on the bridle bit of the lead horse so that the driver is unable to immediately curb his motion. Note the tense muscles and swollen veins of the struggling horses from a front view. The three men sitting on the gun carriages all bear different expressions. The left figure, with upturned coat collar, holds grimly to his seat and appears to have no thought other than keeping his equilibrium. The middle figure, with a face drawn with physical effort, depicts the utmost weariness. The right soldier, with a mustache, has an eager interest in all that is going on—his eyes go beyond the plunging horses to the battlefield to which the gun is being pulled. He appears quizzical, analytical, and quite studious. A small bronze plaque on the rear of the *Artillery Group* lists three West Point cadets, class of 1908, who served as models: Fairfax Ayres; James E. Chaney, a retired major general who is still living; and Henry J. Weeks.

Infantry

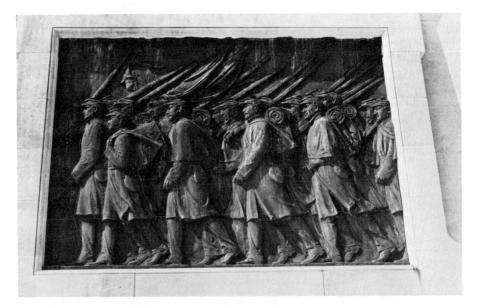

Artillery

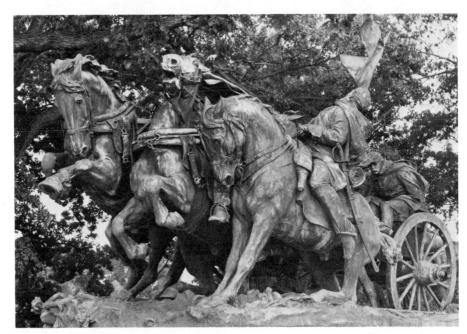

Detail: faces of the
three artillerymen
on the caison

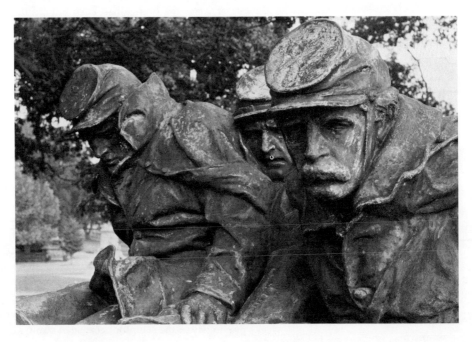

Even the bronze ground on which both the *Artillery Group* and the *Cavalry Group* maneuver is accurate. In both cases the terrain is deeply rutted with stumps of trees, fallen branches, broken sabers, rifles with bayonets fixed, a canteen with frayed strap, and other battle debris. All heighten the realism of activity and illustrate Shrady's infinite pains with every detail yet subordinating them to the emotion and movement of the actual figures in the drama.

It is indeed a miracle that Shrady completed this momentous project with such excellent results and with such little training and experience. The sculptor's son, a New York architect, Henry Merwin Shrady, Jr., explained one of his father's many problems in executing the *Grant Memorial* in a recent letter to the author:

When the full size Artillery Group in plaster was loaded on the truck at my father's studio to be taken to the foundry, the truck caught fire. The fire was put out and the group got to Brooklyn [to the Roman Bronze Foundry owned by Ricardo Bertelli]. A few days later, after the bronze had been poured into the moulds, the foundry burned down. My father nearly lost his mind. John Archibald, who was very fond of my father, packed the family off on his yacht for three weeks, [during] the time that Bertelli begged the Fire Chief to leave the ruins of the building untouched. After the three weeks had passed and the foundry ruins were slowly sifted, it was found that an enormous steel beam had fallen across the moulds and kept the rest of the building, as it fell in, from touching the moulds. When the bronze had cooled for the full twenty-one days, the group came out unharmed as you see it today.

The memorial was dedicated on April 27, 1922, the centennial of Grant's birth. An elaborate military parade proceeded from the White House down Pennsylvania Avenue to the east end of the Mall for the dedication. President Harding at that moment was dedicating the house in which Grant was born at Point Pleasant, Ohio. Thus, Vice President Calvin Coolidge and General of the Armies John Pershing gave the principal addresses at the *Grant Memorial* in Washington. Grant's granddaughter and great-granddaughter unveiled the equestrian statue. The dedication of this monument, which is as much a memorial to Shrady as it is to Grant, was only marred by one event—the death two weeks previously of the sculptor because of strain and overwork.

G-3

Title PRESIDENT JAMES ABRAM GARFIELD MEMORIAL, 1887
Location First Street and Maryland Avenue, sw
Sculptor John Quincy Adams Ward
Architect Unknown
Medium Bronze and marble

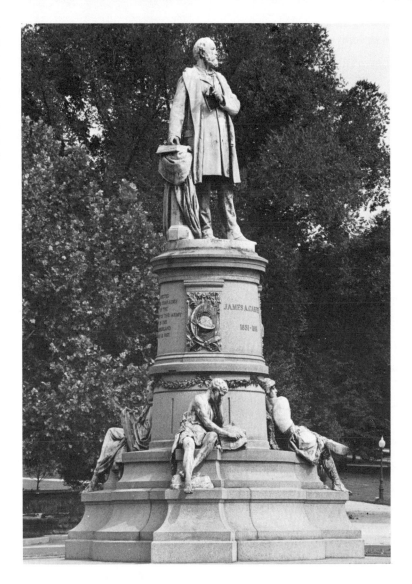

James Abram Garfield (1831–1881), a native of Ohio, is one of the more obscure United States presidents. Born in a log cabin to a pioneer farming family, Garfield worked his way through Williams College (class of 1856) and then taught at Hiram College. His academic successes were repeated on the field of battle, where during the early part of the Civil War, he commanded a regiment of Union infantry composed mostly of his old students. He rapidly advanced to the rank of major general and was appointed chief of staff of the Army of the Cumberland. In 1863 he resigned from the army and was elected to the U.S. House of Representatives, a position he held until he became the Republican president in March 1881.

Garfield, after only three months in office, was shot on July 2, 1881, at the Baltimore and Potomac Railroad Station by Charles J. Guiteau, an erratic lawyer and disappointed office seeker. For almost three months Garfield was confined to bed, first at the White House and then at a summer resort at Elberon, New Jersey, where he died on September 19, 1881. Garfield's two sons later had prominent positions: James was secretary of the interior under Taft, and Harry became president of Williams College. It is interesting to note that Washington's Gallaudet College commissioned a marble bust of Garfield by Daniel Chester French soon after the President's death. Garfield during his many years in the House was the principal patron of the only college in the country for deaf mutes.

The 9-foot statue was erected by the veterans of the Army of the Cumberland. The sculptor has shown Garfield standing and facing

west, holding in his left hand his inaugural address, on which is inscribed: "Law, Justice, Prosperity." The elaborate Baroque pedestal has three seated allegorical Roman figures at the base, each surmounted by a bronze plaque with motifs relating to that statue. The 5-foot-high statues represent Garfield's three successful careers as a scholar, soldier, and statesman. The composition of the soldier figure bears a striking resemblance to Michelangelo's *Day* to be found on the tomb of Giuliano de' Medici at the San Lorenzo Church in Florence, Italy, and executed in 1531.

G-4
Title BARTHOLDI FOUNTAIN, 1876
Location Independence Avenue and 1st Street, sw
Sculptor Frédéric Auguste Bartholdi
Architect None
Medium Iron

The *Bartholdi Fountain* was cast in Paris and entered in the Philadelphia Centennial Exhibition of 1876, winning many honors. The United States government purchased the fountain for $6,000 at the close of the exhibition and erected it, in 1878, on the grounds of the Botanic Garden, at the center of the Mall near Third Street. In 1927 it was placed in storage for five years while the Botanic Garden was moved from the center of the Mall to its present location at the southwest corner of Independence Avenue and First Street, sw. The fountain, reerected in 1932, is made of cast iron coated with bronze. Because of the deterioration of the coating, it must be painted black periodically to prevent it from rusting.

The fountain was one of the major attractions in Washington during the late nineteenth century, since it was illuminated at night with twelve electric light bulbs, one of the earliest public displays of electric lights in the city. The entire 15,000-pound cast-iron fountain is 30 feet high and rests in the center of a 90-foot-wide marble basin. The fountain itself is supported by a triangular marble base, above which appear three reptiles spouting water. Above these figures are three Neoclassical pillars with composite capitals. Three colossal caryatids, 11 feet high, stand back to back, with their outstretched arms supporting the principal upper 13-foot-wide basin, over which some of the water flows. Twelve Victorian electric lamps are suspended gracefully from the rim of this basin. Above this basin kneel three young tritons, who support an upper member of the fountain with their outstretched arms. A small crown, from which water flows surmounts the entire composition.

At the time of the Philadelphia Exposition, French sculptor Frédéric Auguste Bartholdi (1834–1904) was not entirely unknown in the United States, as he had been chosen to design a monument officially approved by the French government as a gift from France to the American people. In 1871 he visited New York to investigate the project, and while there he developed the idea of a colossal statue at the entrance of the harbor welcoming peoples of the world with the torch of freedom. What was later to become the *Statue of Liberty* had earlier been proposed by Bartholdi as an enormous figure of Progress, to be erected at the entrance of the Suez Canal; but the Canal authorities had rejected the idea.

Shortly after his return from the United States, Bartholdi began work on the figure in his Paris studio, enlisting the help of Gustave Eiffel, creator of the Eiffel Tower, in designing the interior steel supporting frame. The right hand of the *Statue of Liberty*, measuring 16 feet, 5 inches in height, was completed in time to be exhibited, along with his

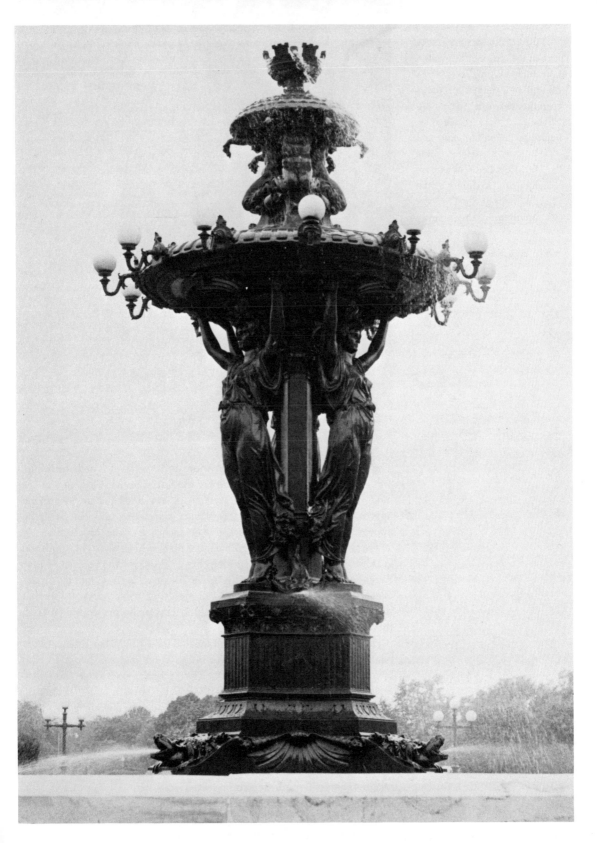

fountain, at the Philadelphia Centennial Exhibition; the hand was later erected for display for several months in downtown New York.

Among Bartholdi's works relating to America are a statue of Lafayette in New York, and one of Lafayette and Washington in Paris. Fond of working on a large scale, he is also responsible for a colossal group in Basel, representing *Switzerland Succouring Strasbourg.* His masterpiece is considered to be the enormous monument *The Lion of Belfort*, which is 36 feet high and 72 feet long, commemorating the heroic resistance of the French city of Belfort against the German siege of 1870–1871.

251 *The Mall*

G-5

Title SOCIAL SECURITY, 1941

Location Department of Health,
Education and Welfare, North
Building, Independence Avenue
entrance, between 3rd and 4th
Streets, SW

Sculptors Emma Lu Davis and
Henry Kreis

Architect Louis A. Simon,
Supervising Architect of the
Department of the Treasury

Medium Polished granite

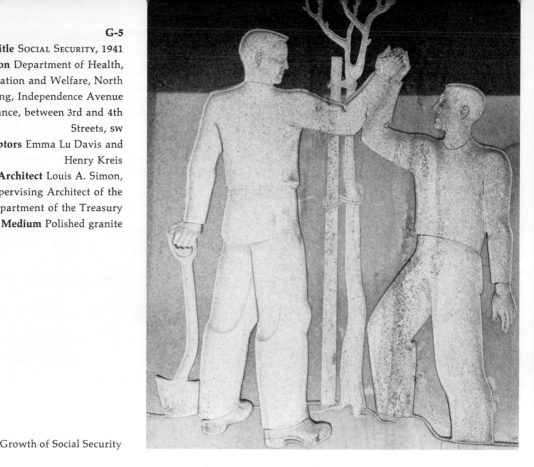

The Growth of Social Security

The Department of Health, Education and Welfare, North Building, was designed as an office building for the Social Security Agency in the modernized Egyptian Revival style. Four overdoor panels measuring approximately 8 feet wide by 9 feet high, all relating to Social Security, appear above the four entrances, one on each side of the structure.

These panels, with curving low-relief incised lines on highly polished granite, were designed by two sculptors working for the Section of Fine Arts, Federal Works Agency in 1938. The Fine Arts Commission requested that the granite panels have highly polished surfaces, so that the carving would be more pronounced; the sculptors complied with this request in 1940.

Henry Kreis executed one panel located over the Independence Avenue door, *The Growth of Social Security*, which pictures two men who have just finished planting a tree. His second panel, over the Third Street door, *The Benefits of Social Security*, shows a man handing an apple, which he has just picked from a tree, to a seated woman.

One of Emma Lu Davis's panels, *Unemployment Compensation*, is located over the Fourth Street door. She pictures a seated dejected worker, evidently jobless, being comforted by a male coworker who is off to the factory carrying his tin lunch pail. Her panel on the C Street façade, *Family Group*, depicts a seated wife with a baby at her feet, saying goodbye to her husband who, lunch pail in hand, is leaving for work.

The fairly recent date of these sculptures reflects the fact that the United States, in contrast to many European countries, was slow to establish any comprehensive plan for administering governmental social services. Previous to the 1935 passage of the Social Security Act, sponsored by Senator Robert F. Wagner of New York, government programs were limited to workmen's compensation, old age and mothers' assistance, and general relief. The new act, now administered by the Department of Health, Education and Welfare, authorizes old age, survivors' and disability benefits; hospital insurance; unemployment insurance; workmen's compensation; and illness insurance.

Title Railroad Employment and
Railroad Retirement, 1941
Location Department of Health,
Education and Welfare, South
Building, 330 C Street, sw
Sculptor Robert Kittredge
Architect Louis A. Simon,
Supervising Architect of the
Treasury Department
Medium Polished granite

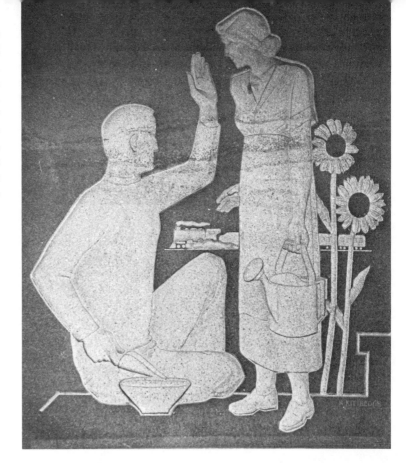

Railroad Retirement

These two relief panels were completed in 1941 for the opening of the new Railroad Retirement Building, erected at the same time as the original Social Security Administration Building immediately to the north. Kittredge's panels over the two C Street entrances are entitled *Railroad Retirement* (left) and *Railroad Employment* (right). In the left panel, a retired railroad employee pauses, while working in his garden with his wife, to wave to a passing steam locomotive in the background. The right panel (not shown here) portrays the interior of a railroad engine cab, with the engineer at the throttle and the fireman stoking the furnace. Both panels measure about 8 feet wide by 9 feet high.

The Railroad Retirement Act was voted into law in 1935, in the same year as enactment of Social Security legislation (see G-5). Complementary to the latter act, it provides similar benefits for one particular group, the workers in the nationwide railway network. It includes a retirement pension system for workers, their spouses, and survivors, and also an unemployment insurance system. This act is under the control of the Railroad Retirement Board, made up of three members appointed by the chief executive with the consent of Congress.

Hirshhorn Museum and Sculpture Garden of the Smithsonian Institution

G7-8

At a White House ceremony on May 17, 1966, President Lyndon B. Johnson announced that Joseph H. Hirshhorn was prepared to donate his famous art collection to the Nation. On November 7 of that year, the Congress of the United States approved "An Act to provide for the establishment of the Joseph H. Hirshhorn Museum and Sculpture Garden" as a unit of the Smithsonian Institution in Washington, D.C.

Said to have been "probably the world's biggest personal collection of modern art," the initial gift numbered more than 1,500 sculptures and over 4,800 paintings and drawings. It also included a small but choice cabinet of prints. Since 1966 the original donor has added several hundred important items in these categories. Although the range is wide, the collection concentrates on a period from the present back to the beginnings of modern art, its focus being on developments in America.

For years this collection had been widely acclaimed by critics in the United States and abroad. Two years before the gift was arranged, the late Sir Herbert Read, one of the foremost art critics in our time, wrote the following to Mr. Hirshhorn: "I have seen many collections, but never one that could rival yours in completeness, in quality, and in display. It is a great achievement and I hope it will remain intact, for the enjoyment of generations to come."

Others felt the same way; and urgent overtures from Great Britain, Israel, and various cities in the United States for its ultimate lodging had been made before Mr. Hirshhorn decided to offer it to the American people through a permanent location in Washington. At an advanced stage of construction as this is being written, the museum building and its adjacent sculpture garden were designed by Gordon Bunshaft for the architectural firm of Skidmore, Owings and Merrill. Situated on the Mall diagonally across from the National Gallery of Art, this imposing structure joins a distinguished company of both old and new buildings which serve the cultural interests of the Nation. Hailing its advent, a *Washington Post* editorial claimed the new museum "the most important development in art for the Capital since Andrew Mellon donated the National Gallery of Art."

The collection itself is an outcome of a characteristic American success story. Joseph Hirshhorn's interest in art began when he was a boy and has kept pace with his expanding career in finance ever since. He was brought to this country from Latvia at the age of six, when his widowed mother and her many children settled, under impoverished circumstances, in Brooklyn. The New York Curb Market, later the American Stock Exchange, caught his youthful fancy, and when fourteen he left a job in a jewelry store to pick up what he could in the financial district. At sixteen he established himself as a broker on the Curb Market with a savings of $255, which grew to $168,000 the first year. By 1929, just two months before the crash, he withdrew $4,000,000 from investment and, as *Current Biography* puts it, "his sagacity in buying and selling has never failed him since." As a boy at home, he had pinned calendar art reproductions above his bed; and, by the time he had his first small office, his compulsion to collect had taken hold. In those days the Curb Market literally conducted business at the curb, and the young Hirshhorn lined his office with etchings bought from a sidewalk artist-vendor. From that time he not only collected art, but befriended many artists as well.

While at one point his fortune was reputed to be in the neighborhood of $100,000,000, his friends say that his successful business affairs never interfered with his passion for art. To them, reports *Current Biography*, "the velocity and quantity of his artistic purchases are consistent with the rest of his character and actions. . . . Such mass buying has given Hirshhorn a private art collection almost unmatched in size. The sculpture collection is truly international, ranging from Etruscan to Henry Moore, but most of his paintings are contemporary American.

As the collection grew, it spilled over from Hirshhorn's two offices, his apartments in Toronto and New York, his homes in Greenwich, Connecticut and the Riviera, into a warehouse."

The Hirshhorn Museum and Sculpture Garden is located south of the National Gallery of Art on the corner of Independence Avenue and Seventh Street, sw. The Sculpture Garden faces the Mall and is centered around a small handsome modern reflecting pool, where visitors may rest on benches to observe the magnificent collection of sixty open-air sculptures.

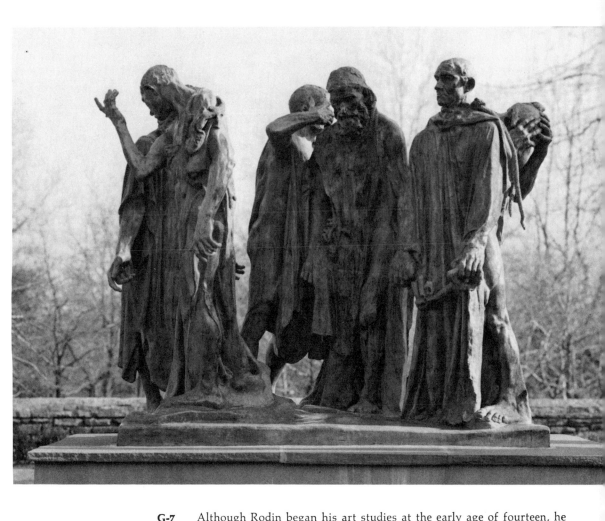

G-7
Title THE BURGHERS OF CALAIS, 1886
Location Joseph H. Hirshhorn Museum and Sculpture Garden, Smithsonian Institution, Jefferson Drive and 7th Street, sw, north front in sculpture garden
Sculptor François Auguste René Rodin
Architect None
Medium Bronze

Although Rodin began his art studies at the early age of fourteen, he was forty before he reached the recognition that brought him commission after commission for the rest of his life. He was forty-four when he started work on *The Burghers of Calais*, producing each figure separately, until the six were ready for grouping and installation in the town square two years later. Casts and studies for the individual figures were exhibited soon after, and a number of these are now distributed in various museums. For his theme, Rodin consulted the chronicles of Jean Froissart, who told of the six townsmen who surrendered themselves to save Calais during the long siege laid by Edward III of England. Rodin shows them barefoot, nooses around their necks, on their way to deliver the keys of the town. The postures, individually and together, are more directly eloquent than speech could ever be. The whole is a deeply moving visual orchestration of shape, texture, movement, and light. A replica of this sculpture has been placed on the embankment at Westminster in London. Overall dimensions are 6 feet 10½ inches high by 7 feet 11 inches wide.

G-8
Title MAN PUSHING THE DOOR,
1966
Location Joseph H. Hirshhorn
Museum and Sculpture Garden,
Smithsonian Institution, Jefferson
Drive and 7th Street, sw, north
front in sculpture garden
Sculptor Jean-Robert Ipousteguy
Architect None
Medium Bronze

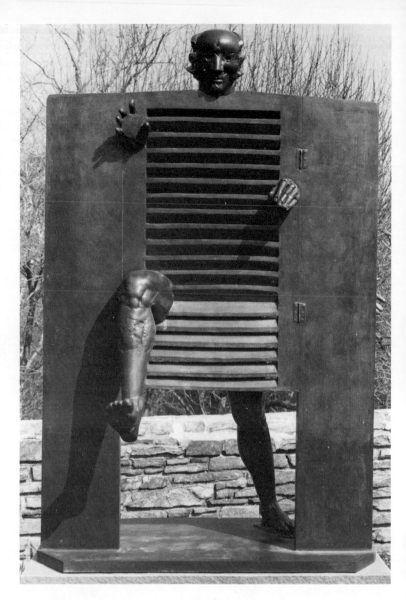

Ipousteguy was a young student in Paris when World War II began.
His work was first shown there while the city was occupied, but recog-
nition came later when he was commissioned to produce a series of
frescoes and stained glass windows for Saint-Jacques-de-Montrouge.
During the 1950s his work appeared in a number of group shows and,
in 1960, was shown in London's famous open-air show at Battersea
Park. Seven years later he was represented in the Guggenheim Inter-
national Exhibit at New York; but prior to that he gave his first one-
man exhibition in Paris, to be followed before long by others in the
United States and Germany. His vision is his own and can scarcely be
pinned down to any trend shared by others. Among the works to be
seen in the Hirshhorn Museum Garden, his statuesque female *Earth* is
comparatively traditional, but the *David and Goliath* shatters its ancient
theme. Although aggressively identifiable, *Man Pushing the Door* is an
even more antic image; nevertheless, its tense contours and sense of
compact energy are in the finest tradition of figurative sculpture. It
measures 7 feet and 5½ inches in height by 4 feet 3 inches in width.

This allegorical Neoclassical sculpture depicts Columbia with arms outstretched over the two seated figures, Science and Industry. Columbia wears a sword and a cloak with a star-encrusted border. Science, on the left, concentrates on reading a large book in her lap while an owl, symbolizing Knowledge, gazes up from her feet. On the right, Industry clasps a surveying tool while other instruments, including an anvil, are grouped around her.

In 1878, the Building Committee for the Arts and Industries Building, composed of Congressman Peter Parker, General William T. Sherman, and Secretary Spencer F. Baird of the Smithsonian Institution, engaged the leading Washington architect, Adolph Cluss (1825–1905), to design the Smithsonian's first separate museum building. Cluss' completely symmetrical structure, in modernized Romanesque style, necessitated a different group of statuary over each of the four entrances. Casper Buberl was to design and execute the four pieces. A second sculpture, *Peace with the Fine Arts,* was modeled in plaster but was rejected by the Building Committee in 1881 due to lack of funds.

The building was first used on March 4, 1881, for James Garfield's Inaugural Ball, when 5,000 invited guests filled the building, one of the city's first to have electric lights. The *Evening Star* reported that the principal interior decoration was a giant plaster allegorical figure, *America,* which stood in the central Rotunda, grasping a large electric light in her uplifted hand, "indictive of the skill, genius, progress, and civilization of the 19th century."

Title ANDREW JACKSON DOWNING
URN, 1856
Location Smithsonian Institution
Building, 1000 Jefferson Drive, SW,
adjacent to east entrance
Sculptor Robert E. Launitz, after
design by Calvert Vaux
Architect None
Medium Marble

The Andrew Jackson Downing Urn was originally erected on the Mall in 1856, near the site of the present National Museum of Natural History, as a memorial to Andrew Jackson Downing (1815–1852), pioneer American landscape architect. Downing's experiments with plant culture and landscape gardening became popular through the publication of his many agricultural and architectural books and periodicals during the 1840s.

Commissioned by Congress to landscape this Mall in 1850, Downing designed a romantic, informal arrangement of circular carriage drives and rare American trees, which resulted in the first landscaped city park in the country. In 1930 the design of the Mall was returned to L'Enfant's original 1791 concept of a great open rectangular lawn extending from the Capitol to the Washington Monument, on the cross axis with the White House. The only remnant of Downing's plan today is the large circular drive of the Ellipse south of the White House and the paths in Lafayette Park.

Downing was also a noted advocate of the Gothic Revival style in architecture for country estates and for rural cottages. Two Italianate villa mansions, which he designed for the Dodge brothers, still stand in Georgetown, D.C., at Thirtieth and Que Streets, and at Twenty-Eighth and Que Streets. Although Downing was killed suddenly at the age of thirty-seven in a steamboat accident on the Hudson River, his influence was considerable throughout the nineteenth century. His writings were important in molding the career of Frederick Law Olmsted, Sr., the prominent American landscape architect.

The urn, 4 feet high, and its original base were restored by the noted local sculptor, Renato Lucchetti, for the Smithsonian Institution and were placed adjacent to Renwick's Smithsonian "Castle" in 1972.

G-11
Title JOSEPH HENRY, 1883
Location Smithsonian Institution
Building, 1000 Jefferson Drive, SW
Sculptor William Wetmore Story
Architect Unknown
Medium Bronze

Detail: Henry's electromagnet

Joseph Henry (1797–1878) is noted as one of the most outstanding American scientists of the nineteenth century and as the first administrator of the Smithsonian Institution. Henry, a native of New York, was the first scientist in America to perfect the electromagnet. His early research on the subject, while a professor at the Albany Academy in New York and at Princeton University in New Jersey in the early 1830s, was contemporaneous with that of Michael Faraday in England, who published his findings first. It is in recognition of Henry's research that the modern practical unit of induction is called "the Henry." Other fields of science to which he contributed important discoveries were solar radiation, sun spots, capillarity, and the cohesion of liquids.

As one of the foremost American scientists, Henry was chosen in December 1846 to become the first secretary of the Smithsonian Institution. The development of the Smithsonian was carefully charted by Henry to follow the concept of the support of original research and the wide distribution of papers relating to original research, both in America and in Europe. In the 1850s, he established the first system of using weather reports received by telegraph for prediction of weather conditions and storm warnings. As president of the Light House Board for the federal government for many years, he devised new inventions for lighthouses along the Atlantic Coast. The American Association for the Advancement of Science was organized by Henry, who was elected president of that body in 1849. For ten years he served as president of the National Academy of Sciences. At his death in 1878, President Rutherford B. Hayes's Cabinet and Congress convened to eulogize him. By act of Congress, this bronze statue of Henry by William Wetmore Story was erected to his memory. Facing the Mall, this 9-foot bronze portrait stands today in front of the Smithsonian Institution Building, where, for twenty-nine years, he not only worked but also lived with his family in the east wing.

At the dedication, John Philip Sousa conducted the Marine Band in the first performance of *The Transit of Venus March*, composed specifically for the unveiling. A relief of the electromagnet was appropriately placed by the sculptor on the side of the pedestal upon which Henry leans.

G-12

Title UNCLE BEAZLEY, 1964
Location National Museum of
Natural History, Smithsonian
Institution, Madison Drive and
10th Street, NW
Sculptor Louis Paul Jonas
Architect None
Medium Painted fiberglass

This 25-foot-long replica of a Triceratops, the dinosaur who lived in the midwestern United States about eighty million years ago during the late Cretaceous Period, was placed on the Mall in 1967. The Triceratops, a vegetarian, lived on dry land and traveled in herds. Its horn was used for defense against other dinosaurs, and it was one of the last types of dinosaurs to exist.

This full-size Triceratops replica and eight other types of dinosaurs were designed by two prominent paleontologists, Dr. Barnum Brown of the American Museum of Natural History, in New York City, and Dr. John Ostrom of the Peabody Museum, in Peabody, Massachusetts. The sculptor, Louis Paul Jonas, executed these prehistoric animals in fiberglass, after the designs of Brown and Ostrom, for the Sinclair Refining Company's Pavilion at the New York World's Fair of 1964. After the fair closed, the nine dinosaurs, which weighed between 2 and 4 tons each, were put on trucks and taken on a tour of the eastern United States. The Sinclair Refining Company promoted the tour for public relations and advertising purposes, since their trademark was the dinosaur. In 1967 the nine dinosaurs were given to various American museums.

This particular replica was used for the filming of *The Enormous Egg*, a movie made by the National Broadcasting Company for television, based on a children's book of the same name by Oliver Butterworth. The movie features a boy in New England who finds an enormous egg, out of which hatches a baby Triceratops; the boy consults with the Smithsonian Institution which accepts *Uncle Beazley* for the National Zoo.

Louis Paul Jonas, the sculptor, immigrated to the United States from Hungary in 1914, and he was one of the leading taxidermists and animal sculptors in the country until his death in 1971.

Title THREE RED LINES, 1969
Location Adjacent to east façade
of the National Museum of
History and Technology,
Smithsonian Institution, Madison
Drive and 12th Street, NW
Sculptor George Rickey
Architect None
Medium Painted stainless steel

This kinetic sculpture of molded stainless steel was a gift to the Smithsonian Institution in 1969 by Joseph H. Hirshhorn, of New York, noted financier and collector of modern American sculpture. The three red-painted blades which sway gently in the breeze are 32 feet long and taper from 8 inches at the base to ¾ of an inch at the top.

The sculptor calls his moving vertical blades "lines." Mr. Rickey has worked with moving metal sculptures since 1949 when he created an early mobile. He learned much from personal instruction by Alexander Calder, one of the most famous contemporary American sculptors and inventor of the mobile. During the 1930s Mr. Rickey devoted his artistic talents to painting. As a machinist during World War II, he learned to appreciate the movement of metal parts, which to him was an art form in itself since it illustrated space. In the early 1950s, sculptor David Smith taught Mr. Rickey to weld metals, and he soon created many fascinating metal sculptures which rock, spin, turn, and gyrate.

George Rickey balances the many metal elements which comprise his sculptures on universal joints so as to make them extremely flexible. He does not use machines to operate his creations. Designed to move with the slightest air current, they can best be appreciated outdoors rather than in the interior of a building. For many years he painted his sculptures so that they would be noticed in the surrounding landscape, and also to prevent the rusting of the metal. For the past several years, however, he has used unpainted metals, which he feels offer sufficient color once the stainless steel, his favorite medium, or bronze, copper, and brass, have been burnished and highly polished. He first makes drawings on paper, followed by small models before actually constructing his works. The largest work by Mr. Rickey is a 65-foot abstract stainless steel sculpture designed for the Mall in Albany, New York. During the period 1971–1973, Mr. Rickey, as a guest of the German government in Berlin, worked on many sculptures. A major one-man show of sixty of his sculptures was held in Hanover and Berlin in 1973–1974. His studio is located in East Chatham, New York.

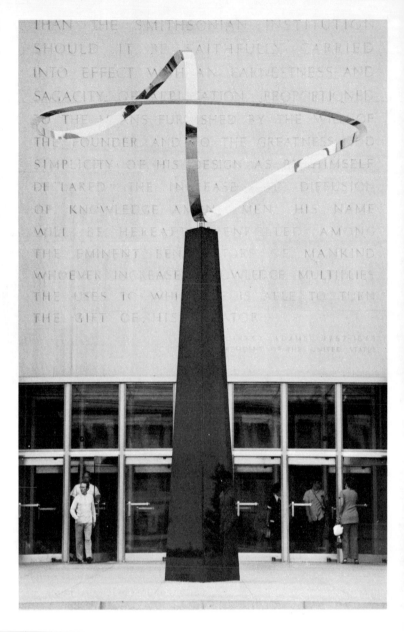

G-14

Title INFINITY, 1967
Location National Museum of
History and Technology,
Smithsonian Institution, Madison
Drive, NW, adjacent to south
façade
Sculptor José de Rivera
Architect Walker O. Cain
Medium Stainless steel

A three-dimensional figure eight floats effortlessly above the crowd, turning slowly until the motion and the design intermix, seeming to change the figure into a new form each moment. *Infinity* is the first abstract work commissioned by the federal government in Washington, D.C., and it is the largest ever completed by its sculptor, José de Rivera. This work, completed in 1967, has polished mirrorlike surfaces made from ³⁄₁₆-inch plates of stainless steel, produced by Allegheny Ludlum Steel Corporation of Pittsburgh.

The sculpture, created to represent Time and Technology, consists of a curved linear form, which looks like a long continuous loop that has been turned in on itself. *Infinity* rotates one revolution every six minutes atop its 16-foot-high black granite triangular base, its highly polished surfaces giving off brilliant refractions and halations of light. While the large stainless steel sculpture seems to float on the air, it changes the area within and around it, seeming to encompass the space. Thus, space becomes part of the sculpture.

De Rivera, who received $104,000 for *Infinity*, worked out the original design on a small brass model. The actual sculpture is 16 feet long, 13½ feet high, and 8 feet wide. The sculptor and his assistant spent fourteen months at Long Island City, New York, to complete the work, including the painstaking process of grinding and polishing to achieve its mirror sheen.

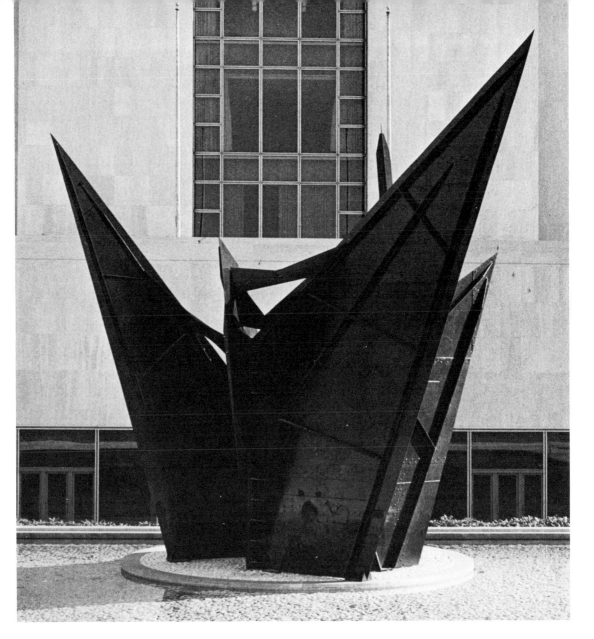

G-15
Title THE GWENFRITZ, 1969
Location National Museum of
History and Technology,
Smithsonian Institution, 14th
Street and Constitution Avenue,
NW, adjacent to west façade
Sculptor Alexander Calder
Architect Unknown
Medium Black painted steel

This stabile, named for Mrs. Gwendolyn Cafritz, the donor, measures 40 feet in height and is one of the many abstract sculptures produced during the long career of Alexander Calder. The 35-ton work, which rises from a shallow pool with a landscaped garden, was designed and fabricated in Sache, France, and shipped to Washington for installation near the Fourteenth Street façade of the new National Museum of History and Technology in June 1969. Calder visited Washington for one week in order to first study the site and make preliminary sketches in 1966; he attended the dedication in 1969.

Alexander Calder was born in Philadelphia in 1898, the son and grandson of Philadelphia sculptors. Calder started a career as a mechanical engineer, taking a degree from Stevens Institute of Technology in Hoboken, New Jersey. Four years later he entered the Art Students League to study painting and sculpture. In 1926 he moved to Paris where he attracted attention with his unique sculptured *Circus*, a collection of wire figures with cork and felt bodies which moved in a miniature ring when activated by turning the handle of an egg beater. Calder was greatly influenced in his work after visiting Piet Mondrian's Paris studio in 1930 and studying his abstract art. He began driving his works in 1931 by small electric motors but two years later tired of this method and developed instead his first free-floating, wind-operated mobiles. A French artist, Marcel Duchamp, visited Calder's studio at the time and

gave them the name "mobile."

Much of Calder's attention has been devoted to the creation of dozens of stabiles since World War II. The artist Jean Arp suggested this title to Calder for his nonmoving abstract sculptures. His early stabiles were less than 10 feet in height since he could not get them into his dealer's New York gallery if they exceeded that size. In 1962, however, Calder began making larger stabiles. Working in an old mill in the French village of Sache, 15 miles from Tours, Calder constructs aluminum models of his stabiles. An intermediate model is then made and tested in a wind-resistant tunnel by the Biemont Ironworks in Tours, after which engineers and artisans actually construct the full-scale work. Some of his largest stabiles have included a 64-foot-high work for Montreal and one in Mexico which towers 80 feet high. He always uses black, white, red, or yellow as the color of the stabiles. The only limitation in size today is that the final sculpture must be able to be dismounted into sections which will fit into railroad freight cars. His Montreal work, weighing 100 tons, required twelve railroad cars to move. He often gives his works names after the shape they resemble, such as *Flamingo* or *Three Discs*.

Calder has developed an attitude of indifference to the reception of his works and their location after he sells them. Even so, his works today demand high prices, from $5,000 for small mobiles to $400,000 for large stabiles. Calder is one of the foremost living sculptors in the world. He has indeed been instrumental in creating an exciting new sculptural art for the twentieth century. Visitors to Philadelphia today can see three generations of Calder sculptures: the colossal statue of *William Penn* atop the City Hall Building by his grandfather, Alexander M. Calder; the *Logan Square Fountain* by his father, Alexander S. Calder; and Calder's own giant mobile, *Ghost,* which hangs in the Philadelphia Museum of Art nearby. Philadelphians refer to these three generations of Calder works as "the father, the son, and the unholy *Ghost.*"

G-16
Title Botany, 1908
Location Department of Agriculture, North Building, Jefferson Drive, between 14th and 12th Streets, SW
Sculptor Adolph Alexander Weinman
Architect Rankin, Kellogg and Crane
Medium Marble

These four sculptured Vermont marble pediments facing Jefferson Drive on the Mall, are, east to west: *Fruit, Flowers, Cereals,* and *Forestry.* Each pediment has two kneeling youths supporting escutcheons, upon which are inscribed the particular aspect of agriculture named above. These pediments, carved at the time of the completion of the two wings in 1908, measure 25 feet in length and 6 feet in height at the apex. The sculptured pediments appear only on the wings of the structure.

The central section of the building was not erected until 1930; it replaced the original brick structure, in Second Empire style, that housed the Department of Agriculture from 1868 to 1930, and was located a few feet north of the present main administration building. James Wil-

Cereals

son, the secretary of agriculture for some sixteen years during the administrations of McKinley, Roosevelt, and Taft, planned the erection of the two wings first, so that the building could be expanded harmoniously. In the late 1920s, after twenty years, the same architectural firm designed the central section of the building. Entering the Mall door the visitor finds an enormous white marble low-relief tablet by sculptor John Flannagan, commemorating the 137 men and women of the Agriculture Department who died in World War I. This unusual sculpture took ten years to complete.

G-17
Title ANIMAL HEADS, 1937
Location Department of Agriculture, South Building, Independence Avenue, between 14th and 12th Streets, sw
Sculptor Edwin Morris, Procurement Division of the Treasury Department
Architect Supervising Architect of the Treasury Department
Medium Painted cast iron

Turkey

The Department of Agriculture, South Building, which was constructed between 1930 and 1937, has extremely severe façades of Indiana limestone, buff-colored mottled brick, and architectural terra-cotta. Until the Pentagon was finished in 1943, this building was the largest office building in the world. The federal government at the time proudly proclaimed the structure to have a total of 1,314,900 square feet of office space covering 10 acres, 11,000 miles of steel framework, 12 million bricks, 2,300 electric clocks, 7 miles of corridors, 4,500 rooms, and 3,000 telephones! The two great covered arches which serve as covered walkways between the South Building and the old North Building on the opposite side of Independence Avenue are memorials to James Wilson (west arch), the secretary of agriculture from 1897 to 1913, and to Seaman A. Knapp (east arch), the founder of the Agriculture Department Extension Service, which sponsors the sending of local agents to farming communities to expound new and improved farming practices. The bronze tablets for the arches were the work of sculptor Carl Mose.

On the façades of the building, including the open courtyards, are several hundred 3-foot-by-5-foot cast-iron relief panels, which weigh 300 pounds each. These plaques, arranged between the third and fourth floor windows, include the heads of 76 American turkeys, 30 eagles, 183 horses, 122 bulls, and 152 rams. The American turkey, incidentally, almost became the national symbol for the United States in the 1780s because of the urging of Benjamin Franklin. The American turkey and the buffalo, however, have been used countless times since 1789 as unofficial national symbols.

The original sculpture designed for this building, but never executed, consisted of a series of brightly colored ceramic panels by sculptor Julian L. Rayfield portraying well-loved characters and legendary figures from American folklore. Rayfield proposed an elaborate design of large panels to flank the first-floor windows and doors portraying over forty figures including Uncle Remus, John Henry, Andrew Jackson, P. T. Barnum, Tecumseh, Sequoyah, Paul Bunyan, Davy Crockett, Mark Twain, Casey Jones, and others. The second-floor windows were to be embellished by panels showing American Indian motifs, such as corn, serpents, and thunderbolts. The design was enthusiastically supported by many prominent officials, including the secretary of agriculture and the regional director of the Public Works of Art Project. The United States Fine Arts Commission, which has governed the design of government architecture and art in the city since 1910, twice flatly rejected Rayfield's design. The Commission members felt the ceramic panels to be out of proportion to the façade of the building and of too gaudy a design. After the second rejection, member Lee Lawrie wrote: "I am sympathetic with this type of design, being a modern sculptor, but I think it is as strange to put this in Washington as it would be to put a Greek statue on the Nebraska State Capitol."

G-18

Title Heating Plant Machinery, 1933

Location Central Heating and Refrigeration Plant, 13th Street, between C and D Streets, sw

Sculptor Paul Cret, designer

Architects James A. Wetmore, Supervising Architect of the Treasury Department; Paul P. Cret

Medium Terra-cotta and limestone

Safety Valve

The main facade of this federal heating plant, which supplies heat to many of the government buildings on or near the Mall, has a striking collection of five terra-cotta and limestone relief panels, two on each side of the entrance and one large panel near the roof line. The small panels, carved in limestone, show various machines installed in the building in 1933. To the left of the door appear a generator, identical to two in the building, and a boiler safety valve, of which there are seven each installed on the six boilers inside. A fan and heat exchanger appear on the two panels to the right of the door.

The large terra-cotta panel near the roof presents an excellent lesson in the engineering of the 1930s. At the time they were built, boilers of this size were used only in electric powerhouses or in very large heating plants. In this case they were adapted for use in a large heating plant. These large boilers, with an output of almost a quarter of a million pounds of steam per hour, are constructed like separate small buildings. They have foundations and steel supporting elements similar to a twelve-story office building. Coal is burned in such a boiler to produce heat, which is contained by use of insulated casings and refractories of fire brick. The tremendous heat thus generated is used to convert water, which passes through the heated boiler in hundreds of pipes, into steam. As the heat is built up, the pressure increases and produces greater amounts of steam as the water circulates through the multitude of tubes and pipes. The steam is finally trapped in a large container known as the main steam drum. It is then piped off for distribution to various buildings in the area. The overhead panel of the principal façade of the building portrays what takes place in a coal-burning boiler producing steam. The large panel measures 9 feet in height and 6 feet in width, while the four small panels are 2 feet high and 3 feet wide.

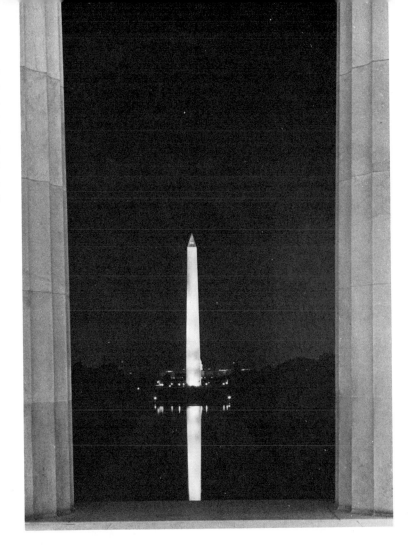

G-19

Title Washington Monument, 1848–1886

Location West termination of the Mall, adjacent to 14th Street, between Constitution Avenue, NW and Independence Avenue, SW

Sculptor None

Architect Robert Mills

Medium Exterior, marble; interior, granite

The Washington Monument, one of the most famous memorials in the United States, is located on the Mall near the spot selected by Pierre Charles L'Enfant for the equestrian statue of George Washington that was voted by the Continental Congress in 1783. After years of government delay in erecting any memorial to "the father of his country," a group of prominent citizens founded the Washington Monument Society in 1833 to raise private funds for this purpose.

Robert Mills, noted South Carolina architect of the Neoclassical style, designed this Egyptian obelisk in 1836. The original design included a circular building at the base, 100 feet in height, surrounded by a colonnade of Doric columns and surmounted by groups of Neoclassical statues, including a monumental quadriga or chariot drawn by four horses abreast. Neither the large colonnade nor the elaborate sculptures were ever executed because of lack of funds. Construction of the obelisk began in 1848, with an elaborate ceremony attending the laying of the cornerstone.

After the shaft had been erected to a height of 150 feet, at a cost of $300,000, construction was stopped in 1854 when funds were depleted. Because of renewed interest of the public in the American Revolution as a result of the Philadelphia Centennial Exhibition of 1876, Congress voted to complete the obelisk at government expense in August 1876. After reinforcing the base, the Army Corps of Engineers completed the 555-foot shaft and opened it to the public in 1886. The 898 steps and 50 landings, which make up the interior, are supported by walls that are 15 feet thick at the base and gradually taper to a width of 18 inches at the top.

The most interesting feature of the interior of the monument is the collection of over 250 memorial stones, which are set in the walls of the

267 *The Mall*

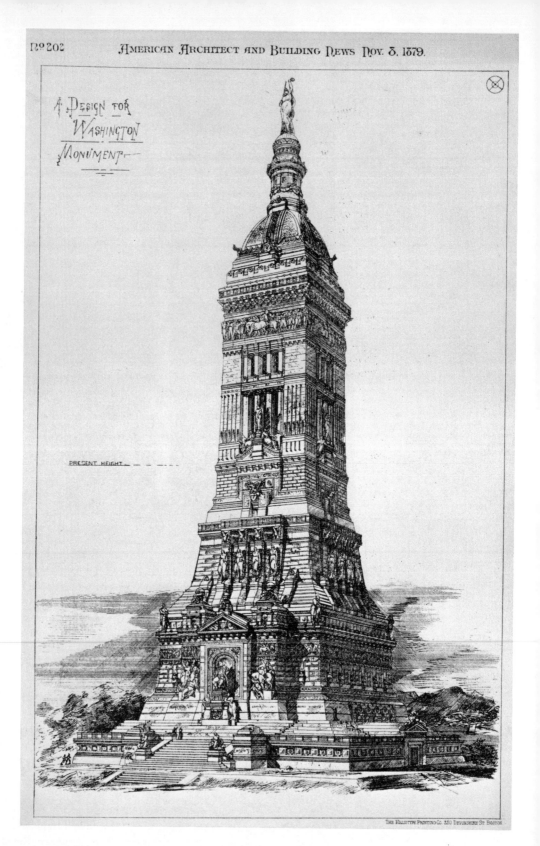

A Design for Washington Monument

PRESENT HEIGHT

THE HELIOTYPE PRINTING CO. 220 DEVONSHIRE ST. BOSTON.

Proposed remodeling of the Washington Monument in the Renaissance style with elaborate sculptural decorations, 1879

stairwell and were presented by cities, states, patriotic organizations, individuals, and foreign governments to the memory of George Washington. Private organizations included divergent groups ranging from the employees of the Robert Norris Locomotive Works of Philadelphia to the Jefferson Literary Society of the University of Virginia. The more exotic carved stones in the wall include those presented by the city of Bremen, Germany; by China (consisting of a message of praise of George Washington in Chinese); by the Cherokee Nation; and by the District of Columbia.

MASSACHUSETTS AVENUE, NW

H

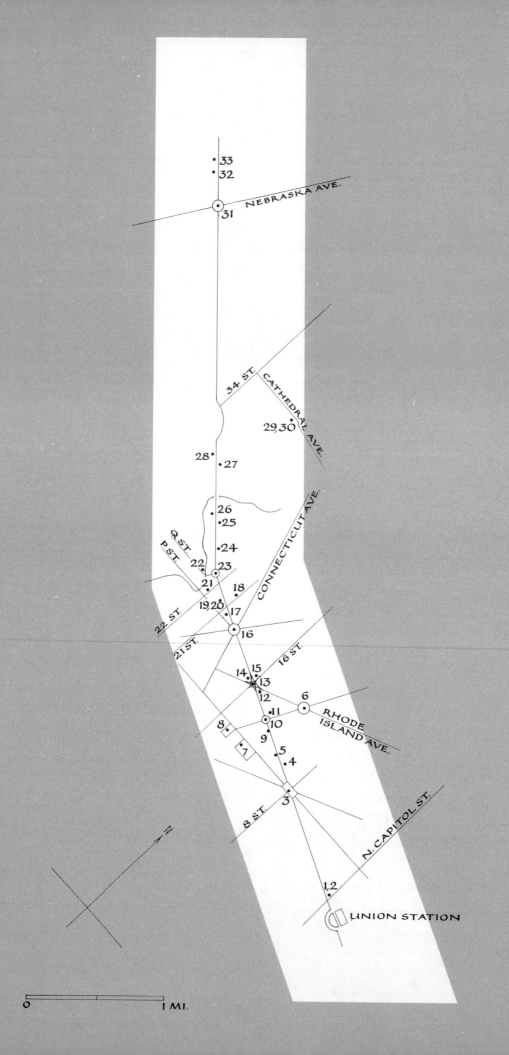

• 33
• 32

NEBRASKA AVE.
31

34 ST.
CATHEDRAL AVE.

29,30

28 •
• 27

• 26
• 25

Q. ST.
• 24

P. ST.
22 • 23
21
18
19 20
• 17
22 ST.
16
21 ST.
16 ST.

14 15
13
12
6
11
8 10
9
RHODE
ISLAND AVE.
7
5
• 4

8 ST.
3
N. CAPITOL ST.

N

1, 2

UNION STATION

0 1 MI.

MASSACHUSETTS AVENUE, one of the most important thoroughfares in the development of Washington, sweeps for eight miles through the heart of the city from the Anacostia River, on the east, to Westmoreland Circle, the western boundary of the District of Columbia. Along this broad avenue, the historical development of the city for the past one hundred years can be easily discerned. Where once there were tidy townhouses for twenty-five blocks east of the Capitol, urban blight has descended, although here and there a few houses have been restored to their original attractiveness. Happily, the Union Station has not been touched by change on the exterior, even though the use of the station for train transportation has diminished radically. Union Station, highlighted by Lorado Taft's beautiful fountain, is being converted into a National Visitor Center for the Nation's Capital, opening in 1976.

Traveling west there is more urban blight evident between Union Station and Thomas Circle, but it is noteworthy to see that the National Guard Association has moved into this area erecting a well-designed building, embellished with various and harmonious sculpture.

On the north side of Massachusetts in the area touched by Thomas Circle, Logan Circle, and Scott Circle, between Thirteenth and Sixteenth Streets is one of the finest collections in the city of old mansions whose grandeur remains well preserved. From Scott Circle to Dupont Circle, the avenue was also lined with private mansions, but after the financial crisis in 1931, many were sold, several for embassies, and others to fifty research institutes which sought offices and headquarters in a convenient and prestigious location. Since intensive research is carried on here by men of great learning, the area has been dubbed "Egg Head Row." Original houses still exist on the south side of the avenue but those on the north side have mostly been razed and new office buildings and apartment houses have taken their place.

Dupont Circle marked the end of Massachusetts Avenue, NW, back in 1900. Later, the avenue was extended west, more mansions were built, and many new embassies constructed impressive buildings in this area. Proceeding west on what is now called "Embassy Row," the British Embassy on the south side of the avenue is very impressive and monumental, with large gates topped by sculptures of lions and unicorns and the Winston Churchill bronze portrait statue nearby. (For information on the handsome Washington Cathedral on Wisconsin Avenue, see chapter N.)

Crossing Wisconsin Avenue, the landscape changes and is filled with fashionable high-rise apartments. Abruptly they stop at Ward Circle which honors Artemas Ward, the first commander of the United States Army in 1775. The last mile of Massachusetts Avenue is given over partly to American University, Wesley Theological Seminary, a shopping center, and single houses. The fact that twenty-three religious structures representing all major faiths are situated on Massachusetts Avenue is unusual. Among them are an Islamic Mosque, Jewish Synagogue, four Episcopal Churches, two Lutheran Churches, a Greek Orthodox Church, a Russian Orthodox Church, a Mormon Church, a Congregational Church, a Baptist Church, and a Protestant Chinese Community Church.

This chapter includes those sculptures found along the entire length of Massachusetts Avenue, NW, beginning with the National Guard Association of the United States Building at Massachusetts Avenue, NW, and North Capitol Street and terminating with the sculpture found on the grounds of the Methodist Theological Seminary near American University. Readers should refer to the chapter on Capitol Hill for sculptures found along Massachusetts Avenue, Northeast.

H-1
Title MINUTE MAN, 1966
Location National Guard
Association of the United States
Building, 1 Massachusetts
Avenue, NW
Sculptor Felix W. de Weldon after
design by Daniel Chester French
Architect Justement, Elam and
Darby
Medium Bronze

The massive bronze figure of the *Minute Man* of the Revolutionary War period is the focal point of the façade of this memorial building. This architectural sculpture is 20 feet high and 7½ feet wide and was designed after the famous original *Minute Man* statue executed by Daniel Chester French in 1874 at Concord, Massachusetts. French's statue has become symbolic of the American citizen-soldier, especially since its image was used on millions of postage stamps and war bonds during World War II. The sculpture is placed in the recessed façade of the Ellard A. Walsh Auditorium of the National Guard Association of the United States Building. The massive bronze eagle on the building nearby is the work of Michael Lantz.

This Association was officially established in 1879 by a group of Union and Confederate officers who had fought either as members of their state militias or as volunteers during the Civil War. The original purpose of this organization of officers was the reform of state militias and the creation of standardized training and uniforms. A number of federal bills have been passed since the famous Dick Act of 1903 which have accomplished this goal, largely through efforts of the National Guard Association of the United States. The National Guard Association of the United States first established a national headquarters in Washington in 1944, and in 1959 it completed its present modern building on Massachusetts Avenue, NW. Today this organization continues to sponsor and support legislation aimed at maintaining the National Guard as a strong, well-trained, and readily available military force.

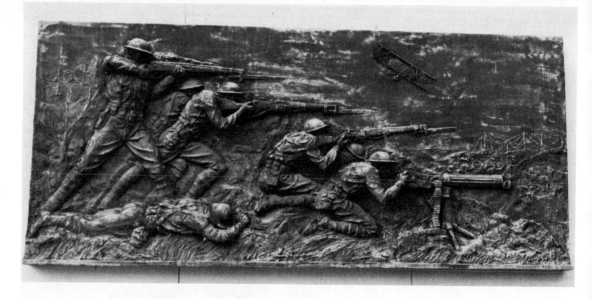

H-2
Title AMERICAN MILITIA, 1966
Location National Guard
Association of the United States
Building, 1 Massachusetts
Avenue, NW
Sculptor Felix W. de Weldon
Architect Justement, Elam and
Darby
Medium Bronze

On the principal façade of the National Guard Association of the United States Building appear four low-relief bronze panels that depict militia composed of Americans in action during the Colonial Period, the Revolutionary War, World War I, and World War II. They are pictorial as well as realistic in conception and execution. These panels are approximately 3 feet high and 8 feet wide.

The adjacent bronze eagle which rises above the entrance to the building is an intriguing presentation of the national symbol. Bold in concept, it fulfills the modern embodiment of the Army and Air National Guard.

H-3
Title THE LIGHT OF KNOWLEDGE,
1903
Location Old District of Columbia
Public Library Building, Mt. Vernon
Place, Massachusetts Avenue and
8th Street, NW
Sculptor Philip Martiny
Architect William S. Ackerman
and Albert Ross
Medium Marble

During the years 1901–1903, the District of Columbia Public Library Building was erected at Mt. Vernon Place, a large park at the intersection of K Street, Eighth Street, Massachusetts Avenue, and New York Avenue, NW. The gift of Andrew Carnegie, the white marble structure exemplifies the civic enthusiasm of the "city-beautiful" era which followed the World's Columbian Exhibition of 1893 in Chicago. The design is Beaux Arts-Neoclassical unencumbered with archeological conscience. The central section of the façade is brought forward and given a rich and dramatic sculptural treatment. Detail is lavish.

Over the entrance appears *The Light of Knowledge*, the principal sculpture group on the structure, about 4½ feet high and 6 feet wide. Two boys appear seated on a broken pediment in the center of which rests an elaborate cartouche, on which is carved an open book between two flaming Roman torches. They wear small, wind-blown capes which resemble wings as they grin down upon the pedestrians entering below. Each boy holds a symbol of the world of knowledge, one a book and the other a globe. The large circular window behind this sculpture group not only acts as a frame but also serves to emphasize the figures against the darker background.

The decorative pediments at the cornice line on each end of the façade contain the classic head of a poet laureate, cornucopias, and vigorous

abstract curvilinear detail. Near the coping, above the entrance, are two tablets graced by putti. There is, in addition, much minor sculptural detail here. Behind this exuberant façade is a functional and well-thought-out library design, having a split-level entrance and an imaginative fenestration which includes extensive use of skylights. The flamboyant detail occurs only on the façade, but the building maintains an exciting rhythm and scale on all sides.

The sculptor, Philip Martiny, immigrated to the United States from France and first worked as a decorative woodcarver on the Vanderbilt Mansion in New York City. After serving as an assistant to Augustus Saint-Gaudens, Martiny opened his own studio for decorative architectural sculpture. He received many commissions from the firms of McKim, Mead and White and also Ackerman and Ross for major buildings. Martiny, who had recently completed many carvings on the Library of Congress Main Building, was employed by Ackerman and Ross in 1900 to design and execute, for $2,000, the six sculptures and other minor carvings on the District of Columbia Public Library Building. The head carver was William Boyd, who also worked for years on the Library of Congress Main Building. The architects planned to have four large statues for the four pedestals of the exedra (semicircular benches) at the main entrance, but lack of funds prevented their execution.

The carved lettering on the main frieze includes the words: "Science, Poetry, History," while the exedra is carved with the inscription: "A University of the People." Three carvings on plaques at the attic level consist of the following inscriptions: "This building a gift of Andrew Carnegie," "Washington Public Library," and "Dedicated to the diffusion of knowledge." The architects arranged the sculptural decoration and the carved inscriptions to produce a sense of order and balance to the whole building, as well as to add richness and decoration.

It is interesting to note that in 1899 the same architects and same sculptor executed the Atlanta Public Library Building, which is similar in general feeling to the old District of Columbia Public Library herewith described. This building is now part of the Federal City College complex.

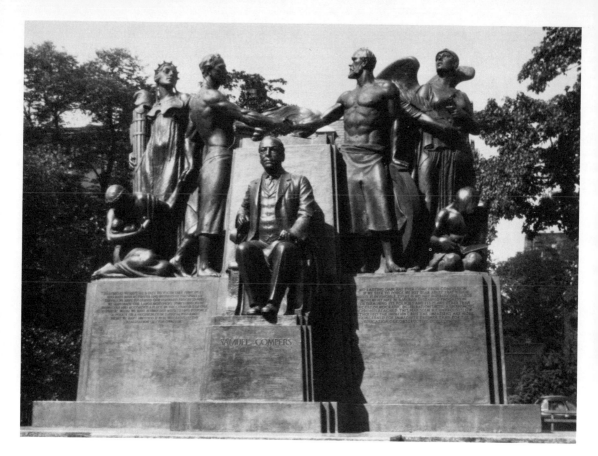

H-4

Title SAMUEL GOMPERS MEMORIAL,
1933

Location Massachusetts Avenue
and 10th Street, NW

Sculptor Robert I. Aitken

Architect Unknown

Medium Bronze

Samuel Gompers (1850–1924), English-born founder and president of the American Federation of Labor, immigrated as a young boy with his parents to New York City. He began work rolling cigars at the age of ten while living in a New York slum. Realizing from personal experience the plight of the worker, he became active in the labor movement in the 1870s. His first accomplishment was to increase, by skillful reorganization, the effectiveness of the Cigar Makers Union. He founded the American Federation of Labor in 1886 and served as its president until his death. During World War I, Gompers served with distinction on President Wilson's Council of National Defense, which directed the war effort at home. Gompers's autobiography, *Seventy Years of Life and Labor,* records the rise of the early American labor unions.

By moderation and wisdom, Gompers greatly enhanced the prestige of the American labor movement. These qualities are reflected in the dignified, heroic, bronze, seated, portrait statue of Gompers, with six allegorical figures in the background representing the American labor movement. In this sculptural group, the seated female on the left symbolizes the protection of the home, while the seated male on the right symbolizes the overthrow of industrial exploitation by education. The two standing women represent justice; the left female holds a fasces, Roman symbol of power and justice. The two principal background figures, two standing men with clasped hands, denote unity and cooperation of the labor movement. Emblems of labor, such as a 1930 steam locomotive engine, are arranged among the Neoclassical figures. Excerpts from the writings of Gompers appear on the granite base.

President and Mrs. Franklin D. Roosevelt were present at the dedication in 1933. Members of the American Federation of Labor donated the $130,000 necessary for the erection of this memorial. In 1951, the small triangle of land on which the statue is located was named Gompers Square.

Children are often seen climbing on this 16-foot-high memorial. In the 1940s a trio of thieves discovered a trapdoor to the hollow interior, which they used as a hideout and cache for their booty.

Detail: locomotive at the foot of one of the allegorical figures

H-5

Title Edmund Burke, 1922
Location Massachusetts Avenue
and 11th Street, NW
Sculptor J. Harvard Thomas
Architect Horace W. Peaslee
Medium Bronze

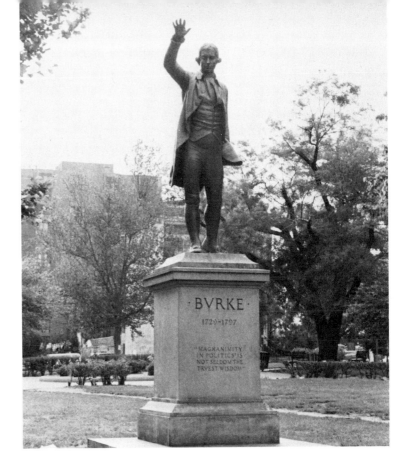

This 8-foot-high bronze portrait statue of the English orator and statesman is a copy of the statue at Bristol, England, the city represented by Burke in Parliament. It was presented to the American people by Sir Charles Wakefield, former Lord Mayor of London, on behalf of the Sulgrave Institution, an organization which has as its purpose the promotion of Anglo-American understanding. This British organization purchased and restored Sulgrave Manor, once the English estate of Lawrence Washington, of whom George Washington is a lineal descendant. In the arch of the main entrance of Sulgrave Manor is the Washington coat of arms with two red stars and three red stripes, after which the District of Columbia flag was patterned.

Because of the eminence of the English statesman Edmund Burke (1729–1797) and his willingness to face unpopularity by espousing the cause of the American colonies in Parliament, it is fitting that he be represented by a portrait statue in the United States capital. The qualities of his mind and the brilliant eloquence of his spoken and written word were early recognized by intellectual and political leaders in London. Dr. Samuel Johnson said of him: "Burke, sir, is such a man that if you met him for the first time in the street, and you and he stepped aside to take shelter for but five minutes, he'd talk to you in such manner that when you parted you would say, 'This is an extraordinary man.'"

He was the son of Richard Burke, an attorney resident in Dublin. Following his graduation from Trinity College in Dublin in 1748, Burke studied law in London at the Middle Temple, practiced law briefly and then turned to literary work. He became the private secretary to the Marquis of Rockingham and, thus, experienced in political affairs because of this service, entered Parliament in 1765 from the pocket borough of Wendover. Burke took a leading part in the debates in Parliament during his period of office, taking the side of religious toleration, public liberty, financial reform and an indulgent American colonial policy. In the latter affair, he was outspoken against government policy in a succession of speeches in Parliament.

Title MAJOR GENERAL JOHN A.
LOGAN, 1901
Location Logan Circle, Vermont
Avenue at 13th and P Streets, NW
Sculptor Franklin Simmons
Architect None
Medium Bronze

Except for the shallow sub-base of pink granite, this elaborate memorial is made entirely of bronze. The equestrian figure rides quietly, but the expression of the face and the gesture of the sword hand mark the determination of the man. The statue, almost 12 feet high and 10 feet wide, produces an impression of dignity and power.

Allegorical figures to the north and south represent War and Peace. The other two sides contain bas-reliefs of episodes in the general's life. The panel on the west shows Logan presiding over a council of war with his officers. The second depicts the general receiving the senatorial oath of office from Vice President Chester A. Arthur in the old United States Senate Chamber. There are four American eagles, representing Patriotism, at the base of the statue; and massive palm leaves, symbolizing Victory, flank the name "Logan" on the east and west sides of the pedestal.

The memorial was dedicated April 9, 1901, at Logan Circle, then known as Iowa Circle, and almost immediately became the subject of controversy. A local news account noted historical inaccuracies in the figures on the relief which show General Logan receiving the oath of office. The article related that he was sworn into office in 1879, while Chester Arthur did not assume his office as vice president until March 1881. In reply, Mrs. Logan said she chose these figures to represent famous men during the years of her husband's public life.

General Logan was born in Illinois and served in the Mexican War before returning to the practice of law and service in the Illinois legislature. He was elected to Congress in 1858, and he entered the Army in 1861 as a colonel. In 1863, he played a significant role in the capture of Vicksburg and was appointed military governor of that district. Logan rose to command the Army of the Tennessee, but his frequent excursions into politics, including his campaigning for President Lincoln in 1864, led to his release from command upon the recommendation of General William T. Sherman. He left the army in 1865.

Following his military service he organized the Grand Army of the Republic, the principal organization of Union veterans after the Civil War, and also the Society of the Army of the Tennessee. Elected again to Congress, he served three terms as a United States senator. It was General Logan who helped conceive the idea of Memorial Day, first celebrated May 30, 1868.

Panel: General Logan Presiding
Over a Council of War

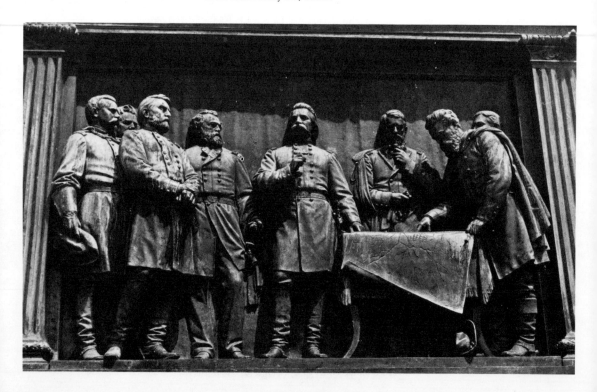

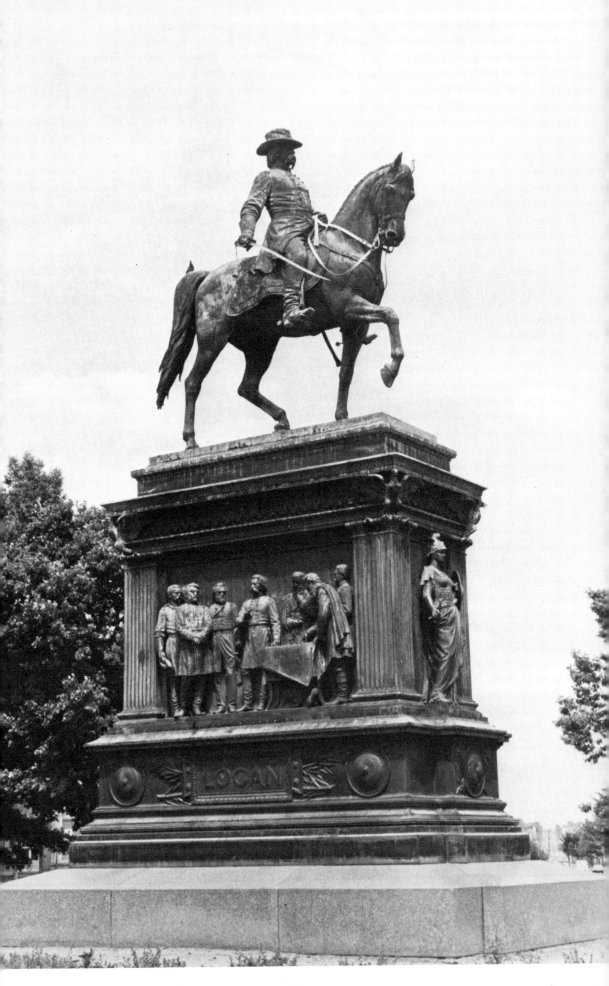

279 *Massachusetts Avenue, NW*

Title COMMODORE JOHN BARRY,
1914
Location Franklin Park, 14th
between I and K Streets, NW
Sculptor John J. Boyle
Architect Edward P. Casey
Medium Bronze and marble

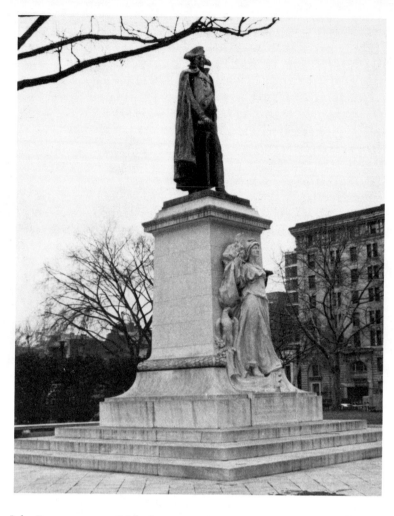

John Barry, a young Irish-American sea captain, was given command of
the 14-gun brig *Lexington* by the Continental Congress on December 7,
1775. Exactly four months later he became the first American naval offi-
cer to capture an enemy ship, and he continued to serve heroically
throughout the Revolution. In the fall of 1780, with the 36-gun frigate
Alliance, he single-handedly defeated two British men-of-war; in
March 1783, in the last engagement of the war, he was victorious over
the British frigate *Sybille* and her escort. When the Navy was recalled
during the desperate winter of 1776–1777, Barry raised a company of
volunteers and joined Washington's land forces in New Jersey. Here he
distinguished himself at the battles of Trenton and Princeton. In 1794
Barry was named "Senior Captain of the Navy" and thus allowed the
title of "Commodore." He retired in 1801 to his estate "Strawberry
Hill," near Philadelphia. A portrait of Barry by Gilbert Stuart hangs in
that city's Independence Hall.

This monument to Commodore Barry, on the west side of Franklin
Park, was erected by Congress at the request of Irish-American groups.
A competition, open only to sculptors of Irish descent, was held in 1908,
but results were inconclusive. After much controversy, John J. Boyle
was awarded the commission. His work portrays Barry in the uniform
of the mixed forces with which he served; it is academic and formally
posed. The Commodore, voluminously cloaked and standing 8 feet
high, grasps his orders in his right hand as it rests decisively on his
sword hilt. "With a belief in the cause and himself and with supreme
confidence of victory, he is surveying the horizon, prepared for action."
On the front face of the pedestal is a draped female figure, Victory,
holding a laurel branch as she stands on the prow of a ship; an eagle
rests at her right side. Thousands of Irish-Americans from all over the
country attended the colorful dedication ceremonies on May 16, 1914.

Title BRIGADIER GENERAL JAMES B.
MCPHERSON, 1876
Location McPherson Square, 15th
between K and I Streets, NW
Sculptor Louis T. Rebisso
Architect General O. E. Babcock
Medium Bronze

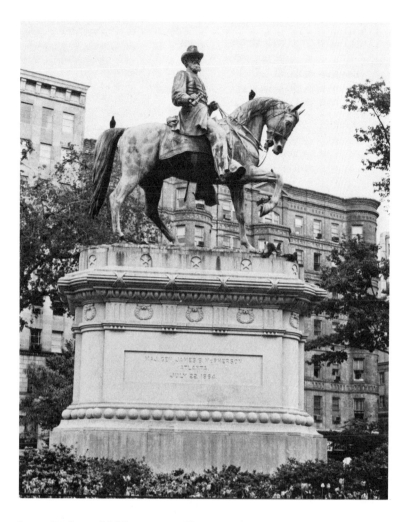

James Birdseye McPherson, an Ohioan and West Point engineer, distinguished himself in service during the Civil War, rising from the rank of first lieutenant to that of brigadier general by August 1, 1863. Placed in command of the Army of the Tennessee, he participated in General William T. Sherman's famous march to the sea. On July 22, 1864, while riding close to Confederate lines during the battle of Atlanta, he was shot and killed. Grant reportedly commented, "The country has lost one of its best soldiers and I have lost my best friend." This equestrian statue was erected in Scott Square, renamed McPherson Square, by McPherson's comrades from the Army of the Tennessee.

Cast from Confederate cannon captured at Atlanta, the statue faces southwest, and portrays the general as he surveys the battlefield. It is a realistic portrait; McPherson's pose is alert as he reins in his horse and turns in the saddle, binoculars in hand. His uniform is creased in the fatigue of battle, the coat and trouser legs are blown back. The massive granite pedestal is adorned with Classical motifs vigorously adapted to commemorative military design.

The Society of the Tennessee originally planned, with the consent of McPherson's mother and close friends, to inter the general in the foundation of the monument. As the body was being exhumed in Ohio, an injunction was brought by the Clyde (Ohio) Monumental Society, thus thwarting this effort. The dedication, coinciding with the eleventh annual reunion of the Society of the Army of the Tennessee, October 18, 1876, was colorful and impressive. Following a military parade led by Generals David Hunter and William T. Sherman, the 12-foot statue was unveiled. The Marine Corps Band played the Centennial Exposition March, Major General John A. Logan delivered the oration and President Rutherford B. Hayes and members of his cabinet were present on the platform.

H-9
Title CHRIST, THE LIGHT OF THE
WORLD, 1949
Location National Catholic
Welfare Conference, 1312
Massachusetts Avenue, NW
Sculptor Eugene Kormendi
Architect Thomas H. Locraft
Associates
Medium Bronze

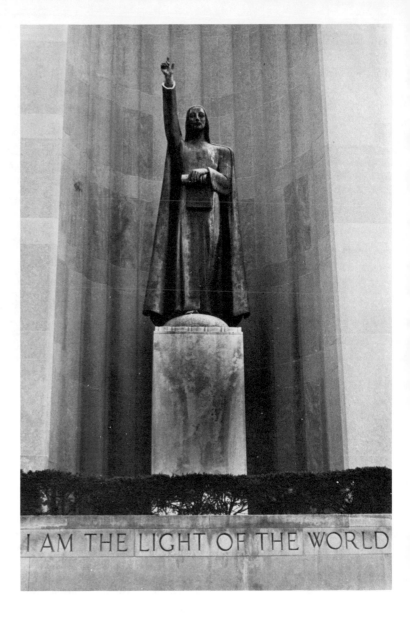

I AM THE LIGHT OF THE WORLD

In October 1936, Catholic Bishop John F. Noll of Fort Wayne, Indiana, announced a fund drive to erect a statue of Christ in the Nation's Capital. Citing the many statues which celebrate men who have made contributions to history and the arts, Bishop Noll noted none had been built to the founder of the Christian religion.

The Catholic newspaper, *Our Sunday Visitor,* initiated the drive and collected over $115,000 during a period of twelve years. Search for a suitable site was unsuccessful until the decision was made to incorporate the statue into the plans for the new National Catholic Welfare Conference Building on Massachusetts Avenue, NW. Frederick Vernon Murphy, head of the school of architecture at the Catholic University of America in Washington, designed the building façade of white limestone, unbroken by windows, as a proper setting for the statue.

Sixty-six entries for the statue design were considered and three were selected for final consideration. Much immediate reaction to the three proposed designs took the form of negative comment on modern art. Eugene Kormendi, head of the school of sculpture at Notre Dame University, won the competition, although he had not been one of the three finalists.

The statue rises 22 feet within a 90-foot semicircular niche. The feeling is one of contemporary simplicity, although the total effect of the statue is diminished by its setting in a heavily traveled area of speeding traffic.

Title Major General George H.
Thomas, 1879
Location Thomas Circle,
Massachusetts Avenue and 14th
Street, NW
Sculptor
John Quincy Adams Ward
Architect Unknown
Medium Bronze

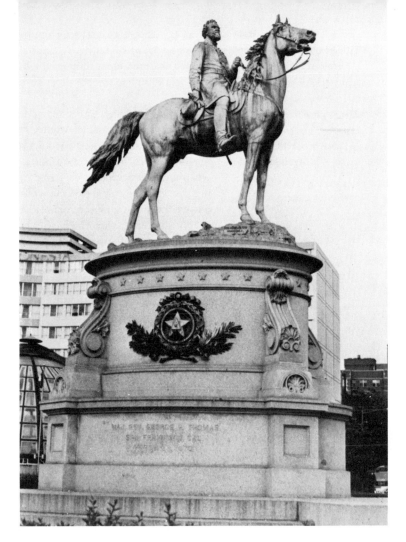

This equestrian statue honoring Major General George H. Thomas (1816–1870) was erected by the Society of the Army of the Cumberland and dedicated November 9, 1879. President Rutherford B. Hayes accepted the statue, considered by many art critics as one of the best equestrian works in the city.

This Union hero of the Civil War is represented as having just arrived at the crest of a hill. The horse's head is thrown back and up by the rider's firm check on the bit. The general sits quietly, a figure of strength as he watches the field below. One almost sees the haze of smoke as the "Rock of Chickamauga" surveys the battle from the heights of Lookout Mountain, Tennessee. The statue is 16 feet high and stands on a granite pedestal which rests on a circular granite base of four steps.

A brilliant dedicatory speech was delivered that day by General Anson G. McCook, who served under General Thomas as a brigade commander and who was one of the famous sixteen-member "fighting McCooks" of Ohio who served as Union officers. The McCook papers were recently presented to the Manuscripts Division of the Library of Congress by General McCook's daughter, Mrs. Katharine McCook Knox of Washington, D.C.

General Thomas, a Virginian, graduated from West Point and served in the Florida and Mexican campaigns. At the outbreak of war in 1861, he chose to remain with the Union Army and was assigned to duty in Kentucky. In 1863, he met and defeated Confederate General Braxton Bragg at Chickamauga. It was here that Thomas prevented a major Union defeat, and for his service he was promoted to brigadier general and given command of the Army of the Cumberland. Following the Civil War, he assumed command of the Military Division of the Pacific in San Francisco, where he died in 1870.

H-11

Title MARTIN LUTHER, 1884
Location Thomas Circle,
Massachusetts Avenue and 14th
Street, NW
Sculptor Replica of statue by E.
Reitschel
Architect Unknown
Medium Bronze

The 11½-foot-high statue of the leader of the Protestant Reformation stands in front of Luther Memorial Church at Thomas Circle. It was erected in commemoration of the 400th anniversary of Luther's birth. The work was made possible by the Martin Luther Society of New York.

Part of the brief unveiling ceremony was the singing of one of Luther's many hymns, *A Mighty Fortress Is Our God.* The Victorian dignity required for such a momentous occasion as the dedication of a new statue in the Nation's Capital was at first seriously jeopardized when the American flag, used to drape Luther's figure before the unveiling, froze to the surface of the statue and refused to come loose. Later, during the singing of the hymn, the calm was completely and irreconcilably shattered when the hastily built high wooden platform supporting the clergy collapsed, spilling all of the dignitaries into the crowd of 5,000 spectators below.

Martin Luther (1483–1546), who became the architect and towering leader of the sixteenth-century German Reformation, originally intended to pursue a career in law. However, as a young man he experienced a personal religious insight which prompted him to enter a monastic order as an Augustinian friar. He felt a call to "explain the Scriptures to all the world." He did not reject the Catholic faith but, remaining within the Church, attempted to reform an institution which demanded blind acceptance of frozen traditions. Luther believed that human hope lay, not in narrow dogmas of the established Church, but in the grace of God and the redeeming work of Christ, accepted by faith.

In 1517, upon the arrival in Wittenberg of a friar sent by Rome to sell indulgences, Luther protested this corrupt practice and other "transgressions" by nailing to the church door a list of 95 theses, or questions, and inviting debate on them. This led to a hearing in Rome and, when he refused to recant his views, Luther was excommunicated. He stood trial at the Diet of Worms in 1521, but the German dignitaries who sat in judgment refused to condemn him. Friends who feared treachery spirited him to safety in the castle of Wartburg in Thuringia. There, in a year of study and meditation, he produced the first German translation of the New Testament, previously available to the faithful only in Greek and Latin. During the next ten years he translated the whole Bible, establishing a standard for the modern German language.

This statue shows Luther as he appeared before the Diet of Worms. He holds the Bible, face upturned with lips slightly apart, as he concludes his defense: "Here I stand, I cannot do otherwise."

The bronze portrait statue of Martin Luther at Thomas Circle was cast in Germany in 1884 as a duplicate of the central figure of the famous bronze sculpture group which was erected in Worms, Germany, in 1868 and which commemorated the entire story of the Reformation. The latter work, unfortunately, was severely damaged from bombing during World War II.

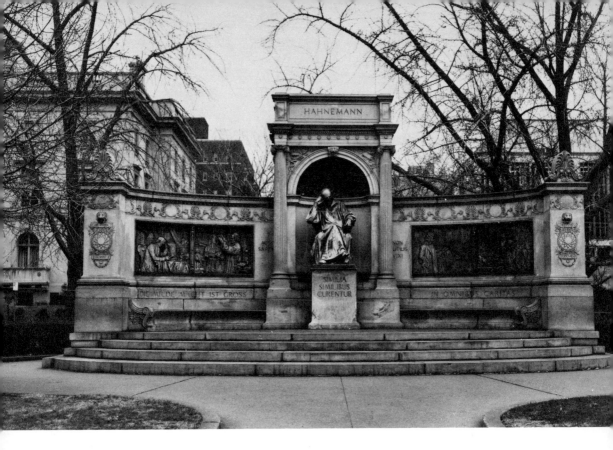

H-12

Title DR. SAMUEL HAHNEMANN
MEMORIAL, 1900

Location Scott Circle,
Massachusetts Avenue and 16th
Street, NW

Sculptor Charles Henry Niehaus

Architect Julius F. Harden

Medium Bronze, granite, mosaic

Panel: Dr. Hahnemann's Role
as a Chemist

This elaborate memorial is dedicated to the medical research and contributions of the German physician, Samuel Hahnemann (1755–1843). While practicing medicine in Leipzig in 1789, he discovered the "law of similars," namely that diseases are cured by those drugs which produce similar symptoms when injected into healthy persons. This developed into a branch of medical science known as homeopathy. He also proved that drugs should be applied to patients in much smaller doses than was then the custom. In 1821 the hostility of the local druggists, who stood to lose much of their business, forced Hahnemann to leave Leipzig. He spent the remainder of his life practicing medicine in Paris. Portrait statues were erected to him in Leipzig and Köthen, in addition to the one here erected by the American Institute of Homeopathy.

Hahnemann's teachings made a striking impact on American medical practices beginning about 1830, due to German immigrant doctors and upper-class Yankees who studied medicine in Europe. The practice of homeopathy reached its height in the early part of the twentieth century and included such famous advocates as John D. Rockefeller and Mark Twain. His teachings have been hotly debated for 150 years, and the American Medical Association has denounced and fought these methods. Nonetheless, its demonstrated ability to cure people was so superior to modern medicine of the times that it was widely acclaimed by the public. Today there are only several hundred regular physicians who practice homeopathy.

The monument is in the form of a Greek exedra, or curving bench, with a life-size bronze portrait statue of Hahnemann sitting in deep contemplation in the center. The top of the niche in which the statue rests is composed of a handsome mosaic. The four bronze relief panels, two on each side of the statue, represent Hahnemann, from left to right, as a student, chemist, teacher, and practicing physician. These panels measure 4 feet high and 10 feet wide. Under the statue is the Latin inscription: "Similia Similibus Curentur" (Likes Are Cured By Likes). The two inscriptions under the panels are "Die Milde Macht Ist Gross" (Gentle Power Is Great) and "In Omnibus Caritas" (In All Things Charity).

Title LIEUTENANT GENERAL
WINFIELD SCOTT, 1874
Location Scott Circle,
Massachusetts and Rhode Island
Avenues and 16th Street, NW
Sculptor Henry Kirke Brown
Architect General O. E. Babcock
Medium Bronze

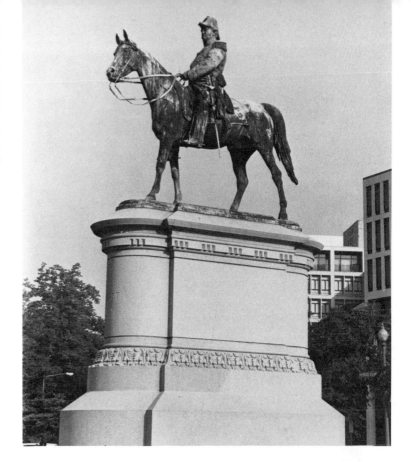

The memorial to Lieutenant General Winfield Scott is an equestrian statue made from cannon captured by General Scott during the Mexican War when he was commanding general of the American army. The statue, which faces south toward the White House, is on a granite pedestal and stands 15 feet high. The platform for the pedestal was carved from a single block weighing more than 150 tons, making it the largest stone quarried in this country at that time. General Scott, hero of three wars, is in the field uniform of a lieutenant general, a brevet rank awarded him by President Franklin Pierce for his service. Man and horse are shown in repose, the general holding the reins in his left hand and field glasses in his right.

This work is particularly interesting because of the individuality of the horse. The artist discovered that Scott's favorite mount was a small mare. Before Brown began casting the statue in Philadelphia, some descendants of Scott saw the model and protested. No general had ever been portrayed riding a mare. A great stallion with arched neck and flared nostrils seemed more suitable. The sculptor relented, in part, and the final result was a reduced stallion with the body of a mare.

Winfield Scott was born in Virginia and educated in the practice of law. He served his country in the military for more than fifty years. In addition to wartime duty, he wrote the first standard set of American military drill regulations. Under commission by President Andrew Jackson, he participated in the pacification of the Cherokee tribes as well as the settlement of the Maine boundary dispute with Great Britain.

In 1852, Scott was nominated for the presidency by the Whig party but was overwhelmingly defeated by Franklin Pierce. He considered his possible candidacy in 1860 but declined because of old age, failing health, and the impending national crisis. On October 31, 1861, General Scott requested retirement because of his infirmities. The next day, President Lincoln and the cabinet met at Scott's home where the President read an affecting eulogy to the venerable old soldier. He died in 1866 at West Point having served every president from Jefferson to Lincoln.

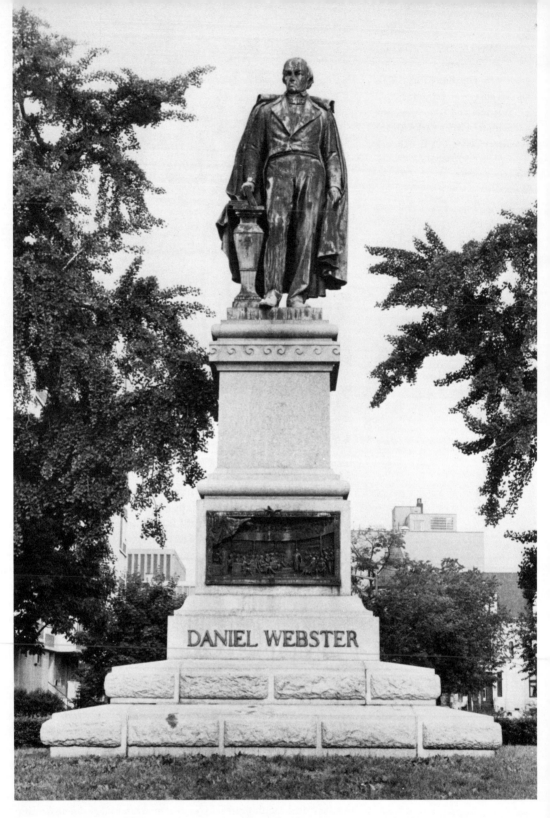

DANIEL WEBSTER

H-14

Title DANIEL WEBSTER, 1900
Location Scott Circle,
Massachusetts Avenue and 16th
Street, NW
Sculptor Gaetano Trentanove
Architect Unknown
Medium Bronze

Standing on a pedestal as massive and rugged as his New Hampshire hills, the 12-foot statue of Daniel Webster looks eastward at Scott Circle. The figure of the famous American orator and statesman is in bronze and portrays Webster in a characteristic pose, his features sternly set. The shoulders are thrown back in a defiant manner as if in answer to a challenge. In his right hand is a book of reference resting on a stand. The total height of the pedestal and statue is 30 feet.

The base is relieved on opposite sides by panels of bronze representing two significant moments in Webster's career. The most striking high-relief panel portrays Webster in his famous reply to Senator Robert Young Hayne of South Carolina in 1830, in which he defended

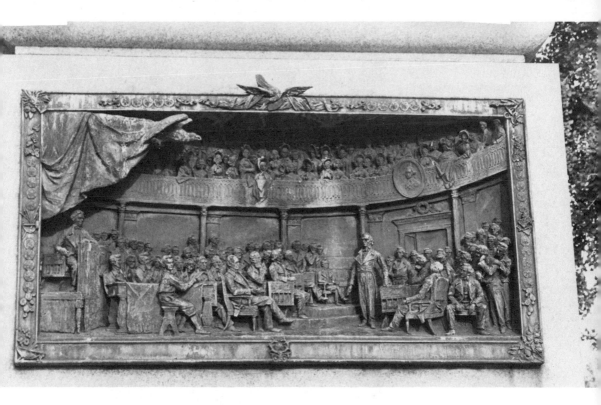

Detail of front relief panel:
Webster's Reply to Hayne

the Union and declared the suggestion of secession by a state to be illegal. Nearly 100 figures appear in high relief with those of Daniel Webster, John C. Calhoun, Robert Young Hayne, and others clearly distinct. Above the panel are the concluding words to that impassioned speech, "Liberty and Union, Now and Forever, One and Inseparable." The second bronze panel, located on the rear side of the base, illustrates Webster delivering the speech of dedication of the Bunker Hill Monument near Boston in 1843. Webster stands on a flag-draped platform with hand outstretched to the audience below. Another famous quotation from Webster, taken from his Bunker Hill speech, appears above this panel: "Our country, ᴏᴜr whole country and nothing but our country." The statue was commissioned by Stilson Hutchins, a native of New Hampshire and a great admirer of Webster. During the last quarter of the nineteenth century Hutchins founded the *Washington Post* and, in addition, became a prominent local businessman. He made a speech at the dedication of this statue in 1900, presenting it as a gift to the federal government.

One of New England's most brilliant sons, Daniel Webster (1782–1852), served the new republic in many important roles, though never achieving the presidency, which at times seemed to be just within his grasp. He was a member of Congress and of the Senate for a total of 23 years, from 1823 to 1841 and again from 1845 to 1850. Throughout his public career he was a staunch supporter of the supremacy of the Union, debating remorselessly against states' righters who wished to loosen ties with the central government. Friends and foes alike admired him as one of the most gifted of American orators. As secretary of state, an office which he held twice, he completed settlement with England of the Northeast Boundary dispute, which after years of controversy established the present boundary between Maine and New Brunswick, Canada. Webster's most famous legal activity was his defense in the Dartmouth College case. New Hampshire had attempted to assert ownership of this private college and convert it to a state-owned university. The case eventually reached the Supreme Court, which made one of its most historic decisions on the validity of contracts. George III's charter to Dartmouth College was a contract, the Court held, and states could pass no laws infringing a contract.

H-15
Title Australian Seal, 1969
Location Australian Embassy, 1601
Massachusetts Avenue, NW
Sculptor Thomas Bass
Architect Bates, Smart, and
McClutcheon
Medium Bronze

The entrance façade of the Australian Embassy, built in contemporary style, is enriched by a 5-by-8-foot sculpture of that nation's seal, designed and cast in an irregularly shaped block of bronze. The sculptured seal is artistically handled as a massive low-relief panel and relates uniquely to the building's modern style. This piece is not an exact replica of the official seal, but is rather an artistic version of the various components which represent the history of Australia. A kangaroo and an emu, native to Australia, stand opposite each other, modeled in low relief, framing a seven-pointed star and shield. The star has a point for each of the six states and one for the Northern Territory. On the shield, six frames represent the states bound together as a self-governing member of the British Commonwealth. The upper left section is for New South Wales, with a St. George's Cross decorated by a lion. The upper center frame shows Victoria's crown as the symbol of the British monarchy, and stars as the symbol for Australia's independence; while the upper right frame denotes Queensland marked by a Maltese Cross. The lower left segment has the native bird, a magpie, of South Australia; the lower center has a black swan symbolizing Western Australia, and the lower right shows a lion, Tasmania's version of the British royal symbol.

The continent of Australia, a huge island of some three million square miles, was probably first sighted by Portuguese seamen about 1601. In the following hundred years it was repeatedly visited by Dutch explorers, who named it New Holland. In 1770 Captain James Cook reached Botany Bay in Australia and before sailing away, after further exploration of the coastline, took "possession" of the eastern part of the continent on behalf of Great Britain. The first English settlement was in 1778, when a penal colony was established at Botany Bay.

During the next century there was steady and large emigration from Britain. On January 1, 1901, the Commonwealth of Australia was proclaimed as a self-governing federation made up of six states, including the island state of Tasmania, and two territories largely inhabited by aborigines. The multiplicity of symbols on the Australian shield is indicative of the wide differences in population and terrain.

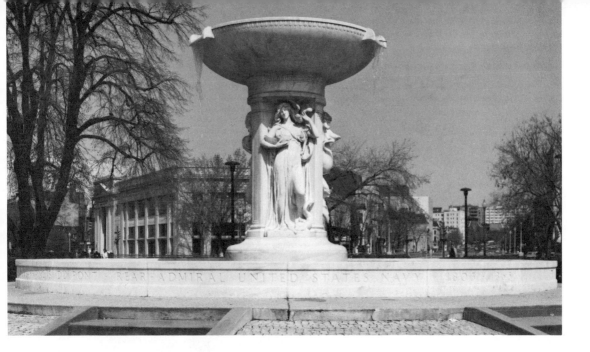

How refreshing is this beautiful marble fountain to mind and spirit, and to the panting dogs, bathing birds, curious children, and tired feet which daily rest at Dupont Circle. This fountain memorial to Rear Admiral Samuel Francis Dupont (1803–1865), properly spelled du Pont, may convince the passerby of the propriety of commemorative art, rather than portraits, for pedestrian thoroughfares.

Within the broad marble lower basin rises a tall pedestal which supports the upper bowl of the fountain. Three figures representing the Arts of Ocean Navigation, which Dupont mastered so ably, form the centerpiece of the fountain. The Sea, a woman, enfolds a boat with one hand and caresses a gull with the other as a dolphin plays at her feet. The male Wind is draped by the swelling sail of a ship. His left hand holds a conch shell for a horn. He presides over the destiny of sailors, as well as admirals. The goddess of the Stars holds a globe. Her eyes look down upon her visitors. Each of the figures is 8 feet high and 4½ feet wide. Around the outer rim of the bowl of the base is the inscription: "Samuel Francis Dupont, Rear Admiral, United States Navy, 1803–1865."

Dupont became the first naval hero for the Union cause in the Civil War when his fleet captured Port Royal, South Carolina, in a daring attack. Dupont retired from active duty several years later, after being defeated in a massive attack on Charleston Harbor. After his death, it was proved that Dupont had advised against the attack, due to the heavily defended Confederate harbor, but was ordered to proceed by the secretary of the navy. The Dupont family, eager to clear his name, erected a bronze portrait statue of Dupont here in 1884. Later, various family members chose to have it removed to Wilmington, Delaware, where it stands today in a public park. The Dupont family commissioned the noted sculptor, Daniel Chester French, to design the present fountain, which was dedicated in 1921.

In the 1880s the circle was known as Pacific Circle, since it was the westernmost residential sector of the city, and it was completely filled with great Victorian mansions when some of the nation's most ambitious status seekers settled here. The James G. Blaine Mansion, erected 1881–1882, at the western corner of Massachusetts Avenue and the circle is one of the last ones left. The nearby Patterson House, at the eastern corner of Massachusetts Avenue and the circle, was designed by Stanford White at the turn of the century. Here President Calvin Coolidge and family lived temporarily in the 30-room mansion in 1927, while the White House was undergoing renovation.

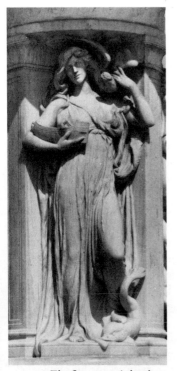

The Sea, one of the three allegorical figures

Title BALINESE DEMONS, ca. 1870
Location Indonesian Embassy,
2020 Massachusetts Avenue, NW
Sculptor Unknown
Architect None
Medium Volcanic rock

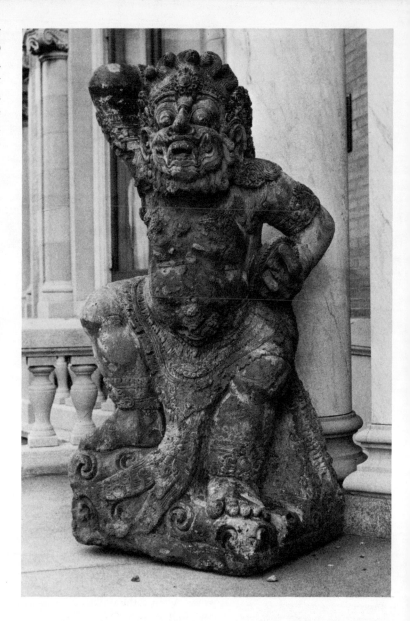

Twin demons from Bali, a small island of Indonesia famous for its artistic people and beautiful scenery, welcome visitors to the Chancery of the Indonesian Embassy. Their bulging eyes and fanglike teeth perhaps serve as well as electronic devices to keep watch on entry to the Chancery. Standing 5 feet in height, the statues were carved of soft volcanic rock a hundred years ago by Balinese craftsmen. The characteristic style reflects a Hindu influence that has lasted for centuries, as well as the dynamic role of demons in the Balinese culture. Such statues, usually in human form, are found in most religious temples on the island. Although these robust fellows are fierce in countenance, their fleshy bodies are graceful in appearance.

The Chancery was designed by architect Henry Andersen and erected in 1903 as the private mansion of Thomas Francis Walsh (1851–1910), an Irish immigrant who came to the United States in 1865 and became a multimillionaire. After working in the east as a carpenter, Walsh moved to Colorado in 1872 and studied geology. He made a fortune in the Black Hills gold rush of 1876 and in the Leadville gold rush a few years later. Although he lost his fortune in the 1893 depression, he returned to a career as a mining engineer and bought old claims thought to be worthless in Quray, Colorado. One of them, the Camp Bird mine, proved to be one of the richest in the world. Walsh refused an offer to sell it for $35,000,000. He was a pioneer in reforms for his employees, building model housing and establishing an eight-hour working day.

He visited Europe frequently, and entertained lavishly both there and at his mansion on Massachusetts Avenue in Washington.

From his marriage to Caroline B. Reed in Leadville, Colorado, in 1879, he had one daughter Evalyn (1886–1947), who became as well known as her father because of her lavish entertainment both at her parents' home and at her own eighty-acre estate, "Friendship," on Wisconsin Avenue in Washington. After two years at the Masters School in Dobbs Ferry, New York, she went to Paris in 1902 to study music and French. Upon her arrival there she shocked her parents by purchasing a sports car and by dying her hair bright red. She was married to Edward B. McLean, the son of John R. McLean, owner of the *Washington Post* and the *Cincinnati Enquirer*. During the 1920s, Evalyn Walsh McLean entertained lavishly, especially during the Harding administration. She made headlines for the $15,000 parties given for her son, Vinson, and for the purchase of a $60,000 sable coat. McLean, who was implicated with Albert Fall in the Teapot Dome scandal, was separated from his wife in 1928; he died in a mental hospital in 1941. A decline in her fortune necessitated Mrs. McLean's selling of the *Washington Post* to Eugene Meyer in 1933. Following the sale of "Friendship," she moved to Georgetown where she was noted for the dinner parties at which she frequently seated social and political enemies together. During World War II she used her parents' mansion to entertain military personnel, as well as for Red Cross use. Mrs. McLean was passionately fond of jewels and owned the Star of the East and the Hope Diamond. Following her death, the New York jeweler, Harry Winston, bought her jewels and gave the Hope Diamond to the Smithsonian Institution in 1958. Mrs. McLean was the author of *Father Struck It Rich* in 1936. Following Mrs. McLean's death, the mansion was purchased by the first ambassador of the newly independent Republic of Indonesia in 1952. The ambassador found the pair of *Balinese Demons* keeping watch at the Netherlands Information Bureau at Rockefeller Plaza in New York City, and he brought them to Washington to assume their present duty as "guardians of the portal."

H-18
Title BRAQUE BIRD, 1960
Location The Phillips Collection, 1612 21st Street, NW
Sculptor Pierre Bourdelle after design by Georges Braque
Architect Frederick King
Medium Marble

The Phillips Collection is housed in two adjacent buildings, the former residence of Duncan Phillips and his artist-wife, Marjorie, and a more recent attractive limestone addition. They provide a charming, informal environment for viewing masters of modern art together with such forerunners as El Greco and Goya. When plans for the new building were being formulated, Phillips was reminded of a 1958 exhibition of the works of the ultra modern French painter Georges Braque (1882–1963) at the Louvre, in Paris, which had been announced by posters bearing the lithograph of a bird. He conceived the idea of translating the bird into a stone relief panel and placing it above the entrance of the new gallery. Braque gave his permission for the use of the design and himself chose Pierre Bourdelle, a French-born sculptor living in New York, to conduct the project. The bird's deep rose-colored marble is handsome against the light rose-veined marble of the lintel. Inside, one can find the Braque drawing on which the design is based. The low-relief carving measures 3 feet high and 7½ feet long.

Duncan Phillips (1886–1966), whose whole life was devoted to building a private art collection, was born into a Pittsburgh family of considerable wealth, his grandfather having made a fortune in steel. His parents, seeking a more suitable climate for his father's health, moved

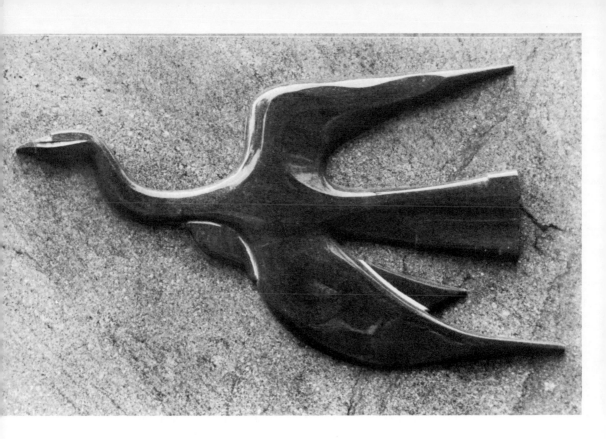

to Washington in 1896, bought property at the corner of Twenty-first Street and Que Street, NW, and built the spacious residence which was eventually to become a gallery for his paintings.

Phillips' interest in art developed early and was shared by his brother. Even as undergraduate roommates at Yale, they began to acquire paintings and drawings for their walls instead of college pennants. In 1913, after Duncan had returned to live at home, studying art history and writing articles on art subjects, the two brothers made a proposal to their father. They suggested that, though unable to compete with the Fricks and the Morgans, they might develop a modest collection through a regular planned program of acquisition; an annual expenditure of $10,000 was discussed and agreed upon. After the deaths of Duncan's father and brother in 1917, within a few months of each other, he and his mother founded in their memory The Phillips Memorial Gallery, which was opened to the public in 1921.

The marriage of Duncan Phillips and Marjorie Acker in the same year began a long and felicitous collaboration. Their tastes were much the same, particularly in a love of Impressionism. Throughout the years they traveled widely, always returning with new works for the collection. They never made use of an agent in their purchases, but bought what they liked, and their impeccable discrimination allowed them to assemble a matchless array of paintings. The gem of the collection is Renoir's *The Boating Party* (*Déjeuner des Canotiers*), which they admired while lunching in a private home in Paris and later bought for $125,000, the highest price paid for any single item in the gallery. Years later Lord Duveen wanted to buy it from them for presentation to the National Gallery in London, and is said to have waved a blank check at Phillips, telling him he could fill in the amount. The open-ended offer was not accepted.

In 1930, when the Phillips family moved to a new home on Foxhall Road, all of their former residence was utilized for display of the collection. Phillips lived to see the realization of another dream, the completion of the new gallery with the *Braque Bird* over the entrance. When this was opened to the public in 1960, the name was officially changed from The Phillips Gallery to The Phillips Collection.

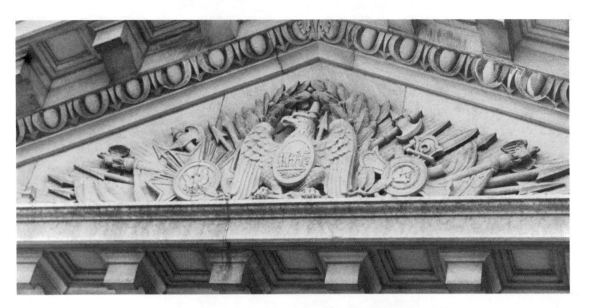

H-19
Title THE SOCIETY OF THE
CINCINNATI PEDIMENT, 1905
Location Anderson House, 2118
Massachusetts Avenue, NW
Sculptor Little and Brown,
designers
Architect Little and Brown
Medium Marble

Anderson House became the national headquarters of the Society of the Cincinnati, the oldest patriotic organization in the United States, in 1937, when this lavish private residence of Larz Anderson (see H-20) was presented to the society by his widow. The imposing 40-room Neoclassical mansion features a handsome circular portico; a distinguished walled entrance court screens the driveway from the street. Towering above this courtyard is a massive pediment on the main façade, 6 feet high and 14 feet wide. At the center of the pediment is found an American eagle, on which is mounted the seal of the Society of the Cincinnati. On each side are numerous Revolutionary War emblems, trophies, and martial symbols. Below the pediment is a marble bust of the Roman Consul Marcus Lepidus, evidently purchased by Anderson in Paris during his travels. Anderson, who had the mansion built in 1905, must have quietly planned to leave it to the Society of the Cincinnati upon his death, for he commissioned the architects to design the pediment when the structure was originally planned.

The Society of the Cincinnati, of which Larz Anderson was a member for forty-three years, is a fraternal order which was formed by officers of the American Revolutionary Army in 1783, just before disbanding. General Washington was its first and lifelong president. The name is derived from the legendary Lucius Quintius Cincinnatus (born 519 B.C.), who left his farm to lead forces defending Rome against the invading Aequians in 458 B.C. Upon the defeat of the barbarians, Cincinnatus resigned his dictatorship and returned to farming. Since then, his name has been associated with simplicity, ability, and virtue in government. Membership was to be limited to officers of the Continental Army and their eldest male descendants. Auxiliary branches were soon organized in each of the thirteen original states and one in France. The badge which members are entitled to wear, consisting of a golden eagle suspended on a ribbon, contains a representation of Cincinnatus at his plow being offered a sword by Roman senators.

The Society aroused strong opposition in some quarters, where the fear was that it might lead to an hereditary military nobility, out of keeping with the democratic ideals of the new nation. Republican adherents organized other clubs or societies to counteract what they feared would be the Cincinnati's influence; one of these, by what would later become historical irony, was the Tammany Society of New York. In fact, the Cincinnati had no intentions of establishing an aristocracy, and had all but died out by the end of the nineteenth century, when it was revived by eligible descendants, proud of their patriotic genealogy. Anderson House, now also a museum of Revolutionary War memorabilia, is open to the public from 2 to 4 o'clock daily except Monday.

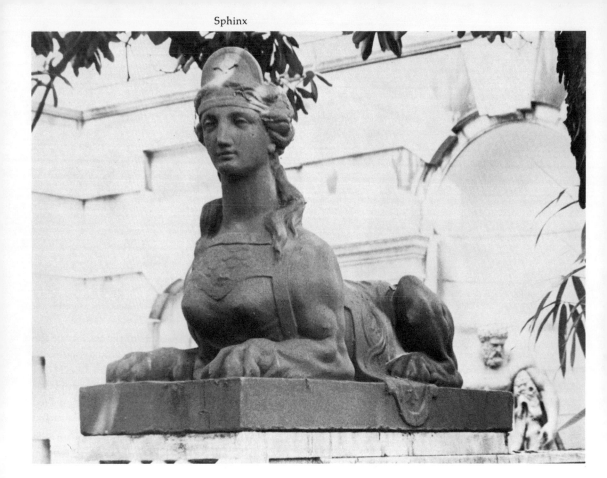

H-20
Title HERCULES, BUDDHA, and
SPHINX, ca. 1900
Location Anderson House, 2118
Massachusetts Avenue, NW
Sculptors Unknown
Architect Little and Brown
Medium Marble, bronze, cast iron

The formal garden of Anderson House, the national headquarters of the Society of the Cincinnati (see H-19), may be approached through the ballroom, the doors of which open onto a stone terrace and garden beyond. Of major interest in the garden is the large seated bronze Shakyamuni *Buddha* in the style of the classical image of Kamakura, Japan. In the center of the halo is the Sanskrit syllable for the historical Shakyamuni Buddha, and the robes are also inscribed with his name. The *Buddha* is shown in his characteristic gesture of *abhaya mudra*, or "do not fear." The *Buddha* measures 5½ feet high and 3 feet wide.

Marking the terrace steps are two identical cast-iron sphinxes, 3 by 3½ feet, with human female heads and chests and with lion bodies. Other sphinxes of this type can be found in the garden of "Dumbarton Oaks" in Georgetown and at "Hillwood," the former residence of Mrs. Marjorie Merriweather Post near Connecticut Avenue, now belonging to the Smithsonian Institution. A cast-iron statue of *Hercules at Rest* on the east terrace is a late nineteenth-century copy of the famous ancient Roman *Hercules* which was discovered in Rome 400 years ago by the patrician Farnese family. For the past 200 years the original has been in Naples and is now on display there in the National Museum. *Hercules*, 6 feet high and 2½ feet wide, leans on his club, which is covered with a lion skin.

Additional statues in the garden include a cast-iron portrait of *Ceres*, the Roman goddess of agriculture, and of a Roman soldier in his battle armor. Although most of these are copies of original pieces in European museums, collected by the Andersons during their travels abroad, they are included here as being representative of dozens of other works located in the gardens of a number of great Washington residences and embassies.

Larz Anderson III (1866–1937), for whom Anderson House and gardens were designed, was a direct descendant of Colonel Richard Clough Anderson, a founding member of the Society of the Cincinnati, who settled in Kentucky on a tract of land given him in recognition of his

Buddha Hercules

services in the American Revolution. His grandson, the first of three Andersons with the name of Larz, later moved appropriately enough to the Ohio city which had been named for the society. Cincinnati received its current name when another member of the society decided while governor of the vast and sparsely settled Northwest Territory, in 1791 that Losantiville, a small collection of mud huts on a bend of the Ohio River, should be rechristened. Some purists felt that towns, like ships, should be of the feminine gender and preferred Cincinnata, but a scholar arbitrated that the name chosen, though grammatically questionable, should be allowed to stand.

Larz Anderson III was born in Paris but spent most of his childhood in the first Anderson House, a mansion in Cincinnati built by his grandfather. Much of his adult life was devoted to travel and government service, as an adjutant general in the Spanish-American War and later in the diplomatic corps, where he rose to the highest rank and was American ambassador to Japan in 1912. The magnificent home in which he and his wife lived for thirty years was built in 1904–1905 at an estimated cost of $800,000. At the time its location was on the outskirts of Washington City. When Mrs. Anderson gave the house to The Society of the Cincinnati, Congress designated it a "museum for the custody and preservation of documents, relics and archives, particularly those pertaining to the American Revolution."

Title TARAS SHEVCHENKO
MEMORIAL, 1964
Location P Street between 22nd
and 23rd Streets, NW
Sculptor Leo Mol
Architect Radoslav Zuk
Medium Bronze and granite

A happier solution might be found for this triangular park than for the placement of this portrait statue and relief panel. These two sculptures are unrelated in shape or size to the park, and serve to block the view of the avenues and rob the area of spatial grace.

There is a touch of irony, perhaps, about this memorial of a Ukrainian national poet, a Soviet hero chosen by Americans as a symbol of oppressed people. Taras Shevchenko (1814–1861) was sentenced to prison for ten years for his ardent patriotic and freedom-minded writings. (The Ukraine was then controlled by Czarist Russians.) He died after four years of confinement. Born a serf, his freedom purchased, Shevchenko is adored in the Soviet Union for his poetry. Although he is not well known in the United States, since there is only one incomplete American edition of his poems, hundreds of towns, collective farms, factories, public buildings, and streets bearing his name are to be found in the Soviet Union today.

The memorial, sponsored by a group of Ukrainian nationalists, was erected amid controversy. The opposition argued: the Ukrainian poet is known to only a few Americans, he is an idol of the Soviet Communist Party, he was anti-Semitic and anti-Polish, and the only reference to American nationalism in his poetry is an overworked quotation expressing the wish that the Ukraine might have a George Washington. Those who favor the memorial insist he was a champion of freedom, inspired by George Washington and the American Revolution, and that his anonymity is due not to lack of genius but the failure of his struggle to achieve freedom.

On June 27, 1964, an estimated 100,000 people jammed the park area for the dedication. President Dwight Eisenhower unveiled the memorial, an immense 24-foot-tall bronze figure and pedestal together with a granite stele showing the martyred Prometheus in bas-relief.

H-22

Title BUFFALOES and INDIAN HEADS, 1914

Location Dumbarton Bridge, carries Que Street, NW, across Rock Creek Parkway

Sculptor Alexander Phimister Proctor (*Buffaloes*); Glen Brown (*Indian Heads*)

Architect Glenn Brown and Bedford Brown

Medium Bronze (*Buffaloes*) and sandstone (*Indian Heads*)

This distinctive bridge with its four massive bronze *Buffaloes* was built in 1914; it was designed to resemble a Roman aqueduct as it turns gracefully on a 12-degree horizontal curve, a feature not wholly appreciated by modern-day motorists. The bridge consists of five reinforced-concrete arch spans. The center arch measures 43 feet, while the flanking arches measure slightly less. Cantilevered walks and solid balustrades of sandstone are supported by corbeled arches which emphasize the Roman design. Within each of these arches is the carved head of an Aztec Indian, twenty-eight on each side of the bridge, gazing down on Rock Creek Parkway.

Four massive *Buffaloes*, each 7 feet high, guard the approaches to the bridge. These animals are the work of A. Phimister Proctor, who also designed the tigers on the Sixteenth Street Bridge. The architects for this unique structure were Glenn Brown and his son Bedford. The design of the *Indian Heads* was most likely executed by Glenn Brown (1854–1932), one of Washington's most prominent architects between 1890 and 1920. Brown was born on a Virginia plantation and came to Washington after the Civil War to enroll in Columbian College (the present George Washington University). Upon completing his later architectural studies at the Massachusetts Institute of Technology at the age of twenty, he returned to Washington and opened his own office. A designer of both private and public buildings, he soon achieved wide recognition, as attested by his admission to prestigious architectural societies in this country and abroad. For years he was an active official of the American Institute of Architects, participating continuously in efforts to improve the taste and quality of architecture in the Nation's Capital and to preserve its historic sites. Brown executed the restoration, in nearby Fairfax County, Virginia, of old Pohick Church, where Washington frequently worshiped, and of Gunston Hall, the home of George Mason, author of the Virginia Constitution which included the famous Virginia Bill of Rights.

Throughout the last decade of the nineteenth century Brown played a leading role, along with other of his colleagues, in efforts to inform the public of how L'Enfant's comprehensive plan for the city's growth was being disregarded and destroyed. In 1900 the Senate appointed a Park Commission to make a report by 1902, instructing it to give some attention to the L'Enfant plan but not to be limited by it. To the delight of Brown and those who shared his views the final report strongly reaffirmed L'Enfant's design as an overall guide for future city planning, and a permanent Park Commission was established. Brown was also successful in blocking proposed "improvements" to the Capitol building that would have destroyed many of its original features, and his published *History of the United States Capitol* is a standard reference on the subject since it was first published in the early twentieth century.

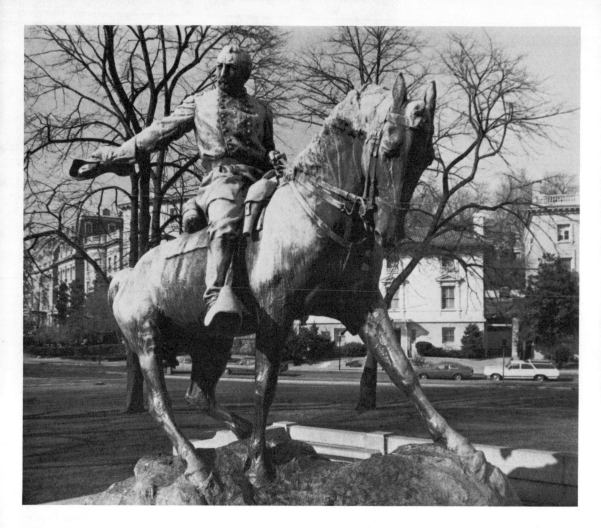

H-23

Title GENERAL PHILIP H. SHERIDAN, 1908

Location Sheridan Circle, Massachusetts Avenue and 23rd Street, NW

Sculptor Gutzon Borglum

Architect Unknown

Medium Bronze

An officer and a gentleman! The officer is Philip H. Sheridan, dashing leader of the Union cavalry during the Civil War and commander of the Army of the Shenandoah. The "gentleman" is Rienzi, the horse that carried Sheridan through eighty-five battles and skirmishes, and who, on October 19, 1864, carried his master into the fight near Winchester, Virginia. Sheridan, a native of New York, is here shown rallying his retreating men. His hurried arrival at the scene of the battle, after a furious twenty-mile ride, won the day for the Union, ending Confederate resistance in the Valley of the Shenandoah. Rienzi, his horse, was immediately renamed Winchester after this important Union victory. This epic ride to victory is also remembered in verse by Thomas Buchanan Read: "Here is the steed that saved the day. . . ."

The well-known sculptor, Gutzon Borglum, has molded speed and power into the bronze gelding. The statue stands approximately 11 feet high. Hard-muscled, triumphant, proud, no other equestian statue in Washington has the tempo of this one. Borglum was equally effective in portraying the character of Sheridan. A short, slight person, the general was a born leader of men. He was at his best in battle, and the sculptor has shown him as he must have looked, waving his hat to rally his retreating troops. Charming hidden pools, located on both sides of the granite base, are supplied with water from small lion's heads.

Mrs. Sheridan selected the site for the memorial to her husband. The setting is enhanced by granite exedras flanking the statue. The memorial was dedicated November 25, 1908, with the unveiling performed by Second Lieutenant Philip H. Sheridan, Jr., who also served the sculptor as a model for his father's statue. President Theodore Roosevelt, in attendance at the ceremonies, called the statue "first-rate."

Detail: General Sheridan's hand grasping his hat

H-24
Title ROBERT EMMET, 1917
Location Massachusetts Avenue
and 24th Street, NW
Sculptor Jerome Connor
Architect Richard Murphy
Medium Bronze

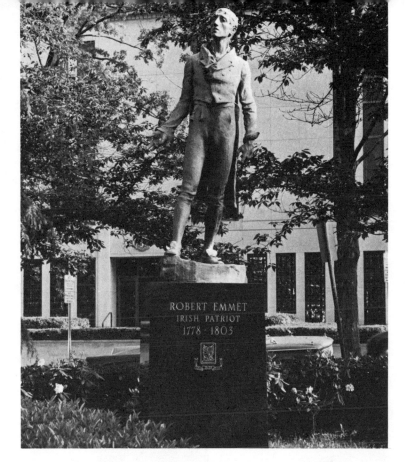

Unchastened, Robert Emmet (1778–1803) stands as he did on that day in Dublin, 1803, when he received a British special court sentence of death by hanging. The fiery young Irish revolutionist, a member of the United Irishmen's Party, futilely traveled to France to seek French aid for Irish independence from Napoleon and Talleyrand in 1802. His last act was to lead an abortive Irish uprising on July 23, 1803, in Dublin which was quickly crushed by British troops. His brother, Thomas A. Emmet, was expelled for his Irish nationalism and immigrated to New York in 1804. Today, the Irish patriot gestures toward the Irish Embassy two blocks away from the small green and white-flowered park on Embassy Row.

On the rear of the pedestal appears the following extracts from Emmet's speech during his trial on September 19, 1803: "I wished to procure for my country the guarantee which Washington procured for America . . . I have parted from everything that was dear to me in this life for my country's cause. . . . When my country takes her place among the nations of the earth, then, and not till then let my epitaph be written . . ."

The statue was commissioned by American citizens of Irish ancestry who wished to commemorate the independence of Ireland. Presented to the Smithsonian Institution in 1917, the statue originally was placed in the main rotunda of the National Museum of Natural History. Later, when Smithsonian officials decided that the room really belonged to the huge mounted elephant who presides there, it was removed to storage. The statue, now on indefinite loan from the Smithsonian, was recovered and rededicated at its present site on April 22, 1966, to mark the fiftieth anniversary of the proclamation of Irish independence.

The 7-foot bronze likeness of Emmet was designed by American sculptor Jerome Connor, an immigrant from County Kerry, Ireland, who worked mainly from sketches done at Emmet's trial. The handsome pedestal of emerald-green Brazilian granite displays the United Irishmen coat of arms. A copy of the statue can be found in San Francisco's Golden Gate Park.

Title THE PROPHET, ca 1960
Location Embassy of Venezuela,
2445 Massachusetts Avenue, NW
Sculptor Harry Abend
Architect None
Medium Bronze

A bronze sculpture modeled by a Venezuelan and donated by the Neumann Foundation in Venezuela has a prominent place on the front lawn of the Embassy of Venezuela on Massachusetts Avenue. It faces the driveway and is located on an axis with the entrance.

Unusual in a city of predominately representational sculpture, this stark black bronze shaft defies easy interpretation. Untitled, it might have been considered merely a monumental design pleasing to the eye. However, because the sculptor has chosen to call it "The Prophet," it may have been his intention to foreshadow a future world of angular and rigid mechanization.

The Venezuelan responsible for this work, Harry Abend (1938–), emigrated from Poland with his parents to Venezuela in 1958. Enrolling in the school of architecture at the Central University of Venezuela, he soon developed an interest in architectural sculpture. As a student of Miguel Arrayo, he displayed distinct talent in his early work on reliefs sculptured in wood. Later, however, he turned to pioneer experiments for fusing bronze, a technique now used by the majority of young sculptors. By 1961 he was recognized as a talented worker in both wood and bronze. Further recognition came in 1963, when he took first place in a competition at the Primio Nacional de Esculture in Caracas. More recently, in 1971, he demonstrated his versatility in a one-man show of jewelry in Caracas, combining gold and silver with precious and semiprecious stones.

H-26
Title ELEPHANTS, ca. 1955
Location India Supply Mission,
2536 Massachusetts Avenue, NW
Sculptor Unknown
Architect A. R. Clas and George
Riggs Associates
Medium Marble

Elephants and India have a natural association; two beautifully carved gray marble pachyderms make fitting entrance sculptures to the India Supply Mission, a branch of the Embassy of India. In no sense are these 3-by-5-foot animal sculptures realistic in pose, but rather they are employed as an architectural adjunct to the building. Details of their trappings are indicated subtly; and their legs, trunks, and ears are restrained in movement to blend into the general mass of the animal. The color of the marble is identical to that of an elephant's skin.

Throughout recorded history elephants have been associated with the Indian subcontinent as both wild and domesticated animals. These largest of living land mammals, related to the extinct mammoth and mastodon and distinguished from their African counterparts by their smaller ears, have been tamed and trained to serve men in a variety of ways. They have been used in the jungle to clear paths and fell trees, as they can carry or pull enormously heavy loads. In war they transported cannon; from platforms strapped to their backs archers and spearmen attacked their enemies.

Indian emperors and princes showed themselves to their subjects from the eminence of howdahs, elaborately embellished canopied divans, atop elephants which were frequently covered with intricate painted designs. Some of the present Indian rajahs and ranees recall that, as children, they watched files of docile elephants being loaded with furniture, household effects, trunks full of clothing and supplies to make the trek from their palaces in the plains to summer "bungalows" in the mountains. A few local princes still keep elephants to be used at ceremonial religious festivals. Like all endangered species, elephants are liable to extinction if not protected, but they are still a not uncommon sight as beasts of burden in India.

In Hindu mythology the eldest son of Siva and Paravati is Ganesa, a godlike human figure depicted with an elephant's head to symbolize his sagacity. He was thought to be the creator of obstacles, and, as such, he was to be placated with offerings. Considered the embodiment of worldly wisdom, Ganesa is frequently invoked on the first page of books, particularly ledgers, as he is believed to bestow prosperity in trade.

The building is further embellished with artistic symbols relating to the cultural history of India. At the second-story level, color is introduced into the setting in a horizontal line of squares with backgrounds of blue. The white water lily on blue denotes peace and tranquility, and alternating blue squares have decorations reminiscent of a wheel, the continuous cycle of life. This last device was taken from the flag of an Indian emperor who lived 4,000 years ago.

Title Embassy of Iran Doors, 1960
Location Imperial Embassy of Iran,
3005 Massachusetts Avenue, NW
Sculptors Ulysses A. Ricci (doors)
Carl L. Schmitz (overdoor relief
panel)
Architect Francis Keally
Medium Bronze

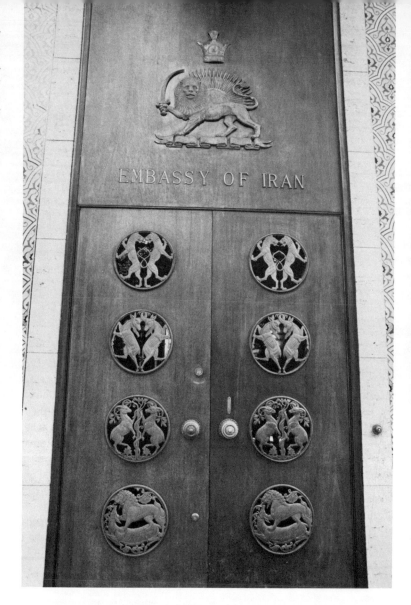

In October 1971, glittering ceremonies at Persepolis and Tehran marked the 2,500th anniversary of the founding of the Persian Empire. Many heads of state and other national leaders, large numbers of scholars from all over the world, and hundreds of international newsmen attended the celebrations. Emphasis was laid upon the old as symbolized by the ruins at Persepolis, capital of ancient Persia, and upon the new as represented by Tehran, capital of the successor to Persia, modern Iran, which is just a half century old.

Also indicative of this combination of old and new is the building occupied by the Imperial Embassy of Iran in Washington. Designed by New York architect Francis Keally and completed in 1960, the structure is contemporary in appearance, having strong, unbroken horizontal and vertical lines. The façade of the embassy is covered in white Italian travertine, a delicate and sophisticated material which emphasizes the colorful faience, the major decorative surfacing of the building. Impervious to the weather, faience has been used throughout the centuries for both interior and exterior Iranian architectural construction, including domes and mosques. This faience, a mosaic-like earthenware often incorrectly referred to as tile, is assembled like a jig-saw puzzle, with each piece having been made especially for the embassy by Iranian artisans. It has a baked, glazed vitreous enamel coating with underglaze designs consisting, in this case, of an ancient pomegranate motif in red and black with gold leaf, all placed against a blue background, with white divider strips separating the designs. The turquoise blue color is re-

Detail: pair of ibexes, the third medallion from the top

peated in the metal grilles at the windows. Turquoise is the national gem of Iran, and the finest quality of turquoise has been mined in the mountains of northeastern Iran for over 800 years.

According to embassy personnel, the bronze and mahogany doors to the building are the subject of many queries from the public. A pair of doors, measuring 8 feet high by 6 feet wide, and an overhead panel 6 feet square constitute the focal point of the entire façade. Centered in the panel is a bronze low-relief figure of the Iranian state emblem, the Lion and Sun. The body of the lion is shown in profile, but his head faces front; he holds a curved sword in his right paw, while his other paws rest on a ceremonial ribbon. The sun rises behind him, and the golden crown of the shahs, rulers of both Persia and Iran, is emblazoned above him; the crown features a sunburst on it similar to the one behind the lion. The Lion and Sun emblem is of very ancient origin, although the lion was shown in a reclining position in its earlier form. The lion traditionally symbolizes the kingdom of the forest and also strength and power. Iran is a traditional monarchy and, like many monarchies, it uses the lion frequently in its design. The state emblem couples the lion with the sun, which symbolizes light and life, Iran being a sunny country and therefore conscious of light. The official flag of Iran consists of wide horizontal stripes of red, white, and green, with this same Lion and Sun motif in the center.

Each of the two doors contains four circular medallions, about 15 inches in diameter and arranged one above the other. These medallions show, in free-standing relief, pairs of animals copied from ancient Persian hunting scenes. Situated between Occident and Orient, Persia has always drawn its artistic inspiration from both sources. After several visits to Iran in search of historical background, architect Keally discovered these designs and assigned sculptor Ricci to reproduce them in cast bronze. The scenes are true reproductions of designs used on such items as pottery, seals, manuscripts, coins, buttons, and textiles; such motifs were also used on buildings as architectural decoration. Arthur Upham Pope's massive work, *A Survey of Persian Art from Prehistoric Times to the Present* (New York, Oxford University Press, 1938), contains detailed accounts of the ways in which these designs were used.

The medallion at the top of each door shows a pair of lions standing back to back on their hind legs, with their heads turned so that they face each other, and with their tails entwined. The second medallion from the top shows two ibexes, wild goatlike creatures, standing on their hind legs, back to back, with their heads facing each other. Their forelegs are bent at the knees and rest against the circular rim of the medallion; their horns are entwined. Each animal wears an elongated mane. Both of these medallions utilize designs from the Achaemenid period of Persian history, approximately 600–300 B.C. The art of this period may be traced to Mesopotamia, Egypt, and occasionally Greece. The third medallion, the most graceful of all, portrays a pair of ibexes standing face to face, with a serpent twisting around a tree trunk between them. They stand on their hind legs, with their forelegs resting against the tree. This motif is from the post-Sassanian period, after A.D. 651. The bottom medallion represents the Sassanian period, A.D. 224–651. It shows a lion standing on its prey, a deerlike animal; the lion has three paws on its back and one at its throat. This last design was taken by the architect from a Persian dinner plate found in the Soviet Union's Hermitage Museum.

Persian animals, primarily the ibex, which is the national animal, possess qualities of simplicity, accuracy, and vigor which are not to be found in the Asiatic art of any other age. Persian art creations, such as ibexes and lions, show a phenomenal strength and simplicity. The artists exhibited unrestricted genius and originality; and their art had a bizarre, nonrealistic style, yet it was full of vigor and might. Persian artists possessed a skill for representing movement and balance. The Iranian love for animals reflects an inherent understanding of form and motion.

All of the figures in the medallions are free standing and have no scenic background. Behind the medallions, on the inside of the doors, are glass panels which are hinged and can be opened for cleaning. At night the lights from the embassy lobby shine through the open spaces in the medallions and present the animals in silhouette. This particular treatment was devised by the architect. He also chose the designs for the brass doorknobs; he selected stock English designs and had the knobs made in England, believing that, although the designs were not Iranian, they had the correct "feel" for the overall pattern of the entranceway.

The bronze medallion animals were executed by the New York sculptor, Ulysses A. Ricci, while the Lion and Sun emblem of state was done by another New York sculptor, Carl L. Schmitz. In both cases, this was about the last work these men created, since Ricci died in 1960 at the age of 72 and Schmitz died in 1967 at the age of 66.

H-28

Title SIR WINSTON CHURCHILL,
1966
Location 3100 Massachusetts
Avenue, NW
Sculptor William M. McVey
Architect Fred Toquchi Associates
Medium Bronze

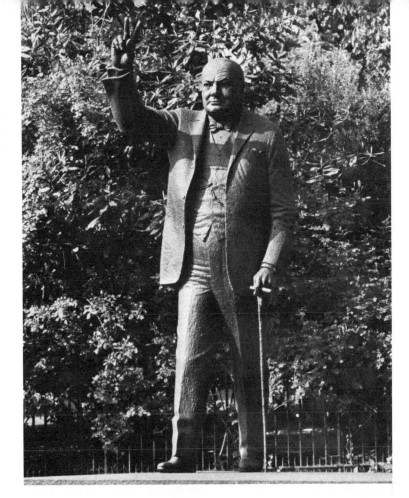

*Churchill's left hand holds his
cane and controversial cigar*

West of Dupont Circle and extending to its intersection with Wisconsin Avenue, Massachusetts Avenue is known as "Embassy Row." Here, the British Embassy with its Georgian architecture, situated on a hillside, is the setting for a statue of Sir Winston Churchill. The location between the street and the garden was chosen so that one foot could stand on the British soil of the embassy and the other on American soil. The former Prime Minister of Great Britain is cast in bronze, 9 feet high, giving the "V for Victory" sign with his right hand upraised, his left hand leaning on his cane and with the ever-present cigar held between his fingers. The pose shows Sir Winston as he was in wartime, defying the Axis powers.

On Churchill's eighty-ninth birthday, the English-Speaking Union of the United States announced its plans for the statue to serve as a symbol of Anglo-American unity. Informed of the proposal, Churchill expressed "the greatest pleasure that the statue should stand on both American and British soil. And I feel it will rest happily and securely on both feet." At this time, Honorary Citizenship of the United States was conferred upon Churchill by President John F. Kennedy, in recognition both of his brilliant leadership in World War II and of the parental tie of his American-born mother.

Of eight sculptors who submitted models for the statue, William McVey was chosen to do the work. His sketch or model, like the finished bronze figure, had a cigar in one hand. Although some members of the English-Speaking Union hotly disputed this feature as undignified, the majority voted for the cigar, and it remains intact.

Beneath the granite plinth on which the figure stands is soil from Blenheim Palace, Churchill's birthplace, from his rose garden at Chartwell, and from his mother's home in Brooklyn, New York. In the year 2063, a capsule beneath the statue will be opened by the president of the United States to celebrate the centenary of Sir Winston's honorary United States citizenship.

H-29
Title EURYTHMY, 1955
Location Swiss Embassy, 2900
Cathedral Avenue, NW
Sculptor Andre Ramseyer
Architect William Lescaze
Medium Bronze

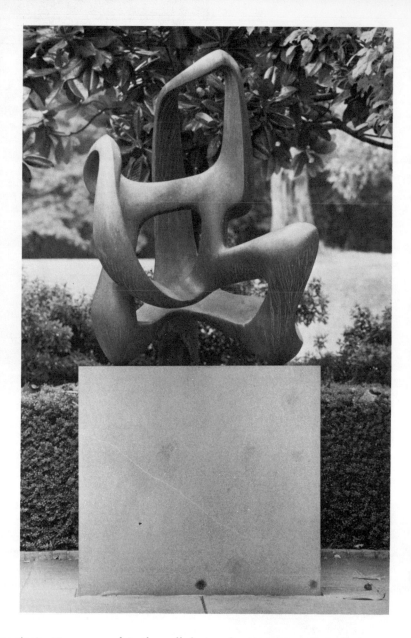

An inviting approach to the well-designed contemporary Swiss Embassy just off Massachusetts Avenue is achieved by a flagstone terrace, to the right of the entrance door, which is bordered by magnolia and apple trees. As the visitor looks toward the end of the terrace he sees a skillfully contrived abstract sculpture in bronze terminating the vista. The title of this work of art is *Eurythmy*, indicating the sculptor's interest in free, fluid, and rhythmic movement. Supported on a smooth stone pedestal 3 feet high by 4 feet, the sculpture is nonrepresentational and is a pure creation of the artist, expressing beauty by the balance of curves and the interplay of masses and voids. It harmonizes equally well with the plain lines of the embassy and the foliage of the garden setting. The sculptor, Andre Ramseyer, lives in Neuchatel, Switzerland.

H-30
Title Orbit, 1972
Location Swiss Embassy, 2900
Cathedral Avenue, NW
Sculptor Walter Linck
Architect None
Medium Burnished steel

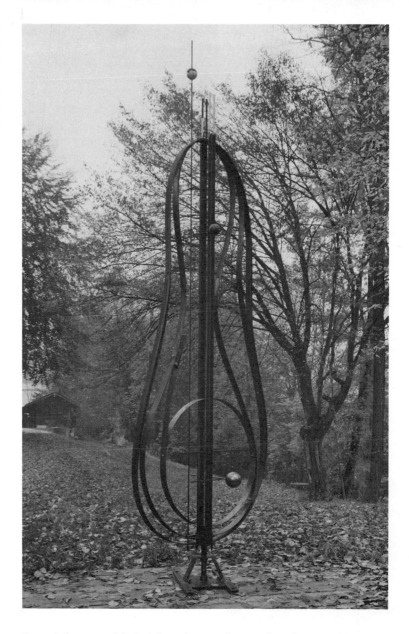

One of the most delightful modern sculptures found in Washington is *Orbit* on the grounds of the Swiss Embassy, the design consisting of a black steel figure reminiscent of a harp. The abstract sculpture, placed on the top of a grassy hill on the grounds of the Swiss Embassy revolves on a pivot powered both by wind currents and by a small electric motor. The sculptor himself selected the site during a visit to Washington in 1973. A whistling sound is produced by the wind striking the work. The sculpture measures 18 feet in height, 5 feet in width, and 2 feet in depth, and rests on a 3-foot concrete pedestal. Mr. Walter Linck, one of the four leading sculptors in Switzerland, executed an outdoor abstract sculpture of a somewhat similar design for the edge of the lake at Bienne, Switzerland, in 1962.

Since 1950 Mr. Linck's abstract sculptures have shown no resemblances to massive strength, as so many works by other sculptors have done, but instead have a free, buoyant character. They blend into the landscape rather than dominate it. The noted popularity of his recent art results from the extraordinary poetic insight they convey. His sculptures have been strongly influenced by the art of Paul Klee, Swiss painter, and by Piet Mondrian, Dutch painter. Although Linck has often used steel for his medium, his works reflect a lightness and freedom of movement which have made them greatly in demand in Switzerland, Germany, France, and Italy.

Title Major General Artemas
Ward, 1938
Location Ward Circle,
Massachusetts and Nebraska
Avenues, NW
Sculptor Leonard Crunelle
Architect Unknown
Medium Bronze

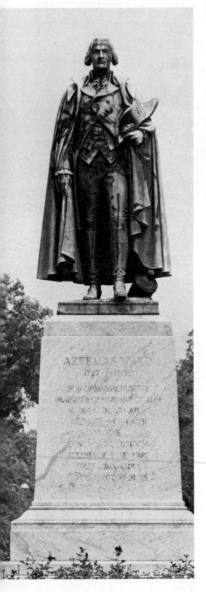

Artemas Ward (1727–1800) was prominent in Massachusetts colonial politics and took part in the British invasion of French-held Canada during the French and Indian War. In 1775, upon the outbreak of the American Revolution, he resigned his post as governor of Massachusetts in order to command the Massachusetts military forces and was in charge of the siege of British-held Boston until the arrival of General George Washington, who had been given supreme command of all Continental forces. Ward was made a major general by General Washington, but he withdrew not long afterward for reasons of health. Not abandoning public life, however, he played an important role in Massachusetts affairs, served in the Continental Congress, and was later a member of the national Congress. The Revolutionary Art*emas* Ward should not be confused (but often is) with Art*emus* Ward, the pseudonym used by Charles Farrar Browne (1834–1867), an American journalist who became well known on both sides of the Atlantic for his humorous sketches featuring dialect and amusing misspellings.

This bronze portrait statue is 10 feet high, as is the pedestal. The inscription reads: "Artemas Ward, 1727–1800, Son of Massachusetts, Graduate of Harvard College, Judge and Legislator, Delegate 1780–1781 to the Continental Congress, Soldier of Three Wars, First Commander of the Patriot Forces." General Ward stands here horseless, since the equestrian statue originally planned for the site could not be cast because of the lack of funds and the rising price of bronze during the years immediately preceding World War II.

In 1927, Harvard University offered a gift of $50,000 for a statue of General Ward, a Harvard alumnus, to the national capital. Congress approved the necessary bill in recognition of services rendered by the general during the Revolutionary War. Leonard Crunelle was selected to create the statue; for models, he used a life-size oil portrait by Charles Willson Peale as well as the actual cape which was worn during the war by Ward. The circle, built especially for the statue, was designed to have a diameter of 120 feet. According to new accounts of the period, the plan met with wide approval among area residents, although one gentleman did suggest that something on a grander scale, similar to the Arch of Triumph in Paris, be erected at this approach to the city.

H-32
Title CHRIST, 1960
Location Wesley Theological
Seminary, 4400 Massachusetts
Avenue, NW
Sculptor Leo Friedlander
Architect Heusel Fink
Medium Limestone

Both the architect and the president of Wesley Theological Seminary decided the key symbol for the new Seminary complex should be a figure of the living Christ with one hand lifted to God and the other outstretched to man. Sculptor Leo Friedlander produced an 8-foot model for the stonecarver to follow in cutting the 16-foot statue of Christ from a 40-ton block of limestone cantilevered into the brick wall of the chapel. The figure, dedicated April 1, 1960, is particularly inspiring when spotlighted at night, showing both the *Christ* and the brilliant chancel windows of the chapel. Motorists, homeward bound in the evening from their downtown Washington offices, feel as if Christ is raising his hand in benediction to all workers at the end of the day. The setting against a slightly concave wall of brick on rising ground is particularly effective as is the landscaping. Upon entering the Seminary grounds, the viewer may respond to the message of peace, love, and compassion which the statue proclaims.

In 1881 the Maryland Annual Conference of the Methodist Protestant Church passed legislation enabling the establishment of a seminary for theological studies. It was officially chartered and began classes the next year. Its original location was in Westminster, Maryland, 50 miles west of Washington, D.C., on the campus of Western Maryland College; it continued a steady growth and, for more than half a century, was the training center for ministers of the Methodist Protestant Church.

When the three major branches of Methodism united in 1939, the Seminary became one of ten schools of theology of the new Methodist Church. In 1955 it was decided to move the school from its Westminster location to its present site, and the actual shift was completed in 1957. At that time its name was changed to Wesley Theological Seminary, and its scope is described as a "graduate professional school preparing Christian men and women for the ministries of the church and for the work of Christian education with particular concern for adequate preparation for the parish ministry." It is accredited by the American Association of Theological Schools and is approved by the University Senate of the United Methodist Church. Although Wesley's campus adjoins that of The American University, there is no official connection between the two institutions. However, there is informal cooperation permitting reciprocal use of libraries and other facilities.

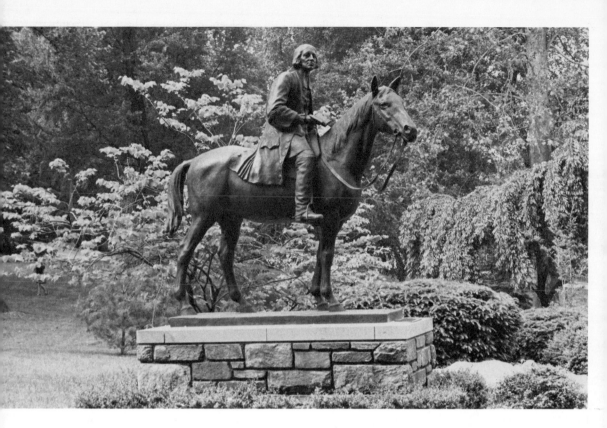

H-33
Title JOHN WESLEY, 1961
Location Wesley Theological
Seminary, 4400 Massachusetts
Avenue, NW
Sculptor Arthur George Walker
Architect Unknown
Medium Bronze

The artistic simplicity of the equestrian statue of John Wesley has won great admiration. The contrast between the less-than-life-size statue of the famous founder of the Methodist Church, as opposed to the many greater-than-life-size statues of military men mounted on fiery chargers, expresses forcibly the differences between the commemoration of war and of peace. Wesley's gentle horse is carrying his master, the Bible open in one hand, toward the west to seek new opportunities for the word of Methodism. Wesley's words were: "I look on the world as my parish."

The statue is a second casting of the original sculpture located at Wesley Chapel in Bristol, England. It is a gift of Lord Rank of England, a prominent Methodist layman, who was anxious to deepen religious ties between his country and the United States. With this statue, dedicated in 1961, and the one nearby of Christ on the chapel, the Seminary campus reflects a religious atmosphere for those studying and dedicating their lives to the ministry. Senator Clinton P. Anderson of New Mexico, who lived across the street, was so pleased with Wesley on his horse that he provided for the landscaping around the statue. Groupings of azaleas, dogwood, redbud, and long-needle pines make an impressive setting for this 8-foot statue.

NORTH CAPITOL
STREET

I

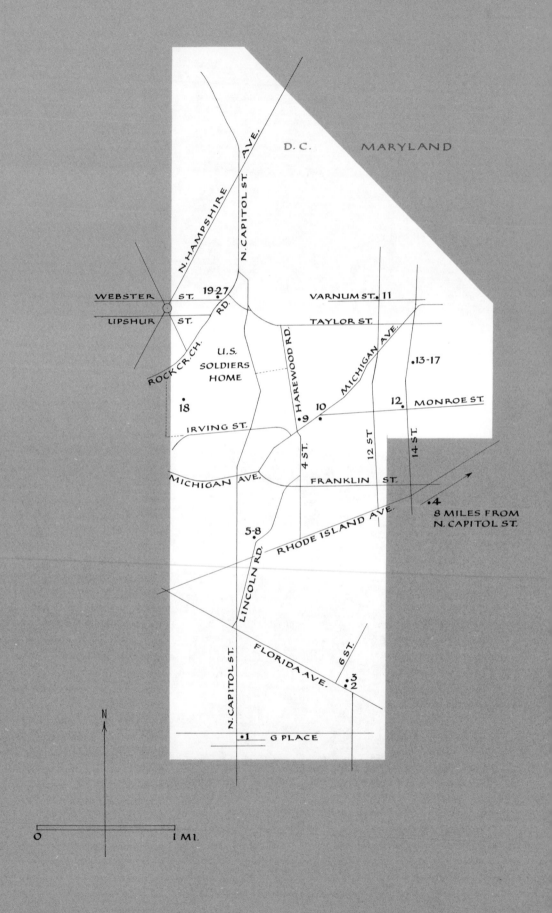

D.C. MARYLAND

N. HAMPSHIRE AVE.

N. CAPITOL ST.

WEBSTER ST. 19·27
 RD.

UPSHUR ST.

VARNUM ST. •11

TAYLOR ST.

ROCK CR. CH.

U.S.
SOLDIERS
HOME

HAREWOOD RD.

MICHIGAN AVE.

•13-17

•18

•10 12 MONROE ST.
•9

IRVING ST.

4 ST.

12 ST.

14 ST.

MICHIGAN AVE.

FRANKLIN ST.

•4

8 MILES FROM
N. CAPITOL ST.

5-8

LINCOLN RD.

RHODE ISLAND AVE.

6 ST.

N. CAPITOL ST.

FLORIDA AVE.

•3
2

N

•1 G PLACE

0 1 MI.

NORTH CAPITOL STREET passes through a section of Washington in which some of the most extensive and beautiful open spaces of the city are found. Gallaudet College, Soldiers' Home, Rock Creek and Glenwood Cemeteries, Catholic University, and the Franciscan Monastery all occupy spacious, beautifully landscaped grounds in the rolling hills to the north and northeast of the Capitol. In the mid-nineteenth century this was an area of small farms and country estates. Institutions, looking for inexpensive land in the Nation's Capital, naturally located there. Gallaudet College occupies what once was the farm of Amos Kendall; a 40-acre farm still supplies the college with produce. The 20-acre campus was landscaped in 1866 by Frederick Law Olmsted. Soldiers' Home, founded in 1851, is located on a 500-acre tract that includes some land of the highest altitude in Washington, much of which is wooded, although some is truck farmed. The immediate grounds of the Home have been developed into a landscaped park of exceptional beauty. Rock Creek Cemetery grew up around St. Paul's Church, begun in 1712. It contains 100 acres also designed in the Olmsted informal idiom with rolling lawns, meandering roads, fine old trees and shrubs, and a small lake. Catholic University is built on "Sidney," the old estate of James Middleton, an early planter. The first building, Caldwell Hall, was erected in 1888. This 60-acre property was later enlarged through the acquisition of "Harewood," the summer residence of the Washington banker and philanthropist, William Wilson Corcoran. The National Shrine of the Immaculate Conception is located on the Catholic University campus. The Franciscan Monastery, in the same neighborhood, was begun in 1899 on a run-down estate of 50 acres in an area formerly known as Turkey Thicket, or Cuckold's Delight.

Title GOVERNMENT PRINTING
OFFICE WORKERS, 1938
Location Government Printing
Office Warehouse, North Capitol
Street and G Street Place, NE
Sculptors Elliot Means and
Armin A. Scheler
Architect Victor D. Abel
Medium Cast stone

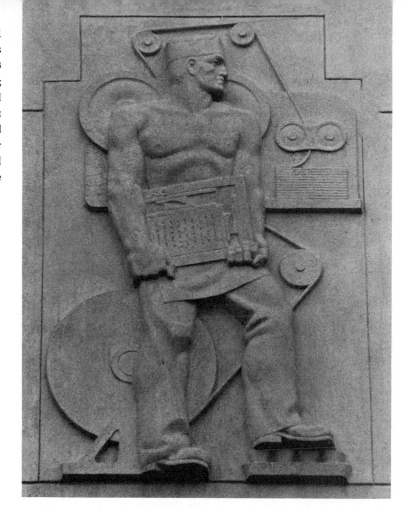

This surprisingly genteel warehouse, designed in a typical late Art Deco style, stands on North Capitol Street with its back against the grimy railroad tracks of Union Station. It is a simple white rectangular concrete structure three stories high. At the second story a straightforward factory fenestration of large metal casements is sandwiched between chastely designed rusticated pilasters. The cornice here is ornamented with a simplified egg and dart motif. On the frieze below, metopes are elaborated with the Greek Key design. A curved cornice at the top of the building bears acanthus detail. The first and third stories are broken only by occasional slit windows, indicating storage space.

Three low-relief panels, each approximately 9 feet high by 5 feet wide, are placed at intervals along the third story of the building on the north side. They overlook an alley, parking lots, and a welding shop. The left panel shows a printer at work. His muscular body, executed in flat rectilinear planes, is contrasted with a design of wheels and belts suggesting a printing press. The center panel bears the seal of the Government Printing Office, with a printing press emblazoned on a vigorous cartouche guarded by an American eagle. The right panel, that nearest North Capitol Street, portrays a worker unloading rolls of newsprint. He is shown from the back, his left leg thrust powerfully forward as he lifts the heavy rolls. The panel bearing the seal is repeated over the three-bay, classically detailed entrance on North Capitol Street. There are panels on the east and south sides of the building. Originally freight cars entered directly into the second floor of the building, where paper was unloaded prior to storage on the first and third floors and eventual movement through a tunnel to the Government Printing Office plant across the street. Today the building is used for storage of paper supplies, money orders, and postal cards. The structure was authorized in 1935 and completed in 1938 by the Charles H. Tompkins Construction Company.

Title THOMAS HOPKINS GALLAUDET, 1889
Location Gallaudet College, Florida Avenue and 8th Street, NE
Sculptor Daniel Chester French
Architect Unknown
Medium Bronze

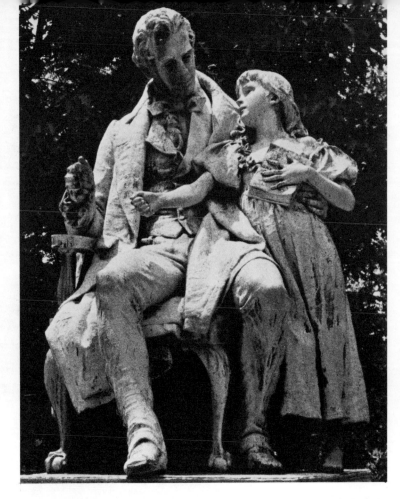

This memorial to Thomas Hopkins Gallaudet, pioneer educator of the deaf, shows him with his first student, Alice Cogswell. Gallaudet is seated, his left arm about the child's waist while with his right hand he demonstrates the sign for the letter "A." Alice responds with her right hand while with her left she clasps an open book to her bosom. There is a delightful spontaneity about the sculpture group, an enchanting warm rapport between teacher and student. A coat is thrown over the back of the chair on which Gallaudet is rather casually seated, as though he has just come in and has been overwhelmed by the child's enthusiasm to show what she has learned. This naturalness is enhanced by lively textural detail: Gallaudet's wavy hair, smiling eyes, ruffled shirt, and the puffed sleeves and ruffled neck of Alice's dress.

Alice Cogswell lost her hearing as the result of a common childhood illness. Her father, a surgeon and one of the founders of the Connecticut Medical Society, raised funds to send Gallaudet, a graduate of Yale Divinity School, to Europe to learn how to educate the deaf. In France he met the Abbé de l'Epée who had derived a sign language from a monastic order in Spain whose members were pledged to silence. Gallaudet combined this system with an English system of oral speech. In 1817 he returned to Hartford and, with the assistance of Laurent Clerc from the Abbé's staff, opened in Hartford, Connecticut, the first school for the deaf in this country.

This memorial was erected with funds raised among the deaf in every state and territory of the nation. Its figures, slightly larger than life size, are placed on a simple pedestal in the center of a small formal garden, surrounded by fine old trees. Daniel Chester French began work on this sculpture in 1887 and finished it for the dedication in 1889; it is signed and dated 1888 on the lower right corner. The site is near the entrance to Chapel Hall at Gallaudet College.

I-3
Title EDWARD MINER GALLAUDET, 1969
Location Gallaudet College, Florida Avenue and 8th Street, NE
Sculptor Pietro Lazzari
Architect Unknown
Medium Bronze

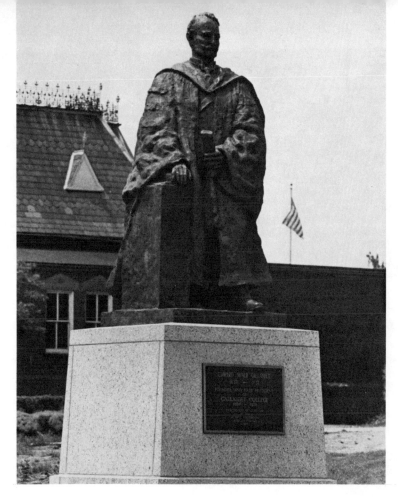

In 1857 Amos Kendall, former postmaster general and member of Andrew Jackson's "Kitchen Cabinet," found a group of deaf children being kept in a pitiable condition in downtown Washington, exploited by an adventurer from New York. Awarded their custody in court, he took the children to his farm, "Kendall Green," a mile from the Capitol. Here, under charter from Congress, February 16, 1857, he established the Columbia Institution for the Instruction of the Deaf, Dumb and Blind.

Edward Miner Gallaudet, son of Thomas Hopkins Gallaudet, founder of the first school for the deaf in America, was made president of the school. Only twenty years old at the time, he had graduated from Trinity College in Hartford, Connecticut, and had taught one year at his father's school. It was his dream to turn the school at Kendall Green into a college for the deaf. On April 8, 1864, this dream was realized when Abraham Lincoln signed into law an act authorizing that the school be allowed to grant college degrees. The new college was first called the National Deaf Mute College, but in 1894 it was renamed Gallaudet College in honor of Thomas Hopkins Gallaudet. The school has been largely supported through Congressional appropriations as an institution of national importance. The president of the United States serves as patron and signs diplomas.

Edward Miner Gallaudet was president of the college for fifty-three years. This memorial shows the noted educator in academic dress, standing at the podium in the act of conferring degrees. It is a sensitively modeled portrait in which bronze is given the kinetic feeling of tactile clay. The sculptor, father of a 1967 graduate, commented, "Gallaudet in the statue is not frozen. In my experience with the deaf, they are people of action—lively people . . ." Dr. Gallaudet was a man of action, of movement. His garment has a forward movement, like the education of the deaf. The statue is placed in a circular plaza facing the newer part of the college.

I-4

Title PYRAMID, 1972

Location University of Maryland
School of Architecture Building,
Campus Drive, College Park,
Maryland

Sculptor Raymond John Kaskey

Architect None

Medium Ferrocement

Leaving North Capitol Street by automobile, one proceeds 8 miles north on Rhode Island Avenue (which becomes U.S. Route No. 1) to the suburban town of College Park, Maryland, home of the main campus of the University of Maryland. Located before the south entrance of the contemporary-style School of Architecture Building of the University of Maryland, designed by the Baltimore firm of Fisher, Nes and Campbell and opened in 1972, is the imposing new abstract sculpture, *Pyramid*, by Raymond J. Kaskey. He designed the 12-foot-high and 24-foot-wide art work as a memorial to the Baltimore architect Herbert E. Rycroft (1923–1969), A.I.A., who died suddenly of a heart attack while playing for the Chesapeake Hockey League in Baltimore in 1969. Rycroft, a junior member of the Baltimore architectural firm which designed the School of Architecture Building adjacent to *Pyramid* and a graduate of the architecture college of Johns Hopkins University, devoted much of his free time to helping young architectural students in the Baltimore area. Funds for the construction of *Pyramid* came from the Herbert E. Rycroft Memorial Fund, established by friends and relatives of the architect at the University of Maryland.

Sculptor Kaskey, who serves as an assistant professor of architecture at the University of Maryland, chose ferrocement as his medium for this work because of its relatively low cost, durability, and texture. The sculpture consists of an inch-thick shell formed by six layers of interwoven wire mesh and reinforcing steel rods over which a layer of cement mortar was applied by plastering. Mr. Kaskey learned the practical application of this technique from several boat construction firms in coastal Maryland which use this method for the practical execution of concrete boats. He was further influenced through the research of an Italian engineer, Pier Luigi Nervi, who began experimenting with ferrocement as a construction medium in Rome as early as 1943.

Pyramid derives its form from a cube standing on its corner rather than from the four-sided pyramid of the Egyptians. All that is visible of

the base cube is one corner which appears as the peak of a three-sided pyramid; the rest of the cube would, like an iceberg, be below the surface.

As one approaches from the parking lot, the central feature of the south face is a circle distinguished by its smooth texture. The circle serves as a transition from the plain geometry of the left face to the more organic, curved forms on the right of the south face. Because it is both strictly regular and also softly curved, the circle can be both geometric and organic at the same time. Proceeding around, the northeast side, which faces the building entrance, is deeply cut away to reveal softer, rounded shapes based on organic forms rather than geometry. The lower center section of this side half emerges from the ground much like the bulb of a plant. Due to its shape and central location, this form is the focus of the piece.

By combining geometric and organic forms, Mr. Kaskey has reflected in his sculpture the coexistence of permanence, stability, and death (qualities traditionally associated with pyramids) with the instability and change associated with life forms. The meaning of this abstract sculpture is thus quite fitting as a memorial to the late Herbert E. Rycroft.

A major influence in Mr. Kaskey's creation of abstract sculptures has been the Russian-born sculptor, Naum Gabo, who immigrated to the United States at the beginning of World War II. Both Gabo's and Kaskey's abstract sculptures are based on mathematical forms, such as cubes, triangles and parallelograms. Kaskey's other sculptures, in a much smaller scale than *Pyramid*, have been executed in bronze, aluminum, and polyester resin; he studies basic biological forms and translates them into abstract sculptures.

In addition to *Pyramid*, a second abstract sculpture, *A Meeting Place: Day and Night*, by University of Maryland art professor Kenneth Campbell, is located near the center of the College Park campus. This work, executed in two sections, each 18 feet high, consists of three columns supporting a lintel which is surmounted by two additional columns which support a second lintel. The space between the two sections is arranged with park benches as an informal meeting place for students. The sculpture, in gray and white marble, was completed in 1973.

The University of Maryland can trace its beginning to 1807 when the Maryland legislature established the Maryland Medical College in Baltimore with a staff of three physicians and eight students. The college was established by Dr. John Beale Davidge after a violent Baltimore mob broke into his residence and wrecked it the same year in protest over his use of a cadaver in teaching medicine to a handful of students. This school, the fifth medical college in North America, was housed in its first permanent building in 1815, the first such structure in the United States to be erected solely as a medical school. Here also was founded the first medical school library in the nation. In 1812 the Maryland legislature authorized a state charter for the expansion of the Maryland Medical College into the University of Maryland, by adding departments of law, arts and science, and divinity. Although the medical curriculum flourished, the attempt to establish other departments did not succeed as well.

The other major component which helped to expand the University was the Maryland Agricultural College founded by state charter in 1856. This third such educational institution was established through the efforts of planters from southern Maryland who were especially interested in agricultural experimentation. Shortly before the Civil War, the trustees purchased the 428-acre plantation belonging to Charles B. Calvert, "Rossborough," 8 miles north of Washington, D.C., and located on the main post road between Washington and Baltimore. The Maryland Agriculture College opened in 1859 with its first students

and with its experimental model farm in operation. The college faced serious economic problems after the Civil War, even with grants from the state and federal governments. In 1912 the two original large buildings were destroyed by fire. In 1914 the Maryland Agricultural College became completely state owned when the stocks of the original investors were deeded to Maryland. It was not until 1920 that the present campus of the Maryland Agricultural College at College Park was merged with the University of Maryland at Baltimore. The University of Maryland College Park campus today is an enormous complex of new buildings, constructed both in the colonial revival and international styles of architecture.

Glenwood Cemetery

I5–8

This fourth oldest major cemetery in Washington, D.C., located at 2219 Lincoln Road, NE, near the Catholic University of America, was chartered by act of Congress on July 27, 1854. The cemetery grounds, one and a quarter miles from the Capitol Building, were dedicated during an impressive ceremony on August 1, 1854. A board of five trustees, elected annually from among the lot owners, has managed the cemetery since Congress amended the original charter in 1877. The cemetery is situated on 90 acres of rolling hills and is laid out in the "rural cemetery" pattern, with the winding, hilly drives and landscaped grounds which were so popular on the east coast before the Civil War. Like its neighboring historic Washington cemeteries, such as Congressional and Oak Hill, Glenwood still possesses a receiving vault, used for the temporary interment of bodies during the winter months when the weather formerly prohibited burials. The cemetery is rectangular in shape, enclosed by an extensive iron fence, and laid out into various sections, designated "A" through "Y." The grounds, which contain some 40,000 burial sites, are open to the public from 9 A.M. to 5 P.M. daily. Glenwood Cemetery is adjacent to two more early cemeteries, Prospect Hill Cemetery to the south, and St. Mary's Cemetery to the east.

During the last three-quarters of the nineteenth century, particular attention was given by many American families to selecting not only the inscription but also the design of a cemetery monument. With the improvement in railroad transportation and the machinery for quarrying marble, many important stonecarving firms were established in Boston, New York, Philadelphia, Baltimore, and other cities on the east coast. The closing of the many urban church graveyards and the establishment of the highly popular "rural cemetery," with its acres of carriage drives and landscaped walks, permitted room for large and elaborate sculptures and mausoleums. The leading stonecarving firms engaged in publishing books with numerous illustrations of the latest sculptured cemetery monuments from which to choose. Numerous nineteenth-century monuments in Washington cemeteries can be traced to these "pattern books." Two of them which were especially popular were Baird's *Portfolio of Original Designs of Monuments*, Philadelphia, 1848, and Jacob Schumacher's *Designs of Monumental Works*, Buffalo, 1865.

There were critics even then, however, because these mass-produced, and often costly, sculptured cemetery monuments frequently possessed highly romantic and sentimental inscriptions with poorly executed carvings. Francis E. Paget's *A Tract Upon Tomb-Stones*, published in London in 1853, was among the first of a number of books attacking the rage for sculptured monuments. Paget advised using brevity and humility of expression for inscriptions on cemetery monuments. He deplored such expressions of family pride which stated the pedigree of the deceased, such as "John Smith, the brother of the Mayor," or "Jane Brown, the daughter of the Governor." The incredible mixture of a variety of lettering styles, selected by the local stonecarver and appearing on the same monument, was another popular form of poor taste. The stonemason was also at fault for copying epitaphs from the pattern books, such as:

Beneath this stone a matron lies,
Who fraud and flattery did despise,
And though to all that's good inclin'd,
Of vice she boldly spoke her mind.
She hated idleness and pride,
Industrious liv'd, respected died.

or

I've lost the comfort of my life.
Death came, and took away my wife:

And now I don't know what to do,
Lest death should come, and take me too.

Often inscriptions displaying poor taste were those which mentioned bodily ailments or unusual diseases of the deceased. More "offences against propriety" which Paget and other critics mentioned are the low-relief carvings of cherubs, doves, scythes, hourglasses, shovels, skulls, crossbones, urns, and reversed torches. Paget felt that most cherubs and doves were so crudely executed that they became grotesque; the other motifs related to heathen emblems, hardly fit for a Christian grave.

The most appropriate single emblem he recommended was the Cross, for it represented the humility of man, the Resurrection, and ascent into Heaven. He advised giving money to the church to be applied to the purchase of new Bibles, altar cloths, stained glass windows, or some other item useful and instructive for the living. He also urged his readers to have their clergyman write the epitaph and engage an architect to design the monument, rather than to rely on the local stonemason. Observant visitors to Glenwood Cemetery, Rock Creek Cemetery, and Oak Hill Cemetery in Washington will most likely agree with many of the criticisms presented by Paget in regard to hundreds of the Victorian monuments found there.

The Victorian chapel at Glenwood Cemetery

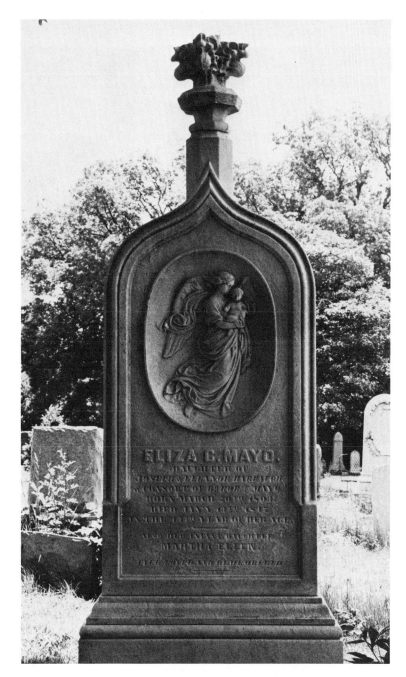

I-5

Title ELIZA C. MAYO MONUMENT,
ca. 1850
Location Glenwood Cemetery,
2219 Lincoln Road, NE, Section A,
intersection of Central and
Magnolia Avenues
Sculptor A. Gaddess
Architect None
Medium Marble

This Baltimore stonecarver has executed a well-designed relief panel in the Neoclassical manner, 2 feet high and 1½ feet wide, showing a standing female figure and child. The upper section of the monument includes a finely carved Gothic Revival finial of foliage. The 5-foot-high monument marks the grave of the wife of Dr. Robert Mayo, Mrs. Eliza C. Mayo (1803–1817), who died at the age of fourteen in childbirth. The monument was erected over thirty years after the death of Mrs. Mayo and her child, and it was formerly located in one of the downtown Washington cemeteries, which were all removed in the 1870s, before being relocated at Glenwood Cemetery.

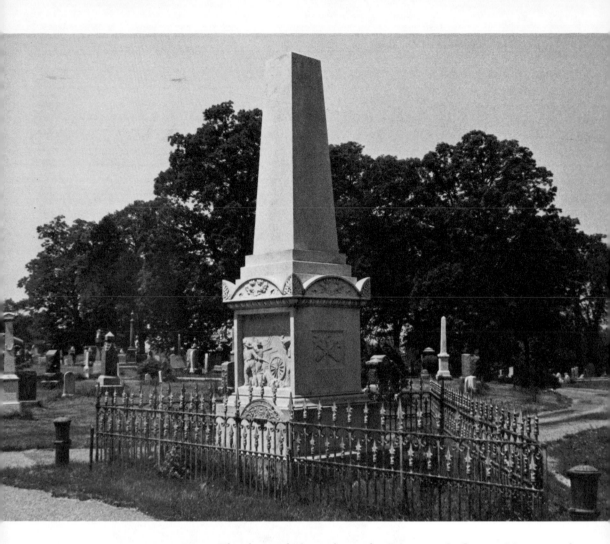

I-6

Title BENJAMIN C. GRENUP
MONUMENT, 1858
Location Glenwood Cemetery,
2219 Lincoln Road, NE, Section D,
Chapel Circle
Sculptor Charles Rousseau
Architect None
Medium Marble

The three relief panels on the *Benjamin C. Grenup Monument* form the most important sculpture, both aesthetically and historically, in Glenwood Cemetery. The monument, erected to honor Benjamin C. Grenup, a volunteer fireman from Capitol Hill killed on duty in 1856, features a 3-foot-square high-relief panel showing the men of Columbia Engine Company Number 1 surrounding their horse-drawn fire engine en route to fight a local fire. Grenup's death occurred when he and other volunteer firemen were pulling the heavy fire engine by hand (as was the custom) from its station on Capitol Hill down to a fire in Shreeves Stables on Seventh Street, NW. Grenup tripped and fell beneath the engine and was instantly crushed to death by the wheels. This incident, so vividly portrayed on the central high-relief panel, was the first recorded death of a fireman in the District of Columbia. The fireman to the rear of the engine throws his hands up in horror as he realizes the plight of his colleague. The inscription reads:

Benjamin C. Grenup, Aged 24 Years, Killed in the Discharge of His Duty, May 6: 1856. This Monument Is Erected by Columbia Engine Co. No. 1 to Perpetuate the Memory and Noble Deeds of a Gallant Fireman. A Truer Nobler Trustier Heart, More Loving or More Loyal Never Beat Within a Human Breast.

Two small reliefs, each 1½ feet square, appear on the other sides of the monument. One includes a design of a crossed fire axe, a gasoline lamp attached to a fire pole, and a fire hook, centrally joined by a long knotted fire rope. Another motif consists of a fire horn entwined with a leather fire hose with brass nozzle. The entire monument, including the base with its three sculptured panels and tall upper shaft, measures approximately 18 feet in height and 4 feet in width. The monument is protected by a mid-nineteenth century cast-iron fence with the label:

"J. H. Mead, Maker, C. St., between 9 & 10 Sts., Washington." Three antique cast-iron fire hydrants, 3 feet high, protect the corners of the triangular enclosure. They bear the inscription, "P. Ayers, New York, Patented 1857."

Most fire companies in the District of Columbia before the Civil War were unofficial, private, volunteer organizations which guarded fires in their particular neighborhoods. The companies would go to any fire in the city, however, if they were needed. In the case of two simultaneous fires, a company would first put out the fire in the building which bore an iron insurance plaque, since the insurance company involved would pay the fire company a reward. The intense pride in each company frequently resulted in violent fights between two or more companies, especially during large fires in the city when a number of companies were called. This condition eventually resulted in the establishment, during the Civil War, of the first city-owned fire company. In 1871, the Washington City Fire Department was organized and the private companies were completely absorbed by 1883. The old volunteer fire stations were usually rectangular, wooden buildings with a tall tower to house the fire bell that summoned the volunteers from their regular jobs when a fire was reported. The tower was also used to spot fires and served as a means for hanging the long leather hoses for drying after the engine was returned to the station following a fire. The oldest existing fire station in Washington today is the Vigilant Fire Company Building on Wisconsin Avenue, NW, in Georgetown near the Chesapeake and Ohio Canal. This company, organized in 1817, constructed the existing building as its new home in 1844. The name of the company, as was usual with most companies of the time, was derived from the name of its engine. For instance, note the name of the engine carved on the central relief panel of the *Grenup Monument*. Albert J. Cassedy in *The Fireman's Record* tells many colorful stories about the numerous volunteer fire companies in the District of Columbia. In 1840, for instance, both the Vigilant Fire Company and the Western Star Fire Company built a huge bonfire on a nearby hill in Georgetown (near the site of the present Grace Episcopal Church) and sent a messenger to the Union Fire Company, their arch rival, in Washington asking for assistance to put out this "dangerous blaze." The Union Company arrived in great haste only to find the incident a practical joke. During the fistfights which resulted, the engine and fire lamps of the Union Fire Company were seriously smashed as a Georgetown mob drove them back into Washington.

Detail: relief panel containing fireman's axe, lamp, hook and rope

I-7

Title VICTOR S. BLUNDON
MONUMENT, 1936

Location Glenwood Cemetery,
2219 Lincoln Road, NE, Section F,
adjacent to Lincoln Circle

Sculptor Unknown

Architect None

Medium Granite

The rather severe but nonetheless charming low-relief panel of Victor S. Blundon (1896–1936) portrays this bachelor and his favorite dog sitting side by side. The 3-foot-square sculpture is centered on the Blundon family plot, where more than seven members of the family are interred. Blundon, a resident of Forest Glen, Maryland, and a real estate salesman, died of a heart attack while on a vacation to Costa Rica in 1936. The Irish Setter, whose name has since been forgotten, was a constant companion of Blundon and, therefore, was included by his parents on the design of the monument.

I-8

Title TERESINA VASCO MONUMENT, 1913

Location Glenwood Cemetery, 2219 Lincoln Road, NE, Section F, adjacent to Masonic Circle

Sculptor Sichi

Architect None

Medium Marble

This strange marble statue, 4 feet high and 2 feet wide, pictures Teresina Vasco (1911–1913) in her child's rocking chair and pre-World War I costume. According to cemetery officials, the child died from burns received while playing with matches. Her remorseful parents ordered the statue to show her in her favorite chair.

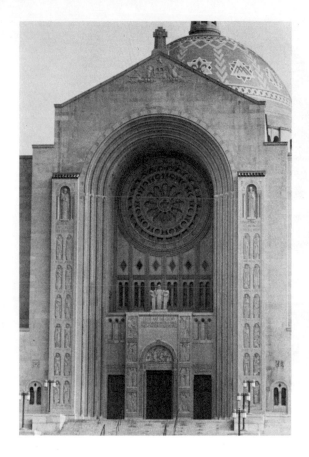
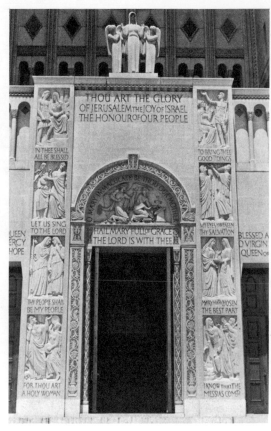

Title SOUTH ENTRANCE PORTAL:
THE ANNUNCIATION, 1959
Location The National Shrine of
the Immaculate Conception,
Michigan Avenue and 4th Street, NE
Sculptors John Angel, Joseph Fleri,
Lee Lawrie, et al.
Architect Maginnis, Walsh and
Kennedy
Medium Limestone, ceramic tile

The relief panels and architectural sculpture which compose the *South Entrance Portal: The Annunciation*, are found on the National Shrine of the Immaculate Conception. Planning for this basilica began in 1914. In 1919 the architects, Maginnis and Walsh (later Maginnis, Walsh and Kennedy) of Boston, were selected. Between 1922 and 1926 the foundations were laid and the crypt church was completed. During 1930–1932 the latter was expanded. Work was interrupted by the Depression and World War II, but was resumed in 1955. On November 20, 1959, the completed church was dedicated. The actual time of principal construction, ten years, is amazingly short for a masonry structure of such magnitude. The Shrine is the largest Catholic church in the United States and is the seventh largest church in the world. It is built on a Latin cross plan with a dome over the crossing. Elements of Byzantine, Romanesque, and Renaissance periods are present in what is essentially a contemporary design. Large cubic masses are played off against each other, their severe planes articulated by surface decoration. The latter includes blind and open arcading, bas-reliefs, mosaics, and inscriptions.

Incorporated into the fabric of the shrine's exterior walls are 137 pieces of sculpture. These were designed by John Angel, Joseph Fleri, Lee Lawrie, Ivan Mestrovic, and others under the direction of the architects and an ecclesiastical committee. They were executed largely by stonecarvers resident at the site. In spite of the number of men critically involved, the ensemble is well coordinated, the carvings effectively complementing each other and the architecture itself. The iconography is organized around the theological virtues of Faith, Hope, and Charity. Faith is illustrated on the east wall; Hope, on the south; and Charity, on the west. On the north is a colossal high relief of Mary, Queen of the Universe, to whom the Shrine is dedicated. The pediment over the central door measures 5 feet in height by 11 feet in width. The relief panels on the sides of the main portal, which itself soars 100 feet into the air, are approximately 8 feet tall and 3 feet wide.

The tympanum of the principal entrance serves as focal point to the sculpture on the south, or front, wall of the shrine. Here the story of the

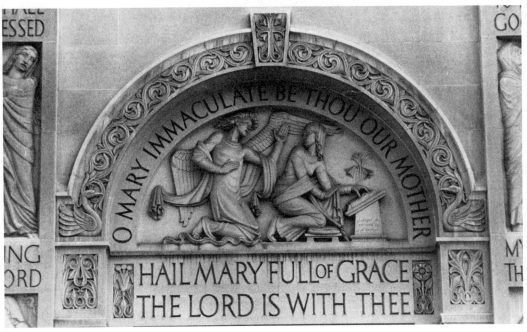

Annunciation is portrayed as Mary turns from her devotions to hear the words of the Archangel Gabriel, "Hail Mary, Full of Grace, the Lord is with Thee. . . ." Sculptor John Angel has created graceful, curvilinear forms, stylized as in a dance. All elements surrounding the entrance are enlivened with decorative carvings which enhance the work of the tympanum. The center entrance is further emphasized by vertical bas-reliefs which contain four separate panels on each side. The work of Lee Lawrie, all are dramatic, each showing two or more people at the crucial moment of a well-known story. Women from the Old and New Testaments are portrayed on the left and right, respectively. The figures are realistic in pose, bulkier, more powerful and restrained than those of the tympanum. A free standing group, *Mary Immaculate Accompanied by Angels*, surmounts this entrance ensemble. Designed by Ivan Meštrović, it is formal, symmetrical, with boldly simplified planes. Meštrović is also responsible for the high relief of Mary on the north apse. Framing the whole, the buttresses of the west and east walls are carved with high-relief figures by Joseph Fleri. St. Peter, on the left, and St. Paul, on the right, appear above paired figures from the Old and New Testaments; each figure is set in its own niche and is static and ritualistic in pose. New Testament figures are placed on the side nearest the entrance while all these sculptures are accompanied by appropriate inscriptions. The latter, deeply incised, are prominently placed in the decorative scheme.

Relief tympana by John Angel are found above the east and west narthex doors, the entrances of both the east and west porches, and the entrance to the Knight's Tower. In addition, the church is elsewhere embellished with many figures of saints whose teachings are illustrative of faith and charity. The work of Thomas Lo Medico, Pietro Montana, Adolph Block, Ulysses A. Ricci, and George Snowden, these figures generally conform in design to the manner of those presented on the south wall. Particularly interesting are the tympana of the east porch portraying *The Founding of Maryland* and *Columbus Discovering America*. Inside the east porch are mosaic tympana by John de Rosen entitled *Founding of the First Parish in the United States, St. Augustine, Florida, 1565; Father Stephen Badin, First Priest Ordained in the United States; Christ Teaching;* and *Father Eusebio Kino, S.J., the Padre on Horseback*. Similar tympana by Francis Scott Bradford portraying charitable activities of American Catholics appear in the interior of the west porch.

I-10
Title Sᴛ. Dᴏᴍɪɴɪᴄ, ca. 1905
Location Dominican House of
Studies, 487 Michigan Avenue, ɴᴇ
Sculptor Unknown
Architect Unknown
Medium Marble

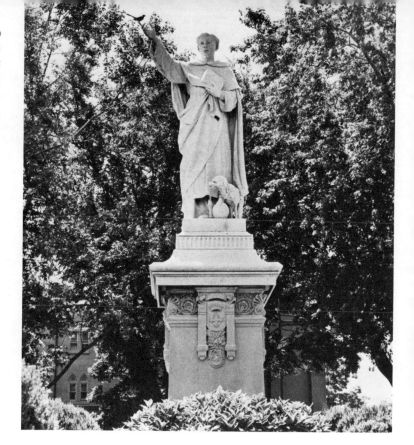

*A friendly robin rests
momentarily on the fingertips
of the statue of* St. Dominic

This statue, *St. Dominic,* was originally intended for the small cemetery of the Dominican House of Studies. When it arrived, however, the members of the Dominican Order were so pleased with it that they placed it in the garden in front of the house on Michigan Avenue. St. Dominic is shown in the habit of the order, the "Evangelium J.C." clasped to his breast with his left hand, his right hand extended in the act of preaching the Gospel. At his feet is a small dog, which carries a torch in his mouth, as his right front paw rests upon a sphere representing the world. Tradition has it that Dominic's mother, shortly before his birth, had a vision in which she gave birth to just such a dog. Its use as a symbol of St. Dominic's mission to preach to the world has become an artistic convention. The 8-foot-high statue is placed on an intricately carved pedestal bearing on each face other symbols of St. Dominic. On the north, or front face, the Dominican motto "Veritas" is inscribed above a shield emblazoned with martyr's crown and Gothic cross; beads carved on each side of the shield indicate the rosary. St. Dominic was given the rosary by Mary and advocated its constant use. Below the shield are a lily symbolic of his purity, a martyr's palm indicating his fervent desire for martyrdom, and a star referring to the one which is said to have appeared on his forehead at baptism. On the east face is a rosary entwined with roses, possibly symbolizing the Joyful Mysteries of Christ. On the south face the Sorrowful Mysteries are represented by a rosary wrapped in a bed of thorns. On the west face a rosary intertwined with lilies symbolizes the Glorious Mysteries. Pollution from rush-hour traffic on Michigan Avenue is seriously damaging the statue.

The Dominican House of Studies, erected in 1903–1905, was designed in fifteenth-century Gothic style by an architect named Von Herbulis, of Philadelphia. The spandrels of the portal arch are decorated with blazing sun motifs, referring to the scholarly and preaching missions of the Dominicans. The motif on the left, with a man's face and a book, represents St. Thomas Aquinas, an early and distinguished Dominican. That on the right, containing the initials IHS and a plume, indicates the Gospel. Within the portal are a plaque in bas-relief, containing the Dominican coat of arms, and marble statues in niches rep-

resenting the scholarly St. Albert the Great and St. Joseph. A large crowned marble statue, *Our Lady of the Immaculate Conception*, by Belgian-born artist and sculptor Van Landeghern of Philadelphia, is placed in a canopied and decorated niche high above the entrance portal. The raising of this statue into its niche was accompanied by the ringing of bells. Traffic on Michigan Avenue stopped, the crowd of spectators gathered below was silent, and every man removed his hat. Inside the house quadrangle is another marble statue of Our Lady of the Immaculate Conception.

I-11
Title St. Vincent de Paul, ca. 1900
Location Providence Hospital,
12th and Varnum Streets, NE
Sculptor Unknown
Architect None
Medium Marble

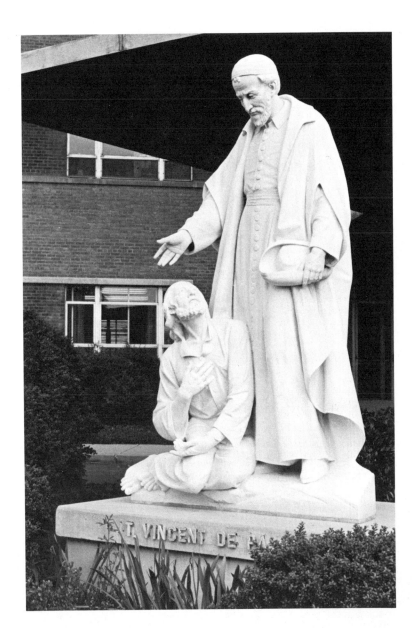

The heroic statue of *St. Vincent de Paul*, approximately 9 feet high, stands in front of the canopy of the main entrance to Providence Hospital. The statue was given to the hospital at the turn of the century in memory of a Father Stanislas, member of the order founded by St. Vincent. Since then, the statue has been moved at least four times and the entire hospital once. Formerly located on Capitol Hill, at Second and E Streets, SE, Providence Hospital was founded during the Civil War under the auspices of the Roman Catholic Sisters of Mercy to provide care for wounded soldiers. The original building was a rented house,

but the hospital quickly grew to occupy an entire city block; it was moved to its present location in 1956.

At the request of the physicians of the District of Columbia, the Convent of the Sisters of Charity in Emmitsburg, Maryland, sent 200 nuns to staff an emergency hospital on Capitol Hill in June 1861. After the Battle of Bull Run in nearby Virginia, there were so many hospital tents erected for the Union casualties on Capitol Hill that the area was nicknamed "Bloody Hill." Congress appropriated funds to operate the hospital during the Civil War. A new massive Romanesque Revival style brick building was erected for the hospital in 1869 on the same site as the original Civil War hospital tents on Capitol Hill. Providence Hospital has pioneered many innovations in hospital service since its founding. In 1882, a unique amphitheater was constructed there to allow medical students of Georgetown University and George Washington University, then known as Columbian College, to observe operations. The hospital established an X-ray Department in 1906, one of the first in the Nation; and in 1907 it established a special children's ward and a free clinic for the poor of the city. In 1912 the hospital had the first electric ambulance in the District of Columbia. Providence Hospital was moved to its present location in 1956 in order to be closer to Catholic University's school of nursing.

The statue depicts the French saint standing, in clerical habit, his right hand extended over the seated figure of a suffering sinner whose hand clutches his breast and whose anguished face looks up at the "Universal Patron of All Charitable Works." St. Vincent de Paul (1581–1660), was known for his care of the poor, the abandoned, and the wayward. Taken prisoner onto a pirate ship when young, he was a galley slave for many years. A church named in his honor is found on M Street near South Capitol Street, SE. This land was given by Daniel Carroll of "Duddington" (owner of much of Capitol Hill before it became the District of Columbia) to his brother, Archbishop John Carroll, who hoped in vain for the eventual construction of a national cathedral at this location.

I-12
Title ST. JEROME THE PRIEST, 1954
Location 1359 Monroe Street, NE
Sculptor Ivan Meštrović
Architect None
Medium Bronze

The learned St. Jerome, with his sensitive penetrating mind and complex personality, has fascinated the greatest of artists. Born "on the confines of Dalmatia and Pannonia" ca. A.D. 345, a Church Father, Scripture scholar, and Doctor of the Church, he became an enormously influential theological figure. This bronze statue was commissioned by the Croatian Franciscan Fathers and is placed before their residence near Catholic University. The sculptor was a protégé of Auguste Rodin.

St. Jerome, an enormous and powerful figure, clothed in a loincloth, is seated in a semi-lotus position bent over a Bible which rests on his legs. His left hand prepares to turn a page as his right hand, braced against his leg, supports his head. There is a feeling of intense concentration, of the total involvement of Jerome in his studies. The surfaces are roughly textured, the modeling tactile and strong. The bone structure, including the fingers, knees, toes, and all points of tension, is finely expressive. The face is powerfully delineated, but is subordinated, bent downward into the shadows above the Bible. An eloquent inwardly enfolding movement is set up through the elements of the composition, transmuting physical power into intellectual and spiritual power. The granite pedestal is inscribed "St. Jerome the Priest, A.D. 341–420, Greatest Doctor of the Church." The statue is approximately 8 feet in height and 3 feet in width. Meštrović also is responsible for some of the most important sculpture at the nearby Shrine of the Immaculate Conception.

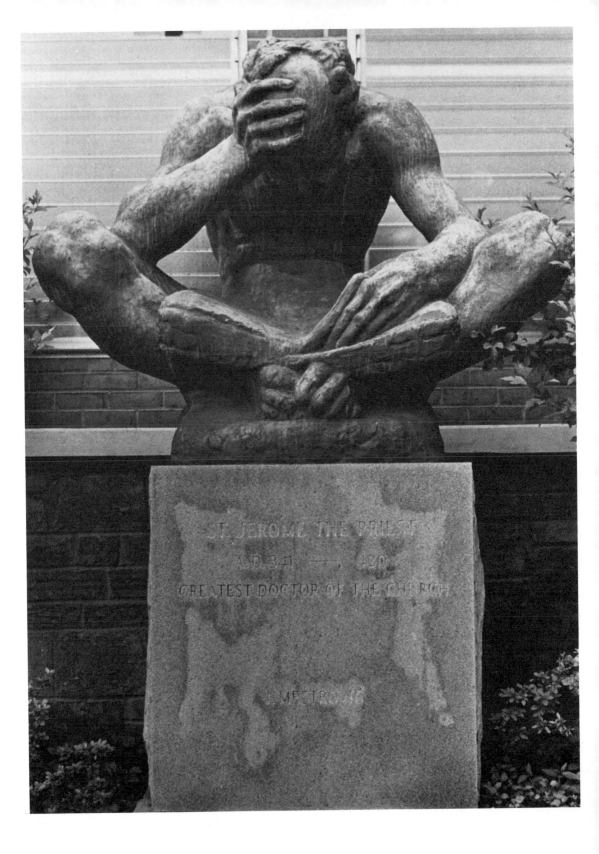

Title FATHER GODFREY SCHILLING,
O.F.M., 1955
Location Franciscan Monastery,
14th and Quincy Streets, NE
Sculptor F. C. Shrady
Architect Unknown
Medium Bronze

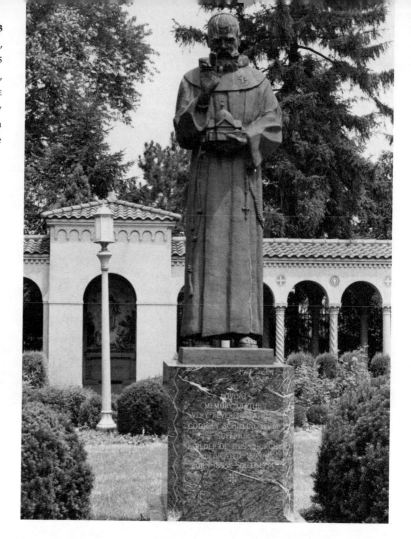

For more than 700 years the Roman Catholic Church has entrusted the Order of St. Francis with the preservation and maintenance of the Holy Shrines of Palestine. In 1897 Father Godfrey Schilling, O.F.M., took the first steps toward establishing in America an institution dedicated to this work. Selecting a high, wooded site near Catholic University, then the McCeeney estate in the Brookland neighborhood, he built the Franciscan Monastery and Memorial Church of the Holy Land. Here, those who are unable personally to visit the Holy Land may view in facsimile the Bethlehem Manger, the Garden of Gethsemane, the Holy Sepulchre, the Catacombs of Rome, the Grotto of Lourdes, and other Christian shrines. The monastery was dedicated in 1899, becoming the Commissariat of the Holy Land for the United States. The church was consecrated September 17, 1924, on the occasion of the Feast of the Stigmata of St. Francis. Sixty Franciscan monks live on the 50-acre monastery property in a strict, cloistered existence. The Franciscan monasteries endeavor to preserve and maintain holy shrines, churches, schools, and missions in Jordan, Israel, Egypt, Syria, Lebanon, and Cyprus, and to educate missionaries in those places.

This memorial to the founder stands in the garden of the monastery church. The statue's pedestal of green marble is inscribed: "In loving memory of the Very Rev. Father Godfrey Schilling O.F.M., Superior, Builder of this Church Dedicated 1899, Born 1855—Died 1934." The fine heroic bronze is formal and ritualistic in pose; it is executed with simplified planes, boldly modeled. Father Schilling, attired in monastic robes, stands with his head slightly bowed, his right hand raised in benediction. In his left hand he holds a model of the church he built. The site on which the monastery is built has been named Mt. Saint Sepulchre in honor of the Holy Sepulchre in Jerusalem.

I-14

Title SAINT MICHAEL, ca. 1924
Location Franciscan Monastery,
14th and Quincy Streets, NE
Sculptor John Joseph Earley
Architect Murray and Olmsted
Medium Cast stone

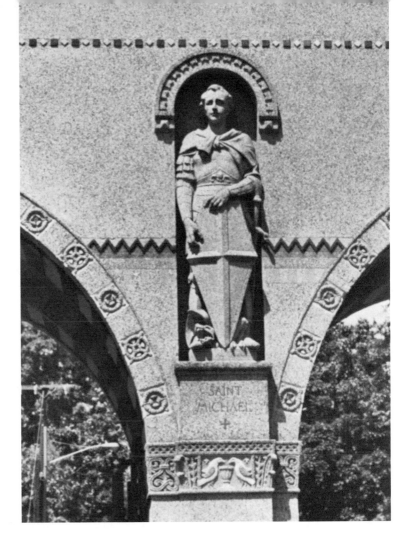

The grounds of the Franciscan Monastery and Memorial Church of the Holy Land are approached on foot through a double-arched gate known as the Rosary Portico. This gate, designed in a style reminiscent of Romanesque monastic architecture, is extended into a colonnaded cloister on each side, enclosing the strikingly beautiful garden in which the monastery church is set. The Rosary Portico is inscribed "Hosanna to the Son of David, Blessed is he that cometh in the name of the Lord." A statue of St. Bernardine, whose mission was to promote reverence to the Holy Name of Jesus, is set in a niche between the arches of the gate. On the inside of the gate, a statue of St. Michael, the Archangel, celestial defender of the Church, is similarly placed. This statue stands approximately 4½ feet high and about 2 feet wide. In the small relief frieze of the pier immediately below the statue, a pair of doves drink from an urn.

The sculptor, John Joseph Earley, a native of the District of Columbia, was one of the great innovators in the field of concrete technology. He invented and pioneered concrete mosaic and was one of the first to build a prefabricated, precast concrete house. The precast curtain wall construction, now so prevalent for large office buildings in Washington and elsewhere, was his idea. Some of his first examples of this type of construction include the Polychrome House and five other private residences built in 1934 on Colesville Road in Silver Spring, Maryland. In addition to these buildings and the cloisters of the Franciscan Monastery, Earley executed many other Washington structures including the main entrance to the Reptile House at the National Zoo, the interior of the Church of the Sacred Heart, the walls and walks of Meridian Hill Park, and the ceilings of the driveway entrances to the courtyard of the Justice Department Building on the Federal Triangle.

I-15
Title St. Christopher, ca. 1924
Location Franciscan Monastery,
14th and Quincy Streets, NE
Sculptor John Joseph Earley
Architect Unknown
Medium Cast stone

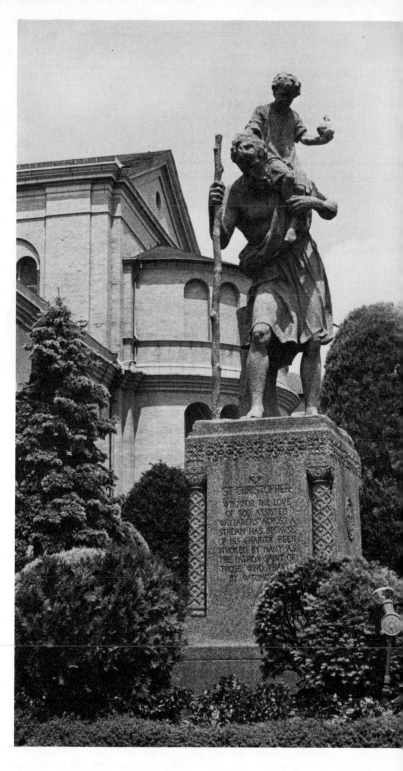

In a formally planted, elliptical reservation in the entrance road, within the Rosary Portico gate, stands an approximately life-size statue of St. Christopher bearing the Christ Child on his shoulders. Christopher leans heavily on a crude staff as he feels, through Christ, the weight of the entire world. The pedestal is inscribed "St. Christopher who from the love of God assisted wayfarers across a stream has because of his charity been invoked by many as the patron saint of those who travel by automobile." The pedestal is ornamented at the corners with columns similar to those in the Rosary Portico. Figures, pedestal, curbing, sidewalks, roadway, portico, and cloister are all constructed of concrete or cast stone, surfaced with the same warm buff aggregate. This aggregate blends very effectively with the buff sandstone of the church and complements the lush foliage and flowers of the garden.

Title ST. FRANCIS AND THE
TURTLEDOVES, ca. 1924
Location Franciscan Monastery,
14th and Quincy Streets, NE
Sculptor Porfirio Rosignoli
Architect Unknown
Medium Bronze

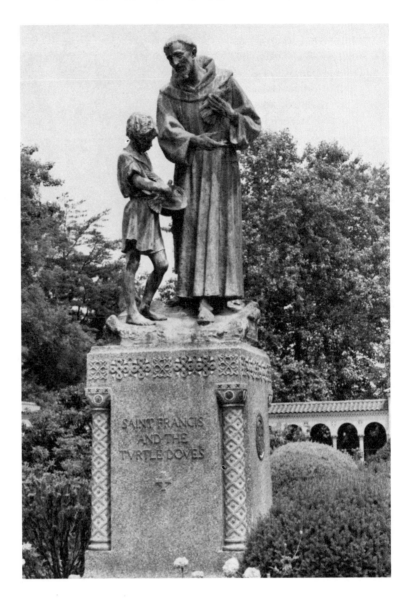

St. Francis of Assisi, known as "Everyone's Saint," dedicated his life to penance through poverty and simplicity. Anticipating the aesthetics of the nineteenth century, he found ideal beauty in the natural world, in plants and animals. The statue *St. Francis and the Turtledoves* is admirably placed in the beautiful Rosary Portico garden. St. Francis, wearing monastic robes, appears to be strolling in the garden. Smiling kindly, he holds a turtledove in his left hand; with his right hand he gestures as he turns, bending slightly to address a small boy by his side. The boy, dressed in a short loose garment, stands with his weight on one foot. He holds his hat in his left hand, a turtledove in his right; and looks down solemnly as he hears St. Francis tell him of the beauty and worth of all God's creatures.

The 6-foot-high figure is of bronze, realistically modeled. It stands on a pedestal of the same material as the statue of St. Christopher and the Rosary Portico, directly in front of the Franciscan Monastery Memorial Church of the Holy Land. The latter is basically Byzantine in inspiration with central dome, closely massed design elements, and plan based on the fivefold cross of the Holy Land. The entrance façade, pedimented, with broad cornice, Corinthian pilasters, and Palladian window, reflects the influence of the Italian Renaissance; Romanesque detailing is used elsewhere on the exterior. These elements are harmoniously blended and simplified in accordance with Franciscan belief. Art Deco polychromed ceramic glazed figures of St. Louis and St. Helena occupy niches on each side of the doorway.

Title ST. BERNADETTE, 1958
Location Franciscan Monastery,
14th and Quincy Streets, NE
Sculptor Unknown
Architect Unknown
Medium Marble

Between February 11 and July 16, 1858, the Blessed Virgin appeared eighteen times to fourteen-year-old Bernadette Soubirous at the Grotto of Massabielle in the village of Lourdes, France. On one of these occasions a spring miraculously appeared; on another, Bernadette was told to build a church to which people could come in processions; and on yet another, the Lady revealed herself as the Immaculate Conception. Enormous crowds, as many as 20,000 people, visited the grotto with Bernadette and witnessed her ecstasies. Numerous cures were attributed to the beneficence of the spring water. The property was acquired by the See of Tarbes in 1861, and the following year the public cult of Our Lady of Lourdes was approved and a chapel begun. Bernadette entered the Sisters of Charity and Christian Instruction in 1865; she was beatified in 1925 and canonized in 1933. Today, approximately two million faithful make the pilgrimage to Lourdes every year. Many of these are sick people seeking cures. By the end of 1959, over 5,000 cures had been reported, of which the Church recognized 58 as being miraculous.

This statue, placed before the replica of the Grotto of Lourdes in the lower garden of the Franciscan Monastery, shows Bernadette kneeling, her hands clasped in ecstasy. Her head is tilted back, and she gazes with rapt expression upon a figure of the Blessed Virgin which stands in a niche hollowed into the rock above the grotto. Bernadette wears a loose, flowing garment and sturdy shoes, and a veil is placed over her long curls. The pose is realistic, the drapery gracefully executed. This sculpture is approximately 4 feet high and 2 feet wide. Another facsimile of the Grotto of Lourdes was built by Pope Leo XIII in the garden of the Vatican in Rome.

Title Lieutenant General
Winfield B. Scott, 1873
Location United States Soldiers'
Home, 2nd and Upshur Streets, NW
Sculptor Launt Thompson
Architect Unknown
Medium Bronze

Lieutenant General Winfield Scott was a soldier's soldier, fighting valiantly for his country during a long, brilliant, and often stormy career. From the administration of Thomas Jefferson to that of Abraham Lincoln, he figured prominently in United States military history, both as a warrior and as a peacemaker. He was a hero of the War of 1812 and of the Mexican War. Scott averted conflict with the Cherokees and the Nullifiers in the 1830s. The defeated Mexicans, impressed by his handling of their affairs, asked him to remain in Mexico and act as dictator. In the election of 1852, Scott was the Whig candidate for president. This campaign, based more on personalities than on issues, was exceptionally vituperative. The blunt, outspoken old warrior was unmercifully assailed by the Democratic press and lost decisively to Franklin Pierce. From 1841 to 1861, Scott served as general in chief of the United States Army. President Pierce awarded him the brevet (honorary) rank of lieutenant general in 1855 for outstanding military service.

This statue was erected on the grounds of the United States Soldiers' Home, which Scott founded in 1851 with part of the tribute money the United States received from General Santa Anna at the conclusion of the Mexican War in 1848. In the heroic bronze, 10 feet high and 4 feet wide, he stands with his weight on his left foot, his left hand resting on his sword hilt, his right hand in the breast of his coat. His bearing is stern yet decorous. He wears a dress uniform with a voluminous cape thrown back from his shoulders. The details of this uniform—epaulets, gold braid, ribbon, embroidery, buttons, and dress saber—are elaborately and realistically detailed, suggesting the uncompromising standards of dress which earned him the nickname "Fuss and Feathers." Bronze for the statue was furnished from captured cannon.

The Soldiers' Home was formerly the 225-acre private country estate of George W. Riggs, who with William W. Corcoran founded the Riggs Bank. It was Riggs who built a summer house here in 1843, which he called "Corn Rigs." When the estate became the Old Soldiers' Home, President Abraham Lincoln spent the Civil War summers in this cottage, which still stands. It was here in July 1862 that he drafted the Emancipation Proclamation in the front drawing room. The historic cottage, where Lieutenant General Scott was a frequent guest, was renamed Anderson Cottage at the beginning of the Civil War by Lincoln to honor the Union commander of Fort Sumter, South Carolina.

Rock Creek Cemetery

I19–27

Rock Creek Cemetery is located near the northern extremity of North Capitol Street, not far from the District of Columbia-Maryland boundary line, on the grounds of St. Paul's Episcopal Church, commonly known as Rock Creek Church. This church was established in 1712, and in 1719 approximately 100 acres of land were donated for building it by Colonel John Bradford of Prince Georges County, Maryland. Lord Baltimore induced the Reverend Mr. George Murdock to accept the appointment as first rector of the church in 1727. The first school in what is now the District of Columbia was begun by St. Paul's in 1764. Although St. Paul's has been severely damaged by several fires, the original 18-inch brick walls, laid in 1775, remain intact. It is the only surviving colonial church today in the city of Washington. Following the Revolutionary War, the church building fell into disrepair until it was restored in 1810 through the efforts of the Reverend Mr. Walter Dulaney Addison, rector of St. John's Church in Georgetown. In 1922 the church building was rebuilt following a serious fire which, one year earlier, had destroyed all of the original interior details. One of the most attractive features of the present interior is the set of stained glass windows, which depict the history of the Episcopal Church in America, and which were installed in the 1940s. St. Paul's Church with its ivy-covered walls, is located near the center of the cemetery grounds.

The first cemetery was begun near the original wooden church in 1719. This church burial ground remained a small private enclosure until 1871, when the present 86 acres of gently rolling land, one of the highest elevations in the city, were laid out as a noncommercial, nonprofit, interdenominational cemetery by permission of Congress. With a few exceptions, all of the important sculpture found here was erected during the period 1875–1925. This oldest cemetery in the city contains the graves of many who were eminent throughout American history: a signer of the Declaration of Independence, Cabinet officers, Supreme Court justices, a bishop of the Episcopal Church, and many others. Little is known of the early history of the present "rural cemetery," with its landscaped curving drives and small lake, since these records were destroyed in a fire in the cemetery gatehouse in the twentieth century. A map of the cemetery grounds may be obtained free of charge from the cemetery office adjacent to the main gate, located at Rock Creek Church Road and Webster Street.

These handsome cast-iron Victorian gates guard the main entrance to Rock Creek Cemetery

Title FREDERICK KEEP MONUMENT,
ca. 1911
Location Rock Creek Cemetery,
Rock Creek Church Road and
Webster Street, NW, Section A
Sculptor James Earle Fraser
Architect Unknown
Medium Bronze

The *Frederick Keep Monument* consists of a bronze sculpture group, including a seminude male and female, executed in the Neoclassical style by Washington's most prolific sculptor, James Earle Fraser. Over twenty open-air sculptures were executed by Fraser in Washington between 1910–1940. His most important works include the *Recorder of the Archives Pediment* on the south portico of the National Archives Building and the portrait statue of *Alexander Hamilton* on the south plaza of the Treasury Department Building. Fraser, who died at the age of seventy-seven in the 1950s, remained a Neoclassicist to the end. Even though he failed to make any mark in the development of twentieth-century American art, many of his portrait statues exhibit a fine sense of naturalism, such as the finely modeled face of Alexander Hamilton at the Treasury Building.

A plain marble backdrop outlines the bronze group comprising the *Frederick Keep Monument*. This sculpture, 9 feet tall and 4 feet wide, is now almost completely hidden from view by a thick growth of bushes. The monument was erected about 1911 upon the death of Frederick Keep, a prominent Washington businessman who had moved to the Nation's Capital from Cleveland, Ohio, in 1900. Mrs. Florence Sheffield Keep, who died in 1954 and who is also buried here, was a Washington socialite and sister of Mabel T. Boardman, one of the founders of the American Red Cross and a Commissioner of the District of Columbia in the 1920s.

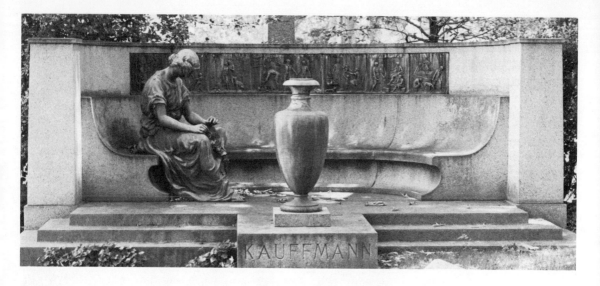

The *Kauffmann Monument*, known as *The Seven Ages* or *Memory*, ranks among the finest six monuments in Rock Creek Cemetery. Three steps invite the visitor to rest on the exedra beside the Neoclassical, draped, seated female figure which expresses a sense of peace and meditation. The curving granite wall behind the statue contains a series of low-relief bronze tablets consisting of scenes illustrating the seven stages of life, as portrayed in Shakespeare's *As You Like It*. A large urn rests on a low granite block in front of this composition. During the period 1895–1940, many funeral monuments included pairs of urns, one on each side of the central monument or mausoleum. The monument measures 5 feet in height and 16 feet in length. Each panel is about 1½ feet square, while the statue is approximately 4 feet high.

Samuel H. Kauffmann (1829–1906), a native of Ohio, owned the Washington *Evening Star* from 1867 until his death. In addition to writing hundreds of editorials, Kauffmann frequently wrote a well-known column on art for the paper. He had, in his home on Massachusetts Avenue, NW, one of the most prominent private collections of American and European paintings in the city. Kauffmann was especially interested in the history of sculpture and at the time of his death was contemplating the publication of a book on the equestrian statues of the world. Nearby is found Gutzon Borglum's *Ffoulke Memorial*, or *Rabboni*, portraying Mary Magdalene as she recognizes the Risen Lord at the empty tomb on Easter.

Detail: Parenthood, the fifth of seven relief panels portraying the ages of life

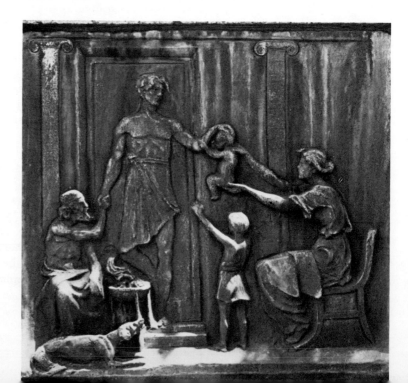

Title LENTHALL MONUMENT, 1809
Location Rock Creek Cemetery,
North Capitol and Webster
Streets, NW, Section C
Sculptor Unknown
Architect None
Medium Sandstone

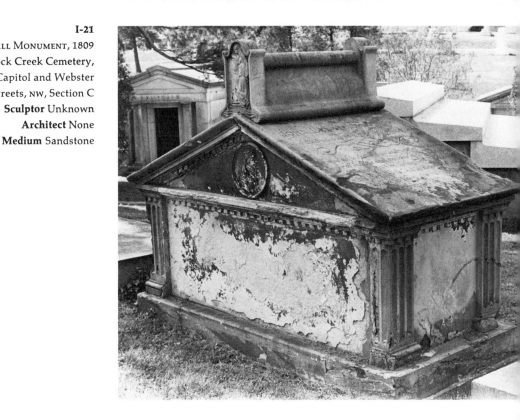

Relief of Fleetness of Time

This early nineteenth-century monument, 6 feet high and 7 feet wide, still elegant although badly damaged by the weather, consists of a miniature Neoclassical temple with a low-relief portrait medallion of the deceased subject in the low pediment. The two pediments are surmounted by vertical low-relief carved panels, each 12 inches high and 6 inches wide, portraying a Classical female figure leaning on an urn, symbolic of Grief, and an elderly angel holding an hourglass and a scythe, representative of the Fleetness of Time for man on earth. The inscription, handsomely executed by a master stonecarver is as follows:

> In memory of John Lenthall, Builder, who died on the 19th of September, 1808, Aged 46 years. He was an industrious and upright citizen, a lover of Justice, and zealous in the discharge of his duty. When living, he was esteemed by those who know the value of talent and integrity in his profession.

Lenthall was born in England in 1762 and immigrated to Washington, D.C., in 1792. He was the son of Sir William Lenthall, Speaker of the House of Commons. Soon after his arrival in Washington, Lenthall married Jane King, whose father and brothers had assisted Pierre L'Enfant in surveying the District of Columbia when it was laid out in the early 1790s. Capitol architect Benjamin Latrobe selected Lenthall as his principal assistant in 1803. It was in the performance of these duties that he was tragically killed in 1808, when one of the arches of the Supreme Court chamber in the Capitol building collapsed and crushed him to death. Although Lenthall's professional career as an architect was cut short by his untimely death, two of his houses still stand in the city, located at 612–614 Nineteenth Street, NW. Number 614 remained as the Lenthall family residence until 1902; it was here that his widow died in 1853. Washington artist Bertha Noyes later resided here, for forty years, until her death at the age of ninety in 1966. In this house a meeting was held by Miss Noyes which resulted in the founding of the Washington Arts Club.

Title ADAMS MONUMENT, 1890
Location Rock Creek Cemetery,
Rock Creek Church Road and
Webster Street, NW, Section E
Sculptor Augustus Saint-Gaudens
Architect Stanford White
Medium Bronze

Augustus Saint-Gaudens, the leading American sculptor of the late nineteenth century, was asked by Henry Adams (1838–1918) to create a memorial to his wife Marian (1843–1885), an invalid who committed suicide because of her great fear of prolonged illness and because of her despondency due to the recent death of her beloved father. The design of the statue was left to the discretion of the master sculptor. Her death was indeed tragic for Adams as their thirteen years of married life were his happiest years. Adams, who was historian, teacher, author, and journalist, was a native of Massachusetts and a distinguished intellectual. He was the great-grandson of President John Adams, the grandson of President John Quincy Adams, and the son of Charles Adams, the United States ambassador to Great Britain during the Civil War years. As a longtime resident of Washington, Adams, along with his wife, entertained the leading intellectual figures in Washington society. The Adams Mansion was constructed at 1607 H Street, NW, adjacent to Lafayette Park, in 1885. His intimate friend, John Hay, assistant to President Abraham Lincoln and secretary of state under President William McKinley and President Theodore Roosevelt, lived in the adjoining residence at 800 Sixteenth Street, NW. Both historic mansions were demolished in 1926 for the construction of The Hay-Adams Hotel.

Adams was often depressed after the Civil War when he saw the well-ordered, genteel society, to which he had been accustomed, overrun by the new breed of ostentatious men who had advanced themselves through political corruption and the new-found wealth of the industrial revolution. This theme appears throughout his autobiography, *The Education of Henry Adams*, one of the classics of American literature. Adams graduated from Harvard College in 1858 and worked in London as secretary to his father. Upon his return to the United States in 1870, he spent seven years teaching history at Harvard. From 1873 to 1876, he was joint editor, with Henry Cabot Lodge, of the *North American Review*. Adams was a prolific writer, publishing a nine-volume history of the United States in 1889 as well as biographies of Thomas Jefferson, Albert Gallatin, and John Randolph.

The *Adams Monument* is located near St. Paul's Church in Section E of the cemetery. Saint-Gaudens began work in 1886 on this "ultimate abstract personification," a work considered by many to be the finest of his achievements. It was erected in 1890–1891. To create this sculpture, Saint-Gaudens put himself in a frame of mind in sympathy with Eastern religious thought; he even studied photographs of Buddhas. The 6-foot-high figure is seated upon a rock, knees slightly parted, with a full-length cloak flowing in folds to the base. The figure, which is neither male nor female, has its chin resting on an upturned hand, while its face is deeply shadowed by the cloak's hood. The eyes of the figure stare acquiescently and eternally downward. The sculptor called it *The Mystery of the Hereafter* and *The Peace of God that Passeth Understanding*. The viewer will realize, while standing before the statue, that it represents many attitudes including peace, calmness, repose, and a contemplation of life beyond the grave. Mark Twain's remark that the figure embodied all of human grief led to its most commonly but incorrectly used name of "*Grief*." This work was the sculptor's finest effort in the sphere of abstraction; the face is conspicuous for its lack of close modeling. Indeed, no inscription even appears on the rather stark base. Two other sculptures by Saint-Gaudens remind one of other attempts he made relating to abstraction. His female figure, *Silence*, with a robe and veil, was executed in 1874 in Rome. This was his first real project to create a semiabstract work, a departure from his typical Neoclassical style. In this work he tried to impart a timeless abstract symbol of an idea or value, while in his *Farragut Monument* for New York City he shows the personification of a noble concept.

The beauty of the *Adams Monument* is partially attained because of

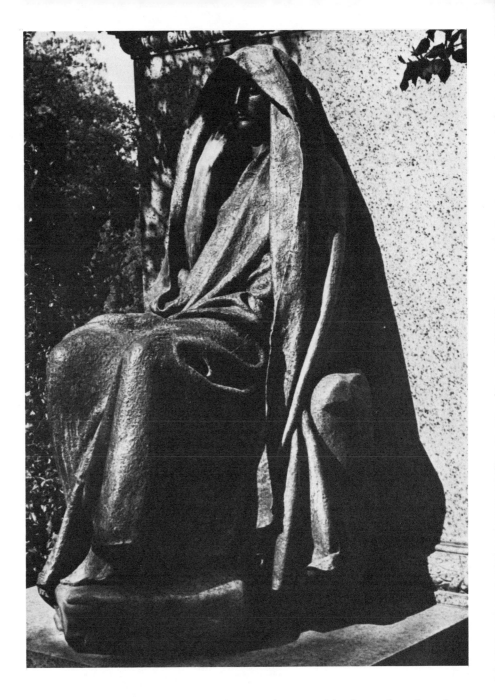

the great extent to which the sculpture and landscape have been harmonized. This is indeed unusual at a time when American society tended to think of a work of art as an isolated object. The sculpture is well integrated with the architectural elements, designed by Stanford White, and with both the site and the plants used. The memorial was designed as an outdoor room with high walls formed from plant materials. The present plant materials were a part of the original design as reflected in the correspondence between Saint-Gaudens and Stanford White at the time, as well as in an early photograph taken in 1907. A level floor has been carved out of the gently sloping hill in that section of the cemetery. From the brilliant sunshine of the open cemetery, the visitor steps into the darkened, dappled shade of this small sanctuary. Another presence is immediately felt as one sits on the marble bench in the coolness and quiet to observe the figure. Meditation and repose result from the setting. The floor of this "room," carpeted with small pebbles, contributes to the textural variation and the feeling of closeness to nature. Indeed, the sculpture and the landscaping make this the most famous cemetery memorial in the city and one of the most outstanding in the United States.

Title THOMPSON-HARDING
MONUMENT, ca. 1898
Location Rock Creek Cemetery,
Rock Creek Church Road and
Webster Street, NW, Section E
Sculptor Unknown
Architect Unknown
Medium Marble and granite

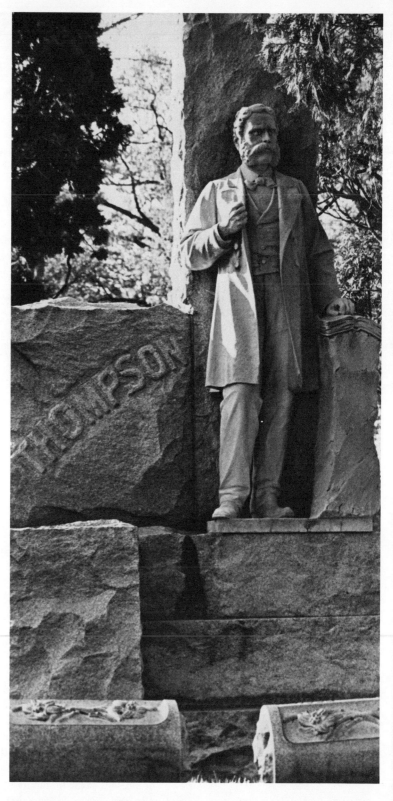

This finely executed, life-size marble statue of N. Elbridge Thompson (1843–1904) is the epitome of Victorian cemetery portraiture. The dignity of Thompson's countenance, with full mustache and "mutton chops," vest and frockcoat, is matched only by the gracefulness of the female figure on the south-side of the monument appearing in a romantic pose holding lilies and wearing a Gibson dress. A large sculptured granite cross towers above. The monument is unusual because it was erected jointly by two families. Mr. and Mrs. William H. Harding and their daughter are buried on the south side of the monument. The female figure evidently portrays the Harding's daughter, Lillie May, who died in 1897, aged twenty-six years.

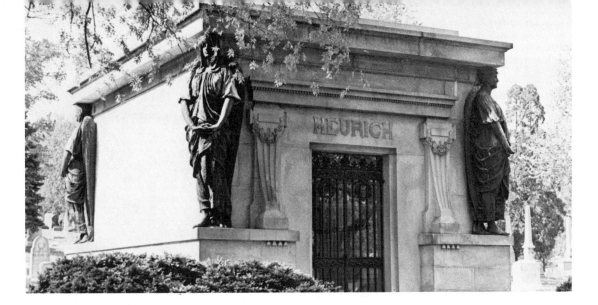

I-24
Title HEURICH MAUSOLEUM, 1895
Location Rock Creek Cemetery,
Rock Creek Church Road and
Webster Street, NW, Section 30
Sculptor Louis Amateis
Architect Louis Amateis
Medium Bronze

This mausoleum, the burial vault for five members of the Heurich family of Washington, was erected about 1895. It contains the remains of Christian Heurich (1842–1945), founder of the Christian Heurich Brewery and prominent figure in Washington society for 75 years. Heurich, born in Sachsen-Meiningen, Germany, worked in a brewery in his home town at the age of fourteen. As a teenager, he hiked through Austria, France, and Italy to learn what he could about the brewery business. Heurich then immigrated to the United States in 1866 and worked in a Baltimore brewery briefly before moving to Washington, where he founded the Heurich Brewing Company in 1872. Although he was forced to close the brewery during prohibition, he reestablished the company upon the repeal of prohibition, when he was ninety years old. The original brewery, located between the Theodore Roosevelt Bridge approach and the Kennedy Center for the Performing Arts, was demolished in the early 1960s. Heurich, very successful in real estate ventures in the Washington area, was for years the city's principal philanthropist. Much of the profits from his business activities were given to the German Orphan Asylum, in nearby Maryland, and to the Ruppert Home for the Aged. At the time of his death at the age of 102, Heurich could claim to be the world's oldest practicing brewer.

The Heurich Mansion, located at 1307 New Hampshire Avenue, NW, near Dupont Circle, remains one of the best preserved great Victorian residences of the city. Most of the original furnishings, designed for the house in the 1890s, remain intact. Architectural features of particular importance include a musician's balcony, suspended between the dining room and the central hallway; an especially designed beer parlor-kitchen in the basement with extensive murals of German scenes; and the children's room located in the top of the main turret, which displays a painted dome. The mansion was left to the Columbia Historical Society by Mrs. Christian Heurich upon her death in 1956.

Prominent on this Beaux-Arts mausoleum in Rock Creek Cemetery are the four caryatids, each 8 feet high and 3 feet wide, which appear to support the roof near each corner of the structure. These pious female angels stand with folded wings and clasped hands as they gaze toward heaven. A Victorian stained glass window, executed by Tiffany of New York, contains a scene of an angel holding a scroll, labeled "Peace," on the rear of the marble tomb. The mausoleum, with its architectural sculpture, was originally erected on the family's 385-acre dairy farm, which was located at the present site of the Prince Georges Plaza Shopping Center in Maryland. Here Heurich bred his 300 Holstein cattle which became famous national award winners. Mrs. Heurich had the mausoleum moved to Rock Creek Cemetery when the farm was sold in the 1950s.

Caryatid

I-25

Title HARDON MONUMENT, 1893
Location Rock Creek Cemetery,
Rock Creek Church Road and
Webster Street, NW, Section I
Sculptor McMenamin, stonecarver
Architect None
Medium Sandstone

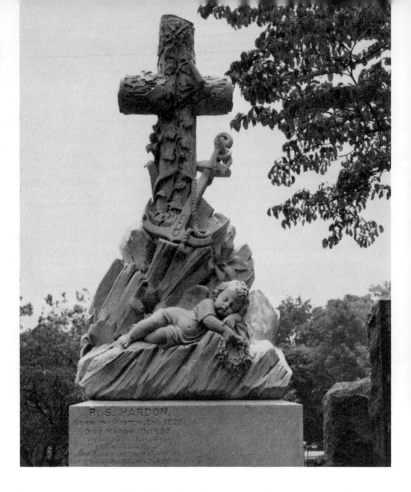

*The sleeping cherub is the
epitome of Victorian sentiment*

This monument to R. S. Hardon (1825–1893) is unique in design in Washington. The stonecarver has included a sleeping cherub (who clasps a wreath of roses in one hand), flowers growing out of the rocks, an anchor, and a log cross entwined with ivy. Note the three chain links on the base of the anchor, indicating that the deceased was a member of the Independent Order of Odd Fellows. The stonecarver has attempted to impart the idea of peace (sleeping cherub), beauty (flowers), eternity (ivy), the resurrection (cross), hope (anchor), and fraternity (chain links) to the memory of R. S. Hardon. The sculpture is likewise a monument to the imagination and skill of this forgotten stonecarver, whose last name, McMenamin, is carved on the base.

It is not unusual to find insignia of fraternal orders on monuments of the nineteenth and early twentieth centuries, when membership in these societies, or "lodges," was a more prevalent and valued aspect of community life than it is today. The Independent Order of Odd Fellows is directly descended from the earliest of the so-called "friendly societies" in England, which in turn can be traced back to medieval trade guilds. They are characterized by voluntary contributions from members to establish a fund that could be drawn on to help "brothers" in the event of sickness, death or loss of employment. A lodge of Odd Fellows is mentioned in England as early as 1745, so named because its members were not of one particular trade or social class—hence "odd fellows." A member who moved to a distant part of the country might be given a letter of introduction to a lodge in that area, which could advance temporary financial help or aid him to find work. These societies also owed some debt to Freemasonry, whose ceremonials, secret rituals and fraternal aims they imitated. Fraternal orders in this country played an important role during the nineteenth century. Most of them were "benevolent" orders—that is, they provided some financial benefits based on payment of dues and length of membership; this aspect later developed into organized mutual insurance provided to members at less cost than commercial policies.

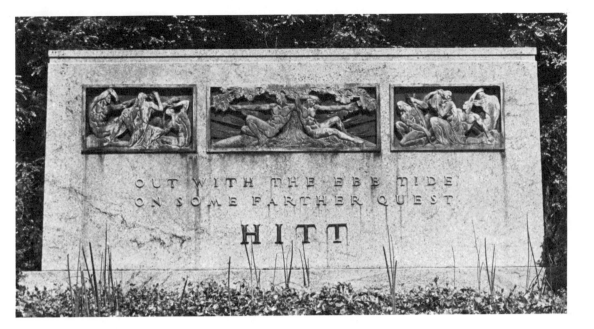

Three handsome bronze low-relief panels compose the decorative feature of this simple and striking monument, executed in 1938. The inscription reads: "Out with the ebb tide, on some farther quest." The central panel, 1½ feet high and 3 feet wide, pictures Adam and Eve under a tree which has great low branches framing the two figures, as they extend to the far corners of the panel. Traces of the Art Deco style can be detected in the arrangement of these figures, so typical of the period between World War I and World War II.

The monument was commissioned upon the death of Robert Stockwell Reynolds Hitt (1876–1938), the son of Robert R. Hitt, United States congressman from Illinois for twenty-four years. Robert S. R. Hitt completed his education at Harvard University and Yale Law School before entering the United States Foreign Service in 1901. During his diplomatic career, Hitt was minister to Panama and Guatemala. The family lived in a handsome residence designed by John Russell Pope and constructed in 1909; it was located at 1501 New Hampshire Avenue, NW, adjacent to Dupont Circle. In the years immediately before the razing of the house, in 1970, it was occupied by the Pan American Health Organization. One of the four handsome 3-foot-wide medallions, representing *The Four Seasons*, which Pope designed for the exterior of the Hitt Mansion, was saved from the wrecking ball and has become a graceful addition to the Washington residence of the Honorable and Mrs. George Renchard.

The central panel is composed in classic Art Deco design

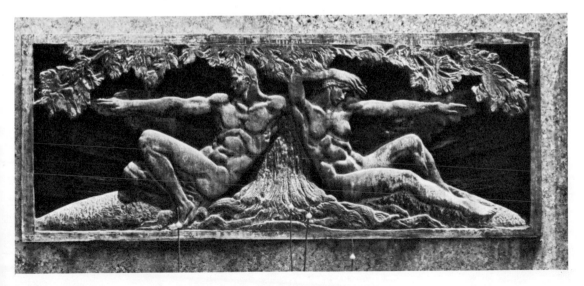

Title Sherwood Mausoleum
Door, 1928
Location Rock Creek Cemetery,
Rock Creek Church Road and
Webster Street, nw, Section 14
Sculptor Gusiofson
Architect Unknown
Medium Bronze

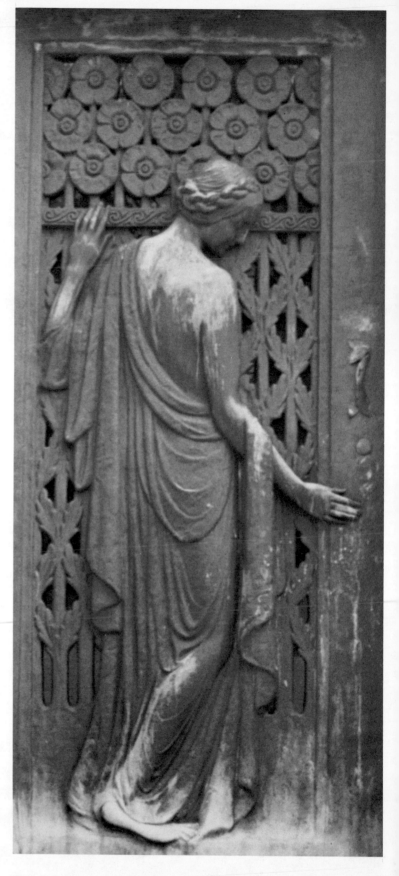

This mausoleum, constructed of great blocks of granite, contains a handsome 7-foot-high bronze relief door executed in a design typical of the 1920s. A female figure, draped in a flowing robe, stands in profile in the center of the door. In addition to the figure a grille composed of crossed leaves, and three rows of identical flowers, completes the composition. A pair of low urns flanks the two steps in front of the door.

PENNSYLVANIA AVENUE, NW

J

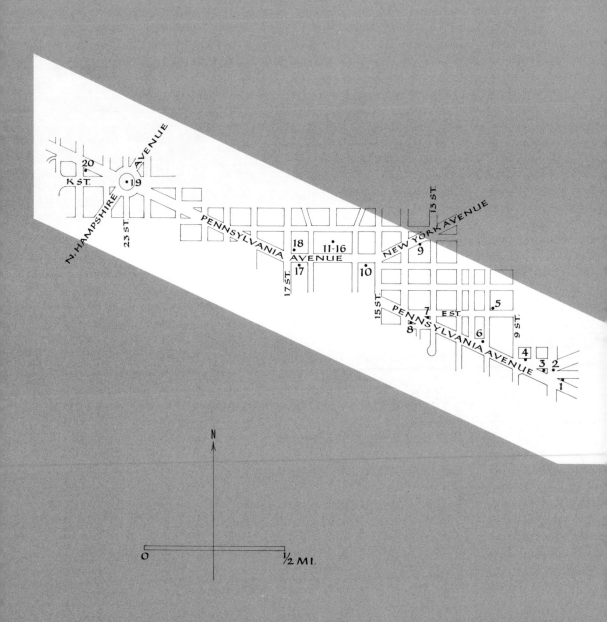

SEVEN-MILE-LONG PENNSYLVANIA AVENUE was destined to become the symbolic route of the Nation from the very beginning of the design of the Nation's Capital. In Major Pierre L'Enfant's plan of 1791, Pennsylvania Avenue was designed to connect the President's House with the Capitol Building. It was laid out as the widest and most important street in the city because Pennsylvania, along with New York and Virginia, was one of the three most important states of the Union at that time, and it was the first one to be paved. In 1803 Thomas Jefferson embellished the avenue with Lombardy poplars, and began using the avenue for national ceremonies. In 1805 he became the first president to hold an inaugural parade along the route from the Capitol to the President's House, which was sixteen blocks to the northwest.

Originally the President's House and the Capitol were the only public buildings situated along Pennsylvania Avenue. The intervening landscape between the two buildings was drab, much like the remainder of the city. Most public officials looked upon Washington as a place to visit in order to perform government business, but not as a place in which to live. Few bought houses in the area, and most chose to live in the hotels or boardinghouses which began to appear along Pennsylvania Avenue.

Public buildings eventually began to take prominence in the Pennsylvania Avenue area because of their proximity to the Capitol and the White House. After the first two Treasury Buildings had been destroyed, the first during the British invasion of 1814 and the second from an accidental fire in 1833, President Andrew Jackson ordered the location of the present Treasury building along the east side of the White House. He did so, according to legend, in 1836 in a fit of impatience after months of indecision by government officials over the site of the new fireproof structure. This impressive Neoclassical structure has become a monument to the abilities of its architect, Robert Mills, and one to poor city planning by President Jackson, since the building blocks the view of the White House from the Capitol Building, a view so carefully planned by L'Enfant.

All of the government offices in the early nineteenth century were housed in a row of townhouses known as the "Six Buildings," on Pennsylvania Avenue near Twenty-First Street. Two of these historical buildings are still standing today, used as shops and restaurants. In 1820, four separate two-storied buildings with Classical porticos were erected at the four corners of the square on which the White House is located: the State, War, Navy, and Treasury Departments. After tremendous pressure for space developed as the size of the Nation grew, the present massive Victorian building in the Second French Empire style, to the immediate west of the White House, was begun in 1871. Originally, it housed the departments of State, War, and Navy. By the 1950s these departments had been relocated in Arlington and West Potomac Park; and the State, War and Navy Building was used exclusively to house Executive offices.

Even though Pennsylvania Avenue stretches for miles, from Georgetown on the west to the Maryland border on the east, the reader's principal interest concerns that mile between the Capitol and the White House. Along this same thoroughfare in solemn procession have passed the bodies of twelve Presidents on their way to their last resting places. The funeral procession of John Quincy Adams, who died in 1848 while a congressman from Massachusetts, was the first of this kind on Pennsylvania Avenue. The body of the distinguished French designer, Major Pierre Charles L'Enfant, was brought in 1909 from "Green Hill," Maryland, where he died in poverty in 1825, to the Rotunda of the Capitol, and from there down Pennsylvania Avenue for reinterment at Arlington National Cemetery. As time passed, during the nineteenth century

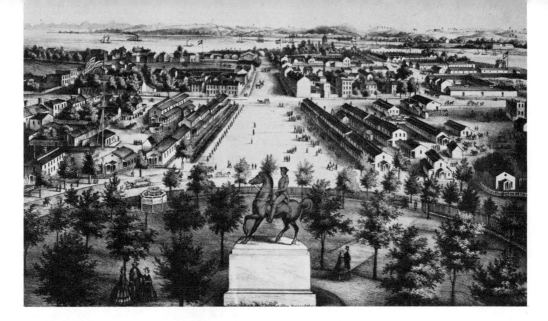

Pennsylvania Avenue became the site of hotels and small businesses. In 1901, the "McMillan Plan" advised that the area between Pennsylvania Avenue and B Street, NW, (Constitution Avenue) be reserved for government office buildings. In 1926, after years of debate, Congress adopted the idea, and work began in 1929 on the "Federal Triangle." Undisturbed by the plan as it was executed were the massive Romanesque Post Office Department Building on Pennsylvania Avenue between Eleventh Street and Twelfth Street, opened in 1899, and the so-called "English Renaissance" District of Columbia Building which dates from 1908, located at Fourteenth and E Streets, facing Pennsylvania Avenue.

The Federal Triangle plan significantly altered the southern face of Pennsylvania Avenue and gave the area the monumental scale which it possesses today. A commission has been created to study the possibility of improving the rather shabby north side of the avenue for the Bicentennial Celebration of 1976. Although the plans have been drawn, there is, at this writing, still doubt that funds will be appropriated by Congress to accomplish this much-needed task. In the meantime, the J. Edgar Hoover Building (FBI headquarters), opening in 1974, on Pennsylvania Avenue between Ninth and Tenth Streets, has greatly improved the appearance of that section of the neighborhood.

During the period of World War I, the historic thoroughfare witnessed Liberty Loan parades, Red Cross parades, military parades, and patriotic demonstrations. President Woodrow Wilson himself marched in the great Preparedness Day parade in 1916, carrying an American flag over his shoulder. After the victory of 1918, General John J. Pershing was honored with a parade on his retirement from the battlefields of France.

Then there have been parades honoring prominent citizens, such as the parade in 1927 to commemorate Colonel Charles Lindbergh's historic flight to Paris. Among great parades held by organizations during the period between the two world wars have been Labor Day parades, suffrage parades, Knights of Columbus, Shriners, school, and circus parades. During the late 1960s and early 1970s, huge parades of citizens demonstrating for the continuation and also for the termination of the Viet-Nam War have marched from the Ellipse along the "national road" to the Capitol.

Since 1791, Pennsylvania Avenue, NW, has remained the symbol of America's government. It is no wonder then that "The Avenue" should have at least one memorial at nearly every corner. As long as Americans think of Washington, D.C., they will be reminded of Pennsylvania Avenue.

Title TEMPERANCE FOUNTAIN,
ca. 1880
Location Pennsylvania Avenue
and 7th Street, NW
Sculptor Henry Cogswell, designer
Architect Unknown
Medium Bronze and granite

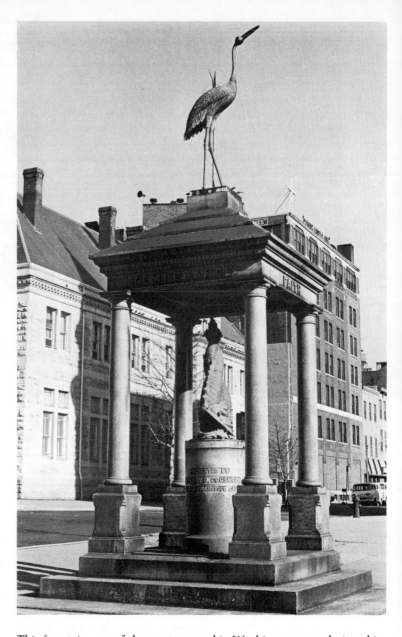

This fountain, one of the most unusual in Washington, was designed in the form of a miniature open temple, with four granite columns supporting a square canopy. Beneath is a drinking fountain of two entwined dolphins; standing fearlessly on top of the canopy is a water crane. The fountain itself is no longer in use, since the city government many years ago stopped providing ice for the Victorian period cooling device built into the base. A San Francisco dentist, Henry Cogswell, donated the fountain so passersby would be able to quench their thirst with its refreshing water rather than with intoxicating liquors. Ironically, the fountain is located directly in front of a contemporary liquor store, which occupies the turreted Victorian bank building designed by Alfred B. Mullet in the 1880s. As a concession to Washington's horses, the overflow of water filled a trough, which has since been covered over.

Dr. Cogswell was born in Connecticut, but journeyed to California during the Gold Rush of 1849. One of the first dentists in San Francisco, Dr. Cogswell made his fortune from real estate and mining stocks. In his spare time he dabbled with inventing, and developed a new method for installing false teeth. To assure that he would always be remembered, Cogswell donated fountains to whatever cities would accept them. He also endowed the Cogswell Polytechnical College in San Francisco.

The fountains were built in a Bridgeport, Connecticut, foundry in the

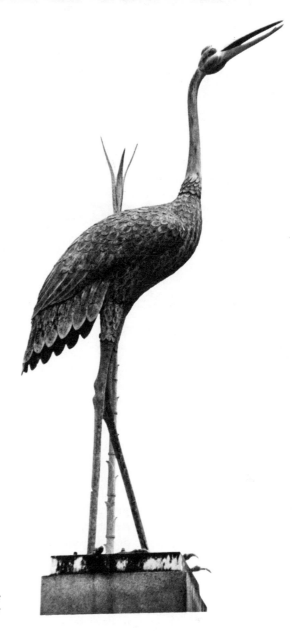

*Water crane symbolizes the
purity of water over liquor*

1870s and 1880s at a cost of about $4,000 each. The fountains varied slightly in design, but they all had such features in common as sculptured marine and animal life, including sea serpents, dolphins, frogs, horses' heads, pigeons, and long-legged birds of the heron or crane family. Besides gargoyles, which the Washington fountain was spared, many of the fountains had a bronze portrait statue of Dr. Cogswell, with full beard and frock coat, standing on the top. In one hand he held a temperance pledge and in the other an empty water glass. Often the fountains were inscribed on the base with these words: "Never Leave Your Work for Others To Do" and "Indefatigable Perseverance, With Patient Industry, Leads to Fortune." Those cities blessed with the Cogswell fountains included Rochester and Buffalo, New York; San Francisco, California; Boston and Fall River, Massachusetts; Pawtucket, Rhode Island; and Willimantic and Rockville, Connecticut.

Most cities have torn down their exotic Cogswell fountains. A New England historian has asserted that the idea of a city having a fine arts commission arose as a reaction to the Cogswell fountains. In 1940, California Senator Sheridan Downey made an abortive attempt to have Congress replace the Washington fountain with a more artistic memorial. The resolution never passed, and the fountain stands as a questionable memorial to the egoistic dentist, but is nevertheless a beloved local landmark.

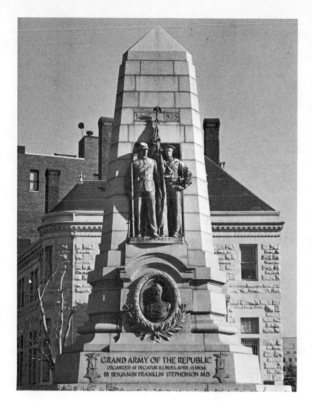
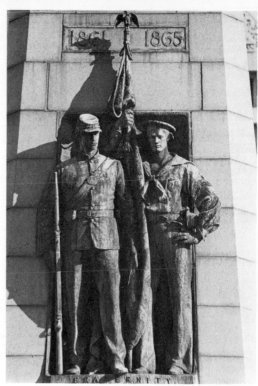

J-2
Title STEPHENSON GRAND ARMY OF THE REPUBLIC MEMORIAL, 1909
Location 7th and C Streets, NW
Sculptor John Massey Rhind
Architect Rankin, Kellogg and Crane
Medium Bronze

The Grand Army of the Republic erected this memorial to its founder, Dr. Benjamin F. Stephenson, in 1909. It is a granite shaft with bronze figures on each of its three faces. The main side faces west and features a sailor and a soldier, symbolizing Fraternity, standing together in Union uniforms from the Civil War period; below is a bronze medallion portrait of Dr. Stephenson and two badges of the Grand Army of the Republic. On the southeast side stands a woman holding a shield and drawn sword, representing Loyalty. On the northeast, a woman protects a child, indicative of Charity. The entire monument is 25 feet high.

Dr. Benjamin F. Stephenson (1823–1871) was born in Wayne County, Illinois. Following the receipt of his medical degree from Rush Medical College in Chicago in 1850, he established a successful medical practice in Petersburg, Illinois. Dr. Stephenson first served as surgeon of the 14th Illinois Infantry Regiment when the Civil War began in 1861. At the time of his honorable discharge from the United States Army in 1864, he had achieved the rank of brigade surgeon. Soon after the conclusion of the war, in January of 1866, he conceived the idea of a national society composed of honorably discharged Union soldiers and sailors. Stephenson also adopted the motto of "Fraternity, Charity, and Loyalty" for the new organization. The following month he wrote the ritual, rules, and regulations for the new society.

Stephenson established Post No. 1, Decatur, Department of Illinois, Grand Army of the Republic, on April 6, 1866, the anniversary of the Battle of Shiloh, in which he and most of the charter members of Post No. 1 had taken an active part. When the Grand Army of the Republic was recognized on a national basis at the National Union Veterans encampment held at Indianapolis, Indiana, on November 20, 1866, Stephenson was elected adjutant general. The organization was dedicated to the assistance of permanently wounded soldiers, and the widows of fallen Union servicemen. It became the first veterans' association in the United States for both officers and enlisted men. Near the end of the nineteenth century, the Grand Army of the Republic exercised considerable political influence. It secured sizable pensions for veterans and sought to assure adequate national defense. The venerable organization passed out of existence in 1959, when Albert Woolson, the last remaining Union veteran, died at the age of 109.

Above right: Fraternity, symbolized by the figures of a Union soldier and sailor

J-3

Title Major General Winfield
Scott Hancock, 1896
Location Pennsylvania Avenue
and 7th Street, NW
Sculptor Henry Jackson Ellicott
Architect Unknown
Medium Bronze

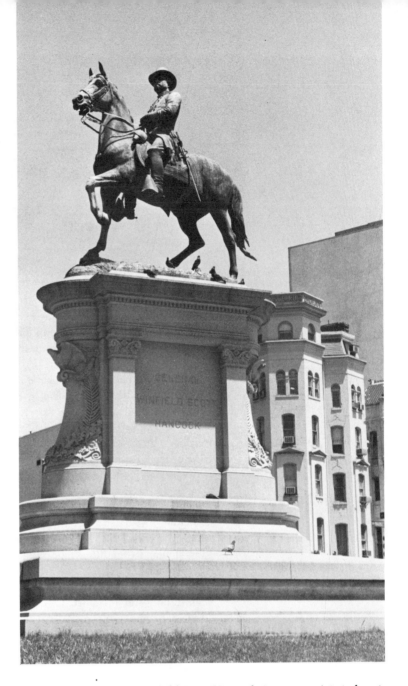

The figure of General Winfield Scott Hancock (1824–1886) is in heroic proportions; he would be 10 feet tall if he stood up. The dimensions of the sculpture are approximately 9 feet in height and 7 feet in width. The 1896 dedication ceremony matched the grandeur of the statue. Every major official in Washington attended, including President Grover Cleveland, Vice President Adlai E. Stevenson, the Chief Justice of the Supreme Court, members of the diplomatic corps, and many American army generals, all to honor "Hancock the Superb."

Hancock graduated from West Point in 1844, and two years later he was fighting with distinction in the Mexican War. He became a Civil War hero when he defeated a massive Confederate assault on the Union lines in Pennsylvania at the Battle of Gettysburg. During the charge he was shot from his horse, but continued to command his troops. In 1880, the Democrats nominated him to run for president against James Garfield. He lost by only 10,000 votes.

General Hancock is dressed in the garb of an American army officer. One noticeable feature of the outfit is the style of hat worn by the general, a broad-brimmed, square-topped soft felt. Hancock thought this hat distinctly American since it derived from the dress of the New England settlers.

J-4
Title EAGLE IN FLIGHT, 1962
Location 813 Pennsylvania
Avenue, NW
Sculptor Paul A. Goettelmann
Architect Murphy and Locraft
Medium Aluminum

Prominently located across Pennsylvania Avenue from the National Archives Building, the National Permanent Federal Savings and Loan Building serves as a backdrop for its *Eagle in Flight*, an example of commercial sculpture. This 8-foot-high aluminum bird measures about 10 feet in width and is surrounded by thirteen metal stars, varying in size from about 1 foot to 1½ feet in height and symbolic of the original thirteen colonies. Looking closely, one will be able to discern the eagle's head facing east and in alignment with its back. The bank staff claims that the *Eagle in Flight* seems to be flying westward toward the White House, while keeping its eye eastward on the Congress.

National Permanent Federal Savings and Loan emerged from the union of the Enterprise Federal Savings and the National Permanent Savings in October 1962. The present building at 813 Pennsylvania Avenue, NW, dates from the same year. At one time the site housed Buberick Shoe Store, a three-story red brick Romanesque Revival building similar to the other office buildings adjacent to the new National Permanent Federal Savings and Loan. About 1948 that building was razed and a one-story building was built to house the Apex Post Office Substation and remained until the site was purchased by Enterprise Federal Savings.

J-5
Title THE HISTORY OF ELECTRIC
POWER, 1929
Location Old Potomac Electric
Power Company Building,
10th and E Streets, NW
Sculptor Carl Mose
Architect Waddy B. Wood
Medium Granite

Eighteen low-relief panels on the Old Potomac Electric Power Company Building, one block north of Pennsylvania Avenue, relate the history of electric power and discoveries since the ancient times. Each panel is 8 feet high and 5 feet wide, carved out of limestone when the building was erected 1929–1930. Sixteen of the panels appear in approximate chronological order and portray men who made contributions to the development of electricity; the two central panels on the E Street façade are symbolic. Unfortunately, the panels were placed by the architect, against the objections of the sculptor, high above the windows of the eighth floor, a position which makes them difficult to identify from the sidewalk.

Starting from the Tenth Street façade on the far left is Vesta, goddess of the hearth and family and protector of eternal fire; she stands with Vulcan, the god of fire, who holds a flaming torch. Next comes Thales (640–546 B.C.), discoverer of static electricity, and Aristotle (384–322 B.C.), the ancient Greek philosophical father of modern science. The third panel shows Alexander Neckham (1157–1217), of England, who successfully magnetized a needle; with him is William Gilbert (1540–1603), of England, another experimenter with magnetism. Next is Otto

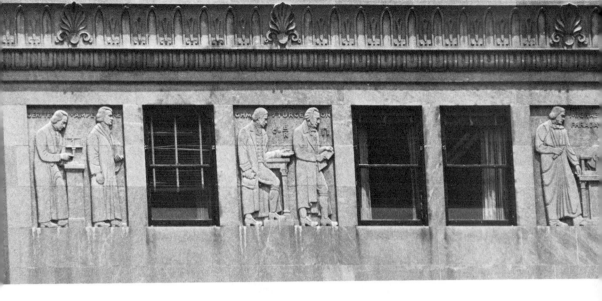

von Guericke (1602–1686), of Germany, who operates the first gen-
erating machine. Following von Guericke, Stephen Gray (1696–1736),
of England, holds his newly insulated wires. E. G. von Kleist (ca. 1720–
1784), of Germany, stands in the next panel with a Leyden jar, and
Benjamin Franklin (1706–1790), of Pennsylvania, flies the kite which
led to his invention of the lightning rod. In the final Tenth Street relief
are Alessandro Volta (1745–1827), of Italy, developer of the electric
battery, and Sir Humphrey Davy (1778–1829), of England, who pro-
duced the first chemicals by electrolysis.

The E Street side, again from the left, shows Hans Christian Oersted
(1771–1851), of Denmark, and André Marie Ampère (1775–1836), of
France, measuring electricity with magnets. George Simon Ohm (1787–
1854), of Germany, theorizes about his law of electrical resistance while
William Sturgeon (1783–1850), of England, discusses the electromag-
netic engine. In the adjoining panel is Michael Faraday (1791–1867), of
England, who regards his electromagnetic generator. Moving on in this
panel, William Stanly (1858–1916), of New York, inventor of the trans-
former, stands with Robert W. Bunsen (1811–1899), of Germany,
known for the Bunsen burner, the modified Grove battery, and the
theory of electrical arc. In the next panel, Thomas Alva Edison (1847–
1931), of Ohio, stands watching his incandescent lamp. America's most
prolific inventor, Edison designed the Ediphone phonograph, micro-
phone, telephone transmitter, dictaphone, vote recorder, tape recorder,
and improved telegraph systems and batteries.

The center reliefs are composed of symbolic figures. On the left,
modern man draws the curtain of darkness from the world, illuminating
it with the incandescent lamp. The figure on the right symbolizies mod-
ern man controlling electric power; he holds back the curtain permitting
light and knowledge to enter.

The first panel right of center depicts Charles P. Steinmetz (1865–
1923), of Germany, working at his desk; he developed lightning ar-
resters for high-powered transmission lines as well as the theory of
alternating current.

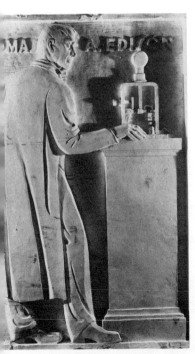

Next, Nikola Tesla (1856–1943), of Yugoslavia, inventor of the in-
duction motor, is shown with Elihu Thompson (1853–1937), of England,
who worked on the watt meter and electric welding. In the penultimate
relief, George Westinghouse (1846–1914), of New York, inventor of air
brake and automatic railroad signals, appears with Frank Julian Sprague
(1857–1934), of Connecticut, designer of electric trolleys and elevators.
Alexander Graham Bell (1847–1922), of Scotland and Massachusetts,
inventor of the telephone, and Samuel F. B. Morse (1791–1872), of
Massachusetts, inventor of the telegraph, are the American subjects of
the final panel.

Title BENJAMIN FRANKLIN, 1889
Location Pennsylvania Avenue
and 10th Street, NW
Sculptor Jacques Jouvenal, after
the design of Ernest Plassman
Architect J. F. Manning
Medium Marble

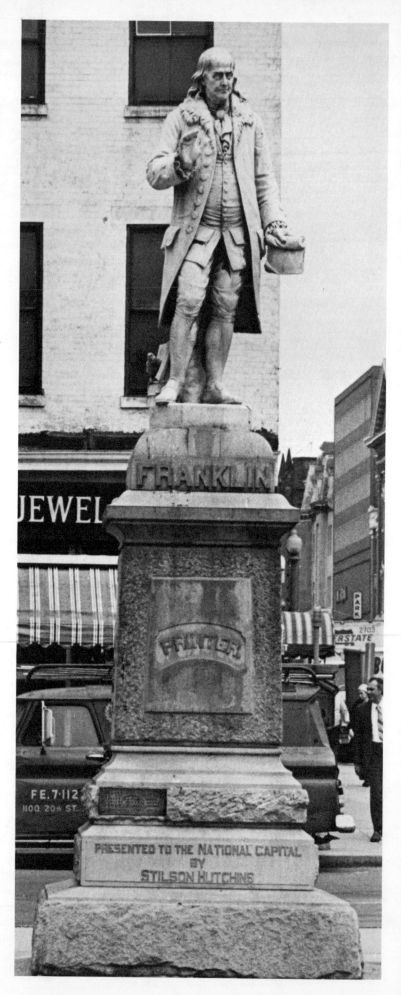

This portrait statue portrays Benjamin Franklin (1706–1790) as an American statesman, in the diplomatic dress of the American Minister to the Court of Louis XVI in Versailles. Not only was Franklin a great statesman, he was a pungent writer, a pithy humorist, a renowned philosopher, the founder of the University of Pennsylvania, a courtly and astute diplomat, as well as America's first and most versatile inventor. Franklin is here depicted at Versailles, for it was there in 1777 that this Pennsylvanian won the support of the French in the fight for American independence from Great Britain. He went to Paris again in 1783 to negotiate with England the peace treaty which officially acknowledged American independence.

The donor of this statue, Stilson Hutchins (1839–1912), was one of the most interesting figures in Washington during the second half of the nineteenth century. A native of New Hampshire, Hutchins became a journalist early in life after graduating from Harvard University. He founded four newspapers, the Dubuque, Iowa, *Herald*, the St. Louis, Missouri, *Times*, and two local papers, the *Washington Post* and the *Republic*. The old *Post* building was located across the street from the statue, at the northeast corner of Tenth Street and D Street, NW, the present location of the new J. Edgar Hoover Building. Since Hutchins had sold both local newspapers by the time this statue was completed in 1889, he donated it to the city in the name of America's newspaper publishers. The 8-foot-high marble portrait of Franklin, who happened to be America's most prominent colonial journalist, was unveiled on January 11, 1889, by Mrs. H. W. Emory, Franklin's great-grand-daughter.

Hutchins succeeded financially in life because he was always willing to try new inventions. It was Hutchins who was one of the first newspaper publishers to use the linotype machine for printing. In 1879, Hutchins visited Thomas A. Edison in his laboratory to discuss the possibilities of commercial use of the newly invented incandescent electric lamp. He founded the Heisler Electric Light Co. in Washington in 1881, and pioneered the lighting of F Street and Pennsylvania Avenue with electricity in 1882. The new company, located in the old *Post* Building, featured in a third-floor niche a 5-foot-high bronze figure of Mercury. This company and many other small electric companies in the city were soon absorbed by the Potomac Electric Power Company after it was established in 1896. Hutchins left an estate of over four million dollars upon his death in 1912.

Title BRIGADIER GENERAL
COUNT CASIMIR PULASKI, 1910
Location Pennsylvania Avenue
and 13th Street, NW
Sculptor Kasimiriez Chodzinski
Architect Albert R. Ross
Medium Bronze

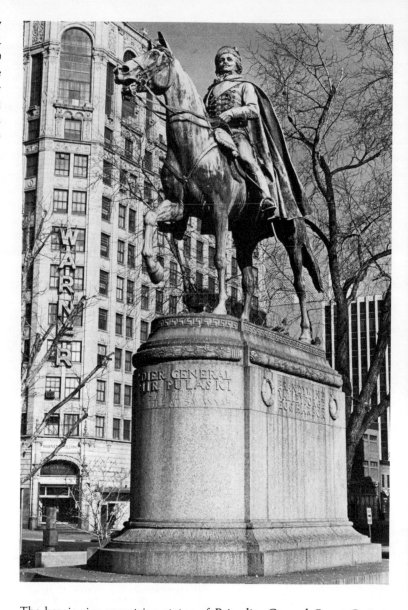

The heroic-size equestrian statue of Brigadier General Count Casimir Pulaski, over 8 feet high, portrays the Revolutionary War patriot in the uniform of a Polish marshal, which he preferred to wear rather than the uniform of the Continental Army. The statue rests on a granite pedestal, on which are carved the names of the American Revolutionary War battles in which he participated. Count Pulaski (1748?–1779) gained fame throughout Europe by fighting to defend the freedom of Poland from Russian, Austrian, and Prussian invaders. Although he had achieved the rank of marshal general in the Polish cavalry, Pulaski was excited enough by the new American republic to join in its fight for independence. Count Pulaski journeyed to Paris, where the American minister, Benjamin Franklin, gave the young officer a letter of recommendation to George Washington.

Pulaski reached Philadelphia in the summer of 1777. Before meeting General Washington, he volunteered and fought valiantly with Lafayette in the Battle of Brandywine, and the impressed Congress commissioned Pulaski as a brigadier general in the American cavalry. General Pulaski, a brilliant and courageous leader, inspired the utmost confidence in his troops. After several victorious assaults against the British, Pulaski was shot from his horse while leading a charge against two British batteries in the battle of Savannah, in Georgia. Severely wounded, he was taken aboard the American brig *Wasp* where he died October 11, 1779. He was afterwards buried near Savannah, where a second statue has been erected to him.

Title ALEXANDER ROBEY SHEPHERD,
1909
Location Pennsylvania Avenue
and 14th Street, NW
Sculptor U. S. J. Dunbar
Architect Unknown
Medium Bronze

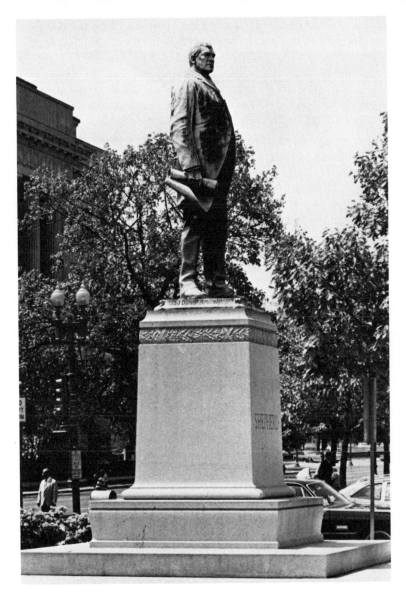

Alexander Robey Shepherd (1835–1902) was the first native of the District of Columbia to be honored by a public outdoor portrait statue. He stands, appropriately holding a map of the city in his right hand, and surveys the modern improvements which he initiated during the decade following the Civil War. The statue formerly stood in front of the entrance to the nearby District of Columbia Building, before it was moved to its present location in 1931 during the construction of the adjacent Federal Triangle buildings.

Alexander Shepherd is both champion and enigma for those who debate the heated issue of self-government for the District of Columbia. When the District of Columbia was given territorial self-government in 1871, Shepherd became the executive officer of the important Board of Public Works. At that time the city was in miserable condition: few roads had been paved, there were still fewer sewers, and the water supply was primitive. Faced with such a squalid city, Congress often debated moving elsewhere. To repair this image, Shepherd embarked on a massive program of public works; in the process he overspent his budget several times. President U. S. Grant did not seem to mind and even appointed Shepherd as Territorial Governor of the District of Columbia. When the first governor, Henry Cooke, resigned, Shepherd became even more extravagant with this project, and he acquired the nickname "Boss Shepherd" for several reportedly questionable deals which led to a congressional investigation. In 1874, Congress took away the District's semi-independent government, replacing it with a com-

mission appointed by the president. When Grant appointed Shepherd to be commissioner, the Senate refused to confirm the nomination. Dejected and impoverished, Shepherd sold his mansion at Seventeenth and K Streets, NW, (the present location of the Y.W.C.A. building) left Washington in 1879 and moved to Batophilis, Chihuahua, Mexico. Here, in the 1880s, he discovered rich veins of silver and gold in a defunct mine and became a millionaire.

During his term of office as director of the Board of Public Works and as governor, Shepherd paved hundreds of miles of Washington streets. He also graded most streets for the first time, installed street lights and sidewalks, established the first city water and sewage systems, and planted thousands of trees. Shepherd died in 1902, and his body was returned from Mexico for burial in Rock Creek Cemetery. Citizens of Washington, grateful for Shepherd's untiring efforts to improve the city, raised the money for this statue. The statue is often criticized because it represents Shepherd when advanced age had impaired his features and corpulence had destroyed the "symmetry of his form." On the other hand, some congressmen may be heard lamenting that Washington should not even have a memorial to "Boss Shepherd." Under the right foot of this 8-foot-high statue can be seen the sculptor's signature, incised in the bronze.

J-9
Title AUTOMOBILE, 1926
Location Capital Garage, 1320 New York Avenue, NW
Sculptor Unknown
Architect Arthur B. Heaton
Medium Granite

One of the most unusual bits of architectural sculpture in the city is the group of Art Deco style *Automobile* relief panels on the main façade of the old Capitol Garage building. Spaced at regular intervals beneath the cornice are six panels of radiator grilles and headlights, mounted above a single winged automobile tire. The most elaborate reliefs, however, are the two identical panels of 1926-vintage automobiles seen frontally and located above the pilasters which flank the entrance. The radiator grille panels measure approximately 3 feet square, while the auto panels are about 4 feet square. This building was purchased in 1973 by the firm of Parking Management, Inc.

The site of the Capital Garage building was formerly occupied by a building known as the Hall of the Ancients, a museum erected in 1898. The museum and exhibits were designed and promoted by Franklin Webster Smith and financed by S. Walter Woodward, of Woodward and Lothrop's department store. The building was complete with a 30-foot-high Egyptian portal reproducing a section of Hypostyle Hall of Karnak, as well as reproductions of the art and architecture of the Greek, Roman, Egyptian, Assyrian, and Saracenic civilizations.

Smith was a successful hardware manufacturer, an organizer of the Y.M.C.A. in America, a founder of the Republican Party in Massachusetts, and a leading Baptist layman. He became fascinated with archeology and, in the 1880s, erected a reproduction of the House of Pansa at Pompeii in Saratoga Springs, New York. Because of the enormous popularity and financial success of this venture, Smith proposed in 1891 a principal archeological museum for downtown Washington, D.C., to be known as the "National Galleries of History and Art," and to cover 60 acres of land between F Street and Constitution Avenue. Each of the various museum buildings would be devoted to showing the history of one of the great civilizations of the world. Congress rejected Smith's grand plan, and his only footnote in Washington history was the Hall of the Ancients, which was demolished in 1925 to make way for the Capital Garage building.

On January 5, 1974, the Capital Garage was destroyed by dynamite to make way for a modern office building, but six of the *Automobile* relief panels survived the blast and have been donated to the Smithsonian Institution by the Blake Construction Company.

369 *Pennsylvania Avenue, NW*

J-10
Title ALBERT GALLATIN, 1947
Location Department of the
Treasury Building, north plaza,
Pennsylvania Avenue and
15th Street, NW
Sculptor James Earle Fraser
Architect Unknown
Medium Bronze

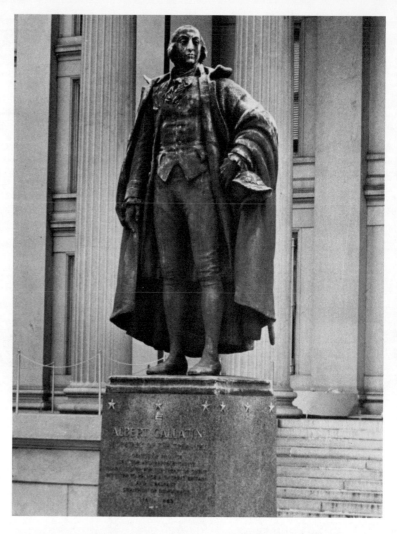

This statue of Albert Gallatin (1761–1849) probably took longer to con-
struct than any other portrait statue in the city. It was proposed in 1926
that, in the Treasury's north plaza, a statue of Gallatin be erected which
would match the memorial to Hamilton already erected on the south
plaza. Democrats were tiring of the expression "the best Secretary of
the Treasury since Hamilton," which was applied whenever anyone in
the Treasury Department accomplished anything of merit. Hamilton
had been the arch rival of Thomas Jefferson, founder of the Democratic
Party. Some Democrats felt that Albert Gallatin, Jefferson's secretary
of the treasury, was even more outstanding than Hamilton. They
pointed out that when Gallatin had been made secretary of the treas-
ury in 1801 there was a $14,000,000 national debt left by Hamilton.
Within six years Gallatin had the debt paid off, and he was first to effect
a Treasury Department surplus. A Republican-controlled Congress de-
cided to allow the statue only if the money came from private funds.

By 1934, sufficient funds had been raised to begin preparation of the
site, which required the removal of a fountain. Delays occurred in the
completion of a model that was acceptable to the United States Fine
Arts Commission. When the statue was ready to be cast, World War II
erupted, and a ban was placed on all civilian use of bronze. The statue
was finally dedicated on October 15, 1947, twenty years after congres-
sional approval.

Albert Gallatin, a resident of New York who had been born in Swit-
zerland, served not only as secretary of the treasury, but also as a nego-
tiator of the Treaty of Ghent, as congressman and senator, and as the
American minister to Great Britain and France. He stands in bronze, 8
feet tall, with knee breeches, and with his great cloak thrown back,
gazing confidently toward Pennsylvania Avenue.

Lafayette Park

J11–16

Lafayette Park is located on Pennsylvania Avenue between Jackson and Madison Places, directly across from the White House. Rectangular in shape, it has an area of approximately seven acres. Originally it had been designated part of the President's Park, but was soon given over to public use. A barren common, it was neglected for many years. A race course was laid out along its west side in 1797, and workmen's quarters were thrown up on it during the construction of the White House in the 1790s. A market occupied the site later and, during the War of 1812, soldiers were encamped there. In 1824, upon General Lafayette's triumphant return to the United States, the area was named Lafayette Square, plantings were made, and walks were laid.

In 1851, as plans were being made for the installation of Clark Mills's equestrian statue of General Andrew Jackson, a prominent landscape gardener named Andrew Jackson Downing was commissioned by Congress to design the grounds. He planned meandering gravel paths leading among trees and flowers to the statue of General Jackson, located in an elliptical area at the center of the square. An axial path led to the statue from the midpoints of the north and south sides of the park, on a line with the White House entrance. The design, after the manner of Englishman Humphrey Repton, combined the elements of both formal and informal planning thought suitable for an important public park. Downing's death, on July 28, 1852, prevented his carrying out the scheme, and the Civil War further delayed matters. Finally, in 1872, as Alexander Robey Shepherd and the Board of Public Works were transforming Washington with their civic improvements, the federal government began to implement the Downing plan. Plantings were made, and the ornamental bronze urns which are still there were set in place, as were lampposts and drinking fountains. In 1889, an iron fence, which had been erected after the dedication of the Jackson statue, was removed to Culp's Hill on the battlefield at Gettysburg, thus allowing freer public use of the park.

In 1890, preparations began for the erection of the Lafayette memorial on a site at the center of the south side of the Park, facing the White House. The pedestal was already under construction when it was noticed that it would block the view of the statue of General Jackson from the White House. A public outcry forced its removal to its present site at the southeast corner of the Park. In 1902, the memorial to the Comte de Rochambeau was erected in the southwest corner of the Park, followed in 1910 by that to General Kosciuszko in the northeast corner and to General Steuben in the northwest corner. In 1936–1937, under the Works Progress Administration, Lafayette Square, since renamed Lafayette Park, was redesigned: the paths were widened and straightened, and the whole area was made more formal, in sympathy with the increasingly monumental character of the neighborhood. More recently, in the late sixties, Lafayette Park has again been redesigned. Fountains, brick paving, and more diversified and informal landscaping, akin to the original Downing plan, have been introduced to enhance the more intimate human scale of John Carl Warnecke's plan for the redevelopment of the Lafayette Park neighborhood.

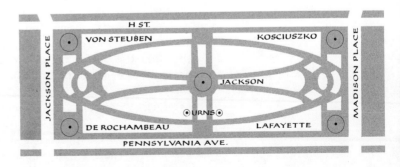

J-11

Title MAJOR GENERAL MARQUIS
GILBERT DE LAFAYETTE, 1891
Location Lafayette Park, southeast
corner, Pennsylvania Avenue
between Jackson and Madison
Places, NW
Sculptors Jean Alexandre Joseph
Falguière and Marius Jean
Antonin Mercié
Architect Paul Pujol
Medium Bronze

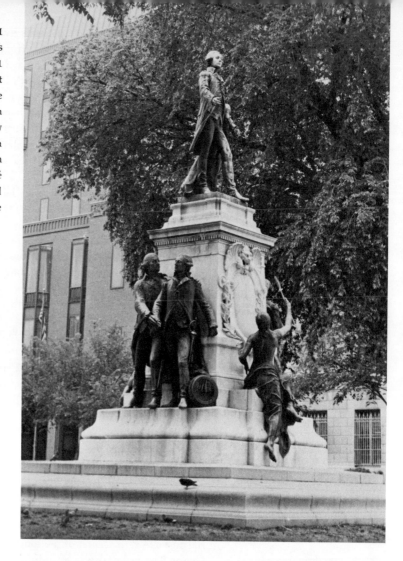

This memorial, inscribed in a cartouche on the south face of the pedestal, "To General Lafayette and his Compatriots, 1777–1783," was described on its completion in 1891 as "not a portrait but a gallery." A heroic bronze portrays Lafayette petitioning the French National Assembly for assistance to the Americans in their fight for independence. He stands on a marble pedestal, facing south, wearing civilian dress but carrying a sword. The general's right arm is outstretched, while a cloak is thrown over his left arm as the left hand rests on the hilt of the sword. On the south pedestal face a bronze female figure, symbolizing America, turns toward him and imploringly lifts up a sword. On the east face are portrait bronzes of the Comte d'Estaing and the Comte de Grasse, discoursing. An anchor indicates their command of the French naval forces sent to America as a result of Lafayette's plea. On the west are similar portrait bronzes of the Comte de Rochambeau and the Chevalier du Portail. A cannon indicates their command of the French army in America. On the north face of the pedestal are two cherubs, proclaimed "the delight of the populace" in the 1890s, holding hands and pointing to a cartouche bearing the inscription: "By the Congress, in commemoration of the services rendered by General Lafayette and his compatriots during the struggle for the independence of the United States of America." The names of the sculptors, architect, and founder are also inscribed on this piece. The memorial was commissioned by Congress, the sculptors chosen through a competition. There were no dedicatory ceremonies.

Lafayette (1787–1834) overcame many obstacles to join the fight for American independence. Only nineteen years old and recently married, he fitted out his own vessel, *La Victoire,* in defiance of Louis XVI and

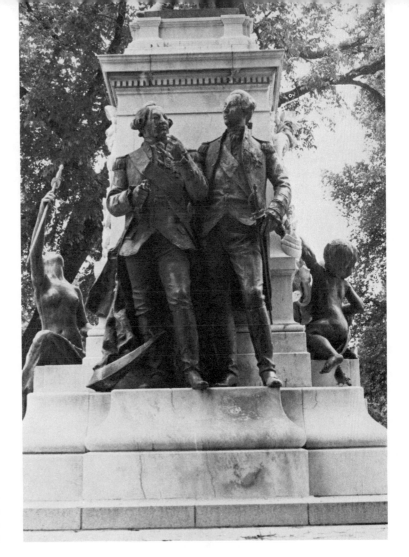

Detail: the east side with the portrait statues of the Comte d'Estaing and the Comte de Grasse

sailed for America in the spring of 1777. He was appointed a major general in the Continental Army and served General Washington as aide-de-camp at Valley Forge. In October 1778, he returned to France to plead the Americans' cause. Though he had hoped to command the French forces himself, he gracefully accepted the appointment of the more experienced de Rochambeau. At Yorktown, Virginia, as Washington and de Rochambeau advanced from the north and Comtes de Barras and de Grasse took command of the coast, Lafayette skillfully maneuvered the British forces, under Cornwallis, into a position from which they could not escape. When Cornwallis surrendered he wished to do so to the French, and, although this was not allowed, it was a tribute to the role Lafayette had played in the war. After the surrender, Lafayette returned to France. He revisited America on two later occasions, in 1784 and in 1824, when he was enthusiastically acclaimed. Lafayette had invested more than $200,000 of his own money in the American Revolution. In appreciation, Congress later granted him $200,000 and a township of land. Although several individual states conferred upon him the title of honorary citizen, he was never made an honorary citizen of the United States, that title having been granted by Congress only to Sir Winston Churchill. When Lafayette died in France on May 20, 1834, his grave was covered with earth from Bunker Hill.

The bronze portrait statue of Lafayette is approximately 8 feet high and 4 feet wide, while the entire monument is 36 feet high and 20 feet wide. Lafayette's full name was Marie Jean Paul Roch Yves Gilbert Motier de Lafayette. During the American Revolution he was known personally by fellow officers as "Gilbert" while official dispatches were usually addressed to "Major General, the Marquis de Lafayette."

J-12
Title BRIGADIER GENERAL
THADDEUS KOSCIUSZKO, 1910
Location Lafayette Park, northeast
corner, Pennsylvania Avenue
between Jackson and Madison
Places, NW
Sculptor Antoni Popiel
Architect Unknown
Medium Bronze

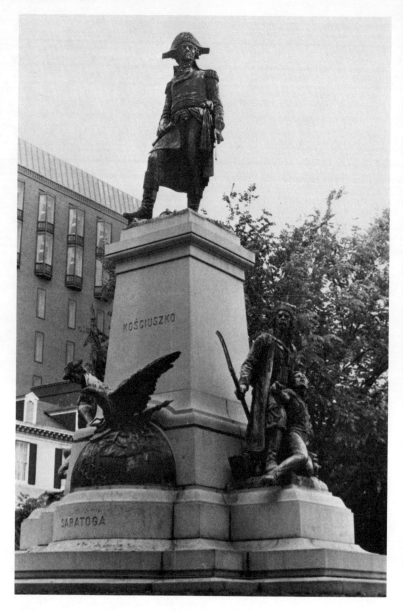

This monument to Polish patriot Thaddeus Kosciuszko (1746–1817) commemorates a lifetime dedicated to fighting for freedom in America and Poland. As a young military engineer, he offered his services to the Americans in the dark days of 1776. His skill in building fortifications on the Delaware River, and at Saratoga and at West Point in New York, contributed greatly to the eventual American victory. In 1783, an appreciative Congress commissioned him a brigadier general and later granted him a bounty of $15,000 and 500 acres of land in Ohio. In 1784, he returned to his homeland, where he led the fight to preserve the freedom of Poland from Russia. In 1794, his outnumbered forces were defeated at the battle of Raclawice, and he himself was imprisoned. Released in 1796, he continued his efforts on behalf of Polish freedom until his death in 1817. Kosciuszko's passionate concern for freedom extended to enslaved blacks. The proceeds from the sale of his Ohio lands were used to found the Colored School at Newark, New Jersey, one of the first educational institutions for Negroes in this country.

In this memorial, a heroic bronze of Kosciuszko stands 8 feet high upon a granite pedestal, facing north. He is attired in the uniform of a general of the Continental Army and holds in his right hand a map of the fortifications at Saratoga. On its north face, the pedestal is inscribed simply: "Kosciuszko." Below this inscription a proudly defiant eagle with outspread wings guards a flag, a shield, and a sword upon a quarter

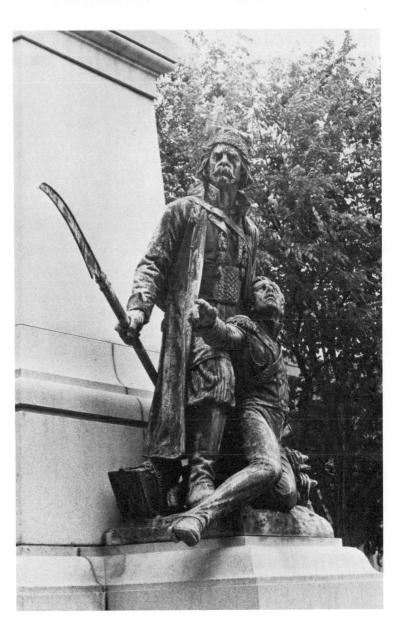

Detail: the west side portraying a fallen Kosciuszko directing a Polish soldier to return to the battlefield

globe showing America. "Saratoga" is inscribed below. The south face of the pedestal is inscribed: "And Freedom shrieked as Kosciuszko fell" and "Erected by the Polish National Alliance of America and presented to the United States on behalf of the Polish American citizens May 11, 1910." Here an eagle, similar to that on the north face, struggles fiercely with a snake on a quarter globe showing Poland. "Raclawice" is the inscription here. On the east pedestal face, a group shows Kosciuszko in American uniform freeing a bound soldier symbolizing the American army. A flag is in Kosciuszko's left hand, and a fallen musket and overturned drum are at the youth's feet. On the west face of the pedestal, a fallen Kosciuszko in Polish uniform attempts to direct a peasant soldier symbolizing the Polish army. Kosciuszko leans upon an overturned basket of shot. All four pedestal groups are sculptured entirely in bronze.

Title NAVY YARD URNS, 1872
Location Lafayette Park, south side center, Pennsylvania Avenue between Jackson and Madison Places, NW
Sculptor Ordnance Department, U.S. Navy Yard, Washington, D.C.
Architect None
Medium Bronze

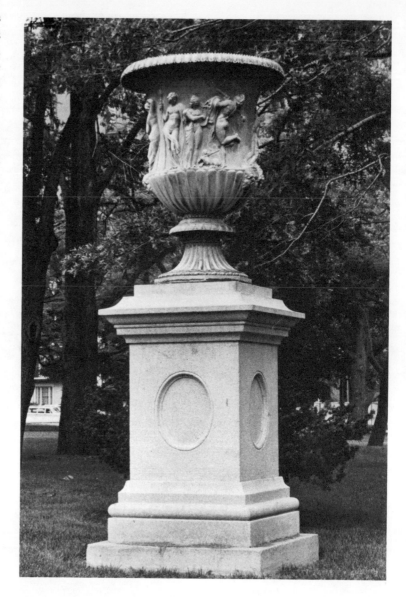

These ornamental bronze urns are Classical in inspiration and are reminiscent of the urns in the gardens at Versailles. Little is known of their creation, and no single Classical precedent can be assigned. They are inscribed: "Ordnance Department, U.S. Navy Yard, Washington D.C. 1872." They were placed in Lafayette Park in that year by order of the secretary of the navy, the Honorable George M. Robeson, who described them, perhaps facetiously, as "extremely good examples of the work of government mechanics and workshops." The furnaces in which they were cast were designed by architect-engineer Adolph Cluss, during the years of his service at the Navy Yard, and were used during the Civil War to cast the brass cannon of the Navy. The location for the urns was indicated by Andrew Jackson Downing in his park plan of 1852; and it is possible that they may have been designed by Downing or his partner, Calvert Vaux. They are similar in general form, but not in the detail of the relief work, to the *Andrew Jackson Downing Urn* (G-10) on the grounds of the Smithsonian Institution. The Lafayette Park urns were originally placed on granite pedestals in the center of two small circular flower beds, located to the east and west of the statue of General Jackson, halfway to Jackson and Madison Places. In 1879, they were fitted with galvanized pans and planted with flowers and vines. When Lafayette Park was redesigned in 1936, they were moved to the entrances on Jackson and Madison Places. The urns, 5 feet high and 4 feet wide, now rest on tall pedestals located on each side of the main approach at the south side of the park.

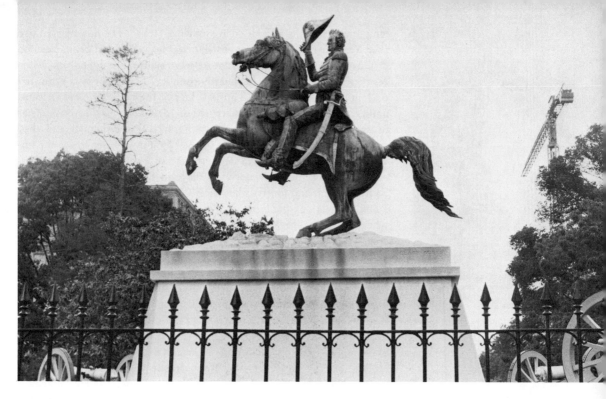

J-14
Title MAJOR GENERAL ANDREW
JACKSON, 1853
Location Lafayette Park, center
axis, Pennsylvania Avenue
between Jackson Place and
Madison Place, NW
Sculptor Clark Mills
Architect Clark Mills
Medium Bronze

This statue portrays Major General Andrew Jackson (1767–1845) as he appeared while reviewing his troops at the Battle of New Orleans, in Louisiana, on January 8, 1815. His spirited mount rears, ready to charge, but is restrained with a steady hand, as Jackson raises his hat in acknowledgment of the salute of his troops. This last battle of the War of 1812, actually fought after peace had been signed in Washington, was a major victory of the American army over the British forces. At first an attempt was made to cast the statue from bronze cannon captured by Jackson at Pensacola, Florida. When this attempt failed, the Navy Department provided the sculptor with surplus brass and copper for casting in 1850. Jackson stands on a simple granite pedestal on which is inscribed: "Jackson" and "The Federal Union, It Must Be Preserved." It is interesting to note that, although Mills devised the latter inscription for the pedestal in 1853, it was not inscribed on the stone until 1909. The statue faces west, and the heads of Jackson and his charger turn slightly south toward the White House. Grouped around the base are four of the cannon captured by Jackson at Pensacola, Florida. These four are rare pieces cast by Josephus Barnola at the royal foundry in Barcelona, Spain, and are named El Aristo (1773), El Apolo (1773), Witiza (1748) and El Egica (1748) after Visigothic kings and Greek gods. They have 3½-inch bores and weigh about 870 pounds each. A cast-iron fence surrounds the elliptical grass plot on which the monument stands.

This bronze statue, measuring about 9 feet high and 12 feet wide, was the first equestrian statue cast in the United States. The sculptor, Clark Mills, was self-taught, and, when commissioned by the Jackson Monument Committee, sponsored by the Democratic Party, to execute the monument, had never even seen an equestrian statue. With a characteristically American inventiveness and dauntless self-confidence, which Andrew Jackson himself would have relished, Mills attacked and solved a problem which had baffled Leonardo da Vinci. He erected a furnace and studio near the square in 1849 at Fifteenth Street and Pennsylvania Avenue, NW, just south of the Treasury Department Building where the statue of General William T. Sherman now stands. Mills had to make six castings of the horse before the final casting was completed in December 1852. The entire work was cast in ten pieces, four of the horse and six of Jackson—a total of 15 tons of bronze. Mills used con-

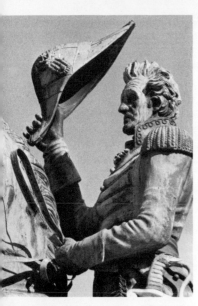

Detail: Jackson saluting his troops

temporary portraits as a guide in modeling Jackson; he doubtlessly also used a number of prints of equestrian statues which had been executed in Europe. Working against almost insurmountable difficulties, Mills cast the statue himself in his nearby foundry. The statue was dedicated on January 8, 1853, the 38th anniversary of the battle of New Orleans, amid extravagant fanfare. The crowd of 15,000 people cheered Mills as he walked in the procession down Pennsylvania Avenue, and they jammed the square and the roofs of the adjoining houses to see the unveiling. President Franklin Pierce, the entire Cabinet, Lieutenant General Winfield B. Scott, Major General John Ellis Wool, Major General Sam Houston, and journalist Francis P. Blair were present. Stephen A. Douglas, senator from Illinois, gave the dedicatory address. Clark Mills, when asked to speak, mutely but eloquently pointed to his epochal creation as it was unveiled, being too overcome with emotion to utter a word.

This work, with its fine attention to naturalistic detail and fiery tension of pose, has about it an air of naive, almost primitive, exuberance. It is a fitting monument to the colorful military figure and president (1829–1837), who saw himself as the political heir of Jefferson, and as the protector of the individual liberties of the people of the United States against the oppression of organized monopolies. Mills cast two replicas of this statue, one for New Orleans, Louisiana, in 1856 and one for Nashville, Tennessee, near Jackson's home, The Hermitage, in 1880. In later years, the statue has been often criticized, and there have been several attempts to move it from Lafayette Park. It has been suggested it be removed to a site elsewhere in the city since all of the other statues in the park relate to the Revolutionary War. In 1917, for instance, government officials attempted to move it out of Lafayette Square but World War I intervened. In 1934, President Franklin D. Roosevelt suggested the Jackson equestrian statue be exchanged for Mills's equestrian portrait of George Washington at Washington Circle on Pennsylvania Avenue, NW. It is this writer's opinion, however, that the statue of Jackson should remain here, for it is far more pleasing aesthetically and it has remained at this location since it was first erected in 1853.

The known works of Clark Mills (1810–1883) include 4 equestrian statues and 124 portrait busts. One of Mills's last major projects was undertaken between 1875 and 1880 when he was commissioned to make plaster life masks of American Indians for the federal government. He completed masks of 64 Indians at St. Augustine, Florida, and 47 Indians near Hampton Roads, Virginia. These masks are now in the collections of the National Museum of Natural History of the Smithsonian Institution.

The success of the Jackson equestrian statue proved that bronze casting could be successfully conducted in America, that American sculptors were capable of creating realistic sculptures uninspired by the Italian masters, and that a sculptor could be successful in the United States without European training. Nothing in Mills' career ever equaled in importance his Jackson equestrian statue.

Just before Mills died in 1883 he was contemplating an enormous sculptured memorial to Abraham Lincoln, which would have included thirty-six figures and a huge pedestal four stories high. This Lincoln memorial was to have six equestrian statues of the most prominent Union generals of the Civil War around the base, portrait statues of Lincoln's cabinet members at the second level, allegorical statues of *Liberty, Justice,* and *Time* at the third level, and a seated figure of Lincoln at the summit. Mills fortunately was never able to secure funds from Congress for this project. The Lincoln memorial was to have been executed by Mills and his two sculptor sons at his nearby farm, "Meadow Bank Spa Springs," three and a half miles from downtown Washington. Today descendants of Clark Mills still reside in the city.

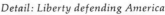

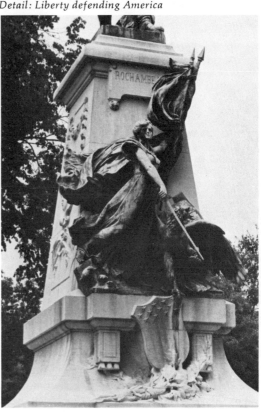

J-15

Title MAJOR GENERAL COMTE JEAN DE ROCHAMBEAU, 1902

Location Lafayette Park, southwest corner, Pennsylvania Avenue between Jackson and Madison Places, NW

Sculptor J. J. Fernand Hamar

Architect Unknown

Medium Bronze

This sculptural group memorializes the arrival of the Comte Jean Baptiste Donatien de Vineur de Rochambeau (1725–1807) in America in 1780, as the commander of the 5,500-man Royal French Expeditionary Force. A heroic bronze of the Comte de Rochambeau, atop a granite pedestal, shows him in the uniform of a major general of the Continental Army, directing his forces. He faces south, pointing decisively with his right hand, a plan of battle unfurled in his left. At his feet, on the south pedestal face, a bronze group symbolizes France coming to the aid of America. A female figure, Liberty, grasps two flags in her left hand, symbolizing the unity of France and America, while, with a drawn sword in her right hand, she prepares to defend an embattled eagle symbolizing America. She has just disembarked from a boat whose prow is visible behind her, and waves break at her feet. The group is placed on a ledgelike extension of the pedestal, enhancing its defensive posture. The eagle grasps with his right claw a shield with thirteen stars symbolizing the thirteen colonies, while with his left he fends off aggressors; a sheaf of laurel lies upon the pedestal at his feet. On the west face of the pedestal is the coat of arms of the de Rochambeau family, and on the east face, that of France. The north face bears the following dedicatory inscription, "We have been contemporaries and fellow laborers in the cause of liberty and we have lived together as brothers should do in harmonious friendship—Washington to Rochambeau, February 1, 1784." A granite plaque bearing the inscription "Rochambeau" is attached near the top of the pedestal on the south side.

The sweeping lines of the pedestal, the billowing of Liberty's garments, the breaking of the waves, the blowing of de Rochambeau's map, and the decisive gestures of the figures all produce a work of great exuberance. The feeling of action as captured by the instantaneous click of a camera shutter is imparted to these allegorical figures. The monument, surmounted by the 8-foot-high portrait statue, is a copy of one at de Rochambeau's birthplace in Vendôme, France. It was erected by Congress, dedicated by President Theodore Roosevelt, and unveiled by the Comtesse de Rochambeau on May 24, 1902, in the presence of the de Rochambeau and Lafayette families, who attended as the guests of the American people.

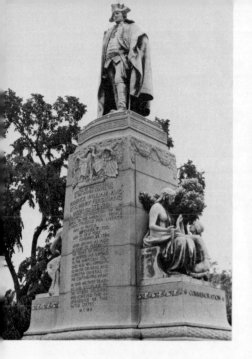

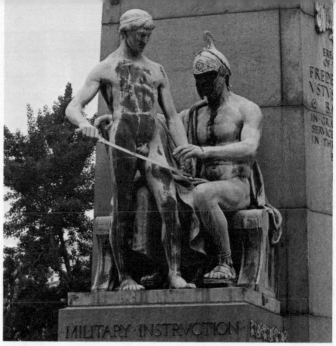

J-16
Title Major General Friedrich
Wilhelm von Steuben, 1910
Location Lafayette Park, northwest
corner, Pennsylvania Avenue
between Jackson and Madison
Places, NW
Sculptor Albert Jaegers
Architect Unknown
Medium Bronze

Baron Friedrich Wilhelm von Steuben arrived in Valley Forge, Pennsylvania, on February 23, 1778, with a letter of introduction from Benjamin Franklin. He had served as general staff officer and aide-de-camp to Frederick the Great during the Seven Years' War and possessed an invaluable knowledge of Prussian techniques of military training, organization, and administration. Though he spoke no English he was able, within a matter of weeks, to mold the raw American recruits into a force equal in training and discipline to the best British regulars—a feat which has been called "the most remarkable achievement in rapid military training in the history of the world." After his discharge from the army on March 24, 1784, he became an American citizen, and was granted 16,000 acres of land in the Mohawk country by the state of New York, plus a pension of $2,500 a year by Congress. He died November 28, 1794, leaving his New York lands to William North and Benjamin Walker, his former aides-de-camp.

This memorial portrays Steuben (1730–1794) as he inspected American troops at the great maneuvers of 1778. A heroic bronze portrait figure, 8 feet high, he is attired in the uniform of a major general of the Continental Army, heavily cloaked against the rigors of the winter at Valley Forge. He faces northwest, and the tall, massive pedestal on which he stands is embellished with low-relief carvings and applied bronze ornament. Below an American eagle, on the front face of the pedestal, an extensive memorial inscription is lettered in bronze. On the northeast face of the pedestal a bronze group, *Military Instruction*, symbolizes Steuben's contribution to the American fight for independence. A seated warrior, his face obscured by the shadows of his helmet, teaches a youth to handle a sword. On the southwest face another bronze group, *Commemoration*, symbolizes a grateful America honoring Steuben. A woman, assisted by a child, grafts his foreign stock into the tree of American national life as she recounts his heroic deeds. These nude figures are Classical in feeling. Their strong modeling creates a dramatic contrast of light and shadow which enhances their quality of timeless self-containment. On the southeast face of the pedestal, a bronze plaque in relief honors Steuben's aides-de-camp, Colonel William North and Major Benjamin Walker.

The sculptural group was dedicated by President William Howard Taft on December 7, 1910, and was unveiled by his daughter Helen. It was enthusiastically received by critics, and a replica was presented to the Emperor of Germany in partial acknowledgment of a gift by the emperor to the United States of a statue of Frederick the Great.

*Above right: detail of the
sculpture group* Military
Instruction *on the northeast face
of the monument*

J-17
Title WAR, ca. 1884
Location Old Executive Office
Building, 1700 Pennsylvania
Avenue, NW
Sculptor Richard von Ezdorf
Architect Alfred B. Mullett
Medium Iron

The first Executive Office Building, completed in time for use at the end of the Adams administration in 1800, was designed to house all the cabinet departments of the executive branch of the young federal government. No more than several hundred officials needed to be accommodated. It did not take long, however, for the government to outgrow its office space; and, in 1820, four almost identical small buildings with Neoclassical porticoes were constructed around the White House: War and Navy on the west side and State and Treasury on the east side. By tradition, after the Treasury Building had burned down twice, President Andrew Jackson, in a fit of impatience, ordered the present building to be erected in 1836.

After the Civil War, President U. S. Grant resolved that no future general should be crammed into the small quarters of the Army Department. In 1871, he ordered construction to begin on the first $1,000,000 government construction project, the Department of State, War and Navy Building, now known as the Old Executive Office Building. Construction was slow, and the pediment was not completed until 1886.

War, the north pediment of this massive Second Empire style structure contains an elaborate display of military symbolism. In the center is a medieval suit of armor; a sword runs through the center of the helmet, and on top of the helmet rests an American eagle. Behind the armor appear two United States shields, which partially obscure four Roman military symbols. On the right is a fasces, a bundle of sticks enclosing an axe, which was originally carried in front of a Roman consul thus becoming a symbol of authority. To the left of the fasces is a Roman standard, indicative of powerful legions. Left of the helmet is a battle-axe, symbol of brute strength, and left of the axe is a torch, symbol of fire and light. Jutting out from each side of the shields are draped spears under which rest cannon and cannonballs. In the left corner are laurel leaves, used by the ancient Greeks to crown their victors, while in the right corner are oak leaves, representing the strength and stability of the Republic. This pediment is about 8 feet high and 30 feet wide.

The intricate detail of the pediment is well suited to the flamboyant architectural style of the building. After War War II, the previous Departments of War and Navy merged into the Department of Defense and assumed new headquarters just across the Potomac River at the Pentagon, erected in 1942. The Department of State also moved, after the war, to a new building at Twenty-third Street, NW; and there has been constructed a new and larger Executive Office Building at Seventeenth and H Street, NW. Yet, when critics have asked to raze the old building, presidents have responded with sentimentality for this remarkable period piece. Harry Truman may have said it best in 1958, "They've been trying to tear this down for 20 years, but I don't want it torn down. I think it's the greatest monstrosity in America."

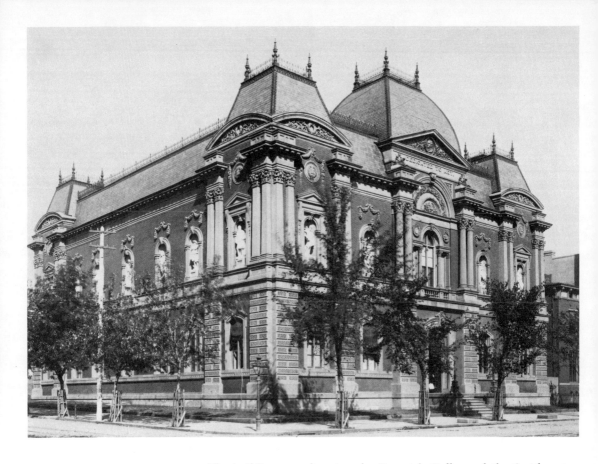

J-18

Title RENWICK GALLERY, 1884–1888

Location Pennsylvania Avenue and 17th Street, NW

Sculptor Moses Ezekiel

Architect James Renwick, Jr.

Medium Bronze, granite

Above: The Renwick Gallery, ca. 1888, at the time all of the sculptural decorations had been completed

The building now housing the Renwick Gallery of the Smithsonian Institution was erected 1859–1861 by William Wilson Corcoran (1798–1888), Washington banker and philanthropist, as an art gallery for his private collection of paintings and sculpture. The building was designed by James Renwick, Jr., the prominent New York architect who designed the original Smithsonian Building on the Mall (1847–1855) and Oak Hill Cemetery Chapel in Georgetown (1859). In New York City, Renwick became famous as the architect of Grace Church, St. Patrick's Cathedral, and many other buildings including banks and hospitals. His mansions for prosperous New Yorkers were scattered throughout Manhattan and Long Island.

Corcoran, who lived on H Street, one block northeast of the gallery, commissioned Renwick to design the building after the Second Empire style then popular in Paris. Napoleon III's new wings to the Louvre, with mansard roofs and corner pavilions, had created a sensation a few years before. Corcoran's extensive private art collection could not be moved into the building when finished, owing to the outbreak of the Civil War. The federal government seized it, first for a temporary hospital, and then as the headquarters of the Quartermaster General's Corps. Throughout the war years, Corcoran, with decided southern sympathies, stayed in Europe, collecting more art works. Finally, in 1869, the building was returned to the rightful owner, who spent five more years repairing the damage done by the military and finishing the interior rooms. Corcoran immediately established the Corcoran Gallery of Art and donated to it both the building and his extensive collection of paintings and sculpture, together with a trust fund. In 1897, the Corcoran Gallery moved to its present quarters on Seventeenth Street, adjacent to the Ellipse, and sold the original building to the federal government, for use as the United States Court of Claims. When the old building was threatened with destruction in 1965, the Smithsonian Institution requested that it be turned over to its custody for restoration as a museum of American decorative arts. After seven years of restoration work, the Smithsonian opened the new museum in January 1972 as the Renwick

Detail: medallion representing Sculpture, relief panel on the right side of the central second-floor window

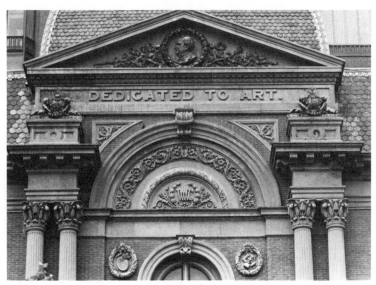

Detail: sculptural decorations at the second-floor level above the main entrance

Detail: decorative putti and cartouche below the central pediment

Gallery, named to honor the architect and to distinguish it from the present Corcoran Galley of Art, three blocks to the south.

The building faces Pennsylvania Avenue and is rectangular in shape. A major feature of this two-story structure is a set of three pavilions, one on each of the exposed corners. Above the center door on Pennsylvania Avenue is a fourth or central pavilion, larger than the others. The pavilions are crowned with French mansard roofs and capped with iron crestings. Eleven large niches, four on the Pennsylvania Avenue façade and seven on the Seventeenth Street façade, all at the second-floor level, are major features. All but two are now bare, but from 1885 to 1900 they contained 7-foot-high marble statues of "the greatest artists and sculptors of all time." In February 1974, copies of two of the original portrait statues, Murillo and Rubens, were reinstalled in two of the second-floor niches of the Seventeenth Street façade (left and right extremities, respectively). These copies are the work of Washington sculptor Renato Lucchetti. It should be noted that a pavilion was never erected on the northeast corner of the building since it was designed only to be viewed from two sides.

During the 1880s many improvements were made to the building, including the decorative sculpture on the front façade. On the second floor of the front, under the three pavilions, are recesses flanked by pairs of pilasters with foliated capitals. Other architectural sculpture devices used include wreaths of finely carved foliage, monograms of William Wilson Corcoran, a round bronze medallion profile of Corcoran on the central pediment, and the legend "Dedicated to Art," carved into the stone work. One of the most interesting features is the lion keystone, 3 feet high and 1½ feet wide, over the main door. Two groups of putti appear over the tops of the pairs of columns. Medallions representing Architecture and Sculpture were also designed by the Richmond, Virginia, sculptor, Moses Ezekiel, working in his Rome studio. The building is constructed of red brick with sandstone trim, and has a slate roof. A bronze plaque declaring the building to be a national landmark was dedicated and attached to the front fence in May 1973.

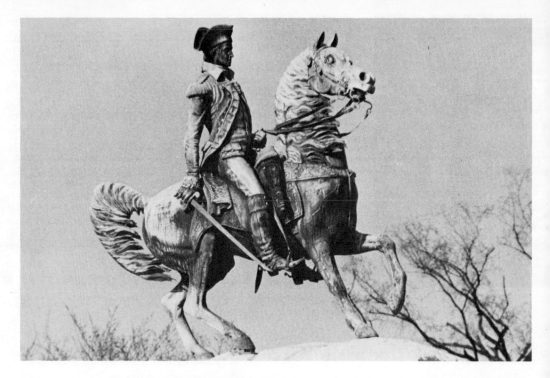

J-19
Title LIEUTENANT GENERAL
GEORGE WASHINGTON, 1860
Location Washington Circle,
Pennsylvania Avenue intersected
by New Hampshire Avenue,
23rd and K Streets, NW
Sculptor Clark Mills
Architect Clark Mills
Medium Bronze

Clark Mills has captured a tense and crucial moment in the Revolutionary War in this early bronze equestrian statue of General George Washington. After months of retreat from the superior British armies in New York and New Jersey, Washington suddenly determined to gamble what was left of the American army on a surprise attack on the British forces at Princeton and Trenton. Washington is pictured advancing in front of the American lines toward the British, with shot and cannonballs exploding all around him. His stallion is terrified at the explosions encircling them; with open nostrils and bulging eyes the stallion refuses to respond to the command of his master.

Washington, whose face here is taken from Houdon's famous bust, a copy of which has always remained at Mount Vernon, is undaunted. He calmly holds the reins as he surveys the battle with unflinching determination. Mills has accurately sculpted the serenity and dignity of Washington's temperament. Both battles, in late December of 1776 and early January of 1777, were American victories; their principal importance was in rallying the flagging morale of the American soldiers and in holding the Continental Army together.

The Continental Congress first voted to erect a statue to Washington in 1783. On several other occasions, Congress voted to build various memorials to the beloved founder of the Republic. Unfortunately, however, nothing was completed until this statue was unveiled in 1860. Congress commissioned this statue in 1853 because of the tremendous popularity of Clark Mills's equestrian statue of Andrew Jackson, unveiled in Lafayette Park the same year. At that time, plans were made to erect the Washington statue just east of the Washington Monument, which was then under construction. When it was finally unveiled at Washington Circle in 1860, it received much criticism because of the unnatural appearance of the horse and because the calm expression of Washington appeared incongruous with the terrified look of the horse. After guarding Washington Circle for over a century, this equestrian statue was temporarily moved to allow for the construction of the K Street Underpass. In 1963, Washington and his horse were released from their wooden cage and returned to a familiar, if not refurbished, home.

*Facing page: Clark Mills's original
1854 design showing elaborate
pedestal which was never
executed*

The elaborate high pedestal which Mills originally designed, with three tiers of sculptured relief panels and smaller equestrian statues of Washington's generals, was never executed because of lack of funds.

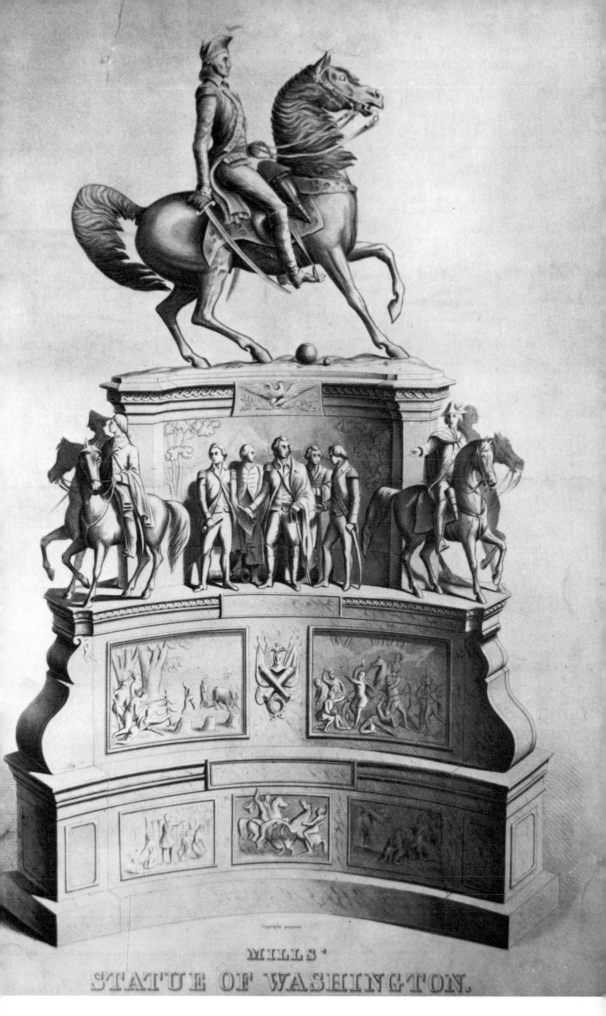

MILLS'
STATUE OF WASHINGTON.

J-20
Title SAINT STEPHEN, 1961
Location St. Stephen's Church,
Pennsylvania Avenue and
25th Street, NW
Sculptor Felix W. de Weldon
Architect Johnson and Boutin
Medium Polychrome porcelain

This polychrome statue of one of the Christian religion's early martyrs is 12 feet high. Although well designed and executed, it occupies an awkward position midway up the wall of the church façade. St. Stephen, whose story is told in Acts 6–7, is portrayed idealistically.

When the Apostles felt burdened by the large influx of converts, they chose deacons to assist them in ministering to the disciples. Stephen was selected first for this honored position. Some of the more tradition-minded Jews were offended by his "blasphemous" teachings, and brought St. Stephen to trial before the high priest. After insulting the attitudes of his judges, Stephen was sentenced to be stoned to death. Saul, later to become St. Paul, was in charge of the execution, the first of many deaths for the cause of Christ.

Pious legend holds that the resting place of St. Stephen was revealed to a priest in Palestine 400 years later. The relics supposedly were moved to Rome and placed beside those of St. Lawrence, who, it is said, moved to one side and extended a hand of welcome, thus acquiring his nickname, "The Courteous Spaniard." The two saints often appear together in Christian art. *St. Stephen,* by Vittore Carpaccio (1455–1525), and *Madonna and Child Between St. Stephen and St. Lawrence* are noted Italian Renaissance paintings from the Kress Collection, now located in the William Rockhill Nelson Gallery of Art in Kansas City.

The present church building was completed in 1961 to replace the original building on this site. The original Victorian church building, designed by Washington architect Adolph Cluss in the Byzantine style in 1866, was the only Catholic church between St. Matthew's Church in downtown Washington and Holy Trinity Church in Georgetown. The site was originally part of "Mexico," the large estate owned by the eighteenth-century Georgetown merchant, Robert Peter.

POTOMAC PARK

K

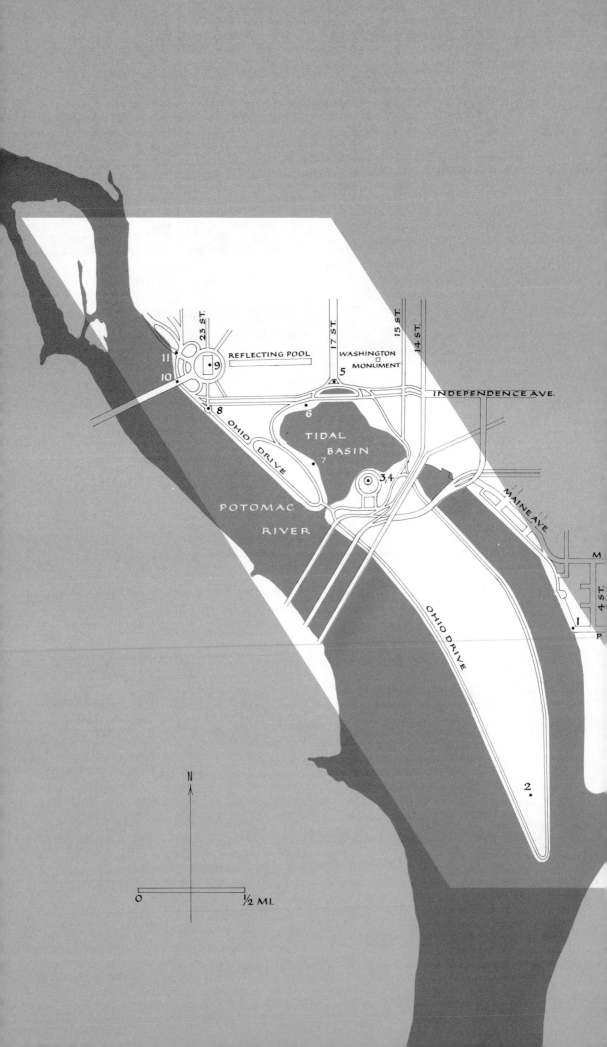

23 ST.

REFLECTING POOL

17 ST.

WASHINGTON
MONUMENT

15 ST.

14 ST.

11

9

10

5

INDEPENDENCE AVE.

8

6

OHIO DRIVE

TIDAL
BASIN

7

MAINE AVE.

POTOMAC

RIVER

3 4

M

4 ST.

1

OHIO DRIVE

P

N

2

0 1/2 MI.

EAST POTOMAC PARK AND WEST POTOMAC PARK are noteworthy in that most of this land as it exists today, encompassing the Lincoln and Jefferson Memorials, the Reflecting Pool, and the area extending to Hains Point, was part of the Potomac River until the end of the nineteenth century. The water's edge was, in fact, almost at the foot of the Washington Monument.

Potomac Park's history dates from 1882, when funds were first appropriated by Congress to dredge the river channel. The primary motivation was to make the river more navigable, but the dumping of silt on the marshlands resulted in 600 acres of new land. The area from the Washington Monument to the Watergate or entrance to the Washington Channel was designated as West Potomac Park; an island separated from the mainland by the Tidal Basin and the Washington Channel became East Potomac Park. Although dredging was completed in 1900, the area was still subject to periodic flooding until flood control measures were initiated in Franklin D. Roosevelt's administration. The Tidal Basin, which separates the parks, serves to "flush" the channel; water let in at high tide and released at low tide inhibits great accumulations of silt in the river.

Aside from its obvious aesthetic appeal, Potomac Park has seen many uses in its short career. On the northern edge of West Potomac Park, Benjamin Latrobe's tollhouse (1835) is a survival from the era when Constitution Avenue was the Washington City Canal. A century later, in 1915, the first scheduled air mail service started on a landing strip near Ohio Drive, along the river's edge. Numerous gray temporary government and military office buildings lined the Reflecting Pool from the First World War until 1971; here, in 1968, the War on Poverty's controversial "Resurrection City" was erected. Today, Potomac Park serves as perhaps the single most important recreational area in Washington. This aspect of the park is its greatest justification for both tourists and Washingtonians. Golf, rugby, polo, swimming, cricket, cycling, tennis, and jogging can all be enjoyed here. And for those less athletically inclined, it is an excellent spot for picnicking, strolling, or merely napping. During the summer of 1973, the area around the Reflecting Pool became a center of activity in the city, when the annual Festival of American Folklife, jointly sponsored by the Smithsonian Institution and the National Park Service, was held here rather than at its earlier site on The Mall.

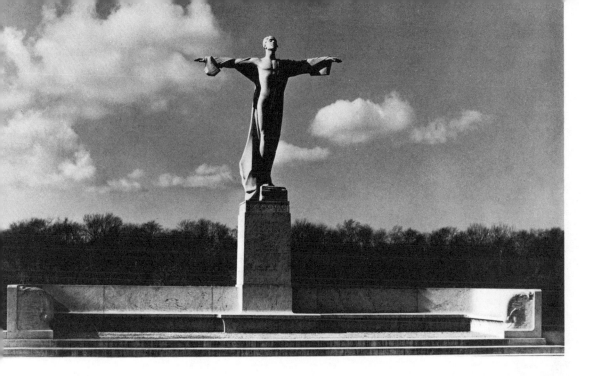

K-1

Title TITANIC MEMORIAL, 1931
Location Washington Channel
Park, 4th and P Streets, sw, across
the channel from East Potomac
Park
Sculptor
Gertrude Vanderbilt Whitney
Architect Henry Bacon
Medium Granite

The memorial to those men who died in the wreck of the *Titanic* is next to the Washington Channel, across from East Potomac Park. It consists of a figure of a partially clad male, facing east with arms outstretched. The 18-foot-high figure stands on a 6-foot-high pedestal, which in turn rests in the center of a 30-foot-long exedra designed by Henry Bacon, architect of the Lincoln Memorial.

The figure with outstretched arms, representing Self Sacrifice, takes the symbolic form of a cross, and is said to depict the last inspiration of a departing soul. This memorial was originally erected along Rock Creek Parkway near its intersection with New Hampshire Avenue. The figure and accompanying stone bench were stored briefly at Fort Washington, Maryland, in 1966, after removal for the construction of the John F. Kennedy Center for the Performing Arts, and then were re-erected here.

The sinking of the British steamship *Titanic* on April 15, 1912, is certainly one of the best remembered of all maritime disasters. The *Titanic* seemed to epitomize the luxury and confidence of the pre-World War I era. The ship, considered unsinkable, sank on its maiden voyage, only hours after striking an iceberg. Over 1,500 persons died, including a quarter of all the children, half of all the women and over three quarters of all the men on board. John Jacob Astor, Benjamin Guggenheim, Isadore Strauss, all of New York; Mrs. J. J. Brown of Denver; and numerous other American and British millionaires were among the first-class passengers, in addition to hundreds of immigrants. The ship carried lifeboats for only half its passengers, and some of those were nearly empty as they left the ship. Hundreds of the male passengers gave up their places in the lifeboats that the women might live.

The sculptor, Mrs. Whitney, executed several small bronze sketches and models before arriving at the final design for the present *Titanic Memorial*. One of these early sculptures that has survived is located today on the grave site of Mrs. Eugene Bowie Roberts, a relative of Mrs. Whitney, in Holy Trinity Cemetery, in nearby Collington, Maryland. The 2-foot-high figure is very similar to the final memorial, except that the male figure here is completely nude, with the drapery flowing over his shoulders behind him to the ground. This miniature work is signed on the base, "Gertrude V. Whitney 1915." The sculptor shortly thereafter lost her own brother, Alfred Gwynne Vanderbilt, who went down on the *Lusitania* when it was sunk by a German submarine on May 7, 1915.

Early bronze study by Gertrude Vanderbilt Whitney for the Titanic Memorial in 1915

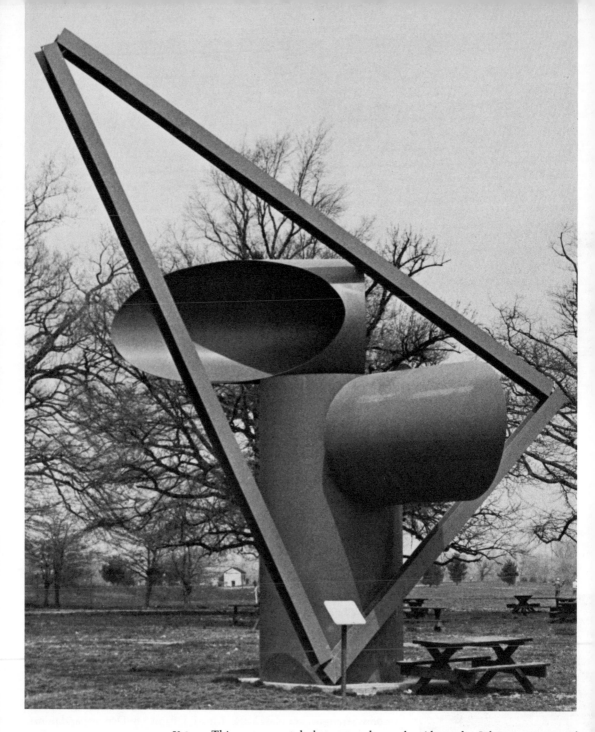

K-2
Title ADAM, 1969
Location East Potomac Park,
south end
Sculptor Alexander Liberman
Architect None
Medium Painted steel

This monumental abstract sculpture by Alexander Liberman is one of the few modern works of outdoor sculpture in southwest Washington. It was formerly on exhibit in front of the Corcoran Gallery of Art Building on Seventeenth Street, but now occupies a somewhat less competitive position in East Potomac Park.

The sculpture consists of an upright cylinder on top of which is a horizontal, hollow, diagonally cut cylinder; a third cylinder, similar to the second, juts out at a right angle from the top of the first and goes through a large triangle, which stands on its apex. The triangle gives the sculpture a soaring effect, or in the sculptor's words, "the triangle form, inverted, open, rising . . . implies, abstractly, elevation of the spirit into realms rendered immaterial."

The sculpture is painted red and measures 28 feet in height and 24 feet in length. It was constructed in 1969, as was another piece by Liberman in the same genre, entitled *Eve*. A 1970 exhibition of Liberman's works at the Corcoran Gallery of Art included these and other pieces of sculpture, as well as a number of his paintings.

K-3
Title Thomas Jefferson, 1943
Location Jefferson Memorial,
Tidal Basin, East Potomac Park,
adjacent to East Basin Drive and
14th Street, sw
Sculptor Rudulph Evans
Architects John Russell Pope,
Otto R. Eggers, and Daniel P.
Higgins
Medium Bronze

The memorial to Thomas Jefferson, third president of the United States and drafter of the Declaration of Independence, is the most recent of the three great monuments to American presidents to be erected in Washington, D.C., following the Washington Monument and the Lincoln Memorial. The building is circular in design with an entrance portico, Ionic colonnade, and a low dome. It is an adaptation of the Pantheon in Rome; and Jefferson, an accomplished architect, used the same form in his design for the Rotunda at the University of Virginia, in Charlottesville. Jefferson was responsible in part for the plan of Washington as it appears today, and it is fitting that this memorial should complete Pierre L'Enfant's five-point plan for the city, although the actual site of Jefferson's memorial was under water until the Potomac River was dredged 1882–1900. It is due primarily to the efforts of President Franklin D. Roosevelt that this monument was built.

The interior of the memorial contains four panels of famous Jefferson quotations; a fifth is found at the base of the dome. The first panel is a quotation from the Declaration of Independence, and it is the most important of the four principal panels on the walls. These words were written in 1776 but were misquoted in 1943. In 1972, Professor Frank W. Fetter of Northwestern University first brought this matter to the attention of the Department of the Interior. The words, it turns out, were carefully and deliberately placed inaccurately on the walls of the Jefferson Memorial for reasons of space, at the request of the architects

Workmen move the plaster statue in place in the Jefferson Memorial in 1943. Shortly after World War II, this plaster statue was replaced by the present bronze

of the building. The punctuation also has been slightly altered. Two words were misspelled and five were omitted from the quotation. This quotation is, in fact, a blending of Jefferson's first draft and the final version of the Declaration of Independence. The second panel is a quotation from the Act for Religious Freedom passed by the Virginia Assembly in 1779 and written by Thomas Jefferson. The third panel concerns slavery and education, and is composed of six separate quotations taken from Jefferson's *Summary View,* his *Notes on Virginia,* two letters written in 1786, and a paragraph written at the age of seventy-seven and found among his papers at his death. The fourth panel shows Jefferson's vision regarding the evolvement of the Constitution and other aspects of government. It was taken directly from a 3,000-word letter he wrote to Samuel Kercheval in 1816, in answer to a request for Jefferson's views on some important issues then before the new Republic. The quotation on the upper walls at the base of the dome came from a letter Jefferson wrote to Benjamin Rush in Philadelphia in 1800: "I have sworn upon the altar of God eternal hostility against every form of tyranny over the mind of man."

The focal point of the interior of this open-air memorial is the centrally located statue of Jefferson by Rudulph Evans. In 1938, 100 sculptors submitted designs, and Evans's was chosen by the Jefferson Memorial Commission. A full-scale plaster model was erected in time for the April 1943 dedication of the memorial, which coincided with the two hundredth anniversary of Jefferson's birth. A permanent bronze cast replaced the plaster one after the World War II restriction on metals was lifted.

The 19-foot high portrait statue, standing on a 6-foot-high bronze-colored marble base, portrays Jefferson in middle age. Evans scrutinized all known portraits and busts of Jefferson, and his own sculpture is a sympathetic mixture of these. His statue is "vigorous but not restless." He wears knee breeches, a waistcoat, and a long fur-collared coat, also shown in the Rembrandt Peale oil portrait. His hands are dropped at his side, and he clutches in his left hand a rolled paper—the Declaration of Independence. Jefferson's expression is one of sensitivity and determination, not unlike that in the Houdon portrait statue.

K-4
Title THE DRAFTING OF THE
DECLARATION OF INDEPENDENCE,
1943
Location Jefferson Memorial,
Tidal Basin, East Potomac Park,
adjacent to the East Basin Drive
and 14th Street, sw
Sculptor Adolph Alexander
Weinman
Architects John Russell Pope,
Otto R. Eggers, and Daniel P.
Higgins
Medium Marble

This sculpted marble pediment, located above the north entrance portico facing the Tidal Basin, is seldom noticed by the thousands who visit the Jefferson Memorial annually. It depicts Jefferson standing before the four other men appointed by the Continental Congress to assist him in writing the Declaration of Independence. Seated on the left are Benjamin Franklin and John Adams; on the right are Roger Sherman and Robert Livingston. The pediment measures approximately 10 feet in height by 65 feet in length.

A formal resolution for the independence of the "United Colonies" from Great Britain was submitted before the Continental Congress in Philadelphia by Richard Henry Lee, delegate from Virginia, on June 7, 1776. This resolution was approved by voice vote on July 2, 1776. In the meantime, on June 11, 1776, the Continental Congress, meeting in closed session, appointed the five-man committee to prepare a written declaration stating the case for independence. On June 28, 1776, the committee submitted the draft to the Congress, which, after various changes were made during three days of debate, approved it on July 4, 1776. This document, which had several early titles, such as "A Declaration by the Representatives of the United States of America, in General Congress Assembled," eventually became known as the Declaration of Independence. It should be noted that the Declaration of Independence was written, not to declare independence, which had been officially done on July 2nd, but to state to the world the justification for so doing. The last paragraph of the document, however, was amended to incorporate the resolution approved on July 2nd.

The five-man committee chose Jefferson and Adams as a subcommittee to draft the Declaration. Jefferson, with the encouragement of Adams, wrote the first draft of the document alone. Jefferson then submitted his draft to Franklin and Adams, who made a number of changes which were incorporated into the final document. Sherman and Livingston merely approved the draft before it was submitted to Congress.

The Declaration of Independence as approved was considerably different from the first draft written by Jefferson. Grammatical changes were made to improve the literary style, while paragraphs, such as those attacking the slave trade, were removed in order not to offend the south-

ern states. Other phrases were added to please various states. Congress debated the wording of the draft for three days and approved it, with amendments, on July 4th.

It was signed by John Hancock, president, and Charles Thomson, secretary, of the Continental Congress on July 4th, and was printed that night in John Dunlay's printing shop in Philadelphia. On July 5th, copies were dispatched to the Continental Army, the various state legislatures, and the Committees of Public Safety. The news took up to four weeks to reach the thirteen states, being celebrated in Savannah, for example, in early August. The signatures of President John Hancock and the other fifty-five delegates were not placed on the document on the same day, but rather over a period of several months, since numerous delegates were absent when the parchment copy was completed.

The Declaration was moved to a number of cities in the eighteenth century, because of the danger of British troops during the Revolution and because of the change in the location of the national capital afterwards. In 1814, it was moved from Washington, D.C., to Leesburg, Virginia, for safety from the British invasion of the capital during the War of 1812. The document was damaged during the nineteenth century, because it was frequently rolled and unrolled and because it was exposed to direct sunlight after it was framed, thereby causing most of the signatures to fade. In 1921 it was moved by a mail truck from the Department of State to the Library of Congress, where it remained in the office of the librarian, stored in a safe, until an especially designed display case was completed and dedicated by President Calvin Coolidge in 1924. In late December 1941, both the Declaration of Independence and the Constitution were taken by train to Fort Knox, Kentucky, for storage in the gold vaults during World War II, when it was thought that Washington was a possible air raid target. In October 1944, both documents were returned to their exhibit cases in the Library of Congress. With great ceremony, in December 1952 these documents were moved from the Library of Congress for permanent keeping in the National Archives Building, where they can be viewed today by the public. Visitors to Washington will also want to inspect the enormous painting *The Signing of the Declaration of Independence*, by John Trumbull, in the Rotunda of the U.S. Capitol, and a mural *The Signing of the Declaration of Independence*, by Barry Faulkner, in the great semicircular hall of the National Archives building.

Title COMMODORE JOHN PAUL
JONES, 1912
Location West Potomac Park,
17th Street and Independence
Avenue, sw
Sculptor Charles Henry Niehaus
Architect Thomas Hastings
Medium Bronze and marble

*Detail: relief panel on the rear of
the pedestal showing Jones
raising the American flag on his
man-of-war*

In 1905, the grave of the flamboyant Revolutionary War naval hero, Commodore John Paul Jones, was discovered in an obscure cemetery in Paris. His remains, perfectly preserved in a barrel of rum, were returned to the United States with great fanfare and reinterred at the United States Naval Academy, in Annapolis, Maryland. The following year, Congress appropriated $50,000 for a monument to Jones, which was completed in 1912. The memorial consists of a bronze statue mounted against a large marble pylon. The pedestal contains water spouts for fountains on the sides, and the water exits from the mouths of dolphins. The portrait statue depicts Jones in the period dress for naval officers, his left hand is on the pommel of his sword, his right hand clenched in sympathy with his taut lips, and his gaze seemingly fixed on the enemy. The pylon is decorated with a series of military symbols, and in the rear is a relief showing Jones hoisting the American flag on a United States man-of-war, following the tradition that he was the first to raise the new flag on a war vessel. Over the relief are his words: "Surrender? I have not yet begun to fight!"

John Paul, who later added the surname Jones, was born in Scotland in 1747. He joined the newly formed United States Navy in 1775. After an extraordinary career in the American military service, he accepted an appointment as a rear admiral in the Russian Navy. He died in poverty in Paris in 1792.

Title JAPANESE LANTERN, ca. 1651
(erected in Washington, 1954)
Location West Potomac Park,
intersection of Independence
Avenue and West Basin Drive, sw
Sculptor Unknown
Architect None
Medium Granite

This seventeenth-century stone lantern is one of the oldest of all outdoor sculptures in Washington. It stood for 300 years on the grounds of a temple in Ueno Park in Tokyo, where its twin remains; appropriately, the Tokyo park from which it came is also famous for its cherry blossoms. The lantern was given to the people of the United States by the governor of Tokyo as a token of Japanese-American understanding. The dedication ceremony, in 1954, took place on the 100th anniversary of the opening of American trade relations with Japan by Commodore Matthew Perry.

The lantern is placed by the Tidal Basin between two of the original cherry trees, which were planted in 1912 by Mrs. William Howard Taft, wife of the United States president, and the Viscountess Chinda, wife of the Japanese ambassador. The lighting of this lantern is part of the annual cherry blossom festivities which have been held since long before World War II.

The hexagonal lantern is about 10 feet tall, and consists of a small base, on top of which rests a circular pillar. The lantern section is above the pillar and contains six small windows. Six scroll-like ornaments and a small sphere are on top, and the lantern contains much decorative carving. It was made in 1651 to commemorate the death of an apparently tyrannical Shogun, or military lord, by the name of Tokugama Iemitsu, who attempted to drive all Christians from Japan. The Japanese embassy, however, assures those interested that the significance of the lantern is in its antiquity rather than in the overlord it commemorates.

Symbolism plays an important part in the design of *Japanese Lantern*. The stone lantern is thought to have originated in India thousands of years ago, where it was considered a fertility symbol. The design was then transported to China, where it was used in old Buddhist ceme-

teries as a five-part monument. A cube formed the base, on which was placed a cylinder-shaped stone, then a sphere, a truncated pyramid, and finally a pointed ball surmounted the entire sculpture. These five parts, according to Chinese philosophy, symbolize the five elements which make up the universe: earth, water, fire, air, and ether. Actually, the picturesque architecture of the Chinese pagodas was derived from the design of the stone lantern. Eventually, the spherical section of the monument was hollowed out to hold a candle, forming a sculptured lantern. About A.D. 1500, the stone lantern was incorporated into Japanese culture, when it was first used extensively to light the path to the tea ceremonial. At that time, the Japanese tea ceremony was frequently held at night. The gardens were then illuminated by glaring fires lit in hanging iron baskets, which were not appropriate for the quiet charm of the gardens. As soon as it was introduced the stone lantern quickly replaced this earlier form of garden lighting.

K-7
Title JAPANESE PAGODA, ca. 1600
(erected in Washington, 1958)
Location West Potomac Park,
Tidal Basin, near intersection of
Ohio and West Basin Drives, SW
Sculptor Unknown
Architect None
Medium Granite

The *Japanese Pagoda* was given to the City of Washington in 1957 by the mayor of Yokohama. When the ancient sculpture arrived, Washington officials found themselves in a rather awkward situation. The 3,800 pounds of granite were packed in five crates, but, unfortunately, no instructions for reassembling the nine-tiered structure were included. Eventually, with help from the staff of the Library of Congress and elsewhere, reconstruction was accomplished and the pagoda was placed near the Tidal Basin.

The stone pagoda is of the type sometimes found in the mountains or along the ancient roads of Japan. Often it is commemorative, with an inscription explaining the circumstances under which it was raised. In this instance, the four seated Buddhas on the faces of the base are the principal ornamentation.

A Japanese official and representatives of the Department of the Interior dedicate the Japanese Pagoda in 1958

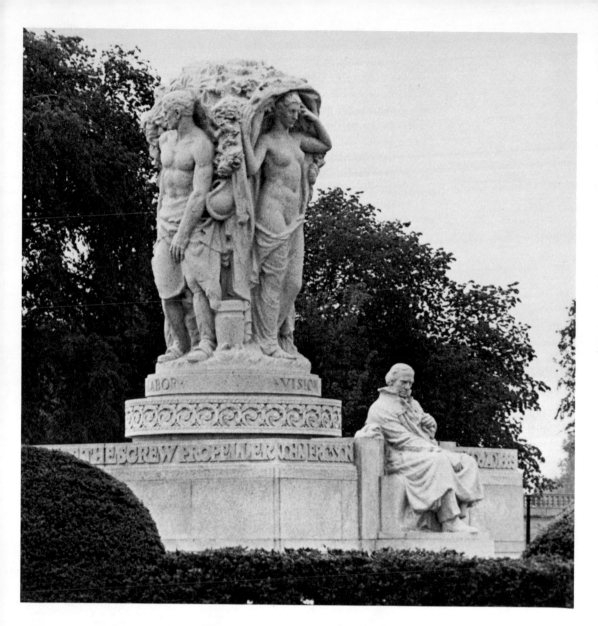

K-8

Title JOHN ERICSSON MONUMENT,
1926

Location West Potomac Park,
Independence Avenue and Ohio
Drive, sw

Sculptor James Earle Fraser

Architect Albert Ross

Medium Granite

This granite memorial to the Swedish-American inventor, John Ericsson, was dedicated in 1926 by President Calvin Coolidge and the subsequent King Gustavus VI, then crown prince of Sweden, and was financed primarily by Americans of Scandinavian descent. Ericsson is shown seated in the foreground. Three allegorical figures, Vision (an inspired woman), Adventure (a Viking), and Labor (an iron molder), represent the characteristics which made him a great inventor. They stand boldly against the Norse Tree of Life as the focal point of the monument. The granite pavement surrounding the statue has the inlaid form of a mariner's compass. The following inscription is located on the four sides of the pedestal: "John Ericsson A.D. 1803–A.D. 1889; Inventor and Builder Of The Monitor; He Revolutionized Navigation By His Invention Of The Screw Propellor."

Contrary to the inscription, Ericsson can be credited with the perfection rather than the invention of the screw propellor. There is little doubt, however, about Ericsson's designing the Union's ironclad ship, *Monitor*, which figured in the most famous Civil War naval encounter. An eyewitness to the battle stepped out of the crowd on the morning of the 1926 dedication, introduced himself to the sculptor, and explained that, as a Union officer, he had been present in March 1862, at Hampton Roads, Virginia, during the historic fight between Ericsson's victorious Union *Monitor* and the Confederate *Merrimac*. The eyewitness was Supreme Court Justice Oliver Wendell Holmes (1841–1935).

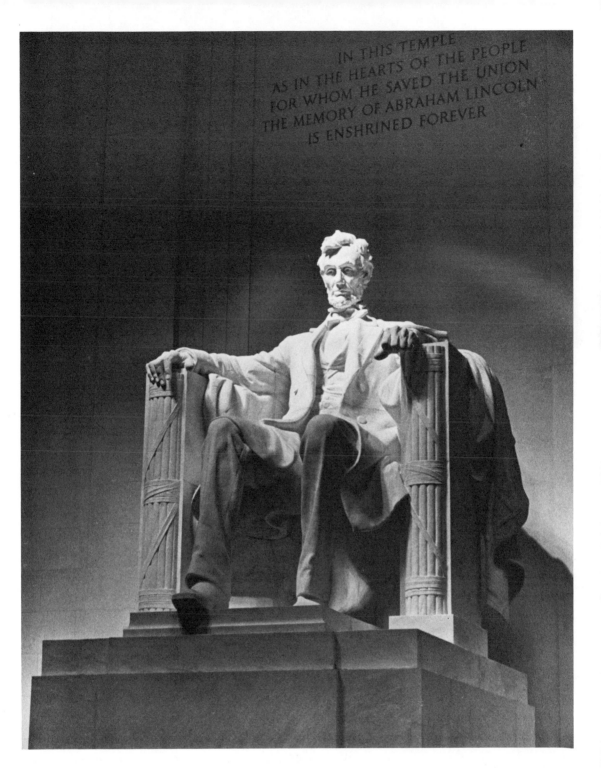

IN THIS TEMPLE
AS IN THE HEARTS OF THE PEOPLE
FOR WHOM HE SAVED THE UNION
THE MEMORY OF ABRAHAM LINCOLN·
IS ENSHRINED FOREVER

K-9
Title LINCOLN MEMORIAL, 1922
Location West Potomac Park,
adjacent to Arlington Memorial
Bridge
Sculptors Daniel Chester French
(statue); Ernest C. Bairstow
(stonework)
Architect Henry Bacon
Medium Marble

Daniel Chester French's statue of Abraham Lincoln is possibly the world's best known sculpture by any American artist. Begun in 1915 and dedicated in 1922, the building which encloses the sculpture is in the form of a Greek temple, but with openings in the sides rather than the ends. The memorial is surrounded by a colonnade of thirty-eight fluted Doric columns, which tilt inward somewhat to give the edifice an increased feeling of height. The top frieze contains the names of the forty-eight states which existed at the time of the dedication of the memorial; the thirty-six states listed above the colonnade are those which existed at the time of Lincoln's death in 1865. A series of Classical details, including swags, wreaths, and eagles, embellish the attic level of the building. The two urns in front and the statue of Lincoln were carved by the Piccirilli Brothers in New York.

The site, considered quite isolated at the time of the monument's in-

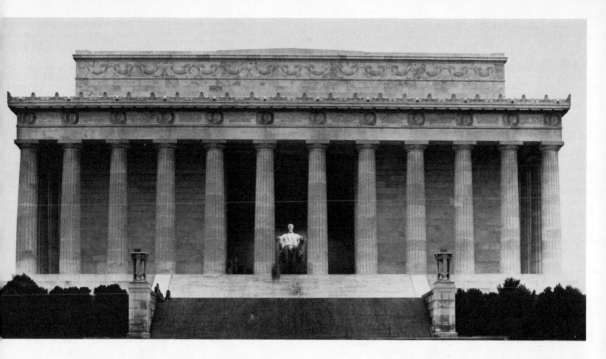

ception, is in a key position today at the west end of the Mall. Terraces surrounding the memorial were built at the same time as the building itself. The Reflecting Pool was also constructed at this time, to enhance the majesty of the building. A drive 760 feet in diameter encircles the monument.

The interior is divided into three sections by 50-foot-high Ionic columns, the center section containing the statue by French. The chambers on each side contain murals by Jules Guerin; on the left wall Lincoln's Gettysburg Address is inscribed, and on the right his Second Inaugural Address appears.

Lincoln's statue, made from twenty-eight identical blocks of Georgia marble, took four years to complete. In its size, dynamism, and clarity, the figure is awe-inspiring. Lincoln is seated in an architectural throne chair with fasces posts, which in turn is placed on a 10-foot marble pedestal. His pose is said to be one of both relaxation and solidity. His coat is unbuttoned; his hands are at rest on the arms of the chair; his facial expression seems to be one of vibrant contemplation. On the wall behind Lincoln the following inscription appears: "In this Temple, as in the hearts of the people, for whom he saved the union, the memory of Abraham Lincoln is enshrined forever."

Such a memorial will mean many things to different people. The sculptor articulates his own sentiments as follows: "The memorial tells you just what manner of man you are come to pay homage to; his simplicity, his grandeur and his power." Abraham Lincoln, sixteenth President of the United States, is remembered by all as the martyred giant whose sense of justice, tact, and competence led the Union during the devastating Civil War years.

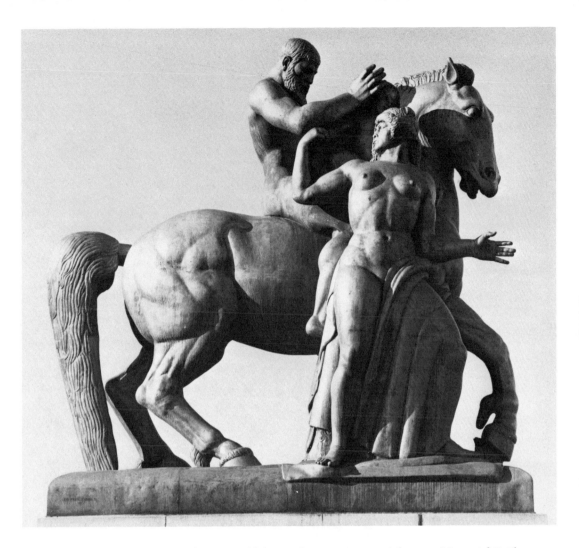

K-10

Title THE ARTS OF WAR, 1951
Location West Potomac Park,
Lincoln Memorial Circle, sw,
entrance to Arlington Memorial
Bridge
Sculptor Leo Friedlander
Architect McKim, Mead, and
White
Medium Gilded bronze

The Arts of War at the entrance to Arlington Memorial Bridge was commissioned at the same time as *The Arts of Peace* nearby, at the entrance to Rock Creek Parkway. Each work consists of a pair of equestrian statues. Designed by Leo Friedlander, *The Arts of War* portrays Valor on the left and Sacrifice on the right. The two buoyant steeds, with their male riders, symbolize the defensive power of the Nation. Valor is represented by a female carrying a shield and walking with a determined stride, symbolic of the indomitable spirit of the American citizen. Sacrifice, a standing female, symbolizes Mother Earth; while Mars, the rider, denotes the Nation's manpower.

The Arts of War and *The Arts of Peace*, while among the most memorable of all Washington statuary, have nonetheless had uncertain futures at various times. Although the sculptors were commissioned in 1925, their designs were not approved until 1933, and the choice of materials fluctuated with the funds available. By World War II, it was questionable as to whether they would be built at all; lack of funds, shortage of bronze, prior commitments by the sculptors, and limited foundry facilities made their futures doubtful. In 1949, however, the Italian government offered to complete the project by casting the statues in bronze and gilding them. The groups were finally dedicated in 1951 and were extensively restored in 1971.

The massive statues have also caused some controversy. The striking gold-leaf surfaces were thought to overpower the more staid Lincoln Memorial. However, many residents have become fond of them. A *Washington Post* editorial described the huge horses as "a credit to any stable. . . . Not the least of the practical merits of these indestructible behemoths is their service to navigation . . . the glittering giants are unbeatable as lighthouses."

Title THE ARTS OF PEACE, 1951
Location West Potomac Park,
Lincoln Memorial Circle, sw,
entrance to Rock Creek Parkway
Sculptor James Earle Fraser
Architect McKim, Mead, and
White
Medium Gilded bronze

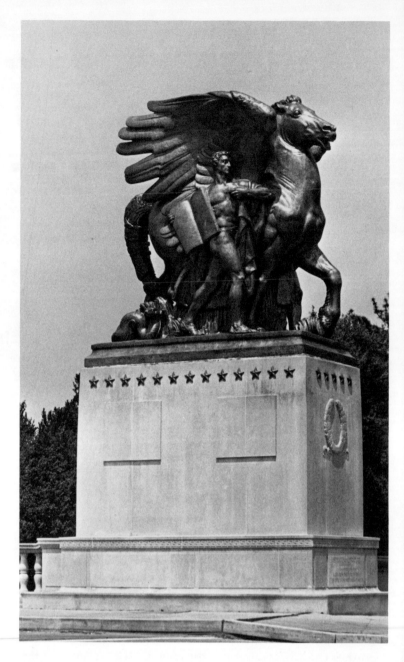

The *Arts of Peace* consists of a pair of heroic bronze statues fronting
the entrance to Rock Creek Parkway. They were designed in 1925 by
the gifted and prolific sculptor, James Earle Fraser, but the statues were
not erected until 1951. The 17-foot statues rest on rather severe pedes-
tals, each decorated with thirty-six stars to represent the number of
states at the close of the Civil War. The Classical wreaths at the front
of each pedestal were executed by a local stonecarver, V. Tonelli. The
statues were cast in 1949 in Italy and were gilded by the now rare
"mercury gilding" process, as a gift of the Italian government to the
United States to symbolize understanding between the two countries.

The Neoclassical statue on the left, entitled *Music and Harvest*, con-
sists of three parts, male and female figures and winged horse. Harvest
on the left is represented by the man with a bundle of wheat; Music on
the right is depicted by a woman holding a harp. The statue on the right
of the entrance to the Parkway is entitled *Aspiration and Literature*. A
male to the right of the horse portrays Literature holding an open book,
while his companion, Aspiration, on the left of the horse, carries a bow.
The winged horses on the statues symbolize the ancient god of poetry,
Pegasus. This pair of statues by Fraser is a companion to the nearby
Neoclassical pair by Leo Friedlander.

SIXTEENTH STREET

L

SELDOM CAN THE DEVELOPMENT of an entire neighborhood be determined by a single individual, but the history of Sixteenth Street cannot be told without telling something of Mrs. John Brooks Henderson, widow of a senator from Missouri, who controlled the destiny of this once fashionable boulevard from the 1880s until her death at the age of ninety in 1935.

Mrs. Henderson was Washington's reigning dowager for many years. An exceedingly strong-willed woman, she espoused causes with great vigor throughout her long life. She was a vegetarian and prohibitionist; in fact, she held a bottle-breaking ceremony shortly after her husband's death in which hundreds of bottles of the "poison stimulant" from his wine cellars were smashed on the curb. Mrs. Henderson was an energetic woman, sawing wood for exercise when she was eighty-five. This society matron entertained extensively, campaigned against short skirts, and was, at times, influential in Congress. But her single greatest effort was to make Sixteenth Street the most splendid boulevard in Washington.

Senator and Mrs. Henderson moved to Sixteenth Street in 1888, when it was still considered very rural. They bought large tracts of land there, and Mrs. Henderson promptly built a Romanesque castle for herself. Not satisfied with that, she spent the rest of her life building villas, manors, chateaux, and castles on Sixteenth Street. She designated many of these as embassies, and they were accepted as such; she even toyed with the idea of building a replacement for the decaying White House on the site that later became Meridian Hill Park. Mrs. Henderson tried to give the government one of her mansions as an official residence for the vice president. Her only grandchild questioned this generosity and was promptly disowned.

The street's rather pedestrian name was a source of irritation to Mrs. Henderson, and, in 1912, she succeeded in coaxing Congress to change it to the Avenue of the Presidents, since the street terminated at the White House. Senator Henry Cabot Lodge said the new title was "pompous, ostentatious, affected" and an "unnatural way to entitle a street in the American capital." Other members of Congress and residents of the street also objected, and the original name was restored one year later.

From the turn of the century until World War II, Sixteenth Street was indeed a grand avenue, lined with churches, embassies, and mansions, with few office buildings or apartment houses. After Mrs. Henderson's death, however, her executor stated his intention to "make as much money as possible out of the Henderson property." Zoning laws were changed, and the road was widened in many places. Apartments and commercial buildings have replaced older structures, and many embassies have abandoned their former quarters; however, handsome statues that line the street, including those in Meridian Hill Park, testify to the street's former elegance. Only the stone walls and gates survive after the Henderson mansion was razed in 1950.

Title American Legion Soldier, 1951
Location American Legion Building, 1608 K Street, NW
Sculptor Adolph G. Wolters
Architects Britsch and Munger; Kuehne, Brooks and Barr
Medium Limestone

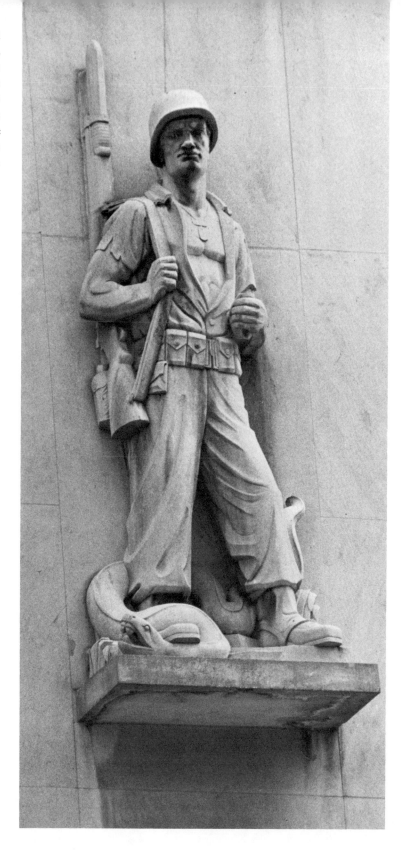

The American Legion, an organization of American military veterans, was incorporated by an act of Congress on September 16, 1919. It is the largest group of its kind in the world, having 2,700,000 members in 58 departments, and having 16,000 posts throughout the United States and its possessions and in six foreign countries. Headquarters groups are located in Indianapolis, Indiana, and Washington, D.C. The legionnaires, with a powerful lobby in Washington, devote themselves to the rehabilitation of disabled veterans, the welfare of prisoners of war and the widows and orphans of veterans, the problems of American chil-

dren, the support of military programs deemed essential to national security, and pro-American activities ranging from Legion baseball tournaments to the work of the F.B.I.

This statue, 13 feet tall, placed on the façade of the Washington national headquarters 40 feet above the street, memorializes the American veteran. It is conceived as a composite of the World War I doughboy and the World War II GI. The model was Lieutenant Hulon P. Whittington, who was awarded the Medal of Honor in World War II. The powerful figure is portrayed in readiness for battle, helmeted, with rifle slung over his shoulder, and dog tags dangling on his bared chest. His expression is one of grim determination. He crushes a snake, symbolic of the Nation's enemies, into the rocks beneath his feet.

Lieutenant Whittington, a native of Louisiana, was awarded the Medal of Honor for action near Grimesnil, France, on July 22, 1944, while serving as a sergeant in the United States Army 44th Armored Infantry, 2nd Armored Division. When a platoon leader and sergeant from his organization were reported missing in action, Sergeant Whittington took command and reorganized the defense of his men, crawling under fire to check the positions of his troops. When the advancing German forces attempted to penetrate the roadblock his men had erected, he completely disregarded enemy action, mounted an American tank, and directed fire at the leading enemy tank. After blowing up the first tank, which blocked the German armed column, Whittington led a bayonet attack. When his first aid man became seriously wounded, the sergeant himself administered first aid to his men while under fire.

The entire façade of the building is conceived as a sculptural entity, becoming a huge monument to the men of the American Legion. The wall is faced with 6-foot-square panels of precast concrete. These form a neutral background against which a format including the lettering "The American Legion" and "For God and Country," the Legion insignia in bronze, and the statue itself are organized. President Harry S Truman was present at the dedication of the building on August 14, 1951. The statue was carved in ninety days by Frank Bowden of Indiana limestone, quarried at Bedford, Indiana, in sculptor Adolph G. Wolters's studio in Indianapolis. The American Legion first established a Washington headquarters in 1934 in a large Victorian house on this site. The mansion was razed in 1949 to make way for the construction of this seven-story office building.

Title AMERICAN WILDLIFE, 1960
Location National Wildlife
Federation, 1412 16th Street, NW
Sculptor Lumen Martin Winter
Architect Harry Barrett
Medium Marble and mosaic

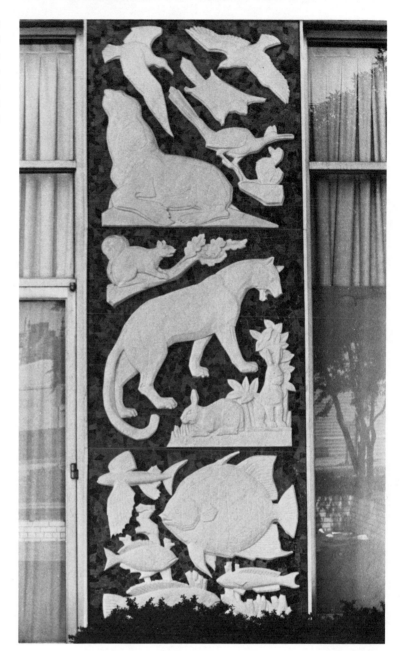

This panel illustrates American wildlife found in California, Hawaii, and Nevada. The top section includes a California gull, red-shouldered hawk, flying squirrel, road runner, and sea lion. The central panel portrays a gray squirrel, mountain lion, and brush rabbits. The bottom section shows a California flying fish, spadefish, sea perch, rainbow parrot fish, bluehead fish, and wrasse

Thirteen panels depicting wildlife indigenous to the United States are found on the Sixteenth Street façade of the National Wildlife Federation building. The bas-relief figures are carved from a single block of white Carrara marble; they are placed against a background of Venetian glass in seven shades and fifteen tones of blue. The effect is striking and reminds one of elephantine cameos.

Each panel is 4 feet wide and 12 feet high. A total of 176 wildlife figures are depicted. The authenticity of each figure was verified by naturalist Roger Tory Peterson; and, since each of the panels was to be indicative of the wildlife of one ecological area of the United States, the animals, birds, reptiles, and fish were segregated into the thirteen different geographical categories. Virtually all types of American wildlife are represented here. One finds otters and ferrets, caribou and woodchucks, pigfish and snooks.

The National Wildlife Federation was founded in 1936 and became "the largest conservation group in the world." Its headquarters, built in 1960, were dedicated by President John Fitzgerald Kennedy the following year. The building itself does not seem especially imaginative, and its blue and white panels are one of the few features which add interest to the main façade.

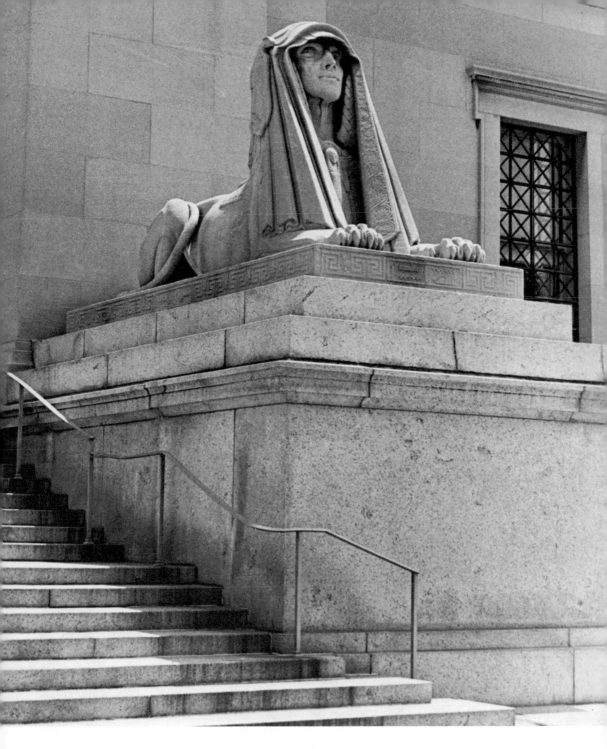

L-3

Title MASONIC SPHINXES, 1915
Location Scottish Rite
Freemasons' Temple, 16th Street
and S Street, NW
Sculptor Adolph Alexander
Weinman
Architect John Russell Pope
Medium Limestone

Beside the upper flight of stairs in the building known officially as the House of the Temple, Scottish Rite Freemasons, Southern Jurisdiction, are two sphinxes, each carved out of a solid piece of limestone. The one on the right is Wisdom, with eyes half closed and face expressing contemplation and repose. The sphinx on the left, Power, is symbolized with wide eyes and a face whose cheeks and chin suggest determination and activity. Each *Masonic Sphinx* is about 7 feet tall and 5 feet wide.

The sphinx has traditionally represented royalty, symbolizing the strength and protection of ancient rulers. The oldest surviving example, erected ca. 2,550 B.C., is found near Giza, Egypt, on the west bank of the Nile River near Cairo. The design later spread to China, Mesopotamia, and Greece, first appearing in the latter civilization about 1,600 B.C. According to ancient Egyptian mythology, the sphinx was the offspring of two giants. The sphinx would devour all those who could not answer the riddle taught to her by the Muses: what animal comes into the world

four-footed, becomes two-footed in maturity and in old age becomes three-footed. The answer was a man, for he crawls in infancy, stands erect when mature, and uses a cane in old age. From this connection of the riddle with the sphinx evolved the legend of the omniscient wisdom of this mythological creature.

On the plinths, or bases of these figures, are inscriptions in Phoenician characters and Egyptian hieroglyphics. The Phoenician characters are the names of the columns which stood in front of Solomon's Temple. The Egyptian hieroglyphics signify Wisdom and Power, and the quotation, "He hath established it in strength."

The building adorned by these sphinxes was designed after the ancient tomb erected to King Mausolus in 350 B.C. at Halicarnassus, now Bodrum, Turkey. The word "mausoleum" was derived from this ancient wonder of the world, which was destroyed by an earthquake in the twelfth century. The frieze from the ancient tomb is now in the British Museum. The Masonic temple's many interior Neoclassical designs, mostly available to public view, include furniture, friezes, lighting fixtures, and panels. The marble seats in the atrium, for example, are copies of the seats in the Theater of Dionysius, at the Acropolis in Athens, Greece. The panels in the banquet hall are imitations of those found in the ruins of Pompeii, Italy. The crypt contains the bodies of Albert Pike (1809–1891) and John Henry Cowles (1863–1954), two revered commanders of the Freemasons; the museum contains the original plaster model for the Albert Pike Memorial located near Judiciary Square.

The Freemasons originated during the Middle Ages in England when skilled stonecutters, working on the Gothic cathedrals, formed guilds or fraternities. Many of the terms now used by the Masons originated in these lodges during the Middle Ages; the elaborate ceremonies for initiation and conferring of degrees are still in use. The organization today is largely concerned with educational projects, but it also serves its members as a fraternity.

• L-4
Title NOYES ARMILLARY SPHERE, 1931
Location Meridian Hill Park, 16th Street and Florida Avenue, NW, south end of park
Sculptor Carl Paul Jennewein
Architect Horace Peaslee
Medium Bronze and copper

This 6-foot-high armillary sphere, located at the foot of the graceful cascade in the southern garden of Meridian Hill Park, was given to the city of Washington in 1931 by the local artist and philanthropist, Bertha Noyes, in memory of her sister Edith Noyes. Little is known of Edith Noyes, who appears to have been an invalid for most of her life. Bertha Noyes, however, was a well-known figure in the Washington art world before her death in 1966. Born in Washington, she studied at the Corcoran School of Art and later held many one-man shows at the Corcoran Gallery of Art, the Washington Arts Club, the George Washington University, and the Rhode Island School of Design. She traveled widely and was noted for the hundreds of fine portraits she executed of native peoples from many remote parts of the world. In 1916, Miss Noyes was a founder of the Washington Arts Club at an organizational meeting of artists in her historic home at 1614 Nineteenth Street, NW. The present home of the Washington Arts Club, in the historic mansion at 2017 Eye Street, NW, once occupied by President James Monroe, was acquired for the society by a committee headed by Miss Bertha Noyes.

In spite of its seemingly contemporary design, the armillary sphere is, in fact, an ancient astrological instrument. The armillary sphere was frequently used in Europe in the seventeenth century to illustrate the Ptolemaic theory of a central earth; it used metal rings which illustrated the nine spheres of the universe. The usual device, a skeleton of the celestial globe with circles arranged into degrees for angular measure-

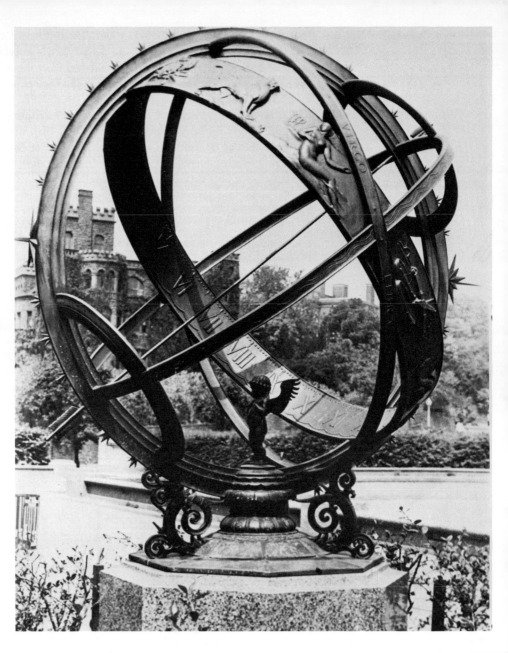

ments, represents the great circles of the heavens. The latter includes the horizon, meridian, equator, tropics, and polar circle. The *Noyes Armillary Sphere* includes a series of bronze rings on which are also found the symbols of the zodiac and the hours, given in Roman numerals. A bronze arrow forms the axis, and, in the center, a small winged genie greets the sun. The sphere rests on a pedestal of green Conway granite, and at the base on the south side of the pedestal is a bronze dial correction table. The sphere is surrounded by a hawthorn hedge which, in turn, is encircled by a concrete coping.

A Romanesque-style granite castle appears in the background, across the street from the park, in this 1931 photograph. This edifice, known as "Boundary Castle," was one of the city's great Romanesque Revival style mansions. It was constructed in 1888 for Senator and Mrs. John B. Henderson, and was demolished shortly after Mrs. Henderson's death in 1935. The actual site of the sculpture, Meridian Hill, derived its name from the 110-acre country estate erected here for Commodore David Porter in 1817 and attributed to architect George Hadfield. The mansion, built with the considerable prize money Porter won during the various naval battles of the War of 1812, was named Meridian Hill after one of the stones on his lawn marking one of the first meridian lines of the city. Unfortunately, no picture of that house has survived.

L-5

Title James Buchanan Memorial, 1930

Location Meridian Hill Park, 16th Street and Florida Avenue, NW, southeast section of park

Sculptor Hans Schuler

Architect William Gordon Beecher

Medium Bronze, marble, and granite

Washington's memorial to President James Buchanan is in the southern half of Meridian Hill Park. Buchanan never married, and his niece, Harriet Lane (Mrs. Henry Elliott Johnston), acted as hostess for her uncle throughout his years in the White House, 1857–1861. Her art collection was later incorporated into the National Collection of Fine Arts of the Smithsonian Institution. Mrs. Johnston also left a bequest for the erection of a monument to her uncle. Congress was slow to act on a site for this memorial, and steps were taken to begin construction only a few weeks before the fifteen-year time limit was to expire in 1918. The Buchanan statue stands 8 feet tall, while the two allegorical figures measure 7 feet in height and about 4 feet in width.

The Pennsylvania-born Buchanan is seated in front of a large white marble pylon, flanked at the end of a curving stone bench by two granite allegorical figures, Law and Diplomacy (not shown here). Since Buchanan did achieve more than modest success as a lawyer and diplomat, these two figures are appropriate; however, the same cannot be said for his tenure as the fifteenth president of the United States. Elected in 1856 as a compromise candidate, he was unable to heal the rapidly deteriorating relations between North and South. The Civil War broke out a month after he left office. Buchanan retired to "Wheatland," his home at Lancaster, Pennsylvania, where he died in 1868.

L-6

Title DANTE, 1920
Location Meridian Hill Park,
16th Street and Florida Avenue,
NW, east side of park
Sculptor Ettore Ximenes
Architect Horace Peaslee
Medium Bronze

The statue *Dante* stands appropriately in the Italianate gardens in the lower half of Meridian Hill Park. The 11½-foot statue shows Dante Alighieri (1265–1321) wearing a scholar's gown and a victor's laurel and holding the book, the *Commedia*. The bronze figure was given in behalf of Italian-Americans by Carlo Barsotti, editor of an Italian-American newspaper in New York City. The dedication, hailed in contemporary newspaper accounts as an "international love feast," was held in 1921 on the 600th anniversary of the poet's death. The statue is a replica of one unveiled the same year in New York City.

Dante, one of the best known figures of the late Middle Ages, was a poet, scholar, and diplomat, and generally seemed to epitomize the greatness of his era. Born in Florence, Italy, of a prosperous merchant family, he was influenced at an early age by the many poets then writing in his native city. His own writings present an important development in literature different from the Sicilian school of traditional love poetry which was then in style. Dante's service in the war between the city-states of Florence and Pisa preceeded his appointment as Florentine ambassador to the Pope. Following charges of conspiracy by the ruling faction of Florence, Dante remained in exile from his beloved city until his death. During these last years he traveled extensively through Italy and France, living and writing under the patronage of nobles in various cities.

His three major works were *La Vita Nuova*, *Monarchia*, and the sublime epic poem *Commedia*. In the *Commedia*, or *Divine Comedy*, one of the great works of literature, Dante describes the punishments which man must encounter after death and the steps of redemption he must take to achieve salvation. In this work, in which the narrator is the hero, Dante begins by describing a scene in the year 1300 in which he is lost in a forest symbolic of worldly cares. His efforts to find his way out are blocked by the temptations of this world. Virgil, the Roman poet, appears before Dante, having been instructed by three female figures, the Blessed Virgin, St. Lucy (symbol of illuminating grace), and Beatrice (a divine Muse who was the principal figure in Dante's *La Vita Nuova*), to guide him to Heaven. Dante is first escorted through Hell, which is inhabited by popes, kings, warriors, Florentine citizens, and Lucifer himself. Virgil then leads Dante upward from a passage in the center of the earth to Purgatory, located on a mountain and divided into seven terraces, according to the seven deadly sins. Dante meets Beatrice on the summit of the mountain Heaven, and blends his will completely with God's, according to mystical theology. Dante's descriptions of Hell, Purgatory, and Heaven became famous even in his own day and had a significant influence in improving morals of that era.

Title JOAN OF ARC, 1922
Location Meridian Hill Park,
16th Street and Florida Avenue,
NW
Sculptor Paul Dubois
Architect McKim, Mead, and
White
Medium Bronze

The 9-foot-high equestrian statue of the French heroine, Jeanne d'Arc, occupies the most prominent position above the fountains in the center of Meridian Hill Park. It is a replica of the original statue in front of Rheims Cathedral in France. Many statues have been erected in Washington, D.C., to commemorate friendship between the United States and other countries, but this one is noteworthy as a gift from the women of France to the women of the United States. At its dedication in 1922, France was represented by Mme. Jules Jusserand, wife of the French ambassador, and Mme. Carlo Poliferne, president of the Société des Femmes de France of New York, the organization which donated the equestrian statue. American women were represented by Mrs. Warren G. Harding, then first lady, and Mrs. George Minor, president of the Daughters of the American Revolution.

The bronze statue depicts a spirited Joan of Arc (1412–1431) seated on horseback, sword drawn, presumably leading her French troops into battle against the Burgundians. She was born on the Feast of the Epiphany in 1412, in a village in the province of Champagne, France. Known throughout the village for her piety, at the age of thirteen she claimed she heard voices and saw blazes of light. The voices, supposedly of St. Michael, St. Catherine, and St. Margaret, instructed her to fight for France. Upon presenting her story to the king's forces, she was given command of the army and successfully drove the English from the occupied town of Orléans in 1429, thus permitting the coronation of Charles VII. Her later military expeditions were not so successful. Captured by the Burgundians outside of Paris, she was sold six months later to the English who relinquished her to the ecclesiastical courts of France. The French clergy, jealous of her influence over the king, tried and condemned her as a heretic and ordered her burned at the stake at the age of nineteen.

L-8
Title SERENITY, 1925
Location Meridian Hill Park,
16th Street and Florida Avenue,
NW
Sculptor José Clara
Architect None
Medium Marble

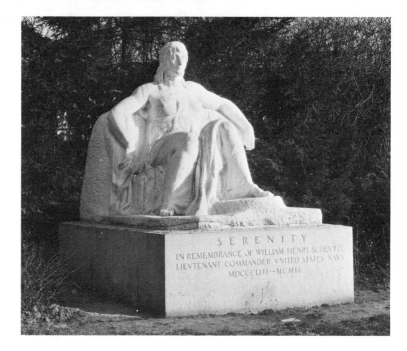

This allegorical statue, installed in the northwest quarter of Meridian Hill Park in 1925, is one of an identical pair by the Spanish sculptor José Clara; the other is in Luxembourg, and is called by its Spanish title, *Serenidad.* Carved out of a single block of white marble, *Serenity* is depicted as a woman in Classical garb, seated in a casual position. Many have complained that *Serenity's* expression is not altogether serene. Fifty years of vandalism and accumulated grime cannot have improved her countenance. Her lips have been rouged, her cheeks painted, her knees chalked, and the nose knocked off at least twice. *Serenity* stands 5½ feet high and is one of the few statues in Washington never to have had a dedication ceremony, and to have been erected by a private individual to honor a relatively unknown and insignificant American figure. To add to her troubles, various citizens' groups have petitioned for her removal.

The statue honors the memory of Lieutenant Commander William Henry Scheutze (1853–1902), a native of Missouri and a minor officer in the United States Navy. In 1873 Scheutze graduated from the U.S. Naval Academy, in Annapolis, Maryland, first in his class. One of his first assignments was to participate in an expedition to the Arctic and bring back the bodies of those American explorers who died in the ill-fated voyage of the *Jeanette.* Having learned to speak the Russian language fluently, Schuetze was sent north again by the State Department to distribute presents among the natives of northern Siberia as a mark of appreciation for their kindnesses to the DeLong exploration party. During the Spanish-American War, Scheutze was navigator of the U.S.S. *Iowa,* taking part in the Battle of Santiago. His last appointments came in 1888, when he was promoted to the position of superintendent of equipment, and from 1889-1890 when he served with the famous U.S. Naval "White Squadron" in Chicago. He died in the Naval Hospital in Washington, D.C. on April 4, 1902.

Charles Deering, a classmate of Scheutze's at the U.S. Naval Academy and a longtime friend, provided the funds for the erection of the statue. Deering served for nine years as a naval officer, resigning in 1881 in order to serve as the secretary of the Deering Harvester Corporation of Chicago, founded by his father, William Deering. Charles Deering, after the merger of the family company with another leading agricultural machinery company, became chairman of the board of the new International Harvester Company. While in retirement, Charles Deering died on his opulent estate in Dade County, Florida, in 1927.

L-9
Title Moroni, 1933
Location The Church of Jesus
Christ of the Latter Day Saints,
2810 16th Street, NW
Sculptor Thorlief Knapus
Architect Ramm Hanson and
Don Carlos Young
Medium Gilded aluminum

The 10-foot-high figure atop the spire of The Church of Jesus Christ of the Latter Day Saints represents the angel *Moroni*, heralding the advent of the "latter days" to Washingtonians of today. Moroni is believed by Mormons to have lived as a mortal in America in the years A.D. 385–421 and to have been the chief compiler of the records which are known as the Book of Mormon. The Book, together with the Holy Bible, constitutes the sacred Scriptures of the Church of Jesus Christ of the Latter Day Saints.

It was the Angel Moroni who, in 1827, is believed to have appeared to Joseph Smith in Palmyra, New York, and directed him to the hiding place of the golden tablets. On these plates was inscribed a partial record of the history and religion of people in the American continents both before and after the sojourn of Jesus Christ on earth. The angel instructed Joseph Smith to translate the tablets, which are known now as the Book of Mormon. The Church founded by Joseph Smith moved west to Utah and settled in Salt Lake City. This odyssey of the Mormons is a vivid part of the history of the American frontier.

This gilded trumpeting angel wears a loose robe and stands on a large sphere. The Sixteenth Street church was designed by Ramm Hanson, a Norwegian convert, and Don Carlos Young, grandson of Brigham Young, who led the Mormons for 30 years after the death of Joseph Smith. The Latter Day Saints, suffering from persecution in Missouri,

were led by Joseph Smith and Judge Elias Higbee to Washington, D.C., in 1837 when the first church was founded in this area.

Another statue of Moroni, 18 feet high, designed by sculptor Avard Fairbanks of Salt Lake City, was erected on the Washington Temple of the Mormon Church at Kensington, Maryland. This slender graceful figure, cast in bronze in Italy and weighing two tons, fulfills the artist's intent of conforming to the architecture and the spirit of the Temple by "aspiring upward" in reaching vertical lines. This unusual structure, with six towers crowned by porcelain-enameled steel spires, is reminiscent of the Salt Lake Temple. Moroni stands on the eastern-most spire of the temple, the largest such Mormon edifice to be built in the United States. This Temple, completed in 1974, is not a house of worship, but is reserved for sacred ordinances, such as baptisms, endowments, and marriages. Regular weekly worship services are conducted in chapels, of which there are about forty in the Washington area, including the Sixteenth Street edifice. After the Temple is dedicated, only members of the denomination in good standing may enter.

L-10
Title ACADEMIC, BUSINESS, AND MANUAL EDUCATION, 1916
Location Francis L. Cardozo High School Building, Clifton Street between 11th and 13th Streets, NW
Sculptor George Julian Zolnay
Architect William B. Ittner
Medium Granite

Business Education

This frieze by the Rumanian-American sculptor George Julian Zolnay consists of three massive, stone relief panels above the third-floor windows of the main entrance to the Francis L. Cardozo High School. The panels were executed in 1916 for the new building, which had just been built to house Central High School. This work was designed to reflect the subjects taught within the school and to exert a constructive influence on the student body. In the first panel on the left, *Business Education*, the figures symbolize the practical careers of shipping, accounting, geography, commerce, and barter. The central panel, *Academic Education*, reflects a quieter and more dignified pursuit than the other two. The figures, left to right, hold symbols or objects relating to careers in chemistry, mathematics, art, music, history, philosophy, and biology. The third panel, *Manual Education*, portrays seven youths in Classical garb, performing household and industrial duties such as cooking, sew-

ing, and surveying. The three panels cover a total area of 50 feet in length and 8 feet in height.

Zolnay followed the custom of the sculptors of ancient Rome in perpetuating in stone the faces of the men directly responsible for the erection of the building. Among others, the sculptor portrayed William B. Ittner, the architect; Snowden Ashford, the architect of the District of Columbia; and Emory M. Wilson, the principal of the school. The original records specifying the exact location of these and other prominent men among the allegorical Neoclassical figures of the three panels have, unfortunately, been lost.

The first high school in the District of Columbia was established in 1876, when the Advanced Grammar School for Girls was established. The Advanced Grammar School for Boys was opened the following year. Because of public opposition to the use of government funds for high schools at that time, these two schools were not officially named high schools. The success of these two schools in preparing city students for entrance into college was quickly realized, and, in 1882, they were combined into the newly created Washington High School and were moved into a new Victorian school building, located at Seventh and O Streets, NW. By 1889, the enrollment at Washington High School had increased to 1,422 students. Two additional city high schools were opened, Eastern High School, on Capitol Hill, and Western High School, in Georgetown; and the Washington High School was renamed Central High School. From 1916 to 1950, Central High School occupied the building on Clifton Street. Because of the extremely overcrowded conditions of the Negro schools in the city, the Board of Education of the District of Columbia voted to abolish Central High School, to transfer the white student body to Roosevelt High School, and to move the all-Negro Cardozo High School into the Clifton Street building. Several years later the racially divided, dual public school system in the District of Columbia was abolished and the schools became completely integrated.

Cardozo High School was established in 1929 as a business high school for Negro students. It was named for Francis Lewis Cardozo (1836–1903), minister, politician, and educator, who was born in Charleston, South Carolina. Cardozo, a free Negro, managed to travel to Britain to advance his education. Between 1857 and 1864 he studied theology in Scotland and England. After serving as pastor of the Temple Congregational Church in New Haven, Connecticut, he returned to South Carolina. There he became an active figure in the Reconstruction politics of that state from 1868 to 1877, serving as a member of the Constitutional Convention, secretary of state of South Carolina, and state treasurer. While holding these positions, he attended the University of South Carolina, and was graduated in 1876. Cardozo left South Carolina at the end of the Reconstruction period and moved to Washington, D.C., where he worked as a clerk in the Treasury Department until 1884. From 1884 to 1903, Cardozo served with distinction as educator-principal of several Negro high schools in the city.

Title FRANCIS ASBURY, 1924
Location 16th and Mt. Pleasant
Streets, NW
Sculptor Henry Augustus
Lukeman
Architect Evarts Tracy
Medium Bronze

The life-size equestrian statue of Francis Asbury, pioneer Methodist bishop, was said to be one of the finest of its kind in the country when erected in 1924. The bishop wears a wide-brimmed hat and cloak, and he has a finger between the pages of his Bible. The rein is slackened, and the bishop looks straight ahead.

Francis Asbury (1745–1810), born of devout Methodist parents near Birmingham, England, became a preacher at the age of sixteen. In 1771, Asbury was sent to the American colonies as a general assistant to John Wesley. At that time the Methodists were still in the Anglican Church and were especially numerous in the colonies of Virginia, Maryland, and Delaware. Following the Revolutionary War, a general conference was held in 1784, which established the Methodist Church's independence from the Anglican Church and confirmed Asbury as the first superintendent of the church in America. Four years later his title was changed to bishop. Following Wesley's death in 1791, Asbury became the leading figure of the church in America. Under his direction, a master plan was carried out which organized hundreds of counties into church districts, with an academy located in each. Asbury visited the early Methodists of Washington City, who first met in the 1790s in a converted tobacco warehouse on New Jersey Avenue, SE, before they erected a church near the Navy Yard. He traveled over 270,000 miles as a circuit rider, preaching some 16,000 sermons and ordaining over 4,000 clergymen. Asbury never married and worked to within a few weeks before his death, preaching his last sermon from a stretcher in Richmond, Virginia. His life was not an easy one, and even he, a Spartan, reflected: "I look back upon a martyr's life of toil and privation and pain."

Guglielmo Marconi (1874–1937), the inventor of radio, was born and educated in northern Italy, the son of an Italian country gentleman and an Irish mother. In the 1890s, his experiments with an induction coil, controlled by a Morse tapping key at the sending end and a simple filings coherer at the receiver, eventually resulted in the invention of the wireless telegraph or radio. In 1899, he equipped several American ships with his device which enabled practical communication between land and sea. Marconi startled the civilized world in 1901 by sending a wireless message, via crude vertical aerials, between Newfoundland, Canada, and Cornwall, England. This marked the beginning of radio communications, broadcasting, and navigation services. Between then and 1919, Marconi invented a score of improvements to the "wireless telegraph," which resulted in the widespread use of radios in American and European homes in the 1920s. He was awarded the Nobel Prize and the Albert Medal of the Royal Society of the Arts. Marconi was appointed an Italian delegate to the peace conference ending World War I, and in this capacity he signed the Treaty of Paris in 1919. Among other honors, he was elected president of the Royal Italian Academy in 1930. His early experimental station on Cape Cod, near Provincetown, Massachusetts, has recently been restored and is now maintained as a museum by the National Park Service.

A public subscription for this memorial was begun in 1938, one year after Marconi's death. It was completed, erected, and landscaped by the summer of 1941. Attilio Piccirilli, sculptor and head of the largest stone-carving firm in the United States at the time, designed the memorial in the form of a double pedestal of Stony Creek granite, arising from a base of the same material. A bronze bust of the great inventor, measuring about 3 feet in height, is placed on top of the smaller pedestal. Behind this pedestal and bust is a taller and broader pedestal, surmounted by the bronze figure of a woman carried on a half globe suspended in clouds, through which ethereal waves pass. The larger pedestal is 14 feet high, while the Art Deco symbolic figure above rises an additional 9 feet. The sculptor described his work as follows:

> Against the shaft of the monument, on a base of classic simplicity, rests the bust of Marconi, as firmly planted as his fame. The head, modeled in its virile strength, stresses purposefulness in the line of the mouth, and vision in the far-seeing eyes under the great brow. Symbolic of Marconi's contribution to science, the Wave speeding through ether, covers the earth. There is the fleetness of lightning in the backward sweep of hair and drapery. There is direction in the outthrust arm guided by the noble head which, as the figureheads of the ships dominated the sea, now commands the heavens. With Promethean gesture, the uplifted hand reaches for still greater gifts to man.

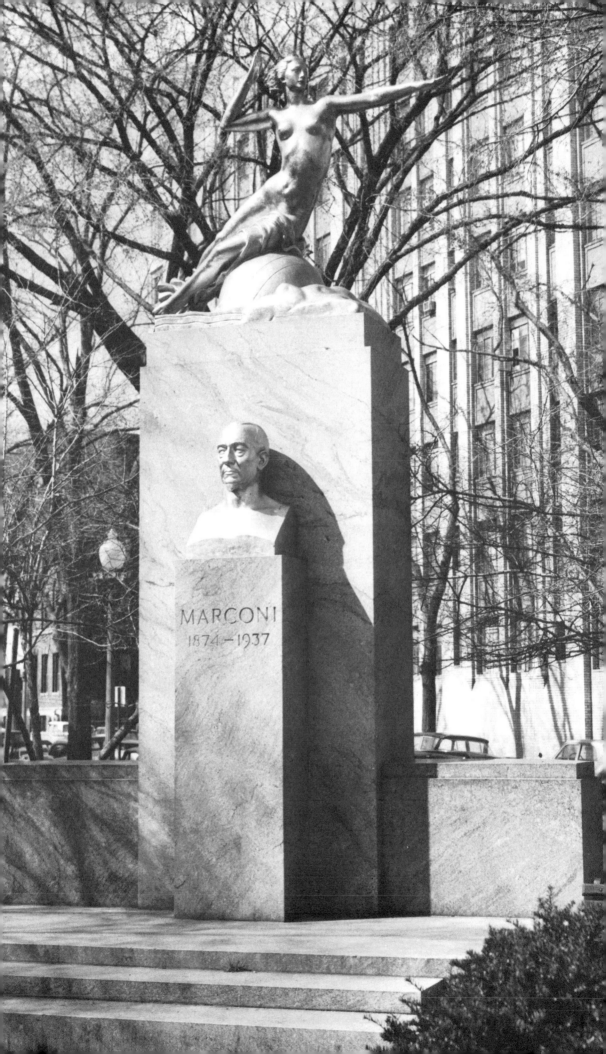

MARCONI
1874–1937

L-13

Title James Cardinal Gibbons, 1932

Location 16th Street and Park Road, NW

Sculptor Leo Lentelli

Architect George Kayl

Medium Bronze and marble

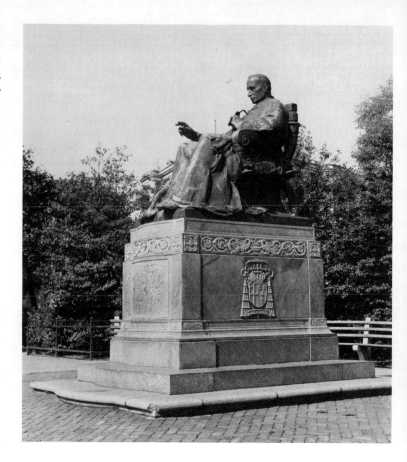

James Cardinal Gibbons was certainly one of the most extraordinary of American clerics, and it is quite appropriate that the Knights of Columbus should have chosen him as the subject of their memorial in Washington. The 6-foot-tall statue, in front of the Shrine of the Sacred Heart, depicts the cardinal seated in a curule chair, wearing ecclesiastical garb. Gibbons's right hand is raised, as if extending a benediction. A marble and mosaic pavement surrounds the statue, which rests on a sculpted granite pedestal. It was dedicated in 1932.

Cardinal Gibbons (1834–1921) was born in Baltimore, Maryland, and lived in Ireland after the death of his father. He was ordained in 1855, and was chaplain at Fort McHenry, in Baltimore Harbor during the Civil War. When he was created Bishop of Adramyttum in North Carolina in 1868, he became the youngest of all 1,200 bishops of the Roman Catholic Church. He became Bishop of Richmond, in Virginia; and, in 1878, returned to Baltimore to head the oldest of American archdioceses. Gibbons was designated a cardinal in 1886, the second American to be so honored.

For many years, Gibbons was a friend and advisor of many American presidents, from Andrew Johnson to Warren Harding. He had a very early sympathy for the American labor movement, and was also known for his patriotism; Theodore Roosevelt once said that Gibbons embodied what was highest and best in American citizenship.

The allegorical coat of arms on the side of the pedestal consists of a shield, on which is surmounted a pontifical hat symbolic of "a leader of the people in prayer," literally a bridgemaker between God and man. The design of the left half of the shield was taken from the coat of arms of the Archdiocese of Washington, while the right half represents the cleric's personal family coat of arms. The shield is framed on each side by an identical row of tassels. These long tassels, which descend in five tiers of from one to five tassels each, represent the five ranks of clergy of the church: priest, monsignor, bishop, archbishop, and cardinal. The coat of arms relieves the severity of the pedestal, and complements the bronze portrait surmounted above.

L-14
Title PROCTOR'S TIGERS, 1910
Location 16th Street, Piney Branch
Bridge, NW
Sculptor Alexander Phimister
Proctor
Architect District of Columbia
Division of Bridges
Medium Bronze

The gifted animal sculptor Alexander Phimister Proctor was commissioned in 1908 to sculpt four tigers as "guards" for the bridge over Piney Branch Parkway. The tigers were to be made of concrete, but Proctor, perhaps with more insight than the District of Columbia commissioners, cast the tigers in bronze (at his own expense) instead.

The four beasts, each about 4 feet tall, are in a prone position: "full of dignity, natural with a certain subtle meaning that is not only characteristically feline, but appropriate . . . Proctor's great tigerine casts will be objects of admiration for all who view them in the ages to come," as a reporter described them in 1911.

The reason for tigers at the Sixteenth Street Bridge is unclear. Proctor had already finished two tigers for the entrance to Nassau Hall at Princeton University, which increased his reputation as an animal sculptor. After these two projects, he undertook the commission of two more for the Pratt estate at Glen Cove, Long Island. Their elegance and ferocity are undeniable. (Note the sculptor's signature on the edge of the shallow bronze platform on which the animals rest.)

When the bridge was built, it was considered eye-filling not only for its artistic embellishments but also as an engineering feat, being the first parabolic arched bridge in Washington. Piney Branch Creek flowed under the bridge at the time, but has long since receded.

Title FAMILY TREE OF HOPE, 1974
Location Rock Creek Park,
16th and Kennedy Streets, NW
adjacent to the Carter Barron
Amphitheater
Sculptor Dennis Stroy, Jr.
Architect None
Medium Wood

This 15-foot-high sculpture in the round is carved from a Red Oak tree cut in Rock Creek Park and supplied to the sculptor by the National Park Service. The *Family Tree of Hope*, three-fourths complete, was begun in May 1970. It represents members of a Negro family, including eight children, one husband, and two wives, whom the sculptor, Dennis Stroy, came to know during the six years he spent in New York City in the 1960s. He met the family through their eight-year-old son he taught in a sculpture workshop. Stroy is completing the work at his own expense on weekends. Although reminiscent of an Eskimo totem pole, the design and idea of carving on tree trunks originated with the sculptor. It is the only such example of outdoor sculpture in Washington.

Rock Creek Park, in which *Family Tree of Hope* is situated, is one of the most beautiful city parks in the country, and stretches along Rock Creek from the District of Columbia-Maryland border to the Potomac River at Georgetown. The northern section of the 1,800-acre park was acquired in 1890 and has been extended since then.

Title MAJOR WALTER REED
MEMORIAL, 1966
Location Walter Reed Army
Medical Center, 16th Street and
Alaska Avenue, NW
Sculptor Felix W. de Weldon
Architects Ronald Senseman and
Anthony Harrer
Medium Bronze

The *Major Walter Reed Memorial* is located just inside the main gate of the well-known United States Army hospital that bears his name. At the time of Dr. Reed's death, a fund had been established to provide an income for his wife and daughter. When the latter died in 1964, it was decided to use the remaining funds for the erection of a memorial, which was dedicated in 1966 in the presence of President and Mrs. Dwight D. Eisenhower. The bust of Reed, three times larger than life, was created by the Austrian-born sculptor, Felix W. de Weldon, who is best known for the *Iwo Jima Memorial* in nearby Arlington, Virginia. The bust is set atop a 15-foot marble shaft and in front of a 25-foot pylon.

Dr. Walter Reed (1851–1902), a native of Virginia, received his medical training at the University of Virginia Medical School at Charlottesville and at the Bellevue Medical College of New York City. After joining the U.S. Army Medical Corps in 1874, Reed studied physiology at Johns Hopkins University, while stationed at Ft. McHenry in Baltimore. Promoted to major in 1893, Reed was assigned to duty in Washington, D.C., and became curator of the old Army Medical Museum (the present Armed Forces Institute of Pathology), and professor of clinical microscopy at the U.S. Army Medical School (the present Walter Reed Army Institute of Research). While in Washington, Reed also taught bacteriology at the medical school of Columbian University (the present George Washington University). Reed's most famous contribution to medicine occurred in 1898, when he headed a group of army physicians sent to Cuba to investigate the causes for the spread of typhoid fever. By microscopic investigations he established the link between human carriers, flies, and impure water. Reed further proved in Cuba that yellow fever, which had caused such large casualties in the Spanish-American War, was carried by the mosquito, thus dispelling the old contagion theory. The fatal disease was practically eradicated in Cuba

and the United States because of his discovery of the cause and the resulting development of an effective serum.

Reed resumed his professorship at the United States Army Medical School, then located at Ft. McNair in Washington, D.C., but died soon afterwards in 1902 of appendicitis. As a tribute to Reed's discoveries, Congress authorized the construction of the Walter Reed United States General Hospital in 1909 at its present location. The hospital's growth was gradual in the eight years preceeding World War I. Most of the present permanent Georgian style brick buildings were erected during the 1920s and 1930s. The United States Army Medical Center was established on the present grounds in 1923 by the consolidation of the Army Medical School, then located in downtown Washington; and the Army Veterinary School, moved from Chicago; the Army Dental School; the Army Nursing School; and the Walter Reed Army Hospital. In 1951, upon the 100th anniversary of Reed's birth, the name was officially changed to the Walter Reed Army Medical Center. The Center today, with more than 6,000 daily patients, includes over 300 buildings on the main grounds in northwest Washington and on the nearby Forest Glen Annex in Montgomery County, Maryland.

L-17
Title PENGUIN FOUNTAIN, 1935
Location Walter Reed Army Medical Center, 16th Street and Alaska Avenue, NW
Sculptor Unknown
Architect James C. MacKensie
Medium Concrete

The *Penguin Fountain* in front of the central hospital building at Walter Reed Army Medical Center was given in memory of Colonel John Van Rensselaer Hoff (1848–1920) from a bequest by his widow, Lavinia. Colonel Hoff entered the U.S. Army in 1874 as a surgeon, retired in 1912, and was recalled to active duty during World War I. When he joined the army, its Medical Corps had little or no recognition, and Hoff's life work became the improvement of the Corps' status. Colonel Hoff's interests were as much military as medical, and he insisted that doctors in the military be accorded all of the rights and privileges of regular army officers. It was in part due to his martinet efforts that the general level of organization and efficiency of the Medical Corps was greatly improved.

The fountain, dedicated in 1935, is circular and contains three tiers, the tall center one being in the shape of an urn. It is much like fountains throughout Washington except for the presence of four penguins, about 2½ feet high, which face outward from the lower tier. These stocky animals are mounted on rectangular pedestals sculpted with cobras. Water spouts from the penguins' mouths, adding a touch of wet warmth to an otherwise austere setting. The penguins are possibly symbolic of Colonel Hoff's service in the Arctic (Russia), while the cobras may be indicative of his duty in the tropics (the Philippines).

Each corner of the fountain is embellished with a penguin standing on a pedestal which has a cobra in relief

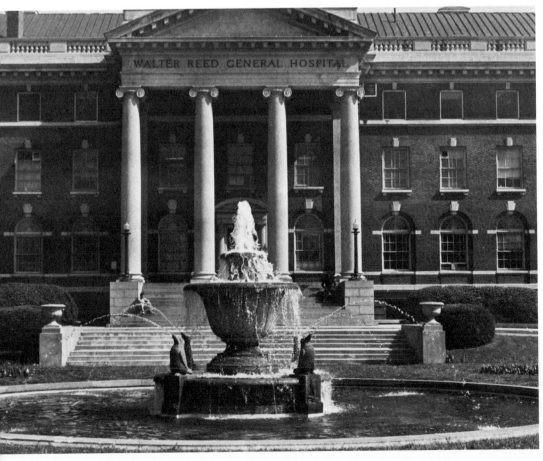

Title SEAHORSE FOUNTAIN, ca. 1850
Location DeWitt Circle, in front of the Main Building, Forest Glen Annex, Walter Reed Army Medical Center, one mile west on Linden Lane from Georgia Avenue, Silver Spring, Maryland
Sculptor Unknown
Architect Unknown
Medium Marble, concrete, and iron

Forest Glen Park, now an annex of Walter Reed Army Medical Center, consists of a densely wooded tract of land, on which are situated some thirty-three buildings and numerous outdoor garden sculptures, located near the District of Columbia line in Silver Spring, Maryland. The hilly terrain is bisected by a stream which eventually empties into Rock Creek. During the colonial period, this area was part of a plantation belonging to the prominent Daniel Carroll family of Maryland. Upon the death of the father, the land was divided between the two sons, Daniel, who became a delegate to the Continental Congress in 1781, and John, who in Baltimore in 1789 became the first Roman Catholic bishop in the United States.

In 1887, the land was purchased by the Forest Glen Improvement Company, named for the small railroad station constructed in 1879 at Forest Glen, Maryland, one-half mile away. This company commissioned a young Washington architect, Thomas F. Schneider (1859–1938), to construct a hotel at this site known as Ye Forest Inn. Schneider, who opened his office in Washington in 1883 after working for the prominent local architectural firm of Cluss and Schultze, designed over 2,000 Washington residences and a number of important local buildings, such as the Cairo Hotel.

The Forest Glen Improvement Company, unable to attract sufficient numbers of Washingtonians to Forest Glen, went out of business and sold the property to Mr. and Mrs. John I. Cassedy about 1890. The Cassedys, owners of the Norfolk Junior College, opened the National Park Seminary at Forest Glen in 1894. Cassedy erected twenty-five school structures on the site between 1894–1907. These buildings were planned for a picturesque effect, most of them being of different architectural styles. The eight sorority houses, all still standing, include an American bungalow, an American Colonial-Revival house, Japanese pagoda, Japanese bungalow, Dutch windmill, California mission, Swiss chalet, and an English castle complete with drawbridge. Many of these structures are today used as officers' quarters.

The most important structure in this collection of exotic buildings is the old Forest Inn or main building, designed in the shingle style so popular in the 1880s. The building originally had shingle-covered walls, broad gable ends, turrets, wide porches, and small-paned windows. The sculpture pictured here is located immediately in front of the old Forest Inn on DeWitt Circle. This fountain and many other garden sculptures still located here were removed from other locations and placed in the rural setting for decoration. Nothing is known of the *Seahorse Fountain* except that it was probably made in the mid-nineteenth century, possibly in Italy.

Facing page, top: this photo from the 1920s features two co-eds enjoying the Seahorse Fountain *when it was still completely intact*

Facing page, bottom: the Seahorse Fountain *today rests in its waterless basin in a neglected state*

Two scalloped basins now compose the fountain, with large seahorses with elongated heads and mermaids supporting the second basin. The fountain originally consisted of three basins. The third scalloped basin, supported by four figures resembling erect falcons, held an arrangement of putti, or small children, executed in the Rococo style. Water fell from the horses' and falcons' mouths and from the top basin. The upper basins and puttis were lost after army personnel removed them in the 1950s while attempting to repair the fountain pipes. The fountain could still be restored to its original condition and placed in working order. The location of this sculpture before the main building of the complex makes it the most important of all the two dozen Victorian garden sculptures which have survived.

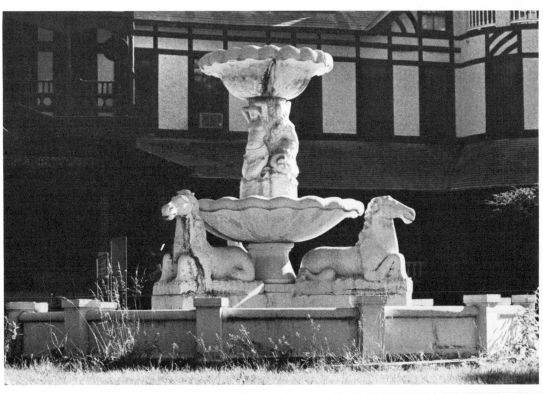

433 *Sixteenth Street*

L-19

Title HIAWATHA, ca. 1900
Location DeWitt Circle, adjacent to
the Main Building, Forest Glen
Annex, Walter Reed Army
Medical Center, one mile west
on Linden Lane from Georgia
Avenue, Silver Spring, Maryland
Sculptor Unknown
Architect Unknown
Medium Cast iron, painted bronze

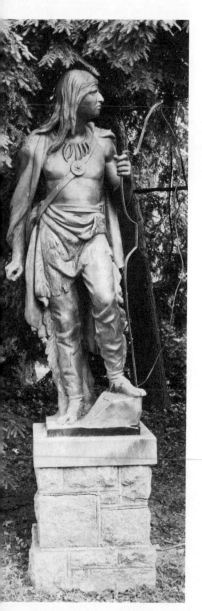

This life-size, cast-iron statue of *Hiawatha*, painted a bronze color, is located adjacent to the main building at Forest Glen Annex of Walter Reed Army Medical Center. Hiawatha, meaning "he makes rivers" was the name of a legendary Indian chief of the North American tribe of Onondaga Indians. Indian tradition claims that he formed the League of Five Nations, known as the Iroquois, in the fifteenth century. Hiawatha was credited with teaching the Indians agriculture, navigation, medicine, and the arts. He was considered a god, the incarnation of human progress and civilization. Henry Wadsworth Longfellow used him as the hero of his famous poem, *The Song of Hiawatha*, first published in 1855. This statue portrays Hiawatha standing with his left knee bent, holding a bow with his left hand, and gazing into the distance over his left shoulder. His headdress, consisting of three feathers, no longer rests vertically for it has long since fallen across his eyes.

Adjacent to the Italianate villa, a building constructed as a girls' dormitory in 1907, were located the formal gardens of the old school. The gardens contained numerous outdoor allegorical statues and urns, many of which are still located on the grounds, often hidden from view by overgrown thickets. They include two cast-iron *Griffins* at the entrance to the main building, a large pair of *Lions* at DeWitt Circle, a small pair of *Lions* near the castle, a cast-iron *Maiden* near the senior house, a granite statue of *The Grief of Actaeon*, a youth with a wounded fawn, near the site of the old railroad footbridge, and four stone *Lanterns* adjacent to the Japanese pagoda. Other sculptures include *Justice* in the villa gardens, *Minerva* also near the villa, a *Woman with Urn*, and the *Porch of the Maidens*. The latter sculpture consists of a row of caryatids which support the roof of an open walkway beside the Aloha Building leading from the main building to the gymnasium. The Aloha was constructed in 1898 as the home for the president of the girls' school. The Neoclassical caryatids were added in the 1920s and are incongruous with the shingle-style architecture of the Aloha Building.

An important feasibility study on Forest Glen was produced in 1972 by Washington architect Francis D. Lethbridge for the Montgomery County Planning Board of the Maryland-National Capital Park and Planning Commission. Mr. Lethbridge has proposed that the government restore most of the original turn-of-the-century buildings and sculptures at Forest Glen, when the U.S. Army leaves the grounds in 1977.

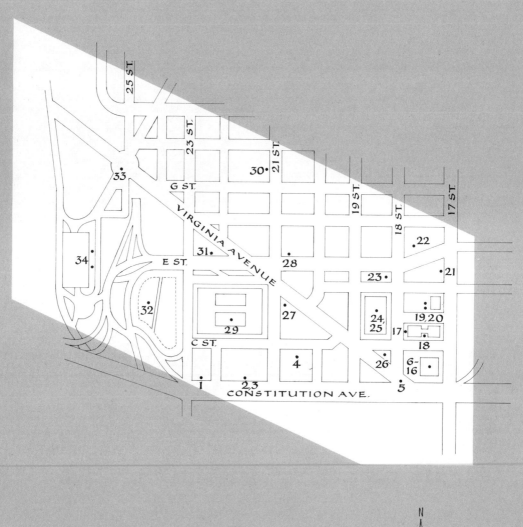

VIRGINIA AVENUE, NW, branching off Constitution Avenue at Eighteenth Street and extending west, is relatively short, about one mile in length, before it joins Rock Creek Parkway along the bank of the Potomac. Originally, this area was known as Foggy Bottom, linking the Potomac tidal flats and the extensive municipal gasworks to an area of old nineteenth-century row houses. Many of these Victorian row houses were in bad repair in the 1930s and becoming uninhabitable.

When the gasworks decided to move and urban renewal began to flourish in the 1950s, this area proved charming to both government and real estate developers. After battles between owners, redevelopers, and zoning boards, court suits established the guidelines for the urban renewal program. The old Virginia Avenue houses were razed, the Potomac waterfront was cleaned up, extensive government quarters were built, and the prized area overlooking the river was completed with the Columbia Plaza complex, the Watergate Apartments, and the Kennedy Center. A large part of this area has become part of the growing campus of The George Washington University.

Due to some foresight in renewal plans, small parks were retained, relieving the monotony of government buildings. Parks commemorating Artigas, Bolívar, and Juárez are located near the Pan American Union building. Kelly, Rawlins, and Whitman Parks, as well as the Navy installation grounds, which contain the historic pre-Civil War Old Naval Observatory Building, and the Pan American Union garden all provide oases for statuary, trees, gardens, shrubbery, and benches.

At present, the Departments of State and Interior, World Health Organization, Red Cross, Federal Reserve Bank, Peoples Life Insurance, Pan American Health Organization, General Services Administration, Civil Service Commission, and several other large agencies have their headquarters between Constitution Avenue and Twenty-Third Street.

One of the more important intersections on Virginia Avenue is the crossing with New Hampshire Avenue. Here, L'Enfant's plan for a circle has been reinstated. The circle, featuring the statue of Juárez, is one approach to the Kennedy Center.

A few blocks to the south of Virginia Avenue is situated the more famous Constitution Avenue. It is difficult to imagine that in 1931 Constitution Avenue was an underdeveloped thoroughfare called B Street and a dirty strip of water known as the Washington Canal in 1870.

Attempts to build a canal connecting Tiber Creek with the Anacostia River date back as early as 1791, but lack of funds delayed actual construction until 1815. Silting and tidal wash made the canal difficult to navigate for commercial transport, and the swampy regions along its borders became breeding grounds for insects carrying malaria and typhoid. During the Civil War years, the smell was so unpleasant that President Lincoln often rode out North Capitol Street to spend the night at the Old Soldier's Home during the summer months when the White House windows remained open. In 1872, after years of unsuccessful efforts to make the canal workable, a sewer main was built along the Tiber Creek bed, the waterway was filled and named B Street.

The McMillan Commission of 1901 was composed of Senator James McMillan, sculptor Augustus Saint-Gaudens, and architects Daniel Burnham, Charles F. McKim, and Frederick Law Olmsted, Jr. They suggested a grouping of federal buildings on the triangle between B Street and Pennsylvania Avenue (see chapter D), and urged a return to the architectural classicism L'Enfant had envisioned.

B Street became Constitution Avenue in 1933. The Fine Arts Commission pursued the aims set by the McMillan Commission, supervising the landscaping and approving the construction of all new buildings. Most of the edifices along Constitution Avenue were built in a modified Neoclassical style whose emphasis on purity and linear elegance kept sculptural decor to a minimum.

Title THE ADVANCEMENT OF
PHARMACY, 1934
Location American Institute of
Pharmacy Building,
2215 Constitution Avenue, NW
Sculptor Ulysses A. Ricci
Architect John Russell Pope
Medium Marble

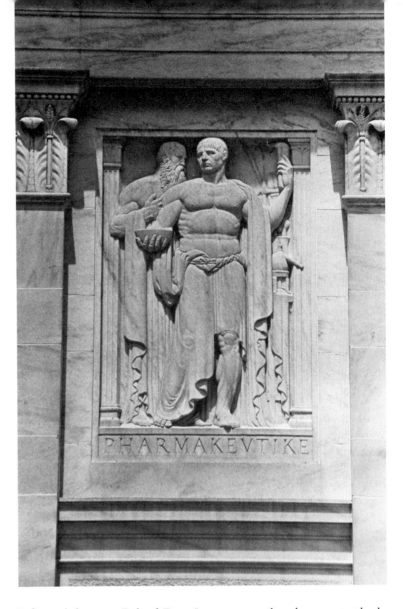

Left relief panel: The Progressive
Spirit and the Pioneer

Failure of the 1846 Federal Drug Law to prescribe adequate standards
for drugs and chemicals resulted in the organization of the American
Pharmaceutical Association. This building, dedicated in May 1932, is
the official home of the American Institute of Pharmacy. It houses a
valuable collection of historically important pharmaceutical objects and
is the headquarters for several organizations dedicated to the advance-
ment of pharmacy as a public health profession.

The building, designed by John Russell Pope in the Neoclassical style,
was described by Charles Moore, former chairman of the Fine Arts
Commission, as "a vital portion of the frame to the Lincoln Memorial
picture." The pair of high-relief panels, created by Ulysses A. Ricci,
are symbolic portrayals of the ideals of the institution; they measure
about 6 feet tall and 4 feet wide.

The left panel next to the main entrance shows two male figures in
classical dress. The youth in the foreground holds a bowl with an old
man looking over his shoulder. The youth represents the Progressive
Spirit; the senior stands for the Pioneer, observing the advancements
resulting from his earlier researches. The Greek inscription underneath
means "Pharmaceutical." The right panel depicts two classical figures, a
female in the foreground with an invalid male looking over her shoul-
der. The woman, symbolic of Hope, leads the invalid toward a lamp—
the Light of Curative Knowledge. The woman holds the staff of
Aesculapius (Roman god of healing); the invalid follows, hoping the
science of medicine will restore him to health. The inscription under-
neath reads "Light and Hope."

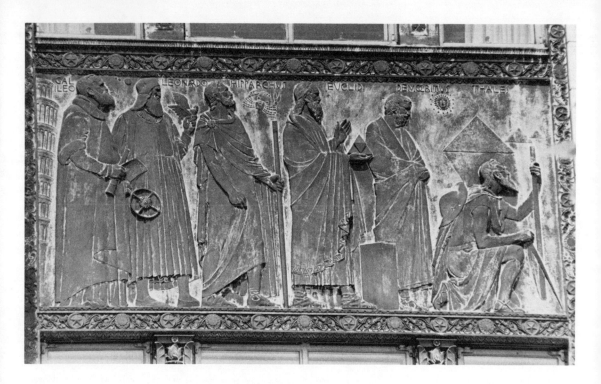

M-2
Title THE PROGRESS OF SCIENCE, 1923
Location National Academy of Sciences Building, 2101 Constitution Avenue, NW
Sculptor Lee Lawrie
Architect Bertram C. Goodhue
Medium Bronze

The National Academy of Sciences resided at the Smithsonian Institution until 1920. Then, under the leadership of George Ellery Hale, a noted solar physicist and founder of the National Research Council branch of the Academy, it was decided the organization needed a separate headquarters. Bertram C. Goodhue, an architect with a firm predilection for the freer Gothic style, was at first reluctant to assume the job. He is responsible only for the plan and massing of the building; all of the detail, exterior and interior, relating to sculpture, was created by Lee Lawrie.

Lawrie's six large bronze low-relief panels, measuring about 8 feet high and located between the windows, depict the Progress of Science to modern times. From the west end of the building, near Twenty-Second Street, the personages are: Sir Francis Galton (1822–1911) of England; Josiah Willard Gibbs (1839–1903) of Connecticut; Herman L. F. von Helmholtz (1821–1894) of Germany; Charles R. Darwin (1809–1882) of England; Sir Charles Lyell (1797–1875) of Scotland; Michael Faraday (1791–1867) of England; Alexander von Humboldt (1769–1859) of Germany; John Dalton (1766–1844) of England; and Jean de Monet Lamarck (1744–1829) of France. Others include James Watt (1736–1819) of Scotland; Benjamin Franklin (1706–1790) of Pennsylvania; Christian Huygens (1629–1695) of The Netherlands; Galileo Galilei (1564–1642) of Italy; and Leonardo da Vinci (1452–1519) of Italy. Next appear the following figures of ancient Greece: Hipparchus (146–127 B.C.), Euclid (fl. 300 B.C.), Democritus (ca. 470–380 B.C.), Thales (ca. 624–545 B.C.), Hippocrates (fl. 460 B.C.), and Aristotle (384–322 B.C.).

Others, continuing toward the east, include Nicolaus Copernicus (1473-1543) of Poland; Andreas Vesalius (1514-1564) of Belgium; William Harvey (1578–1657) of England; René Descartes (1596–1650) of France; Sir Isaac Newton (1642–1727) of England; Carolus Linnaeus (1707–1778) of Sweden; Antoine Laurent Lavoisier (1743–1794) of France; Pierre Simon Laplace (1749–1827) of France; Frederick Dagobert Cuvier (1769–1832) of France; Karl Friedrich Gauss (1777–1855) of Germany; Nicolas Carnot (1796–1832) of France; Claude Bernard (1813–1878) of France; James Prescott Joule (1818–1889) of England; Louis Pasteur (1822–1895) of France; Gregor Johanes Mendel (1822–1884) of Austria; and James Clerk Maxwell (1831–1879) of Scotland.

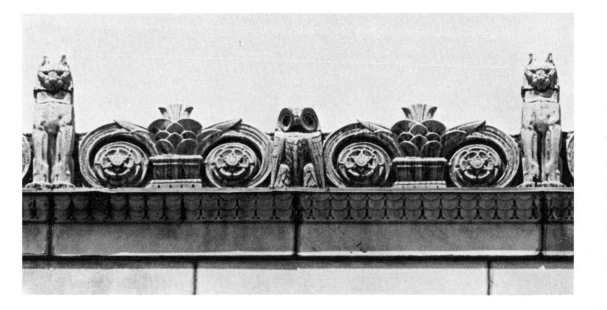

M-3

Title WISDOM AND OBSERVATION, 1923

Location National Academy of Sciences Building, 2101 Constitution Avenue, NW

Sculptor Lee Lawrie

Architect Bertram C. Goodhue

Medium Copper

The eaves of this handsome building are decorated with a 3-foot-high copper cresting composed of alternate figures of an owl and a lynx, typifying Wisdom and Observation; a serpent at each corner also symbolizes Wisdom. Below the cornice is a Greek inscription from Aristotle: "The search for Truth is in one way hard and in another easy. For it is evident that no one can master it fully nor miss it wholly. But each adds a little to our knowledge of Nature, and from all the facts assembled there arises a certain grandeur." A number of Neoclassical buildings in Washington have handsome cresting but the National Academy of Sciences Building possesses the most striking and unusual of them all.

Two sliding sculptured bronze doors, about 8 feet tall and usually concealed in the central entrance, show eight episodes in the scientific history of the world from Aristotle to Pasteur. Above the doorway is a small marble pediment in which the sculptor has portrayed the table of natural elements. The lampposts are interesting rectangular green marble shafts surmounted by a Classical female bust, who balances the globular light on top of her headdress.

The serpent at each corner of the cresting symbolizes Wisdom

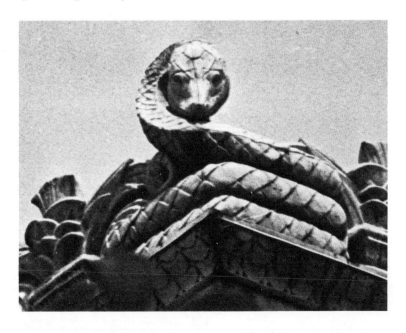

M-4
Title AMERICA AND THE FEDERAL
RESERVE BOARD, 1937
Location Federal Reserve Board
Building, Constitution Avenue and
20th Street, NW
Sculptor John Gregory
Architect Paul P. Cret
Medium Marble

*Left relief panel: figure symbolic of
the Federal Reserve Board holds a
caduceus and the seal of the
Federal Reserve Board*

In the Federal Reserve Board Building, architect Paul P. Cret of Phila-
delphia has fulfilled the Fine Arts Commission's recommendation that
the "... aesthetic appeal of the exterior design should be made through
dignity of conception, purity of line, proportion and scale rather than
through stressing merely decorative or monumental features."

The sole embellishments are an American eagle mounted over the
Constitution Avenue doorway by Sidney Waugh and the two high-
relief panels by John Gregory at the top of the piers or shafts on each
side of the C Street entrance. As the architect had stipulated, Sidney
Waugh's 6-foot-high eagle is "in the neo-Greek feeling, conventional-
ized to harmonize with the architecture." The pier reliefs were designed
by John Gregory. They consist of two seated female figures in Classical
dress. The figure to the right represents America; she is sitting in pro-
file, her right hand supporting the United States seal. The figure to the
left, symbolic of the Federal Reserve Board, is seated in the same man-
ner and measures about 10 feet tall; her right hand supports the Federal
Reserve Board seal, and her left holds the caduceus of Mercury, Roman
god of commerce.

M-5
Title GENERAL JOSÉ GERVASIO
ARTIGAS, 1950
Location Constitution Avenue and
18th Street, NW
Sculptor Juan M. Blanes
Architect Unknown
Medium Bronze

The bronze portrait statue standing in a small triangle at Constitution Avenue and Eighteenth Street is a replica of one in Uruguay. Sometimes called the "Gaucho Statue," it depicts the Uruguayan national hero in battle dress, one hand holding his hat, the other resting on the hilt of his sword. The inscription reads: "From the people of Uruguay to the people of the United States. Liberty of America is my dream and its attainment my only hope." The 9-foot-tall statue was paid for by the contributions of Uruguayan school children and an appropriation of the Uruguayan Chamber of Deputies.

José Gervasio Artigas (1764–1850), regarded as the revolutionary hero and father of modern Uruguay, was born in what was then known as La Banda Oriental (East Bank), son of a well-known rancher of Spanish ancestry. He was reared on the open plains, where he became a superb horseman, strong in mind and body, and possessed with a burning love for freedom.

As a young man he fought with Spanish forces against the English in the battle of Buenos Aires. However, it was not until the revolutionary movement in Argentina had succeeded in establishing a government

that he was drawn into the struggle for independence. The Buenos Aires junta persuaded him to head an insurrection in Uruguay. Marshaling a small force, mainly of gauchos (ranchers), some of whom were armed only with long knives attached to poles, and with the help of Argentine volunteers, he defeated the royalist troops. He captured 500 prisoners, most of whom came over to his side, proclaimed his allegiance to the government in Buenos Aires, and laid siege to Montevideo.

Artigas was a dedicated federalist, strongly influenced by the United States Articles of Confederation and the Constitution, a copy of which he was reputed to carry with him at all times. In line with his federalist views, he instructed the five delegates he sent to the 1813 Congress in Buenos Aires to advocate a complete break from Spain and almost absolute autonomy for Uruguay. When the Argentine government refused to recognize these delegates and displayed an arrogant disregard for Uruguayan interests, Artigas abandoned Montevideo and led an amazing exodus into the interior. His army, numbering 3,000, was followed by 13,000 men, women, and children loyal to him. He proclaimed himself "Protector of Free Peoples," and in the next few years gained control of most of the interior of present Uruguay and some provinces of Argentina.

Unfortunately, his movement lacked the support of any central organization and was without economic or financial resources. When Brazil invaded along the coast and conquered Montevideo, Artigas was defeated in a bloody battle and was forced to flee. For the next thirty years he lived as an almost forgotten exile in Paraguay. In recognition of his former exploits, he was given a small farm some distance from the capital. On the death of the Paraguayan dictator in 1840, there was evidently some fear that the 76-year-old former revolutionary might be a threat to the new head of state, and he was imprisoned. When he was released a year later, his farm had fallen into ruins, but the new dictator permitted him to live on as his pensioner until he died at the age of 86 in 1850.

It was the fate of Artigas, as with other of the early leaders in the struggle to free South America from foreign domination, that he was not to be accorded his rightful place as national hero and founding father until after his death.

M-6
Title QUEEN ISABELLA I, 1966
Location Pan American Union Building, Constitution Avenue and 17th Street, NW
Sculptor José Luis Sanchez
Architect Unknown
Medium Bronze

Isabella I, Queen of the Three Kingdoms of Spain and the New World, meets with regal serenity the visitors to the Organization of American States within the Pan American Union Building. The bronze life-sized statue wears the crown of Castile, and a mantle that bears the crests of Aragon and Leon. She holds a pomegranate from which a dove bursts forth. A gift of the Institute of Hispanic Culture of Madrid, the statue was cast using the lost-wax process.

Remembered as the queen who pawned her jewels to finance the first voyage of Columbus, *Queen Isabella I* was dedicated on April 14, 1966, on the 475th anniversary (old calendar) of Columbus's first sighting of

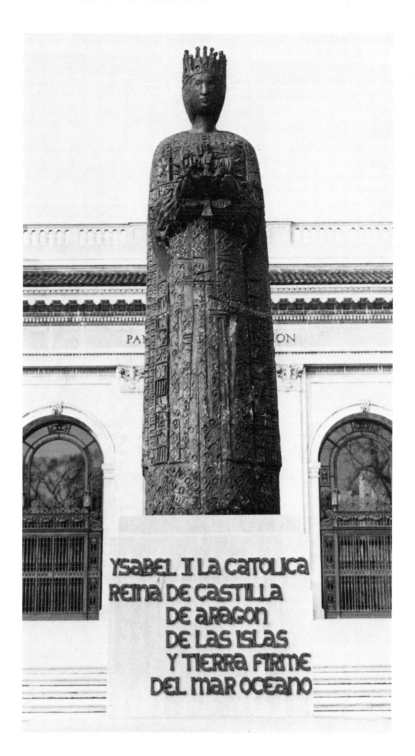

YSABEL I LA CATOLICA
REINA DE CASTILLA
DE ARAGON
DE LAS ISLAS
Y TIERRA FIRME
DEL MAR OCEANO

the New World. Queen Isabella (1451–1504) came from parentage of mixed nationalities. She was married to Ferdinand of Aragon in 1469; upon the death of her brother, Henry IV, in 1474, she was proclaimed Queen of Castile and Leon. In 1479 her husband became King of Aragon, thus uniting Spain under joint rulers for the first time in history. Queen Isabella had a profound moral influence on the nation, creating a court of complete virtue. She strongly supported the arts, forming the palace school and supporting such men of letters as Peter Martys d'Anghiera. Unfortunately her religious fervor resulted in several grave errors of national policy such as the Inquisition of Castile and the proscription of the Spanish Jews. Fernando Maria Castiella y Maiz, foreign minister of Spain, told the assembled ambassadors from North and South America at the time of the dedication that the gift was not simply an historical relic, "but a testimony of your European past and above all a token of future collaboration" with Spain.

M-7
Title SOUTH AMERICA, 1910
Location Pan American Union
Building, Constitution Avenue
and 17th Street, NW,
left of main entrance
Sculptor Isidore Konti
Architect Albert Kelsey and
Paul P. Cret
Medium Marble

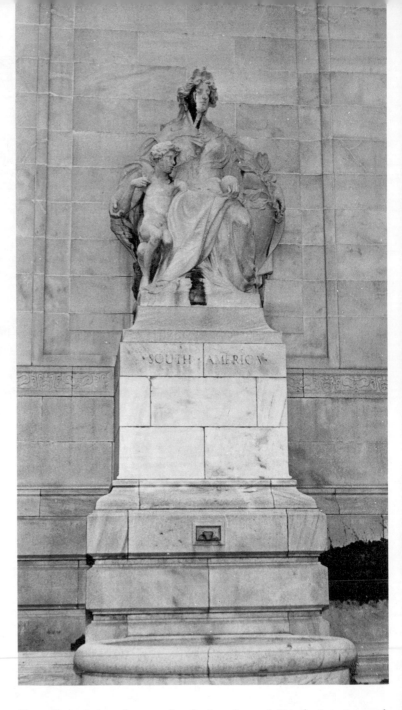

Two allegorical sculptures, *South America* and *North America*, each about 6 feet high and 5 feet wide, flank the entrance to the Pan American Union Building and symbolize the two continents of the Western Hemisphere. The bases of both pedestals serve as fountains. The draped female, representing South America, holds in maternal affection a nude boy approaching adolescence; the boy represents the youthful character of South America. The 1910 guidebook to the building describes this sculpture as follows: "The figure of South America, while young and strong, has a softer and more sensuous quality, expressive of tropical ease and luxuriance. The boy has likewise an easy grace of carriage; his friendly, lovable expression, imaginative and dreamy, conveys a sense of great future possibilities of which he is not yet conscious. The woman holds an olive branch, the boy a winged sphere."

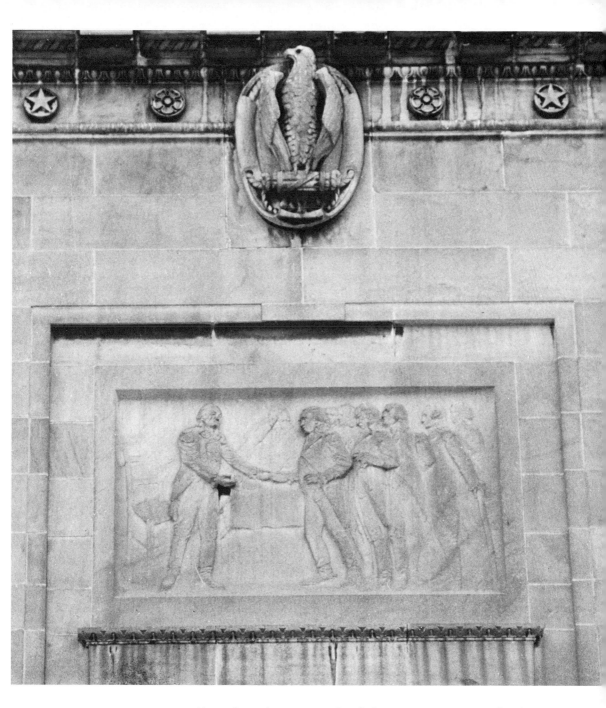

M-8
Title THE MEETING OF BOLÍVAR AND
SAN MARTÍN and
SOUTH AMERICAN CONDOR, 1910
Location Pan American Union
Building, Constitution Avenue
and 17th Street, NW
Sculptors Isidore Konti (*The
Meeting of Bolívar and
San Martín*); Solon Borglum
(*Condor*)
Architect Albert Kelsey and
Paul P. Cret
Medium Marble

Above the sculpture group *South America* appear two panels. The upper one, *South American Condor*, is a high-relief medallion about 3 feet in width. Below this is a 6-foot wide panel in low-relief depicting one of the most significant events in South American history, *The Meeting of Bolívar and San Martín*.

These two heroes of the struggle to free South America from Spanish domination, Simon Bolívar (see M-26) and José de San Martín (see Appendix I, 16), met only once during their careers, in Guayaquil on July 26 and 27, 1822.

San Martín, having been successful in forcing withdrawal of Spanish forces from Peru, set his next sights on the liberation of Ecuador, but he knew his troops were not strong enough for this undertaking without help from Bolívar. He also wished to discuss with Bolívar the status of the port city of Guayaquil, which his intelligence sources informed him wished to become a part of Peru. When he heard that Bolívar had entered Guayaquil early in July, peaceably at the head of a small force of 3,000 men, he considered the time for a meeting appropriate and set sail from Lima.

It was when San Martín was about to enter the harbor at Guayaquil that he learned from a passing ship what had occurred during the previous two weeks. Following street demonstrations of pro-Peruvian and pro-Colombian elements, Bolívar had declared the city under his protection and had raised Colombian flags on the public buildings. He announced that the final decision would rest with the vote of the Electoral College on July 28, but San Martín realized that the annexation of Guayaquil to Greater Colombia was a *fait accompli*.

San Martín may well have considered returning to Lima without going ashore, but the arrival of two properly couched letters of welcome from Bolívar convinced him that he could not refuse to participate in a meeting—the first of its kind—between the two men universally recognized as arbiters of South America's future. On short notice Bolívar arranged a ceremonial welcome for the vice-regal "Protector of Peru." The two men met twice, without anyone else present, once for thirty minutes and once for five hours.

The details of their discussions will probably never be known, though they have been the subject of continuing controversy among scholars and historians, clouded by later manuscripts which proved to be forgeries. San Martín never wrote an account of these meetings, and the notes made by Bolívar a few days later have been under suspicion by proponents of San Martín as misrepresenting San Martín's well-known views. It is probable that Bolívar gave only vague replies to the request for assistance in Ecuador. And it is known that Bolívar strongly opposed San Martín's belief that Peru should emerge into full independence only after a temporary stabilization period as a monarchy under a prince invited from Europe.

On the night of July 27, a ball was given in honor of San Martín. Before the end of the festivities he and his party slipped away, boarded ship and set sail for Lima. His total stay in Guayaquil had been forty hours.

Shortly after his return, discouraged by the abortive meeting with Bolívar, he became further disheartened by growing dissidence in Lima, government incompetence, lack of support from Buenos Aires, and a growing attitude of Peruvian unfriendliness. He returned to Argentina, resigned his command, and, not long after, sought exile in Europe, where he died in poverty in 1850.

Title NORTH AMERICA, 1910
Location Pan American Union
Building, Constitution Avenue
and 17th Street, NW, right
of main entrance
Sculptor Gutzon Borglum
Architect Albert Kelsey and
Paul P. Cret
Medium Marble

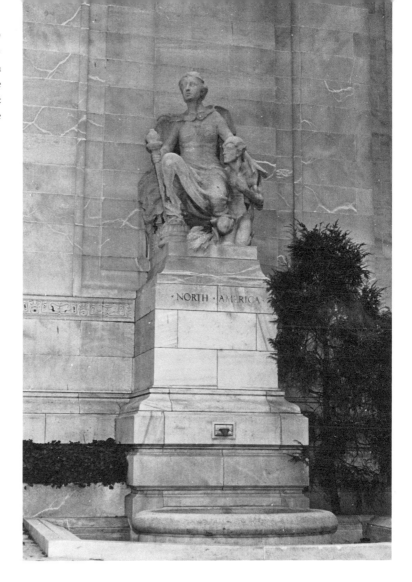

The North American group, right of the main entrance of the Pan American Union Building, consists of a draped woman holding a torch in her right hand. The boy with her was designed to appear more alert than his mate on the companion statue, *South America*, apparently to express the energetic spirit of the more fully awakened North.

The building against which *North America* rests is the headquarters of the General Secretariat of the Organization of American States (OAS). This oldest international organization unites twenty-four American republics in the common purpose of maintaining peace, freedom, and the welfare of the hemisphere. The architects designed the structure with a combination of French and Spanish Renaissance styles, with Aztec, Zapotec, Inca, and Maya motifs on the interior recalling the earliest inhabitants of this New World. The building, dedicated on July 26, 1910, was financed by contributions from each country and a generous gift from Andrew Carnegie. The United States donated the land. White marble from Georgia and black granite from the Andes were used during the two-year construction.

The Latin American character of the interior finds an architectural parallel in the richly designed bronze grilles of the three gates located between *South America* and *North America*. These gates recall work of a similar character in the choirs of the great cathedrals of Latin and Spanish America. The designs were suggested specifically by the grilles in the Cathedral of Saragosa in Spain. But the ideas thus conveyed have been freely adapted with the introduction of the eagles, condors, and tropical motifs from Latin America. Each archway of the grilles bears a pair of ornate lanterns filled with clusters of lamps.

Title WASHINGTON'S FAREWELL TO
HIS GENERALS and
NORTH AMERICAN EAGLE, 1910
Location Pan American Union
Building, Constitution Avenue
and 17th Street, NW, right
of main entrance, above
North America
Sculptors Gutzon Borglum
(*Washington's Farewell to His
Generals*); Solon Borglum (*Eagle*)
Architect Albert Kelsey and
Paul P. Cret
Medium Marble

These two reliefs are the work of brother sculptors. The upper one, a
3-foot-wide medallion of an eagle, representing North America, is by
Solon Borglum. The other is by Gutzon Borglum, a low-relief panel, 6
feet long and 4 feet high, depicting George Washington near the end of
his military career, bidding farewell to officers who had served under
him during the Revolution. Both panels are located to the right of the
main entrance above the allegorical statue *North America*.

As the American struggle for independence drew to a protracted
close, following the surrender of Cornwallis at Yorktown in 1781, there
were many months of negotiations during which General Washington
was still in command of a shrinking Continental Army that was not
called upon to fight and that was inadequately financed by the Congress.
On April 18, 1783, Washington formally dismissed the bulk of his
troops, assuring them of future consideration by Congress and con-
gratulating them on having assisted in "protecting the rights of human
nature and establishing an asylum for the poor and oppressed of all
nations." However, because there were still British forces on American
soil, he retained a small body of troops in a military camp at Newburgh
on the Hudson, New York.

Notification finally reached George Washington that the last British
contingent would leave New York City on November 25, 1783. Accord-
ing to contemporary observers, that morning dawned sunny and crisp,
as Washington, at the head of his small army, advanced down the island
of Manhattan. What they saw must have amazed and depressed them.
Hardly a tree remained standing; fences, barns, outhouses, and any-
thing that would burn had been chopped down for fuel. Houses still
intact, which had been used as barracks, stood in a landscape of barren
desolation.

A halt was ordered at the barrier of the inner city, Third Avenue and
the Bowery, to await the sound of cannon that would signal the final
embarkation of British troops. Then there was a further delay because
some of the departing British had removed halyards and cleats from
the flagpole and greased it. They watched derisively from the harbor as
one American climber after another attempted to reach the top of the
pole, only to slide down ignominiously. However, Yankee ingenuity
soon overcame this hurdle. Cleats were found, and the roar of thirteen
cannon shots announced that American colors now flew over the last
bit of territory to be held by the British.

Then, for the first time in the war, Washington assumed his rightful
role and led a triumphal procession into what was left of New York
City. He was mounted on a magnificent gray, with Governor George
Clinton riding at his side and with officers and prominent citizens fol-
lowing. The next few days were filled with celebrations and banquets
and fireworks, congratulatory addresses and toasts to the future of the
new Nation. A barge was readied to take General Washington to New
Jersey, but his military duties would not be ended until the actual
departure of the British fleet, which was still anchored in the harbor.

The fleet weighed anchor on December 4, 1783, and Washington was
free to start his journey. But first he wished to say a personal farewell to
officers still in his service and available to meet with him. It is this event
that the sculptured panel commemorates. At noon the small group met
in Fraunces Tavern—only three major generals and one brigadier, with
a scattering of other officers and friends. When all glasses were filled,
Washington raised his and said in a choked voice, "With a heart full of
gratitude, I now take leave of you. I most devoutly wish that your latter
days may be as prosperous and happy as your former ones have been
glorious and honorable." After drinking in silence, followed by the
others, Washington said, as his eyes filled with tears, "I cannot come
to each of you, but shall feel obliged if each of you will come and take
me by the hand." Then, as a member of the group recorded in his
memoirs, "every officer in the room marched up to, kissed, and parted

from his general in chief. Such a scene of sorrow and weeping I had never before witnessed."

Immediately after these moving farewells, General Washington boarded the barge and began his journey, along roads clogged by cheering crowds eager to see him and touch his hand. On December 23, 1783, his resignation was accepted by Congress duly assembled in Annapolis. He was then what he most wanted to be—George Washington, private citizen. On Christmas Eve, he reached his beloved Mount Vernon, where he hoped to spend the rest of his life in peace and retirement.

M-11

Title AZTEC FOUNTAIN, 1910
Location Pan American Union
Building, Constitution Avenue
and 17th Street, NW,
open-air interior courtyard
Sculptor Gertrude Vanderbilt
Whitney
Architect Albert Kelsey and
Paul P. Cret
Medium Red stone

The fountain in the center of the patio was modeled and executed by Gertrude Vanderbilt Whitney, who interpreted from the architect's design. The patio, with its exotic plants and the fountain, is surrounded by open stairways and corridors. It reflects Latin America at its best. By means of a sliding glass roof, a constant temperature could be maintained throughout the year. Since 1965, however, the roof has been kept closed because of the installation of central air conditioning.

The 8-foot-tall fountain has two superimposed basins, supported by three figures, each representing a period in the aboriginal civilization of countries south of the Rio Grande. The first is an archaic figure symbolizing the Mayan period, the second the Aztec, and the third the Zapotecan period. The basins are decorated with hieroglyphics of the three periods, among which the sculptor has carefully wrought out the date of the completion of the building (1910) by means of contemporaneous cycle marks and other hieroglyphics. Eight feathered serpent's heads are used in the center basins as gargoyles for the falling water. The serpent was assigned as a prominent feature of the fountain since it was long worshiped by the natives of Central America. The bottom of the fountain is of mottled marble, pink and white, with a Mexican star in the center, in which the superstructure stands.

The pavement of the patio, executed in especially designed Enfield tiles, contrasts with the polished marble floors of the surrounding corridors. This pavement reproduces well-known archeological fragments from Mexico, Guatemala, and Peru. One of the most striking mosaic designs is that of an ancient warrior in full feathered costume surrounded by exotic accessories.

This fountain was one of the wonders of Washington in 1910. The following account was published when the building was dedicated: "On occasion the national colors of the various countries are displayed in luminous running water; above, other effects in electric illumination show in the feathered serpents of primitive American forms, and the fiery tiny jewelled eyes of these creatures seem to wink. Both the colors and the changes of water are controlled at a keyboard desk in an adjacent room. Here they can either be set playing automatically, or a performer may even make the luminous jets keep time to the music of a band. It is doubtful if any electric fountain has heretofore been reduced to so compact a compass, the mechanism so completely concealed and so ingeniously combined with sculpture."

*One of the eight feathered serpent
gargoyles from which water spouts*

M-12
Title THE PROPHET DANIEL, 1962
Location Pan American Union
Building, Constitution Avenue
and 17th Street, NW
Sculptor Antonio Francisco Lisboa
(sculptor of the original)
Architect None
Medium Concrete

On the grounds of the Pan American Union Building, to the right of the main façade, is an 8-foot concrete replica of a statue of the Prophet Daniel, a gift of the Brazilian government in 1962. The original was carved in soapstone in 1805 by Antonio Francisco Lisboa, the first important sculptor of Brazil. Lisboa's carvings of the twelve prophets late in his career marked the high point of exuberant Brazilian Baroque style. The sculptor was in possession of some medieval manuscripts which he used as a basis for his own "brooding and twisting style." The original of *The Prophet Daniel* and the other prophets still adorn the stairway of the church of Bom Jesús do Matosinhos in the town of Conqonhas do Campo.

According to the Old Testament book of the same name, Daniel was one of the Judean captives in Babylon. He was chosen, along with other nobly born Jewish youths, to serve in the court of Nebuchadnezzar.

When it was learned that he had the power to interpret visions, the king summoned him to unravel the meaning of a dream that had troubled him. Daniel foretold that Nebuchadnezzar, because he had sinned against heaven, would lose his reason and wander among the beasts of the field, eating grass like the oxen, until such time as he should admit that there was a God on high more powerful than any earthly ruler, and then he would be restored to sanity and his throne. And so it came to pass, exactly as Daniel had prophesied.

Nebuchadnezzar was succeeded by his son Belshazzar, who in the course of a banquet drank wine from the gold and silver vessels which his father had taken from Solomon's temple in Jerusalem. Suddenly a hand appeared in the air and wrote four incomprehensible words on the wall, "Mene, Mene, Tekel, Upharsin." None of the royal astrologers or magicians could interpret this message, but the queen remembered that there was a man named Daniel, who in the days of Nebuchadnezzar was reputed to have "understanding and wisdom, like the wisdom of the gods." Daniel was brought before the king, where he told him that the words meant: "God has numbered your kingdom and finished it; you are weighed in the balance and found wanting; your kingdom will be divided among the Medes and the Persians." Despite this baleful prophecy, according to the Biblical account, Belshazzar ordered scarlet raiment and a gold chain for Daniel and proclaimed him the third ruler of the kingdom. But that very night the king was slain!

Daniel prospered under Darius, who looked upon him as the foremost of the three princes who governed under him. This favoritism aroused jealously among the courtiers, and, knowing that Daniel was faithful to the Jewish religion, they hatched a plot against him. Darius was persuaded to issue a decree that for thirty days none of his subjects could make a petition or pray to any god or man but him, on pain of being thrown into a den of lions. Daniel made no attempt to conceal his daily prayers to the God of Judah, and was duly accused by his detractors. In spite of Darius's longing to save Daniel from death, the laws of the Medes and Persians were considered so unalterable that he had to order the sentence carried out. After a sleepless night the king went at dawn to the lions' den and called, "O Daniel, is thy God able to deliver thee from the lions?" Overjoyed to learn that Daniel had been miraculously spared, Darius ordered the accusers thrown to the lions and issued a decree that all in his kingdom should "tremble and fear before the God of Daniel, for he is the living God."

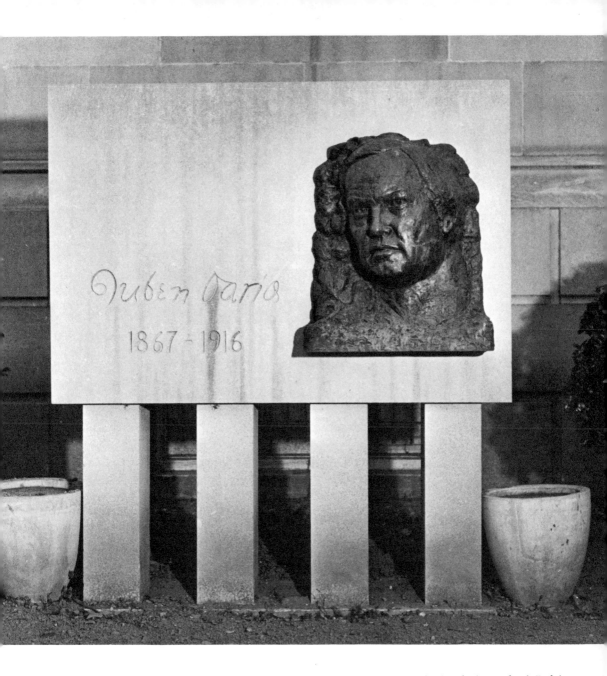

M-13

Title RUBÉN DARÍO, 1967
Location Pan American Union
Building, Constitution Avenue
and 17th Street, NW
Sculptor Juan José Sicre
Architect Unknown
Medium Bronze

This twice larger than life size, bronze, high-relief panel of *Rubén Darío* (1867–1916), Nicaraguan poet and literary critic, was erected in the south garden of the Pan American Union Building in 1967 by the Council of the Organization of American States to honor the poet on the hundredth anniversary of his birth. Darío, who is thought by many to be the greatest author to have written in Spanish in modern times, was the leader of the "Modernist" movement in Spanish literature. His works mark the first significant change from the traditional to the modern style in poetry in Latin America. He revived old meter techniques while at the same time inspiring bold new innovations. Darío's contribution to the "new poetry" was his vivid imagination, variety of literary allusion, flexibility, and rhythmical adaptation. His famous *Cantos de Vida y Esperanza* (1905) reflects his unique fervent dispair; while *Azul* (1888), a collection of short stories and poems, and *Prosas Prosanas* (1896), a collection of poems which exhibit the influence of the French Symbolist School, are his most significant literary productions. Darío resided both in South America and Europe, becoming consul of Nicaragua at one point. The portrait relief of Darío is mounted on a rectangular concrete slab supported by four concrete posts and framed by a low urn on each side.

Title José Cecilio del Valle, 1967
Location Pan American Union
Building, Constitution Avenue
and 17th Street, NW, rear garden;
north side
Sculptor Juan José Sicre
Architect None
Medium Bronze

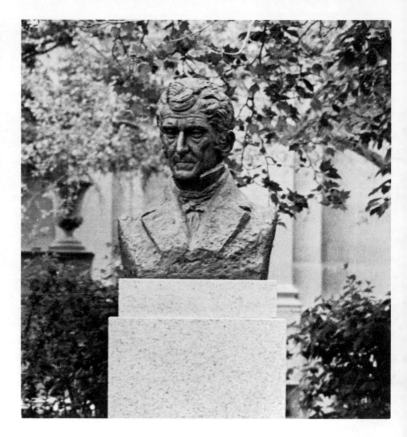

This slightly larger than life size bronze bust of *José Cecilio del Valle* (1776–1834) is located in the rear garden of the Pan American Union Building which now houses the Organization of American States. It was commissioned by the Council of the Organization of American States in 1966 to celebrate the twenty-fifth anniversary of the inter-American system designed to promote peace within the Western Hemisphere and to encourage trade and commerce among its member nations. The bust was placed here in December 1967.

José Cecilio del Valle was a distinguished Central American statesman, lawyer, and newspaper reporter who was born in Honduras. In 1820, with the achievement of Mexican independence from Spain, del Valle recommended the unification of most of Central America under a single legislative body. Iturbide, the conservative dictator of Guatemala, imprisoned del Valle shortly before the Guatemalan revolution. Del Valle then served in the Guatemalan legislature and was elected president of Guatemala shortly before his death in 1834. Del Valle remains important today as one of the most far-sighted leaders in Spanish-speaking America in his attempt to foster cooperation and unity among the nations of the Western Hemisphere.

Title CORDELL HULL, 1956
Location Pan American Union
Building, Constitution Avenue
and 17th Street, NW,
rear garden, south side
Sculptor Bryant Baker
Architect None
Medium Bronze

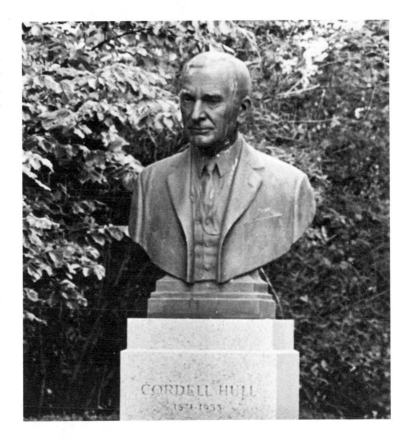

Cordell Hull (1871–1955) may have been the last famous public figure with what was once considered a necessary qualification for political success: he was born in a log cabin in Overton County, Tennessee. He graduated from Cumberland University and was admitted to the Tennessee Bar in the same year. After serving as a captain of volunteers in the Spanish-American War, Hull resumed his career and was appointed a judge in the Fifth Judicial District. In 1907 he was elected to Congress, where he served in the House with distinction, except for a two-year break, until his election to the Senate in 1931.

Hull was one of this country's early "internationalists." During the Wilson administration he came to believe that lower tariffs and the removal of other trade barriers would go far toward fostering peace and good relations between nations. He was a staunch supporter of the League of Nations and shared Wilson's bitter disappointment when the United States refused membership.

President Franklin D. Roosevelt chose Hull as his first secretary of state in 1933. In that office Hull negotiated far-reaching agreements designed to liberalize international trade. He also actively pursued the "Good Neighbor" policy in Latin America, playing an important role in various conferences and sponsoring a united front of American Republics against aggression. Hull also despatched the final American note to Japan on November 26, 1941, urging Japan to abandon its military conquests in China—not knowing that this was the same day on which the Japanese fleet had sailed for Pearl Harbor.

Throughout World War II he championed the idea of an organization of nations dedicated to the preservation of world peace. President Roosevelt called him the Father of the United Nations, and it was his role in the inception and establishment of the United Nations that won him the Nobel Peace Prize in 1945.

This bust of Cordell Hull, about 3 feet high, a copy of a 1945 work executed when he was 72 years old, was erected by the council of the Organization of American States in 1956 to commemorate his invaluable contribution to the cause of Pan Americanism and international harmony.

M-16

Title Xochipilli, Aztec God of
Flowers, ca. 1910
Location Pan American Union
Building, Constitution Avenue
and 17th Street, NW,
rear garden
Sculptor Unknown
Architect Albert Kelsey and
Paul P. Cret
Medium Painted stone

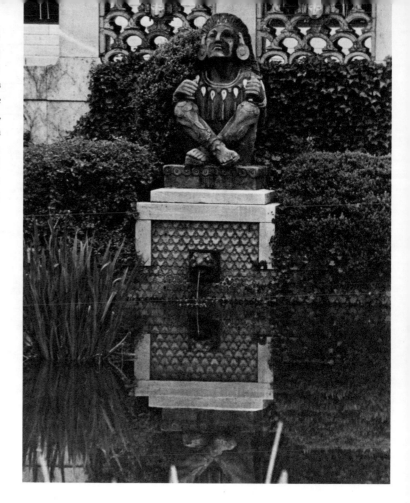

The grounds of the Pan American Union Building contain a number of statues and busts. The most colorful is a stone replica of the Aztec god of flowers, Xochipilli, who sits with crossed legs on a low pedestal at the west end of the reflecting pool. He is about 5 feet tall. During the summer months, water lilies float on the tranquil waters of the flower-rimmed pool.

This peaceful setting, however, belies the uses to which statues of this kind were put during the short-lived Aztec empire, which flourished in much of what is now Mexico for about two hundred years. Its final annihilation came at the hands of Cortez in 1521. The Aztecs were fierce and bloodthirsty warriors whose cruelty to their prisoners of war and to their own subjects has become legendary. They were sun worshipers who believed that the sun god would cease to shed his light if not propitiated by frequent offerings of his favorite drink—human blood. And the lesser gods, demons, and snakes shared his insatiable thirst. Sacerdotal idols and altar stones were erected not merely to terrify, but to hold a nation in religious fear and subjugation. Victims were sacrificed by having their hearts cut out and offered to the gods, while their limbs were roasted and eaten. The blood of thousands of prisoners was shed to sanctify the famous Aztec calendar, the Stone of the Sun, a circular sculptured block 12 feet in diameter and weighing over 25 metric tons, when it was dedicated in 1481.

The god of flowers, Xochipilli, who had the power to grant or withhold fertility and good harvests, was not a benign deity. The periodic rites held in his honor were known as the Feast of Revelations, during which the participants induced religious frenzy by the use of hallucinogenic drugs—peyote, hashish, and certain mushrooms known as the food of the gods. Statues of Xochipilli, many of which included carved representations of snakes and blossoms of the opiate white morning glory, were more frequently drenched in blood than covered with flowers.

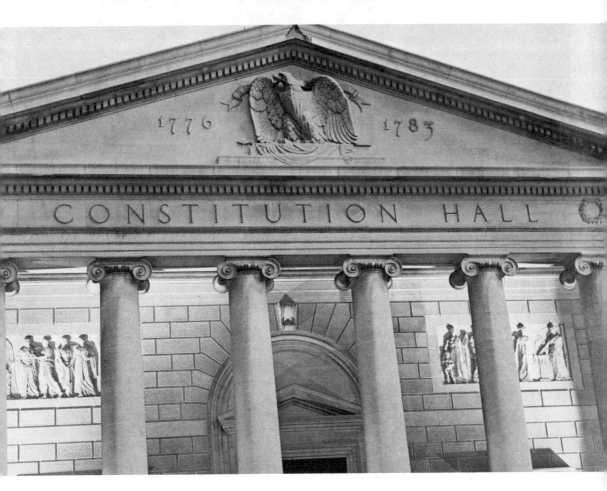

M-17

Title D. A. R. Eagle Pediment and
D. A. R. Neoclassical Relief
Panels, 1930
Location Constitution Hall, 18th
Street between C and D Streets, NW
Sculptor Ulysses A. Ricci after design
of John Russell Pope
Architect John Russell Pope
Medium Limestone

Because of District of Columbia fire regulations, Memorial Continental Hall, located to the east of Constitution Hall, was declared no longer safe to be used as an auditorium. The members of the Daughters of the American Revolution, owners of the building, voted at their thirty-fourth Continental Congress to build Constitution Hall on the remaining land back of Memorial Continental Hall, at a cost of $1,825,000. John Russell Pope presented ideas for the new building at this meeting in 1925; Pope's plans were drawn and accepted by April 1926, when construction began.

Pope's building contains an auditorium seating 4,000 persons. An Ionic entrance portico, surmounted by a 90-foot-wide pediment bearing a sculptured American eagle, accents the west façade. To the right and left of the eagle, respectively, appear "1776" and "1783," dates of the American Revolution. The huge elaborate low-relief panels on the wall under the portico show groups of Neoclassical figures. The specifications for the building dated September 25, 1928, contain the following information: "All specialized carving shall be done under this contract by skilled carvers, selected by the Architect, in a spirited and artistic manner from the plaster models prepared and approved by the Architect . . . for the flanking panels in the main portico and the figures in the pediment." Although the building opened for use in October 1929, the carving, executed *in situ*, of both the pediment and panels, was still in progress. No records exist today to explain the allegorical meaning of these 5-foot-tall panels, either in the Daughters of the American Revolution Library or in the Fine Arts Commission files. The building was built and is still maintained by the Daughters of the American Revolution.

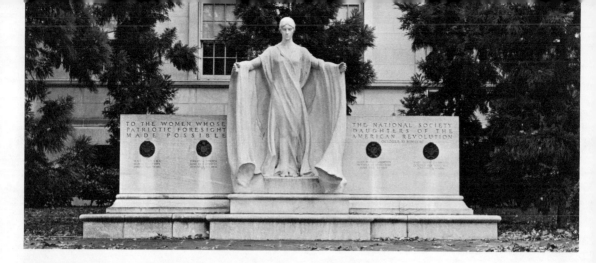

TO THE WOMEN WHOSE
PATRIOTIC FORESIGHT
MADE POSSIBLE

THE NATIONAL SOCIETY
DAUGHTERS OF THE
AMERICAN REVOLUTION

M-18
Title THE FOUNDERS OF THE DAUGHTERS
OF THE AMERICAN REVOLUTION, 1929
Location Garden, adjacent to
Administration Building, C Street,
between 17th and 18th Streets, NW
Sculptor Gertrude Vanderbilt
Whitney
Architect Unknown
Medium Marble

A memorial honoring the four founders of the Daughters of the American Revolution was dedicated in a beautiful garden setting adjacent to the society's two other buildings, Memorial Continental Hall and Constitution Hall, on April 17, 1929, anniversary of the Battle of Lexington. The single 9-foot-high figure, with flowing drapery and outstretched arms, symbolizes American womanhood. The founders are separately honored by engraved bronze medallions located on the long horizontal stele which forms the background for the statue. The design seems fitting, and the flagstone patio, together with the fine landscaping, is effective and beautiful.

Mrs. Whitney, the sculptor of the memorial and a D.A.R. member, was an artist of recognized ability. The Whitney Museum in New York City was her creation. She aided and encouraged many painters and sculptors of the 1920s and 1930s. Other works of Mrs. Whitney include the *Aztec Fountain* in the garden of the Pan American Union Building, a memorial to the *Titanic* victims, the *St. Nazaire Memorial* to the landing of American troops in France, and the *Columbus Memorial*, a gift to Spain.

The inscription on this memorial reads: "To the Women whose foresight made possible the National Society of the Daughters of the American Revolution." It was on October 11, 1890, that four women—Eugenia Washington, Mary Desha, Ellen Hardin Walworth, and Mary Smith Lockwood—founded this society dedicated to historic, educational, and patriotic service. Eligibility for membership is based on documentary proof of descent from a man or woman who played an active part, either as a member of the armed forces or as a civilian, in the struggle for American independence. In this connection the society has stimulated interest in genealogical research and has assembled an outstanding genealogical library, now housed in Memorial Continental Hall. Constitution Hall, built to accommodate the society's annual meeting, the D.A.R. Continental Congress, has been used during the rest of the year for concerts, lectures, and other cultural events, and was the home of the Washington Symphony Orchestra until its move to the Kennedy Center.

The society has a membership of almost 200,000, with 2,900 chapters in the United States and abroad. In addition to educational programs in history and citizenship available to public and parochial schools, it offers numerous scholarships; it also owns and operates two schools in which American history and patriotism are stressed. The society has been active in locating, restoring, and marking historic sites. One of these projects, that of marking the Old Trails used by westward-bound pioneers, has a connection with outdoor sculpture. Twelve identical sculpture groups of the *Madonna of the Trail* (see N-18), a 10-foot-high representation of a frontier mother in homespun carrying a baby and holding a small boy's hand, have been erected on historic roads from Maryland to California.

Title THE RED CROSS MEN AND WOMEN KILLED IN SERVICE, 1959
Location Garden of Red Cross Headquarters, D Street between 17th and 18th Streets, NW
Sculptor Felix W. de Weldon
Architect Unknown
Medium Bronze

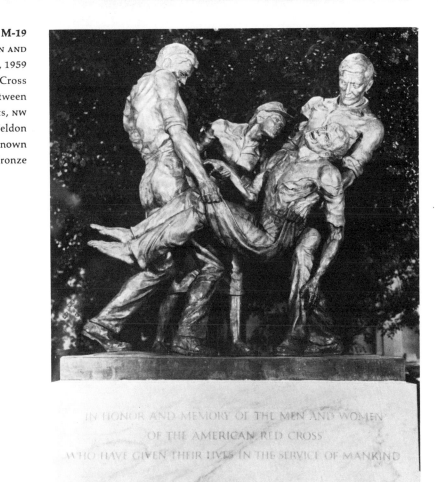

IN HONOR AND MEMORY OF THE MEN AND WOMEN
OF THE AMERICAN RED CROSS
WHO HAVE GIVEN THEIR LIVES IN THE SERVICE OF MANKIND

This 7-foot-tall sculpture group in the garden is a memorial to the men and women of the American Red Cross who gave their lives in the service of mankind. On the occasion of its dedication, sculptor Felix W. de Weldon discussed what he felt the monument should symbolize.

He had tried to show people giving generously of themselves to alleviate suffering, ready to serve with strong arms and sympathy. The faces of the statues show a compassion which occurs everywhere in the world; the figures wear no definite uniform, thus conveying the universality of Red Cross service. The central figure is a Red Cross woman aiding the suffering. Two men carry a wounded man; his helplessness is shown in the tension of the arms lifting him.

The memorial was presented by General Mark Clark to Roland Harriman, national Red Cross chairman, on June 25, 1959. It occupies a 5-foot marble base and consists of four 7-foot bronze figures. On the base is inscribed:

> In honor and memory of the men and women of the American Red Cross who have given their lives in the service of mankind in peace and war

The memorial was sponsored jointly by a national committee headed by General Clark and the American Overseas Association.

On the same day in Solferino, Italy, another monument was dedicated, incorporating stones from each country having Red Cross societies. It was there in 1859 that the French defeated the Austrians in a bloody battle which left 40,000 wounded and dying on the field. On that day Jean Henry Dunant, a young Swiss on a business trip, was in the nearby town of Castiglione. He joined in the work of relief and for several days saw at first hand the carnage and suffering of battle. But he was also impressed by the peasant women who paid no attention to the color of uniform when helping the wounded. "Tutti fratelli," they repeated—all are brothers. On his return to Geneva he determined to

write a brief account of his experience which might move people to prevent or reduce the suffering of soldiers. In 1862, Dunant published *A Memory of Solferino*, its final pages emphasizing the need for trained volunteers and international cooperation for the sake of humanity.

The response to this modest effort, which he circulated to influential people throughout Europe, far exceeded his expectations. The Geneva Society for Public Welfare rallied to the cause by appointing a "permanent international committee" and calling for an international conference. The end result was the diplomatic conference of 1864 in Geneva, with representatives from sixteen governments, which issued the first Geneva Convention and launched the movement for organizing volunteer societies. In recognition of Dunant's initiative, the Swiss flag with its colors reversed was chosen as the symbol of this humanitarian experiment.

When Dunant went bankrupt in 1867, he left Geneva and lived obscurely in various Swiss villages for the next thirty years. Final recognition came in 1901, however, when he was one of two recipients of the first Nobel Peace Prize. The anniversary of his birth, May 8, 1828, is now celebrated as World Red Cross Day.

M-20
Title JANE A. DELANO AND THE NURSES WHO DIED IN SERVICE IN WORLD WAR I, 1933
Location Garden of the Red Cross Headquarters, D Street between 17th and 18th Streets, NW
Sculptor Robert Tait McKenzie
Architect Unknown
Medium Bronze

This monument north of the garden walk of the Red Cross Headquarters honors Jane Delano, founder of the Red Cross nursing programs, and the 296 nurses who died in World War I. Miss Delano was born in Townsend, New York, in 1862, and received her training at Bellevue Hospital in New York City. She worked in the South, combatting yellow fever, and in mining towns of the Southwest before becoming Superintendent of Army Nurses. With the outbreak of the first World War, she became chairman of the Committee of Red Cross Nursing Services. Miss Delano died in a barracks hospital at Savenay, Brittany, France, in 1919, while on an inspection tour after the Armistice. On the day after her death, fellow nurses began a drive for a monument in her honor.

The monument was unveiled in 1933 by Anna Kerr, who was Miss Delano's friend during their days as student nurses. The 7-foot bronze statue represents the Spirit of Nursing coming forward with compassion, as shown by the outstretched hands. The figure is veiled and draped, but wears no specific uniform, thus conveying the universality of service. On a low pedestal is inscribed: "To Jane A. Delano and 296 Nurses Who Died in the War 1914–1918." A verse from the Ninety-first Psalm is inscribed on the white marble benches which extend on both sides of the statue: "Thou shalt not be afraid for the terror by night; nor for the arrow that flieth by day; nor for the pestilence that walketh in darkness; nor for the destruction that wasteth at noonday."

Miss Delano's devotion to the Red Cross recalls an earlier dedicated woman, Clara Barton, (1821–1912), founder of the American Red Cross, who was working in Washington when the first federal troops of the Civil War poured into the city in 1861—some wounded, many sick or lonely, poorly clothed and fed. So began her work of service to men in uniform, collecting supplies, storing and distributing them, even reading to and writing letters for men in hospitals. By badgering leaders in government and the army, she finally obtained a pass to carry volunteer services to the battlegrounds and field hospitals.

While traveling in Switzerland after the end of the Civil War, Clara Barton was introduced to the Red Cross idea and read for the first time Dunant's *A Memory of Solferino* (see M-19). During the Franco-

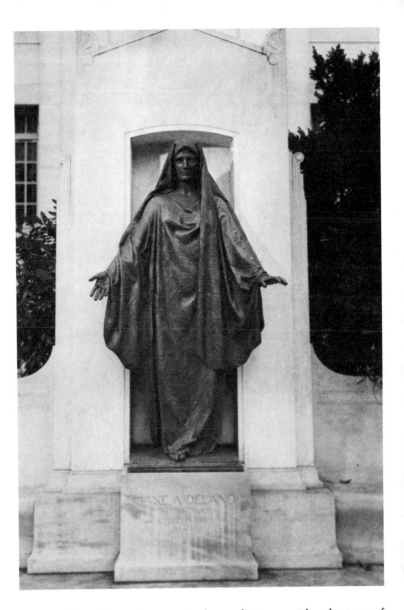

Prussian War of 1870 she went to the combat zone with volunteers of
the International Red Cross, distributing relief supplies in Strassburg
and setting up workshops for making clothes. In 1877, because of her
connection with the international movement, she was asked to present
a letter to President Rutherford B. Hayes urging the United States to
sign the Geneva Treaty. The Hayes administration did not accede to
this request, considering the Convention a possible "entangling alli-
ance"; Miss Barton's continued efforts were not successful until 1882,
when President Chester A. Arthur signed and the Senate ratified the
treaty.

In 1881 Miss Barton and a group of supporters formed the
American Association of the Red Cross as a District of Columbia cor-
poration, later to be reincorporated as The National Red Cross and
given charters by the Congress. The Red Cross flag was first flown in
this country in the same year, in an appeal for aid to forest fire victims
in Michigan. The idea of disaster relief in peacetime was new in the
Red Cross movement, but it dominated the first twenty years of the
American organization, and was adopted by other national societies. As
an indication of the magnitude of such services, the most costly year to
date saw $30 million in emergency relief given to 330,000 persons and
30,000 families at no cost to the recipients—and all accomplished by
volunteers and voluntary contributions.

Miss Barton's home in nearby Glen Echo, Maryland, where she lived
until her death, is now open to the public.

Title CANOVA LIONS, copies ca. 1860
after originals 1792
Location Corcoran Gallery of Art,
17th Street between New York
Avenue and E Street, NW
Sculptor Antonio Canova
Architect Ernest Flagg
Medium Bronze

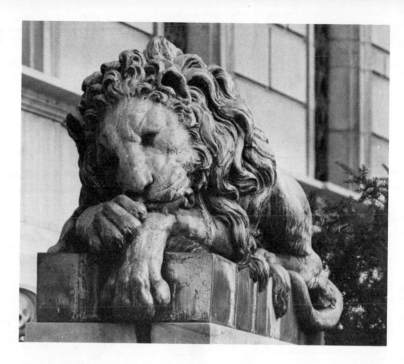

*A section of the original cenotaph
by Antonio Canova in memory
of Pope Clement XIII*

William Wilson Corcoran, Washington's first great philanthropist, became a millionaire in the 1840s from his banking and investment activities. In 1869 he founded the Corcoran Gallery of Art, located then at Seventeenth Street and Pennsylvania Avenue, NW, but later moved to the present Renaissance Revival building completed in 1897.

Two bronze lions with massive manes frame the entrance doorway. Facing each other in a reclining position, their muscular bodies measure about 8 feet in length. One is fully awake while the other appears to be half asleep. Their front paws are also slightly different. The *Canova Lions* were purchased in Rome about 1860 by businessman Benjamin Holladay for the front steps of his Victorian mansion located at 1311 K Street, NW, near the Franklin School. The lions, which cost $6,000, were a favorite of Holladay while they graced his front steps. They are bronze copies from molds made of the original marble pair carved by the celebrated Italian Neoclassical sculptor, Antonio Canova (1757–1822) for a cenotaph completed in 1792 for Pope Clement XIII, located in St. Peter's in Rome. In 1888, after Holladay's death, the Corcoran Gallery purchased the lions for $1,900 at an auction of his estate. They were erected on the steps of the old Corcoran Gallery on Pennsylvania Avenue that year but were moved to the present building in 1897.

The original owner of the lions, Benjamin Holladay (1819–1887), was born in a log cabin in Kentucky but became a multimillionaire by building the largest privately owned transportation empire in the West. By 1840, Holladay owned several wagon caravans which transported settlers from St. Louis to California. By 1862, his Holladay Overland Stage Company, which acquired the government contract for carrying the mails by pony express, had some 15,000 employees, 20,000 wagons and stagecoaches, and 150,000 horses and mules. His corporation bought out many poorly managed small stage lines during the Civil War years, extending his own stage system to over 4,000 miles. Immediately following the Civil War, he sold his stage line, reported to be the largest in the world, and invested in western steamships and railroads. He entered politics in Oregon shortly before the Civil War but failed to win election as the first United States Senator from that state. Badly damaged financially in the Depression of 1873, Holladay sold his transportation empire in 1876 and retired from business. During the Civil War, Holladay erected luxurious mansions in San Francisco, New York, and Washington, D.C.

Title MEMBERS OF THE AMERICAN
INSTITUTE OF ARCHITECTS WHO DIED
IN WORLD WAR II, ca. 1955
Location Octagon House, courtyard,
New York Avenue and 18th
Street, NW
Sculptor Lee Lawrie
Architect None
Medium Marble

The quiet garden between Octagon House and the headquarters building of the American Institute of Architects has been designated as a memorial to Institute members who died in World War II. This stele, placed in the southwest corner against the brick exterior wall of Octagon House attests to that dedication. Its inscription, in V-cut letters, reads: "This ancient garden in a new fashioning is dedicated to the memory of the men of the American Institute of Architects who gave their lives in world conflict for the security of their country and the cause of peace."

The form of this memorial is one not frequently seen in this country. It is an adaptation of the Greek funerary slab which evolved over the centuries from an earlier custom of erecting an upright wooden plank above a grave with the name of the deceased painted on it. For greater permanence the wood gradually gave way to crude stone slabs, incised with a name and often a short inscription meaning "farewell." The Greek genius soon elaborated these flat shafts into monuments on which, above the base, was carved in relief a standing figure or figures in profile representing what the deceased had been in life—a warrior with spear and leg greaves, a senator in flowing robes of office, a matron with a distaff. Many of the early steles were finished off with a flat capital on which sat a sphinx carved in the round, or occasionally the representation of a Greek temple.

By the fifth century B.C. the stele, though varying in richness of carving and ornamentation, had become the fairly standardized memorial in a Greek necropolis. Although their use persisted until the Hellenistic period, not many of these ancient steles are extant, partly because their cost confined their erection to wealthy patrician families and partly because many were cannibalized to be incorporated as building blocks in walls and public edifices.

The finial of this 10-foot-high memorial stele is a representation of the insignia of the American Institute of Architects—an American eagle with outstretched wings in front of a Doric column surmounted by a five-pointed star. Below this are two symbolic figures carved in high relief. Columbia, on the right, wears a Phrygian bonnet, the adaptation of a Greek warrior's helmet popularized during the French Revolution as a "liberty cap." In her left hand she holds a spear, and in her right hand a sprig of laurel which she is offering to the figure symbolizing Architecture, whose headpiece is a simple Greek temple.

Lee Lawrie, the sculptor of this stele, is known for the portrait relief of President Franklin D. Roosevelt which appears on the Roosevelt dime and the familiar statue of Atlas at Rockefeller Center in New York City.

Title MAJOR GENERAL JOHN A. RAWLINS, 1874

Location Rawlins Park, 18th and E Streets, NW

Sculptor Joseph A. Bailey

Architect Unknown

Medium Bronze

The portrait statue of Civil War *Major General John A. Rawlins,* cast from captured Confederate cannon, is well suited to the park in which it stands. It is one of the better portrait statues in Washington, and, despite a rather naive quality, has a certain elegance and spirit. Rawlins stands in repose, his field glasses in one hand, the other resting on his sword. The statue of Rawlins is one of the most traveled ones in Washington. Originally placed in Rawlins Park in 1874, he was visited in 1880 by veterans of the Grand Army of the Republic. Dismayed by the unkept grounds in one of the city's less desirable areas, they asked for another site; and the statue was moved to a corner at Tenth Street and D Street, NW. Its tenure there was short-lived, however, as the erection of a newspaper plant saw *Rawlins* replaced by *Benjamin Franklin,* a former printer and newspaper publisher. *Rawlins* next moved to Pennsylvania Avenue between Seventh Street and Ninth Street, until a public comfort station caused him to move across the street, where he rested until a new government administration building sent him back to then-more-respectable Rawlins Park. An unsuccessful effort was made in 1963 to remove the statue to Rawlins, Wyoming. In 1938, a reflecting pool and walks were added to the park where he now stands. The park, a delightful oasis in the center of the city and surrounded by small Victorian townhouses, has completely changed in character since the 1950s, when large office buildings replaced all of the small-scale historic structures. A lone survivor today is the historic Octagon House, erected in 1799 for the Tayloe family on the corner of Eighteenth Street and New York Avenue, NW.

Major General John Aaron Rawlins (1831–1869) was born and reared on a timber farm near Galena, Illinois, where his family produced charcoal for the nearby lead mines. After spending three years in California during the gold rush of 1849, Rawlins returned home and took up the study of law. He was admitted to the Illinois Bar in 1854 and practiced until the outbreak of the Civil War in 1861, at which time he strongly supported the Union cause. Rawlins took an active part in forming the organization of the 45th Illinois Infantry. At the same time, Ulysses S. Grant, his neighbor in Galena, reentered the United States Army as a colonel of the 21st Illinois Infantry. In August 1861, Grant asked Rawlins to serve on his staff as an aide-de-camp with the rank of lieutenant. From this date until the termination of the Civil War, Rawlins became Grant's closest military and personal adviser. Although untrained in the military, Rawlins possessed high moral standards, excellent business experience, and a strict sense of justice. Rawlins was especially important in persuading Grant to refrain from using spirits to excess during the war years. Grant saw that Rawlins was promoted in rank and responsibility each time that he himself received a higher rank. In March 1865, Rawlins was promoted to brigadier general and the following month to major general. In 1867 Rawlins accompanied General Grenville Dodge on a trip to the West in order to try to recover from a serious case of tuberculosis. During this trip, the town of Rawlins, Wyoming, was established at the site of one of their camp sites. Rawlins was further appointed to Grant's cabinet in March 1869 as the new secretary of war but he died five months later from tuberculosis, a disease which was not improved by his attempted recovery trip to the West two years before.

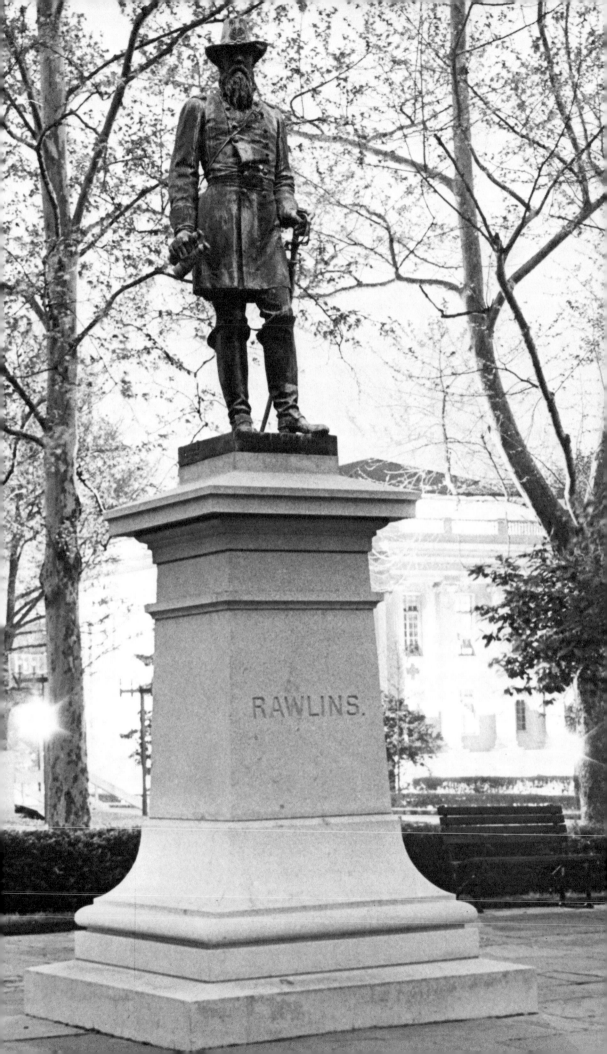

RAWLINS.

M-24

Title NEGRO MOTHER AND CHILD, 1934

Location Department of the Interior Building, C Street between 18th and 19th Streets, NW, inner courtyard

Sculptor Maurice Glickman

Architect None

Medium Bronze

One of the few monuments to American blacks in Washington is this statue by Maurice Glickman, *Negro Mother and Child*. The work was commissioned in 1934 by the Public Works of Art Project, Treasury Department, one of the four New Deal agencies which fostered art for public buildings. The original plaster cast of the statue is located in the library of Howard University in Washington, D.C. This piece received popular acclaim by the public and by leading New York art critics when it was first exhibited. It is practically unknown to most Washingtonians as its location is in the inner courtyard of the Interior Department Building. The statue measures approximately 6 feet high and 2 feet wide.

Depression years of the 1930s, when former brokers were jumping out of Wall Street windows and business executives were selling apples in the streets, were not conducive to a favorable climate in which the arts could flourish. To meet this problem the New Deal established the Works Progress Administration of 1935, renamed the Works Projects Administration in 1939 and liquidated in 1942. It was designed to provide jobs at minimum hourly wages, mostly in construction, but also in fields ranging from landscaping to the theater, in painting, sculpture, music, historical writing, and preservation of historical sites. Some of the best guidebooks of the United States were published under its aegis. Many post offices and other public buildings were enlivened by the murals it commissioned. Such government assistance for artists in all fields helped to transform a potentially disastrous period into an era of minor renaissance. Among names associated with these endeavors are John Steinbeck, William Faulkner, Thomas Wolfe, Ben Shahn, and Aaron Copland.

Title ABE LINCOLN, RAIL JOINER,
1940

Location Department of the Interior
Building, C Street between 18th
and 19th Streets, NW, interior
courtyard

Sculptor Louis Slobodkin

Architect None

Medium Bronze

Of the four statues of Lincoln in Washington, this bronze 7½-foot statue in the courtyard of the Department of the Interior Building is the least known. The sculptor's plaster cast of the statue was originally exhibited in the inner court of the Federal Building at the New York World's Fair of 1939. The bronze sculpture was commissioned by the Section of Fine Arts, Treasury Department, and installed in its present location in 1940.

The Interior Building, a massive structure occupying the entire block, was designed by the prominent Washington architect, Waddy B. Wood, and was constructed in 1935–1936. The only ornamental features are the seals of the thirteen original colonies, to be found across the south façade. Many of the original New Deal murals still decorate the interior corridors.

This portrait statue of Lincoln is not of the sixteenth president of the United States but of a tall, lanky farm hand who never dreamed of living in the White House or of signing an emancipation proclamation. This is Abe Lincoln, the friendly, easy-going, seemingly shiftless young giant who had been the ox-cart driver when, aged 21, he had trekked with the Lincoln family from Indiana to Illinois. There his father settled on a small farm. Young Abe's prowess with an ax stood him in good stead. Not only did he split logs for his own rail fences, but he contracted with a neighbor to split 3,000 fence rails for him—a contract that took more than a year to complete.

Abraham Lincoln (1809–1865) was born on a small farm in Kentucky, where he spent the first eight years of his life. His father tried to provide for his family—some farming, some carpentry—but was always restless, hoping that a move would bring better times. In 1816 the family moved to a small settlement in an unbroken forest in southern Indiana. During their first winter they lived in a "half-faced camp," a log cabin with only three walls, the fourth side being open. Young Abe, then eight years old, was given an ax and expected to assume his part in the frontier task of clearing the land for farming. There followed years of "pretty pinching times," as Lincoln later described them. He probably had little more than a year of formal education in a one-room country schoolhouse, with nothing much beyond "readin', writin' and cipherin'." Although, as he later pointed out, there was little incentive for a poor farm boy to get an education, he seemed to have an innate thirst for knowledge. He read and reread the few books that came his way. Some of these can be seen as sources for his mature literary style: the Bible, *Pilgrim's Progress*, Aesop's *Fables*, *Robinson Crusoe*, and Franklin's *Autobiography*.

M-26
Title GENERAL SIMÓN BOLÍVAR, 1959
Location 18th Street at C Street and
Virginia Avenue, NW
Sculptor Felix W. de Weldon
Architect Faulkner, Kingsbury, and
Stenhouse
Medium Bronze

General Simón Bolívar, "The George Washington of South America," is a symbol of the bond between the United States and her Latin American neighbors. The bronze figure, 27 feet from the top of its base to the tip of the sword, probably makes it the largest equestrian statue in the United States. This work was designed by Felix W. de Weldon, who fashioned the *Iwo Jima Memorial.* It was cut into five pieces for the journey from the New York foundry to Washington, a slow four-day trip in a flatbed truck that made numerous detours to avoid narrow bridges and other constructions unable to hold the 8-ton load.

The equestrian figure, donated by the Venezuelan government, shows Bolívar astride his horse with sword upraised urging victory. He wears a bronze reproduction of the gold medal given him by Lafayette and sent by George Washington Custis, adopted son of the first president. The statue stands on a base of black Swedish marble, flanked by a marble walk and a handsome reflecting pool with six fountains representing the countries Bolívar liberated.

Simón Bolívar (1783–1830) is generally recognized as one of the geniuses of the revolutionary movement that was abroad in the world during the latter part of the eighteenth century and the early decades of the 1800s. In addition to his brilliance as a political and military leader, his writings contain some of the finest perceptive analyses of

the theory of revolution and methods of achieving revolutionary aims. He can be credited, either directly or indirectly, with the independence of Venezuela, Colombia, Ecuador, Panama, Peru, and Chile, and has been officially invested with the title of Liberator by the congresses of all these countries.

Born in Caracas, Bolívar was the son of a wealthy Spanish nobleman, owner of vast tracts of land and numerous slaves. As a boy he was educated by tutors, one of whom, Simón Roderiguez, was steeped in the philosophy of Rousseau and his liberal views on education and the perfectability of the natural man. When Bolívar was fifteen, his widowed mother died, and he was sent to Spain to complete his education.

As a handsome young man of almost unlimited means, he traveled widely in Europe, where he was warmly received in fashionable and literary circles, and where he must have heard discussion of social changes and revolutionary theories. He was reunited with his former tutor Roderiguez, and it was to him, one day in 1805 as the two friends sat on a hill overlooking the once imperial city of Rome, that Bolívar announced his fateful decision: he vowed that he would devote the rest of his life to the freeing of Venezuela.

Arriving in Caracas in 1806, Bolívar was in time to join a junta that forced the Spanish captain-general to abdicate and that formed the first locally chosen government in South America. For the next few years the tide of fortune swung back and forth; the revolutionary government was opposed not only by Spanish forces but by fierce fighting from the native plainsmen. During this period Bolívar, at times in exile in Curaçao or Haiti, urged that a federal type of government be established once independence should be achieved. Bolívar declared war to the death against the Spanish rulers in South America and proposed that each colony there, as it was freed, join to form a single large new republic, to be named Colombia.

Throughout his career, Bolívar insisted that he wanted no office, but that he would be found with his soldiers whenever there was need. He was involved in more than two hundred battles, not all of which were either decisive or successful. His most notable achievement, still viewed with awe by military professionals, was in leading a tattered and ill-equipped army over the high Andes. He defeated the Spanish forces and was received tumultuously in Bogotá as the Liberator of Nueva Granada (now Ecuador).

During this same period, revolutionary forces were successful in the southern part of South America. San Martín, with a base in Argentina, had also crossed the Andes and gained a foothold in Chile and Peru. He and Bolívar, the two architects of South American independence, met for the first and only time in the west coast port of Guayaquil in 1822 (see M-8). What was discussed at this meeting will never definitely be known, but San Martín soon returned to Buenos Aires and, after retiring from public life, went into exile in Europe.

The field was now open for Bolívar to complete his grand scheme for a Greater Colombia. He eventually eliminated the last vestiges of Spanish influence from Peru, occupied upper Peru, which proclaimed itself the Republica Bolívar (present Bolivia), with Bolívar as its president.

The last years of Bolívar's life were clouded with dissent, criticism that he wished to be a supreme dictator, and factional quarrels that saw the various states pulling away from confederation to form separate nations. In 1830 Bolívar resigned in Bogotá and set out for the coast with the intention of returning to Caracas. His fortune now dissipated in the cause of South American independence, he was forced to stay in Santa Marta because he lacked funds to pay for his sea passage. There the tuberculosis from which he had suffered for years became acute, and he died on December 17, 1830. Twelve years later his body was taken to Caracas, where it is enshrined in the national Pantheon.

Sculptor de Weldon supervises assembly of the sections of General Simón Bolívar in 1959

M-27

Title DISCUS THROWER, 1956
Location Virginia Avenue and 21st
Street, NW, in Kelly Park
Sculptor Copy after Myron
Architect Unknown
Medium Bronze

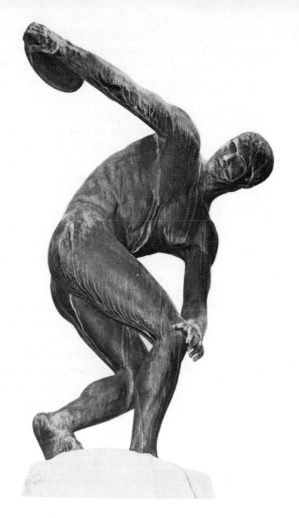

This bronze reproduction, ca. 1956, of the ancient Greek statue by Myron (fl. 450 B.C.) was cast in Florence, Italy, as a gift from the people of Italy to the people of the United States. It was presented by President Grondisi of Italy to President Dwight D. Eisenhower in appreciation for the return to Italy by the United States of Italian sculpture seized by the Nazis and removed to Germany during World War II. The most famous of the sculptures returned was *Discobolus*, or *Discus Thrower*, a Roman copy of the Greek original.

The original bronze statue was executed by the ancient Greek sculptor Myron, a native of the town of Eleutherae and a pupil of Ageladas of Argos. The little information known about him today has come from the writings of Pliny. Myron executed his earliest sculptures of animals. This training was excellent, for his later masterpieces executed in Athens of the *Discobolus*, the wrestler, and the runner, all reflect the mastery of the anatomy of the human form. He portrayed the glory of young athletes delighting in natural motion. In the *Discobolus*, Myron fixed the youthful athlete in that moment of rest which lies between two opposed motions—the backward swing of the right arm and the foreward movement on which the left foot is in the very act of starting. His face is turned back toward the discus about to be thrown by his right hand. The sculpture reflects the fantastic enthusiasm in ancient Greece for the *gymnasia*.

The 5-foot-tall sculpture is located in an attractively landscaped park, whose benches provide an ideal lunch-hour retreat for those who wish to admire the movement of the athlete and the simplicity of the 2,000-year-old Roman column on which it rests. The park was named for Edward J. Kelly, a local park official. Although the original Greek bronze statue by Myron has never been located, the image has survived through several ancient Roman marble copies, now located in museums in Paris, Munich, Naples, and London.

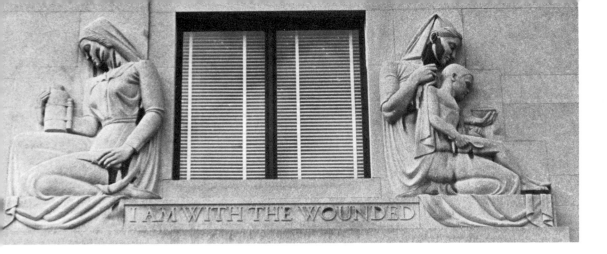

I AM WITH THE WOUNDED

M-28

Title AMERICAN RED CROSS NURSES,
1953

Location District of Columbia
Chapter of the Red Cross Building,
E Street between 20th and 21st
Streets, NW

Sculptor Edmond Romulus Amateis

Architect Eggers and Higgins

Medium Limestone

The Commission of Fine Arts in July 1951 referred to these reliefs as "vigorous and bold sculpture." In approving the design, the Commission questioned the original plans as unfavorable from the viewpoint of composition. Various members thought the placement of a window between the two figures detracted from the desired effect. Chairman David E. Finley objected to the drapery overlapping the corners of the façade as naive realism, which he believed weakened the architectural presentation. It was even suggested that the figures be reversed in order to improve the harmony of the entrance.

The sculptor, explaining his final design, shed interesting light on the work. The two figures and the words below, "I am with the wounded," were inspired by a telegram which had been sent from Havana by Clara Barton, founder of the American Red Cross (see M-20). It seems that a man named Harvey had written a three-stanza poem, with each stanza commencing: "I am with the wounded, I am with the starving, I am with the happy." Amateis felt that this poem expressed a sentiment worthy of this building, which was to serve as a blood bank headquarters. He created two kneeling figures, one holding a transfusion bottle and the other feeding and clothing the starving. The design attempts to symbolize the emergency and disaster relief work of the Red Cross. The Fine Arts Commission accepted the plan in July 1951, and the cornerstone was laid by President Harry S. Truman. The building was dedicated on October 1, 1953, by President Dwight D. Eisenhower.

The American Red Cross, whose early decades were devoted mainly to emergency and disaster relief to civilians, mushroomed during World War I; active chapters increased from 197 to 3,700 and membership from 16 million to 20 million. In addition to its many activities in war zones, the Red Cross supervised nationwide training in first aid and personal services to the armed forces in this country. Its total contribution for the war period was in excess of $400 million in money and supplies.

Another period of expansion took place during World War II, membership more than doubled, from 15 million to 36 million. An average of more than 4 million volunteers served in each of the war years. In four fund-raising campaigns voluntary contributions totaled $666.5 million. More than 75 million people in 40 countries received war relief. Also an important new service was instituted, that of the blood bank; 13 million pints of blood were collected. Recognizing the widespread need for blood plasma in times of peace as well as of war, the government has designated the Red Cross as the official institution to manage the blood bank program.

Furthermore, the American Red Cross is the instrument chosen by Congress to help carry out obligations assumed by the United States under certain international treaties, known as the Geneva or Red Cross Conventions. It is governed by volunteers, most of its duties are performed by volunteers, and it is financed by voluntary contributions.

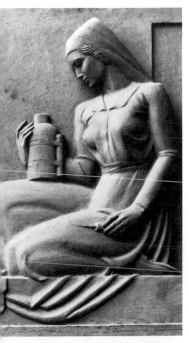

Clay model for the left figure of
American Red Cross Nurses

Title THE EXPANDING UNIVERSE
FOUNTAIN, 1962
Location Department of State, the
Foreign Service Court, 21st through
23rd Streets, on C Street, NW
Sculptor Marshall Maynard
Fredericks
Architect T. Clifford Noonan
Medium Bronze, nickel alloy, glass
mosaic, and granite

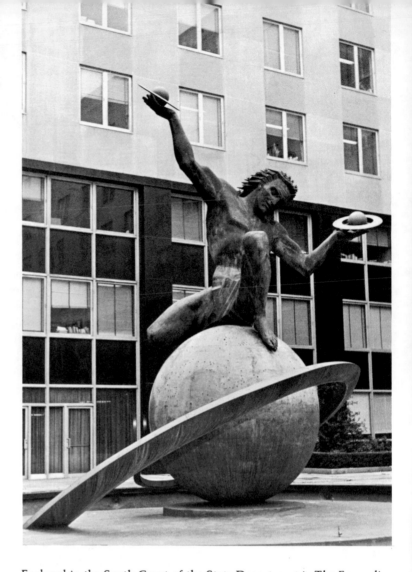

Enclosed in the South Court of the State Department is *The Expanding Universe Fountain*. Though bound on four sides by buildings, the strength and drama of the sculpture free the viewer from the architectural confinement of its site. Centered in a fountain, the statue is of a man, atop a globe, whose raised hands hold planets to the sky. Marshall Fredericks has modeled a statue which to him "represents this age of great interest, exploration and discovery in outer space . . . (and) the immensity, order and mystery of the universe."

The sculptor describes his design: "The monumental central figure suggests a superhuman mythological being. He is seated upon a 10-foot sphere, encrusted with a multitude of stars of various magnitudes set in the pattern of the principal constellations of the celestial system. In his hands he holds two planets which he is sending off into space. His hair, designed with jagged lightning-like forms, is studded with clusters of multipointed stars. The dynamic spiral orbit form, swirling around the sphere, represents the speed and perpetual movement of the heavenly bodies in space. Water sprays from numerous star-shaped jets in spiral pattern upon the figure—sphere, and orbit increasing the feeling of movement. The central figure and sphere are of cast green-patinaed bronze, while the orbit, planets, water sprays and the stars in the hair and on the surface of the sphere are of nickel alloy. The circular fountain basin, lined with glass mosaic with a graduation of color from dark to light green, is rimmed with a dark polished granite coping."

Fredericks, who lives in Cleveland, has studied in Munich, Paris, and London. His work reflects the influence of Swedish sculptor Carl Milles, with whom he has studied. He has been the recipient of many honors, including the Gold Medal of the American Institute of Architects.

Title ASCENSION, 1967
Location George Washington
University campus, Cloyd Heck
Marvin Center, 21st Street between
G and H Streets, NW
Sculptor Rudolph A. Heintze
Architect Mills, Petticord and Mills
Medium Stainless steel

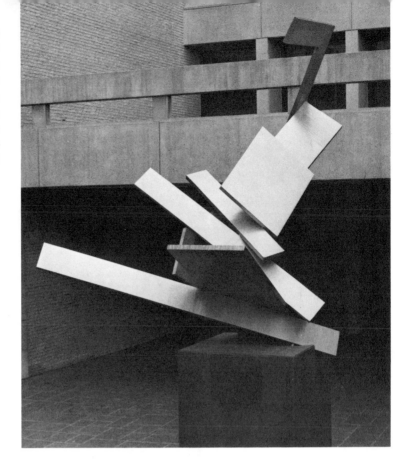

This sculptured work, which rises 20 feet into the air against the background of the George Washington University student center, is the creation of Rudolph Heintze who completed it for his master's thesis while a graduate student at the University. The piece is an abstract composition of varied-size rectangular components of stainless steel, welded together, resting on a 4-foot cubed granite base. It was purchased by Julian H. Singman, an alumnus, and given to the University.

In the written thesis, entitled "The Significance of Welded Stainless Steel Sculpture as a Reflection of Contemporary Existence and a Vehicle for Dynamic Artistic Expression," which accompanied the construction, Heintze places his work in perspective historically. He discusses the decline of traditional materials and concepts and cites historical precedents to his own work such as Picasso, Naum Gabo, Anthony Caro, and David Smith. He explains that the work embodies the existentialist idea that art should express human freedom or man's will to live and create. "It is the union of space and object which I am attempting to create as opposed to the traditional concept of the object merely occupying space," Heintze wrote. The sculpture is not a static mass resting on a horizontal plane surrounded by space; its multiple planes penetrate space and move through it. It is important to understand that the shapes are not symbols; they do not represent anything other than the plastic relationships between them. This work, with its stainless steel and machinelike structure, is not meant to symbolize modern technology. It is a "Constructivist" piece, not an "Expressionistic" one.

Heintze further explains in his thesis that work on the construction began with sketches, followed by experimental constructions on a small scale with stainless steel. After the design was decided upon, strips were cut from stainless steel sheets with an oxyacetylene outfit and then welded into the individual rectangles with an arc-welder. These pieces were ground down with an industrial hand grinder to remove all traces of welding and then were assembled into the final structure, again with the arc-welder. The final stage consisted of polishing the surfaces with various grained sanding discs.

Title THE NATIONS OF THE PAN AMERICAN HEALTH ORGANIZATION, 1970

Location Pan American Health Organization Building, 525 23rd Street, NW

Sculptor Michael Lantz

Architect Roman Fresnedo Siri

Medium Bronze

Seal of Barbados

The modern Pan American Health Organization Building is unusual in design because it consists of a curved rectangular main section connected to a circular council chamber completely faced with a concrete grille. The site, near the State Department buildings, valued at one million dollars, was donated to the Pan American Health Organization by the United States government in 1961. Roman Fresnedo Siri, the architect from Montevideo, Uruguay, solved the problem of the unusually shaped, 1-acre triangular site by designing a building which is raised above the ground on piers. Señor Siri, who admires the work of the French architect La Corbusier, was selected from among fifty-eight architects who entered the competition for the plans of the new structure. He planned four fountains for the plaza space in 1961. The original plans called for two fountains to hold bronze sculptures, one to portray the "birth of life" and the other "the spirit of space." Señor Siri designed the latter sculpture at the time but neither had been commissioned in 1973.

The architect originally planned for the seals of the founding nations of the Pan American Health Organization to be carved in granite panels and placed between the vertical fins of the exterior of the building as a symbol of unity. The twenty-nine seals, each approximately 2½ feet in diameter, were actually executed in bronze in the United States, having been designed by New York sculptor Michael Lantz. On the west end of the south façade can be found the following seals from left to right (adjacent to Twenty-third Street): Argentina, Barbados, Bolivia, Brazil, Canada, Chile, Colombia, Costa Rica, Cuba, Dominican Republic, Ecuador, and El Salvador. On the east end of the south façade are located the seals, from left to right, of France, Guatemala, Guyana, Haiti, Honduras, Jamaica, Mexico, The Netherlands, Nicaragua, Panama, Paraguay, Peru, Trinidad and Tobago, United Kingdom, United States, Uruguay, and Venezuela.

Shown here is the attractive seal or coat of arms of Barbados, which became independent from Great Britain in November 1966, yet has remained within the British Commonwealth sharing many political, cultural, and commercial ties with the mother country. This island nation's coat of arms was presented by Her Majesty Queen Elizabeth the Second in February 1966, during her first visit there. The gold shield

in the center consists of a bearded fig tree, after which the island was allegedly named, with two red Pride of Barbados flowers at the top. The crest at the top displays the raised forearm of a Barbadian holding two crossed sugar canes above a helmet. The dolphin on the left symbolizes the fishing industry, while the pelican on the right is a symbol itself of Barbados. The nation's motto, "Pride and Industry," appears on a ribbon at the bottom.

The fundamental aims of the Pan American Health Organization are to lengthen life and combat diseases in the Western Hemisphere. Twenty-six American governments are members with France, The Netherlands, and the United Kingdom as participating members because all three still have possessions or cultural and commercial connections in the Western Hemisphere. The organization was established in 1902 at an international conference in Mexico City due to the epidemics then raging in South America and Central America. The quarantine restrictions were not then uniformly enforced and, when they were implemented, travel was greatly disrupted. The original organization, the International Sanitary Bureau, became the Pan American Health Organization in 1958. The Pan American Health Organization, with headquarters in Washington, D.C., has regional central offices in Caracas, Mexico City, Guatemala City, Lima, Rio de Janeiro, and Buenos Aires.

The World Health Organization, organized in 1948 as a branch of the United Nations, headquartered in Geneva, Switzerland, operates to improve health services throughout the world. The Pan American Health Organization in Washington, D.C., serves as the regional office for the World Health Organization in the Western Hemisphere. Other World Health Organizations are in Brazzaville, Zaire, for Africa; Alexandria, Egypt, for the Mediterranean Sea area; Copenhagen, Denmark, for Europe; New Delhi, India, for southeast Asia; and Manila, The Philippines, for the Western Pacific.

M-32
Title DR. BENJAMIN RUSH, 1904
Location Naval Bureau of Medicine and Surgery, 23rd and E Streets, NW
Sculptor Roland Hinton Perry
Architect Louis R. Metcalf
Medium Bronze

Dr. Benjamin Rush (1745–1813) stands thoughtfully in the wooded park of the United States Naval Bureau of Medicine and Surgery. With his back to the Kennedy Center and the fast rising modern apartment houses below, he seems to have paused in reflection on his way into the fine old building which was, in 1843, the first Naval Observatory. A graduate of Princeton University, with a medical degree from the University of Edinburgh, Dr. Rush settled in Philadelphia to teach and practice medicine. Becoming active in the movement for independence, he was subsequently elected a member of the Second Continental Congress, signed the Declaration of Independence, and served for a time as surgeon-general. After the war, Rush was influential in support of the Federal Constitution and helped to draft the constitution of Pennsylvania. He was treasurer of the United States Mint for sixteen years before his death. Rush maintained a close attachment to Thomas Jefferson throughout his life. Indeed, his versatile interests and liberal and progressive tendencies were as marked as Jefferson's.

In his medical practice, Rush treated both wealthy and poor in Philadelphia. He opened America's first public health clinic (1786) and was famed for his courage in the Philadelphia yellow fever epidemic of 1793. Although Rush's medical knowledge was representative of the time, his theories and treatment of mental patients were surprisingly modern, earning him the title of the first American alienist (one who treats diseases of the mind). Further evidence of his humanitarian concern was his advocacy of temperance, education for women, and the abolition of public and capital punishment. Rush was cofounder of the

first American antislavery society and a founder of Dickinson College. He was a prolific correspondent and his recently published papers form an important record of the political and intellectual developments of the Revolutionary War period. Richard, one of his thirteen children, later became a distinguished American diplomat, serving as minister to Britain and France. It was Richard Rush who successfully argued the case of the United States in the disputed will of James Smithson in the London courts in 1836–1838. He personally brought back the Smithson bequest of one-half million dollars in gold coin, which was used to establish the Smithsonian Institution in Washington in August 1846.

The portrait statue *Dr. Benjamin Rush* was erected by the American Medical Association. The dedication on June 12, 1904, was attended by President Theodore Roosevelt, cabinet members, prominent officers of the Army and Navy and a distinguished group of American Medical Association members. The bronze statue is situated on a columnar pedestal of Indiana limestone. The inscription on the pedestal was at that time an often-quoted Latin phrase: "Studium Sine Calcamo Somnium," ("Study without a pen is dreaming"), perhaps best translated— "A scholar must record his findings otherwise his efforts are fruitless."

Title Benito Juárez, 1969
(copy, original executed 1895)
Location Virginia and
New Hampshire Avenues, NW
Sculptor Enrique Alciati
Architect Louis Ortiz Macedo
Medium Bronze

This 12-foot standing figure of Benito Juárez, called the builder of modern Mexico, was dedicated on January 7, 1969, a gift from the Mexican people to the people of the United States. Taking part in the ceremonies were former Secretary of State Dean Rusk, the United States ambassador to Mexico, the Mexican ambassador to the United States, and representatives of the Organization of American States.

In 1966 President Lyndon B. Johnson had presented the Mexican people with a portrait statue of Abraham Lincoln, erected in Mexico City. This portrait statue of Juárez completed the exchange of gifts. It was cast in Mexico City and was crated and trucked to Laredo, Texas; from there it continued the trip to Washington by rail. The statue arrived with a cracked leg and an arm almost severed; a local welding firm made the necessary repairs. The pedestal and base were designed in the United States. At the back of the base is buried an urn of soil taken from the Juárez birthplace in Guelatao, Oaxaca, where the original statue is located. Placed in the vicinity of the Pan American Union Building and the statue of Simón Bolívar, this monument has a particularly suitable location.

A more unlikely person to achieve preeminence in a country with a rich Spanish heritage could hardly be imagined than Benito Pablo Juárez (1806–1872), a pure-blooded Zapotec Indian. He was born to illiterate parents in a village in Oaxaca, one of Mexico's southernmost states. Orphaned at the age of three, he lived with an uncle and herded sheep until he was twelve, when he ran away to the city of Oaxaca, intent on learning to read and write and perhaps be educated for the Church. An older sister was already in the city, living with a middle-

class family and serving as cook. Juárez was taken on as houseboy, and once, he recalls in his biographical notes written forty years later, he waited on table when Santa Anna was a guest in the house.

Juárez was soon installed in the house of a bookbinder, who was also a member of a lay religious order. Here he quickly proved himself an apt pupil but soon showed little inclination to enter the priesthood. Liberal ideas were afloat in the city, and in the law he saw an opportunity to redress wrongs committed against the people.

In 1832, Juárez received a law degree and soon after was made an advocate of the Supreme Court; he became known as a liberal in politics and a defender of Indians in the courts. At the age of forty-one he was named Governor of Oaxaca and thus became more closely associated with the national scene. His views that the power of the Church should be curbed and greater democracy given to the common citizen made him suspect in clerical and conservative circles. It was no surprise, therefore, when Santa Anna seized the government in 1853, that Juárez was arrested. He managed to escape to New Orleans, however, where he joined other liberal exiles planning a return to power.

The next turn of the wheel saw Santa Anna overthrown and forced from the country. In the ensuing liberal regime, headed by Comonfort, Juárez was minister of justice and, within three years, pushed through a series of reform measures restricting privileges of the Church and the military. He also helped draft the anti-clerical Constitution of 1857, one provision of which was that, in the absence of a president, the minister of justice would succeed to the presidency until an election could be held. When a rightist coup captured the capital in 1858 and Comonfort fled the country, Juárez declared himself *de jure* president and set up the government in Vera Cruz. Encouraged by United States recognition early the next year, Juárez felt strong enough to issue sweeping reform laws that completely secularized and nationalized the Church. Two years later he was able to reenter Mexico City, where he was elected president. The task that faced him was almost insoluble— a huge national debt and no means of liquidating it. In 1861 he issued a decree suspending all payment of foreign debts for two years.

This touched off one of the most bizarre and tragic episodes in Mexican history. Napoleon III persuaded England and Spain, two of the other debtor countries, to join him in a Convention to force debt settlement. When his two partners withdrew their cooperation, Napoleon sent troops to Mexico, occupied the capital and declared the country a monarchy. The ill-starred Austrian Archduke Maximilian and his wife, Princess Carlotta of Belgium, were crowned as Emperor and Empress of Mexico. Juárez and his followers withdrew to the north, where they dug in near the United States border and stubbornly maintained that Mexico was still a republic with Juárez its legitimate president.

Maximilian's rule was beset by increasing political and financial troubles. His attempts to placate both the liberals and the rightists satisfied neither extreme, and France became less than eager to pour money into a shaky regime. The United States, after the Civil War, was able to look beyond its own borders, and demanded that French troops be withdrawn. The last of these left Vera Cruz in February 1867. Maximilian, who had stayed behind with a small group of his aides, was captured and executed, despite pleas for clemency from the United States and many European countries.

Juárez now returned to Mexico City, where he was almost immediately elected president. He was successful again in the election of 1870 against strong and rebellious opposition from Diaz. The problems he faced during his latter years were overwhelming—an impoverished country, devastated by decades of almost continuous fighting, hampered by a poor and ignorant populace too easily swayed by demagoguery from rival leaders. However, Juárez never swerved from his dream that Mexico should achieve independence under constitutional law.

Title AMERICA and WAR OR PEACE,
1969
Location Entrance Plaza to the
John F. Kennedy Center for the
Performing Arts, 26th Street and
New Hampshire Avenue, NW
Sculptor Jurgen Weber
Architects Edward Durell Stone;
Severud Associates
Medium Bronze

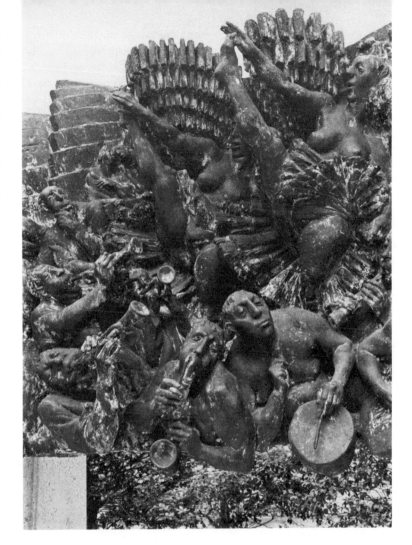

*These figures represent Peace in
the right relief panel,* War or
Peace

Two huge bronze panels, attached to the front of concrete piers, are
located on the entrance plaza opposite the main doors of the Kennedy
Center. These allegorical sculptures, Germany's gift to the Kennedy
Center, are among the most exciting bronzes in the city.

America, the 16-foot-wide panel to the west as one enters the plaza,
begins with a crowd of nude, starving Europeans, eagerly waiting for
an American freighter to unload bulging sacks of grain. To the right,
five plump American politicians argue before a Neoclassical building,
representative of government architecture. New York City, in the cen-
ter of the panel, is represented by skyscrapers with letters in place of
windows. One has the word "softsell" repeated many times, while an-
other is inscribed: "The meek shall inherit the earth." Canyons created
by the skycrapers are filled by monster cars, with giant teeth for grills.
Sensuous female mouths float above, portraying "love and lust." The
façade of St. Patrick's Cathedral is wedged between the masses of glass
and steel, indicating the predicament of modern religion. Huge flames
and smoke appear to envelop the *Statue of Liberty*, and *America* ends
with warships and a rocket to the moon.

The second panel, to the east, entitled *War or Peace*, portrays the
condition of the world today. It is not possible to be indifferent to the
ideas presented here: violence, sex, gaiety. On the far left, a person is
trapped in an underground bunker while the city burns above him. To
the right, a murder takes place in a bombed-out building; the city
smolders around these two scenes. After the violence, a father, a mother,
and a nursing baby appear. Through the family the viewer arrives
at Peace, presented by an orgy of kissing nude couples, people singing,
and finally a large party with can-can dancers and a jazz band. Louis
Armstrong is on the trumpet, and the lusty Greek goat-god, Pan,

plays the saxophone. Paul Richard, art critic of the *Washington Post*, described this sculpture accurately when it was erected in September 1971 as "comic strips in bronze." Few sculptures in the city have attracted as much curiosity as these by Germany's Jurgen Weber.

The numerous gifts by foreign governments to the Kennedy Center include two Matisse tapestries and a pair of Henri Laurens sculptures from France, and a sculpture by Dame Barbara Hepworth from Great Britain. The director of the National Gallery of Art, the secretary of the Smithsonian Institution and stage designer of the Kennedy Center constitute a panel who consider the acceptability of all art works offered as gifts.

In 1958 Congress authorized the establishment of a National Cultural Center, to be financed by federal funds and private contributions. After President Kennedy's assassination, the name of the Cultural Center was changed to The John F. Kennedy Center for the Performing Arts. The building, designed by Edward Durell Stone, was opened on September 8, 1971. Under one roof are the Opera House, Symphony Hall, the Eisenhower Theater, a smaller theater for motion pictures, and three restaurants.

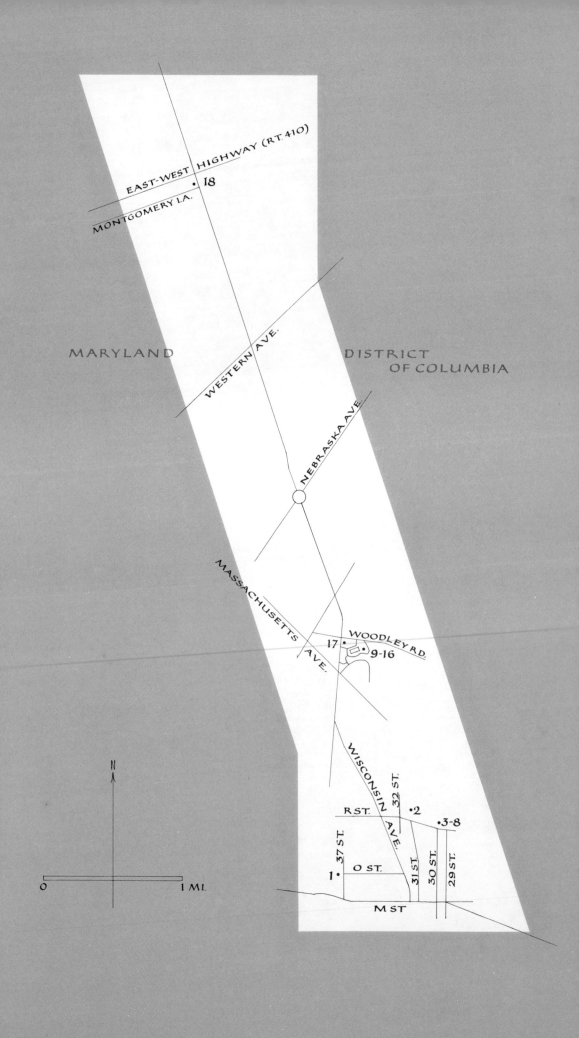

To MOST WASHINGTONIANS, Wisconsin Avenue means the main street of Georgetown, with its antique shops, boutiques, restaurants, and crowded sidewalks. This avenue, however, has a history which no other major street in the city can claim. It was the main commercial artery for the busy tobacco port of Georgetown, Maryland, from 1750 until the District of Columbia was created by Act of Congress in 1790. Known then and until 1881 as High Street, it existed as Thirty-Second Street from 1881 to 1906 when Congress renamed it Wisconsin Avenue. The western end of the street was known for many years as Braddock Road after the ill-fated march by British Major General Edward Braddock from Alexandria, Virginia, in 1755 to drive the French from western Pennsylvania.

Several of the original eighteenth-century warehouses still exist at the foot of the avenue on the waterfront. The Francis Dodge Warehouse, dating from 1790, has a foundation of great stone walls from an earlier warehouse thought to have been erected about 1760. During Georgetown's formative period, these warehouses were the center of commercial activity. They remained so until the Civil War, when the town began to lose commercial importance. Not until the 1930s did Georgetown come alive with the restoration of its many historic buildings.

Little sculpture can be found in Georgetown proper except for Oak Hill Cemetery, five blocks east of Wisconsin Avenue on R Street. Most of the sculptured monuments date from the late nineteenth century. Oak Hill is open during the week and offers the visitor a chance to wander along the intricate, terraced paths in a forestlike setting.

From Georgetown, the avenue extends due north to the Washington Cathedral area, a major concentration of fashionable apartment houses and gateway to the suburbs. The Washington Cathedral (Episcopal) is rich in both exterior and interior sculpture. Several medieval sculptured fragments from English and German cathedrals are located there in the Bishop's Garden adjacent to the flying buttresses which support the cathedral walls. The south portal is a lesson itself in religious iconography.

Beyond the gamut of commercial buildings in Bethesda, Maryland, where little sculpture exists, the avenue runs into relatively open countryside after finally passing the mammoth government agencies which include the Bethesda Naval Medical Center and the National Institutes of Health.

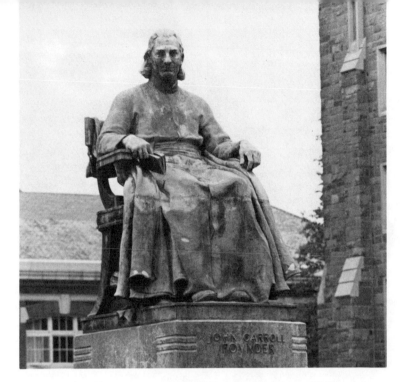

Title BISHOP JOHN CARROLL, 1912
Location Georgetown University campus, 37th and O Streets, NW
Sculptor Jerome Connor
Architect Jerome Connor
Medium Bronze

Bishop John Carroll, founder of Georgetown University, sits gazing toward the city of Washington. The portrait statue was given by the Georgetown Alumni Association after years of oratorical expressions on the aptness of such a monument for the main campus entrance.

John Carroll was born in Upper Marlboro, Maryland, in 1735. After studying at Liège, Belgium, he entered the Society of Jesus or the Jesuit Order. While teaching in England in 1773, Carroll heard about the Boston Tea Party and learned of the English oppression of his native land. He returned to Maryland in June 1774 and began teaching in the colony. His brother, Charles Carroll of Carrollton, was a signer of the Declaration of Independence. At that time, Father Carroll was asked to accompany Benjamin Franklin on the ill-fated negotiations with Canada concerning an alliance against the British.

Like most Jesuits, John Carroll believed the future of America lay in education. To achieve that goal he began to establish a university college just outside Georgetown, Maryland, on the banks of the Potomac in 1789. During that year, Pope Pius VI named Carroll the first Bishop of Baltimore, giving him spiritual responsibility for all American Catholics. Since Bishop Carroll's death, Georgetown has been given a federal charter and has become one of the largest and most prestigious Catholic universities in the United States still under the control of the Jesuits.

The statue of Bishop Carroll has become the focal symbol of the University. As such, it has been the butt of many college pranks. Students have been known to place commodes under the Bishop's chair. The University administration tried repeatedly to stop such desecration. In 1934, the space below the chair was blocked up with bronze books. In 1963, the statue was covered with red paint; Halloween jack-o-lanterns have appeared on Carroll's head. Students, it seems, have achieved an imaginative relationship with the Bishop.

The 6-foot-high bronze portrait statue stands in front of the University's fortresslike Romanesque Revival style Healy Building, designed by the Washington, D.C., architectural firm of John L. Smithmeyer and Paul J. Pelz. These architects, who had just designed the Library of Congress Main Building, were commissioned by Father Patrick Healy of Georgetown University in 1875. The spires and tower of the building form the most dominant landmark of Georgetown. With the completion of the structure, 1877–1879, President Rutherford B. Hayes and other dignitaries attended the dedication.

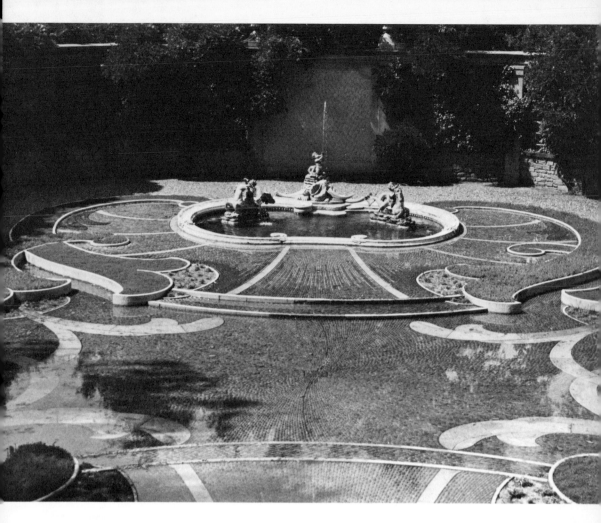

Title PEBBLE GARDEN FOUNTAIN:
sculpture, ca. 1800; garden,
ca. 1928
Location Dumbarton Oaks, R and
32nd Streets, NW
Sculptor Unknown; Vincent
Benedetto (garden)
Architect Mrs. Robert Woods Bliss;
Mrs. Beatrix Farrand, designer
Medium Lead

The Dumbarton Oaks Center for Byzantine Studies, which now belongs to Harvard University, was founded by Mr. and Mrs. Robert Woods Bliss, who bought the historical estate in 1920 and transformed the rambling wild lands and careworn house into their present glory. Mrs. Bliss's interest in landscape gardening and her enchantment with the formal gardens of Europe prompted her to employ Mrs. Beatrix Farrand, one of the finest landscape architects of the time, to supervise the renovation of the grounds. The house, which had been much altered since its construction in 1801, was restored to its original Georgian style. Between 1801 and 1920 the estate changed hands nine times and it was renamed four times. The original colonial grant for this land was made in 1702 to Ninian Beall, a Scot who was born at Dumbarton on the Clyde. He named his estate The Rock of Dumbarton for his birthplace. The Bliss family readopted this name when they acquired the property.

The Dumbarton Oaks Gardens are the most beautiful of any gardens open to the public in the city. They can be visited daily from 2 to 5 P.M. except on legal holidays, but are closed July 1 through Labor Day and during inclement winter weather. Scattered throughout the gardens are various European sculptures purchased by Mrs. Bliss in the 1920s and 1930s when she was traveling extensively with her husband who served in the United States Foreign Service.

Adjacent to the swimming pool is a delightful small terrace, backed by masses of boxwood, from which one can view the entire Pebble Garden. The terrace was originally built for spectators to watch tennis matches on the court below. During the spring and summer seasons the rectangular Pebble Garden, composed of a paving of especially designed pebble mosaics, is covered with a shallow layer of water about 2 inches deep. The view of this vast expanse of water is climaxed at the north end where one finds the graceful *Pebble Garden Fountain*, com-

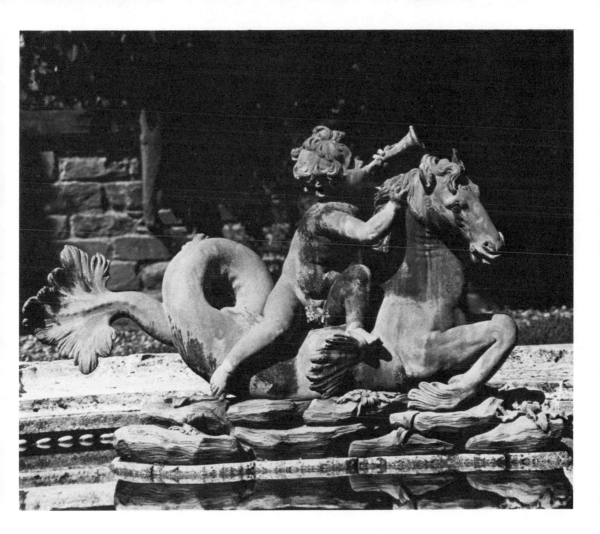

Detail: putto and seahorse on the right side of the Pebble Garden Fountain

posed of three sculptures. From the hands of the putto in the center a tall stream of water spouts skyward. On each side are found putti riding seahorses, each about 3 feet high. The Italian character of the scene can be attributed to its creator, Vincent Benedetto. This sculpture was purchased in Paris in 1933 by Mr. Erwin Laughlin for the garden of his home, Meridian House, and presented by his daughter, Mrs. Hubert Chanler, to Dumbarton Oaks in 1959.

Many other miscellaneous garden sculptures, some purchased in Europe and others created when the gardens were laid out, are found throughout the 16-acre estate. In the "Orangerie" are two copies of eighteenth-century terra-cotta sphinxes, while four oval medallions representing the seasons line the walls. In the Ellipse is found *The Urn Fountain*, a 6-foot-high shaft supporting a marble urn swathed with drapes and mounted on a pedestal which sports four putti's heads spilling water into the pool below. This antique French garden work was purchased by Mrs. Bliss in 1927.

Visitors to Dumbarton Oaks can purchase an excellent guide to the plantings, individual gardens, and garden sculpture at the entrance on Thirty-Second Street: *Dumbarton Oaks, A Guide to the Gardens*, by Georgina Masson. While on the estate, visitors should see the Byzantine and Pre-Columbian Collections housed in a modern wing north of the main house. This collection, assembled over many years by Mr. Bliss, is one of the most prominent in the United States.

Oak Hill Cemetery

Oak Hill Cemetery is located at R Street and Thirtieth Street, NW, at the top of the long hill above the Potomac River which forms Georgetown. Its 12½ acres descend from R Street, in a series of ravines alternating with plateaus, to the rocky banks along the rushing waters of Rock Creek Park below. The land was purchased by Washington banker and philanthropist William Wilson Corcoran and established as a nonprofit cemetery with a trust fund. It was chartered by Congress on March 3, 1849, as Oak Hill Cemetery, so named for the grove of huge oak trees which still stand among the 17,000 graves.

Corcoran commissioned George F. de la Roche to lay out the original drives of the cemetery and the handsome three-story brick Italianate Gatekeeper's House in 1849. In 1850, the New York architect James Renwick, Jr., designed the small and charming Gothic Revival chapel which still stands nearby. This site was used from the late eighteenth century until its formation into a cemetery as a fairgrounds and picnic area by Georgetowners. It was here, on the land formerly known as "Parrott's Woods," that the annual Fourth of July celebrations were held. In June 1814, a huge banquet was held for Colonel George Peter and the 280 District of Columbia militiamen under his command who had just returned from Benedict, Maryland, where they had unsuccessfully tried to locate the British invaders. Two months later, on August 24, the same troops fought the British Army at the Battle of Bladensburg in nearby Maryland and received a sound beating.

Behind the iron fences and massive gates of Oak Hill Cemetery, the visitor finds a striking view of thickly clustered white monuments, shafts, broken columns, pedestals, angels, crosses, and granite globes. These cemetery sculptures cling to narrow terraces along the wood ravines which plunge to Rock Creek. Here one finds the names of those families most closely associated with the growth of Georgetown and Washington City—Linthicum, Thomas, Marbury, Poe, Beall, Abbott, Magruder, Orme, and many more. Many of the early nineteenth-century graves and monuments were moved here from the old Presbyterian Cemetery which once occupied the block in Georgetown on Que Street between Thirty-Third Street and Thirty-Fourth Street. Two small Neoclassical temples serve as final resting places for families who have made distinctive contributions—the Corcoran-Eustis Mausoleum and the Van Ness Mausoleum. The cemetery contains the remains of many persons who have left their mark on the destiny of the Nation—Edwin M. Stanton, secretary of war under President Lincoln; John Nicolay, private secretary to President Lincoln; Peggy O'Neale Eaton, whose marriage to President Andrew Jackson's secretary of war split the Cabinet in two; John A. Joyce, the poet; and many others.

Italianate Villa Gatehouse at entrance to Oak Hill Cemetery is still used as the superintendent's lodge and office

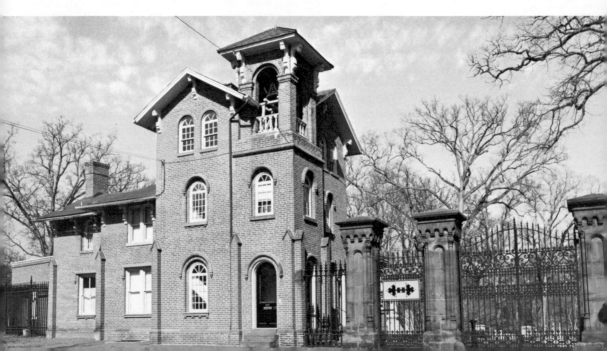

Title BISHOP WILLIAM PINKNEY, 1883
Location Oak Hill Cemetery, R and
30th Streets, NW, adjacent to the
rear of the gatehouse
Sculptor Unknown
Architect None
Medium Marble

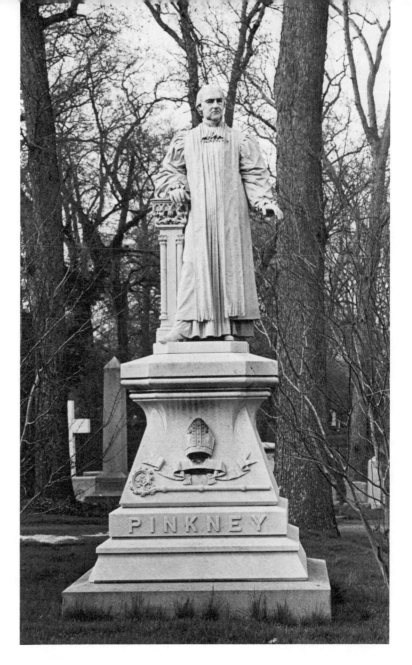

This life-size marble statue of the Right Reverend William Pinkney (1810–1883) was erected by his life-long friend William Wilson Corcoran. Pinkney, upon graduation from St. John's College in his native Annapolis, studied law briefly before he began the study of theology at Princeton University and the General Theological Seminary in New York City. He was ordained a deacon at Christ Church, Cambridge, Maryland, before his appointment as an Episcopal priest at All Saints' Church in Frederick, Maryland, in 1836. Most of his professional career as a clergyman was spent as rector of St. Matthew's Church, Bladensburg, Maryland, and of the Church of the Ascension at Massachusetts Avenue and Twelfth Street, NW. In 1879 he became the fifth Protestant Episcopal Bishop of the state of Maryland. From then until his death on July 4, 1883, he donated half of his annual salary of $4,000 to the poor and needy.

The base of the statue has the following inscription, typical of the Victorian cemetery prose of that era:

A guileless and fearless man of God: brilliant in intellect, steadfast in trial, tender and true in friendship, he so adorned his life with manly virtues and Christian graces that his earthly career remains an imperishable memento of that apostolic spirit of which he was both eloquent advocate and beautiful example.

Title Spencer Monument, 1928
Location Oak Hill Cemetery, R and
30th Streets, NW
Sculptor Tiffany Studios
Architect None
Medium Granite

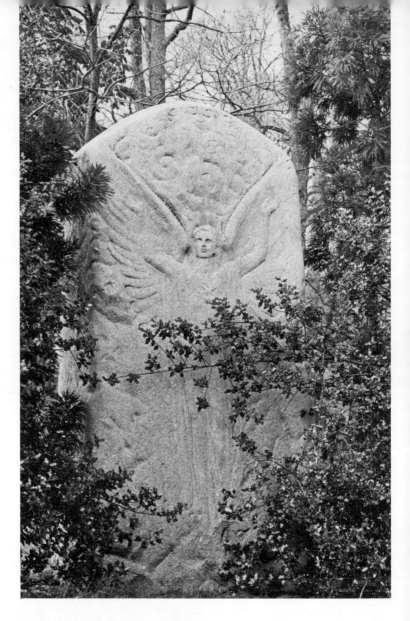

In the Spencer family burial ground, 30 yards northwest of the gate-house, is a large granite low-relief panel of an angel with upraised wings and arms. The monument, 12 feet high and 6 feet wide, is unusual in that most angel motifs in the cemetery are executed as free standing statues.

The panel is also unusual in its attribution of origin: on the lower rear corner it is signed "Tiffany Studios, 1928." This is the famous art atelier first established by Louis Comfort Tiffany (1848–1933) in 1879 under the name "Louis C. Tiffany and Company, Associated Artists" and personally supervised by him until a year before his death, when depression years and changes in public taste forced it into bankruptcy.

The recent revival of interest in Tiffany creations, particularly glass, has resulted in a new evaluation of a man who exerted a tremendous influence on this country's taste in home furnishings, but whose work was almost forgotten for several decades. Son of the founder of Tiffany and Company, Jewelers, he showed no interest in his father's business but as a young man studied painting under George Inness and in Paris studios. During his wide travels he was impressed by Byzantine mosaics and the stained glass windows of Europe. He experimented with both media, but soon concentrated on the making of glass, attempting to produce glowing colors and gradations within the glass itself that could imitate flesh tones and variegated foliage without the necessity of added etching or painting. He was eminently successful in these efforts, as well as in achieving an opalescence that allowed spectacular effects. He

obtained patents for his special process under the trade name of Favrile Glass—the word adapted from the Old English *fabrile*, meaning "made by hand." He then embarked on a long career of employing highly skilled craftsmen to execute his designs for windows, vases, lamps, and many objects of everyday use that combined glass with metal and wood. For years he personally designed almost everything produced in his studio. It was his belief—almost a crusade—that good taste could be engendered if people were surrounded by objects of beauty and fine workmanship in their homes. During the presidency of Chester A. Arthur, Tiffany was commissioned to redecorate all the public rooms in the White House. One of the most ambitious items in this undertaking was a massive stained glass screen (since removed) that filled all one side of the entrance foyer.

As the years passed, Tiffany Studios became more commercial, with catalogs from which any of their standard patterns could be ordered. However, the high quality of craftsmanship was not sacrificed. Though objects were no longer individually designed as one-of-a-kind, Tiffany fashioned them with the intention of their becoming treasured family possessions, to be handed on to future generations as heirlooms.

N-5

Title JOHN HOWARD PAYNE MONUMENT, 1882
Location Oak Hill Cemetery, R and 30th Streets, NW, adjacent to the chapel
Sculptor Moffitt and Doyle, New York stonecarvers
Architect Unknown
Medium Marble

John Howard Payne (1791–1852), born into a prosperous New York City family, left Union College to become an actor in 1809. After a tremendous initial success on the stage, he spent much of the remainder of his life a mediocre actor and theater manager. Because of his family connections, however, he moved in the best social and literary circles of

his time. Payne spent many years in London and Paris managing theaters and writing plays. During the 1820s, in Paris, he wrote several plays in collaboration with American author Washington Irving. His three-act comedy, *Charles the Second; or The Merry Monarch,* was one of his few brilliant successes on the London stage in 1824. Finding himself heavily in debt, Payne returned to America in 1832. In 1835 he traveled from New York to Georgia to study the Cherokee Indians, but was arrested as a northern abolitionist and was forced to return to New York.

Through his friend Daniel Webster, Payne successfully applied to President John Tyler for an appointment in the United States Foreign Service. He was consequently appointed as U.S. consul at Tunis, 1842–1845. President Millard Fillmore reappointed Payne to his old post in 1851, where he was serving at the time of his death in April 1852. Payne, a life-long bachelor, was buried in the Protestant Cemetery in Tunis.

From a single song, in an obscure play, *Clari, or, The Maid of Milan,* Payne gained immortality. His *Home, Sweet Home!* became one of the most widely sung songs in the English language during the nineteenth century. Payne received 50 pounds for the play, written in Paris in 1823, but not a penny for his song.

William Wilson Corcoran, Washington philanthropist and founder of Oak Hill Cemetery, arranged to have Payne's body exhumed and brought to Washington for burial thirty-one years after his death. In 1883, the lead casket arrived in Washington and was deposited overnight in the old Corcoran Gallery of Art (present Renwick Gallery). The following day the body was taken in a formal procession to Oak Hill Cemetery for reburial. President Chester A. Arthur, General William T. Sherman, cabinet members, and justices of the Supreme Court took part in the impressive procession and reinterment ceremonies conducted by Bishop William Pinkney on June 9, 1883.

The monument itself has had an interesting history. Corcoran ordered a one and a half times life-size bust sculpted (showing the poet-actor with a full beard) from a Mathew Brady photograph of Payne. Two weeks after the reinterment a rumor began in Georgetown that Payne never had a beard and an official of Oak Hill Cemetery hastily and incorrectly ordered the beard shaved off the bust by a Washington stonemason. A photograph of the bust on the day of the reinterment does indeed show Payne with a full beard. Corcoran, who had seen Payne act on the stage in Washington as a boy, was not a close friend of the poet but was very fond of the poem, *Home, Sweet Home!*. The inscription on the base of the 12-foot-high monument includes part of the famous verse:

Sure when thy spirit fled,
To realms beyond the azure dome,
With arms outstretched God's angels said,
Welcome to Heaven's Home, Sweet Home.

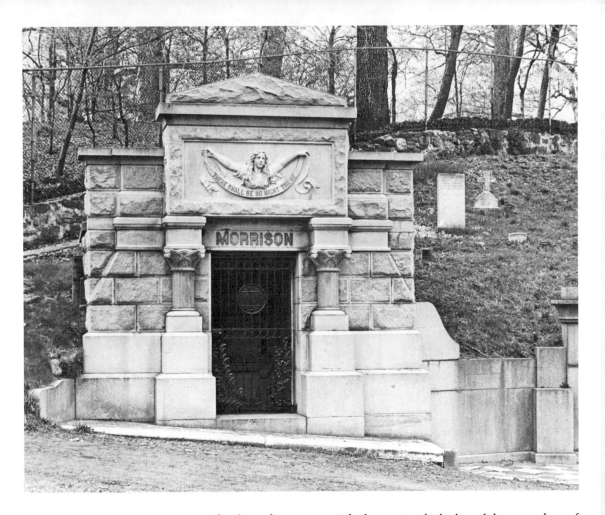

N-6

Title MORRISON MAUSOLEUM, 1889
Location Oak Hill Cemetery, R and
30th Streets, NW, Lot 216, west end
of cemetery
Sculptor J. F. Manning
Architect J. F. Manning
Medium Granite

This funeral monument, which contains the bodies of three members of the Morrison family, includes a relief panel of an angel holding a ribbon with the inscription "There Shall Be No Night There." This stylized figure possesses both a staring glance and lifeless arms. The rusticated blocks of granite make for an interesting contrast between smooth and rough surfaces. The mausoleum was most likely constructed in 1889 soon after the death of David L. Morrison (1827–1888) who was first interred within. The architectural style of this mausoleum is typical of several hundred found in Washington cemeteries, which were constructed in the Romanesque Revival style during the last quarter of the nineteenth century.

Title SAMUEL P. CARTER MONUMENT, 1895
Location Oak Hill Cemetery, R and 30th Streets, NW
Sculptor Bradley and Sons, stonecarvers
Architect None
Medium Marble

This monument to Rear Admiral Samuel Powhatan Carter contains a richly embellished pedestal and a standing female in Classical gown. As usual, statues executed by stonecarvers, such as this one, lack correct understanding of the human anatomy. Nevertheless, many of these rather amateur sculptures display original ideas in design and great charm. Underneath the head of the infant, which is nestled in the middle of a pair of angels' wings, is a bunch of roses suspended from an elaborate set of ribbons. The pediment on top of the pedestal reflects a decided Baroque influence.

Samuel P. Carter (1819–1891), a native of Carter County, Tennessee, reportedly is the only American officer who ever held the highest grades in both the United States Army and the United States Navy. Carter entered the Navy in 1840 as a midshipman. After service in the Mexican War, he was well experienced when the Civil War began in 1861. During the Civil War he served simultaneously as a lieutenant commander in the Navy and as a brevet major general in the Army. He, along with a handful of other officers were known as "horse marines" because of their dual duties. Carter commanded the cavalry division of the 23rd United States Army during most of the Civil War. He then commanded the gunboat *Monocacy* in Asiatic waters, served as the commandant of the United States Naval Academy at Annapolis 1869–1872, commanded the frigate *Alaska* in European waters 1872–1875, and then served on the Lighthouse Board in Washington, before becoming a rear admiral in 1882.

Title VAN NESS MAUSOLEM, ca. 1825
Location Oak Hill Cemetery, R and 30th Streets, NW, eastern end of cemetery
Sculptor Unkown
Architect George Hadfield
Medium Sandstone and stucco-covered brick

This finely detailed and proportioned monument was originally built at a cost of $30,000 as the Van Ness family tomb. It was first located in a small cemetery on H Street between Ninth and Tenth Streets in downtown Washington. In 1872 it was moved to its present location. The structure, which contains the remains of John Peter Van Ness and four other family members, was designed by architect George Hadfield after the ancient Temple of Vesta in Rome. It is, unfortunately, in a very dilapidated state today. Its stucco veneer has almost completely disintegrated, many of the columns have begun to crumble at the base, and the original ornamental urn, which surmounted the dome and which was moved to Oak Hill Cemetery with the main structure, has disappeared. The skillfully executed triglyphs, mutules, and proportioned metopes reflect the work of an experienced stonecarver. Architect George Hadfield (buried in Congressional Cemetery) is better known for his Washington City Hall (present District Court House) and the Custis-Lee Mansion.

John Peter Van Ness, a representative from New York in the United States Congress, married Marcia Burns in 1802. Through this marriage, Van Ness became one of the wealthiest landowners in the District of Columbia; his father-in-law, David Burns, owned much of what is downtown Washington when the District of Columbia was surveyed in 1790. The park opposite the White House, for example, was known as the "Burns' Orchard" until renamed Lafayette Park following that patriot's historic visit to Washington in 1824. The Burns tobacco farm extended from the present Twenty-Second Street, NW, to the foot of Capitol Hill.

Van Ness employed Benjamin Latrobe to design his handsome townhouse, at the corner of Constitution Avenue and Seventeenth Street, NW, about 1820. This Neoclassical mansion, with porticos on both north and south façades, was one of the largest private residences in the city at the time, and remained standing until 1908, when it was razed to make way for the present Pan American Union Building. Included in the mansion grounds, which encompassed one entire block, was the original Burns Cottage, erected about 1749. This structure, the oldest in the city, was torn down in 1894 by George Washington University officials to make way for an athletic field. The Washington Van Ness family, one of the most prominent in the city before the Civil War, has all but disappeared in the area today.

Washington Cathedral, officially known as The Cathedral Church of Saint Peter and Saint Paul, is one of the three great structures which dominate the Washington, D.C., skyline. The other two are the Capitol Building and the Washington Monument. This majestic Episcopal structure, sometimes referred to as the finest Gothic-style piece of architecture in the United States, is still under construction. The preliminary design adopted in 1907, in the manner of fourteenth-century English Gothic, was prepared by Sir George Bodley of London and his former student Henry Vaughan of Boston. In 1921 the firm of Frohman, Robb and Little became Cathedral architects and continued until the retirement of architect Philip Frohman in 1971. Frohman, a genius in Gothic design, worked for fifty years on the Washington Cathedral and executed many major revisions from its original plan. Present plans call for completion of the structure about 1982. When finished, the total length will be 517 feet and it will become the sixth largest cathedral in the world.

The principal form of enrichment of the monumental architecture consists of over 3,000 handcarved stone sculptures, mostly executed on scaffolding *in situ* or in the Cathedral carving studios by artisans of European birth. Consistent with Gothic style, the architecture and sculpture closely complement each other in this cathedral. From among all native American stones, Indiana limestone was chosen for this building, because of its fine even texture and the ease with which it can be handcarved. The vast array of carvings serve to soften the angles of intersections between molded and flat surfaces. They encompass forms from all of nature—a veritable catalog of flora and fauna. The major carved stones have a definite symbolism relating to the Bible, worship, or the history of the church. The many small architectural carvings have such names as label-mold terminations, square flowers, finials, crockets, rosettes, dentils, spandrels, trefoils, drip-mold terminations, grotesques, and gargoyles. Over 600 carved vaulting bosses will enrich the ceiling interior when the church is completed. A boss, similar in function to a keystone, is an elaborately carved stone placed at the intersection of the ceiling vaulting ribs. They are integral parts of the iconographic or didactic art of the cathedral.

Most of the exterior carvings in addition to adding interest to the monumental architecture are functional by adding weight to masonry. They provide important touches of light and shadow, thereby relieving the massiveness of the structure. At the end of each door or window molding is a carved stone known as a drip-mold termination, whose primary function while still decorative is to prevent the rainwater from running down the glass or walls and staining the stone. Such drip stones are usually fashioned in the likeness of decorative foliage, human faces, and mythological demons.

On the flying buttresses, where the small canopies intersect, there appear decorative carvings called "grotesques." They are carved to represent dog or cat faces, buffaloes, monkeys, lions, or demonic faces with a large nose from which the rainwater can drip to the roof below. Gargoyles serve the same function but project from balustrade railings and are drilled through the center to remove the water from the gutters through a long spout. Hence the rainwater runs out the animal's mouth.

This cathedral and most Gothic churches of the Middle Ages were designed in the cruciform plan. The apse (altar end) and the nave (body of the cathedral) form the long axis. The transepts form the short axis. The principal tower in this cruciform plan is located above the intersection of the two axes and referred to as the Central Tower.

The major concentrations of exterior cathedral sculpture are in the South Transept Portal, on the Central Tower, and on the majestic West Façade now under construction.

Title THE LAST SUPPER: SOUTH
TRANSEPT PORTAL, completed in
1962
Location Washington Cathedral,
Mount St. Alban, Wisconsin and
Massachusetts Avenues, NW
Sculptors Heinz Warneke—
tympanum low-relief, St. Alban
statue, low-relief quatrefoils;
Enrique Monjo—8 biblical figures
and 44 voussoir angels; Granville
Carter—Archangels Gabriel and
Michael
Architects George Bodley, Henry
Vaughan, Donald Robb, Henry
Little, Philip H. Frohman
Medium Limestone

*One of the four life-size Biblical
figures to the left of the door*

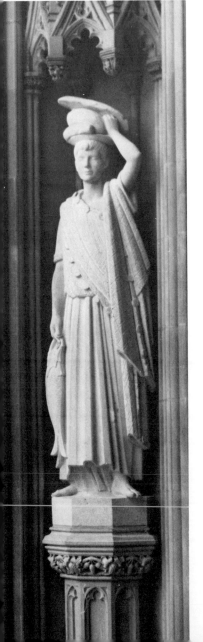

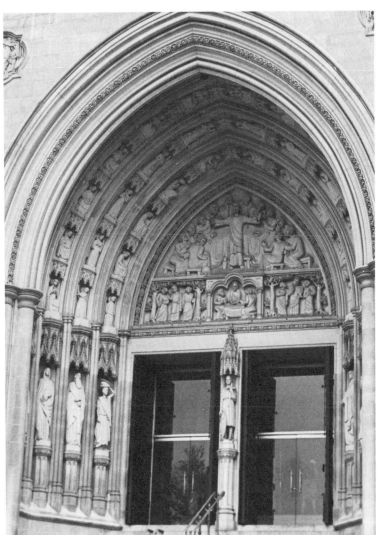

The deeply recessed entrance of the South Transept rises majestically out of the ground with a broad flight of steps. The richly carved portal features a bold relief sculpture in the tympanum above the entrance doors depicting the last supper of Jesus with His disciples. Christ appears as the dominating figure holding forth bread and wine in invitation. He is surrounded by the disciples in various positions of supplication. Beneath this assembly are three vignette scenes recalling His postresurrection appearance on the road to Emmaus. The tympanum, with a strong border of wheat shocks, was sculptured by Heinz Warneke. It was executed *in situ* by stonecarver Roger Morigi and two assistants.

Warneke also sculptured the model for the figure of Alban, the first English martyr, located in the canopied niche, or trumeau, between the doors. The first sculpture works of this transept also were provided by Warneke, being the two large quatrefoil low-reliefs above the entrance. One depicts the *Flight into Egypt*, and the other records *His Triumphal Entry into Jerusalem*.

On each side of the massive wood doors, located in canopied wall niches, are four biblical figures. They relate to the Christ figure and His invitation, "Come Unto Me." Those on the right side portray: The widow who gave her mite; the sick spirit; Nicodemus; and Lazarus. Those on the left portray: The boy with the loaves and fishes; blind Bartimaeus; the woman by the well; and Judas Iscariot, who rejected the invitation of His Master. These figures and their carving were executed in the Barcelona studio of Enrique Monjo. He also provided the forty-four angelic-figure plaster models for the four arch rings. Each

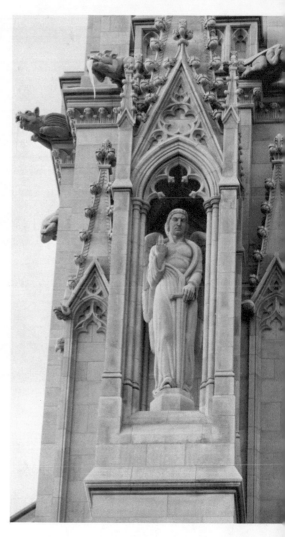

Above left: stonecarvers Frank Zic (standing) and Roger Morigi (seated) carve in place the 44 angels on the portal ceiling

Above right: Archangel Michael appears in a niche on the South Transept above the Portal

figure is approximately 2 feet in height. It took Roger Morigi and one assistant, Frank Zic, five years to carve the figures and intricate canopies in place.

Two niches high on the transept façade flanking the large rose window contain the heroic figures of Gabriel and Michael, foremost of archangels. They were carved in the Cathedral studio before installation, and reflect the design of sculptor Granville Carter.

The South Transept Façade is more characteristic of Spanish Gothic than of the cathedrals of northern Europe. It is composed of bold massive masonry, with a rich burst of concentrated sculpture at the entrance doors. The larger-than-life-size archangel niches at rose window level were included by the architect to help accomplish a pleasing translation from heavy masonry to lighter, more intricate architecture topping the transept façade.

Readers are referred to the excellent publication of the Washington Cathedral Association, *A Guide to Washington Cathedral*, for a summary of the carvings and embellishments of the building. A more serious and detailed history of the Cathedral sculpture can be found in *For Thy Great Glory*, by Richard T. Feller and M. W. Fishwick, published in 1965.

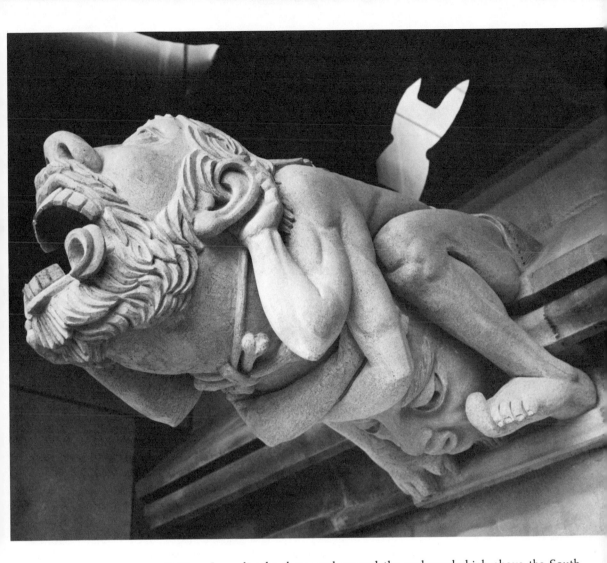

N-10

Title FOUR-ARMED BEAST, 1965
Location Washington Cathedral, Mount St. Alban, Wisconsin and Massachusetts Avenues, NW
Sculptor Carl L. Bush
Architects George Bodley, Henry Vaughan, Donald Robb, Henry Little, Philip H. Frohman
Medium Limestone

Immediately above and around the archangels high above the South Transept Portal are numerous gargoyles, carved drip-mold termination stones, and crocketed canopies. The architectural carvings on this transept were modeled by Carl L. Bush, while he was Cathedral sculptor-in-residence. The funds needed for the execution of the hundreds of gargoyles and grotesques found on the South Transept were donated in large part, by individuals. In many cases the design of the particular grotesque or gargoyle reflects the occupation or some characteristic of the individual (but not their disposition)! Thus we find an owl for a scholarly donor, a fish for a donor who was an avid fisherman, two cats for a lady who had many more live ones, the head of a horse and ears of corn for a donor from Kansas, and for a joint contribution a beast with four arms intended to be the ugliest on the Cathedral. The *Four-Armed Beast* measures 1 foot in height and 2 feet in width. For those donors who failed to specify any design, the stonecarvers have amusingly created such gargoyles and grotesques as a hooved beast with bells (symbolic of the Cathedral bellringers) and an intoxicated stonecarver with chisel and mallet in hand.

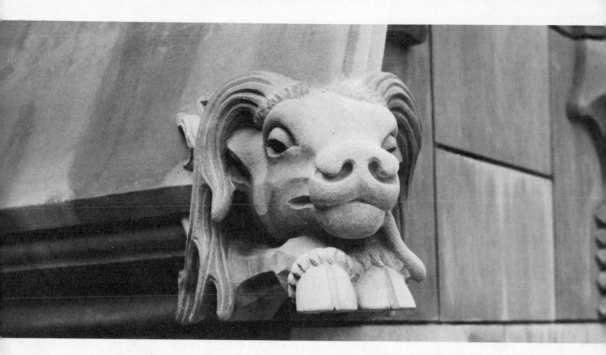

N-11
Title GOAT, ca. 1965
Location Washington Cathedral,
Mount St. Alban, Wisconsin and
Massachusetts Avenues, NW
Sculptor Constantine Seferles
Architects George Bodley, Henry
Vaughan, Donald Robb, Henry
Little, Philip H. Frohman
Medium Limestone

The hundreds of handcarved grotesques found on the roof where the buttresses intersect with the canopies, such as this *Goat*, serve as a point where the rainwater can drip to the lower roof. The water thus dripping from the noses of these limestone animals saves the walls from being stained or weakened.

If visitors have difficulty in viewing the lofty grotesques on the upper roofs, perhaps a visit to the interior would satisfy those lovers of Gothic-inspired sculpture. Above the altar are the magnificently carved Ter Sanctus (thrice holy) Reredos. These ninety-six carved figures represent the figures in the history of Christianity who have exemplified the ideals of Christ. Some 600 carved bosses have been planned for the interior ceiling at the points where the vaulting ribs intersect. Those bosses on the interior ceiling near the West Portal relate to the lines of the Nicene and Apostles' Creeds. The label mold terminations found in the nave depict scenes from the Old Testament and the Book of Acts. In other parts of the nave, such as the Great Choir area, these stones are sculptured in the form of musical instruments. Others illustrate foliage and animals. Other interior sculpture, such as the shields of the various Episcopal seminaries under the balconies, are purely decorative.

Title Angels: The Gloria in Excelsis Central Tower, completed 1964
Location Washington Cathedral, Mount St. Alban, Wisconsin and Massachusetts Avenues, NW
Sculptors Carl L. Bush—angel frieze, crockets, finials, angelic termination stones; Marion Brackenridge—free standing angel figures at balustrade level
Architects George Bodley, Henry Vaughan, Donald Robb, Henry Little, Philip H. Frohman
Medium Limestone

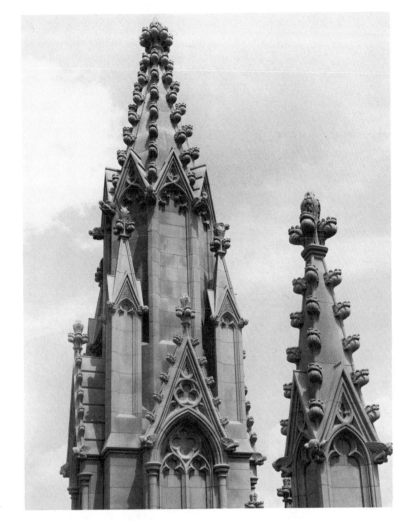

Hundreds of praying angels are located on the pinnacles of the Central Tower

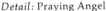

Detail: Praying Angel

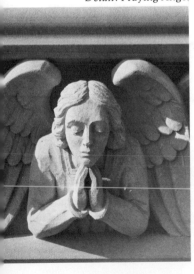

The Central or Gloria in Excelsis Tower, completed in 1964, rises 301 feet above the South Transept roadway, to form the highest building structure in the District of Columbia. It houses a 53-bell carillon and 10-bell English ring. Carillon concerts are given regularly by the full-time carillonneur, whereas the ring of Whitechapel bells is served by a band of volunteer ringers who pull the hand ropes.

This tower is enriched with 388 carved angelic figure heads. The angel frieze just beneath the top balustrade of this tower is unique among Gothic cathedrals. Over ninety-five different facial features distinguish the faces. They were created by Carl L. Bush and carved in place by Cathedral stonecarvers. There are no demonic likenesses in the tower carvings, as here the angels cast their eyes downward to the gargoyles and grotesques below. Bush, as the then sculptor-in-residence, provided all the models for the sundry crockets, finials, and termination stone carvings.

Topping the tower as a lacy crown is the open balustrade, with four majestic pinnacles at the corners. The pinnacles point heavenward to lift the eyes ever higher. Their use atop flying buttresses is for a practical purpose in helping to anchor the buttresses to the ground, but here on the tower they are essentially decorative. Eight smaller pinnacles rise from each balustrade. These pinnacles are enriched with a multitude of carved crockets, and each is topped with a beautiful and delicate finial stone. A finial, the topmost stone on any Gothic pinnacle, resembles a cross when observed against the skyline.

Gracing the balustrade of each face of the tower are three free standing angelic figures. Models for these were created by Marion Brackenridge. These figures are the finial stones for the trio of gablet openings in the belfry beneath.

N-13
Title THE CREATON, work in progress, 1973
Location Washington Cathedral, Mount St. Alban, Wisconsin and Massachusetts Avenues, NW
Sculptors To be selected
Architects George Bodley, Henry Vaughan, Donald Robb, Henry Little, Philip H. Frohman
Medium Limestone

Second only to the reredos of the high altar in the east end of the Cathedral, will be the sculpture of the West Façade and its three portals. After sixty years of building the Cathedral from east to west, the first stone of the soaring West Façade was laid in May 1970. Thus began the twelve to fifteen years of effort necessary to build the West Façade to sufficient height to enclose the now unfinished end of the nave. There are three portal entrances, each having a twin pair of monumental door openings separated by a trumeau niche. The iconographic scheme for the façade sculpture calls for an expression of the doctrine of creation—not creation that ceased at the end of the sixth day, but ongoing creation.

The center portal tympanum will portray a working God in the act of beginning His creation: the act of creating something out of nothing; of bringing order out of vast chaos. Notwithstanding the fact that there may be intelligent life on other planets, it is our realm to believe that Man (Homo sapiens) is God's noblest creation and is a reflection of the image of God. The trumeau niche between the doors and beneath the tympanum low-relief will contain a figure of an unfinished Adam. On several levels this sculpture will suggest the uncompleted state of Man's development.

The tympanum of the North Tower Portal will offer a panoply of the visible universe inhabited by Man. This is the earth on which Man lives, moves, and sustains himself. The trumeau niche beneath will contain a figure of Peter, the fisherman and disciple. The north tower of the Cathedral is named for this apostle.

Man does not live by bread alone. He enjoys spirit, history, philosophy, and music. There is also an invisible universe created by Divine Will that was unknown to artist and scientists of earlier periods. In the not too distant future artists will be challenged to symbolize the invisible world in the carving of the South Tower Portal. The trumeau statue beneath will aptly be the Apostle Paul, greatest intellect of the early Christian church, and namesake of the south tower.

Other carvings, and twin large low-relief medallions of the Central Portal will depict aspects of the Creation theme. Of particular note should be the large bronze gates for each door opening. Entirely sculptural in design, they will be a universal assembly of flora and fauna, each pair containing the flora and fauna of one of the major continental land masses. In all probability the last Gothic cathedral ever to be built, the rising West Façade provides an opportunity for the observer to witness monthly or yearly the assembly of such a monumental array of sculpture.

Title PRODIGAL SON, 1961
Location Washington Cathedral,
Mount St. Alban, Wisconsin and
Cathedral Avenues, NW
Sculptor Heinz Warneke
Architect Unknown
Medium Granite

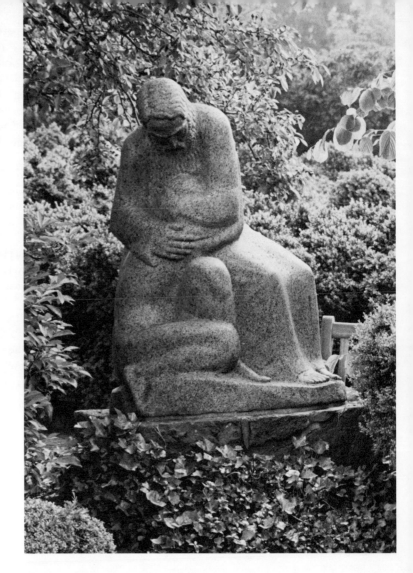

The statue of the father embracing his wayward son was carved directly on granite by Heinz Warneke and is located adjacent to the Herb Cottage in the Bishop's Garden of the Washington Cathedral. It is 6½ feet overall; the life-size figures appear on a low pedestal of mortared field stone. The sculpture depicts the moment of the son's return: the seated father embraces his kneeling child. It is not a detailed carving, but rather one which suggests the poignancy—the love and forgiveness—of the welcome. The Biblical reference is found on a plaque at the back of the statue. In memory of Hennen and Mary Jennings and dedicated in 1961, the statue is sequestered in the shrubbery of the formal rose garden inside the Bishop's Garden.

The story of the Prodigal Son is found in the Bible in Luke 15: 11–32. The younger of two sons belonging to a prosperous farmer requested his inheritance. After he received the money from his father he traveled into a foreign country where he wasted it on "riotous living." He soon was forced to become a tender of swine to gain the bare necessities of life. Remembering that his father's servants were well fed he decided to return home, ask forgiveness, and apply for a position as servant. Upon his unexpected return, his father received him back as his son, dressed him in the best of clothes, and called for a feast. The older son returned from the fields to find the entire household celebrating the return of the prodigal son. The older son complained that he had labored for many years while his brother was wasting his inheritance and now, upon his return, he was treated as an honored guest. The father therefore told his older son that he loved them equally well but that "This thy brother was dead, and is alive again, and was lost, and is found."

Title LIEUTENANT GENERAL GEORGE
WASHINGTON, 1959
Location Washington Cathedral,
Mount St. Alban, Wisconsin and
Cathedral Avenues, NW, in the
close south of South Transept
Sculptor Herbert Hazeltine
Architect Unknown
Medium Gilded bronze

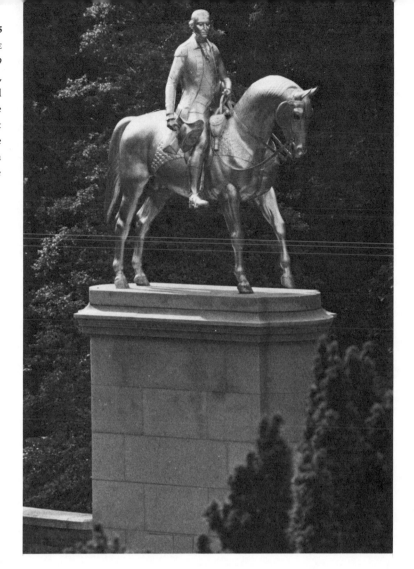

In a clearing near the foot of the Pilgrim Steps is a statue of *Lieutenant General George Washington* on horseback. His pose suggests that he has ridden through the woods and, coming to a clearing, pulls up his horse to view the hilltop as a site for the Cathedral. The statue is one and a half times life size, 10 feet in height on a 15-foot pedestal. Sculptor Herbert Hazeltine is known for his animal and portrait figures. The head of Washington was inspired by a Rembrandt Peale painting, property of the Cathedral. Other horses done by Hazeltine are the mount of Field Marshal Sir John Dill in Arlington National Cemetery and a statue of the thoroughbred Man o' War in Lexington, Kentucky. Note that the horse's eyes are turned almost full view to the South Transept, although the head is directed west. The statue was cast in bronze and finished in satin gold in Brussels, Belgium. The gold over-leaf, a mixture of gold and mercury, was done in a rather dark studio and the elderly Hazeltine put more gold leaf on the statue than perhaps was adequate. The sculpture is unique in the city in that the eyes of the horse are glass, executed in the Egyptian manner. Dedicated on February 22, 1959, in memory of Washington's "exalted patriotism, integrity, and wise statesmanship," the work is best viewed from a distance, from the top of the Pilgrim Steps, for example.

It is not impossible that Washington, when alive, might have ridden where the statue now stands, while surveying the area as a site for the new capital city. In 1790 Congress authorized the creation of a 10-mile-square federal district to be given to the government by the adjacent states of Maryland and Virginia. Washington was instrumental in choosing the present site, not far north of his Mount Vernon estate and

including two centers of population, Georgetown and Alexandria. (In 1846 Washington, D.C., residents south of the Potomac, dissatisfied at the slow development of that area, succeeded in having it returned to Virginia. The present District of Columbia comprises only 69 square miles instead of the original 100.)

It was fitting that the new capital should be named for the country's first president, all the more so because it became practically his child. With remarkable sagacity he entrusted a young French engineer who had served in the Revolutionary War, Pierre Charles L'Enfant, with the task, then unique, of planning a national capital from scratch. Perhaps only a Frenchman, familiar with the broad avenues, squares, gardens, and monumental architecture of Paris, could have had the vision of space and grandeur which L'Enfant put in his plan. The focal center of the city, as he saw it, would be "Congress House," from which cere- monially wide avenues would radiate in four directions, intersecting other avenues and superimposed on the grid of streets. For this building he could discover no situation more advantageous than "the west end of Jenkins Heights, which stands as a pedestal waiting for a monu- ment." Washington wrote that the Nation "would produce a city, though not as large as London, yet with a magnitude inferior to few others in Europe."

In 1800, with the Congress House, the President's House, and the original Treasury Building nearing completion, the federal government officially moved from Philadelphia to Washington, D.C.

N-16
Title GARTH FOUNTAIN, 1968
Location Washington Cathedral,
Mount St. Alban, Wisconsin and
Cathedral Avenues, NW, small
enclosure near North Transept
Sculptor George Tsutakawa
Architect None
Medium Silicone bronze

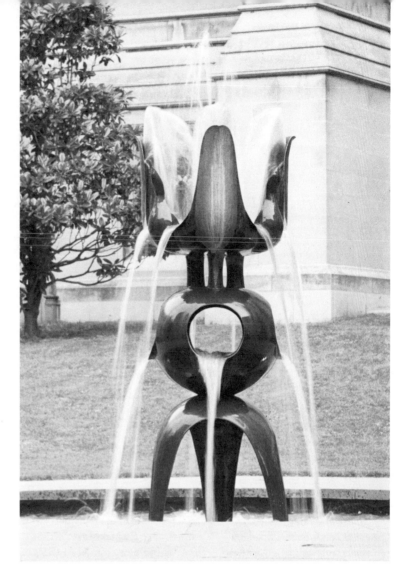

A large, abstract fountain, suggestive of a lotus flower, is found in the Garth or small enclosure, near the Cathedral's North Transept. Sheets of silicone bronze, a durable marine metal, were used by sculptor George Tsutakawa of Seattle, Washington, in modeling the 15-foot fountain. The water flowing in the center of the fountain (some 400 gallons per minute) resembles a blossom unfolding; it falls through leaflike forms to a pool which is home for several frogs. The fountain, dedicated in 1969, was given in memory of Irenée duPont by descendants of her family and members of the Delaware National Cathedral Association.

This sculpture was created in the studio of George Tsutakawa in Seattle. Mr. Tsutakawa, who teaches art and sculpture at the University of Washington, has produced over forty fountains since 1950. These works, almost all made of silicone bronze and designed with pumps within the fountains themselves, are located throughout the United States and Canada. Most of these fountains were designed in the shape of stacked forms. The water systems built into the fountains become one with the bronze forms. The harmony and rhythm created by this method have made his works extremely popular with the public.

N-17

Title QUALITIES OF WOMANHOOD, 1900

Location Hearst Hall, Washington Cathedral grounds, Wisconsin Avenue and Woodley Road, NW

Sculptor Louis Amateis

Architect Robert W. Gibson

Medium Limestone

Standing in the northwest corner of the grounds of the Washington Cathedral is Hearst Hall, a large three-story limestone Italian Renaissance building completed in 1900 for use as the first home of the National Cathedral School for Girls. The school was the first building erected on the church property (even before construction began on the Cathedral itself in 1914). At that time, it was envisioned that all structures would be designed in the same architectural style. However, this proved not to be the case and the Cathedral now nearing completion is pure Gothic both in design and in construction.

The construction of Hearst Hall was made possible by a contribution of $200,000 by Mrs. Phoebe Apperson Hearst. Born a Virginian, Mrs. Hearst, while still young, moved with her prosperous farmer-father to Missouri. At the age of nineteen, while teaching school there in 1862, she married George Hearst (1820–1891), a native of Missouri who became a very successful prospector and miner in California. Their son, William Randolph Hearst, managed the *San Francisco Examiner* and other family-owned newspapers. Mrs. Hearst continued to maintain a residence in Washington at 1400 New Hampshire Avenue, NW, after the death of her husband, who served as United States senator from California 1886–1891. She devoted the last years of her life as a benefactor of education, founding many kindergartens in California and in the District of Columbia, the Parent-Teachers Association, the National Cathedral School for Girls, and establishing many scholarships for women. In 1893, when Congress chartered the National Cathedral Foundation, the rector of St. John's Church, Lafayette Square, approached Mrs. Hearst and asked her to assist with the establishment of a school for girls under the direction of the proposed National Cathedral. In 1896, the present site of Mount St. Alban was selected for the Cathedral and, in 1897, construction began there on Hearst Hall. The National Cathedral School for Girls opened in the new 160-room building in 1900. Through the early efforts of the first principals, Miss Mary B. Whiton and Miss Lois A. Bangs, the school achieved such high national academic standing that its graduates were soon admitted without examination into the best women's colleges in the country.

With the growth of the National Cathedral School for Girls, a decision was reached to move the school two blocks away to the recently acquired "Rosedale" estate, consisting of the 1790 residence built by General Uriah Forrest and the surrounding 10 acres. Here three modern residence halls were erected in the late 1960s and Hearst Hall was transferred for use as the National Cathedral Association Center.

The sculpture on the west side of Hearst Hall (facing Wisconsin Avenue) is done in low-relief and fills the spandrels between the four stately arches resting on pilasters which enclose four great windows. Five Neoclassical female figures represent from left to right the *Qualities of Womanhood*: "Purity," "Faith," "Art (Music)," "Motherhood," and "Nursing." These gracefully designed figures with flowing drapery were well executed by the sculptor Louis Amateis and undoubtedly the meanings of the sculptured panels, 6 feet high and 6 feet wide, reflected the ideals and inspiration for the education of young girls at the beginning of the twentieth century.

N-18
Title THE MADONNA OF THE TRAIL, 1929
Location Wisconsin Avenue, Bethesda, Maryland, at the Post Office corner
Sculptor Auguste Leimbach
Architect None
Medium Aldonite stone

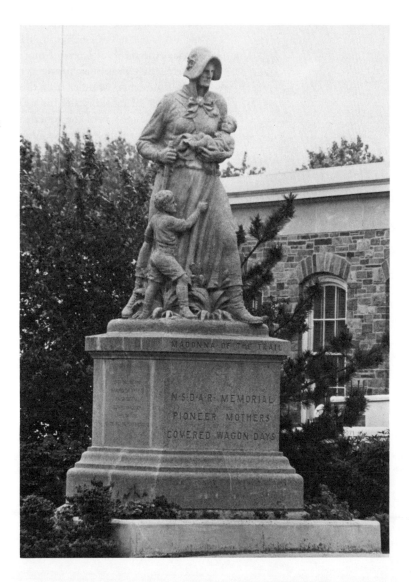

The Madonna of the Trail is one of twelve statues erected in the 1920s by the National Society, Daughters of the American Revolution, in those states through which passed from the East to the West the old trails of the American pioneers. All are identical in design. The Bethesda statue is farthest east; the one in Uplands, California, the westernmost.

Consisting of the figure of a woman, clad in homespun, holding her baby while her son looks forward by her side, the memorial commemorates the pioneer mothers of the covered wagon days. The statue is 9 feet high and 3½ feet wide.

The Wisconsin Avenue site was selected because it was the popular Georgetown-to-Frederick Town Road of the eighteenth century. It was also known as "Braddock Road," for here on April 14, 1755, British Major General Edward Braddock and his troops, with young George Washington as aide-de-camp, passed en route to Fort DuQuesne, now Pittsburgh, Pennsylvania.

Westward from Bethesda, the next statue is located at Washington, Pennsylvania, where a road was authorized in 1807 by Congress to proceed through the Allegheny Mountains. Thomas Jefferson selected the route, which extended from Baltimore, Maryland, to Vandalia, Illinois.

The third statue is located at Wheeling, West Virginia; the fourth statue at Springfield, Ohio; the fifth statue at Richmond, Indiana; and the sixth statue at Vandalia, Illinois. These six statues mark the famous Cumberland Road, also called the Old National Trail, or National Pike.

The remaining six statues are west of the Mississippi River. The seventh is located at Lexington, Missouri; the eighth at Council Grove, Kansas; the ninth at Lamar, Colorado; the tenth at Albuquerque, New Mexico; the eleventh at Springerville, Arizona; and the twelfth at Uplands, California (20 miles from the Pacific Ocean).

The idea of marking the trails resulted from a 1909 attempt by the Missouri Daughters of the American Revolution to locate the old Santa Fe Trail. All roads had names until 1926 when major highways were assigned numbers by both the state and federal governments.

Unfortunately, the once bucolic beauty of Wisconsin Avenue has been transformed, and the statue in Bethesda has become "lost" in a sea of commercialism. The D.A.R. maintains the statue and the small plot of landscaped greenery on which it stands next to the Bethesda Post Office.

INDEX